D0514588

SIMPLICITY
the art of complexity

Edited by
Herausgegeben von
Gerfried Stocker und Christine Schöpf

Ars Electronica 2006
Festival für Kunst, Technologie und Gesellschaft
Festival for Art, Technology and Society

Organization
AEC Ars Electronica Center Linz
Museumsgesellschaft mbH

Managing Directors
Gerfried Stocker, Rainer Stadler

Hauptstraße 2, A-4040 Linz, Austria
Tel. +43.732.7272-0
Fax +43.732.7272-77
festival@aec.at
www.aec.at/simplicity

Co-organizers

ORF Oberösterreich
General Director: Helmut Obermayr

LIVA – Veranstaltungsgesellschaft mbH
CEO: Wolfgang Winkler, Wolfgang Lehner

O.K Centrum für Gegenwartskunst
Managing Director: Martin Sturm

Directors Ars Electronica
Gerfried Stocker / Ars Electronica Center
Christine Schöpf / ORF Oberösterreich

Production Management
Martin Honzik

Coordination Prix Ars Electronica
Iris Mayr

Production Team
Iris Mayr, Bianca Petscher, Manuela Pfaffenberger,
Gerlinde Pöschko, Elisabeth Sachsenhofer, Karl J.
Schmidinger, Carola Unterberger-Probst, Ewald Elmecker,
Ingrid Fischer-Schreiber, Carmen Lauss, Dieter
Mackinger, Sonja Panholzer, Jutta Schmiederer,
Klemens Schuster

Curatorial Advisors
John Maeda for Simplicity Symposium.
Kati Åberg, Sonja Bettel, David Cuartielles, Dennis
Russell Davies, Andreas Hasch, Andreas Hirsch, Naut
Humon, Pascal Maresch, Dietmar Offenhuber, Manuela
Pfaffenberger, Christa Sommerer, Ina Zwerger

Marketing & Sponsoring, Public Relations
Ursula Kürmayr, Doris Ruland, Maria Hieslmayr

Press
Wolfgang A. Bednarzek, Robert Bauernhansl

Web Editors
Maria Hieslmayr, Cornelia Sulzbacher

Web Design & Development
Michael Badics, Martin Bruner, Stefan Eibelwimmer,
Clemens Häckel, Nicolas Naveau, Dietmar Suoch,
Harald Welser

Architecture
Scott Ritter

Technical Expertise & Know-how
Ars Electronica Futurelab
www.aec.at/futurelab

Ars Electronica Center
Nicoletta Blacher, Renata Aigner, Ellen Fethke,
Michaela Lang

Ars Electronica Center System
Administration & Technical Maintainance
Gerold Hofstadler, Florian Arthofer, Bogdan
Florescu, Ulrike Gollner, Gerhard Grafinger,
Stefan Kaindlstorfer, Alexander Kneidinger,
Faruk Kujundzic, Günter Mayr, Michael Müllegger,
Florian Wanninger

Ars Electronica Administrative Team
Elisabeth Kapeller, Olivia Desl, Rita Thaller, Michaela
Wimplinger, Ronald Weber

Ars Electronica 2006 Catalog
SIMPLICITY—the art of complexity

Editors: Christine Schöpf, Gerfried Stocker

Editing: Jutta Schmiederer, Ingrid Fischer-Schreiber,
Heimo Ranzenbacher

Copyediting: Ingrid Fischer-Schreiber,
Catherine Lewis, Jutta Schmiederer

Graphic Design and Production:
Gerhard Kirchschläger

Typeface: Thesis Sans

Printed by: Gutenberg-Werbering
Gesellschaft m.b.H., Linz

Paper: Prelude matt, 135 g/m²

Binding: CPI Moravia Books, Korneuburg

© 2006 Ars Electronica
© 2006 for the reproduced works by the artists
or their legal successors

Published by
Hatje Cantz Verlag
Zeppelinstraße 32
73760 Ostfildern
Germany
Tel. +49 711 4405-200
Fax +49 711 4405-220
www.hatjecantz.com

*Hatje Cantz books are available internationally
at selected bookstores and from the following
distribution partners:*

USA/North America – D.A.P., Distributed Art
Publishers, New York, www.artbook.com
UK – Art Books International, London,
www.art-bks.com
Australia – Tower Books, Frenchs Forest (Sydney),
www.towerbooks.com.au
France – Interart, Paris, www.interart.fr
Belgium – Exhibitions International, Leuven,
www.exhibitionsinternational.be
Switzerland – Scheidegger, Affoltern am Albis,
www.ava.ch

For Asia, Japan, South America, and Africa, as
well as for general questions, please contact
Hatje Cantz directly at sales@hatjecantz.de,
or visit our homepage at www.hatjecantz.com
for further information.

ISBN-10: 3-7757-1834-6
ISBN-13: 978-3-7757-1834-9
Printed in Austria

Cover illustration: Tsuyoshi Ozawa, Vegetable
Weapon: Saury fish ball hot pot / Tokyo, 2001;
Courtesy: Ota Fine Arts, Tokyo

ARS ELECTRONICA

HATJE
CANTZ

The Ars Electronica Center Linz
is an institution of the
municipality of Linz.
Das Ars Electronica Center Linz
ist eine Einrichtung der
Stadt Linz.

Ars Electronica Center Linz &
Festival Ars Electronica are supported by:

Stadt Linz
Land Oberösterreich
Bundeskanzleramt/Kunstsektion

Organization / Veranstalter

Cooperation Partners / Kooperationspartner

Kunstuniversität Linz

Lentos Kunstmuseum Linz

architekturforum oberösterreich

KunstRaum Goethestraße

Ars Electronica and Prix Ars Electronica receive support from:
Ars Electronica und Prix Ars Electronica werden unterstützt von:

Stadt Linz

Land Oberösterreich

Bundeskanzleramt / Kunstsektion

Telekom Austria

voestalpine

BBRZ Gruppe

LINZ AG

Linz AG

FESTO

FESTO

SIEMENS

Siemens Österreich

Institut Français de Vienne

Ö1

vodafone

Haberkorn

Mayer Linz

Microsoft Österreich

Sony DADC

Sony DADC

3com

CASINO LINZ

Casinos Austria

Additional Support: Frank & Partner, Pöstlingbergschlößl, Nikon, Triple X, VS Fickenscher, KulturKontakt Austria, Lenz Moser

Contents

Gerfried Stocker / Christine Schöpf
SIMPLICITY—the art of complexity 10/12

SIMPLICITY

John Maeda
SIMPLICITY—the art of complexity 14/16

John Maeda
Law 1: Reduce 18/22

Paola Antonelli / John Maeda
The Goal of Safety is about as
Simple as it Gets 28/30

Sam Hecht
The Acceleration of Having More with Less 32/35

Walter Bender
One Laptop per Child 38/41

Olga Goriunova
When New Media are No Longer New and
Everyone Creates on the Internet 44/50

Jason Kottke
Aggregating the Whole World 56/58

Peter Wippermann
Simplexity 60/64

Gary Chang
Simplicity in Space in the Age of Complexity ... 68/72

Wolfgang Blau
Longing for Simplicity 76/81

Re-Defining Public Service
What is Public Value and What Do Community
Media Have to Do with it? 86/89

Tsuyoshi Ozawa
Vegetable Weapons 92/93

GOING TO THE COUNTRY

Going to the Country 98/104

FEATURED ARTISTS

Paola Antonelli
John Maeda's Fundamental Idea 111/111

Golan Levin
Some Thoughts Regarding John Maeda ... 112/114

John Maeda
Nature 116

Toshio Iwai
Beyond Media, Connecting Senses 124/126

Toshio Iwai
Morphovision – Distorted House 132/134

MOBILE CITY

Gerhard Blechinger
Art Becomes Technology 136/137

Bernd Wiemann
Innovation is No Coincidence 138/139

M+M
Song for C 140/142

Empfangshalle
As if we were alone!
New Spaces in the Public Sphere 144/146

Ran Tao / Jenny Chowdhury
Mobile Assassins 148/149

Jenny Chowdhury
The Cell Atlantic CellBooth 150/151

Aram Bartholl
Silver Cell 152/153

Graham Budgett / Jane Mulfinger
REGRETS Linz 154/156

Taylor Hokanson
Sledgehammer Keyboard 158/159

Christopher Romberg / Tobias Zucali
maschine – mensch 160/162

Sonja Meller
Wish Visuals
You Pick It, We Play It 163/163

Assocreation
Moon Ride 164/166

HyperWerk
nomadix – interaction on the move! 168/170

INSTALLATIONS

Aram Bartholl
Random Screen 172/173

Aram Bartholl
Papierpixel 174/175

Jonathan den Breejen / Marenka Deenstra
The PingPongPixel 176/177

Martin Frey
CabBoots 178/179

Gerhard Dirmoser / Dietmar Offenhuber
SemaSpace 180/181

Markus Decker / Dietmar Offenhuber
from dust till dawn 182/183

Nicole Knauer
curious implantation 184/186

Ars Electronica 2006

electrolobby

David Cuartielles
Make It Simple
In the space between the KISS principle
and DIY philosophy . 188/191

David Cuartielles
electrolobby – Make It Simple 195/200

Karin Ohlenschläger / Luis Rico
Productive Interventions from the Fringes
of Media Art . 204/206

CAMPUS

Philip Dean, Media Lab at the University
of Art and Design Helsinki (TaiK)
The Beta Lounge . 208/209

Christa Sommerer & Laurent Mignonneau
Tangible, Audible, Playable, Wearable
Interface Culture Student Works
at Ars Electronica 2006 234/235

Dieter Daniels / Claus Pias
When Cybernetics meets Aesthetics 244/246

Andreas Broeckmann, Dieter Daniels
Placing and Re-placing Media Art 248

The Upgrade! International 249

MUSIC FOR THE EYES

Dennis Russell Davies
Music for the Eyes . 250/252

Maki Namekawa
When Music and Computer Programs
Grow Together . 258

Some Sounds and Some Fury 260/261

Klangpark 2006
Music for a Landscape . 269/271

ARS ELECTRONICA FUTURELAB

Susanne Scheel
Music Visualization – The Interplay
of Color and Sound . 273/281

Ars Electronica Futurelab
The Further Adventures of Surfaces,
Sounds, Pixels and Colors
3-D Music Visualizations from the
Ars Electronica Futurelab 290/293

Johannes Deutsch
Vision Mahler . 296/298

Wolfgang Winkler
The Visualization of Music 300/301

Ars Electronica Futurelab
The Visualization of Le Sacre
du Printemps . 302/305

Klaus Obermaier
Music – Dance – Space
The Visualization of Le Sacre
du Printemps . 303/306

Ars Electronica Futurelab
Pixelspaces 2006: Goblin City
Media, Art and Public Spaces 308/309

Ars Electronica Futurelab
WikiMap . 324

Ars Electronica Futurelab
Theater and New Technologies
The Electric Grandmother 326/327

ARS ELECTRONICA ANIMATION FESTIVAL

Christine Schöpf / Dietmar Offenhuber
Ars Electronica Animation Festival 329/330

Prix Ars Electronica 2006 .336

ARS ELECTRONICA CENTER

Nicoletta Blacher
Space Conquests: Do It Yourself! 339/342

Andrew Hieronymi
MOVE . 346/347

Corebounce Art Collective
Digital Marionette . 348/349

The Sancho Plan
The Sancho Plan . 350/351

Takafumi Aoki
Kobito – Virtual Brownies 352/353

Kumiko Kushiyama – Presto / JST
Thermoesthesia . 354/356

Sheldon Brown
The Scalable City . 357/358

Tmema (Golan Levin and Zachary Lieberman)
The Manual Input Station 360/361

John Gerrard
Smoke Tree – A virtual sculpture 362/363

FESTO
Airacuda – Bionic Object with fin drive 364/366

Biographies . 368

Gerfried Stocker / Christine Schöpf

SIMPLICITY—the art of complexity

SIMPLICITY—the pipedream of a society dominated by technical revolutions, global networks and inundations of information from mass media? The mantra of a new generation of user-centered information designers? Dogma of technophobic naysayers to progress? Or merely the—as yet unfulfilled—promise of IT companies?

There has been hardly a concept of late that has been laid claim to in so many different quarters, and none that delivers such a trenchant reading of the vital signs of our times.

So then: just how are we to cope with the increasing degree of complexity in the reality we inhabit? How can we tap and utilize the potential of global communication and realtime-access to information and ideas, to people and markets in an efficient as well as responsible way?

How can we develop flexible, adaptable systems, devices and programs that are responsive to our strengths and intuitive capabilities, to support our activities in complex contexts?

Which options and features could we possibly do without? And which would we be only too glad to dispense with?

SIMPLICITY is not the opposite of complexity; rather, it is its complementary key, the formula that permits us to access and utilize the polyvalencies of virtual realities and global knowledge networks.

Simplicity is a complex topic that has no single, simple answer. We live in an increasingly complex technological world where nothing works like it is supposed to, and at the end of the day makes all of us hunger for simplicity to some degree. Yet ironically when given the choice of more or less, we are programmed at the genetic level to want more. "Would you like the big cookie or the smaller cookie?" or "Would you like the computer with ten processors or just one?" The choice is simple really, or is it?

For the Ars Electronica Symposium on Simplicity we think together about what simplicity (and complexity) means in politics, life, art, and technology. Expect more than you can ever imagine, and less.

John Maeda

Isn't it odd that we are incessantly at work developing new technologies meant to simplify our lives and labours, and yet in the final analysis we are left with the impression that everything's gotten a lot more complicated?

An investigation of the essence of simplicity must necessarily get involved with the psychology of human-machine interaction. Why do we display such a strong proclivity to regarding technology as an externally imposed authority, to condemning or venerating it? Why is it so hard to maintain a dis-passionate working relationship with high tech? Isn't it rather the case that complexity (supposed or actual) is often just a convenient excuse for delegating responsibility?

Our highest-priority need is not technological competence but rather the social competence that's called for in making the decisions about deploying technologies. We have to make an active effort to acquire this competence.

Simplicity begins, of course, with usability. The wish for user-friendly devices and programs is fervent and widespread. We will realize how justified it is when we inspect the plethora of shabbily designed user interfaces that hit the retail shelves in ever-shorter marketing cycles. So even as the writers of advertising-copy are busy ballyhooing the latest results of their company's purported fixation on user experience and user-centered design, the reality that we, the ones who have actually purchased these applications, are familiar with is, sadly, a different one. How very often we wish that industrial designers would pay more frequent courtesy calls on media artists and soak up a bit of the ambient inspiration during their visits!

Among the things in which human beings identify consummate artistry are the highly complex elements of nature. For centuries, models based on this elegant simplicity have been the objective and the standard of measurement for scientific as well as artistic achievement.

If we merely equate simplicity with simplification and reduction, simply let the technology become "invisible", we not only manifest our inability to even recognize the type and extent of the technological deployment, but we also relinquish the ability to perceive its consequences and side effects. In doing so, we cheat ourselves out of not only our capacity for self-determination, but also the possibility of fully utilizing technology's capabilities. But simplicity is significantly more than that. If this truly is a matter of technology suitable for use by human beings, then this also involves a cultural attitude and political stance towards technology, towards the issue of our autonomy and self-determination in dealing with technology and in designing the conditions of our interaction with technological systems. In large portions of our planet's surface, though, simplicity is also a matter of technology that's affordable, that can withstand some punishment, can stay on the job even at 105 degrees in the shade, and that doesn't need to make a pit stop at an electrical outlet every two hours.

Technology is not a force of nature. It has been made to work by humankind—so it should also be possible to make it work for humankind.

The interfaces and front lines between human and machine are the domain of artistic work that reflects the framework conditions of this liaison: in that artists create their own tools to translate between the languages of the arts and those of the machines; in that they reject industry norms and their closed systems and adopt the practices of open source and the creative commons instead; in that they defend free zones, set up portals, and create alternative models and prototypes. The strategies that result from these activities and approaches to dealing with complexity will be presented at this year's Ars Electronica Festival by artists, industrial and software designers and scientists in symposia and addresses, exhibitions and installations, concerts and performances, workshops and seminars, and artistic interventions in public spaces throughout the city.

Don't be afraid, upgrade to simplicity!

Gerfried Stocker / Christine Schöpf

SIMPLICITY – the art of complexity

SIMPLICITY – Wunschtraum einer von technischen Revolutionen, globaler Vernetzung und massenmedialer Informationsflut dominierten Gesellschaft? Mantra einer neuen Generation von nutzerorientierten Informations-Designern? Dogma technophober Fortschrittsverweigerer? Oder einfach bislang uneingelöstes Versprechen der IT-Companies?

Kaum ein Begriff ist in letzter Zeit von so unterschiedlichen Seiten in Anspruch genommen worden und trifft so sehr den Nerv unserer Zeit: Wie können wir den steigenden Komplexitätsgrad unserer Lebensrealität bewältigen? Wie können wir uns die Potenziale der globalen Kommunikation und des Realtime-Zugangs zu Informationen und Ideen, zu Menschen und Märkten effizient und verantwortungsvoll erschließen?

Wie können wir flexible, adaptive Systeme, Geräte und Programme entwickeln, die auf unsere Stärken und intuitiven Fähigkeiten eingehen, um uns bei unserem Agieren in hoch komplexen Zusammenhängen zu unterstützen? Auf welche Optionen und Features können und wollen wir verzichten?

Simplicity ist nicht das Gegenteil von Komplexität, sondern ihr komplementärer Schlüssel, die Formel, durch die sich die Polyvalenzen der virtuellen Realitäten und vernetzten Wissensräume erschließen und nutzen lassen.

Simplicity ist ein komplexes Thema, auf das es nicht eine einzige, einfache Antwort gibt. Wir leben in einer zunehmend komplexen technologischen Welt, in der nichts so funktioniert, wie es eigentlich sollte, und die uns alle am Ende des Tages mit dem Verlangen nach einer gewissen Einfachheit erfüllt. Dennoch, welch Ironie, wenn wir vor die Wahl nach mehr oder weniger gestellt werden, so sind wir wohl genetisch so programmiert, mehr zu wollen. „Möchtest du den großen oder den kleineren Keks?" oder „Hättest du gerne den Computer mit zehn Prozessoren oder nur mit einem?" Die Antwort ist doch wirklich einfach, oder doch nicht?

Beim Themensymposium SIMPLICITY der Ars Electronica wollen wir gemeinsam über die Bedeutung von Simplicity (und damit auch Complexity) in Politik, Leben, Kunst und Technologie nachdenken. Erwarten Sie mehr, als Sie sich jemals vorstellen können, und weniger.

John Maeda

Ist es nicht seltsam, dass wir ständig neue Technologien entwickeln, um uns Leben und Arbeit einfacher zu machen? Und am Ende haben wir den Eindruck, es sei alles viel komplizierter geworden.

Die Hinterfragung des Wesens von Simplicity muss sich einlassen auf die Psychologie der Mensch-Maschine-Beziehung. Warum neigen wir so sehr dazu, Technologie als eine externe Instanz zu betrachten und sie zu verdammen oder zu verherrlichen? Warum ist es so schwierig, eine nüchterne Beziehung zu ihr zu finden? Ist uns der Befund vermeintlicher oder tatsächlicher Komplexität nicht allzu oft eine bequeme Ausrede, um Verantwortung zu delegieren?

Was wir brauchen, ist nicht vorrangig Technologiekompetenz, sondern Sozialkompetenz, um über den Einsatz von Technologien entscheiden zu können. Um den Erwerb dieser Kompetenz müssen wir uns aktiv bemühen.

Simplicity beginnt natürlich bei der Bedienbarkeit, der Usability. Der Wunsch nach Geräten und Programmen, die man auch ohne lange Einschulung bedienen kann, ist groß und höchst berechtigt, denkt man an die vielen schlampig entwickelten User-Interfaces, die in immer kürzeren Zyklen auf den Markt geworfen werden. Auch wenn Hersteller gerne die Rede von der User Experience und dem User Centered Design inflationär im Munde ihrer Werbekampagnen führen, die Realität der technischen Lösungen, die uns verkauft wird, ist eine traurig andere. Wie oft wünscht man sich, die Industrial Designer würden häufiger bei den Medienkünstlern vorbeischauen und sich inspirieren lassen.

Zu den kunstvollsten Dingen für den Menschen zählen die hoch komplexen Elemente der Natur. Für Jahrhunderte war die Nachempfindung dieser eleganten Einfachheit Ziel und Maß wissenschaftlicher wie künstlerischer Leistungen.

Wenn wir Simplicity nur als Vereinfachung und Reduktion verstehen, die Technologie „unsichtbar" werden lassen, und so Art und Umfang des Einsatzes von Technologie einfach ausblenden, dann können wir auch die Aus- und Nebenwirkungen nicht mehr nachvollziehen. Dann berauben wir uns nicht nur der Selbstbestimmung, sondern auch der Möglichkeit, die Kapazitäten und Potenziale der Technologie voll auszunutzen.

Simplicity ist aber wesentlich mehr. Wenn es tatsächlich um menschengerechte Technologie gehen soll, dann ist es auch eine kulturelle und politische Haltung zur Technologie und eine Position der Autonomie und Selbstbestimmung in den Interaktionsbeziehungen zu den technischen Systemen. Für weite Teile unseres Planeten ist Simplicity ganz einfach eine Angelegenheit von billiger und robuster Technologie, die auch bei 40 Grad im Schatten noch klaglos funktioniert und nicht schon nach zwei Stunden wieder an eine Steckdose muss.

Technologie ist keine Naturgewalt, sondern wird von Menschen gemacht – also sollte es doch auch möglich sein, sie für Menschen zu machen.

An diesen Schnittstellen und Frontlinien zwischen Mensch und Maschine findet die künstlerische Arbeit statt und reflektiert die Umstände und Rahmenbedingungen dieser Liaison: indem sich KünstlerInnen ihre eigenen Werkzeuge schaffen, um zwischen den Sprachen der Künste und der Maschinen zu übersetzen, indem sie sich den Industrienormen und ihren geschlossenen Systemen verweigern und Open Source und Creative Commons praktizieren, indem sie Freiräume verteidigen und Portale schaffen und alternative Modelle und Prototypen kreieren.

Strategien und Lösungsansätze für den Umgang mit Komplexität werden bei der diesjährigen Ars Electronica im Dialog zwischen KünstlerInnen, Industrie- und Software-DesignerInnen, WissenschaftlerInnen und KulturtheoretikerInnen diskutiert und in vielfältiger Form präsentiert: in Symposien und Künstlervorträgen, Ausstellungen und Installationen, Konzerten und Performances, Workshops und Seminaren und durch künstlerische Interventionen in öffentlichen Räumen, überall in der Stadt.

Don't be afraid, upgrade to simplicity!

John Maeda

SIMPLICITY—the art of complexity

A simple life. It seems like something we would all like to have. But like everything you don't have and desire, once you get what you want, boredom inevitably sets in. The hustle and bustle of daily work motivates you to go on a vacation and relax. Simplicity achieved. But after relaxation has settled in, complexity beckons. There has to be more to life! So we douse ourselves with complexity and continue the ritual of complexity, simplicity, complexity, simplicity, complexity until at the very end of our lives when by no longer existing we achieve the ultimate in simplicity—nonexistence.

On the surface, all artistic practices support complexity: the *addition* of a concept to the visual, auditory, or tactile realm. However some art, although additive to the universe of concepts and objects around us, helps to simplify the world by having a subtracting effect more than it adds to the surrounds. Technology art, in particular that which pertains to the computer as opposed to purely kinetic art, is generally neither simple nor complex. It is both. And that is what makes technology art difficult to fit comfortably into any previous genre. It's complex: there are cryptic instructions and rituals required to maintain and interact with most technology art. It's simple: many of the codes used to create technology art are trivial in comparison to the complex experiences they synthesize. If asked to choose whether to have a traditional oil painting or a computational art piece hanging in my living room, I would choose the painting for simplicity's sake. But I'm unlikely to be in my living room and enjoy the painting, because I am usually in front of my computer—which has become the living room of most contemporary minds.

To embrace the computer's world is to accept complexity at a level that we truly cannot comprehend. The computer screen deceives us with its array of pixels—we believe that we are seeing the entire picture that the computer sees. But we're not. What is on the screen only represents a minority of the thought processes active at any given moment on the computer. We are only catching the merest glimpse of the swirl and torment of the computer's mind. The simplicity of the computer's interface helps us sit atop the complexities rampant inside the computer. Do we really want to dip deeper into its inner chaos?

I used to believe that programming was an important skill for any technology artist. I no longer believe that. I still believe that it's a critical set of concepts to master of course, but not for the objective of creating technology art. Computer programming is limited in ways that have always bothered me. But you need to understand programming to say that. A new generation of programming languages or paradigms has to emerge before we can finally harness the power of the computer. I do not know what these new systems will look or feel like. To get there, we will have to master the understanding of complexity, or *the art of complexity* as is the title of this year's Ars Electronica symposium.

The stellar international panel of speakers that we have invited will all speak about various aspects of simplicity, and undoubtedly complexity. How do we live? How will we live? What do we fear? What do we desire? The discussion, I expect, will become extremely complex. And then, it is my hope, we will begin to see the connections that bind any discussion from multiple disci-

plines on simplicity. We will organize, reduce, and synthesize a body of knowledge together as a trusted panel, with the hope that participants can make the choice themselves regarding their path to simplicity, or complexity.

I recently finished the writing of a new book, entitled *The Laws of Simplicity*, which is available for the first time in Europe here at Ars Electronica. People ask me to summarize the book in a few sentences. I find this difficult, as I know simplicity to be such a complex subject. In short the book is about my own personal perspectives on simplicity, as communicated through ten laws on how we value simplicity. For example, the Third Law *TIME* is "Savings in time feel like simplicity." I open my discussion of the Third Law in *The Laws of Simplicity* as follows:

> "The average person spends at least an hour a day waiting in line. Add to this the uncountable seconds, minutes, weeks spent waiting for something that might have no line at all.
>
> Some of that waiting is subtle. We wait for water to come out of the faucet when we turn the knob. We wait for water on the stove to boil, and start to feel impatient. We wait for the seasons to change. Some of the waiting we do is less subtle, and can often be tense or annoying: waiting for a Web page to load, waiting in bumper-to-bumper traffic, or waiting for the results of a dreaded medical test.
>
> No one likes to suffer the frustration of waiting. Thus all of us, consumers and companies alike, often try to find ways to beat the ticking hand of time. We go out of our way to find the quickest option or any other means to reduce our frustration. When any interaction with products or service providers happens quickly, we attribute this efficiency to the perceived simplicity of experience.
>
> Achieving notable efficiencies in speed are exemplified by overnight delivery services like FedEx and even the ordering process for a McDonald's hamburger. When forced to wait, life seems unnecessarily complex. *Savings in time feel like simplicity.* And we are thankfully loyal when it happens, which is rare.
>
> Then there's the implicit benefit: reducing the time spent waiting translates into time we can spend on something else. In the end it's about choosing how we spend the time we're given in life. Shaving ten minutes off of your commute home translates to ten more minutes with your loved ones. Thus a reduced wait is an invaluable reward not only with respect to business, but also to life and your well-being."[1]

The other Laws cover issues ranging from the superficial aspects of an experience like the interface, to the deeper issues that embody an experience such as emotional concerns. All of the Laws are available on my website *lawsofsimplicity.com,* where the discussion will continue for many years I hope. And I am happy to be at the very beginning of this discussion here at Ars Electronica with all of you.

1 From John Maeda, *The Laws of Simplicity*, Cambridge, MA: The MIT Press 2006, p.26

John Maeda

SIMPLICITY – the art of complexity

Ein einfaches Leben. Eigentlich wollen wir das doch alle. Aber wie alles, das man nicht hat und sich sehnlichst wünscht, paart es sich unweigerlich mit Langeweile, sobald es in Erfüllung geht. Das hektische Treiben in der täglichen Arbeit motiviert uns zu Urlaub und Erholung. Endlich Einfachheit! Sobald sich aber Erholung einstellt, lockt die Komplexität. Es muss doch noch mehr im Leben geben! Wir tauchen wieder in die Komplexität ein und setzen das Ritual von Komplexität, Einfachheit, Komplexität, Einfachheit, Komplexität fort, bis wir am Ende unseres Lebens durch unser Nicht-mehr-Sein die höchste Stufe der Einfachheit erlangen – Nicht-Existenz. Oberflächlich betrachtet, unterstützen alle künstlerischen Praktiken Komplexität: durch das *Hinzufügen* eines Konzepts zum visuellen, auditiven oder taktilen Bereich. Dennoch vereinfacht so manche Kunstform – obwohl sie dem Universum aus Konzepten und Objekten um uns Dinge hinzufügt – dank ihres eher subtrahierenden als addierenden Charakters die Welt. Technologiekunst, und im Besonderen die Computer- im Gegensatz zur kinetischen Kunst, ist im Allgemeinen weder einfach noch komplex. Sie ist beides. Deswegen will die Technologiekunst auch nicht so recht in eine der vorher genannten Kategorien passen. Sie ist komplex: Zur Erhaltung des Kunstwerks und zur Interaktion damit sind kryptische Anweisungen und Rituale notwendig. Sie ist einfach: Im Vergleich zu den komplexen Empfindungen, die sie hervorrufen, muten die Codes hinter den Kunstwerken geradezu trivial an. Vor die Wahl gestellt, ein traditionelles Ölgemälde oder ein Computerkunstwerk in meinem Wohnzimmer aufzuhängen, würde ich mich der Einfachheit wegen für das Gemälde entscheiden. Es ist aber sehr unwahrscheinlich, dass ich im Wohnzimmer bin und mich am Bild erfreue, weil ich für gewöhnlich vor dem Computer sitze – der für die meisten von uns zum Wohnzimmer geworden ist.
Um die Computerwelt annehmen zu können, müssen wir einen Grad an Komplexität hinnehmen, den wir definitiv nicht erfassen können. Der Computer täuscht uns mit seinen Pixelreihen – wir meinen das gesamte Bild zu sehen, das auch der Computer sieht. Das stimmt aber nicht. Am Bildschirm sehen wir nur einen Bruchteil der zu jedem beliebigen Zeitpunkt am Computer aktiven Prozesse. Wir erfassen nur einen winzigen Ausschnitt des Gewirrs und der Pein des Computerhirns. Die Einfachheit der Computerschnittstelle lässt uns über den im Inneren des Rechners überbordenden Komplexitäten stehen. Wollen wir wirklich tiefer in dieses innere Chaos vordringen? Ich war immer der Meinung, Programmieren wäre für jeden Technologiekünstler eine wichtige Fertigkeit. Das glaube ich nicht mehr. Ich bin zwar überzeugt, dass die Beherrschung der Grundbegriffe des Programmierens unumgänglich ist, aber nicht, um Technologiekunst schaffen zu können. Die Grenzen des Programmierens haben mich immer gestört. Um das sagen zu können, muss man sich allerdings damit auskennen. Es muss erst eine neue Generation von Programmiersprachen oder -paradigmen entwickelt werden, um das Potenzial des Computers voll ausschöpfen zu können. Ich habe keine Vorstellung, wie diese neuen Systeme aussehen oder sich anfühlen werden. Um aber dorthin zu gelangen, müssen wir die Komplexität – oder „The Art of Complexity", den Titel des diesjährigen Ars-Electronica-Symposiums – verstehen lernen.
Wir haben eine illustre Reihe von Vortragenden eingeladen, die über die unterschiedlichen Aspekte der Einfachheit – und wohl auch der Komplexität – sprechen werden. Wie leben wir? Wie werden wir leben? Was fürchten wir? Wonach sehnen wir uns? Ich denke, dass die Diskussion darüber ausgesprochen komplex wird. Und dann, so hoffe ich, werden wir allmählich die Zusammenhänge sehen, die jede interdisziplinäre Diskussion zum Thema Einfachheit verbinden. Gemeinsam werden wir auf diesem Podium des Vertrauens einen Wissenskatalog organisieren,

reduzieren und synthetisieren und hoffen, dass dabei jeder Teilnehmer die Wahl für seinen Weg zur Einfachheit oder Komplexität treffen kann.

Vor kurzem habe ich mein neues Buch *The Laws of Simplicity* fertiggestellt, das in Europa erstmals hier bei der Ars Electronica erhältlich sein wird. Immer wieder werde ich gebeten, es in ein paar Sätzen zusammenzufassen. Das ist meines Erachtens schwierig, da Einfachheit ein so komplexes Thema ist. Kurz gesagt, handelt das Buch von meinen persönlichen Ansichten über die Einfachheit, die in zehn Gesetzen vermittelt werden. Das dritte Gesetz, TIME (Zeit), lautet: „Zeitersparnis nimmt man als Einfachheit wahr." Das Kapitel über das dritte Gesetz in *The Laws of Simplicity* beginnt wie folgt:

> Der Mensch verbringt im Durchschnitt mindestens eine Stunde täglich damit, dass er sich in einer Warteschlange anstellt. Dazu kommen die unzähligen Sekunden, Minuten, Wochen, die er anderswo mit Warten verbringt.
>
> Manche dieser Wartezeiten sind kaum spürbar. Wir warten darauf, dass Wasser aus der Leitung kommt, wenn wir den Wasserhahn aufdrehen. Wir warten – meist etwas ungeduldig – darauf, dass das Wasser am Herd zu kochen beginnt. Wir erwarten den Wechsel der Jahreszeiten. Andere Wartezeiten hingegen sind eher enervierend oder ärgerlich: etwa das Warten auf das Laden einer Webseite, im Stau oder auf das Ergebnis einer ärztlichen Untersuchung, vor dem man Angst hat.
>
> Niemand schätzt das Frustrationserlebnis des Wartens. Daher versuchen alle, Konsumenten ebenso wie Firmen, Mittel und Wege zu finden, um am Rad der Zeit zu drehen. Wir suchen nach der schnellsten Abkürzung oder einer anderen Möglichkeit, um diese Frustration zu vermeiden. Geht etwas rasch vonstatten, schreiben wir diese Effizienz der wahrgenommenen Einfachheit der Erfahrung zu.
>
> Effizienz und Geschwindigkeit zeigen sich exemplarisch bei Kurierdiensten wie FedEx oder auch der Bestellung eines Hamburgers bei McDonald's. Sind wir gezwungen zu warten, erscheint das Leben unnötig komplex. Zeitersparnis wird als Einfachheit wahrgenommen. Wir sind voller Dankbarkeit, wenn wir diese seltene Erfahrung machen.
>
> Zeitersparnis hat einen weiteren impliziten Vorteil: Die reduzierte Wartezeit wird zu einer Zeit, die wir mit etwas anderem verbringen können. Letztendlich geht es um die Wahlmöglichkeit, wie wir die Zeit, die uns gegeben ist, verbringen. Zehn Minuten weniger Wegzeit werden zu zehn zusätzlichen Minuten, die man im Kreis seiner Lieben verbringen kann. Eine kürzere Wartezeit ist daher nicht nur im Geschäftsleben ein wichtiger Posten, sondern für unser Leben und Wohlbefinden im Allgemeinen von unschätzbarem Wert.[1]

Die übrigen Gesetze behandeln ein breites Themenspektrum, das von oberflächlichen Wahrnehmungen wie jener einer Schnittstelle bis hin zu profunderen Themen wie emotionalen Erfahrungen reicht. Sämtliche Gesetze sind auf meiner Website *lawsofsimplicity.com* abrufbar, auf der die Diskussion, wie ich hoffe, noch viele Jahre weitergeführt wird. Und ich freue mich, hier bei der Ars Electronica mit Ihnen gemeinsam diese Diskussion ins Rollen zu bringen.

Aus dem Englischen von Michael Kaufmann.

1 Auszug aus John Maeda, *The Laws of Simplicity*, Cambridge, MA: The MIT Press 2006, Seite 23

John Maeda

Law 1: Reduce

The simplest way to achieve simplicity is through thoughtful reduction

————

The easiest way to simplify a system is to remove functionality. Today's DVD, for instance, has too many buttons if all you want to do is play a movie. A solution could be to remove the buttons for Rewind, Forward, Eject, and so forth until only one button remains: Play. But what if you want to replay a favorite scene? Or pause the movie while you take that all-important bathroom break? The fundamental question is, where's the balance between simplicity and complexity?

HOW SIMPLE CAN ← → HOW COMPLEX DOES
YOU MAKE IT? IT HAVE TO BE?

On the one hand, you want a product or service to be easy to use; on the other hand you want it to do everything that a person might want it to do.

The process of reaching an ideal state of simplicity can be truly complex, so allow me to simplify it for you. *The simplest way to achieve simplicity is through thoughtful reduction.* When in doubt, just remove. But be careful of what you remove.

SHE'S ALWAYS RIGHT

We would find it hard to remove any given button from a DVD player if forced to do so. The problem is one of choosing what deserves to live, at the sacrifice of what deserves to die. Such decisions are not easy when most of us are not trained to be despots. Our usual preference is to let live what lives: we would choose to keep all the functionality if we could.

When it is possible to reduce a system's functionality without significant penalty, true simplification is realized. When everything that can be removed is gone, a second battery of methods can be employed. I call these methods SHE: SHRINK, HIDE, EMBODY.

SHE: SHRINK

When a small, unassuming object exceeds our expectations, we are not only surprised but pleased. Our usual reaction is something like, "That little thing did all that?" Simplicity is about the unexpected pleasure derived from what is likely to be insignificant and would otherwise go unnoticed. The smaller the object, the more forgiving we can be when it misbehaves.

Making things smaller doesn't make them necessarily better, but when made so we tend to have a more forgiving attitude towards their existence. A larger-than-human-scale object demands its rightful respect, whereas a tiny object can be something that deserves our pity. When comparing a kitchen spoon to a construction bulldozer the larger scale of the vehicle instills fear, while the rounded utensil appears harmless and inconsequential. The bulldozer can run you over and end your life, but if the spoon were to fall on top of you, your life would likely be spared. Guns, mace cannisters, and little karate experts of course are the exception to this rule of "fear the large, endear the small."

Technology is SHRINK-ing. The computational power of a machine that sixty years ago weighed

60,000 pounds and occupied 1,800 square feet can now be packed onto a sliver of metal less than a tenth the size of the nail on your pinkie. Integrated circuit (IC) chip technology—commonly referred to as "computer chips"—allows far greater complexity at a much tinier scale. IC chips lie at the heart of the problem of complex devices today as they enable increasingly smaller devices to be created. A kitchen spoon and a mobile phone can share the exact same physical dimensions, yet the many IC's embedded inside the phone make the device easily more complexthan the bulldozer—so looks can be deceiving.

Thus while IC's are a primary driver of complexity in modern day objects, they also enable the ability to shrink a frighteningly complex machine to the size of a cute little gumdrop. The smaller the object is, the lower the expectations; the more IC's that are inside, the greater the power. In this age of wireless technology that connects the IC inside the phone with all the computers in the world, power has now become absolute. There is no turning back to the age when large objects were complex and small objects were simple.

Babies are examples of complex machines that although small, require constant attention to the point of driving most parents insane. Yet in the midst of the havoc they wreak, a precious moment can give way when their big beautiful eyes peer into your tired bleariness with a look of, "Help me! Love me!" It is said that this irresistible cuteness is their key self-preservation mechanism, which I know myself works for a fact, having experienced it many times over. Fragility is an essential counteracting force to complexity because it can instill pity—which by coincidence also occurs in the word SIMPLICITY!

The science of making an object appear delicate and fragile is a skill practiced throughout the history of art. An artist is trained to evoke emotion in his fellow human being through the work he creates, whether that emotion be pity, fear, anger, or any other feeling or combination thereof. Of the many tools at the artist's disposal to achieve enhanced small-ification are lightness and thinness. For example, the mirrored back of an Apple iPod creates the illusion that the object is only as thin as the floating white or black plastic layer because the rest of the object adapts to its surroundings. Already thin, flat-screen displays like LCD's or plasmas are made to appear even lighter by sitting atop minimal structural supports or in the extreme case floating on an invisible Lucite platform. Another common approach to achieving thinness is seen in the Lenovo ThinkPad's beveled clamshell as your eyes travel down and off the bottom edge of the keyboard to nothingness. A further collection of these types of designs can be browsed at *lawsofsimplicity.com* at your convenience.

Any design that incorporates lightness and thinness conveys the impression of being smaller, lesser, and humbler. Pity gives way to respect when much more value is delivered than originally expected. There is a steady stream of core technologies that will make things smaller, such as nanotechnology—the science of building machines that fit between your squeezed thumb and forefinger. Lessening the inevitable complicating blow of these technologies by way of shrink may seem like a form of deception, which it is. But anything that can make the medicine of complexity go down easier is a form of simplicity, even when it is an act of deceit.

▬▬▬ SHE: HIDE

When all features that can be removed have been, and a product has been made slim, light, and thin, it's time for the second method: hide the complexity through brute-force methods. A classical example of this technique is the Swiss army knife. Only the tool you wish to use is exposed, while the other blades and drivers are hidden.

With an endless array of buttons, remote controls for audio/video equipment are notoriously confusing. In the 90s, a common design solution was to hide the less-used functions, such as setting the time or date behind a hidden door, while keeping only the primary functions such as Play, Stop, and Eject exposed. This approach is no longer popular, probably due to a combination of the added production costs and the prevailing belief that visible features (i. e. buttons) attract buyers.

As style and fashion have become powerful forces in the cell phone market, handset makers have been pushed to find the balance between the elegance of simplicity and need-it-all complexity. Today, the clamshell design is the most evolved example of hiding functionality until you really need it. All buttons are sandwiched between the speaker and microphone such that when it is closed it is a simple bar of soap. Many recent designs have gone beyond the clamshell, and employ slide-away or flip-out mechanisms. Such evolutions are driven by a market that demands innovation and is willing to pay for clever ways to HIDE complexity.

But there might be no better example of the hide method than today's computer interfaces. The menu bar at the top hides the functionality of the application. And the other three sides of the screen contain other click-to-reveal menus and palettes that seem to multiply as the computer increases in power. The computer has an infinite amount of capacity to hide in order to create the illusion of simplicity. Now that computer screens are shrunken onto cell phones, microwave ovens, and every manner of consumer electronics, the power to hide incredible amounts of complexity is everywhere.

Hiding complexity through ingenious mechanical doors or tiny display screens is an overt form of deception. If the deceit feels less like malevolence, more like magic, then hidden complexities become more of a treat than a nuisance. The earcatching "click" when opening a Motorola Razr cell phone or the cinematic performance of an on-screen visual in Apple's Mac OS X creates the satisfaction of owning the power to will complexity from simplicity. Thus complexity becomes a switch that the owner can choose to flip into action on their own terms, and not by their device's will.

SHRINK-ing an object lowers expectations, and the hiding of complexities allows the owner to manage the expectations himself. Technology creates the problem of complexity, but also affords new materials and methods for the design of our relationship with complexities that shall only continue to multiply. Although instilling "pity" and choosing how to "control" it sound like draconian approaches to simplicity, they can be seen in a positive light for the feelings of enjoyment they create.

▬▬▬ SHE: EMBODY

As features go into hiding and products shrink, it becomes ever more necessary to embed the object with a sense of the value that is lost after hide and shrink. Consumers will only be drawn to the smaller, less functional product if they perceive it to be more valuable than a bigger version of the product with more features. Thus the perception of quality becomes a critical factor when making the choice of less over more.

EMBODY-ing quality is primarily a business decision, more than one of design or technology. The quality can be actual, as embodied by better materials and craftsmanship; or the quality can be perceived, as portrayed in a thoughtful marketing campaign. Exactly where to invest—real or believed quality—to get maximum return is a question with no single definitive answer.

Perceived excellence can be programmed into consumers with the power of marketing. When

we see a super-athlete like Michael Jordan wearing Nikes, we can't help but imbue the sneakers with some of his heroic qualities. Even without the association of a celebrity, a marketing message can be a powerful tool to increase belief in quality. For instance, although I'm usually loyal to Google, I've been recently exposed to a bevy of Microsoft live.com and Ask.com television commercials and now I find myself Google-ing much less. The power of suggestion is powerful. Embodying an object with properties of real quality is the basis of the luxury goods industry and is rooted in their use of precious materials and exquisite craftsmanship. Relatedly, a designer of Ferrari cars once told me that a Ferrari has fewer parts than a common car, but the parts themselves are significantly better than anything else on this earth. This elegant tale of construction uses the simple philosophy that if good parts can make a great product, incredible parts can lead to a legendary one. Sometimes there are instances of overkill, such as the titanium-clad laptop I own—I'm unlikely to need titanium's strength to shield myself from a bullet. But I enjoy the personal satisfaction that a higher quality material is used instead of an inferior plastic. The upside of materialism is that the way something we own feels can change how we feel.

Sometimes mixing actual and perceived qualities works well, like in the design of the Bang & Olufsen remote control. The unit is thin and slender in composition and made with the finest materials, but is significantly (and intentionally) heavier—as a means to subtly communicate higher quality—than you would expect from its appearance. Substantive technologies, like three CCD imaging arrays inside a video camera instead of the standard single array, are usually invisible. Thus the perception needs to be made visible somehow, unfortunately in direct contradiction to hide. An unobtrusive sticker on the unit like "3 CCD's" or a message that appears when the unit is first turned on helps to advertise this extra hidden power. It is necessary to advertise qualities that cannot be conveyed implicitly, especially when the message of embodiment simply tells the truth.

▬▬ SHE SHE'D

Lessen what you can and conceal everything else without losing the sense of inherent value. EMBODY-ing a greater sense of quality through enhanced materials and other messaging cues is an important subtle counterbalance to SHRINK-ing and HIDE-ing the directly understood aspects of a product. Design, technology, and business work in concert to realize the final decisions that will lead to how much reduction in a product is tolerable, and how much quality it will embody in spite of its reduced state of being. Small is better when SHE'd.

From John Maeda, *THE LAWS OF SIMPLICITY*, Cambridge, MA: The MIT Press, 2006

From John Maeda, *The Laws of Simplicity*, Cambridge, MA: The MIT Press 2006

John Maeda

1. Gesetz: Reduzieren
Am einfachsten erreicht man Einfachheit durch eine durchdachte Reduktion

Die einfachste Art, ein System zu vereinfachen, besteht in der Entfernung einer Funktionalität. Die heutigen DVD-Player etwa haben zu viele Tasten dafür, dass man eigentlich nur einen Film ansehen will. Eine Lösung bestünde darin, die Vor-, Rückspul-, Auswurftaste etc. zu entfernen, bis nur eine Taste übrig bleibt: Play. Aber was dann, wenn Sie eine Lieblingsszene noch einmal sehen wollen? Oder den Film anhalten möchten, weil Sie die Toilette aufsuchen wollen? Die fundamentale Frage ist, wie man die richtige Balance zwischen Einfachheit und Komplexität findet.

WIE EINFACH KANN WIE KOMPLEX
MAN ES MACHEN? MUSS ES SEIN?

Einerseits soll ein Produkt einfach zu verwenden sein, andererseits soll es sämtliche Erwartungen erfüllen. Der Prozess, einen idealen Zustand der Einfachheit zu erreichen, kann wirklich komplex sein; gestatten Sie mir, ihn für Sie zu vereinfachen. *Am einfachsten erreicht man Einfachheit durch eine durchdachte Reduktion.* Im Zweifelsfall einfach wegnehmen! Aber achten Sie darauf, was Sie wegnehmen.

SHE HAT IMMER RECHT

Es würde uns nicht leicht fallen, eine beliebige Taste eines DVD-Players zu entfernen, wenn wir dazu gezwungen wären. Das Problem besteht in der Auswahl dessen, was bestehen darf, und was geopfert werden kann. Solche Entscheidungen sind nicht einfach, weil die meisten von uns es nicht gewohnt sind, despotische Entscheidungen über Sein und Nicht-Sein zu treffen. Im Allgemeinen ziehen wir es vor, alles, was existiert, existieren zu lassen: Ginge es nach uns, würden wir sämtliche Funktionen beibehalten. Wenn sich die Funktionalität eines Systems ohne wesentlichen Nachteil reduzieren lässt, wird wahre Vereinfachung realisiert. Ist alles weg, was entfernt werden konnte, ist ein zweiter Methodensatz an der Reihe. Ich nenne diese Methoden *SHE: SHRINK*, *HIDE*, *EMBODY* – SCHRUMPFEN, VERBERGEN, VERKÖRPERN.

SHE: SCHRUMPFEN

Wenn ein kleiner, bescheidener Gegenstand die in ihn gesetzten Erwartungen übertrifft, sind wir nicht nur überrascht, sondern erfreut. „Dieses kleine Ding hat all das zuwege gebracht?", wundern wir uns. Einfachheit hat mit der unerwarteten Freude zu tun, die uns etwas scheinbar Unbedeutendes bereitet. Je kleiner ein Gegenstand ist, umso nachsichtiger sind wir, wenn er aus der Rolle fällt. Verkleinert man Dinge, werden sie dadurch nicht zwangsläufig besser, aber wenn sie miniaturisiert sind, neigen wir ihnen gegenüber zur Nachsicht. Ein Gegenstand, der größer ist als ein Mensch, flößt uns zu Recht Respekt ein, während ein winziges Objekt Mitleid erregen kann. Vergleicht man einen Löffel mit einer Planierraupe, flößt die Größe des Fahrzeugs Angst ein, während das abgerundete Küchenutensil harmlos und belanglos erscheint. Die Planierraupe kann einen Menschen überrollen und töten, während ein Löffel, selbst wenn er einem auf

23

den Kopf fiele, kein großes Unheil anrichten würde. Gewehre, Pfeffersprays und Knirpse, die Karatemeister sind, wären natürlich Ausnahmen von der Regel „Hüte dich vor Größe, suche das Kleine". Die Technik schrumpft. Die rechnerische Kapazität einer Maschine, die vor 60 Jahren etwa 27.000 Kilogramm wog und 160 Quadratmeter groß war, kann nunmehr in eine Metallscheibe gepresst werden, die nicht einmal ein Zehntel Ihres kleinen Fingernagels groß ist. Die Technik der integrierten Schaltkreise (ICs) – besser bekannt als „Computer-Chips" – ermöglicht eine weitaus größere Komplexität bei viel winzigeren Dimensionen. Diese Chips sind die eigentliche Ursache der Problematik der heutigen Komplexität, da sie die Konstruktion immer kleinerer Geräte ermöglichen. Ein Löffel und ein Mobiltelefon können dieselben Dimensionen haben, doch die vielen in das Telefon integrierten Schaltkreise machen das Gerät komplexer als eine Planierraupe – so täuschend kann das Äußere sein. Während ICs einerseits ein wesentlicher Motor für die Komplexität heutiger Alltagsgegenstände sind, können sie eine erschreckend komplexe Maschine andererseits auf die Größe eines klitzekleinen Bonbons schrumpfen lassen. Je kleiner ein Gegenstand, umso niedriger sind auch die in ihn gesetzten Erwartungen; je mehr ICs darin integriert sind, umso größer seine Macht. Im Zeitalter der drahtlosen Technik, das den IC im Inneren des Telefons mit allen Computern der Welt verbindet, ist diese Macht uneingeschränkt. Es gibt kein Zurück in die Zeit, als große Gegenstände komplex und kleine einfach waren. Babys können mit komplexen Maschinen verglichen werden, da sie, obwohl sie klein sind, konstant Aufmerksamkeit verlangen – in einem Ausmaß, das die meisten Eltern an den Rand des Wahnsinns treibt. Doch inmitten des Chaos, das sie anrichten, lassen sie ihre Eltern unvergleichliche Augenblicke erleben, wenn sie ihre schönen großen Augen auf deren müdes Gesicht richten, mit einem Ausdruck, der sagt: „Hilf mir! Liebe mich!" Es heißt, dass dieser unwiderstehliche Liebreiz ihr wichtigster Selbsterhaltungsmechanismus ist, der, wie ich aus eigener Erfahrung weiß, auch funktioniert. Zerbrechlichkeit ist eine wesentliche Gegenkraft der Komplexität, da sie Mitgefühl erregen kann.

Die Technik, einen Gegenstand zart und zerbrechlich wirken zu lassen, wird in der Geschichte der Kunst seit jeher eingesetzt. Ein Künstler ist darin geschult, durch sein Werk Emotionen bei seinen Mitmenschen zu erwecken, ob dies nun Mitleid, Angst, Zorn oder auch eine Kombination von Gefühlen ist. Zu den vielen Mitteln, über die der Künstler verfügt, um eine Überhöhung durch Verkleinerung zu erreichen, zählen unter anderem Leichtigkeit und Dünnheit.

Die spiegelnde Rückseite des Apple iPod lässt beispielsweise die Illusion entstehen, dass der Gegenstand nur so dünn ist wie die wahlweise weiße oder schwarze Kunststofoberfläche, weil sich der Rest an die Umgebung anpasst. Flache LCD- oder Plasmabildschirme erscheinen noch leichter, wenn sie auf zarten Trägerelementen angebracht sind oder im Extremfall über einem unsichtbaren Plexiglas-Sockel zu schweben scheinen. Eine weitere verbreitete Methode, Dünnheit zu erreichen, demonstriert das abgeschrägte Clamshell-Design des Lenovo ThinkPad, bei dem der Blick, geht er über den unteren Rand des Keyboards hinaus, sich im Nichts zu verlieren scheint. Auf der Website *lawsofsimplicity.com* finden Sie noch weitere solche Designbeispiele.

Jedes Design, das Leichtigkeit und Dünnheit verkörpert, vermittelt den Eindruck, kleiner, unbedeutender und bescheidener zu sein. Aus Mitleid wird Respekt, wenn der erbrachte Wert die ursprünglichen Erwartungen übertrifft. Es gibt eine Reihe von Kerntechnologien, die die Miniaturisierung der Dinge weiter vorantreiben werden, wie etwa die Nanotechnologie – die Wissenschaft, Maschinen zu bauen, die sich zwischen Daumen und Zeigefinger pressen lassen. Es mag wie eine Form der Täuschung erscheinen und ist letztlich auch eine, wenn man der unaufhaltsamen Tendenz zur Verkomplizierung, die diesen Techniken inhärent ist, durch Schrumpfen entgegenwirkt. Aber alles, was uns die Pille der Komplexität leichter schlucken lässt, ist eine Form von Einfachheit, auch wenn es ein Akt der Täuschung ist.

▬▬ SHE: VERBERGEN

Wenn alle entbehrlichen Leistungsmerkmale entfernt wurden und ein Produkt schlank und leicht erscheint, wird es Zeit für die zweite Methode: das rücksichtslose Verbergen der Komplexität. Ein klassisches Beispiel dafür ist das Schweizer Armeemesser. Nur das Werkzeug, das man gerade verwenden möchte, ist exponiert, während alle anderen Klingen und Funktionen versteckt sind.

Die Fernbedienungen für Audio- und Videogeräte mit ihren zahllosen Tastenreihen sind bekannt verwirrend. In den 1990er Jahren war die Design-Lösung verbreitet, weniger häufig verwendete Funktionen wie Zeit- und Datumseinstellung hinter einer Klappe zu verbergen und nur die primären Funktionen wie Play, Stop und Eject zu zeigen. Dieser Ansatz ist mittlerweile überholt; vermutlich wegen der erhöhten Produktionskosten und der vorherrschenden Meinung, dass sichtbare Leistungsmerkmale (z. B. Tasten) auf Käufer anziehend wirken.

Seit Styling und Mode bestimmende Kriterien auf dem Mobiltelefonmarkt sind, haben Produzenten die Aufgabe, die Balance zwischen der Eleganz des Einfachen und der Wir-brauchen-alles-Komplexität zu finden. Heute ist das Clamshell-Design das am weitesten entwickelte Beispiel für das Verbergen einer Funktionalität, bis man sie wirklich benötigt. Alle Tasten sind zwischen dem Lautsprecher und dem Mikrofon eingezwängt, sodass es zusammengeklappt an ein einfaches Stück Seife erinnert. Viele neuere Designs haben die Clamshell hinter sich gelassen und verwenden Slide-away- oder Flip-out-Mechanismen. Solche Entwicklungen werden von einem Markt beschleunigt, der Innovation verlangt und bereit ist, für kluge Methoden zur Verbergung von Komplexität zu bezahlen.

Doch gibt es wohl kein besseres Beispiel für die Methode des Verbergens als die heutigen Benutzeroberflächen von Computern. Die Menüleiste am oberen Rand verbirgt die Optionen. Und auf den anderen drei Seiten des Bildschirms sind weitere Menüs und Paletten zu finden, die sich auf Mausklick öffnen und zu multiplizieren scheinen, je stärker ein Computer ist. Der Computer hat unendliche Möglichkeiten des Verbergens, um die Illusion von Einfachheit entstehen zu lassen. Heute, wo Computerbildschirme geschrumpft sind und auf Mobiltelefonen, Mikrowellenherden und unterschiedlichster Unterhaltungselektronik Platz finden, ist die Fähigkeit, Komplexität in unglaublich hohem Maße zu VERBERGEN, allgegenwärtig.

Komplexität durch ausgeklügelte Klappmechanismen oder winzige Bildschirme zu verbergen, ist offenkundig eine Form der Täuschung. Wenn die Täuschung nichts Böswilliges hat, sondern vielmehr wie Magie erscheint, werden verborgene Komplexitäten eher zu einem besonderen Vergnügen als zu einem Ärgernis. Der faszinierende „Klick", wenn man ein Motorola Razr-Handy aufklappt, oder die Desktop-Animation unter Mac OS X von Apple vermitteln die Befriedigung, nach Belieben zwischen Komplexität und Einfachheit wechseln zu können. Komplexität wird auf diese Weise zum Schalter, den der Besitzer nach eigenem Belieben betätigen kann, ohne sich an die Vorgaben des Geräts halten zu müssen.

Das SCHRUMPFEN eines Gegenstands verringert die Erwartungen, und das Verbergen der Komplexitäten ermöglicht es dem Besitzer, die Erwartungen selbst zu steuern. Die Technik schafft das Problem der Komplexität, bietet aber auch neue Materialien und Methoden für die Gestaltung unserer Beziehung zu den Komplexitäten, die im Übrigen noch zunehmen werden. Obwohl das „Erregen von Mitleid" und die Wahl der „Kontrolle" darüber sehr rigorose Annäherungen an die Einfachheit zu sein scheinen, sind sie aufgrund des Vergnügens, das sie bereiten, positiv zu bewerten.

John Maeda

◼◼◼ SHE: VERKÖRPERN

Das Verbergen von Leistungsmerkmalen und das Schrumpfen der Produkte erhöhen die Notwendigkeit, den Gegenstand aufzuwerten, da durch das VERBERGEN und SCHRUMPFEN Werte verloren gehen. Konsumenten werden nur dann von einem kleineren, weniger funktionalen Produkt angezogen, wenn sie es für wertvoller halten als eine größere Variante mit mehr Leistungsmerkmalen. Daher wird die Wahrnehmung von Qualität ein wesentliches Kriterium bei der Entscheidung für Weniger und gegen Mehr.

Welche Qualität VERKÖRPERT wird, ist in erster Linie eine ökonomische Entscheidung und nicht eine des Designs oder der Technik. Die Qualität kann eine tatsächliche sein, wie sie durch bessere Materialien oder deren Verarbeitung bewirkt wird, oder auch nur eine vermeintliche, wie sie durch eine durchdachte Marketingkampagne insinuiert wird. In welche Qualität man nun investiert, um maximales Feedback zu bekommen – in die reale oder die vermeintliche – ist eine Frage, auf die es keine definitive Antwort gibt.

Vermeintliche Vorzüge können den Konsumenten mit dem machtvollen Instrument des Marketings eingetrichtert werden. Wenn wir einen Weltklasseathleten wie Michael Jordan mit Sneakers von Nike sehen, schreiben wir ihnen automatisch einige seiner herausragenden Eigenschaften zu. Auch ohne Assoziation mit einer Berühmtheit kann eine Marketingbotschaft ein machtvolles Instrument sein, um den Glauben an Qualität zu stärken. Ich bin beispielsweise im Allgemeinen ein Fan von Google, wurde aber kürzlich einer Flut von Microsoft *live.com*- und *ask.com*-Fernsehwerbespots ausgesetzt und seither google ich bedeutend weniger. Die Macht der Suggestion ist groß. Die Verkörperung wirklicher Qualität ist die Basis der Luxusgüterindustrie und auf die Verwendung kostbarer Materialien und bester Handwerkskunst zurückzuführen. Ein Ferrari-Designer hat mir einmal erzählt, dass ein Ferrari weniger Bestandteile hat als ein gewöhnliches Auto, die Qualität der Teile aber kaum zu überbieten ist. Diese elegante Geschichte über die Konstruktion eines Autos basiert auf einer einfachen Philosophie: Wenn gute Bestandteile ein großes Produkt ausmachen, lassen bessere ein legendäres entstehen. Es gibt natürlich auch Beispiele für ein Zuviel des Guten, wie etwa den Laptop mit Titangehäuse, den ich besitze – ich werde die

Stärke des Titan wohl kaum brauchen, um mich vor einer Kugel zu schützen. Aber ich genieße die persönliche Befriedigung, dass ein qualitativ hochwertiges Material anstelle von Kunststoff verwendet wurde. Die positive Seite des Materialismus ist, dass die Art und Weise, wie wir etwas besitzen, unser Befinden verändern kann.

Manchmal funktioniert die Mischung tatsächlicher und vermeintlicher Qualitäten gut, wie das Design der Bang & Olufsen-Fernbedienung zeigt. Das Gerät ist schlank und aus besten Materialien, aber deutlich (und bewusst) schwerer, als man seinem Äußeren nach erwarten würde – wodurch auf subtile Weise höhere Qualität kommuniziert wird. Substanzielle Technik, wie drei CCD-Zeilensensoren in einer Videokamera anstatt der standardmäßigen einzelnen, sind meist unsichtbar. Die Wahrnehmung muss daher erst darauf gelenkt werden, was bedauerlicherweise in direktem Widerspruch zum VERKÖRPERT steht. Ein unauffälliger Aufkleber auf dem Gerät wie etwa „3 CCDs" oder eine Information, die beim ersten Einschalten des Geräts erscheint, könnte für diese verborgene Qualität werben. Auf Qualitäten, die nicht implizit vermittelt werden, muss eigens hingewiesen werden, insbesondere wenn sie schlicht und einfach der Wahrheit entsprechen.

▬▬ KLEIN IST BESSER

Reduzieren Sie, was Sie können, und verbergen Sie alles andere, ohne das Gefühl für den inhärenten Wert zu verlieren. Die Verkörperung höherer Qualität durch verbesserte Materialien und andere Botschaften ist ein wichtiges und subtiles Gegengewicht zum SCHRUMPFEN, indem es die unmittelbar verständlichen Aspekte eines Produkts VERBIRGT. Design, Technik und kaufmännisches Denken können konzertiert die Entscheidung erleichtern, wie viel Reduktion in einem Produkt tolerierbar ist und wie viel Qualität es trotz seiner Reduziertheit verkörpern wird. Klein ist besser, wenn es den SHE-Kriterien entspricht.

Aus dem Englischen von Martina Bauer

Aus: John Maeda, THE LAWS OF SIMPLICITY, Cambridge, MA: The MIT Press, 2006.

Paola Antonelli / John Maeda

The Goal of Safety is about as Simple as it Gets

▬

Paola Antonelli, Acting Chief Curator of the Department of Architecture and Design, MoMA, New York, in conversation with John Maeda

John Maeda: What does the word "simplicity" mean in the context of architecture and design?

Paola Antonelli: As in any other context, also in architecture and design simplicity is the most complex virtue to attain. It may require years and years of redesign to achieve for instance a remote control that is truly universal AND universally understandable.

Real simplicity is structural, not formal, and as such not stereotypical. There is a style of simplicity that can be misleading, as in the work of Tadao Ando or in some of the objects by several contemporary designers. The case of Droog Design, the Dutch design collective founded in 1994, is particularly interesting. Droog Design came at a moment when no one in the material world seemed able to tolerate redundancy anymore and ushered in the beginning of what some labelled the neo-minimalist era. At the time when Droog was born, the fashion world was celebrating the work of Miuccia Prada and Tom Ford, the two who, with bare-boned yet sophisticated simplicity took garments one step beyond the previous Japanese avantgarde.

Subsequently, at the third edition of Doors of Perception, the 1995 design conference organized in Amsterdam by the Netherlands Design Institute and entitled that year *On Matter,* the trend forecaster Lidewij Edelkoort gave a poignant audio-visual presentation that, in the end, made the audience feel clean and purified, if slightly sensorially overloaded. She showed natural fibers, minimal furniture, recyclable materials, and even translucent soap bars. The world, I assumed from her talk, wanted and wants fewer, better, clearer, sounder things, and is willing to pay more to have them. Oxygen bars, non-carbonated water in translucent bottles, nothing seemed to be as deeply sensual as nothing—a transparent, odorless substance that cleanses the body inside and outside. I realize today that that was an illusion, and that simplicity is about making things be, and not look, simple. The simpler they are, the better they can interact with each other, and the more they can be used to their full potential.

John Maeda: What are the three or so examples that come to mind when you think of "simplicity" and the MoMA collection?

Paola Antonelli: The Post-it Note, the Volkswagen Beetle (original model, from 1959), the Thonet chair, and the iPod. For all them, it took years of complex efforts, experiments, failures, and turmoil in order to achieve simplicity for the final user.

John Maeda: I was really enamored by your *Safe: Design Takes on Risk*[1] show. I feel that it's important to simplicity because when faced with a life/death situation, life is about as complex as it gets. Do you agree? Was that part of the reason why you did this show?

Paola Antonelli: Thank you for liking my show. I was not thinking of simplicity *per se* when I selected the objects for the show, but definitely there is nothing closer to the big bang of design, to its prime reason to exist, than objects that deal with self-preservation. They have to be easy to understand and use, period. They are created to protect body and mind from dangerous or stressful situations, convey information, promote awareness, and provide a sense of comfort and security. Does this make them necessarily simple? I can see in hindsight that in most cases that is true. These objects offer not only efficiency and reliability, but also grace under pressure. Simplicity in design can be about knowing with clarity what the particular design is about. The best objects display a remarkable economy of thought and materials, achieved because of the clarity of their goals. They work well and are easy to use.

John Maeda: As a multicultural person that constantly travels and finds new inspirations, do you have a particular preference for situations of simplicity or situations of complexity when you are remote from NY.
Note that I personally don't feel strongly one way or the other—I think we need both simplicity and complexity to remain sane and happy.

Paola Antonelli: I actually appreciate simplicity in the objects that I have to use—not always, most of the time—and instead I cherish complexity in the world that I navigate. I like how diverse the world is, and I do not mind feeling displaced and disorientated—actually, I get a thrill out of it.

John Maeda: Do you use a blackberry, treo, or sidekick (multi-function telephone)? If so, do you find them too complex to use? Or simple to use?

Paola Antonelli: I use a blackberry. No problems whatsoever with it, I type away as fast as lightning. I wish it were more elegant-looking, if anything. I have memories of those horrible years when we had to drag our laptops all over the world and we would have the wrong plug, the connections were slow, the server would be down. Now I have more time to sleep and to try and tackle my need to simplify my reading lists...

1 *SAFE: Design Takes On Risk*, organized by curator Paola Antonelli, was the first major design exhibition at MoMA since its reopening in November 2004 and presented more than 300 contemporary products and prototypes designed to protect body and mind from dangerous or stressful circumstances, respond to emergencies, ensure clarity of information, and provide a sense of comfort and security.

Paola Antonelli / John Maeda

Sicherheit als oberstes Ziel
Das Nonplusultra der Einfachheit

Paola Antonelli, Hauptkuratorin der Abteilung für Architektur und Design am MoMA, New York, im Gespräch mit John Maeda

John Maeda: John Maeda: Was bedeutet „Einfachheit" im Kontext von Architektur und Design?

Paola Antonelli: Wie in jedem anderen Bereich ist Einfachheit auch in der Architektur und beim Design die komplexeste aller Tugenden. Die Entwicklung einer Fernbedienung, die universell verwendbar UND universell verständlich ist, kann beispielsweise Jahre dauern.
Echte Einfachheit bedeutet Einfachheit auf einer strukturellen, nicht einer formalen Ebene und ist dadurch auch nicht stereotyp. Es gibt eine Art von Einfachheit, wie sie sich etwa in den Arbeiten von Tadao Ando oder in Gegenständen mancher zeitgenössischer Designer zeigt, die irreführend sein kann. Droog Design, eine 1994 gegründete niederländische Designergruppe, ist in dieser Hinsicht besonders interessant. Droog Design wurde zu einem Zeitpunkt gegründet, an dem in unserer materiellen Welt niemand mehr Toleranz für Redundanz aufzubringen schien; dadurch wurde der Beginn einer von manchen als neo-minimalistische Ära bezeichneten Phase des Designs eingeläutet. Als Droog das Licht der Welt erblickte, bejubelte die Modewelt Miuccia Prada und Tom Ford, die sich mit ihren reduzierten, doch raffinierten einfachen Kleidungsstücken einen Schritt über die bis dato dominierende japanische Avantgarde hinaus gewagt hatten.
Auf dem 3. *Doors of Perception*-Designsymposium, das 1995 unter dem Thema *On Matter* vom niederländischen Designinstitut in Amsterdam veranstaltet wurde, präsentierte Trend-Orakel Lidewij Edelkoort dann einen mitreißenden audio-visuellen Beitrag, der das Publikum rein und gereinigt zurückließ, wenn auch mit leicht überstrapazierten Sinnen. Sie zeigte Naturfasern, minimalistische Möbel, wieder verwertbare Materialien und sogar durchsichtige Seife. Die Menschen, so entnahm ich ihrem Vortrag, wollten und wollen weniger, dafür jedoch bessere, klarere, qualitätsvollere Dinge, und sie sind bereit, dafür mehr zu bezahlen. Sauerstoffbars, kohlensäurefreies Wasser in durchsichtigen Flaschen – nichts schien sinnlicher als dieses Nichts; eine transparente, geruchlose Substanz, die den Körper von innen wie außen reinigt. Heute ist mir klar, dass das eine Illusion war und dass Einfachheit bedeutet, dass Dinge einfach sind und nicht, dass sie einfach aussehen. Je einfacher sie sind, desto besser können sie miteinander in Wechselwirkung treten und desto eher kann ihr Potenzial voll ausgeschöpft werden.

John Maeda: Was sind die drei (oder mehr) besten Beispiele für Einfachheit, die Ihnen im Zusammenhang mit der MoMA-Sammlung einfallen?

Paola Antonelli: Der Post-it-Haftnotizblock, der VW Käfer (Originalmodell von 1959), der Thonetstuhl und der iPod. Bei allen bedurfte es jahrelanger intensiver Bemühungen, zahlreicher Experimente, Fehlschläge und einem gewissen Quantum an Aufruhr, um dem Endnutzer Einfachheit bieten zu können.

John Maeda: Ich war begeistert von *SAFE: Design Takes On Risk.*[1] Ich bin der Ansicht, diese Ausstellung war wichtig für die Einfachheit, denn nichts im Leben ist komplexer als Situationen, in denen es um Leben und Tod geht. Wie sehen Sie das? War das einer der Gründe für diese Ausstellung?

Paola Antonelli: Es freut mich, dass Ihnen die Ausstellung gefallen hat. Ich dachte bei der Auswahl der Objekte nicht an Einfachheit per se, aber ohne Zweifel kommt nichts dem Urknall des Designs, seinem Hauptexistenzgrund näher, als Gegenstände, die mit dem Schutz des Menschen zu tun haben. Diese Gegenstände müssen einfach zu verstehen und zu handhaben sein, mehr nicht. Ihr Zweck ist, Körper und Psyche in Notfällen oder Stresssituationen zu schützen, sie liefern Informationen, sensibilisieren und bieten ein Gefühl von Trost und Sicherheit. Doch macht sie das notwendigerweise einfach? Rückblickend kann ich sagen, dass das in den meisten Fällen zutrifft. Diese Gegenstände stehen nicht nur für Effizienz und Zuverlässigkeit, sie bieten auch Anmut in der Not.
Im Design kann Einfachheit bedeuten, dass man sicher weiß, wozu ein Gegenstand dient. Die besten Gegenstände sind die, bei denen sparsamer Materialeinsatz mit geringem Verständnisaufwand gepaart ist: Man muss nicht lange über die Verwendung nachdenken, da ihr Zweck klar ist. Sie funktionieren gut und sind einfach zu bedienen.

John Maeda: Haben Sie als multikultureller Mensch, der ständig reist und neue Inspiration sucht, eine Präferenz für einfache oder komplexe Situationen, wenn Sie reisen? Ich persönlich habe keine Vorliebe – ich denke, wir brauchen sowohl Einfachheit als auch Komplexität, um gesund und glücklich zu bleiben.

Paola Antonelli: Ich bevorzuge Einfachheit bei Gebrauchsgegenständen – zwar nicht immer, aber meistens. Dafür genieße ich die Komplexität der Welt, in der ich mich bewege. Mir gefällt die Diversität der Welt, und ich fühle mich nicht fremd oder orientierungslos – im Gegenteil, ich liebe diesen Nervenkitzel.

John Maeda: Verwenden Sie einen Blackberry, Treo oder Sidekick (PDA-Mobiltelefone)? Wenn ja, finden Sie die Bedienung kompliziert oder einfach?

Paola Antonelli: Ich verwende einen Blackberry und habe damit keine Probleme. Ich kann superschnell darauf schreiben. Wenn überhaupt, dann würde ich mir ein eleganteres Design wünschen. Ich erinnere mich mit Entsetzen an jene Zeiten, als wir unsere Laptops um den Globus schleppen mussten, die Stecker nicht passten, die Verbindungen langsam und die Server ausgefallen waren. Jetzt bekomme ich mehr Schlaf und kann dem Bedürfnis nachgeben, meine Leselisten zu kürzen ...

Aus dem Englischen von Sonja Pöllabauer

1 *SAFE: Design Takes On Risk* wurde von Paola Antonelli kuratiert und war die erste große Designausstellung nach der Wiedereröffnung des MoMA im November 2004. Gezeigt wurden mehr als 300 Objekte und Prototypen zeitgenössischer Designer, die Körper und Geist bei Gefahr oder in Stresssituationen schützen, in Notfällen eingesetzt werden, klare Informationen liefern und ein Gefühl von Sicherheit und Trost vermitteln.

Sam Hecht

The Acceleration of Having More with Less

In a recent conversation with John Maeda over a meal of sushi, I remarked how a good designer has the ability to skillfully make use of their receptors that humans all share, when creating or improving man-made objects that surround us. Many people who go about their daily life are oblivious to the fact that everything they see, hear, touch or smell has a profound effect on their temperament. The city, the building, the room, the chair, the table and the sushi, are all interconnected, and equally influential. I am often surprised that this idea is often either neglected, not involved, forgotten or misunderstood during the process of commissioning, making and consuming goods. Consequently, the public, the consumer, the user (whatever you might call us) becomes oblivious to subtlety and simplicity, because our receptors are challenged by an ever greater dependence on marketplace 'wow' factors created by designers and delivered by manufacturers. A consumer may not know all reasons for desiring an object—but nevertheless, desire is there. The foundation for this desire is discovered with use and the appreciation acquired over time.

Going back to the sushi meal: If we think of the most primordial of activities like food intake, humans rely upon all their senses to establish whether the food they are about to eat is good or bad. When we first 'see' the meal we make a conscious decision as to whether it is suitable for its function. When we 'touch' it, its particular texture establishes its standard further. When we 'smell' it, it tells us whether it is good to eat. As we 'taste' it, we can further tell if it will poison us or satisfy us. And as we chew, we 'hear' the satisfaction of its consistency. Our senses that allow us to eat successfully are tools given to us at birth, and developed in early life so we can navigate our world. They protect us, and allow us to enjoy our experiences. If we think of objects, the common failure of contemporary design is assuming that when we use a coffee maker, sit on a chair, or walk into a room, that we switch off the senses that are not applicable to the activity at hand. Why should we associate sound with a coffee maker, or smell with a chair? In truth, every scale of every activity will be assessed by our senses, because as humans, our survival depends on it. The temperature of a wooden chair is very different to a plastic one, and it provides a different emotional feeling. The smell of each room differs, affecting our sensibility. The sound of different coffee makers contributes to our judgment of which will have the perfect brew.

Instead of involving and recognizing the complex receptors that humans have, we have become much too dominated by the visual. The sushi might well be beautiful to look at, but its beauty is not forced. It is what I call 'resultant beauty'—beauty that is coincidental, a result of its existence rather than something applied to it. The simplicity of its content, its preparation and its presentation, does not overwhelm each corresponding sense. It feels natural even though, in the west, the thought of raw food is an unnatural concept. This is the essence of simplicity; it is being able to naturalize what at first might seem unnatural.

How does this idea translate into an object like a chair, or a coffee maker or something that involves more high technology? These are the objects that need more than ever to involve intelligent and appropriate design that engages, or at least registers the criteria of the senses.

Through the work of our studio Industrial Facility, we acknowledge that all things are dependent on each other. Rather than seeing contemporary life through an outdated Renaissance model, where everything is human-centered, self-contained and focused towards the human,

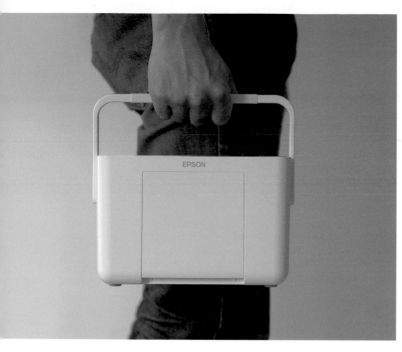

instead we see that everything affects and communicates with each other, at times even inde-
pendent of the human. This means seeing the world without imagining we can control it all.
Imagine designing a printer or a coffee maker for the room that it sits in, the table that it is on,
or the person operating it. This idea allows the evacuation of superfluous functions, and the
abandonment of complexity, because it acknowledges what already exists, and doesn't see a
need for duplication or replication. The environment for an object, as much as its use, deter-
mines its form and content.

We recently designed a cordless telephone, and realised quite quickly that even though it had
periods of being active and nomadic, the majority of its life was stationary and turned off. This
inactivity became the starting point for the design. The turned-off state was seen as a possibil-
ity, rather than being a negative condition. It became a phone that does not constantly beckon
to be turned on by the use of garish-coloured graphics or sexy 'applied' beauty—irrelevant
visual grabbing devices that consider nothing of its actual life. Instead, the phone became a
background object, but when needed, became alive. Why are so many electronic products,
including phones painted silver? For instance, when you turn a TV off, you no longer need it, so
why give it such foreground power? The 'turned-off' state of electronic products should be
viewed as much a function of the product as anything else. Manufacturers put enormous ener-
gy into the marketing and sales of the product so that the decision-making moment of pur-
chase gives the best chance of success. But the reality is that 99.9 percent of the product's life
is spent away from the shop. If the product is not bought, then it has 'failed' in commercial
terms, but we should also understand that a product that damages our senses and lowers our
surrounding life and our standards is failure of a far bigger magnitude.

Another point about dependence is that objects can start to share senses of tactility, smell,
sound and so on. A designer does not have to ensure that the product should involve every sense
for every condition, senses can be shared. And similarly, objects can start to have their own abil-
ity to see, and to taste. Imagine a camera that could also see, and adjust its focus accordingly:

but of course, this already exists. It seems more and more, as technology continues to move ahead of design by involving the senses, that the role of the designer becomes also more and more vital. For they are the ones who must bring together the sum of parts—the functional, the aesthetic and the technological qualities of each project.

The process of involving dependence is first to understand that design is not always, as some might suggest, about invention or innovation. In design education and their school projects I still witness an immediate desire to invent, to try as hard as possible to break away from what already exists, regardless of whether what already exists works sufficiently well. For the student it is as if everything that came before is either wrong or inconsequential to the process. The idea of incremental steps, of small improvements and an understanding of history, seems of little concern. But like nature, incremental steps will always lead to a more realistic and 'of this world' feeling. In our office we still physically make everything that we conceive, in cardboard, plastics, anything that is appropriate for the task. We know that the majority of our work is essentially dealing with things the hand will be manipulating in some way. If you rely only on the computer, there is sometimes a tendency to make the designs quite expressive because the ability to do that is there, built into the tool. The computer is important, but it can only present one sense— the visual. It is extremely difficult to make things that are very simple and graceful on the computer because the screen by nature has luminosity, which is already quite expressive. If you make something out of cardboard your ability to appreciate the form and the simplicity of it becomes much easier—you don't have to resort to any applied thought; it can actually be the thought.

Muji Fan, Design 2006
Much of the work we do for Muji has simplicity at its core. Yet there is also much depth to the work. In this example, the fan's motor is presented as a powerful engine, rather than a wishy-washy form. The remote control sits in the base, completing the product.

Viele der Arbeiten, die wir für Muji machen, basieren im Wesentlichen auf Einfachheit. Sie haben aber auch Tiefgang. Das Design präsentiert den Motor des Ventilators als starke Maschine und verwässert ihn nicht zur bloßen Form. Die Fernbedienung, die das Produkt vervollständigt, steckt im Sockel.

Sam Hecht

Weniger ist zunehmend mehr

Als ich vor kurzem mit John Maeda Sushi essen war, habe ich erkannt, dass gute Designer die Fähigkeit besitzen, die allen Menschen eigenen Rezeptoren bei der Herstellung oder Optimierung der uns umgebenden Dinge geschickt einzusetzen. Viele Menschen vergessen im Alltag, dass alles, was sie sehen, hören, berühren oder riechen, Einfluss auf ihre Stimmung hat. Die Stadt, das Gebäude, der Raum, der Stuhl, der Tisch und das Suhsi – alles steht miteinander in Verbindung und beeinflusst uns. Ich bin oft überrascht, dass dieser Gedanke beim Kauf, der Herstellung und dem Konsum von Dingen meist vernachlässigt, übersehen, vergessen oder missverstanden wird. In der Folge verdrängen die Öffentlichkeit, der Konsument, der Benutzer (wie immer wir uns nennen) Subtilität und Einfachheit, weil unsere Rezeptoren mit immer Fantastischerem gefüttert werden wollen und eine gewisse Abhängigkeit von dieser von Designern und Produzenten geschaffenen Reizüberflutung besteht. Ein Konsument mag nicht alle Gründe für sein Verlangen nach einem Gegenstand kennen – das Verlangen ist jedenfalls da. Worauf es basiert, erschließt sich erst mit der Verwendung und der Wertschätzung des Gegenstands, die sich im Lauf der Zeit einstellt.

Zurück zu unserem Sushi-Essen: Denkt man an wesentliche Aktivitäten wie etwa das Essen, verlassen sich die Menschen auf alle ihre Sinnesorgane, um festzustellen, ob ein Gericht gut oder schlecht ist. Wenn wir ein Gericht zum ersten Mal „sehen", treffen wir eine bewusste Entscheidung, ob es seiner Funktion gerecht wird. Wenn wir es „berühren", erhärtet sich dieses Urteil durch die unverwechselbare Konsistenz. Wenn wir es „riechen", erfahren wir, ob es gut schmeckt. „Kosten" wir es, können wir sagen, ob es uns vergiften oder zufrieden stellen wird. Und beim Kauen „hören" wir seine Konsistenz. Die Sinne, die diese Einschätzung des Essens ermöglichen, sind angeboren und werden in den ersten Lebensjahren weiterentwickelt, damit wir uns in der Welt zurechtfinden. Sie schützen uns und ermöglichen uns, Erfahrungen zu genießen. In Bezug auf Gegenstände geht man im zeitgenössischen Design häufig von dem Irrtum aus, dass wir, wenn wir eine Kaffeemaschine benutzen, auf einem Stuhl sitzen oder einen Raum betreten, die Sinne ausschalten, die für die jeweilige Aktivität nicht erforderlich sind. Warum sollten wir Geräusche mit einer Kaffeemaschine oder Geruch mit einem Stuhl in Verbindung bringen? Dennoch werden sämtliche Aspekte einer Aktivität von unseren Sinnen bewertet, weil unser Überleben davon abhängt. Die Temperatur eines Holzstuhls unterscheidet sich von der eines Plastiksessels und vermittelt auch ein anderes Gefühl. Jeder Raum hat einen anderen Geruch, der sich auf unsere Sinneswahrnehmungen auswirkt. Das Geräusch verschiedener Kaffeemaschinen beeinflusst durchaus unser Urteil, von welcher der beste Kaffee zu erwarten ist.

Anstatt die komplexen Rezeptoren einzubeziehen, über die der Mensch verfügt, lassen wir uns zu sehr vom Visuellen dominieren. Sushi mag schön anzusehen sein, seine Schönheit wird aber nicht forciert. Ich nenne eine solche Schönheit eine resultierende – eine zufällige, die eher Resultat als etwas Aufgesetztes ist. Die Einfachheit des Gerichts, sowohl hinsichtlich Zubereitung als auch Präsentation, beansprucht alle unsere Sinne in gleichem Maß. Sie hat etwas Natürliches, wenngleich im Westen die Vorstellung von rohen Nahrungsmitteln eher etwas Unnatürliches hat. Das Wesen der Einfachheit besteht eben darin, dass sie etwas, das auf den ersten Blick unnatürlich wirkt, natürlich erscheinen lässt. Wie kann man diese Idee nun auf einen Gegenstand wie einen Stuhl, eine Kaffeemaschine oder ein Hightechprodukt anwenden? Diese Gegenstände erfordern mehr denn je ein intelligentes und angemessenes Design, das die Sinnesorgane als Kriterium berücksichtigt oder zumindest wahrnimmt.

Sam Hecht

In unserer Arbeit im Atelier Industrial Facility erkennen wir an, dass alle Dinge voneinander abhängen. Unser Weltbild orientiert sich nicht an einem überkommenen Renaissancemodell, dem zufolge alle Dinge in sich abgeschlossen und der Mensch das Maß aller Dinge ist, sondern daran, dass alles aufeinander einwirkt und miteinander kommuniziert – manchmal sogar unabhängig vom Menschen. Das impliziert eine Weltsicht, die ohne die Vorstellung auskommt, dass wir alles kontrollieren können. Beim Entwurf eines Druckers oder einer Kaffeemaschine stellen wir uns den Raum vor, für den diese Dinge gedacht sind, den Tisch, auf dem sie stehen werden, oder die Person, die damit umgehen wird. Dieser Ansatz ermöglicht die Ausklammerung überflüssiger Funktionen und den Verzicht auf Komplexität, weil bereits Vorhandenes anerkannt und versucht wird, Verdopplung oder Wiederholung zu vermeiden. Die Umgebung eines Gegenstands bestimmt Form und Inhalt ebenso wie seine Verwendung.

To Go Cutlery, Design 2006
Found Beauty. Plastic cutlery, the things that we tolerate even though we dislike them, are transferred materially to metal. Suddenly, the same cutlery is beautiful and practical. The beauty is a result of this transference, rather than an application.

Vorgefundene Schönheit. Plastikbesteck – Dinge, die wir tolerieren, obwohl wir sie nicht mögen, werden in Metall verwandelt. Plötzlich ist dasselbe Besteck schön und praktisch. Die Schönheit ist eher das Ergebnis dieser Übertragung als eine Applikation.

Vor kurzem entwarfen wir ein schnurloses Telefon und erkannten dabei schnell, dass dieser Gegenstand zwar Zeiten der Aktivität und Bewegung hat, die meiste Zeit aber stationär und passiv ist. Diese Inaktivität wurde der Ausgangspunkt für das Design. Die Passivität wurde weniger als Negation denn als Möglichkeit gesehen. Das Resultat war schließlich ein Telefon, das nicht ständig durch aufdringliche bunte Grafiken oder aufgesetzte Reize – überflüssige Eyecatcher –, die nichts mit seiner eigentlichen Funktion zu tun haben, zur Verwendung auffordert, sondern vielmehr ein Hintergrundobjekt, das zum Leben erwacht, wenn es gebraucht wird. Warum sind so viele elektronische Produkte, einschließlich Telefone, silberfarben? Einen Fernseher schaltet man aus, wenn man ihn nicht mehr braucht; warum gesteht man ihm dann eine solche Auffälligkeit zu? Der Zustand des Ausgeschaltet-Seins eines elektronischen Produkts sollte ebenso als Funktion desselben betrachtet werden wie alles andere. Die Hersteller stecken enorme Energie in das Marketing und den Verkauf des Produkts, weshalb der Moment des Kaufs als der entscheidende betrachtet wird. Die Realität sieht aber so aus, dass 99,9 Prozent des Produktlebens sich nicht im Laden abspielen. Wird das Produkt nicht gekauft, hat es in kommerziellen Begriffen „versagt". Wir sollten aber auch verstehen, dass ein Produkt, das unsere Sinne beleidigt und unsere Umgebung und Wertvorstellungen herabsetzt, in viel umfassenderer Weise versagt.

Zur Abhängigkeit ist auch noch zu sagen, dass Gegenstände unterschiedliche Sinne wie Tast-, Geruchs-, Hörsinn usw. ansprechen können. Ein Designer muss nicht gewährleisten, dass ein Produkt immer jeden der Sinne einbezieht – das kann sich auch verteilen. Gleichzeitig können Objekte die Fähigkeit entwickeln, selbst zu sehen oder zu schmecken. Stellen Sie sich eine Kamera vor, die sehen und automatisch scharf stellen könnte – aber das gibt es natürlich bereits. In dem Maß, in dem die Technik dem Design vorauseilt, scheint die Rolle der Designer immer wichtiger zu werden. Sie sind es nämlich, die sämtliche Teile – die funktionellen, ästhetischen und technischen Eigenschaften eines Projekts – zu einem Ganzen zusammenfügen müssen.

Die Integration von Abhängigkeit erfordert allem voran das Verständnis, dass Design nicht immer, wie manche meinen, mit Erfindung oder Innovation zu tun hat. In der Ausbildung und bei schulischen Projekten beobachte ich nach wie vor die Neigung, Erfindungen machen zu wollen. Die größten Anstrengungen werden unternommen, um sich von Vorhandenem wegzubewegen, ungeachtet dessen, ob es gut funktioniert oder nicht. Studenten scheinen oft zu glauben, dass alles, was schon da war, falsch oder irrelevant für den Designprozess ist. Das Konzept schrittweiser Verbesserungen und ein Verständnis für Geschichte scheinen nebensächlich. Doch wie in der Natur führen kleine Schritte immer zu einem realistischeren und weltbezogenerem Gefühl. In unserem Büro machen wir nach wie vor alles, was wir konzipieren, zunächst aus Karton, Plastik, was immer sich dafür eignet. Wir wissen, dass der Großteil unserer Arbeiten sich mit Dingen befasst, die in irgendeiner Weise mit der Hand bedient werden. Wenn man sich nur auf den Computer verlässt, besteht mitunter die Tendenz, das Design sehr ausdrucksstark zu machen, weil die Möglichkeit dafür gegeben, dem Werkzeug inhärent ist. Der Computer ist wichtig, kann aber nur einen Sinn ansprechen – den visuellen. Es ist äußerst schwierig, sehr einfache und anmutige Dinge auf dem Computer zu machen, weil das Leuchten des Bildschirms per se bereits ausdrucksstark ist. Wenn man etwas aus Karton macht, ist es leichter, die Form und die Einfachheit zu beurteilen – es bedarf keiner Vorstellung, der Gedanke selbst darf Form annehmen.

Aus dem Englischen von Martina Bauer

Walter Bender

One Laptop per Child

At a lecture at MIT in the late 90s, Bill Buxton characterized the challenge for the user-interface-design community as minding the growing gap between the complexity of the world, which he argued was growing exponentially—Buxton's Law, and the human capacity to accommodate complexity, which he argued was growing linearly—God's Law. He proposed that good design could be used to both reduce complexity and to facilitate interaction.

While it is hard to argue that one should not strive for human-centric design, simplicity is not necessarily a preferred outcome: complexity is much of what makes life enjoyable; it is often the goal. We rarely seek a simple wine. We never seek a simple mind.

More problematic is Buxton's characterization of God's Law. Darwinists (and Creationists) would agree that the slope of human evolution is near (or at) zero. However this narrow reading does not take into account a fundamental human trait: people learn. It is only through learning that humanity can reach to complexity.

Eliot Soloway advocates learning-centered design: an approach that takes into consideration the unique needs of learners. It is Soloway—rather than Buxton—who inspires the underlying design principals of the *One Laptop per Child (OLPC)* program, which strives to provide Internet-enabled laptop computers to school-aged children in the developing world.

In addition to the capacity to learn, *OLPC* is capitalizing on two other human traits: the ability to express and the need to socialize. We are building an "expression" machine, whose basic modality is to create and share. We are emphasizing "Constructionism": you learn through doing; to encourage more learning, foster more doing. The laptop is deployed with a full complement of tools for constructing text, music, and graphics.

We are confident that the laptop will be used for the dissemination of received knowledge without any intervention on our part: the first English word learned by the children in one of our pilot programs in Cambodia was "Google." Equally sure is the extent to which the laptop will be used for communication: child-to-child and teacher-to-teacher; a sense of presence is always present in the interface, which supports chat and is voice overlaid upon all tasks.

Our goal is for children to appropriate knowledge. Any books and texts they download are embedded in a wiki; the children will be able to add comments and reflections, illustrations, etc. Their expressive output will also be stored in the wiki, to be shared within the community and thus encouraging criticism and reflection.

We have opted to use open-source software in a project for children because it gives them the opportunity to "own" the machine in every sense. While we don't expect every child to become a programmer, we don't want any ceiling imposed on those children who choose to reach towards complexity. We are diligent about using open document formats for much the same reason: transparency is more empowering than simplicity. The children—and their teachers—will have the freedom to reshape, reinvent, and reapply their software, hardware, and content.

The mechanical design of the laptop considers safety first. The team from *Fuse Project* have given the laptop soft, rounded edges and a visually distinctive, colorful design; with its light weight—less than 1.5 kilograms—and integrated handle sized for small hands, it is easy to carry. It contains no hazardous materials; it is fully ROHS compliant.

With the expectation that the laptop will be used in a harsher environment than the typical office computer, it has extra robust design: there is no hard drive to crash and few internal cables-another common point of failure. The laptop is molded with 2.0 millimeter thick plastic

walls (over 50 percent thicker than the walls found on most commercial laptops). The I/O ports are protected externally and internally; there are internal "bumpers" to protect display and a soft external bumper for additional shock protection. The sealed rubber-membrane keyboard provides additional protection from dust and moisture.

The keyboard, which has a smaller key pitch for smaller hands, also has a lighter touch than normal keyboards. There is a dual-mode (capacitive for fingers and resistive for styli) extra-wide touch-pad to support pointing, drawing, and writing. While there are an internal microphone and stereo speakers, the external microphone input doubles as an analog-sensor input, enabling the laptop to be used for applications such as an oscilloscope. Other interface features include dual cursor-control pads for "gaming." Three USB-2.0 ports are available for expansion.

A 7.5-inch dual-mode TFT display is mounted on a "transformer" hinge, supporting both electronic-book mode for reading and laptop mode for computing tasks. With an 8:1 contrast ratio and 1200x900 pixel resolution in reflective mode, the laptop will rival technologies such as E-Ink in sunlight. With the backlight on—transmissive mode—the display is full color.

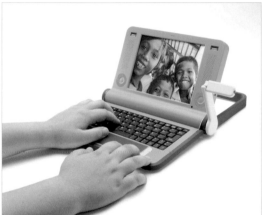
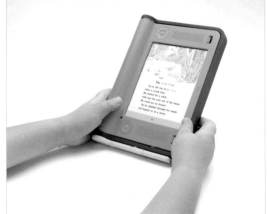
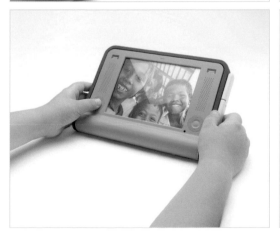
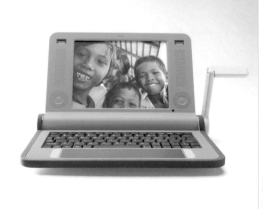

Design Continuum

The built-in wireless mesh network will ensure that even in situations where the connectivity to the Internet is intermittent, the children will have a reliable local high-speed channel of communication. Peer-to-peer "service discovery" ensures that the children will be able to chat, talk, and share with each other, even when they don't have access to remote services such as Google search and Skype. When the children are not using their laptops, they will serve as routers for other children, adding robustness to the mesh.

The laptop has a 2000-cycle removable NiMH battery, but human power is priority; many of the communities where we will be deploying have little or no power. There are a variety of human-power options and the expectation that there will be indigenous power systems adapted to the laptop as well: NiMH is much more tolerant to a wide and varied range of voltages than lithium; there is some evidence that varying the voltage actually improves the lifetime of the battery.

Hand-in-hand with human power is power-efficiency: the laptop consumes $^1/_{10}$th of the power of conventional laptops. This translates into a longer battery life and an expected ratio of ten minutes of use for every one minute spent in generating power.

At *OLPC*, we are not building a "simple," inexpensive machine for the world's children; inexpensive is a necessary specification for the laptop, as we are trying to reach children in the developing world. However, it is not sufficient: the laptop must be learning-centered. Our goal is to provide every child with the opportunity to explore, experiment, and express. We are not underestimating children's need and capacity to engage in the "art of complexity."

http://www.laptop.org

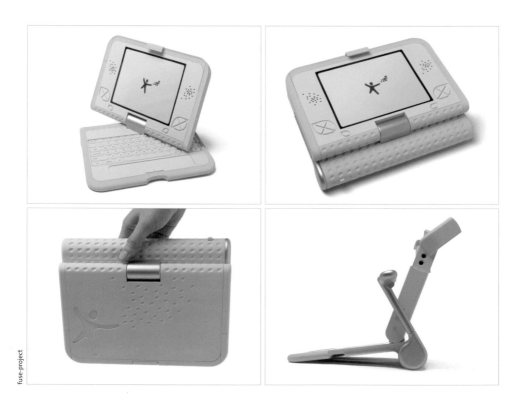

fuse-project

Walter Bender

Ein Laptop pro Kind

In einem Vortrag am MIT Ende der 1990er-Jahre meinte Bill Buxton, die Herausforderung bei der Gestaltung von Benutzerschnittstellen läge darin, die wachsende Kluft zwischen der nach Buxtons Gesetz exponenziell wachsenden – Komplexität der Welt und dem – seiner Meinung nach linear steigenden – menschlichen Vermögen zur Bewältigung von Komplexität (Gottes Gesetz) geschickt zu überbrücken. Gutes Design soll sowohl Komplexität reduzieren als auch Interaktion fördern.

Während sich unschwer argumentieren lässt, dass Design benutzerzentriert sein sollte, ist Einfachheit nicht unbedingt wünschenswert: Komplexität macht das Leben erst lebenswert und ist oft das eigentliche Ziel vieler Handlungen. Selten wollen wir einen einfachen Wein, nie einfache Gemüter.

Problematischer ist Buxtons Beschreibung des Gesetz Gottes. Darwinisten (und Kreationisten) würden bejahen, dass die Steigung der menschlichen Evolutionskurve auf null zugeht oder bereits dort angelangt ist. Diese kurzsichtige Lesweise lässt eine grundlegende menschliche Eigenschaft außer Betracht: Menschen lernen. Nur durch Lernen kann die Menschheit nach Komplexität streben.

Eliot Soloway spricht sich für ein lernerzentriertes Design aus, bei dem die besonderen Bedürfnisse von Lernenden berücksichtigt werden. Soloways Sichtweise und nicht Buxtons Vorstellungen inspirieren die Grundprinzipien von *One Laptop per Child* (OLPC), einer Initiative, die Schulkindern in Entwicklungsländern Laptops mit integriertem Internetanschluss zur Verfügung stellen möchte.

Neben der menschlichen Lernfähigkeit macht sich OLPC zwei weitere menschliche Eigenschaften zu Nutze: die Ausdrucksfähigkeit und das menschliche Bedürfnis nach Gesellschaft. Wir entwerfen eine „Ausdrucksmaschine", die zwei Grundfunktionen hat: Gestalten und Teilen. „Konstruktionismus" steht für uns im Vordergrund: Lernen durch Tun. Um Lernen zu fördern, wird Tun forciert. Der Laptop verfügt deshalb über verschiedene Programme zur Textverarbeitung, Musik- und Grafikbearbeitung.

Wir sind davon überzeugt, dass der Laptop auch ohne unser Zutun zur Weitergabe von Informationen genutzt werden wird: Das erste englische Wort, das Kinder in einem unserer Pilotprojekte in Kambodscha lernten, war „Google". Sicher ist auch, dass der Computer zur Kommunikation zwischen den Kindern einerseits und den Lehrern andererseits genutzt wird. Die Schnittstelle vermittelt eine Art ständiger Präsenz: Sie verfügt über eine Chatfunktion und eine Sprachausgabe für alle Aufgaben.

Unser Ziel ist es, dass die Kinder sich Wissen aneignen. Alle Bücher und Dokumente, die sie herunterladen, sind in einem Wiki gespeichert, in dem die Kinder Kommentare, Gedanken, Bilder, ergänzen können. Ihr eigenes schöpferisches Schaffen wird ebenfalls im Wiki gespeichert: So hat die Gemeinschaft Zugriff und wird zu Kritik und Reflexion eingeladen.

Da es sich um ein Projekt für Kinder handelt, haben wir uns für eine Open-Source-Software entschieden, da diese den Kindern die Möglichkeit bietet, im wahrsten Sinn des Worts vom Gerät „Besitz" zu ergreifen. Zwar erwarten wir nicht, dass jedes Kind zum Programmierer wird, doch wollen wir jenen Kindern, die nach Komplexität streben, keine Grenzen auferlegen. Aus dem gleichen Grund verwenden wir Open-Document-Formate: Transparenz bietet vielfältigere Möglichkeiten als Einfachheit. Die Kinder und ihre Lehrer können Software, Hardware und Inhalte neu gestalten, an ihre Bedürfnisse anpassen und innovativ nutzen.

Beim mechanischen Design des Laptops hat Sicherheit für uns oberste Priorität. Das Team von Fuse Project hat die Ecken des Laptops abgerundet und ihm ein auffälliges, farbenfrohes Design verpasst. Aufgrund seines geringen Gewichts (unter 1,5 kg) und dank des für Kinderhände dimensionierten Tragegriffs ist er leicht transportabel. Das Gerät enthält keine gesundheitsgefährdenden Stoffe und entspricht der RoHS-Richtlinie.[1]

Da angenommen wird, dass der Laptop in einer raueren Umgebung als herkömmliche Bürocomputer genutzt wird, ist er besonders robust: Es gibt keine zerstörbare Festplatte und nur wenige eingebaute Kabel – ein weitere Fehlerquelle bei vielen herkömmlichen Laptops. Der Laptop hat ein 2-Millimeter-Plastikgehäuse (um mehr als 50 Prozent dicker als das vieler kommerzieller Laptops). Die I/O-Ports sind außen und innen geschützt. Der Laptop verfügt weiters über eingebaute „Stoßdämpfer", die den Bildschirm schützen, und einen weichen zusätzlichen Stoßdämpfer zum Schutz vor Erschütterungen. Die versiegelte Gummi-Tastatur hält Staub und Feuchtigkeit ab.

Die Tastatur hat einen speziell für Kinderhände kleineren Tastenabstand und leichteren Anschlag als herkömmliche Tastaturen. Der Laptop hat außerdem ein besonders großes Touchpad zum Zeigen, Zeichnen und Schreiben, das in zwei Modi betrieben werden kann (kapazitiv durch Berührung mit den Fingern und resistiv mittels Stift zur Schrifteingabe). Weitere Merkma-

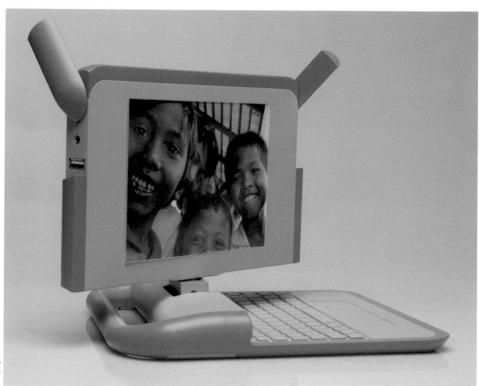

fuse-project

le sind ein eingebautes Mikrofon und Stereolautsprecher, während der externe Mikrofoneingang auch als analoger Sensoreingang fungiert, sodass Geräte wie ein Oszilloskop angeschlossen werden können. Als weitere Funktion für Spiele hat der Laptop auch zwei Cursor-Kontrollpanels. Drei USB-2.0-Ports dienen als Erweiterungsanschlüsse.

Der 7,5-Zoll-Dual-Mode-TFT-Bildschirm des Laptops ist an einem drehbaren Schanier montiert; im Buchmodus können E-Bücher gelesen, im Laptopmodus Computerarbeiten durchgeführt werden. Mit einem Kontrastverhältnis von 8:1 und einer Auflösung von 1200 x 900 Pixel im Reflektivmodus kann sich das Gerät auch bei grellem Sonnenlicht mit Technologien wie E-Ink messen. Im Transmissivmodus wird es durch die Hintergrundbeleuchtung zu einem Vollfarbdisplay.

Dank der integrierten WLAN-Mesh-Netzfunktion können die Kinder auch bei fehlendem Internetzugang lokal eine schnelle, zuverlässige Verbindung untereinander aufbauen. Die Peer-to-Peer-Diensterkennung ermöglicht den Kindern, miteinander zu chatten, zu kommunizieren oder Inhalte auszutauschen, auch wenn sie nicht auf Internetdienste wie Google und Skype zugreifen können. Wenn die Kinder ihre Laptops nicht verwenden, fungieren diese als Router und erhöhen so die Stabilität des Mesh-Netzes.

Der Laptop wird mit einem NiMH-Akku (2000 Ladezyklen) betrieben, die Stromversorgung kann aber auch über einen manuellen Antrieb erfolgen, da die Geräte in Gegenden zum Einsatz kommen, in denen es keine oder eine nur unzureichende Stromversorgung gibt. Es können verschiedene Möglichkeiten zur Stromversorgung durch manuellen Antrieb genutzt werden, und der Rechner wird vermutlich auch an lokale Stromerzeugungssysteme angeschlossen werden: NiMH-Akkus vertragen eine größere Bandbreite unterschiedlicher Spannungen als Lithium-Akkus. Es gibt sogar Hinweise dafür, dass verschiedene Netzspannungen die Lebensdauer des Akkus verlängern.

Ein manueller Antrieb garantiert eine erhöhte Energieeffizienz: Der Laptop verbraucht ein Zehntel des Stroms, den herkömmliche Geräte benötigen. Dies resultiert in einer längeren Lebensdauer des Akkus und einer erwarteten Betriebszeit von zehn Minuten pro Minute Stromerzeugung. OLPC baut keinen „einfachen", „billigen" Computer für Kinder. Billig ist eine notwendige Spezifikation, da wir Kinder in Entwicklungsländern mit Laptops versorgen wollen. Billig allein ist jedoch nicht genug: Der Rechner muss lernerzentriert sein. Unser Ziel ist es, jedem Kind die Möglichkeit zu geben, Neues auszuprobieren, damit zu experimentieren und den eigenen Gefühlen Ausdruck zu verleihen. Auf keinen Fall unterschätzen wir das Bedürfnis und die Fähigkeit von Kindern, sich an der „Kunst der Komplexität" zu beteiligen.

http://www.laptop.org

Aus dem Englischen von Sonja Pöllabauer

1 Anm. d. Ü.: EU-Richtlinie zur Beschränkung der Verwendung bestimmter gefährlicher Stoffe in Elektro- und Elektronikgeräten.

Olga Goriunova

When New Media are No Longer New and Everyone Creates on the Internet
On Platforms and Art

Simplicity is worse than theft.
Russian proverb

Our starting point is the topic of Ars Electronica 2006—Simplicity. What is simplicity today and why is simplicity central for the new media/communication/cyber/digital avantgarde art of 2006? The topic is good, old, and could have been expected. In addition to this, the Transmediale 2005 theme was: *Basics!*

Ars Electronica's themes over the last ten years, as far as I can judge, have more or less reflected what was happening in the scene: *CODE, The language of our time* in 2003, the year of software art; *Unplugged, Art as the Scene of Global Conflicts* in 2002, the year of faith in the power of politically-minded art and activist projects, just before the war on Iraq was launched, which ruined that faith; a whole series of topics relating to gender, body and sex, summarizing discourses of the late 80s and 90s (1996, *Memesis, The Future of Evolution;* 1997, *Fleshfactor;* 1999, *LifeScience;* 2000, *Next Sex);* and *Welcome To The Wired World* in 1995, pointing to the rise of WWW technology and net art.

So what is happening today that evokes such a topic as simplicity? Simplicity means authenticity. Is it a sign of some kind of a crisis? What do people do when they are in crisis? They turn back to simple, basic things that supposedly won't prove wrong.

There have been talks and texts on the crisis in new media art appearing all year round. There have been discussions, for instance, on the *Spectre* mailing list in the summer/autumn 2005, relating to the closing or scaling down of media labs across the developed countries;[1] there have been texts and reviews stating or analyzing the ongoing changes.[2]

I will try to look at the issue from the point of view of "simplicity". Simple means authentic, true, basic. Simplicity cannot deceive or make a mistake. Simplicity cannot be forged. Simplicity is a kind of synonym for "bare life", with something "nature" does and "people" do.

Here is the key. What do people do today with communication technology? They blog, they contribute to encyclopedias, they share their photographs and videos, they date and maintain relationships with friends, they bookmark together, they link, they broadcast, they map. And all these activities they perform everyday and, dare I say this—and I am not mocking, without the (media) artists and institutions.

In the early days the Internet, WWW and new media used to be inhabited by scientists, programmers and artists. Today, with the dropping costs of technology and bandwidth, with the wide use of mobile devices, we witness the true "massovization" of the Internet and, more generally, communication technology. The number of Internet users worldwide reached one billion in 2005.[3]

If there is a crisis in new media art, it is also because people do not need artists anymore to guide them through media experiences and to shape media experiences for them. As the book title and the, since then, much-loved slogan "the wisdom of crowds"[4] proves, the crowd became wise. Full stop. Why does it need anyone else?

Everyone is becoming a content producer these days. People do creative things: write diaries,

take photographs, annotate. There are platforms for publishing and managing all kinds of content created by users. There are open encyclopedias, friend-of-a-friend networks, social bookmarking sites, group-forming networks, photoblogs and other blogs, collaborative mapping and other visualization and sonification tools, not to mention various digital product repositories. *Orkut,* a social network service "providing friendships", similar to *Friendster, FaceBook* and MySpace, had reached 2 million users already in 2004, half a year after it had been launched. A well-known phenomenon is that around 70 percent of its users are Brazilians.[5] In Brazil, as the Brazilian artist Giselle Beiguelman says, it is safer for teenagers to meet online than outside the house.

LiveJournal, a blogging service, has a distinct aura in the Russian part of the Internet. Some researchers believe blogging is new journalism and the main activity of bloggers is commenting on political news.[6] As shown by other academics, the typical blog is maintained by teenage or adolescent girls.[7] *Russian LiveJournal* (this particular service has become synonymous to Blog in general), as researcher Eugene Gorny demonstrates, was firstly populated by male professionals, including Internet workers, journalists, writers, philosophers and artists. Thus, *LiveJournal* in Russia "acquired the aura of a playground for intellectuals".[8] *Russian LiveJournal* has become a source of news and information competing with official media, a platform for politicians, writers, researchers, critics, a discussion forum and a socializing tool. Besides, *Russian LiveJournal* was often organizing offline meetings for, for instance, Moscow-based users.

Here are some more geography-specific facts on bloggers' capacities. One of the well-known *LiveJournal* campaigns was the Anti-Barbie campaign of 2005. An online contest for the most beautiful girl in Russia was organized.[9] Anyone could enter their profile and be voted for. The one who received the most votes would go to the Miss Universe contest. Soon after it was launched a *LiveJournal* user found a profile of a girl who didn't conform to the "Barbie" 90-60-90 measurements, but who entered her data for the contest. A large voting campaign was launched over *LiveJournal* in the course of a few days, and when more than 10,000 original users had voted for Alena Pisklova, pushing her through to the semi-final, the service hosting the contest announced that she didn't qualify to represent Russia in the Miss Universe contest as she was only 15.

If we turn to mapping, we can find projects ranging from annotating Google maps, basically overlaying things other than business data or statistics onto existing Google maps, to projects linking *Wikipedia* to mapping, and to projects building entirely free maps from scratch using GPS devices. *Wikimapia, OpenStreetMap, GlobeFeed, Tagzania* is a very incomplete list of such platforms. With *Tagzania,* for instance, people create as different maps as the *Da Vinci Code guide of Paris* and police action chronicles.

MapOMatix is an open-source collaborative environment for creating and editing maps; it is a psycho-geographic "geo-wiki" or, better, a tactical mapping tool. As the developers state: "In the times of real-time fear watching, when centralized and controlled instances deliver localized and time-stamped information, based on satellite data but processed through a chain controlled by big telecommunication companies, a need for a tool based on the exact negation of these characteristics seems useful and draws a line between service providers and self-organized groups of individuals".[10] GPS, mapping both physical elements, human practices, and relations between them, not centralized, horizontal exchange, not involving the usage of any expensive technology—all these elements are their choice.

Everything mentioned above covers a tiny part of today's Internet users' activities. I haven't referred to people sharing their music,[11] building semi-professional and professional communi-

ties on digital photography,[12] VJ-ing[13] or sharing links.[14] Nor have I paid attention to the miracle of *Wikipedia* referenced in this text a dozen times. The range of social media platforms uniting manifestations of digital folklore and practices of everyday lives (in the sense of De Certeau[15]) to possibilities of professionalization and education is vast.

The history of some of these tools as well as of these activities trace back not only, but also, to early net art practitioners and new media art practices in general.[16] The origin of today's blogs and photoblogs can be found in online diaries and reports, such as Kathy Rae Huffman's and Eva Wohlgemuth's *Siberian Deal* project from 1995, which consisted of "text and picture files ... sent regularly from different locations on the road to majordomos Chrono Popp in Vienna, who forwarded ... information to the ... on-line report" through which, "viewers could follow the travel, interact..., and (the authors) ... were able to react to their questions and remarks".[17] Another example is a mapping project by Heath Bunting *Visitor's Guide to London*[18] from 1995 that suggests an alternative sightseeing tour.

Micromusic, a platform for 8-bit music, was co-created by a former member of ETOY group that got a Golden Nica in the World Wide Web category at Ars Electronica 1996 with their *etoy—The Hijack Project.*[19]

However, not only artists or engineers create platforms. Corporations buy existing platforms and create new ones. *LiveJournal* created by an enthusiastic student and based on open-source software existed as an independent project from March 1999 till January 2005 when it was bought by *Six Apart* (one of the largest blog providers) that also owns *TypePad,* which will be mentioned later. *Orkut* as well as other platforms announce in their copyright statement that "By submitting, posting or displaying any materials on or through the www.*orkut.com* service, you automatically grant to us a worldwide, non-exclusive, sublicenseable, transferable, royalty-free, perpetual, irrevocable right to copy, distribute, create derivative works of, publicly perform and display such materials".[20]

And finally there appear announcements concerning future Windows Live™, a platform that will unite a set of personal Internet services and software, and will include search, e-mail, instant messaging, file and photo sharing, PC based calling, and much more.[21]

There is also a trend called moblogging (from mobile weblogging) meaning maintaining an Internet blog by posting photographs and comments to it from a mobile phone or a PDA.

Nokia, for instance, equips its suitable phone models with software such as *Lifeblog* that gathers all information produced with your phone, including text messages, photos and video and as follows from a Nokia official guide to moblogging[22]: "automatically organizes your digital media between your mobile phone and PC so you can view, search, edit, and share your images and messages". Such blogs are published online by services such as Typepad.com.

Apart from the issue of surveillance that is getting hotter and hotter these days, what comes to mind is actor network theory,[23] turned from an academic concept into an essential element of a capitalist enterprise. As Victor Pelevin, a contemporary Russian writer, has noted: when one buys downhill skis, one also pays for the snow.

Buying a phone with software enabling moblogging, one buys and signs up for a certain culture. Working and the popular concept of moblogging are as central to Nokia, and especially to its sales department, as the work of the chief engineer of the phone. Moblogging makes sure that the features of the phone will be used and phones will be sold out. Technical and cultural production goes hand in hand. Maintaining a moblog phone is included into the capitalist production cycle, as much as working on assembling the phone itself.

A number of books have appeared recently about terms and myths on blogging and other forms of Internet activities,[24] but what seems a more relevant concept to use when talking about these issues today is the concept of immaterial labor.

The concept originates from the Marxist debate on post-Ford production. Among the key figures in the debate Italian thinkers such as Maurizio Lazzarato, Paolo Virno, and Tiziana Terranova could be mentioned.

Labor no longer produces material commodities; it is formed by the montage of humans and technology and often performed outside the official experiences, during free time. The production of surplus value tends to depend on the expansion of commodities, as Tiziana Terranova explains: "information-rich commodities ... (that) are not destroyed in the act of consumption but...persist and reverberate as events able to transform the sensorial basis of subjectivity".[25] The creation of wealth depends on the production of subjectivity, on cultural production and based on the usage of the whole time of life. For Terranova: "...this is socialized wealth, which cannot be measured by money but resides in the intensive value of relations, affections, modes of expressions, and forms of life".[26]

Precarious cultural production becomes central to this type of economy. For Virno, culture provides training in precariousness and variability,[27] it drives innovation. For Marazzi, cultural production helps in identifying potential future social needs and desires. For Terranova, culture provides a new type of product—a commodity that is "more akin to a work of art rather then a material commodity".[28] The worker experiments as an artist, transforming subjectivity. Immaterial labor feels more like Art.

Immaterial labor is paradoxical because it contains the potential for emancipation as well as for the intensification of exploitation.

As Terranova sums up: "this mode also signals the emergence of new machines of control and subjectification which re-impose hierarchical relations at the service of social reproduction and the production of surplus value. These are moments which turn qualitative, intensive differences into quantitative relations of exchange and equivalence; which enclose the open and dissipative potential of cultural production into differential hierarchies; which accumulate the rewards or work carried out by larger social assemblages ...".[29]

Do we all recognize the place our platforms, users and corporations take in this picture? Coming back to new media art and simplicity, in the final part of the text I would like to draw an optimistic picture of open platforms not subsumed to new forms of control and built by people like us, of people creating artistic work that doesn't become a commodity so easily, of people making a change on the cultural landscapes—with instructions of how to do it.

These are relatively small platforms based on databases, voting systems, blogging tools, commenting threads, little chats, hit charts and other tools. The main idea here is to have an idea. If there is a key idea, inspiration, some common ideology, the platform is open for change, and if there is a relatively small devoted group of people-administrators, it can produce wonderful results.

I have co-published elsewhere a paper analyzing three platforms, two of which were partly built by (new media) artists: www.Micromusic.net (a label and a community focused on 8-bit music that has received wide recognition as a cultural phenomenon), www.Runme.org (a software art repository that we, the co-creators, believe contributed to software art becoming a more open and interesting thing that it could have become), and a third one—www.Udaff.com (a Russian language-based literary resource that managed to establish a "literary trend" of its own).[30] Here

I could also add *MapOMatix* that was mentioned earlier and many others. I will quickly repeat the reasons for their—I believe—success.

Such platforms appear as reactions to the development of a particular practice they focus on. They are quickly built by a few enthusiasts, which is possible with modern technology. Such platforms are always moderated. Platforms need to be open and customizable, moreover they must be able to change significantly according to the needs and demands of a cultural practice and the social groups of people it works with. Such platforms accumulate quite a number of creative products that in turn attract new people. Platforms often suggest new modes of education, knowledge building, creative work and a supportive social environment, as well as models for the development of some creative activity. Working with "gray" zones of cultural production, with grass-root practices, such platforms can create significant artistic and cultural phenomena. It is not very important what form the platform takes, whether it is a blog, a database or a wiki. If there is a shared aesthetic, social, political horizon, if there appears a need to build a piece of knowledge or art, a group of people is able to filter and shape the data using similar, but still very varied techniques of administration, voting, ranking, commenting, linking, editing, etc, and thus transfer the practice onto a different cultural level. Still such a platform or corner of a larger platform is very distinct from most popular spaces described earlier.

The dream of net artists came true: people can exchange their creative work without institutions and corporations, they can build collaborations, communicate; they can do art; people have technologies now. We should just beware.

Is it simplicity? Maybe. Russians say: "Things of genius are simple".

But more likely it is complexity.

1 See threads entitled "ART iT article: Is the ICC (Tokyo) closing?", "the media art center of 21 c" at:
 http://coredump.buug.de/cgi-bin/mailman/listinfo/spectre
2 For instance a review of Transmediale by Armin Medosch: *Good Bye Reality! How Media Art Died But Nobody
 Noticed* at: *http://www.mazine.ws/node/230*
3 See *http://www.c-i-a.com/pr0106.htm*
4 James Surowiecki, *The Wisdom of Crowds: Why the Many Are Smarter Than the Few and How Collective Wisdom
 Shapes Business, Economies, Societies and Nations,* Bantam Dell Pub Group, 2004
5 See *http://en.wikipedia.org/wiki/Orkut*
6 J. D. Lasica, "Blogging as a form of journalism", in *USC Annenberg Online Journalism Review,* May 24, 2001.
 http://www.ojr.org/ojr/workplace/1017958873.php
7 "Perseus Blog Survey": *http://www.perseus.com/blogsurvey/index.html*
8 Gorny, Eugene: "Russian LiveJournal. The Impact of Cultural Identity on the Development of a Virtual
 Community", in Schmidt, Henrike, Teubener, Katy, Konradova , Natalja (Ed.) (2006): *Control + Shift. Public
 and Private Usages of the Russian Internet,* Norderstedt: Books on Demand. Available online at:
 http://www.ruhr-uni-bochum.de/russ-cyb/library/texts/en/control_shift/control_shift.htm
9 *http://www.miss.rambler.ru/*
10 "PGS versus GPS: On Psycho/Subjective Geographic Systems" by elpueblodechina dialoguing with yves
 degoyon *(MapOMatix)* in Goriunova, Olga, (Ed.): *Readme 100. Temporary Software Art Factory,* Norderstedt:
 Books on Demand, 2006. Available at: *http://mapomatix.sourceforge.net/mapOMatix-3.pdf*
11 *http://micromusic.net*
12 *http://fotokritik.ru/*
13 *http://vjcentral.com/*
14 *http://listible.com*
15 de Certeau, Michel: *The Practice of Everyday Life,* University of California Press, 1984
16 For an excellent account of the history of blogs, see the *Wikipedia* entry "blog":
 http://en.wikipedia.org/wiki/Blog
17 *http://nroo226.vhost2.sil.at/siberian/vrteil.htm*
18 Some documentation is left at: *http://www.irational.org/heath/london/*
19 Have a look at: *http://www.etoy.com/*
20 *http://en.wikipedia.org/wiki/Orkut*
21 *http://www.microsoft.com/presspass/press/2005/nov05/11-01PreviewSoftwareBasedPR.mspx*
 Thanks to Mercedes Bunz for this link.
22 *http://europe.nokia.com/BaseProject/Sites/NOKIA_MAIN_18022/CDA/ApplicationTemplates/About_Nokia/
 Content/_Static_Files/moblogbackgrounder.pdf*
23 The actor network theory was developed primarily by Bruno Latour, Michel Callon and John Law; it is applied
 to explaining technological products, events or productions as structures, components of which act together
 to produce certain results. Such components could be scientific facts, tasks, human relations, economic factors
 and others that are traditionally excluded from thinking about technology and society.
24 For example, Rheingold, Howard: *Smart Mobs: The Next Social Revolution,* Basic Books, 2003
25 Terranova, Tiziana: "Of Sense and Sensibility: Immaterial Labor in Open Systems", in Krysa, Joasia (Ed.):
 Curating Immateriality, Autonomedia, Data Browser 03, 2006, p.28
26 Ibid., p.29
27 Virno, Paolo: *A Grammar of the Multitude,* Semiotext(e), 2004
28 Terranova, Tiziana: ibid.
29 Ibid., p.33
30 Goriunova, Olga, Shulgin, Alexei: "From Art on Networks to Art on Platforms", in Krysa, Joasia (Ed.): *Curating
 Immateriality,* Autonomedia, Data Browser 03, 2006

Olga Goriunova

Wenn die Neuen Medien nicht mehr neu sind und jeder etwas im Internet macht
Über Plattformen und Kunst

Einfachheit ist schlimmer als Diebstahl.
Russisches Sprichwort

Mein Ausgangspunkt ist das Thema der diesjährigen Ars Electronica – Einfachheit. Was heißt das heute und warum ist Einfachheit 2006 von grundlegender Bedeutung für die Neue Medien-/Kommunikations-/Cyber-/Digital-Kunstavantgarde? Das Thema ist gut, alt und kommt nicht unerwartet. Schließlich ging es schon bei der Transmediale 2005 um *Basics!*
Die Ars-Electronica-Themen der letzten zehn Jahre haben, soweit ich das beurteilen kann, stets das jeweilige Szenegeschehen widergespiegelt: *CODE, The language of our time* 2003, im Jahr der Softwarekunst; *Unplugged, Art as the Scene of Global Conflicts* 2002, im Jahr des Glaubens an politisch engagierte Kunst und aktivistische Projekte, bevor dann der Irakkrieg diesen Glauben zerstörte; eine ganze Reihe von Themen zu Gender, Körper und Sexualität, die die Diskurse der späten 1980er und 1990er Jahre zusammenfassten (*Memesis, The Future of Evolution,* 1996; *Flesh-factor,* 1997; *LifeScience,* 1999; *Next Sex,* 2000); und *Welcome to the Wired World* 1995, parallel zum Aufstieg der WWW-Technologie und der Netzkunst.
Was steckt also heute hinter einem Thema wie Einfachheit? Einfachheit heißt Authentizität. Ist das ein Krisenzeichen? Was tut man, wenn man sich in einer Krise befindet? Man greift auf die einfachen, grundlegenden Dinge zurück, die angeblich nie falsch sind. Das ganze letzte Jahr über ist von einer Krise der Medienkunst geredet und geschrieben worden. Im Sommer und Herbst 2005 wurde zum Beispiel auf der *Spectre*-Mailinglist über die Schließung und Verkleinerung von Medialabs in der gesamten entwickelten Welt diskutiert,[1] zahlreiche Texte und Besprechungen widmeten sich der Beschreibung und Analyse der im Gang befindlichen Veränderungen.[2]
Ich möchte mir diese Dinge vom Standpunkt der „Einfachheit" aus ansehen. Einfach heißt authentisch, wahr, grundlegend sein. Einfachheit blendet nicht und macht keine Fehler. Einfachheit lässt sich nicht fälschen. Sie ist gewissermaßen ein Synonym für das „unverfälschte Leben", die Verfahrensweise der „Natur" und das, was „man" tut.
Und hier ist der Schlüssel. Was macht man heute mit der Kommunikationstechnologie? Man bloggt, man schreibt Beiträge für Enzyklopädien, man tauscht Fotos und Videos aus, man vereinbart Rendezvous und unterhält Beziehungen mit Freunden, man bookmarkt gemeinsam, man verlinkt, man broadcastet, man mappt. Und das alles Tag für Tag und – ich meine das nicht ironisch – ohne (Medien-)Künstler und Institutionen.
In ihren Anfängen waren Internet, WWW und Neue Medien ein Habitat für Wissenschaftler, Programmierer und Künstler. Heute, mit den sinkenden Kosten für Technik und Bandbreite, mit der weiten Verbreitung mobiler Geräte, erleben wir eine „Vermassung" des Internet und der Kommunikationstechnologie im Allgemeinen. 2005 überschritt die Zahl der Internetnutzer auf der Welt die Milliardengrenze.[3]
Wenn es eine Krise in der Medienkunst gibt, so auch deshalb, weil man Künstler nicht mehr als Begleiter oder Gestalter bei der Medienerfahrung benötigt. Wie der zum beliebten Slogan gewordene Buchtitel *Die Weisheit der Vielen*[4] zeigt, sind die Massen, im Gegensatz zu ihrem bisherigen Verständnis, weise geworden. Punkt. Wozu sollten sie noch jemand anderen brauchen?

Heutzutage wird jeder zum Content-Produzenten. Die Menschen sind kreativ: Sie schreiben Tagebücher, machen Fotos, verfassen Kommentare. Es gibt Plattformen für die Publikation und Verwaltung aller möglichen von Nutzern geschaffenen Inhalte. Es gibt offene Enzyklopädien, Friend-of-a-Friend-Netzwerke, Social-Bookmarking-Sites, Gruppen bildende Netzwerke, Foto und andere Blogs, Tools für das gemeinsame Erstellen von Landkarten, sonstige Visualisierungen oder Sonifizierungen, ganz zu schweigen von den diversen digitalen Produktdepots.

Orkut, ein soziales Netzwerk zum „Knüpfen von Freundschaften" in der Art von *Friendster*, *Face-Book* oder *MySpace* erreichte 2004, nur ein halbes Jahr nach Inbetriebnahme, zwei Millionen Benutzer. Bekannt ist, dass rund 70 Prozent davon Brasilianer sind.[5] In Brasilien – so die Erklärung der brasilianischen Künstlerin Giselle Beiguelman – ist es für Teenager sicherer, sich online zu treffen als außer Haus.

Das Blogging-Service *LiveJournal* hat im russischen Teil des Internet eine ganz spezielle Aura. Einige Wissenschaftler halten Blogging für eine neue Form des Journalismus und das Kommentieren von politischen Nachrichten für die Haupttätigkeit von Bloggern.[6] Anderen zufolge ist der typische Blog eine Sache weiblicher Teenager und Halbwüchsiger.[7] Das russische *LiveJournal* (das Blogging-Service ist mittlerweile ein Synonym für Bloggen im Allgemeinen) wurde, wie Jewgenij Gorny gezeigt hat, anfangs vorwiegend von männlichen Freiberuflern, u. a. Internetarbeitern, Journalisten, Schriftstellern, Philosophen und Künstlern frequentiert. So kam es, dass *LiveJournal* in Russland „die Aura eines Tummelplatzes für Intellektuelle" annahm.[8] Das russische *LiveJournal* ist zu einer mit den offiziellen Medien konkurrierenden Nachrichten- und Informationsquelle geworden, zu einer Plattform für Politiker, Schriftsteller, Wissenschaftler, Kritiker, zu einem Diskussionsforum und Sozialisationsmedium. Überdies hat das russische *LiveJournal* auch häufig Offline-Meetings etwa für seine in Moskau ansässigen Benutzer organisiert.

Hier noch ein geospezifisches Faktum über die Macht von Bloggern. Eine der bekannten *LiveJournal*-Kampagnen war die Anti-Barbie-Kampagne von 2005. Sie bezog sich auf einen Online-Wettbewerb für das schönste russische Mädchen,[9] zu dem alle ihr Profil einreichen und sich zur Abstimmung stellen konnten. Das Mädchen mit dem meisten Stimmen sollte an der Wahl zur Miss Universum teilnehmen. Kurz nach Beginn des Wettbewerbs fand ein *LiveJournal*-Nutzer unter den Einreichungen zum Wettbewerb das Profil eines Mädchens, das den „Barbie"-Kanon von 90-60-90 sprengte. Innerhalb weniger Tage wurde eine große Wahlkampagne für sie auf die Beine gestellt, und als Alena Pisklova mit 10.000 Stimmen ins Semifinale einzog, musste der Veranstalter des Wettbewerbs erklären, sie könne Russland in der Wahl zur Miss Universum nicht vertreten, weil sie erst 15 sei.

Werfen wir einen Blick auf das Erstellen von Landkarten, so finden wir Projekte, die von der Annotierung von Google-Karten, dem Einfügen von nichtkommerziellen Daten oder Statistiken in existierende Google-Karten, über solche, die *Wikipedia* mit der Erstellung von Karten verknüpfen, bis hin zur vollkommenen Neuentwicklung von Karten mittels GPS-Geräten reichen. *Wikimapia*, *OpenStreetMap*, *GlobeFeed* oder *Tagzania* sind nur einige solcher Plattformen. Mit *Tagzania* zum Beispiel werden so ganz neue Karten erstellt wie ein Da-Vinci-Code-Führer für Paris oder eine Aufzeichnung von Polizeieinsätzen.

MapOMatix, eine gemeinschaftliche Open-Source-Umgebung zum Erstellen und Editieren von Landkarten, ist ein psychogeografisches „Geo-Wiki" oder, genauer gesagt, ein Tool für *tactical mapping*. „In Zeiten, da man in Echtzeit Angst beobachten kann", schreiben die Entwickler, „da zentralisierte und kontrollierte Instanzen mit Ort- und Zeitangaben versehene Informationen verbreiten – Angaben, die zwar auf Satellitendaten beruhen, aber einen von den großen Telekommu-

nikationsfirmen kontrollierten Weg durchlaufen –, scheint das Bedürfnis nach einem Werkzeug zu bestehen, das auf der exakten Negation dieser Merkmale beruht und eine Grenze zwischen Service-Providern und selbst organisierten Gruppen von Individuen zieht."[10] GPS, das Kartografieren nicht nur physischer Elemente, sondern auch menschlicher Praktiken und zwischenmenschlicher Beziehungen, ein nicht zentralisierter, horizontaler Austausch, der keine Verwendung kostspieliger Technologie impliziert – das sind die Elemente, für die sie sich entschieden haben.

All die oben erwähnten Dinge decken nur einen kleinen Teil heutiger Useraktivitäten im Internet ab. Nicht genannt habe ich zum Beispiel das gemeinsame Nutzen von Musik,[11] den Aufbau halbprofessioneller und professioneller Communities zu digitaler Fotografie,[12] VJ-ing[13] oder den Austausch von Links.[14] Und auch auf das Wunder der in diesem Text etliche Male erwähnten *Wikipedia* bin ich nicht näher eingegangen. Die von Manifestationen digitaler Folklore und wohl überlegter Alltagspraktiken (im Sinn von De Certeau[15]) zu Möglichkeiten der Professionalisierung und Bildung reichende Palette sozialer Medienplattformen ist ungeheuer breit.

Die Geschichte einiger dieser Tools und Aktivitäten gehen zum Teil auf die Praktiker der frühen Netzkunst und Medienkunstpraktiken im Allgemeinen zurück.[16] Der Ursprung heutiger Blogs und Fotoblogs ließe sich in Online-Tagebüchern und Berichten wie Kathy Rae Huffmans und Eva Wohlgemuths *Siberian Deal*-Projekt von 1995 suchen, das aus „Text- und Bilddateien" bestand, „die von unterschiedlichen Orten auf Reisen regelmäßig an den Mayordomus Chrono Popp in Wien gesandt wurden, der … die Information … an den Online Report weiterleitete", so dass „die Betrachter die Reise mitverfolgen, interagieren …, und (die Autoren) … auf deren Fragen und Bemerkungen reagieren konnten".[17] Ein weiteres Beispiel von 1995 ist Heath Buntings Kartografieprojekt *Visitor's Guide to London,[18]* das eine alternative Sightseeing-Tour offeriert.

Micromusic, eine Plattform für 8-bit-Musik, wurde von einem früheren Mitglied der Gruppe etoy mitaufgebaut, die mit *etoy – The Hijack Project[19]* 1996 die Goldene Nica in der Kategorie World Wide Web gewann.

Plattformen werden aber nicht nur vor Künstlern und Technikern geschaffen. Auch Firmen kaufen bestehende Plattformen oder schaffen neue. Das 1999 von einem idealistischen Studenten auf Open-Source-Software aufgebaute *LiveJournal* war ein unabhängiges Projekt, ehe es im Januar 2005 von *Six Apart* (einem der größten Blog-Provider) gekauft wurde, dem auch das weiter unten erwähnte *TypePad* gehört. *Orkut* und andere Plattformen geben ihn ihrem Copyright-Statement an: „Mit dem Einreichen, Posten oder Ausstellen von Materialien auf oder durch *Orkut* überlassen Sie uns automatisch das weltweite, nicht-exklusive, unterlizenzierbare, übertragbare, tantiemenfreie, dauerhafte und unwiderrufliche Recht, alle diese Materialien zu kopieren, vertreiben, weiterzuverarbeiten, öffentlich aufzuführen und auszustellen."[20]

Und schließlich gibt es Ankündigungen zum neuen Windows Live™, einer Plattform, die ein Set persönlicher Internetdienste und verschiedener Softwaren vereint: Suche, E-Mail, Instant Messaging, File- und Foto-Sharing, Internet-Telefonie und viele andere Funktionalitäten.[21]

Ferner gibt es einen Trend namens Moblogging (mobiles Weblogging), das Betreiben eines Internet-Blogs durch Posten von Fotos und Kommentaren mittels Handy oder PDA.

Nokia zum Beispiel stattet seine Mobiltelefone mit Software wie *Lifeblog* aus, die sämtliche mit dem Handy produzierten Informationen, einschließlich SMSs, Fotos und Videos archiviert und, wie es in einem offiziellen Moblogging-Leitfaden[22] von Nokia heißt, „Ihre digitalen Medien automatisch zwischen Mobiltelefon und PC so organisiert, dass sie Ihre Bilder und Nachrichten ansehen, durchsuchen, editieren und mit anderen teilen können." Derartige Blogs werden von Diensten wie *Typepad* online publiziert.

Was einem dabei, abgesehen von der immer heißer werdenden Frage der Überwachung, in den Sinn kommt, ist die Akteur-Netzwerk-Theorie,[23] die sich von einem akademischen Konzept zu einem wesentlichen Element kapitalistischer Unternehmen gewandelt hat. Wie Victor Pelevin, ein russischer Autor, dazu bemerkt hat: Wer Alpinski kauft, zahlt auch für den Schnee.

Wer ein Handy mit Software für Moblogging kauft, kauft und unterstützt auch eine bestimmte Kultur. Die Arbeit an der populären Idee des Moblogging ist für Nokia und vor allem seine Verkaufsabteilung ebenso wichtig wie die Arbeit des Handy-Chefkonstrukteurs. Das Moblogging sorgt dafür, dass die Funktionen des Geräts genutzt werden und sich die Handys verkaufen. Technische und kulturelle Produktion gehen Hand in Hand. Mit dem Betrieb eines Weblog wird man genauso Teil des kapitalistischen Produktionskreislaufs wie mit der Konstruktion des Handys selbst.

In letzter Zeit sind über das Bloggen und andere Internet-Aktivitäten eine ganze Reihe von Büchern erschienen und Begriffe und Mythen aufgekommen.[24] Aber der relevanteste Begriff, wenn man heute über diese Dinge spricht, ist wohl der der immateriellen Arbeit.

Der Begriff kommt aus der marxistischen Debatte über die postfordistische Produktion. Als Schlüsselfiguren dieser Debatte lassen sich italienische Denker wie Maurizio Lazzarato, Paolo Virno und Tiziana Terranova anführen.

Arbeit produziert keine materiellen Güter mehr; sie entsteht durch die Verknüpfung von Menschen und Technologie und findet häufig außerhalb der offiziellen Arbeitswelt in der Freizeit statt. Die Mehrwertproduktion hängt, wie Tiziana Terranova erklärt, von der Expansion der Waren ab, von „informationsintensiven Waren ... (die) nicht im Konsumakt zerstört werden, sondern ... fortbestehen und als Ereignisse nachhallen, die imstande sind, die sinnliche Basis der Subjektivität zu verändern".[25] Die Produktion von Reichtum hängt also von der Subjektivitätsproduktion ab, von kultureller Produktion, die auf der Nutzung der gesamten Lebenszeit basiert. Für Terranova ist dies „ ... ein sozialisierter Reichtum, der sich nicht in Geld messen lässt, sondern im Intensitätswert von Beziehungen, Emotionen, Ausdrucks- und Lebensformen liegt."[26]

In dieser Wirtschaftsform rückt die prekäre Kulturproduktion ins Zentrum. Für Virno erzieht die Kultur zu Prekarität und Variabilität,[27] sie ist die Triebfeder der Innovation. Für Marazzi trägt die Kulturproduktion dazu bei, potenzielle soziale Bedürfnisse der Zukunft zu erkennen. Für Terranova bietet die Kultur ein neues Produkt an – ein Produkt, das „eher einem Kunstwerk als einem materiellen Konsumartikel gleicht."[28] Arbeiter experimentieren wie Künstler und verändern so die Subjektivität. Immaterielle Arbeit fühlt sich eher wie Kunst an. Immaterielle Arbeit ist paradox, insofern ihr sowohl ein Emanzipationspotenzial als auch das Potenzial zur Intensivierung der Ausbeutung innewohnt.

Terranova schreibt: „Dieser Modus kündigt auch die Entstehung neuer Kontroll- und Subjektivierungsmechanismen an, die im Dienst der gesellschaftlichen Reproduktion und der Mehrwertproduktion wieder hierarchische Verhältnisse einführen. Es handelt sich hierbei um Momente, die einen Umschlag qualitativer, intensiver Differenzen in quantitative Tausch- und Äquivalenzverhältnisse bewirken; die das offene, sich versprühende Potenzial kultureller Produktion in differenzielle Hierarchien einzwängen; die den Lohn der von größeren sozialen Verbänden geleisteten Arbeit akkumulieren ..."[29]

Begreifen wir alle, welchen Ort unsere Plattformen, Nutzer und Konzerne in diesem Bild einnehmen? Um nun auf die Medienkunst und die Einfachheit zurückzukommen, möchte ich abschließend ein optimistisches Bild offener, nicht den neuen Kontrollmechanismen unterworfener Plattformen zeichnen, geschaffen von Leuten wie uns, Leuten, die nicht so leicht zur Ware wer-

dende künstlerische Arbeiten machen, Leuten, die eine Veränderung der kulturellen Landschaft bewirken – mit einer Anleitung zum Selbermachen.

Es handelt sich dabei um relativ kleine Plattformen, die mit Datenbanken, Abstimmungssystemen, Blogging-Tools, Kommentarthreads, kleinen Chats, Hitlisten und anderen Mitteln arbeiten. Das Wichtigste dabei ist, dass man eine Idee hat. Wenn es eine gute Idee, eine Inspiration, eine gemeinsame Ideologie gibt, die Plattform offen für Veränderungen ist und eine relativ kleine engagierte Gruppe von Teilnehmer-Administratoren besitzt, dann kann sie wunderbare Ergebnisse zeitigen.

Ich habe an anderer Stelle eine Analyse dreier Plattformen kopubliziert, von denen zwei zum Teil von (Medien-) Künstlern geschaffen wurden: *Micromusic.net* (ein Label und eine Community, die sich auf 8-bit-Musik spezialisiert und allgemeine Anerkennung als ein Kulturphänomen genießt), *Runme.org* (ein Softwarekunst-Depot, das nach Ansicht von uns Koproduzenten dazu beigetragen hat, dass Softwarekunst zu einer offeneren und interessanteren Angelegenheit wurde, als sie es hätte sein können) und *Udaff.com* (eine russischsprachige Literaturplattform, die es geschafft hat, einen eigenen „Literaturtrend" zu etablieren).[30] Hier ließen sich auch das früher erwähnte *MapOMatix* und viele andere anführen.

Lassen Sie mich kurz die Gründe für deren Erfolg rekapitulieren. Solche Plattformen entstehen als Reaktionen auf die Entwicklung einer bestimmten Praxis, auf die sie sich spezialisieren. Sie werden schnell von einigen wenigen Enthusiasten eingerichtet, was sich dank moderner Technologie leicht bewerkstelligen lässt, und werden stets moderiert. Plattformen müssen offen und anpassungsfähig sein, sie müssen in der Lage sein, sich je nach den Bedürfnissen und Erfordernissen einer kulturellen Praxis und der sozialen Gruppen, mit denen sie arbeiten, zu verändern. Sie akkumulieren eine beträchtliche Anzahl kreativer Produkte, die ihrerseits neue Menschen anziehen. Plattformen versprechen oft neue Formen der Bildung, des Wissensaufbaus, schöpferischer Arbeit und eine ermutigende soziale Umgebung und dienen als Modelle für die Entfaltung einer kreativen Betätigung. Mit Graswurzelpraktiken in den „Grauzonen" kultureller Produktion operierend, können solche Plattformen signifikante künstlerische und kulturelle Phänomene hervorbringen.

Signifikant ist dabei nicht, welche Form eine Plattform hat, ob es sich um einen Blog, eine Datenbank oder ein Wiki handelt. Wenn es einen gemeinsamen ästhetischen, sozialen und politischen Horizont gibt, wenn das Bedürfnis erkennbar ist, an einem Wissensbereich oder einem Kunstwerk zu arbeiten, dann ist eine Gruppe in der Lage, die Daten mittels ähnlicher, wenngleich immer noch recht unterschiedlicher Administrations-, Abstimmungs-, Wertungs-, Kommentar-, Verlinkungs- und Editiertechniken zu filtern und zu formen und so die Praxis auf eine andere kulturelle Ebene zu heben. Gleichwohl ist eine solche Plattform oder eine Ecke einer größeren Plattform immer noch sehr verschieden von den früher beschriebenen populären Räumen.

Der Traum der Netzkünstler ist wahr geworden: Man kann seine kreativen Arbeiten ohne Institutionen und Unternehmen austauschen; man kann zusammenarbeiten, kommunizieren; man kann Kunst machen; es gibt jetzt die Technologie dazu. Wir sollten nur auf der Hut sein.

Ist das Einfachheit? Möglicherweise. In Russland sagt man: „Geniales ist simpel". Wahrscheinlicher ist aber, dass es komplex ist.

Aus dem Englischen von Wilfried Prantner

1 Vgl. die Threads „ART iT article: Is the ICC (Tokyo) closing?", „the media art center of 21 c" auf:
 http://coredump.buug.de/cgi-bin/mailman/listinfo/spectre
2 Z. B. Armin Medoschs Besprechung der Transmediale: *Good Bye Reality! How Media Art Died But Nobody
 Noticed* at: *http://www.mazine.ws/node/230*
3 Vgl. *http://www.c-i-a.com/pr0106.htm*
4 James Surowiecki, Die Weisheit der Vielen, C. Bertelsmann, München 2005
5 Vgl. *http://en.wikipedia.org/wiki/Orkut*
6 J. D. Lasica, „Blogging as a form of journalism", in: *USC Annenberg Online Journalism Review,* May 24, 2001
 http://www.ojr.org/ojr/workplace/1017958873.php
7 Perseus Blog Survey: *http://www.perseus.com/blogsurvey/index.html*
8 Eugene Gorny, „Russian LiveJournal. The Impact of Cultural Identity on the Development of a Virtual
 Community", in: Henrike Schmidt, Katy Teubener, Natalja Konradova (Eds.): *Control + Shift. Public and Private
 Usages of the Russian Internet.* Norderstedt: Books on Demand 2006. Online bestellbar bei:
 http://www.ruhr-uni-bochum.de/russ-cyb/library/texts/en/control_shift/control_shift.htm
9 *http://www.miss.rambler.ru/*
10 „PGS versus GPS: On Psycho/Subjective Geographic Systems" by elpueblodechina dialoguing with yves degoyon
 (MapOMatix) in: Olga Goruinova (Hrsg.) *Readme 100. Temporary Software Art Factory,* Norderstedt: Books on
 Demand 2006. Bestellbar bei: *http://mapomatix.sourceforge.net/mapOmatix-3.pdf*
11 *http://micromusic.net*
12 *http://fotokritik.ru/*
13 *http://vjcentral.com/*
14 *http://listible.com*
15 Michel de Certeau, *Kunst des Handelns,* Berlin: Merve 1984
16 Für eine ausgezeichnete Darstellung der Geschichte des Blogs vgl. den *Wikipedia*-Eintrag "blog":
 http://en.wikipedia.org/wiki/Blog
17 *http://nr00226.vhost2.sil.at/siberian/vrteil.htm*
18 Etwas Dokumentationsmaterial findet sich immer noch unter: *http://www.irational.org/heath/london/*
19 Siehe: *http://www.etoy.com/*
20 *http://en.wikipedia.org/wiki/Orkut*
21 *http://www.microsoft.com/presspass/press/2005/nov05/11-01PreviewSoftwareBasedPR.mspx*
 Dank an Mercedes Bunz für diesen Link.
22 *http://europe.nokia.com/BaseProject/Sites/NOKIA_MAIN_18022/CDA/ApplicationTemplates/About_Nokia/
 Content/_Static_Files/moblogbackgrounder.pdf*
23 Die Akteur-Netzwerk-Theorie wurde vor allem von Bruno Latour, Michel Callon und John Law entwickelt; sie
 wird dazu verwendet, technologische Produkte, Ereignisse und Produktionen als strukturelle Komponenten
 zu erklären, die auf ein bestimmtes Ergebnis hin zusammenwirken. Solche Komponenten können
 wissenschaftliche Tatsachen, Aufgaben, menschliche Beziehungen, wirtschaftliche Faktoren usw. sein, die
 herkömmlicherweise von der Reflexion über Technologie und Gesellschaft ausgeschlossen sind.
24 Vgl. Howard Rheingold, *Smart Mobs: The Next Social Revolution,* 2003, Basic Books.
25 Tiziana Terranova, „Of Sense and Sensibility: Immaterial Labor in Open Systems", in: Joasia Krysa (Hrsg.)
 Curating Immateriality, Data Browser 03, Autonomedia 2006, S.28
26 Ibid., S.29
27 Paolo Virno, *A Grammar of the Multitude,* Semiotext(e) 2004.
28 Tiziana Terranova, ibid.
29 Ibid., p.33
30 Olga Goriunova, Alexei Shulgin, „From Art on Networks to Art on Platforms", in: *Curating Immateriality,* op. cit.

Jason Kottke

Aggregating the Whole World

"There is no reason not to consider the world as one gigantic painting."

Robert Rauschenberg

In an article for *Feed* in 2000,[1] Julian Dibbell compared weblogs to *wunderkammers*, "cabinets of wonders" that were popular in 17th century Europe. Enthusiasts carefully curated their cabinets, filling them with treasures of the natural and pre-Modern world, crafting an aesthetic whole from the cultures and ideas those objects represent. *kottke.org*, a weblog I've been editing for more than eight years, is my *wunderkammer;* one that's curated daily from current links, ideas, and information, my particular simplification of a complex world. As the curator, I proceed as follows:

Each morning as part of my work on *kottke.org*, I sit down with my computer and open my newsreader. A newsreader is a magical piece of software which, at the simultaneous touch of two buttons, collects updates from nearly all of the web sites I wish to read that day, some 600 daily items from 300 sites in all. In a way, my newsreader assembles a giant scrolling daily newspaper from a global pool of sources for me, including the latest science news from *New Scientist,*[2] typographic notes from *Typographica,*[3] economics discourse from *Marginal Revolution,*[4] the latest Apple goings-on from *Daring Fireball,*[5] clever pop culture from *Goldenfiddle,*[6] photography from *Eliot Shepard,*[7] food news from *Megnut,*[8] opinions from *The Wall Street Journal,*[9] and personal observations from dozens of active designers, artists, technologists, entrepreneurs, parents, photographers, waiters, call girls, filmmakers, and writers.

On an average day, I receive about 70–90 substantive emails along with 900+ spam messages which my mail program helpfully filters from my view. In the course of reading these emails and the items my newsreader has served up for me, the hyperlinked serendipity engine that is the web takes over, and I sprawl through dozens of sites about any and every available topic, clicking giddily from link to link on an informational bender.

I view 2–3 movies a week, read 1–2 books per month, and listen to music almost constantly. Periodically I hit the bookstore or library and browse through the stacks, skimming dozens of books as I go. Online and off, I read 8–10 magazines a month and browse through 30–40 others. I record some of my adventures with a cameraphone and DSLR camera. Museums, concerts, talks, conferences, restaurants, parties, coffee with friends, shopping … you get the idea; it's all part of my informational diet. In contemporary society, information consumption of this scale and breadth is not unusual. And for those doing technological or creative work, dealing with vast amounts of diverse information is not just an incidental task, it *is* the work.

From all that "stuff", representing several hundred diverse biases, world views, and perspectives,

I assemble a daily update to *kottke.org* that, depending on your interests, can be read in a few minutes or explored for hours. *kottke.org* is my interpretation of what's going on in the world, a simple trail through a complex information space. In the introductory paragraph, I described this activity as curating, but you could also call it aggregating. I am an aggregator of information and ideas.

In his book *The Wisdom of Crowds,* James Surowiecki describes the conditions under which you can extract good information from a group of people. The group's membership needs to be diverse, independent from one another, and decentralized in organization. And finally, you need aggregation, a way of determining the group's "answer" to a particular question, the *zeitgeist* of the group if you will. As the first three factors increase, so does the complexity of the system. More diversity, more independent ideas, and more decentralization introduces more factors and combinations for the aggregator to track and evaluate. On the other hand, effective aggregation is necessarily a process of simplification; in order to have value in answering a particular question or expressing a particular idea, the aggregate answer or expression must be simpler than a basic collection of each member's raw opinion. In other words, you can't just cram everything into your cabinet.

From this it follows that the more effective the aggregator is at effectively determining what the group thinks, the better the end result will be. But somewhat paradoxically, the quality of the end result can also improve as the complexity of the group increases. In constructing *kottke.org,* something that I hope is a simple, coherent aggregation of the world rushing past me, this complexity is my closest ally. Keeping up with so many diverse, independent, decentralized sources makes my job as an aggregator difficult—reading 300 sites a day (plus all the other stuff) is no picnic—but it makes *kottke.org* much better than it would be if I only read *Newsweek* and watched Hitchcock movies. As artists, designers, and corporations race to embrace simplicity, they might do well to widen their purview and, in doing so, embrace the related complexity as well. With apologies to Mr. Rauschenberg, there is no reason not to consider the world as one gigantic palette with which to paint your small part of the world.

http://www.kottke.org

1 *http://www.juliandibbell.com/texts/feed_blogger.html*
2 *http://www.newscientist.com/*
3 *http://www.typographi.com/*
4 *http://www.marginalrevolution.com/*
5 *http://www.daringfireball.net*
6 *http://www.goldenfiddle.com*
7 *http://www.slower.net*
8 *http://www.megnut.com*
9 *http://www.opinionjournal.com/*

Jason Kottke

Meine Wunderkammer

*Es gibt keinen Grund, warum man die Welt nicht als
ein riesiges Gemälde betrachten sollte.*

Robert Rauschenberg

In einem Artikel für *Feed* 2000[1] verglich Julian Dibbell Weblogs mit den Wunderkammern, die im Europa des 17. Jahrhunderts populär waren. Diese Kammern wurden von begeisterten Sammlern sorgsam betreut und mit Naturalien und Artefakten der vormodernen Welt vollgeräumt, wobei man bemüht war, aus den Objekten, die Kulturen und Ideen repräsentierten, ein ästhetisches Ganzes zu schaffen. *kottke.org*, ein Weblog, das ich seit über acht Jahren betreue, ist meine Wunderkammer, die ich täglich kuratiere und durch aktuelle Links, Ideen und Informationen aktualisiere – und darüber hinaus mein spezieller Beitrag zur Vereinfachung einer komplexen Welt. Meine Tätigkeit als Kurator sieht dabei folgendermaßen aus:

Ich setze mich jeden Morgen an meinen Computer und öffne den Newsreader. Ein Newsreader ist eine geradezu magische Software, die auf einen einfachen Befehl hin Updates von nahezu allen Websites einsammelt, die ich an diesem Tag lesen möchte – etwa 600 Artikel von insgesamt 300 Websites. Mein Newsreader stellt für mich eine überaus umfangreiche Tageszeitung aus einem globalen Fundus zusammen: etwa die letzten wissenschaftlichen Berichte aus *New Scientist*,[2] typografische Informationen von *Typographica*,[3] ökonomische Diskurse von *Marginal Revolution*,[4] die letzten Neuigkeiten aus der Apple-Welt von *Daring Fireball*,[5] Aktuelles aus der Popkultur von *Goldenfiddle*,[6] Fotografie von Eliot Shepard,[7] Kulinarisches von *Megnut*,[8] Kommentare aus dem *Wall Street Journal*[9] sowie persönliche Betrachtungen zahlreicher Designer, Künstler, Techniker, Unternehmer, Eltern, Fotografen, Kellner, Callgirls, Filmemacher und Schriftsteller. Im Durchschnitt erhalte ich täglich 70 bis 90 relevante E-Mails neben mindestens 900 Spam-Nachrichten, die mein E-Mail-Programm angenehmerweise filtert und vor mir verbirgt. Bei der Lektüre dieser E-Mails und der vom Newsreader zugestellten Texte übernimmt allmählich der durch Hyperlinks organisierte Zufallsgenerator – das Web – die Leitung über meine Informationstour und ich surfe durch alle möglichen Themen auf Dutzenden von Websites, indem ich mich wie besessen von Link zu Link klicke.

Ich sehe zwei bis drei Kinofilme pro Woche, lese ein bis zwei Bücher monatlich und höre nahezu ständig Musik. Ich besuche regelmäßig eine Buchhandlung oder eine Bibliothek, stöbere in den Regalen und überfliege Dutzende von Büchern. On- und offline lese ich acht bis zehn Magazine pro Monat, dreißig bis vierzig weitere blättere ich durch. Außerdem nehme ich so manches meiner Abenteuer mit dem Kamerahandy und einer digitalen SLR-Kamera auf. Museen, Konzerte, Gespräche, Konferenzen, Restaurants, Partys, Cafébesuche mit Freunden, Einkaufsbummel ... Sie erraten schon, worauf es hinausläuft – alle diese Einrichtungen und Ereignisse liefern Informationen, die ich aufsauge. In der heutigen Gesellschaft ist ein Informationskonsum dieses Umfangs nichts Ungewöhnliches. Für alle jene, die einen technischen Beruf ausüben oder kreativ tätig sind, ist der Umgang mit riesigen Informationsmengen nicht nur eine gelegentliche Aufgabe, sondern die eigentliche Arbeit.

Aus diesem „Stoff", der Hunderte unterschiedliche Tendenzen, Weltsichten und Perspektiven repräsentiert, stelle ich eine tägliche Aktualisierung von *kottke.org* zusammen, die man, je nach Interesse, in einigen Minuten lesen oder stundenlang studieren kann. *kottke.org* ist meine Interpretation dessen, was in der Welt vorgeht, ein einfacher Pfad durch einen komplexen Informa-

tionsraum. In der Einleitung bezeichnete ich diese Tätigkeit als „Kuratieren", man könnte es aber auch Aggregation nennen. Ich bin ein Aggregator von Informationen und Ideen.

In seinem Buch *Die Weisheit der Vielen* beschreibt James Surowiecki die Bedingungen, unter denen man relevante Informationen von einer Gruppe von Menschen gewinnt. Die Zusammensetzung einer solchen Gruppe muss heterogen sein, die Mitglieder sollen unabhängig voneinander und die Organisation dezentralisiert sein. Und dann bedarf es der Aggregation, um die „Antwort" der Gruppe auf eine bestimmte Frage zu ermitteln, den Zeitgeist herauszudestillieren, wenn man so will. Je ausgeprägter die genannten drei Faktoren sind, umso komplexer wird auch das System. Ein höheres Maß an Diversität, an voneinander unabhängigen Ideen und an Dezentralisation bringt auch mehr Faktoren und Kombinationen ein, die der Aggregator zu erfassen und zu evaluieren hat. Andererseits ist effiziente Aggregation notwendigerweise ein Vereinfachungsprozess; damit die Antwort auf eine bestimmte Frage oder der Ausdruck einer bestimmten Idee Aussagekraft hat, muss die aggregierte Antwort bzw. der Ausdruck einfacher sein als die Sammlung der Meinungen der einzelnen Mitglieder. Oder anders gesagt, man kann nicht einfach alles in seine Wunderkammer hineinstopfen.

Daraus folgt: Je effizienter der Aggregator ermittelt, was die Gruppe denkt, umso besser ist das Endergebnis. Paradoxerweise kann die Qualität des Endergebnisses sich auch verbessern, wenn die Komplexität der Gruppe zunimmt. Beim Aufbau der Website *kottke.org*, die, wie ich hoffe, eine einfache, kohärente Aggregation meiner Welt und der an mir vorbeirauschenden Eindrücke ist, ist diese Komplexität mein engster Verbündeter. Sich über so viele unterschiedliche, unabhängige, dezentralisierte Quellen auf dem Laufenden zu halten, macht meinen Job als Aggregator schwierig – täglich 300 Websites (plus all das andere Material) zu sichten, ist keine leichte Sache – macht *kottke.org* aber viel besser, als wenn ich nur *Newsweek* lesen und Hitchcock-Filme sehen würde. Künstler, Designer und Unternehmer, alle setzen im Augenblick auf Einfachheit; sie täten gut daran, ihr Blickfeld zu erweitern und die mit der Einfachheit verbundene Komplexität einzubeziehen. Herr Rauschenberg möge verzeihen: Es gibt keinen Grund, warum man die Welt nicht als eine riesige Palette betrachten sollte, mit der man seinen eigenen kleinen Weltausschnitt malt.

http://www.kottke.org

Aus dem Englischen von Martina Bauer

1 *http://www.juliandibbell.com/texts/feed_blogger.html*
2 *http://www.newscientist.com*
3 *http://www.typographi.com*
4 *http://www.marginalrevolution.com*
5 *http://www.daringfireball.net*
6 *http://www.goldenfiddle.com*
7 *http://www.slower.net*
8 *http://www.megnut.com*
9 *http://www.opinionjournal.com*

Peter Wippermann

Simplexity
The New and Efficient Brand of Cleverness

New technologies and data services are coming onto the scene to simplify our lives. They open up for us an infinitely larger spectrum of information and possibilities. The only problem is, we understand these technologies less and less and are more and more dependent on them in our daily lives. What we need is a fast and easy way to cope with the growing complexity of our world. The flood of information, features and possibilities only bewilders us. We long for simplicity and satisfaction. *Simplexity* therefore stands for a balance between the growing complexity of daily life and our own personal satisfaction. In order to attain this state, we have to stop always striving to make optimal decisions. In the future, it will be more important to make judgments that are just good enough. Today's consumer demands maximum choice with a minimal loss of orientation.

Growing complexity and an increasing need for simplicity

Atomization of attention span

Our world today is plastered over with advertisements. It's hard to find a single TV show that's not sponsored by a brand, or a website without a banner. Posters are starting to communicate with passersby via Bluetooth, and buildings like the SAP headquarters in Berlin have facades whose complete surface forms a screen for media presentations. Advertising pressure is rising steadily, with the result that the intended "buzz" is instead heard as diffuse background noise made up of competing offers. The quantity of advertising messages sent every week by email has gone up in the past 15 months from an average of 800 million in December 2004 to 1.2 billion in March 2006. Some 60 percent of all emails can be classified as Spam *(Technology Review,* March 2006). Every new advertisement or media offering only serves to thicken the information smog. Media and brands exert more and more energy courting the increasingly rare commodity of consumer attention. At the same time, our attention spans are growing frayed in the face of ever-tighter time budgets.

As a consequence, our visual habits are becoming more superficial as we strive to absorb the most important information as quickly as possible. A study of the perceptual habits of Google users showed that all users take the time to examine the first three hits in a Google search. But from the sixth hit on, half of the test subjects broke off their investigation. The attention span is limited to a few top listings. Websites unable to reach these top positions disappear in the anonymous crowd. This reflects the drama of today's progress: despite all that's out there, we are only able to attend to and remember a limited amount of information.

Featuritis and isolated solutions generate frustration

Gadgets are evolving more and more into all-purpose multimedia wonders, as they grow ever smaller and more complex to operate. For example, the borderline between mobile phone, digital camera and MP3 player is becoming increasingly blurred. New functions are constantly being integrated into these devices. According to *Stern Markenprofile,* 73 percent of those surveyed today agree that most devices have more functions than the user really needs. This points up a key dilemma. In the store, the number of features helps to boost sales. Touting

a product's many possibilities suggests added value and a good offer, as a recent study by *Harvard Business Week* concluded. But once a new device finds its way back home, its plethora of features only makes for user frustration; the extra functions inflate the user manual to unreadable proportions and are incomprehensible, complicated to use or even fully unnecessary. After all, the main thing is that the device should work when carrying out its main purpose.

User frustration can also be found on the content side. One quarter of all order transactions begun on the Internet are broken off again by users unable to navigate their way through the online shop. The superabundance of categories and available options confuses, frustrates and ultimately prevents us from taking action. The same thing goes for digital rights management. The jungle of different standards and limitations robs the customer of any joy he might have using the products. This situation makes it clear that we are over-challenged rationally and under-challenged emotionally. We long for simplicity so that we can enjoy ourselves once again and feel satisfied.

Information flood causes confusion

Parallel to advertising pressure, innovation pressure is also spiraling. Technology is forging ahead faster and faster and leaving more and more people behind in its wake, with a question mark over their heads. Whether it's electronic glitches in the car or yet another unexplained PC crash—the problem remains a mystery, leaving us unable to solve it by ourselves. At the same time, it costs us more and more energy to adapt to new computer programs and to new device generations coming out in ever-shorter cycles.

The focus in the technology-drive industries lies squarely on whatever is technically possible, instead of how the new technologies will be accepted by the consumer, or how they can be conveyed in a way the layperson is able to understand. But the majority of people see themselves as users who want to—and must—be able to operate these technologies without assistance. They need interfaces that give them quick, intuitive access to the growing complexity of their world. This is where Simplexity comes in.

▬▬ The ability to make rapid and smart decisions

We have more freedom today than ever and, with it, more personal responsibility. We are faced with more decisions. But we are increasingly lacking in security, reliability, meaning, orientation and time. As a result, we constantly have too much to cope with and feel stressed-out. This blocks and hinders our decision-making capability. But not choosing is always the worst choice. Information annihilation is becoming a critical skill. The new survival kit "Simplexity" consists of trust, aesthetics and rules of thumb. They help us to consolidate the complexity of the available information and thus accelerate the decision-making process. Gradually, a new pragmatism is starting to prevail: decide more swiftly in order to live more intensively.

Trust compensates for confusion

We compensate for insecurity, incomplete information and time pressure with trust. But trust changes. Trust in institutions is practically no longer existent, and media, brands and commerce are also having a hard time lately fighting dwindling consumer trust. For example, more than half of the professional sales staff in Germany don't know the differences between the four different seals of approval for HDTV television sets.

Our reaction to dishonest advertisers and clueless salespeople is to believe much more strongly

in what we are familiar with, what we have experienced ourselves, or what is recommended to us directly by friends. Therefore, testing products in real life is becoming more and more crucial. But since in the face of constant change we have fewer and fewer relevant experiences to go on, it's no wonder that we rely so much today on the experiences of friends and acquaintances. Models of success such as *OpenBC, MySpace,* or word of mouth from the neighborhood show that it's the weak ties, in other words the contacts of our contacts, that we find especially useful.

Rules of thumb enable us to act

Rules of thumb are an expression of our everyday logic. The accumulated daily experiences of those in our private circle are condensed into general rules that are constantly adapted to our needs. The American military thus works with the so-called "70 percent solution": make a decision when you have evaluated 70 percent of the available information to 70 percent satisfaction and when you are 70 percent convinced that your decision is the right one. The results are of course not exactly optimal. But they enable people to make individual and rapid decisions that are good enough.

Aesthetics lend meaning

Similar to trust, aesthetics are also a central filter of our actions. Familiar forms, colors and surfaces are emotional hooks. Aesthetics promises continuity in a world that is changing faster and faster. This continuity becomes even more important in a society in which young people are becoming the minority and that is at the same time driven by innovation. We know from our media socialization that the willingness and ability to take for granted the use of new, interactive media declines in proportion to advancing age, just like visual acuity, motor skills and the powers of comprehension. Aesthetically appealing design builds a bridge between growing technological complexity and a society that doesn't want to get old. It gives people the feeling: "You can stay just like you were." The example of the iPod makes this abundantly evident. A simple Braun design from the 1960s today makes this device a lifestyle icon. These days, design is a central purchasing criterion, second only to price. It works like an interface since it makes a product quick and easy to use and provides clear orientation. This metaphor could also be applied to the way we live our lives. Our interface with life is like a user interface that hides from us the complexity of the hardware, software and network technologies behind it. We trust in the icons to guide us and have no interest in trying to understand the programming codes that make it all happen. Marketing could learn something from this comparison. After all, the future will be more about information destruction than informational variety. The way the interface to the market offerings is designed is critical to their success.

Easy decision-making is what counts

For developers and marketers, simplexity means taking seriously consumers' growing need for simplicity and usability. Offers must be designed to provide consumers with much more support in reaching a decision than used to be the case. There are three basic strategies for reacting to this need: Servolution, Try(Ad)vertising and Sense Branding.

Servolution: service with a smile

Today, if you work for a big company and have a computer problem, you just call the HelpDesk. IT Support logs into your computer, and you can sit back and watch as they take over control and

solve the problem in real time. This way, users can see for themselves how to solve the problem. These kinds of personal services that solve problems on-demand, quickly and easily, will in future develop more strongly in the private sector as well. And consumers and users will be increasingly willing to pay for this kind of service.

On the other hand, automated services will become even more significant. We are leaving more and more digital traces and feedback behind, which have yet to really be analyzed or exploited. Chris Anderson, Editor-in-Chief of *Wired*, presumes that the future of the 21st-century economy is already slumbering today in the world's databases. The information there will make it possible to put together customized, automated offers. Amazon has long since spearheaded this development with its collaborative filtering. This helps users to conveniently orient themselves according to the behavior and preferences of others.

Try(Ad)vertising: try and buy

Personal services are relatively expensive. To reduce HelpDesk costs, it is worthwhile investing in helping users to help themselves. This can be done by creating positive involvement and experiences with products and applications. This form of advertising by testing is ultimately aimed at boosting user satisfaction. Pioneer here is the Apple store in London. In addition to selling, the store serves primarily to explain to users the possibilities offered by the computers and the various Apple software applications. To this end, both demos and free intro courses are offered. Another example of successful Tryvertising is Adobe Live. This is a kind of roadshow at which, in the course of two days, visionaries present and explain the functions of the various Adobe products. They should know how to operate the hardware and software and how to communicate their positive experiences to others.

Sense branding: sense and sensibility

The aesthetic answer to the growing complexity of our world is to create offers with emotional appeal that stand out from the crowd. Conveying a sense of simplicity in the face of high-tech complexity is the wave of the future. After all, an aging society with aesthetic preferences based on their younger years will continue to go for retro trends. However, no matter how old-fashioned, the interface must still be designed for quick and easy handling. This involves in particular intuitive navigation and optimized operability. Whole new jobs have been created in this field in the past few years, from Information Architect to Search Engine Optimizer. The central goal is to increase logical consistency, comprehensibility and usability. Office supplies dealer Staples, for example, was able to reduce the break-off quota in its online shop by 73 percent merely by cleaning things up a bit, boosting sales to the tune of 6 million USD per month.

Simplexity creates satisfaction

Simplexity is the key answer to the growing desire for satisfaction, and is at the same time the major challenge of the coming years. The fundamental innovation represented by the network economy is increasingly turning consumers into producers, driving individualization forward with the effect of making things even more complex. Decisions are becoming a duty. The new motto is: "Simplexify my life!"

<div align="right">Translated from German by Jennifer Taylor-Gaida</div>

Peter Wippermann

Simplexity
Die neue effiziente Klugheit

Neue Technologien und Datendienste treten an, unser Leben zu vereinfachen. Sie eröffnen uns eine unendlich viel größere Bandbreite an Informationen und Möglichkeiten. Aber wir beherrschen die Technik immer weniger und sind gleichzeitig mehr und mehr von ihr abhängig. Es fehlt ein einfacher und schneller Zugang zur wachsenden Komplexität unserer Welt. Die Flut an verfügbaren Informationen, Features und Möglichkeiten verwirrt uns. Wir sehnen uns nach Einfachheit und Zufriedenheit. *Simplexity* steht daher für eine Balance aus wachsender Alltagskomplexität und persönlicher Zufriedenheit. Dafür müssen wir uns von der Idee optimaler Entscheidungen verabschieden. Zukünftig wird es stärker darum gehen, Urteile zu fällen, die gut genug sind. Die Anforderungen der Konsumenten lautet: maximale Auswahlmöglichkeiten bei minimaler Orientierungslosigkeit.

Wachsende Komplexität und ein
steigendes Bedürfnis nach Einfachheit

Atomisierung der Aufmerksamkeit

Die Welt ist heute mit Werbung zugepflastert. Keine Sendung, die nicht von einer Marke präsentiert wird, kaum eine Webseite, die kein Banner trägt. Poster beginnen via Bluetooth mit Passanten zu kommunizieren, und Gebäuden wie die SAP-Zentrale in Berlin erhalten komplett medial bespielbare Fassaden. Der Werbedruck nimmt stetig zu, mit der Folge, dass der angestrebte „Buzz" zum diffusen Offerten-Rauschen wird. Die Menge der wöchentlich per E-mail versandten Werbebotschaften stieg in den vergangenen 15 Monaten von durchschnittlich 800 Millionen im Dezember 2004 auf 1,2 Milliarden im März 2006. Ca. 60 Prozent aller verschickten E-mails sind als Spam einzustufen *(Technology Review,* März 2006). Jede weitere Werbung und jedes neue Medienangebot verstärken diesen Informationssmog. Medien und Marken buhlen immer härter um die Ressource Aufmerksamkeit. Aber diese zerfasert angesichts knapper Zeitbudgets zusehend.

Als Folge davon werden unsere Sehgewohnheiten oberflächlicher, denn es geht darum, möglichst schnell die wichtigsten Informationen zu erfassen. Eine Untersuchung über die Wahrnehmung von Nutzern bei Google ergab, dass die ersten drei Ergebnisse einer Google-Suche noch von allen wahrgenommen werden. Aber bereits ab der sechsten Fundstelle bricht die Hälfte der Testpersonen ab. Die Aufmerksamkeitsspanne beschränkt sich auf wenige Spitzenplätze. Wer keinen dieser Spitzenplätze erreicht, geht in der anonymen Masse unter. Darin spiegelt sich das Drama des Fortschritts wider: Wir sind nur sehr begrenzt aufnahme- und merkfähig.

Featuritis und Insellösungen erzeugen Frust

Gadgets entwickeln sich mehr und mehr zu multimedialen Alleskönnern, sie werden kleiner und immer komplexer zu bedienen. So verschwimmt z. B. die Grenze zwischen Mobiltelefon, Digitalkamera und MP3-Player zunehmend. Es werden laufend neue Funktionen in die Geräte integriert. Laut *Stern Markenprofile* stimmen heute 73 Prozent der Befragten der Aussage zu, dass die meisten Geräte heute mehr Funktionen haben, als man wirklich braucht. Dabei tritt ein bedeutendes Dilemma zutage. Im Geschäft wirkt die Zahl der Features verkaufsfördernd. Die

Auslobung vieler Möglichkeiten suggeriert einen Mehrwert und ein gutes Angebot, so das Ergebnis einer aktuellen Studie der *Harvard Business Week*. Zuhause sorgt die Featureflut dann aber für Frust, denn die zusätzlichen Funktionen blähen die Handbücher auf, sind unverständlich, umständlich zu bedienen oder gar unnütz. Schließlich soll das Gerät funktionieren und seinen Zweck erfüllen.

Frust seitens der User gibt es auch auf der Content-Seite. Ein Viertel aller im Internet getätigten Bestellvorgänge wird abgebrochen, da die User die Shops nicht verstehen. Die Vielzahl zur Verfügung stehender Kategorien und Möglichkeiten verwirrt, frustriert und blockiert uns letztlich. Ähnliches gilt auch für das Digital Rights Management. Die Menge an unterschiedlichen Standards und Limitierungen raubt den Konsumenten jegliche Freude an den Produkten. Dies macht deutlich: Wir sind rational über- und emotional unterfordert. Wir sehnen uns nach Einfachheit, um wieder genießen zu können und zufrieden zu sein.

Informationsflut sorgt für Verwirrung

Parallel zum Werbedruck steigt der Innovationsdruck. Die Technologisierung schreitet schneller voran und lässt immer mehr Menschen mit einem Fragezeichen zurück. Ob Elektronikfehler im Auto oder der Absturz des PCs – das jeweilige Problem bleibt uns rätselhaft und kann schon aus diesem Grund nicht mehr von uns selbst gelöst werden. Gleichzeitig wächst der Aufwand, mit dem wir uns in immer kürzeren Zyklen auf neue Computerprogramme und neue Generationen von Geräten einstellen müssen.

Die Fokussierung in technologiegetriebenen Branchen liegt sehr stark auf dem, was technisch möglich ist, und nicht darauf, wie neue Technologien angenommen werden oder wie die Technik verständlich vermittelt werden kann. Aber die überwiegende Zahl der Menschen versteht sich als User, die die Technik bedienen können will – und muss. Sie brauchen Interfaces, die ihnen einen schnellen, intuitiven Zugang zu der wachsenden Komplexität ermöglichen. Hier setzt Simplexity an.

■■■■ Die Fähigkeit smart und schnell zu entscheiden

Wir haben heute mehr Freiheit und damit mehr persönliche Verantwortung. Wir müssen mehr Entscheidungen treffen. Aber es fehlt uns zunehmend an Sicherheit, Verlässlichkeit, Sinn, Orientierung und Zeit. Entsprechend sind wir permanent überfordert und gestresst. Das blockiert und hindert uns an Entscheidungen. Aber keine Wahl zu treffen ist definitiv die schlechteste Wahl. Informationsvernichtung wird damit zur entscheidenden Fähigkeit. Das neue Survial Kit „Simplexity" besteht aus Vertrauen, Ästhetik und Faustformeln. Sie helfen uns, die Komplexität der verfügbaren Informationen zu verdichten und Entscheidungsprozesse zu beschleunigen. Allmählich setzt sich daher ein neuer Pragmatismus durch: schneller entscheiden, um intensiver zu leben.

Vertrauen kompensiert Konfusion

Wir kompensieren Unsicherheit, unvollständige Informationen und Zeitdruck durch Vertrauen. Aber Vertrauen ändert sich. Das Vertrauen in die Institutionen ist quasi nicht mehr existent, aber auch Medien, Marken und Handel haben neuerdings stark mit einem Vertrauensverlust zu kämpfen. So kennen in Deutschland mehr als die Hälfte der Fachverkäufer nicht die Unterschiede bei den vier unterschiedlichen Gütesiegeln der HDTV-Fernsehgeräte.

Als Reaktion auf lügende Werber und ahnungslose Verkäufer glauben wir viel stärker dem, was

wir kennen, selbst erfahren oder direkt von Freunden empfohlen bekommen. Die Überprüfung von Produkten und Anwendungen im RealLife wird einerseits immer entscheidender. Anderseits haben wir aufgrund des permanenten Wandels immer weniger relevante Erfahrungen. Daher verwundert es nicht, dass die kommunizierten Erfahrungen von Freunden und Bekannten einen Siegeszug erfahren. Erfolgsmodelle wie *OpenBC, MySpace* oder die Kiezkollegen zeigen zudem, dass gerade die Weak Ties, also die Kontakte unserer Kontakte, besonders nützlich sind.

Faustformeln sichern Handlungsfähigkeit

Faustformeln sind Ausdruck unserer Alltagslogik. Die gesammelten täglichen Erfahrungen unseres privaten Umfelds werden zu Faustformeln verdichtet und permanent angepasst. So arbeitet das amerikanische Militär mit der sogenannten „70 Percent Solution": Entscheide, wenn Du 70 Prozent der verfügbaren Informationen zu 70 Prozent ausgewertet hast und du zu 70 Prozent von der Richtigkeit überzeugt bist. Die Ergebnisse sind natürlich nicht optimal. Aber sie ermöglichen es den Menschen individuell und schnell Entscheidungen zu treffen, die gut genug sind.

Ästhetik stiftet Sinn

Ähnlich wie Vertrauen ist Ästhetik ein zentraler Filter unseres Handelns. Bekannte Formen, Farben und Oberflächen sind emotionale Widerhaken. Die Ästhetik verspricht Kontinuität in einer Welt, die sich immer schneller verändert. Diese Kontinuität wird wichtiger in einer Gesellschaft, in der die Jugend zur Minderheit wird und die gleichzeitig von Innovationen getrieben ist. Wir wissen aus der Mediensozialisation, dass die selbstverständliche Nutzung neuer, interaktiver Medien mit zunehmendem Alter ebenso deutlich nachlässt wie die Sehkraft, die Motorik und die Auffassungsgabe. Ästhetik schlägt die Brücke zwischen wachsender Technikkomplexität einerseits und einer Gesellschaft, die nicht altern will. Es vermittelt das Gefühl: „Du kannst so bleiben, wie du warst." Das Beispiel des iPod zeigt dies deutlich. Simples Braun Design der 1960er Jahre macht das Gerät zur Lifestyle-Ikone. Design ist schon heute nach dem Preis zentrales Kriterium bei der Produktwahl. Es funktioniert wie ein Interface, da es eine schnelle, einfache und verständliche Handhabung und Orientierung ermöglicht. Diese Metapher lässt sich auf unsere Lebensgestaltung übertragen. Das Interface ist die Benutzeroberfläche, die die Komplexität der Hard-, Soft- und Netzwerktechnologien vor uns verbirgt. Wir vertrauen den Icons und wollen die Codes der Programme nicht verstehen. Davon kann das Marketing lernen. Schließlich geht es in Zukunft mehr um Informationsvernichtung als um Informationsvielfalt. Die Oberflächengestaltung der Angebote ist entscheidend für den Erfolg.

▄▄▄▄ Entscheidungsfreundlichkeit der Angebote zählt

Simplexity bedeutet für die Entwickler und Vermarkter von Angeboten, dass sie das wachsende Bedürfnis nach Einfachheit und Bedienbarkeit ernst nehmen müssen. Über die Gestaltung des Angebots müssen sie viel stärker als früher Entscheidungshilfen anbieten. Grundsätzlich gibt es drei Strategien darauf zu reagieren: Servolution, Try(Ad)vertising und Sense-Branding.

Servolution: Neue Services statt Abservieren

Jeder, der in einem großen Unternehmen ein Computerproblem hat, ruft heute den HelpDesk an. Der IT-Support loggt sich dann in den jeweiligen Computer ein, und man kann

zusehen, wie der eigene Computer gesteuert und das Problem in Echtzeit behoben wird. Darüber können die User selber sehen, wie Probleme zu lösen sind. Solche persönlichen Services, die on-demand, schnell und einfach Probleme lösen, werden sich zukünftig auch im privaten Bereich stärker entwickeln. Und: Verbraucher und User werden im wachsenden Maß bereit sein, für diese Service-Leistungen zu bezahlen.

Auf der anderen Seite wird die Bedeutung von automatisierten Services weiter zunehmen. Wir hinterlassen heute immer mehr digitale Spuren und Feedbacks, die bislang kaum ausgewertet werden. Chris Anderson, Chefredakteur von *Wired*, geht davon aus, dass die Zukunft der Ökonomie des 21. Jahrhunderts bereits in den Datenbanken schlummert. Die Bedeutung maßgeschneiderter, automatisierter Angebote wird daher weiter zunehmen. Vorreiter ist hier seit langem Amazon mit seinem Collaborative Filtering. Hier können sich User sehr leicht anhand des Verhaltens anderer Nutzer orientieren.

Try(Ad)vertising: Ausprobieren statt Anzeigen

Persönliche Services sind vergleichsweise teuer. Wer die Kosten für den HelpDesk reduzieren will, der muss darin investieren, dass die User die Probleme selbst lösen können. Es geht darum, positive Erlebnisse und Erfahrungen mit Produkten und Anwendungen zu schaffen. Diese Form der Werbung durch Ausprobieren zielt letztlich auf die Zufriedenheit der User. Vorreiter ist der Apple-Store in London. Neben dem Verkauf dient die Ladenfläche vor allem dazu, die Möglichkeiten der Computer und die verschiedenen Anwendungen der Apple-Software zu erklären. Dafür gibt es sowohl Vorführungen als auch kostenlose Einzelstunden. Ein weiteres Beispiel für erfolgreiches Tryvertising ist Adobe Live. Dabei handelt es sich um eine Art Roadshow, bei der in zwei Tagen die Funktionen der verschiedenen Adobe Produkte von Visionären erklärt wurden. Sie sollen wissen, wie sie die Hard- und Software bedienen können und ihre positive Erfahrung nach Möglichkeit kommunizieren.

Sense-Branding: Sinn stiften statt Verstand rauben

Die ästhetische Antwort auf die wachsende Komplexität liegt einerseits darin, Angebote zu schaffen, die die User emotional ansprechen und in der Auswahl überzeugen. Hier wird in Zukunft die gefühlte Einfachheit der High-Tech-Komplexität vorgezogen werden. Denn eine älter werdende Gesellschaft, die sich ästhetisch an ihrer Jugend orientiert, wird auch weiterhin von Retro-Trends geprägt werden. Andererseits müssen die Oberflächen so aufbereitet sein, dass sie ein schnelles und einfaches Handeln erlauben. Das beinhaltet vor allem die intuitive Benutzerführung und die Optimierung von Interfaces. Hier sind in den vergangenen Jahren komplett neue Berufe entstanden, vom Information Architect bis zum Suchmaschinenoptimierer. Zentrales Ziel ist die Steigerung der logischen Konsistenz, der Übersichtlichkeit und Bedienbarkeit. So konnte der Büromittelhändler Staples durch eine Entrümpelung des Online-Shops die Abbruchquote um 73 Prozent reduzieren und darüber zusätzliche 6 Millionen USD monatlich einnehmen.

Simplexity schafft Zufriedenheit

Simplexity ist die wichtigste Antwort auf das wachsende Bedürfnis nach Zufriedenheit und ist gleichzeitig die große Herausforderung der kommenden Jahre. Die Basisinnovation der Netzwerkökonomie macht Konsumenten zunehmend zu Produzenten, treibt damit die Individualisierung voran und erhöht die Komplexität weiter. Entscheidungen werden zur Pflicht. Das Motto lautet: „Simplexify my life!"

Gary Chang

Simplicity in Space in the Age of Complexity

Immerse in the age of technology, where entities, phenomena, technologies, concepts and ideologies inevitably abound in your life on an unprecedented scale. This is a time where your senses are scrupulously calculated and maneuvered to shape the life and experiences you are familiar with today. This manifestation of technology comes in both physical and virtual form, whether it be daily commodities, or in a form that contrivances in their essentials assume.

It is this rapid technological advancement where the awareness of *Simplicity* has its significance. This has burgeoned into a discussion regarding the logic behind this inescapable complexity brought by the immense presence of events: to cope with technology that has started haunting us in our everyday life. We would like to illustrate here the significance that simplicity could have on architectural design through 2 of our projects, the *Suitcase House* and the *Domestic Express*. This would, as we intend, provide clues to solutions that have arisen from this increasingly complicated context.

Simplicity

Simplicity is more than the pursuit of the minimalist's manifestation. It is a reciprocal to the complexity of the system. Complexity exists in the relationships between events. Today, in the digital age that we inhabit, the existence of complexity is almost inescapable through the massive creation of events in all forms. To seek simplicity one proposes a thorough understanding of what is disguised as complexity. Simplicity is thus an organized complexity, established by stressing the similarities between events instead of their differences. Through such categorization, events could be related to each other understandably, a matrix that explains the state we confront.

Space

Space is the stage, and the relationship matrix the protagonist, together playing an intertwining two-folded interpretation. On the one hand, it signifies the boundary where one could experience the possibility of simplicity under the circumscription of resources. It is the sensible use of resources through making sense of the relationships. On the other hand, space exists through the constitution of the relationship matrix, where the array of relationships forms a system that defines space. Space is thus more than a physical boundary, but fluid in nature, made to work as a machine that confines the relationship matrix within its containment.

Sensible Use of Resources—The 4Cs

Change

Change is the universal law: in all things created through such a process. One beholds its progression along the trajectory of time. Confined within the boundaries and structures of space, where we witness the intermediate products in the process of transformation with no final form. This system signifies the composition and relationships of things, and eventually reveals the possibility of events.

To recognize change is to understand the framework in which conditioned flexibilities could be indulged, allowing users' customization under different circumstances. In such a framework, all combinations of all events could be possible, depending solely on the desire of the individual who initiates the change. Therefore, the focus of facilitating change is about establishing the rules of relationship through providing the logic of change, which itself could provide limitless possibilities.

Choice

Choice is the multiple answer to desire, whether it be individual or collective. The extent of choice is to recognize the limitation of resources within the system, and to provide as many solutions for one's priority as possible. Thus, within this limited realm of resources, the choice of individuals is regulated, whilst the priority one has could never be controlled. To design and regulate choice, one takes into account the context and conditions, where the constraints and limitations are illustrated and reorganized to provide a maximum number of solutions. This flexibility created within definite circumstances in a resources-conscious fashion is the deliverance to one's ceaseless desire.

Choice signifies flexibility and adaptability. The deviser, in the delivery of the system, polishes and pours in additional value without complicating the relationship matrix. It is therefore crucial to understand the relationships and limitations of the context, and to derive a simple but sophisticated system that users could decipher and manipulate.

Coexistence

Coexistence is realized by recognizing and establishing relationships between scattered events, and by organizing them in a single symbiotic manner. This is achieved through stressing their similarities and overcoming differences, without negating the idiosyncrasy of each individual event, so that they flourish and still interlace events into a practical whole. Coexistence thus encourages diversity of events within one system. This is particularly important nowadays when products of all sorts inundate your life, and there's no way to sort out the particular.

The co-existing approach favors diversity instead of homogeneity, while providing more choices allows greater flexibility within the system. It makes possible the accomplishment of the same task using a multitude of approaches. It also encourages adaptation and reuse, instead of imposition and erasure. Under the parameters of limited resources and tight spaces, events are allowed to self-develop throughout their varied life spans, creating a possibility of generating a systemic value that is collective and efficient, which has definite advantages over the summation of values from individual events.

Connectivity

Connectivity is the act of constructing relationship between systems to form a super-system. A super-system embeds a number of systems varied in scales and nature. The relationships between systems are totally volatile, where there is no framed order, but it would comprise mobile systems submitting to one another and in constant motion. This dynamic organization, with the simultaneous presence of inter-related systems, perpetuates the underlying complexities into a singular and complete whole.

Connectivity evokes a matrix of relationship and a platform for interaction. It results in a separate super-system that contains numerous existing systems, makes possible the functioning of

different systems as components that complement each other, making better use of resources while working together as an efficient ensemble. In short, connectivity opts for a strategic construction that stretches complexity to its full potential.

███ ### *Case studies: a manifesto to the 4Cs towards simplicity*

Suitcase House

Questioning the preconception of the 'house', *Suitcase House Hotel* attempts to rethink the nature of intimacy, privacy, spontaneity and flexibility. It is a simple demonstration of the desire for ultimate adaptability, in pursuit of a proscenium of infinite scenarios.

The dwelling represents a stacking of strata. The middle stratum embodies a reincarnated *piano nobile par excellence* for habitation, activity and flow. Adapting a non-hierarchical layout with the help of mobile elements provided by the envelope, it transforms itself readily according to the nature of the activities, number of inhabitants, and personal preferences for degrees of enclosure and privacy. A metamorphic volume, it slides effortlessly from an open space to a sequence of rooms, depending on the inhabitants' specific requirements. Each room is then differentiated by the provision of a unique amenity.

The bottom stratum acts as a container for dedicated spaces. Compartments are concealed by a landscape of pneumatically assisted floor panels. At any point in time only the essential elements required will have a spatial presence. The chambers are of specific assignation in terms of use and mode.

To blur the boundaries between House, Interior and Furniture, the entire structure and elements are clad with monotonous timber, with the steel structure supported by and cantilevered from the concrete base, housing all necessary facilities.

The Domestic Express

Exemplifying the contextual composition of compactness, the *Domestic Express* suggests a series of gestures in response to connectivity, privacy, spontaneity and flexibility. It suggests an adaptation of space in continuous transformation depending upon desire and constraints.

The cottage has been suggested to serve as a transition between the land and water. Taking the design rationale of a cottage together with a platform as a pier, we have decided, instead, to unite the two, creating a cottage that could be as small as a 5 x 8 meters room, but as big as the room and pier together. A set of mobile furniture runs on sliding tracks through the house onto the platform, abbreviates the differentiation between interior and exterior. An abstract bulk when juxtaposed, the furniture units can be (re)arranged to accommodate all desires and needs of its inhabitants for enclosure and activity.

The movable furniture units assembled incipiently in a box resting on a set of tracks, where table, sofa and bench are juxtaposed with and incorporated into one another. Freely adjusting the internal environment by extracting furniture along the tracks, users are given activity spaces adaptable to suit anyone's desires.

The *Express* does not merely occupy the internal, but could well be extended onto the pier deck. Making use of the horizontality of the whole length of pier, furniture guided outside the cottage assembles external 'rooms' allowing multiple outdoor activities in response to all possible uses, including outdoor sleeping, dining and outdoor bathing.

Re: Simplicity

The concept of *Simplicity* makes significant contributions to the way we understand and deal with the complexities with which we are confronted in the age of massive and intensive creation of events. We recognize the inescapability of these complexities, and by reorganizing the relationship between system and space, as in the *Suitcase House* and the *Domestic Express,* we have sought to provide solutions for an alternative and simplified way of living.

The importance of *Simplicity* as a strategy is thus recognized. *Simplicity* is a "solution that is not a real solution to a specific problem in a way of relieving intellectual uneasiness and even existential anxiety" (Claude Lévi-Strauss)—a state of mind that enables us to deal with the overwhelming complexities that exist and which are inescapable in the world in which we live. These could all be achieved through the sensible use of limited resources, and consciously assembling systems through sorting out relevance and similarities.

Gary Chang

Einfachheit des Raums im Zeitalter der Komplexität

Tauchen Sie ein in das Zeitalter der Technik, in dem Entitäten, Phänomene, Techniken, Konzepte und Ideologien in noch nie da gewesener Weise über Ihr Leben hereinbrechen. Es ist dies eine Zeit, in der Ihre Sinne akribisch berechnet und geschickt manipuliert werden, um das Ihnen vertraute Leben und Ihre Erfahrungen zu gestalten. Die Technik manifestiert sich sowohl in konkreter als auch in virtueller Form, ob es sich nun um Waren des täglichen Gebrauchs oder um die Grundlagen technischer Erfindungen handelt.

Dieser rapide technische Fortschritt rückt die *Einfachheit* wieder in das Bewusstsein. Die Frage, wie wir mit der Technik, die unseren Alltag mehr und mehr durchdringt, zurande kommen, löste eine Diskussion über die Logik hinter der unabwendbaren Komplexität aus, die mit einer ausufernden Präsenz von Ereignissen einhergeht. Wir möchten anhand von zwei Projekten, dem *Suitcase House* und dem *Domestic Express,* die Bedeutung von Einfachheit im architektonischem Entwurf veranschaulichen. Damit könnten wir, so zumindest unsere Intention, Anhaltspunkte für Lösungen, die sich in diesem Kontext zunehmender Komplexität ergeben haben, liefern.

Einfachheit

Einfachheit ist mehr als das Streben nach Minimalismus. Sie ist die Kehrseite der Komplexität des Systems. Komplexität ergibt sich aus den Beziehungen zwischen Ereignissen. Im digitalen Zeitalter, in dem wir heute leben, ist Komplexität durch die Häufung von Ereignissen aller Art nahezu unvermeidlich. Die Suche nach Einfachheit setzt daher ein umfassendes Verständnis dessen voraus, was sich als Komplexität darstellt. Einfachheit ist demnach eine organisierte Komplexität, die dadurch entsteht, dass Ähnlichkeiten von Ereignissen und nicht ihre Unterschiede hervorgehoben werden. Durch eine solche Kategorisierung könnten Ereignisse auf verständliche Weise miteinander in Beziehung gesetzt und zu einer Matrix zusammengefasst werden, die die Situation erklärt, in der wir uns befinden.

Raum

Der Raum ist die Bühne und die Beziehungsmatrix der Protagonist – gemeinsam bieten sie eine ineinandergreifende, wechselseitige Interpretation dar. Einerseits bezeichnet der Raum die Grenze, die Beschränktheit der Mittel, durch die man die Möglichkeit von Einfachheit erfahren könnte. Es geht dabei um den bewussten Einsatz von Ressourcen durch sinnvoll gestaltete Beziehungen. Andererseits existiert der Raum durch den Aufbau der Beziehungsmatrix, in der die Anordnung der Beziehungen ein System bildet, das den Raum definiert. Der Raum ist demnach mehr als eine physische Grenze, er ist seinem Wesen nach fließend und funktioniert wie eine Maschine, indem er in seiner Begrenztheit die Beziehungsmatrix definiert.

Vernünftiger Einsatz von Ressourcen – die vier Cs

Change – Veränderung

Veränderung ist das universelle Gesetz, dem alle Dinge unterstehen, die durch einen solchen Prozess entstanden sind. Ihr Fortschritt zeigt sich an der Zeitkurve: eingeschlossen in den Grenzen und Strukturen des Raums, wo wir die Zwischenprodukte des Verwandlungsprozesses

ohne finale Form sehen. Dieses System zeigt die Zusammensetzung und die Beziehungen der Dinge an und offenbart schließlich die Möglichkeit von Ereignissen.

Veränderung zu akzeptieren heißt den Rahmen verstehen, in dem bedingte Flexibilitäten Raum bekommen, um eine individuelle Anpassung an unterschiedliche Bedürfnisse zuzulassen. In einem solchen Rahmen wären beliebige Kombinationen beliebiger Ereignisse möglich, es hinge nur von den jeweiligen Wünschen des Einzelnen ab, der die Veränderung in die Wege leitet. Um Veränderung zu ermöglichen, muss man Beziehungsregeln aufstellen, indem man eine Logik der Veränderung schafft, die ihrerseits grenzenlose Möglichkeiten eröffnen könnte.

Choice – Wahlmöglichkeit

Wahlmöglichkeit ist die vielgestaltige Reaktion auf individuelle oder kollektive Wünsche. Die Bandbreite der Wahlmöglichkeiten ergibt sich aus der jeweiligen Begrenztheit der Ressourcen innerhalb des Systems, wobei möglichst viele Lösungen für die jeweilige Priorität zu finden sind. Deshalb sind die Wahlmöglichkeiten des Einzelnen im beschränkten Bereich der Ressourcen geregelt, während Prioritäten, die man setzt, nie zu kontrollieren sind. Um die Wahlmöglichkeit zu konzipieren und zu steuern, muss man den Kontext und die Bedingungen berücksichtigen, in denen Beschränkungen und Grenzen veranschaulicht und reorganisiert werden, um eine maximale Anzahl von Lösungen zu liefern. Diese im Rahmen definierter Umstände geschaffene, ressourcenbewusste Flexibilität wäre eine Lösung für unsere nie enden wollenden Wünsche. Wahlmöglichkeit bedeutet Flexibilität und Anpassungsfähigkeit. Der Designer des Systems verfeinert und produziert einen Mehrwert, ohne die Beziehungsmatrix zu komplizieren. Es ist daher entscheidend, dass man die Beziehungen und die Grenzen des Kontexts versteht und ein einfaches, aber ausgeklügeltes System daraus ableitet, das die Benutzer dechiffrieren und handhaben können.

Coexistence – Koexistenz

Koexistenz wird durch die Akzeptanz und Etablierung von Beziehungen zwischen weit verstreuten Ereignissen und durch ihre Organisation zu einer einfachen Symbiose realisiert. Sie wird erreicht, indem die Ähnlichkeiten der Ereignisse betont und ihre Differenzen überwunden werden, ohne dass die Idiosynkrasie eines einzelnen Ereignisses negiert wird, sodass sie sich untereinander austauschen und in ein praktikables Ganzes integrieren können. Koexistenz fördert auf diese Weise die Diversität von Ereignissen innerhalb eines Systems. Dies ist heute, in einer Zeit, in der Produkte aller Art in den eigenen Lebensbereich eindringen und kein Weg am Partikularen vorbeiführt, von besonderer Wichtigkeit.

Koexistenz begünstigt Diversität statt Homogenität, während die Bereitstellung mehrerer Wahlmöglichkeiten eine größere Flexibilität innerhalb des Systems zulässt. Sie ermöglicht die Erfüllung ein- und derselben Aufgabe mittels verschiedenster Ansätze. Koexistenz ermutigt auch zur Adaptierung und Wiederverwendung und wehrt sich gegen Festlegung und Eliminierung. Unter den Voraussetzungen beschränkter Ressourcen und enger Räume bekommen Ereignisse in der ihnen zugewiesenen Zeitspanne die Möglichkeit zur Selbstentfaltung und zum Generieren eines effizienten systemischen Gesamtwerts, der wesentlich vorteilhafter ist als eine Summe von Einzelwerten.

Connectivity – Anschlussfähigkeit

Anschlussfähigkeit ermöglicht es, Beziehungen zwischen Systemen zu knüpfen, um ein Supersystem zu kreieren. Ein Supersystem umfasst eine Reihe von Systemen, die sich in

Größe und Eigenart unterscheiden. Die Beziehungen zwischen den Systemen sind äußerst flüchtig, da keine starre Ordnung besteht, sondern mobile Systeme miteinander kommunizieren und in ständiger Bewegung sind. Diese dynamische Organisation und die simultane Präsenz in Wechselbeziehung stehender Systeme lassen die zugrunde liegenden Komplexitäten in einem einzigen und vollständigen Ganzen fortbestehen.

Anschlussfähigkeit evoziert eine Beziehungsmatrix und eine Interaktionsplattform. Sie führt zu einem eigenständigen Supersystem, das zahlreiche bestehende Systeme enthält und ermöglicht das Funktionieren verschiedener Systeme als Komponenten, die einander ergänzen, wodurch eine bessere Nutzung der Ressourcen bei gleichzeitigem Zusammenwirken in einem effizienten Supersystem ermöglicht wird. Kurz gesagt, Anschlussfähigkeit versucht mittels einer strategischen Konstruktion das ganze Potenzial von Komplexitäten auszuschöpfen.

▬▬▬ Fallstudien: Ein Manifest für die vier Cs der Einfachheit

Suitcase House

Das einem Koffer nachempfundene *Suitcase House* versucht den Begriff des „Hauses" zu hinterfragen und damit das Wesen von Intimität, Privatsphäre, Spontaneität und Flexibilität neu zu überdenken. Es demonstriert den Wunsch nach ultimativer Anpassungsfähigkeit und versteht sich als Bühne für eine unbegrenzte Anzahl von Szenarien.

Das Haus besteht aus übereinander gelagerten Schichten. Die mittlere Schichte verkörpert einen *piano nobile* par excellence, der als Wohnbereich, als Raum für Aktivität und Bewegung gedacht ist. Durch die Adaption eines nicht hierarchischen Plans mithilfe der von der Gebäudehülle vorgegebenen mobilen Elemente lässt sich der Raum bereitwillig an die jeweilige Aktivität, die Anzahl der Bewohner und den persönlichen Wunsch nach Privatsphäre anpassen. Als metamorphes Volumen erfüllt er die spezifischen Bedürfnisse der Bewohner und lässt sich mühelos von einem offenen Raum in abgetrennte Zimmer verwandeln. Die Räume unterscheiden sich dann durch eine Besonderheit in der Ausstattung.

Die unterste Schicht fungiert als Container für zweckgebundene Räume. Die Abteile verstecken sich hinter einer „Landschaft" aus pneumatisch gestützten Bodenplatten. Räumliche Präsenz wird immer nur den wesentlichen und gerade benötigten Elementen zuteil. Nutzung und Ausstattung der Räume ist vorgegeben.

Um die Grenzen zwischen Haus, Interieur und Mobiliar aufzuheben, wurden der gesamte Bau und die einzelnen Elemente einförmig mit Holz verkleidet, während das Äußere der Stahlkonstruktion von einem Betonfundament gestützt und getragen wird, in dem die Versorgungseinrichtungen untergebracht sind.

Domestic Express

Als Beispiel für eine kontextbezogene Gestaltung von Kompaktheit evoziert *Domestic Express* eine Reihe plastischer Gesten, die Anschlussfähigkeit, Privatsphäre, Spontaneität und Flexibilität thematisieren. Das Gebäude veranschaulicht die Anpassung eines Raums, der den jeweiligen Wünschen und Beschränkungen entsprechend permanent in Verwandlung begriffen ist.

Das Cottage ist als Übergang vom Land zum Wasser konzipiert. Die Grundprinzipien des architektonischen Entwurfs waren ein Cottage und eine Plattform, die als Pier fungiert. Wir beschlossen, die beiden zu verbinden, und ein Cottage zu entwerfen, das zwar nur 5 x 8 Meter groß ist, sich aber auch über den Pier erweitern lässt. Mobile Möbel können auf Schienen durch das Haus auf die Plattform bewegt werden und heben dadurch die Grenze zwischen Innen und Außen auf. Die Möbel, die nebeneinander gestellt wie ein abstraktes Objekt wirken, können immer wieder neu arrangiert werden und sich an alle Wünsche und Bedürfnisse der Bewohner anpassen, egal, ob nun ein abgeschlossener Raum für mehr Privatsphäre oder ein Bereich für eine bestimmte Aktivität verlangt wird.

Die beweglichen Möbelmodule sind ursprünglich in einer auf Schienen ruhenden Box montiert, in der Tisch, Sofa und Bank ineinander verschachtelt stehen. Die Bewohner können das Interieur nach Belieben an ihre Bedürfnisse anpassen, indem sie die Möbel über die Schienen ziehen und Räume für unterschiedliche Aktivitäten ganz nach ihren Wünschen gestalten.

Der „Express" beschränkt sich nicht auf die Innenräume, sondern kann auch auf den Pier hinaus erweitert werden. Indem die gesamte Länge des Piers genutzt wird, können Möbel, die aus dem Cottage geführt werden, Außenräume erschließen, die vielfältige Aktivitäten im Freien, wie etwa Schlafen, Essen und nicht zuletzt Baden, ermöglichen.

Re: Einfachheit

Das Konzept von Einfachheit leistet einen wesentlichen Beitrag zu unserem Verständnis der Komplexitäten, mit denen wir in einem Zeitalter der Ereignishäufung konfrontiert sind. Wir erkennen die Unabwendbarkeit dieser Komplexitäten an und versuchen, wie etwa beim *Suitcase House* und dem *Domestic Express*, durch eine Reorganisation der Beziehungen zwischen System und Raum Lösungen für ein alternatives und vereinfachtes Leben zu finden.

Wir akzeptieren *Einfachheit* als Strategie. Einfachheit ist eine „Lösung, die keine wirkliche Lösung für ein spezifisches Problem ist, sondern eine Möglichkeit, intellektuelles Unbehagen und selbst existenzielle Angst zu lindern (Claude Lévi-Strauss) – eine Haltung, die uns ermöglicht, mit den überwältigenden und unausweichlichen Komplexitäten der heutigen Welt zurande zu kommen. Zu erreichen ist dies durch einen vernünftigen Umgang mit beschränkten Ressourcen und den bewussten Aufbau von Systemen, indem Ähnlichkeiten erkannt und Prioritäten gesetzt werden.

Aus dem Englischen von Martina Bauer

Wolfgang Blau

Longing for Simplicity

Every era has its myths. The defining myth of the so-called Information Age proclaims that our world is supposedly becoming increasingly complex. Nevertheless, complexity is perceived subjectively; it depends on the observer's point of view.

Thanks to digitization and pervasive networks, we in the G8 states for example, are experiencing a knowledge explosion; meanwhile many intellectuals of other ethnic groups perceive our Western worldview as increasingly ill-suited to do justice to the complex needs of human existence. Are we really living in an age of exponentially growing information? Or isn't the current mass extinction of species along with the disappearance of ancient languages and traditional knowledge the most severe loss of genetic and cultural information in the history of humanity? Both statements are true.

Complexity is the simultaneous presence of seemingly contradictory truths. Unifying these contradictions within us calls for mental tools and learning techniques that our culture is hardly providing.

After two thousand years of male-dominated and monotheistic patterns of thought, we are accustomed to structuring our world of experience hierarchically from top to bottom and, in case of doubt, to perceiving mono-causality as the more truthful answer of choice.

In order to be able to make our way in a world that is poly-causal, less hierarchical and increasingly organized along the lines of network structures, we have to adopt more holistic methods of thinking. We need a worldview that derives the greatest feeling of security, authenticity, rootedness and sense of belonging precisely from the complexity of our existence and not from oversimplifying everything.

Simplicity could be characterized as the ability to describe a lot with a little; whereby the "little" must not be flat and monocausal but rather embraces dual principles, profound and multicausal, much like the periodic table of elements which describes the complex characteristics of the elements in a simple system without oversimplifying.

The New Homelessness

Nowadays, thanks to Google Earth, we can marvel at our planet's most remote regions via satellite, while it becomes ever more challenging for us to map out our own lives. Nothing is straightforward anymore now that all of our grandparents' cultural anchors have come loose of their moorings: the future of nation-states is uncertain; the significance of once identity-endowing national languages is diminishing; the concepts of the nuclear family and lifelong marriage are making room for new lifestyles; while the monotheistic religions are losing their monopoly on interpreting our spiritual needs.

Few of us would willingly re-erect the mental prisons of the past, though many of us long for the seeming simplicity of bygone times.

What makes this longing for simplicity even more bewildering is the fact that even its own social icons are themselves anything but simple: the open source movement, the slow food movement, citizen journalism and experiments in participatory democracy are all much more complex and more difficult to get a comprehensible overview of than the monopolies and monocultures to which they are juxtaposed. In our minds, though, these movements are still associated with a positive feeling of the new simplicity.

Also the popular reference to nature as a symbol of simplicity can only hold up as long as we don't equate simplicity with primitivity. In comparison to playing a computer game, time spent lolling on a lush summer meadow might indeed seem to be the more simple pleasure. However, the chemical and physical processes transpiring in this meadow are nevertheless more complex than anything that humanity has ever been able to fully understand, let alone invent.

In her ability for complexity that is efficient and of unsurpassed beauty, nature is our most important teacher to understand simplicity. This perspective on nature Is being described by author Janine M. Benyus as "biomimicry." As a research approach, biomimicry has led to surprising breakthroughs in many different fields in recent years-from trucking companies' fuel-saving algorithms based on the communication patterns of ants to super-efficient turbines whose flow designs are derived from marine algae.

What biomimicry researchers have in common is their recognition of the fact that nature has considerably more design experience than humanity does, and that we human beings are inseparably part of nature. According to this way of thinking, even an automobile is a manifestation of natural life, though its current design doesn't even come close to mirroring the simplicity-expertise of nature.

▬▬ Simplicity and Simplification

Simplicity is the art of reduction to the essential. The simplicitas of Antiquity, however, was far more than a value-neutral design principle; it was in equal measure a synonym for honesty and directness. Striving to attain such directness and authenticity often succumbs to the allure of shallow foreshortenings. After all, nothing produces the illusion of simplicity faster than a bogeyman: open source versus commercial software, slow food versus fast food, citizen journalism versus old media, non-profit versus global corporatism, David versus Goliath, us against them, good versus bad.

Adherents of a misconceived simplicity also easily fall victim to the unIversally explanatory pseudo-logic of conspiracy theories. Or, for example, they fervently hope for crises to escalate and come to a head so that the world might "finally come to its senses." Experience shows, however, that catastrophic climaxes of crises do not lead to more rationality; instead, they are likely to result in increased fundamentalism and more resource wars to the detriment of a society's weakest members. Simplicity is fragile.

Democratic forms of government constitute one of the oldest collective experiments in search of simplicity. Too much complexity leads to a loss of cohesion and governability; too little of it results in dictatorial conditions. Yet, even in the G8 states, the advantages of democratic societies are again being fundamentally called into question. President Putin's dangerous contempt for democratic constitutions is tolerated in the West and shrugged off with the suggestion that Russia just wasn't made for democracy; as if democracy were, in truth, merely a luxury and not a necessity essential to every society's capacity to innovate. Even China's murderous disdain for the human rights of its citizens is dismissed in the West by pointing out that the country first has to develop economically.

Some people even advocate dictatorship for a limited time in reference to the looming catastrophe of global warming because they believe that our democratic decision-making processes are too complex and time-consuming to prevent the melting of the polar ice caps and the halting of the Gulf Stream. Thus, the historical experience that dictators do not voluntarily abdicate is giving way to a longing for supposedly "simple solutions."

Amartya Sen, 1998 Nobel Prize winner in economics, has already impressively refuted this myth of temporary dictatorship for the purpose of faster development. In his essay "Democracy satisfies," he shows that a high degree of political participation has a demonstrably positive effect on a society's economic development and its ability to respond effectively to crises.

"The rights of political participation are important not only for the fulfillment of needs but also for their formulation," wrote Sen, who went on to quote from a speech by Chinese dictator Mao Tse-Tung: "Without democracy, you learn nothing about what is taking place at the bottom; the situation becomes unclear; you will not be in a position to obtain sufficient opinions from all sides," said Mao in 1962 after his reforms had failed and millions of Chinese had died of starvation. "There is no communication between above and below," according to Mao. "Top leaders will have to base their decisions on one-sided, incorrect information; it will thus be difficult for you to proceed in a way that is anything other than subjective."

Simplification and simplicity often appear in similar attire but they differ dramatically in their readiness to respect complexity and to nurture diversity.

Unsuitable Pyramids

Complexity is not inherently overwhelming. We experience complexity as overwhelming only when we feel forced to set priorities where it is impossible to do so. We could term this quintessentially European conflict "The Pyramid Dilemma." This is our inheritance from the Age of Feudalism, when there was no conceivable organizational form-either in the material world or the spiritual realm-other than a hierarchical system of vertical gradations of power.

King

Noble Men

Common Folk

Some examples of the characteristic pyramids of feudalistic thinking are: "God, angel, devil" / "man, woman" / "pope, emperor, king, clergy, aristocracy, the common folk, serf" / "human being, animal, plant" / "employer, white-collar worker, blue-collar worker, unemployed" / "fellow citizen, fellow European, foreigner" / "government minister, member of parliament, voter."

Those who structure their world in pyramids can only conceive of coups within these hierarchies, but not horizontal or spherical forms of organization that, for instance, might acknowledge that an adolescent schoolgirl could possess entrepreneurial instincts that are just as sharp as those of the CEO of a major corporation.

In this vertical attitude of mind, even the earth's fauna has a feudalistic hierarchy mapped out for it: an "animal kingdom" with the "lion king" reigning over the desert, the bull elk as "king of the forest" and with ants or bees serving their respective "queens."

The societal pyramid is an innovation-inhibiting system that fosters unhappiness. The population of every tier battles against those on the tier below to prevent their own relegation. New

ideas rise very slowly to the top, if at all. Non-hierarchical patterns for organizing highly complex matters do indeed exist; this is illustrated by the cultures of North American Indians with their so-called "Medicine Wheels." Instead of structuring the world in pyramids, these cultures tend to order the various aspects of our existence on an equal basis in circular configurations. Within this way of thought, our basic human needs, for example, are of a spiritual, physical, emotional and mental nature. In contrast to the well-known pyramid of needs proposed by Abraham Maslow, the founder of humanistic psychology, none of each of these needs is said by the Indian cultures to be pre-eminent or to possess greater importance in life than the other three.
The very idea of forcing these four realms of needs into a vertical ranking order would be considered primitive in these cultures. Instead of hierarchical-linear thinking, these cultures tend towards spherical ways of looking at things.

The history of the Iroquois Confederacy illustrates that a culture which conceptualizes human nature in non-hierarchical circles is well-suited to bringing forth different representative forms of government. The Iroquois Confederacy endured for many centuries and featured a very sophisticated balance of power, equal rights for women and men and a complex legislative process. It inspired several of the USA's founders. In their correspondence, Thomas Jefferson, Benjamin Franklin and Thomas Paine repeatedly expressed their admiration for the elegant simplicity of this Indian system of government. They felt it was more democratic and more efficient than all of the Old World's forms of state that were known to them.

Paralyzed Decision-Makers

Anyone who views this excursion into other cultures as merely esoteric, might want to, for example, take note of the divergent behavior of current European and American media managers.
It is a well-known fact that the top executives of traditional media enterprises in the US and Europe are confronted by a dilemma. In the 1990s, the digitization of media production enabled more and more channels and periodicals. Today, an even more radical process of transformation is rearing its head. After the digitization of production, now the distribution of media content is also being increasingly digitized, and this makes possible—in the TV industry for example—

such a complex multitude of new transmission methods, playback devices and, thereby, new forms of programming that even industry experts are loosing their overview.

Americans and Europeans seem to have different ways of dealing with the frightening impossibility to get an overview. European media managers tend to visualize the world of new ideas as a pyramid. They naturally assume that in the near future some medium will once again establish itself as the king-medium, just like TV once was, and that a specific transmission technology will dominate. They perceive the current upheavals simply as the chaos phase between the collapse of an old pyramid and the rise of a new one.

Accordingly, the Europeans' preferred tactic is to wait. Their assumption: the longer they postpone their critical investments in new infrastructure and business concepts, the greater their chance of recognizing the future "king" and putting their money on the right horse.

The Americans, on the other hand, seem to be having an easier time getting comfortable with the idea that the time of pyramids just might be coming to an end for good and making way for a media ecosystem in which provisional diversity becomes permanent. They're investing more frequently and are experimenting more. They accept narrower profit margins and, paradoxically, are making bigger profits by doing so.

Whereas the Europeans first want to take a wait-and-see approach to establish whether an idea has what it takes to make it to the pyramid's peak, Americans are getting involved earlier and have thereby gained market leadership in almost all digital media industries.

Here, the key difference is not the American entrepreneurs' often-cited readiness to take risks, but rather the increasing inability of our vertical worldview, still imprinted by feudalism, to arrive at a state of simplicity and from there to generate the appropriate strategies.

We can never afford to not have hierarchies and ranking orders. Yet, they are only able to provide us with orientation as long as they constitute one ordering principle among many and coexist with spherical and horizontal orders. Our current feeling of being stressed and burdened by the world's complexity and new technologies is due above all to our unconscious compulsion to establish priorities and ranking orders where this is no longer possible. At this point, we know too much to be able to still find our way to simplicity in this antiquated way of thinking.

What we're experiencing today is the long, slow decline of the Feudal Age whose political institutions have for the most part been extinct for centuries but whose internalized patterns of thinking are still impeding us to this day. The growth of knowledge via the Internet did not trigger this process; it merely accelerated it. One result of this process is our ever greater longing for simplicity.

Wolfgang Blau

Sehnsucht nach Einfachheit

Jede Ära hat ihre Mythen. Der prägende Mythos der sogenannten Informationsgesellschaft besagt, dass unsere Welt angeblich immer komplexer werde. Komplexität wird jedoch subjektiv erlebt; sie hängt vom Standpunkt der Betrachterin ab.

Während wir zum Beispiel in den G8-Staaten dank Digitalisierung und Vernetzung eine Explosion des Wissens erleben, empfinden Intellektuelle anderer Ethnien unsere westliche Weltsicht oft als immer weniger geeignet, um den komplexen Bedürfnissen menschlichen Daseins noch gerecht zu werden.

Leben wir wirklich in einem Zeitalter exponenziell wachsender Information? Oder bedeutet das derzeitige Artensterben und das Verschwinden alter Sprachen und Erfahrungswissens nicht den schwerwiegendsten Verlust an genetischer und kultureller Information in der Geschichte der Menschheit? Beides trifft zu.

Komplexität ist die gleichzeitige Präsenz scheinbar widersprüchlicher Wahrheiten. Diese Widersprüche in uns zu vereinen, erfordert mentale Werkzeuge und Lerntechniken, die unsere Kultur bisher aber kaum bereithält.

Nach zweitausend Jahren männlich dominierter und monotheistisch geprägter Denkweisen sind wir es gewohnt, unsere Erfahrungswelt bevorzugt hierarchisch von oben nach unten zu strukturieren und Monokausalität im Zweifelsfall als wahrhaftiger zu empfinden.

Um uns in einer polykausalen, weniger hierarchisch und immer mehr in Netzwerkstrukturen organisierten Welt bewegen zu können, müssen wir uns ganzheitlichere Denkmethoden aneignen. Wir brauchen eine Weltsicht, die uns gerade in der Komplexität und nicht mehr in der Verflachung das größte Gefühl von Sicherheit, Authentizität, Verwurzelung und Heimat bieten kann.

Einfachheit könnte dabei als die Fähigkeit skizziert werden, vieles mit wenig zu beschreiben. Wobei das „Wenige" nicht platt und monokausal sondern auf dualen Prinzipien beruhend, durchaus tiefgründig und multikausal sein muss; etwa so, wie in der Chemie das Periodensystem die komplexen Eigenschaften der Elemente in einem System der Einfachheit beschreibt, ohne deshalb zu vereinfachen.

Die neue Heimatlosigkeit

Wir können heute zwar mit Google Earth die entlegensten Regionen unseres Planeten via Satellit bestaunen, unser eigenes Leben zu kartografieren gelingt uns indessen kaum noch. Nichts ist mehr eindeutig, alle kulturellen Anker unserer Großelterngeneration sind ins Rutschen geraten: Die Zukunft der Nationalstaaten ist ungewiss, einst identitätsstiftende Landessprachen verlieren an Bedeutung; das Konzept der Kernfamilie und lebenslangen Ehe macht neuen Lebensformen Platz, während die monotheistischen Religionen ihr Deutungsmonopol auf unsere spirituellen Bedürfnisse verlieren.

Nur wenige würden gerne die mentalen Kerker der Vergangenheit wiedererrichten; nach der scheinbaren Einfachheit früherer Zeiten sehnen sich jedoch viele.

Was diese Sehnsucht nach Einfachheit noch verwirrender macht ist, dass ihre gesellschaftlichen Ikonen selbst alles andere als simpel sind: Die Open-Source-Bewegung, die Slow-Food-Bewegung, der Bürger-Journalismus oder Experimente mit partizipatorischer Demokratie sind allesamt viel unüberschaubarer und komplexer als die Monopole und Monokulturen, denen sie gegen-

überstehen. Und dennoch verbinden wir mit ihnen ein positives Gefühl von neuer Einfachheit. Auch der beliebte Rückgriff auf die Natur als Sinnbild von Einfachheit hält nur dann stand, solange wir Einfachheit nicht mit Primitivität gleichsetzen. Ein besinnlicher Nachmittag in einer Sommerwiese mag uns im Gegensatz zu einem Computerspiel zwar als das simplere Vergnügen erscheinen, die chemischen und physikalischen Vorgänge in dieser Sommerwiese sind dennoch komplexer als alles, was bisher von Menschen verstanden, geschweige denn erfunden wurde. Die Natur ist in ihrer Fähigkeit zu effizienter und unerreicht schöner Komplexität unsere wichtigste Lehrerin, um Einfachheit zu verstehen. Dieser von Janine M. Benyus als „Biomimicry" beschriebene Forschungsansatz hat in den letzten Jahren in vielen Branchen zu überraschenden Durchbrüchen geführt; von spritsparenden Speditions-Algorithmen, die sich an die Kommunikationsmuster von Ameisen anlehnen, bis hin zu super-effizienten Turbinen, deren Strömungsdesign von Meeresalgen abgeleitet wurde.

Was die Biomimicry-Forscher gemeinsam haben, ist das Verständnis, dass die Natur wesentlich mehr Design-Erfahrung hat als wir Menschen und dass wir Menschen zugleich Teil der Natur sind und nicht separat von ihr existieren. Auch ein Auto ist in dieser Denkart eine Erscheinung natürlichen Lebens; wenn auch sein heutiges Design noch längst nicht die Einfachheit-Expertise der übrigen Natur widerspiegelt.

Simplicity und Vereinfachung

Simplicity ist die Kunst der Reduktion auf das Essentielle. Die „Simplicitas" der Antike war jedoch weit mehr als nur wertneutrales Design-Prinzip, sie war genauso auch Synonym für „Ehrlichkeit" und „Direktheit". Das Streben nach einer solchen Direktheit und Authentizität erliegt dabei oft dem Reiz platter Verkürzungen. Nichts verschafft uns die Illusion von Simplicity schließlich schneller als ein Feindbild: Open-Source gegen kommerzielle Software, Slow-Food gegen Fast-Food, Bürger-Journalismus gegen Old Media, Non-Profit gegen globalen Corporatismus, David gegen Goliath, wir gegen die, gut gegen böse.

Anhänger falsch verstandener Einfachheit fallen auch leicht der alles erklärenden Pseudologik von Verschwörungstheorien anheim oder hoffen zum Beispiel auf die eskalierende Zuspitzung von Krisen, damit die Welt „endlich zur Besinnung" komme. Die Erfahrung zeigt aber, dass katastrophale Zuspitzungen von Krisen nicht zu mehr Vernunft, sondern eher zu noch mehr Fundamentalismus und zu noch härteren Verteilungskämpfen auf Kosten der Schwächsten führen. Einfachheit ist zerbrechlich.

Demokratische Staatsformen sind eines der ältesten kollektiven Experimente auf der Suche nach Einfachheit. Ein Zuviel an Komplexität führt zum Verlust von Zusammenhalt und Regierbarkeit, ein Zuwenig an Komplexität resultiert in diktatorischen Zuständen. Selbst in den G8-Staaten werden aber die Vorzüge demokratischer Gesellschaften heute wieder grundsätzlich in Frage gestellt. Präsident Putins gefährliche Verachtung für demokratische Verfassungen wird im Westen mit dem achselzuckenden Hinweis toleriert, Russland sei nicht für die Demokratie geschaffen; ganz so, als ob Demokratie in Wahrheit nur ein Luxus und keine essenzielle Notwendigkeit für die Innovationsfähigkeit jeder Gesellschaft wäre. Auch Chinas mörderische Verachtung für die Menschenrechte seiner Bürger wird im Westen mit dem Hinweis abgetan, das Land müsse sich nun eben erst einmal wirtschaftlich entwickeln.

Sogar im Zusammenhang mit der drohenden Klimakatastrophe werden nun vereinzelte Rufe nach einer zeitlich befristeten Diktatur laut, da unsere demokratischen Entscheidungsprozesse angeblich zu komplex seien, um das Abschmelzen der Polkappen und einen eventuellen Still-

stand des Golfstroms noch zu verhindern. Die historische Erfahrung, dass Diktatoren nicht mehr freiwillig abdanken, macht hier dem Wunsch nach vermeintlich einfachen Lösungen Platz.

Amartya Sen, der Wirtschafts-Nobelpreisträger des Jahres 1998, hat diesen Mythos von der zeitlich befristeten Entwicklungsdiktatur bereits eindrücklich widerlegt. In seinem Essay „Demokratie macht satt" zeigt er auf, dass ein höherer Grad an politischer Mitwirkung sich nachweislich positiv auf die wirtschaftliche Entwicklung und Krisenreaktionsfähigkeit einer Gesellschaft auswirkt.

„Politische Mitwirkungsrechte sind wichtig – nicht nur für die Erfüllung von Bedürfnissen, sondern auch für deren Formulierung", schreibt Sen und zitiert aus einer Rede des chinesischen Diktators Mao Zedong: „Ohne Demokratie erfahrt ihr nichts darüber, was am unteren Ende vorgeht; die Situation wird unklar; ihr werdet nicht in der Lage sein, in genügendem Maße Meinungen von allen Seiten einzuholen", sagte Mao 1962, nachdem seine Reformen gescheitert und Millionen Chinesen verhungert waren. „Es gibt keine Kommunikation zwischen oben und unten", so Mao, „weit oben angesiedelte Führungsorgane werden sich bei der Beschlussfassung auf einseitiges, unkorrektes Material stützen müssen; es wird euch daher schwer fallen, euch anders als subjektiv zu verhalten."

Vereinfachung und Einfachheit kommen oft im selben Gewand daher, sie unterscheiden sich aber dramatisch in ihrer Bereitschaft, Komplexität zu respektieren und Vielfalt zu fördern.

Untaugliche Pyramide

Komplexität stellt auch nicht automatisch eine Überforderung dar. Wir erleben Komplexität nur dann als überfordernd, wenn wir uns gezwungen fühlen, Prioritäten zu setzen, wo keine Prioritäten möglich sind. Diesen vor allem europäischen Konflikt könnten wir auch als das „Pyramiden-Dilemma" beschreiben. Es ist unser Erbe aus dem Zeitalter des Feudalismus, in dem es für das Diesseits wie das Jenseits keine andere denkbare Organisationsform mehr gab als die der hierarchischen, vertikalen Machtabstufungen.

Charakteristische Pyramiden des feudalistischen Denkens sind zum Beispiel: „Gott, Engel, Teufel" / „Mann, Frau" / „Papst, Kaiser, König, Klerus, Adel, Volk, Leibeigene" / „Mensch, Tier, Pflanze" / „Arbeitgeber, Angestellter, Arbeiter, Arbeitsloser"/ „Inländer, Europäer, Ausländer" / „Regierung, Parlamentarier, Wahlvolk".

Wer seine Welt in Pyramiden strukturiert, kann sich nur Umstürze innerhalb dieser Hierarchien vorstellen, nicht jedoch horizontale oder sphärische Organisationsformen, die beispielsweise auch einer Grundschülerin ebenso wertvolle Unternehmer-Instinkte zubilligen würden wie einem Konzernchef.

Selbst die Tierwelt wird aus dieser vertikalen Geisteshaltung heraus noch als „Tier-Reich" karto-grafiert; scheinbar selbstverständlich mit Tierkönigen an der Spitze, dem Löwen als „König der Tiere", dem Großhirsch als „König des Waldes" oder Ameisen und Bienen, die ihren jeweiligen „Königinnen" dienen.

Die gesellschaftliche Pyramide ist ein innovationsfeindliches System der Unglücklichen. Jede Stufe kämpft gegen die darunterliegende Stufe, um den eigenen Abstieg zu verhindern. Neue Ideen schaffen es, wenn überhaupt, dann nur langsam an die Spitze.

Dass es aber auch nicht-hierarchische Ordnungsmuster für hoch komplexe Sachverhalte gibt, zeigen beispielsweise die Kulturen der nordamerikanischen Indianer mit ihren sogenannten Medizinrädern. Statt die Welt in Pyramiden zu strukturieren, neigen diese Kulturen dazu, die ver-schiedenen Aspekte unseres Daseins gleichberechtigt und in Kreisen anzuordnen. Unsere menschlichen Grundbedürfnisse sind hier zum Beispiel von spiritueller, physischer, emotionaler und mentaler Natur. Im Gegensatz zur bekannten Bedürfnis-Pyramide von Abraham Maslow, dem Gründervater der humanistischen Psychologie, ist in den indianischen Kulturen kein Bedürf-nis höherrangiger oder lebenswichtiger als die anderen drei.

Die Vorstellung, hier überhaupt eine vertikale Rangordnung erzwingen zu wollen, würde in die-sen Kulturen als primitiv gelten. Statt zu hierarchisch-linearem Denken neigen diese Kulturen zu sphärischem Denken.

Dass eine Kultur, die ihr Seelenleben in nicht-hierarchischen Kreisen organisiert, dann auch zu anderen Staatsformen findet, zeigt die Geschichte der Irokesen-Konföderation. Dieses viele Jahr-hunderte während Staatengebilde mit ausgefeilter Gewaltenteilung, vollständiger Gleichbe-rechtigung zwischen Frauen und Männern und einem komplexen Gesetzgebungsverfahren inspirierte zahlreiche Gründer der USA. Thomas Jefferson, Benjamin Franklin und Thomas Paine bewunderten in ihren Briefwechseln immer wieder die elegante Einfachheit dieses indianischen Regierungssystems, das ihnen demokratischer und effizienter erschien als alle bekannten Staats-formen des alten Kontinents.

▬▬ Gelähmte Entscheider

Wer nun diesem Exkurs in andere Kulturen nur esoterischen Wert beimisst, sollte bei-spielsweise einmal das unterschiedliche unternehmerische Verhalten europäischer und ameri-kanischer Medienmanager vergleichen.

Die Geschäftsführer traditioneller Medienhäuser in den USA wie auch in Europa stehen bekanntlich vor einem Dilemma: In den 1990er Jahren hat die Digitalisierung der Medienproduktion den kostengünstigen Betrieb von immer mehr Kanälen und immer mehr Print-Titeln ermöglicht. Jetzt steht eine noch tiefgreifendere Umwandlung ins Haus. Nach der Produktion wird nun auch die Distribution von Medieninhalten zunehmend digitalisiert und ermöglicht beispielsweise in der TV-Branche eine solch komplexe Vielzahl neuer Übertragungswege, Abspielgeräte und damit auch wieder neuer Programmformen, dass selbst Branchenexperten den Überblick verlieren.

Amerikaner und Europäer scheinen mit dieser beängstigenden Unübersichtlichkeit verschieden umzugehen. Europäische Medienmanager tendieren dazu, die Welt neuer Ideen als Pyramide zu visualisieren. Sie gehen selbstverständlich davon aus, dass es auch in Zukunft wieder ein Königsmedium wie einst das Fernsehen und eine Königsdisziplin der Übertragungstechnologien geben wird. Den gegenwärtigen Umbruch erleben sie nur als Chaos-Phase zwischen dem Einsturz einer alten und dem Entstehen einer neuen Pyramide.

Die bevorzugte Taktik der Europäer ist es deshalb, abzuwarten. Je länger sie ihre entscheidenden Investitionen in neue Infrastrukturen und Geschäftsideen hinauszögern, so die Annahme, um so größer ist ihre Chance, den zukünftigen „König" zu erkennen und auf das richtige Pferd zu setzen.

Die Amerikaner hingegen scheinen sich leichter mit der Vorstellung anzufreunden, dass die Zeit der Pyramiden vielleicht ganz zu Ende gehen könnte und einem Medien-Ökoystem Platz machen wird, in dem die provisorische Vielfalt zum Dauerzustand wird. Sie investieren häufiger und experimentieren mehr. Sie akzeptieren geringere Gewinnspannen und machen dadurch paradoxerweise größere Profite. Während die Europäer erst einmal abwarten wollen, ob eine Idee es an die Spitze einer Pyramide schafft, steigen die Amerikaner früher ein und haben damit die Marktführerschaft in fast allen digitalen Medienindustrien erworben. Der zentrale Unterschied ist dabei gar nicht die vielbeschworene Risikobereitschaft amerikanischer Unternehmer, sondern die wachsende Unfähigkeit unserer immer noch vom Feudalismus geprägten vertikalen Weltsicht, zunächst Einfachheit und daraus dann entsprechende Strategien zu erzeugen.

Hierarchien und Rangordnungen werden nie verzichtbar sein. Sie bieten uns aber nur noch dann Orientierung, wenn sie ein Ordnungsprinzip von vielen sind und parallel zu sphärischen und horizontalen Ordnungen existieren. Unser heutiges Gefühl von Stress und Überforderung durch die Komplexität der Welt und neuer Technologien entsteht vor allem durch den unreflektierten Zwang, Prioritäten und Rangordnungen etablieren zu wollen, wo dies gar nicht mehr möglich ist. Wir wissen heute zuviel, um in dieser veralteten Denkart noch Einfachheit finden zu können.

Was wir nun erleben, ist der langatmige Niedergang des feudalistischen Zeitalters. Seine politischen Institutionen sind zum Teil schon seit Jahrhunderten erloschen, seine verinnerlichten Denkmuster stehen uns noch heute im Weg. Der Wissensanstieg über das Internet hat diesen Prozess nicht ausgelöst, sondern nur beschleunigt. Ein Ergebnis davon ist unsere wachsende Sehnsucht nach Einfachheit.

Veronika Leiner, Alexander Baratsits / Radio FRO

Re-Defining Public Service
What is Public Value and What Do
Community Media Have to Do with It?

The much-discussed cultural revolution of the last ten years has had an especially strong impact on how media mediate information, and has put in place completely new ground rules with respect to possibilities for the active expression of opinions. The emergence of what are basically interactively oriented Internet media such as weblogs and wikis has exponentially increased not only the number of available sources of information, but also the complexity of an ever-more-multifaceted media world. At the same time, though, it's remarkable how "old-fashioned" analog technologies are still able to assert themselves and even expand their turf as instruments for networking within civil society and as alternative medial and cultural production facilities. Community radio and TV are once again on the upswing worldwide.

In this changed media world, the time has come to restart the discussion of the mission to serve the public interest that most Western democracies assign to public broadcasting systems and finance with public funds—above all, fees paid by users. The Treaty of Rome[1] that established the European Economic Community, for instance, requires that commissions "subject to public law" be granted only for activities performed in the public interest. According to the provisions of the Amsterdam Protocol of the Treaty of Rome, the only activities that can be part of such a mission to broadcast public interest content are those that serve society's democratic, social and cultural needs and that contribute to maintaining pluralism in the media.[2]

There is an essential structural difference between the mission carried out by participative community media oriented on enhancing communicative rather than economic value and that of traditional public broadcasting systems like Austria's ORF, RAI in Italy and the "mother of all public broadcasting systems," the BBC. Whereas governments assign these institutions an explicit mission to broadcast informational, educational and cultural programming—which they have a harder and harder time carrying out in an increasingly commercialized media landscape—alternative and community media explicitly assign themselves the mission to broadcast in the public interest. These media outlets are open to anyone wishing to articulate his/her opinion; thus, their highest priority is on the active production of opinions and the expression thereof, and not merely on consuming information. Accordingly, these public access media outlets are the ones that are actually doing the essential work of actively implementing the right to freedom of expression established in Article 10 of the European Convention on Human Rights. The European Court of Human Rights (ECHR) and the European Court of Justice (ECJ)[3] have continually reiterated the view that the state is obliged to actively support the process of putting this freedom into actual practice.

From this perspective, it seems indisputable that community media—and especially free radio and community TV outlets that operate according to the public access principle—are fulfilling a specific mission to broadcast in the public interest that no other media outlets are in a position to carry out. Accordingly, there is less and less doubt expressed as to public access media's relevance to the process of nurturing a healthy, functioning democracy and to encouraging citizen involvement in the political process; the important job that community media are doing on behalf of the social integration of (medially) marginalized social groups, for the promotion of local and regional artistic and cultural production, or in the regional development of isolated rural areas seems to be ever more widely acknowledged and accepted. In their absence, it would hardly be possible to bring together in such a highly concentrated form the necessary medial expertise, intercultural competence and social skills that result from active work with media and the establishment of linkages across the entire spectrum of social groups that almost inevitably goes along with this.

In many European countries, these facts are acknowledged both legally and financially. In Ireland, Great Britain, the Scandinavian countries, Germany and France, it is considered standard practice of a developed democracy to grant these media both explicit legal recognition and financial subsidies. The respective legal regulations in these countries refer to, among other factors, the "services in the public interest" that these media provide. Nevertheless, most Eastern and Central European states—including Austria—do not proceed in accordance with this "public interest mission" line of argumentation, even though ample declarations have been produced by European institutions that underscore, in light of increasing media concentration, the state's responsibility to maintain or create media diversity and opinion diversity, and that explicitly refer to the essential role that free and community media play in this regard.

These developments also confront traditional public broadcasting systems with a new situation. They have long since ceased to be the only media explicitly carrying out public service functions, and they thus face growing pressure to justify the fact that they are financed by fees paid by users. After all, the legitimacy of this arrangement is ultimately based on their claim to be providing broadcast services in the public interest, and increasing doubt has been expressed about these services in recent years in many countries. In Germany, for instance, the ARD has had to confront charges of illegitimately using surreptitious advertising to generate revenue. There is widespread criticism that there has been a decline in the quality of the offerings on public

broadcasting stations, whose programming and formats have increasingly come to resemble those of their commercial competitors. Furthermore, Austria's ORF is accused of having abandoned its independence, of being subjected to ruthlessly partisan influence by political parties and government officials, of permitting virtually no critical reportage to be aired[4] and of allowing art and culture "to vanish into a black hole."[5]

In contrast to the ORF, the BBC, the British public broadcasting system, must face a public consultation process every 10 years in order for its license to produce programming financed by user fees to be renewed. In March 2006, the British government released the latest BBC White Paper[6] that was designed to define the BBC's role, function and structure in a changed media environment. In a paper published by the BBC itself in 2005,[7] that institution summarized its mission as "building public value," the production of which—as well as the lack thereof—could purportedly be tested in a practical way. The BBC was said to produce five-fold public value: democratic value, cultural and creative value, educational value, social and community value, and global value. It went on to maintain that all of the BBC's broadcast services could be objectively evaluated by a "public value test."[8] Nevertheless, a precise definition of public value seems to be a difficult matter since, in contrast to the market value of a service, the non-material value a broadcast service provides to society is an abstract magnitude that immediately raises more questions than it answers.

In an increasingly commercialized media world of global media conglomerates, democracy-threatening media concentration and market-oriented disinformation, Radio FRO's contribution to this year's Festival is focusing on questions having to do with the public value of media and media production. What demands do democratic societies place on media today? How does "public broadcasting" define itself in a changed media world? How do various different media go about fulfilling their mission to work in the public interest? To what extent are traditional public broadcasting systems even pursuing this mission nowadays? What are the obligations of the state with regard to the public service mission of community media? Can a mission to provide public service content be conveyed to Internet media? And: How is public value to be defined in contemporary societies? What actually is the public value of productions in the various different media? Can public value be "measured"?

http://www.fro.at/ars06

Translated from German by Mel Greenwald

A Radio FRO project in collaboration with Ars Electronica.

1 See Art 86 para 2 EG
2 See Kletter, M.: *Die Finanzierung des ORF mittels Programmentgelten. Eine Betrachtung im Lichte der Novelle des ORF-Gesetzes und der neuesten Entwicklungen im Gemeinschaftsrecht* (The Financing of the Austrian Broadcasting Company through Program Fees: Considerations in Light of Amendments to the Public Broadcasting Law and the Latest Developments in Community Law). MR 2001, 260.
3 The European Court of Human Rights (ECHR) is an organ of the European Council, whereas the European Court of Justice (ECJ) is an organ of the European Union.
4 See *http://www.sos-orf.at*
5 See *http://kulturrat.at*
6 "A public service for all. The BBC in the digital age," 2006.
 http://www.bbccharterreview.org.uk/have_your_say/white_paper/bbc_whitepaper_march06.pdf
7 "Building public value. Renewing the BBC for a digital world," 2005.
 http://www.bbc.co.uk/thefuture/pdfs/bbc_bpv.pdf
8 See "A public service for all. The BBC in the digital age. 2006," p. 30 ff.
 http://www.bbccharterreview.org.uk/have_your_say/white_paper/bbc_whitepaper_march06.pdf

Veronika Leiner, Alexander Baratsits / Radio FRO

Re-Defining Public Service
Was ist Public Value und was haben Community-Medien damit zu tun?

Die viel beschworene Kulturrevolution der letzten zehn Jahre hat insbesondere im Bereich von medialer Informationsvermittlung und den Möglichkeiten der aktiven Meinungsäußerung völlig neue Voraussetzungen geschaffen. Die Entwicklung von – grundsätzlich interaktiv angelegten – Netzmedien (Weblogs, Wikis etc.) hat gleichzeitig mit dem Informationsangebot auch die Komplexität einer immer differenzierteren Medienwelt potenziert. Zugleich haben sich bemerkenswerter Weise auch „alte" analoge Technologien als Instrumente zivilgesellschaftlicher Vernetzung und alternative Medien- und Kulturproduktionsstätten wieder verstärkt durchgesetzt: Community-Radio und -TV erleben erneut einen weltweiten Aufschwung.

In einer veränderten Medienwelt muss aber auch die Diskussion um den öffentlich-rechtlichen Auftrag neu geführt werden, den ein Gros westlicher Demokratien an Rundfunkanstalten vergibt und öffentlich – vor allem aus Gebührengeldern – finanziert: Der EG-Vertrag[1] etwa setzt für die Erteilung eines „öffentlich-rechtlichen" Auftrags eine Tätigkeit voraus, die im Interesse der Allgemeinheit erbracht wird; im Sinn des Amsterdamer Protokolls zum EG-Vertrag können nur solche Aktivitäten Bestandteil des öffentlichen Auftrags sein, die den demokratischen, sozialen und kulturellen Bedürfnissen der Gesellschaft dienen und dazu beitragen, den Pluralismus in den Medien zu wahren.[2]

Der Auftrag, den partizipative, auf einen kommunikativen, nicht ökonomischen Mehrwert ausgerichtete Community-Medien erfüllen, unterscheidet sich strukturell wesentlich vom Auftrag traditioneller öffentlich-rechtlicher Rundfunkanstalten wie dem ORF, der RAI oder der „Mutter aller öffentlich-rechtlichen Anstalten", der BBC: Während ihnen ein expliziter staatlicher Informations-, Bildungs- und Kultur-Auftrag erteilt wird, den wahrzunehmen sie sich in einer zunehmend kommerzialisierten Medienlandschaft immer schwerer tun, erteilen sich Alternativ- und Community-Medien explizite Selbstaufträge im öffentlichen Interesse. Sie sind Medien, die allen zur Artikulation ihrer Meinung offen stehen und die dadurch die aktive Produktion von Meinungen und deren Äußerung in den Vordergrund stellen, nicht lediglich den Konsum von Information. Damit sind sie diejenigen Medien, die durch den Offenen Zugang (Public Access) wesentlich die im Artikel 10 der Europäischen Menschenrechtskonvention verankerte aktive Meinungsäußerungsfreiheit gewährleisten. Der Staat ist nach ständiger Rechtssprechung des Europäischen Gerichtshofs für Menschenrechte (EuGHMR) und des Europäischen Gerichtshofs (EuGH)[3] dazu verpflichtet, die Verwirklichung dieser Freiheit aktiv zu unterstützen.

Aus dieser Perspektive scheint unbestreitbar, dass Community-Medien – wie insbesondere die Freien Radios oder Community-TV, die nach dem Public-Access-Prinzip arbeiten – einen spezifischen öffentlich-rechtlichen Auftrag erfüllen, den kein anderes (Rundfunk-)Medium zu erfüllen imstande ist. Die demokratiepolitische Relevanz und die politisch-partizipative Aktivierung von Menschen durch Public-Access-Medien wird denn auch immer weniger angezweifelt; die Leistungen von Community-Medien für die gesellschaftliche Integration (medial) marginalisierter Gesellschaftsgruppen, für die Promotion lokaler und regionaler Kunst- und Kulturproduktion oder in der regionalen Entwicklung ländlicher Randgebiete scheinen immer unbestrittener. Mediale, interkulturelle und soziale Kompetenzen durch die aktive Medienarbeit und die fast

zwangsläufige Vernetzung mit den verschiedensten Gesellschaftsgruppen können wohl kaum sonstwo in so geballter Form hergestellt werden.

In vielen europäischen Ländern wird diesen Tatsachen sowohl legistisch als auch finanziell Rechnung getragen: Von Irland über Großbritannien, die skandinavischen Länder bis nach Deutschland und Frankreich gehört es zum Standard als entwickelte Demokratie, diese Medien sowohl rechtlich explizit anzuerkennen als auch öffentlich zu fördern. Bezug nehmen die gesetzlichen Regelungen in diesen Ländern u. a. auf eine „Dienstleistung von öffentlichem Interesse", die diese Medien erbringen. Die meisten Staaten Zentral- und Osteuropas – Österreich eingeschlossen – folgen dieser Argumentation eines „öffentlich-rechtlichen Auftrags" allerdings nicht, obwohl nicht wenige Dokumente europäischer Institutionen angesichts zunehmender Medienkonzentration auf die Verantwortung des Staates für die Wahrung bzw. Herstellung von Meinungs- und Medienvielfalt hinweisen und auf die wichtige Rolle von Freien und Community-Medien im Sinn von Vielfalt und Meinungsäußerungsfreiheit Bezug nehmen.

Diese Entwicklungen stellen auch die traditionellen öffentlich-rechtlichen Rundfunkanstalten vor eine neue Situation: Längst sind sie nicht mehr die einzigen Medien, die explizit Public-Service-Funktionen wahrnehmen, ihr Rechtfertigungsdruck für die Finanzierung aus Gebührengeldern steigt, denn diese Legitimation speist sich letztlich immer aus dem Anspruch einer Leistung, die im Interesse des Gemeinwohls erbracht wird. Und diese Leistungen werden in den letzten Jahren in verschiedensten Ländern verstärkt angezweifelt: In Deutschland sah sich die ARD mit dem Vorwurf konfrontiert, durch „Schleichwerbung" illegitimerweise Gelder zu lukrieren; allgemein wird der Qualitätsverlust bei öffentlich-rechtlichen Sendern kritisiert, die sich in Programm- und Formatgestaltung immer mehr ihren kommerziellen KonkurrentInnen angleichen. Dem ORF schließlich wird darüber hinaus vorgeworfen, seine Unabhängigkeit aufgegeben zu haben, rücksichtslosem Parteien- und Regierungseinfluss ausgesetzt zu sein, kaum noch kritischen Journalismus zu-[4] und Kunst und Kultur „in einem Schwarzen Loch verschwinden"[5] zu lassen.

Im Gegensatz etwa zum ORF muss sich die britische öffentlich-rechtliche Rundfunkanstalt BBC alle zehn Jahre einem öffentlichen Konsultationsprozess stellen, um ihre Lizenz zur durch Gebührengelder finanzierten Programmproduktion erneuert zu bekommen. Im März 2006 veröffentlichte die britische Regierung das neueste *BBC White Paper*,[6] das Rolle, Funktion und Struktur der BBC in einer veränderten Medienwelt definieren soll. Ihren Auftrag in einer „digitalen Welt" fasst die BBC selbst in einem 2005 veröffentlichten Papier[7] als *building public value* zusammen, dessen Produktion – oder auch dessen Fehlen – praktisch getestet werden könne: Die BBC produziere

Public Value in fünffacher Weise, nämlich *democratic value, cultural and creative value, educatio-nal value, social and community value* und *global value;* jedes Service der BBC könne mittels eines „Public Value Test" objektiv bewertet werden.[8] Dennoch scheint eine eindeutige Definition von Public Value schwierig, denn im Gegensatz zum Marktwert einer Leistung ist der ideelle Wert, der durch eine Leistung für die Gesellschaft erbracht wird, eine abstrakte Größe, die zunächst mehr Fragen aufwirft als beantwortet.

In einer zunehmend kommerzialisierten Medienwelt der globalen Medienkonzerne, demokratie-gefährdender Medienkonzentration und marktorientierter Des-Information widmet sich der diesjährige Festival-Beitrag von Radio FRO Fragen nach dem „Public Value" von Medien und Medienproduktion: Welche Anforderungen stellen demokratische Gesellschaften heute an Medien? Wie definiert sich „öffentlich-rechtlich" in einer veränderten Medienwelt? Wie erfüllen unterschiedliche Medien Aufgaben im Interesse der Allgemeinheit? Wie weit nehmen traditio-nelle öffentlich-rechtliche Medien ihren Auftrag überhaupt noch wahr? Welche Verpflichtungen hat der Staat hinsichtlich des öffentlich-rechtlichen Auftrags von Community-Medien? Ist ein „öffentlich-rechtlicher Auftrag" auch auf Netzmedien übertragbar? Und: Wie ist Public Value in aktuellen Gesellschaften zu definieren? Was ist der Public Value der Produktionen von verschie-denen Medien? Lässt sich Public Value „messen"?

http://www.fro.at/ars06

Ein Projekt von Radio FRO in Zusammenarbeit mit Ars Electronica.

1 Vgl. Art 86 Abs 2 EG
2 Vgl. Kletter, M.: *Die Finanzierung des ORF mittel Programmentgelten. Eine Betrachtung im Lichte der Novelle des ORF-Gesetzes und der neuesten Entwicklungen im Gemeinschaftsrecht,* MR 2001, 260.
3 Während der Europäische Gerichtshof für Menschenrechte (EuGHMR) eine Einrichtung des Europarates ist, ist der Europäische Gerichtshof (EUGH) ein Organ der Europäischen Union.
4 Vgl. *http.//www.sos-orf.at*
5 Vgl. *http://kulturrat.at*
6 *A public service for all. The BBC in the digital age,* 2006.
 http://www.bbccharterreview.org.uk/have_your_say/white_paper/bbc_whitepaper_march06.pdf
7 *Building public value. Renewing the BBC for a digital world,* 2005.
 http://www.bbc.co.uk/thefuture/pdfs/bbc_bpv.pdf
8 vgl. *A public service for all. The BBC in the digital age,* 2006. S. 30 ff.
 http://www.bbccharterreview.org.uk/have_your_say/white_paper/bbc_whitepaper_march06.pdf

Tsuyoshi Ozawa

Vegetable Weapons

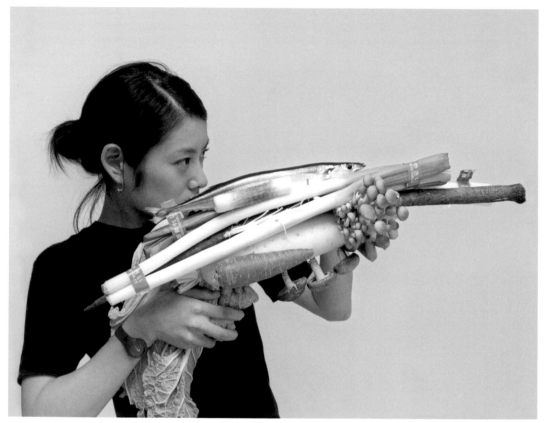

Tsuyoshi Ozawa, *Vegetable Weapon: Saury fish ball hot pot*, Tokyo

Following in the footsteps of Dada and Fluxus artists, Ozawa adapts subcultural visual languages to suggest political and social transformation, and uses humor and interaction to break down stereotypes. In *Museum of Soy Sauce Art*, 1998 – 2000, he used soy sauce as a drawing medium to create parodies of historical Japanese masterpieces. The ongoing work, *Vegetable Weapon*, begun in 2001, presents photographs of people holding foodstuffs arranged in the shape of a gun. Each of these "weapons" is composed using the ingredients of that person's favorite local dish. That a gesture of conflict can become an opportunity for sharing suggests that enmity and friendship sometimes represent two sides of the same coin.
Text: Yukie Kamiya

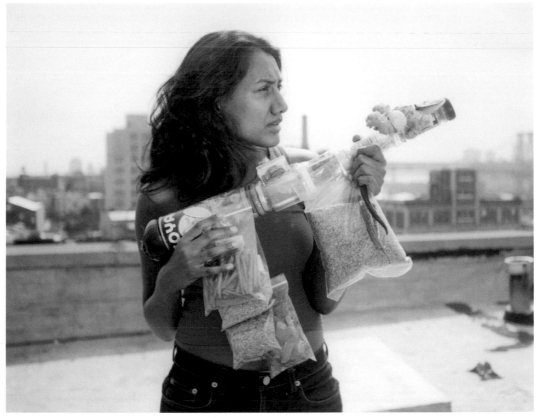

Tsuyoshi Ozawa, *Vegetable Weapon: Parippu (Lentil Curry)*, New York

Inspiriert von Dada- und Fluxus-Künstlern bedient sich Tsuyoshi Ozawa subkulturel-ler visueller Codes, um auf politische und soziale Veränderungen hinzuweisen, wobei er Humor und Interaktion zum Aufbrechen von Stereotypen einsetzt. In seinem Werk *Museum of Soy Sauce Art*, 1998 – 2000, parodierte er mit Sojasauce historische japanische Meisterwerke. Das 2001 begonnene Work-in-progress *Vegetable Weapon* besteht aus Fotografien von Menschen, die in Form einer Waffe arrangierte Lebensmittel in der Hand halten. Jede dieser „Waffen" ist aus den Zutaten der regionalen Lieblingsspeise der fotografierten Person hergestellt. Eine kriegerische Geste wird so zu einer Chance des Teilens und zeigt, dass Feindschaft und Freundschaft manch-mal zwei Seiten der selben Münze sind.

Text: Yukie Kamiya Aus dem Englischen von Wilfried Prantner.

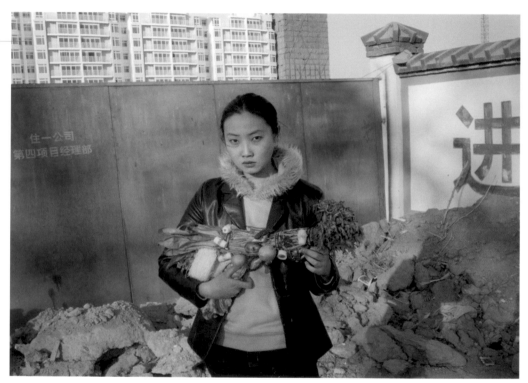

Tsuyoshi Ozawa, *Vegetable Weapon: Mutton hot pot*, Beijing

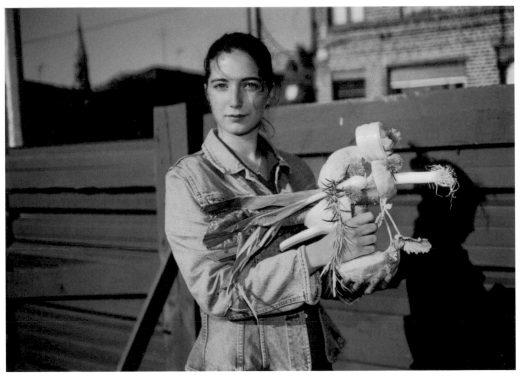

Tsuyoshi Ozawa, *Vegetable Weapon: Waterzoi*, Lille, France

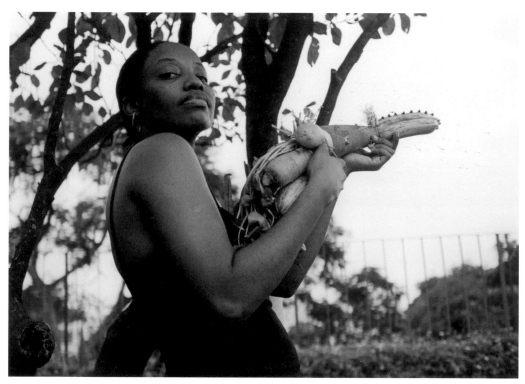

Tsuyoshi Ozawa, *Vegetable Weapon: Vaca atolada*, Rio de Janeiro

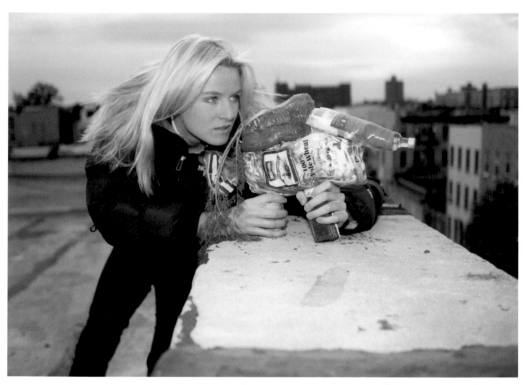

Tsuyoshi Ozawa, *Vegetable Weapon: Graflax (Salmon in salt and herb)*, New York

Going to the Country

An outing to the hinterland in search of simplicity, a one-day excursion designed to get the Festival's activities off the beaten track and onto a path less surfed as a way of seeing things in a productive new light.

▬▬▬▬

The trend towards simplicity is reflected not only in information technology and design; it's also manifested by an ever-more-fervent longing for tranquility amidst the commotion all around us and an often cliché-ridden conception of the simple life. Back to nature, the new spirituality, and buzzwords like "cocooning" and "neo-Biedermeier" are examples of people's efforts to demarcate realms for a retreat inwards. In order to investigate these aspects of simplicity—including the contradictions inherent in them—Ars Electronica will be going on a retreat of its own and moving the Festival for a day to St. Florian, a baroque monastery near Linz. The choice of this location alludes to the Baroque as metaphor of the interplay between simplicity and complexity. This is simplicity as manifestation of "focusing on the essentials," the connotations of which range across a spectrum extending from spirituality to design; at the same time, it is simplicity's implicit effort to recognize the "essence" of things, to establish its place in a grand order, and—as J. S. Bach did in music—to endow it with an algorithmic form. Here, simplicity is one of the two sides of a single coin.

The baroque splendor of the St. Florian Monastery of the Canons Regular of St. Augustine, a center of religiosity and spirituality since the 4th century, will serve as both venue and resource conducive to fruitful experience. This abbey is an amplifier and catalyst of the complex interrelationship between the simple and the simplistic, and the unfolding of what turns out to be their manifold, multidimensional facets. A program tightly scheduled with attractive options means that attendees will constantly be called upon to make decisions about where to concentrate their energies, but also makes it possible to switch back and forth between lineups of activities running parallel. The aim is to split up the interpretational pattern of the theme's juxtaposed conceptual pair in the manner of a kaleidoscope and to keep it in motion—through programmatic linkups, cross-positionings, parallel channelings, diametrical oppositions, concrete and associative references; in the form of musical presentations and performances in which the collegiate church's spectacular organ encounters contemporary electronic sounds; in settings including speeches, workshops, installations, projections and readings, as well as during excursions through the monastery's historical strata and spiritual realms, tours of the organ builder's workshop, and even an introduction to the art of origami.

▬▬▬ Music and Sound

The musical lineup will be dominated by the monastery's grandiose organ, the so-called Bruckner Organ. This monumentally resonant instrument with its 7,386 pipes is both the point of departure of a musical journey and itself an impressive symbol of the Festival theme. This is an instrument that produces sound in a way that is as simple as can be—a current of air is passed over a sharp edge and is thus made to vibrate—and yet its complexity has led it to be crowned the "Queen of Instruments" whose modular mode of construction anticipated that of the modern synthesizer. In collaboration with monastery organist Robert Kovács, two of the leading protagonists of the Spire collective, Mike Harding and Charles Matthews, have put together an itinerary of musical time travel that begins at the roots of organ music (Roberts-

bridge Codex from 1335) and culminates in the digital loops and tonal transformations of Christian Fennez.

In between, there'll be sound installations—for example, Norwegian artist Leif Inge's granular synthesis that extends J. S. Bach's famed *Toccata and Fugue in D minor* to over 200 minutes.

The Marble Hall with its powerfully vibrant acoustics is a most impressive venue in which to see and hear *Scapha*, a sound sculpture by Hilke Fährmann and Jürgen Schneider.

The 14 strings of this 10-meter-long instrument generate tonal strata that come across as just as archaic as they are seemingly orchestral. The way music resonates in the Marble Hall and the length of time it reverberates there mean that each note can consummately unfold.

Viennese digital composer Rupert Huber will also take advantage of the harmonic resonant space of the 15-meter-high Marble Hall for his piano improvisations.

This journey through musical history will then proceed to the monastery basilica's crypt for a sampling of the Gregorian vocal artistry of Wiener Wiener Choralschola under the direction of Robert Kovács.

The minimalism of the Gregorian chant enters into a dialog with the sound poetry that Charles Amirkhanian has selected for the sound installations in the monastery's long ambulatories.

One of the monastery's most fascinating features is its set of chimes, eight bells precisely tuned to the C major scale, which will ring out this Festival day with a composition by Michael Nyman.

Then, it's back to the monastery basilica for the big *Spire* concert (organ & electronics) that will conclude our 10-hour journey through the history of music and sound art.

Sift St. Florian

▬ Theory and Discourse

In accordance with the multifarious aspects of the Festival theme, the discursive program elements are dispersed. Lecture-presentations, round-tables, and demos take place in many instances simultaneously at different locations. You have to make a choice.

■ The Panel Discussions

John Maeda & Friends (Olga Goriunova, Jason Kottke, Burak Arikan)
> How a new generation of designers is dealing with the growing
> complexity of our world.

Wolfgang Blau (journalist), **Oliviero Toscani** (artist) and
Donatella della Ratta (media researcher)
> How pressure exerted by the mass media to simplify messages
> is ruining politics and democracy.

Thomas Macho (cultural theoretician), **Peter Wippermann** (trend spotter/analyst)
and a representative of the canons of St. Augustine
> How the wish for deceleration and simplification is manifesting
> itself in commerce, culture and religion.

Bill Buxton (Microsoft Research), **Bernd Wiemann** (Vodaphone Research),
Marko Ahtisaari (Nokia Design Strategy).
> How software developers, hardware producers and service providers
> are trying to create user-oriented technologies.

■ Lecture Performances

Tmema featuring Erkki Huhtamo
> This lecture performance brings
> together interactive visuals & sound
> performances and media archeology,
> and builds an artistic bridge to the
> speeches by the interface designers.

A Journey into Sound Poetry
> Charles Amirkhanian conducts his audience through more than 50 years of
> artistic work with voice and language as tonal and musical material, and
> presents the works he has selected for the sound installation in the
> monastery's ambulatories.

Inside—Toshio Iwai

One of the most interesting personalities in interactive media art today is Toshio Iwai, a native of Japan and this year's Ars Electronica featured artist. His career path, philosophy and works will be the focus of a two-hour presentation including some demos and a live performance.

SemaSpace—Gerhard Dirmoser

The systems analyst and tireless producer of gargantuan semantic networks dealing with media art themes presents a huge archive installation in the monastery library and elaborates on the analyses and principles of depiction.

■ The Readings

No condensed rundowns, no abstracts, no executive summaries—what you'll get are texts the way they were written, word for word. You can spend the entire day listening in the monastery's impressive baroque library. Texts are by Paul Virilio and St. Augustine. An added highlight: the premiere of John Maeda's new book *The Laws of Simplicity*.

■ The Aesthetics of Complexity

Perusing the collections of minerals, fossils and paintings assembled during the Baroque Period makes it clear to visitors that the age-old human compulsion to put things in order, to order the insights into those things, and to arrive at new insights as a result of this ordering is a strategy of simplicity, a sort of cognitive ergonomics whose aesthetic ideal is to be found in the fields of mathematics and theoretical physics in the concept of symmetry—that the way of the world is most probably the way of theoretical consistency.

It is into this centuries-old setting that we are implanting the media of our age—semantic network visualizations, generative computer graphics and digital worlds of sound. This is a correspondence whose purportedly diametrical oppositions refer to precisely that which they have in common.

Soundpoetry in the monastery's ambulatories, a sound installation by Rupert Huber in the Prelate's Garden, visualizations of digital data and networks by Nomadix, Ben Fry, Lia and others in the Baroque Gallery.

■ Contemplation

Meditation in the quiescence of the crypt and garden conversations with the fratres of the monastery.

■ **Workshops and Exercises**

Origami intro class, Arduino—open hardware, archery, organ-building workshop, as well as tours through the monastery grounds (crypt and vaults, library, Imperial Room, organ, set of chimes).

▬▬ **The Location: The St. Florian Monastery of
The Canons Regular of St. Augustine**

The grave of Florian (who died a martyr in 304) became a place of Christian pilgrimage that gradually developed into an abbey-like settlement. The remains of walls under the collegiate church date back to the 4th century. The first documentary mention of the monastery's existence was in the 8th century, when it was severely damaged by raiding Avars and Magyars. In 1071, Bischop Altmann of Passau reformed monastic life there and restored the church and the other buildings. Provost David Fuhrmann (1667 – 1689) initiated a comprehensive reconstruction of the entire complex. This ambitious project lasted 66 years and was completed in 1751.
The St. Florian Monastery is one of Austria's most impressive works of baroque architecture. It is a consummate, harmonious baroque ensemble in which each successive master-builder left a trace of his own inimitable personal style.

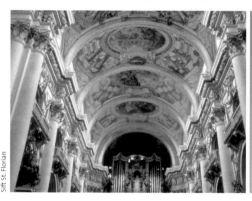

Sift St. Florian

■ **The Monastery Library**

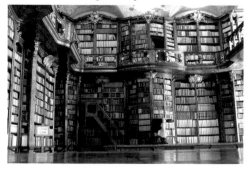

St. Florian's library is one of the oldest and most impressive monastery libraries in Austria. Its holdings total approximately 150,000 volumes, of which 108,000 (60,000 titles) were printed prior to 1900. Of these, 952 titles (1.6%) are incunabula, 35,443 titles (59.2%) stem from the 16th–18th centuries, and 23,493 (39.2%) from the 19th century. The approximately 800 medieval manuscripts are the monastery's most valuable treasures. In 1930, St. Florian acquired the estate

of Viennese orientalist Rudolf Geyer (1861 – 1929). Even twenty years later, Geyer's holdings were still regarded as the greatest collection of Arabic literature between Rome and Berlin. To date, only about a third of Geyer's books have been catalogued.

■ The "Bruckner Organ"

The instrument was constructed by Slovenian organ builder Franz Xaver Krismann (1726 – 1795) under Provost Matthäus Gogl between 1770 and 1774. With 74 registers (including several duplex ranks of pipes) distributed over three keyboards, it was a monumental piece of work in its day. Until 1886, it was the largest organ in the Austro-Hungarian Monarchy. Over the years, it has been structurally altered and enlarged many times.

Sift St. Florian

Following restoration in 1994 – 96 by the Kögler Company, Upper Austrian organ builders, the instrument was upgraded with an electrical power supply for the organ's action and a completely new console with an electronic system of presets (4 x 640 combinations, a floppy-disk-drive memory unit and a device for automatic playback via magnetic tape). Today, the organ is set up with 7,386 pipes divided into seven departments, and has 103 registers.

Sets of Chimes Installed in the Year 2000

A unique feature of the monastery's basilica is its set of chimes acquired at the turn of the millennium. The tones of the heavy-ribbed bells radiate an unexpected sonority and warmth. The chimes include all eight notes of the C major scale. Their precise ringing characteristics and exacting internal harmonies make possible a huge number of combinations.

Program: Gerfried Stocker, Martin Honzik
Spire: Mike Harding, Charles Matthews, Christian Fennesz, Philip Jeck
Stift St. Florian: Prelate Johannes Holzinger, Dean Ferdinand
Reisinger, Father Harald R. Ehrl, Werner Grad, Klaus Sonnleitner, Karl
Rehberger, Gernot Grammer, organist Robert Kovács, Gerald Eichinger

Going to the Country

**Eine Landpartie auf der Suche nach Simplicity, eine Exkursion,
die das Festivalgeschehen für einen Tag vom Weg abbringen und
in andere Umlaufbahnen des Themas lenken soll**

Der Trend zu „Simplicity" spiegelt sich nicht nur in Informationstechnologie und Design, sondern auch in einer immer stärkeren Sehnsucht nach Ruhepolen und einer oft klischeehaften Vorstellung vom einfachen Leben wider. Zurück zur Natur, neue Spiritualität, Schlagwörter wie „Cocooning" oder „neues Biedermeier" sind Beispiele dieser Suche nach Rückzugsräumen. Um diesen Aspekten von Einfachheit – aber auch ihren Widersprüchen – nachzugehen, verlagert Ars Electronica für einen Tag das Festivalgeschehen in das Barockstift St. Florian bei Linz.

Die Wahl des Ortes nimmt Bezug auf das Barock als Metapher für das Wechselverhältnis von Einfachheit und Komplexität. Einfachheit als Ausdruck für die unterschiedlich, von Spiritualität bis zum Design konnotierte „Konzentration auf das Wesentliche" ebenso wie das darin genauso angesprochene Bemühen, das „Wesen" der Dinge zu erkennen, es zu ordnen und ihm – wie J. S. Bach es in der Musik getan hat – algorithmisch Gestalt zu geben. Einfachheit als eine der zwei Seiten einer Medaille.

Das Augustiner Chorherrenstift St. Florian ist in seiner barocken Pracht und als religiös geistliches Zentrum seit dem 4. Jahrhundert Schauplatz und Ressource der Erfahrung. Das Kloster ist Verstärker und Katalysator für die (komplexe) Beziehung zwischen Einfachheit, vermeintlicher Einfalt („simplicare") und der Entfaltung seiner eigentlich vielgestaltigen Aspekte. Ein sehr dichtes Programmangebot fordert ständig nach Entscheidung der eigenen Konzentration, erlaubt aber auch ein freies Wandern zwischen den parallel laufenden Programmsträngen. Ziel ist es, die Bedeutungsmuster des thematischen Gegensatzpaares kaleidoskopisch aufzusplitten und in Bewegung zu halten. Durch programmatische Verknüpfungen, Verweise, Parallelführungen, Gegenüberstellungen, konkrete und assoziative Bezugnahmen – in Form von musikalischen und performativen Ereignissen, in denen die einzigartige Orgel der Stiftskirche auf zeitgenössische Electronic-Sounds trifft; in Form von Vorträgen, Workshops, Installationen, Projektionen, Lesungen, von Exkursionen durch die historischen und spirituellen Ebenen des Stifts und der Orgelbauerwerkstatt bis zur Unterweisung in der Kunst des Origami.

Musik und Klang

Die Musikschiene wird von der grandiosen Stiftsorgel, der „Bruckner-Orgel", dominiert. Das klangmächtige Instrument mit seinen 7386 Pfeifen ist Ausgangspunkt der musikalischen Reise und selbst eindrucksvolles Symbol für das Festivalthema. Ein Instrument, dessen Klangerzeugung auf einfachste Form durch einen an einer scharfen Kante in Schwingung versetzten Luftstrom erfolgt und das in seiner Komplexität zur „Königin der Instrumente" avancierte, das modulare Bauprinzip der moderner Synthesizer vorwegnehmend. In Zusammenarbeit mit dem Stiftsorganisten Robert Kovács haben Mike Harding und Charles Matthews, zwei Schlüsselfiguren des *Spire*-Kollektivs, eine Klangreise entworfen, die an den Wurzeln der Orgelmusik beginnt (Robertsbridge Codex von 1335) und in den digitalen Loops und Klangtransformationen von Christian Fennesz endet.

Dazwischen gibt es Klanginstallationen wie z. B. von Leif Inge aus Norwegen, der mit Granularsynthese J. S. Bachs berühmter *Toccata* und *Fuge in d-Moll* auf über 200 Minuten gestreckt hat.

Der Marmorsaal mit seiner machtvollen Akustik ist auch der Schau- und Hörplatz für *Scapha*, eine Klangskulptur von Hilke Fährmann und Jürgen Schneider. Auf diesem zehn Meter langen Instrument werden durch 14 Saiten ebenso archaisch wie orchestral anmutendend Klangschichtungen erzeugt, die sich in den Resonanzen und Hallzeiten des Marmorsaals entfalten.

Den harmonischen Resonanzraum des 15 Meter hohen Marmorsaals nutzt auch der Wiener Digital-Komponist Rupert Huber für seine Klavierimprovisationen.
Danach führt eine musikalische Zeitreise in die Gruft der Stiftsbasilika und in die gregorianische Vokalkunst der Wiener Choralschola unter Robert Kovács.
Der Minimalismus der gregorianischen Choräle setzt sich in Dialog mit der Soundpoetry, die Charles Amirkhanian für die Klanginstallationen in den langen Wandelgängen des Klosters ausgewählt hat.
Zu den Besonderheiten des Stiftes zählen die Chorglocken, acht exakt in der C-Dur-Tonleiter gestimmte Glocken, die den Abend dieses Festivaltages nach einer Komposition von Michael Nyman einläuten werden, bevor es zurück in die Stiftsbasilika zum großen *Spire*-Konzert (Orgel & Electronic) geht, das die in Summe zehnstundige Musik- und Klangreise abschließt.

Stift St. Florian

▬▬ Theorie und Diskurs

Den verschiedenen Aspekten des Festivalthemas entsprechend, sind die diskursiven Programmteile verteilt. Lecture-Presentations, Gesprächsrunden und Demonstrationen finden zum Teil gleichzeitig in verschiedenen Räumlichkeiten statt. Man muss sich entscheiden.

■ Die Gesprächsrunden

John Maeda & Friends (Olga Goriunova, Jason Kottke, Burak Arikan)
Wie eine neue Designergeneration die wachsende Komplexität
unserer Welt bewältigt.

Wolfgang Blau (Journalist), **Oliviero Toscani** (Künstler) und
Donatella della Ratta (Medienforscherin)
Wie der massenmediale Druck zur Vereinfachung der
Botschaften Politik und Demokratie ruiniert.

Thomas Macho (Kulturtheoretiker), **Peter Wippermann** (Trendforscher) und
ein Vertreter der Augustiner Chorherren
Wie sich der Wunsch nach Entschleunigung und Vereinfachung in Wirtschaft,
Kultur und Religion widerspiegelt.

Bill Buxton (Microsoft Research), **Bernd Wiemann** (Vodaphone Research),
Marko Ahtisaari (Nokia Design Strategy)
Wie Softwareentwickler, Hardwareproduzent und Serviceprovider versuchen,
User-orientierte Technologien zu schaffen.

■ Lecture Performances

Tmema feat. Erkki Huhtamo
In dieser Lecture-Performance
treffen interaktive Visual-Sound-
Performances auf Medienarchäo-
logie und schlagen eine künstleri-
sche Brücke zu den Vorträgen der
Interface-Designer.

A Journey into Sound Poetry
Charles Amirkhanian führt sein Publikum durch mehr als 50 Jahre künstlerischer
Arbeit mit Stimme und Sprache als klangliches und musikalisches Material
und stellt die Werke vor, die er für die Klanginstallation in den Wandelgängen
ausgewählt hat.

Inside – Toshio Iwai

Eine der interessantesten Persönlichkeiten der interaktiven Medienkunst ist der Japaner Toshio Iwai (Featured Artist der diesjährigen Ars Electronica). Sein Werdegang, seine Philosophie und seine Werke stehen im Mittelpunkt seiner zweistündigen Präsentation – Live-Performances inklusive.

SemaSpace – Gerhard Dirmoser

Der Systemanalytiker und rastlose Produzent riesiger semantischer Netzwerke zu Themen der Medienkunst realisiert eine Archivinstallation in der Stiftsbibliothek und erläutert die Analyse und Darstellungsprinzipien seiner Arbeiten.

■ Lesungen

Kein komprimierter Kurzvortrag, kein Abstract oder Executive Summary, sondern der Text, so wie er geschrieben wurde: Wort für Wort. In der eindrucksvollen barocken Stiftsbibliothek können Sie den ganzen Tag zuhören. Texte von Paul Virilio und Augustinus sowie die Premiere des neuen Buches von John Maeda über die Gesetze der Simplicity.

■ Ästhetik der Komplexität

Wandert man durch die in der Barockzeit angelegte Mineralien-, Fossilien- und Gemäldesammlungen, so wird der menschheitsalte Drang, die Dinge und die Erkenntnisse über die Dinge zu ordnen, um durch diese Ordnung zu neuer Erkenntnis zu gelangen, als eine Strategie von Simplicity erfahrbar, als eine Art kognitiver Ergonomie, wie sie in der Mathematik oder theoretischen Physik ihr ästhetisches Ideal im Begriff der Symmetrie hat – die Welt ist am wahrscheinlichsten so, wie ihre Theorie konsistent ist.

In das Jahrhunderte alte Umfeld implantieren wir die Medien unserer Zeit: semantische Netzwerkvisualisierungen, generative Computergrafiken und digitale Klangwelten. Eine Korrespondenz, deren vermeintliche Gegenstücke auf das Gemeinsame verweisen.

Soundpoetry in den Wandelgängen, Klanginstallation von Rupert Huber im Prälatengarten, digitale Daten- und Netzwerkvisualisierungen von Nomadix, Ben Fry, Lia u. a. in der Barockgalerie.

■ Contemplation

Meditation in der Stille der Krypta; Gartengespräche mit den Chorherren des Stifts St. Florian.

■ **Workshops und Übungen**

Origami, Arduino – Open Hardware, Bogenschießen, Orgelbauwerkstätte sowie Führungen durch die Stiftsanlage (Krypta, Gruft, Bibliothek, Kaiserzimmer, Orgel, Chorglocken).

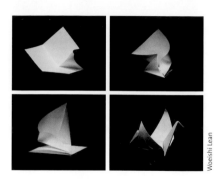

Woeishi Lean

Der Ort, das Augustiner Chorherrenstift Sankt Florian

Sift St. Florian

Über dem Grab des Märtyrers Florian (gestorben 304) entstand aus einer Wallfahrtsstätte allmählich eine klosterähnliche Niederlassung. Die Mauerreste unter der Stiftsbasilika weisen bis ins 4. Jahrhundert zurück. Das im 8. Jahrhundert erstmals schriftlich erwähnte Kloster erlitt bei den Einfällen der Awaren und Ungarn schwere Schäden. 1071 reformierte Bischof Altmann von Passau das Klosterleben und restaurierte Kirche und Klostergebäude. Unter Propst David Fuhrmann (1667 – 1689) kommt es zu einem Neubau des gesamten Stiftes. 1751 findet das ehrgeizige Projekt nach 66-jähriger Bauzeit sein Ende.

Das Stift St. Florian zählt zu den eindrucksvollsten Barockanlagen Österreichs. Es präsentiert sich als in sich geschlossenes, harmonisches Barockensemble, in dem zugleich jeder Baumeister seine ganz persönlichen Akzente setzte.

■ **Die Stiftsbibliothek**

Sift St. Florian

Die Stiftsbibliothek St. Florian zählt zu den ältesten und eindrucksvollsten Klosterbibliotheken Österreichs. Bei einem Gesamtbestand von etwa 150.000 Bänden besitzt die Stiftsbibliothek St. Florian 108.000 Bände (60.000 Titel) aus der Zeit vor 1900. Davon sind 952 Titel (1,6 Prozent) Inkunabeln, 35.443 Titel (59,2 Prozent) entfallen auf das 16. bis 18. Jahrhundert und 23.493 (39,2 Prozent) auf das 19. Jahrhundert. Den wertvollsten Schatz stellen die rund 800 mittelalterlichen Handschriften dar. 1930 erwarb die Stiftsbibliothek den Nachlass des Wiener Orientalisten Rudolf Geyer (1861 – 1929). Diese Büchersammlung galt noch 20 Jahre später als größte Sammlung arabischer Literatur zwischen Rom und Berlin. Etwa ein Drittel der Bücher Geyers ist bislang katalogisiert.

■ **Die Bruckner-Orgel**

Das Instrument wurde von dem slowenischen Orgelbauer Franz Xaver Krismann (1726 – 1795) unter Propst Matthäus Gogl zwischen 1770 und 1774 erbaut; mit 74 Stimmen (teilweise mehrfach besetzte Züge), verteilt auf drei Manuale, entstand ein für die damalige Zeit monumentales Werk. Bis 1886 war sie die größte Orgel der Donaumonarchie. Im Lauf der Jahrhunderte wurde die Orgel oftmals umgebaut und erweitert.

Sift St. Florian

Nach den Restaurierungsarbeiten der OÖ. Orgelbauanstalt Kögler/1994 – 1996) erhielt das Instrument eine elektrische Traktur und einen komplett neuen Spieltisch mit elektronischer Setzeranlage (4 x 640 Kombinationen, Diskettenspeicherwerk und automatische Abspielanlage per Magnetband). Die heutige Orgel besitzt 7386 Pfeifen, die sich auf Positiv, Hauptwerk, Oberwerk, Labialwerk (schwellbar), Trompetenwerk, Regalwerk und Pedalwerk verteilen, die Registerzahl beläuft sich auf 103.

■ **Das Chor- bzw. Zimbelgeläute aus dem Jahr 2000**

Eine Besonderheit der Stiftsbasilika ist das Chorgeläute aus dem Jahr 2000. Die schwerrippigen Glocken erklingen in unerwarteter Klangfülle und Wärme. Die Zimbeln umfassen alle acht Töne der C-Dur-Tonleiter. Durch die präzise Schlagtonlinie und die genauen Innenharmonien sind eine Unzahl von Kombinationen möglich.

Programm: Gerfried Stocker, Martin Honzik
Spire: Mike Harding, Charles Matthews, Christian Fennesz, Philip Jeck
Stift St. Florian: Prälat Johannes Holzinger, Stiftsdechant Ferdinand Reisinger, Stiftspfarrer Harald R. Ehrl, Werner Grad, Klaus Sonnleitner, Karl Rehberger, Gernot Grammer, Gerald Eichinger, Stiftsorganist Robert Kovács

From John Maeda, *The Laws of Simplicity*, Cambridge, MA: The MIT Press 2006

Paola Antonelli

John Maeda's Fundamental Idea

The most important part of Maeda's production, and the one he is most proud of, is nonetheless not the final object, but rather the process. In his work, the process is the core that informs the final outcome. Maeda's fundamental idea is that to successfully design with a computer, one has to design, or at least understand the program one uses.

By stressing the necessity to know in depth the tools of the trade, Maeda also responds to one of the major criticisms advanced by the detractors of the computer, the lack of self-discipline that the computing machine allows. Even though it is true that, in general appreciation, the new fields of design action, like computer-based graphic design ten years ago and websites or wearable computing today, seem to attract many amateurs and to provoke in designers a short circuit that erases the school memory of a correct design process, it is also true that it always takes time. Graphic design is undergoing today a post-industrial revolution similar to the industrial revolution that shook object design more than a century ago.

Maeda tries to bring designers and amateurs alike to a level of knowledge of one particular design process that paradoxically has almost Arts-and-Crafts feeling. He teaches people an approach to computer graphic design that is not different from an approach to wood-carving. The more the awareness of the new tools will be disseminated, the more designers will learn to incorporate them in their practice without being unsettled by them.

Der wichtigste Part in Maedas Produktionen – auf den er auch am meisten stolz ist – ist nicht das endgültige Objekt, sondern der Prozess. Im Zentrum von Maedas Schaffen liegt der Prozess, der letztendlich das Ergebnis bestimmt. Um mit dem Computer erfolgreich gestalterisch arbeiten zu können, meint er, müsse man das eingesetzte Programm selbst entwickeln oder zumindest verstehen.

Mit seinem Beharren auf einer profunden Kenntnis des Werkzeugs entkräftet Maeda einen Hauptkritikpunkt der Computerverdammer, dass nämlich die Rechenmaschine die Selbstdisziplin ausschalte. Zwar stimmt es, dass, ähnlich wie vor zehn Jahren im computergestützten Grafikdesign oder wie heute in den Bereichen Websites oder Wearable Computing, das neue Designumfeld viele Amateure anlockt und bei Designern einen Kurzschluss auszulösen scheint, der die gesamte Erinnerung an einen sauberen Designprozess löscht, wahr ist aber auch, dass dem nur anfangs so ist. Das Grafikdesign befindet sich heute in einer postindustriellen Revolution, so wie vor mehr als einem Jahrhundert das Objektdesign durch die industrielle Revolution aus dem Gleichgewicht geworfen wurde.

Maeda möchte Designern und Amateuren einen ganz bestimmten Designprozess nahebringen, der sich paradoxerweise, fast handwerklich ausnimmt. Sein Lehransatz für das Computergrafikdesign unterscheidet sich in nichts von einem Holzschnitzkurs. Je verbreiteter das Wissen um die neuen Werkzeuge, desto mehr Designer werden sie in ihre Praxis einbinden können, ohne durch sie aus der Bahn geworfen zu werden.

Aus dem Englischen von Michael Kaufmann

Golan Levin

Some Thoughts Regarding John Maeda

john maeda is a professor at the mit media lab
john maeda is distressed at the state of the design arts
john maeda is frequently credited with pioneering a revolution in computer arts
john maeda is the son of a japanese tofu maker
john maeda is an anomaly

Googlism.com[1]

Before I started my studies with John Maeda at MIT, about nine years ago, I pestered a mutual acquaintance to tell me more about the man who would become my graduate advisor and mentor. His enigmatic reply was that Maeda was a hybrid of the last living Samurai and the last living exponent of the Bauhaus. Certainly, the influence of the Bauhaus tradition on Maeda's thinking seemed plausible enough, given his careful attention to the formal properties of design materials (in his case, software), his principled yet intuitive consideration of aesthetics and utility, and his profound commitment to education. The connection between Maeda's work and Samurai ethics, if indeed there was one, took me much longer to perceive. It seemed incongruous that there could be a kinship between the quiet artistic practice of my charming and pacifist advisor, and the ruthless warrior philosophy I knew (only) from the movies of Akira Kurosawa and Hiroshi Inagaki. The connection became clear to me much later when I happened to read *Hagakure*, the Edo-era behavior code of the Samurai class, which stressed a particular combination of honor, courage, loyalty, and moral character as necessary precursors to the perfection of an artistic practice. Although the *Hagakure* was compiled nearly three centuries ago, and Maeda had not read it (I asked him once), the book nevertheless predicted, in rather uncanny detail, the precise character of discipline I learned from him. It also seemed to foreshadow and explain Maeda's abiding preoccupation with the topic of Simplicity. A representative passage from the *Hagakure* illustrates both ideas:

> How should a person respond when he is asked, "As a human being, what is essential in terms of purpose and discipline?" First, let us say, "It is to attain a mind that is pure and lacking complications." When one has a pure and uncomplicated mind, his expression will be lively. When one is attending to matters, there will then be just one thing that comes forth from his heart. That will be, in terms of one's master, loyalty; in terms of one's parents, filial duty; in martial affairs, bravery; and apart from that, something that can be used by all the world.[2]

The *Hagakure* describes an interrelationship between simplicity and discipline which, I believe, Maeda comprehends with a singular intuition. As we know from this year's conference, since 2004 Maeda has applied himself to the ambitious project of identifying the "Laws of Simplicity." Does it seem surprising that something as elusive as simplicity might obey law-like principles, or that it should take years to discover them? In nature—which Maeda has been observing a great deal recently—simplicity and discipline are both manifest in a core law of energy minimization, in which maximal efficiency is achieved with the least material and effort.[3] Inasmuch as structure in nature is a strategy for design,[4] Maeda posits analogous principles for the creation of artifacts and experiences—encouraging artists and designers, as for example in his Eleventh Law of Simplicity, to *subtract the obvious, while adding the meaningful.*[5] If the laws of simplicity can indeed be divined, it will surely take great discipline to apply them well.

In addition to its discussion of discipline and simplicity, the *Hagakure* also devotes considerable space to discussing the logic and appropriate circumstances for ritual suicide. According to the Samurai code, this path should be chosen in preference to a dishonorable death at the hands of an enemy. As extreme as this might sound, this concern is no less true for Maeda, whose declared enemies are stagnation and complacency. Indeed, twice in the time that I have known him, Maeda has—in his own words—deliberately "killed himself" to avert the possibility of self-repetition. The first time was the publication of his exhaustive career retrospective (at age 35), *Maeda@Media*, which he made "with the intention of terminating a line of thinking that I once had"; the second time was when he closed down his still-thriving research team, the Aesthetics and Computation Group, despite its successful and indisputably productive eight-year run. Both of these occasions have demanded almost Madonna-like skills in professional re-invention. In his most recent reincarnations, Maeda has shifted his focus to new aesthetic and pedagogic questions, through projects such as his Simplicity industrial consortium, his ongoing study of business administration, and his new research group at MIT, the Physical Language Workshop.

In light of Maeda's determination to reinvent himself, it might seem that his new *Nature* series of digital works, on display this year at the Ars Electronica Festival, represent an unexpected return to his previous interests in dynamic computational form, which he began investigating in the early 1990s. I think Maeda provides an answer to this puzzle in one of his recent blog entries, which he wrote after observing one of his own mentors, the great designer Wolfgang Weingart:

> I was visiting Weingart in Maine to give a lecture for his then regular summer course. I marveled at Weingart's ability to give the exact same introductory lecture each year. I thought to myself, "Doesn't he get bored?" Saying the same thing over and over has no value in my mind. Yet it was on maybe the third visit that I realized that although Weingart was saying the exact same thing, he was saying it simpler each time he said it.[6]

Maeda's new "motion paintings" (a formulation which he has earned the right to borrow from Oskar Fischinger) return for their inspiration to the artist's greatest and oldest master, Nature. These works restate themes which Maeda has studied before—but, like Weingart's lecture, with greater simplicity. Similar to the work of the Abstract Expressionists, these works "assert flux and indefiniteness of identity as qualities that can be found in the world," shaping energy, in the words of Thomas McEvilley, to model the real.[7] Maeda's magic is to present a glimpse of reality wherein the fundamentally brittle and impersonal logic of computation seems to bend, not merely naturally, but *inevitably* to accommodate the breeze of a highly idiosyncratic intuition. In so doing, his works embody traits that transcend any particular philosophy—Bauhaus, Samurai, or otherwise: humility, candor, grace, and a sense of humor.

1 *Googlism.com* scrapes Google for brief summaries on any topic of interest.
2 Tsunetomo, Yamamoto. *Hagakure: The Book of the Samurai*. Chapter 1.
3 As discussed by, notably, D'Arcy Thompson in *On Growth and Form* and Cyril Stanley Smith in *Search for Structure*.
4 The title of a related book by Peter Jon Pearce.
5 *http://weblogs.media.mit.edu/SIMPLICITY/archives/000296.html#law*
6 *http://weblogs.media.mit.edu/SIMPLICITY/archives/000216.html#law*
7 McEvilley, Thomas. "Thirteen Ways of Looking at a Blackbird", in *Art & Discontent: Theory at the Millennium*, 1993.

Golan Levin

Einige Gedanken zu John Maeda

━━━━━━

john maeda ist künstler und computerwissenschaftler
john maeda ist professor des mit media lab
john maeda ist beunruhigt über den zustand der designkunst
john maeda wird oft als pionier der revolutionären computerkunst gesehen
john maeda ist der sohn eines japanischen tofu-herstellers
john maeda ist eine anomalie

Googlism.com[1]

Bevor ich vor rund neun Jahren mein Studium bei John Maeda am MIT aufnahm, drängte ich einen gemeinsamen Bekannten, mir mehr über den Mann zu erzählen, der meine Abschlussarbeit betreuen und mein Mentor werden sollte. Ich erhielt die kryptische Antwort, Maeda sei ein Hybrid aus dem letzten lebenden Samurai und dem letzten lebenden Vertreter der Bauhaus-Bewegung. Gewiss erschien es angesichts der behutsamen Aufmerksamkeit, mit der Maeda den formalen Eigenschaften von Designmaterialien (in diesem Fall Software) begegnete, seiner prinzipientreuen, doch intuitiven Berücksichtigung von Ästhetik und Nützlichkeit sowie seines profunden Engagements für Bildung plausibel genug, dass seine Denkweise von der Bauhaus-Tradition beeinflusst wäre. Um den Zusammenhang zwischen seiner Arbeit und der Ethik der Samurai – so vorhanden – zu erkennen, brauchte ich viel länger. Es schien mir abwegig, dass zwischen der stillen künstlerischen Praxis meines charmanten, friedfertigen Betreuers und der unbarmherzigen Kriegerphilosophie ein Konnex bestand. Dieser offenbarte sich mir erst viel später, nachdem ich das *Hagakure* gelesen hatte, den Verhaltenskodex der Samurai aus der Edo-Ära, der die Kombination von Ehre, Mut, Loyalität und moralischem Charakter als unabdingbare Voraussetzung für eine perfekte künstlerische Praxis ansieht. Obwohl das *Hagakure* vor dreihundert Jahren verfasst wurde und Maeda selbst es gar nicht gelesen hat, fand sich darin mit geradezu unheimlicher Genauigkeit der präzise Charakter jener Disziplin beschrieben, die Maeda mich lehrte.

> Wie beantwortet man die Frage „Wie viel Zweck und Disziplin braucht der Mensch?" Sagen wir zuerst: „Sein Geist soll einen Zustand erreichen, der rein und frei von Komplikationen ist." Hat er diesen Zustand erreicht, so wird sein Ausdruck lebhaft sein. In seinem Umgang mit den Dingen wird dann alles von Herzen kommen. Gegenüber seinem Meister wird er Loyalität zeigen, gegenüber den Eltern Sohnespflicht, in kriegerischen Angelegenheiten Mut, und ganz allgemein wird er in seinem Tun der ganzen Welt Nutzen bringen.[2]

Das *Hagakure* beschreibt die Verflechtungen zwischen Einfachheit und Disziplin, die Maeda meiner Ansicht nach mit beispielhafter Intuition begriffen hat. Maeda widmet sich seit 2004 dem ehrgeizigen Projekt, die *Gesetze der Einfachheit* zu entschlüsseln. Überrascht es uns, dass etwas so Flüchtiges wie Einfachheit gesetzesähnlichen Prinzipien unterliegt bzw. dass diese Prinzipien jahrelang unentdeckt bleiben konnten? In der Natur – deren Beobachtung sich Maeda in letzter Zeit mit großer Aufmerksamkeit widmet – manifestieren sich Einfachheit und Disziplin in einem der Grundgesetze der Energieminimierung, dem zufolge mit dem geringsten Materialaufwand und Einsatz maximale Effizienz zu erzielen ist.[3] In Anlehnung daran, dass die Strukturiertheit der Natur als Designstrategie gesehen werden kann,[4] stellt Maeda analoge Prinzipien zur Schaffung von Artefakten und zur Gestaltung von Erfahrungen auf – etwa in seinem 11. Gesetz der Einfachheit, das vorschreibt, man möge *das Offensichtliche subtrahieren und zugleich das Sinnvolle addie-*

ren.[5] Sollte man die Gesetze der Einfachheit tatsächlich intuitiv erfasst werden können, so wird ihre korrekte Anwendung gewiss große Disziplin erfordern.

Abgesehen von der Abhandlung über Disziplin und Einfachheit befasst sich das *Hagakure* eingehend mit den logischen und angemessenen Umständen für rituellen Selbstmord. Nach dem Ehrenkodex der Samurai ist dieser Weg einem unehrenhaften Tod durch Feindeshand vorzuziehen. So extrem dies auch klingen mag, gilt dieser Ansatz auch für Maeda, zu dessen erklärten Feinden Stagnation und Selbstgefälligkeit zählen. Um der Schmach, sich selbst zu wiederholen, zu entgehen, hat Maeda sich allein in der Zeit unserer Bekanntschaft zweimal absichtlich „umgebracht", um es mit seinen eigenen Worten auszudrücken. Das erste Mal geschah dies durch die Veröffentlichung seines umfassenden Karriererückblicks *Maeda@Media,* den er im Alter von 35 Jahren „mit der Absicht, die Denkweise abzuschließen, der ich einst anhing" verfasste. Das zweite Mal durch die Auflösung der *Aesthetics and Computation Group,* seines bereits acht Jahre erfolgreich bestehenden und nach wie vor florierenden Forschungsteams. Beide Fälle erforderten die an Madonna gemahnende Gabe, sich beruflich neu zu erfinden. In seinen jüngsten Reinkarnationen konzentriert sich Maeda auf neue ästhetische und pädagogische Fragen und geht diesen im Rahmen von Projekten wie dem Simplicity-Industriekonsortium, dem Studium der Betriebswirtschaft und seiner neuen Forschungsgruppe Physical Language Workshop am MIT nach.

Angesichts seiner Entschlossenheit, sich fortwährend selbst neu zu erfinden, mag man den Eindruck gewinnen, seine neue Serie digitaler Arbeiten, die dieses Jahr unter dem Titel *Nature* beim Ars Electronica Festival gezeigt wird, sei eine unerwartete Rückkehr zu seinem früheren Interesse an der dynamischen, rechnerischen Form, das zu Beginn der Neunzigerjahren den Ausgangspunkt seiner Arbeiten bildete. Meiner Ansicht nach nimmt Maeda in einem seiner jüngsten Blogeinträge dazu Stellung. Der Eintrag gibt seine Beobachtung des großen Designers Wolfgang Weingart, eines seiner Mentoren, wieder:

> Ich besuchte Weingart in Maine, um in seinem damals regelmäßigen stattfindenden Sommerkurs eine Vorlesung zu halten. Ich wunderte mich, dass Weingart es schaffte, jedes Jahr genau dieselbe Eröffnungsvorlesung zu halten. Ich fragte mich: „Wird ihm das nicht langweilig?" Immer wieder dasselbe zu sagen, hat meiner Meinung nach keinen Wert. Doch erst bei meinem dritten Besuch erkannte ich, dass Weingart zwar immer genau dasselbe sagte, jedoch von Mal zu Mal mit einfacheren Worten.[6]

Maedas aktuelle *Motion Paintings* (eine Bezeichnung, die er zu Recht von Oskar Fischinger entlehnt hat) holen sich ihre Inspiration vom ältesten und großartigsten Meister des Künstlers: der Natur. Die Arbeiten greifen Themen auf, mit denen Maeda sich bereits früher befasst hat – allerdings sind sie (wie Weingarts Vorlesung) viel einfacher geworden. Ähnlich den Arbeiten der Abstrakten Expressionisten „machen diese Werke das Fließen und die Unbestimmtheit der Identität als Qualitäten fest, die in der Welt zu finden sind" und verleihen – in den Worten von Thomas McEvilley[7] – der zur Modellierung des Realen erforderlichen Energie Gestalt. Maedas Magie gibt einen Blick auf eine Realität frei, in der die grundsätzlich spröde, unpersönliche Berechnungslogik nicht nur auf natürliche, sondern auf *unausweichliche* Weise so gebeugt zu werden scheint, dass sie Platz für den Hauch einer höchst idiosynkratischen Intuition bietet. Und bei all dem weisen seine Arbeiten Wesenszüge auf, die über jegliche individuelle Philosophie – Bauhaus, Samurai, etc. – hinausgehen: Demut, Offenheit, Anmut und Sinn für Humor.

<div align="right">Aus dem Englischen von Susanne Steinacher</div>

Fußnoten siehe Seite 119

John Maeda

Nature

The *Nature* series consists of a series of seven "motion paintings", representing abstract forms evocative of those found in nature. Between three to six minutes in length, each motion painting is made up of several short sequences depicting intensely colored abstract shapes and patterns that constantly move, expand and evolve. Culling his metaphors from nature—trees, sky, grass, moon, fire, wind, rain, snow—John Maeda offers us a glimpse of digital space in the spirit of landscape painting.

Projected onto translucent suspended screens, these digital landscapes are generated by a new software technology that the artist created in order to "paint in space and time." Inspired by the dynamic spirit of Abstract Expressionism, the artist designed this technology so that he could "paint" animated images on the computer in a simple gestural manner. Following a long line of abstract painters such as Paul Klee, Mark Rothko and Barnett Newman, John Maeda employs subtle changes of form, color and pattern to create works that are both visually stunning and profound. Through the hypnotic beauty and sensuality of these images, the artist aspires to bring us closer to the computer and lead us to a deeper understanding of its inner nature.

Der Zyklus *Nature* umfasst eine Serie von sieben „bewegten Gemälden", die, angelehnt an die Natur, abstrakte Formen darstellen. Jedes dieser bewegten Gemälde zeigt mehrere, insgesamt drei bis sechs Minuten lange Sequenzen von abstrakten Figuren und Mustern mit kräftigen Farben, die ständig wandern, größer werden und sich entwickeln. Mit seinen Metaphern aus der Natur – Bäume, Himmel, Gras, Mond, Feuer, Wind, Regen, Schnee – eröffnet uns John Maeda einen Blick auf den digitalen Raum in der Tradition der Landschaftsmalerei.

Die auf frei hängenden, durchscheinenden Projektionswänden gezeigten digitalen Landschaften werden mittels einer neuartigen Softwaretechnologie erzeugt, die der Künstler entwickelt hat, um „in Raum und Zeit malen" zu können. Beeinflusst von der Dynamik des Abstrakten Expressionismus erlaubt diese Technologie dem Künstler, die animierten Bilder am Computer gestisch zu „malen". In der Nachfolge abstrakter Maler wie Paul Klee, Mark Rothko oder Barnett Newman setzt John Maeda auf subtile Wechsel in Form, Farbe und Muster, um sowohl visuell bestechende als auch tiefgründige Werke zu schaffen. Der Künstler möchte uns durch die hypnotische Schönheit und die Sinnlichkeit dieser Bilder den Computer näher bringen und ein besseres Verständnis für dessen Innenleben vermitteln.

Aus dem Englischen von Michael Kaufmann

John Maeda, *Nature*—a series of seven "motion paintings"

John Maeda

John Maeda, *Nature*—a series of seven "motion paintings"

John Maeda, *Nature*—a series of seven "motion paintings"

John Maeda

John Maeda, *Nature*—a series of seven "motion paintings"

John Maeda, *Nature*—a series of seven "motion paintings"

John Maeda

John Maeda, *Nature*—a series of seven "motion paintings"

John Maeda, *Nature*—a series of seven "motion paintings"

Toshio Iwai

Beyond Media, Connecting Senses

This age is full of moving images, but why do we, myself included, find simple things such as flipbooks and phenakisti-scopes fascinating? This was the first question that interested me in interactive media. I find these things fascinating probably because they expose the mechanism of our physical body. Flipping a flipbook by consciously moving your fingers confirms each function of your body. And this is a totally different experience to feeling something unconsciously and passively. Think of your eyes. Just seeing something, or actually looking at something should produce different emotions, if you understand the mechanism itself. To manipulate something by actually putting your hand on it and to actually look at something real, something that is not a created image, is very important. Looking at something real has nothing to do with frame rates and resolutions. When you look at something, the more you look, the more you can see and the more the resolution improves. Similarly, it is also possible to break down time into microseconds or into smaller units. We understand this naturally through our body. After all, I believe that watching a created image is a totally different experience to seeing something real, something that actually moves.

Since the invention of time movies and videos, the aspect ratio of frames and the number of frames per second have become common property for creators. And these formats have never been thought over. Everyone just accepts these formats and creates their work within these formats. But if you stop and think about it, these formats were imposed by people who have nothing to do with the work of the creators. These formats have been set as the standard for commercial reasons, and to facilitate things. If everybody had to draw pictures in a frame of the same size, wouldn't that be very restrictive? It is the great diversity that fascinates—and not just in paintings and sculptures. That is why it is important to break away from standards and consider what you really want to create, and what you really want to see. By doing my bit in creating things that do not correspond to the existing format of image devices, I express my doubts. And at the same time, I wish to see things from beyond existing standards.

I want to see images not as a world apart, but as part of our environment. I probably have developed this perspective from flipbooks as well. Flipbooks are much more enjoyable when you flip the pages yourself, in your own hands, rather than just watching someone else flip the pages for you. When I saw animation films that I had made on a projector, I felt like the machine was doing everything for me. I worked on the animation for days, drawing and shooting each frame, but it seemed distant to me. I felt like something was missing. On the other hand, flipbooks are close to me. I feel like I am always in the same position as the piece of work I create. This feeling is what led me to the ideas of my later pieces of interactive work.

My ultimate goal is to be honest to my own body. I want to see and experience with all of my senses something that I have never seen or experienced before. And to create such a thing is a challenge to me. I find things that stimulate my senses, which I normally do not use, interesting without the need for reasons. I want to make something that will push those buttons of one's senses that have never been pushed before. I have many buttons that I am not aware of, and I

Toshio Iwai, *XY Plotter Flipbook*, 1983

am looking for these and am pushing them, one by one, as I make new creations. What I want to achieve is to find out what kind of fascinating things I can do using all the senses of my own body. Every time I naturally sense that something is interesting, I try to connect each of these senses. I try to connect my visual senses with my auditory senses. I also want to connect these to the movement of my body and hands.

I have also always felt that the world we see and hear is only a part of a thin layer of the universe. There are high and low frequencies that cannot be heard by the human ear. Also for the eyes, there is only a certain range of lights that we can see. As you know, infrared and ultra violet rays are not visible. But there are other animals that can see these rays. If aliens existed, they might see the world in a very different way. When you think of height, humans cannot live in deep water. Where we live is in an extremely thin layer of air. In the same way, if you consider the world we see and hear from a cosmic point of view, you will realize that the range of stimuli we receive and perceive is very narrow. I wonder what it would be like if I could see and hear every sound that comes through a mobile phone or every electric wave received by a television and radio.

Finding beauty in things that exist in nature, or transmitting the fascinating aspects and beauty of something through pieces of work is what artists have always been doing. I follow this same path, although the media I use is different. In the 20th century, everyone was interested in expressing things visually or through sound. I would like to go beyond this, and create pieces of work that will stimulate all of the senses through various elements.

Toshio Iwai

Alle Sinne stimulieren

Unsere Zeit strotzt vor Laufbildern. Warum aber finden wir dann so einfache Dinge wie Daumenkinos und Phenakistikope so faszinierend? Diese Frage war das Erste, was mich an interaktiven Medien interessierte. Vermutlich faszinieren mich diese Dinge deshalb, weil sie einem die Mechanismen des Körpers vor Augen führen. Beim Durchblättern eines Daumenkinos unter bewusster Verwendung der Finger erfährt jede Körperfunktion ihre Bestätigung. Das ist ein vollkommen anderes Erlebnis, als wenn man etwas unbewusst und passiv wahrnimmt. Nehmen wir die Augen. Wenn man etwas nur sieht, sind damit andere Gefühle verbunden, als wenn man es betrachtet und versteht, wie der Mechanismus funktioniert. Dinge mit eigenen Händen zu manipulieren und bewusst etwas Wirkliches – kein künstliches Bild – zu betrachten, ist ungeheuer wichtig. Etwas Wirkliches zu betrachten hat nichts mit Bildfrequenz oder Bildauflösung zu tun. Je länger man es betrachtet, umso mehr sieht man und umso besser wird die Auflösung. Ähnlich lässt sich auch die Zeit in Mikrosekunden oder noch kleinere Einheiten zerlegen. Wir begreifen das ganz natürlich mit unserem Körper. Und deshalb glaube ich, dass es etwas ganz anderes ist, ein künstliches Bild zu betrachten, als etwas Wirkliches, das sich tatsächlich bewegt. Bildfrequenz und Bildformat sind seit der Erfindung von Film und Video zu einem Allgemeingut geworden, das niemand hinterfrägt und an das sich jeder hält. Denkt man aber einmal darüber nach, so wird schnell klar, dass diese Formate von Leuten festgelegt wurden, die nichts mit der Arbeit der Kreativen zu tun haben. Die Gründe für diese Standardformate sind vielmehr kommerzieller und praktischer Natur. Mal ehrlich, empfände man es nicht als überaus restriktiv, wenn sich beim Zeichnen und Malen alle an dasselbe Bildformat halten müssten? Das Faszinierende an Gemälden und Skulpturen ist ihre ungeheure Vielfalt. Darum ist es so wichtig, die Standards zu durchbrechen und sich genau zu überlegen, was man wirklich machen und sehen möchte. Mit meinem kleinen Beitrag zur Schaffung von Arbeiten, die nicht den gängigen Formaten der Bildapparaturen entsprechen, bringe ich meine Zweifel und den Wunsch zum Ausdruck, die Dinge von einem Standpunkt jenseits der existierenden Standards zu betrachten.

Ich will Bilder nicht als eine Welt für sich, sondern als Teil unserer Umwelt sehen. Vielleicht habe ich diese Einstellung auch aufgrund von Daumenkinos gewonnen. Sie machen viel mehr Freude, wenn man die Seiten eigenhändig durchblättert, als wenn man nur zuschaut, wie es jemand anderer tut. Wurde einer meiner Animationsfilme vorgeführt, so hatte ich das Gefühl, dass der Projektor alles für mich machte. Obwohl ich an den Filmen tagelang gearbeitet, jeden Kader einzeln gezeichnet und fotografiert hatte, erschienen sie mir fern. Irgendetwas fehlte. Daumenkinos hingegen sind mir nah. Ich habe das Gefühl, immer am selben Ort zu sein wie die Sache, an der ich arbeite. Dieses Gefühl brachte mich auf die Ideen für meine späteren interaktiven Arbeiten.

Mein Ziel ist es letztlich, ehrlich zu meinem Körper zu sein. Ich möchte mit allen meinen Sinnen etwas wahrnehmen und erfahren, das ich noch nie wahrgenommen und erfahren habe. Und es ist eine Herausforderung für mich, so etwas zu schaffen. Dinge, die Sinne stimulieren, die ich normalerweise nicht verwende, finde ich auch ohne jeden Grund interessant. Ich versuche, etwas zu machen, das die Schalter von Sinnen betätigt, die noch nie betätigt wurden. Ich besitze viele sol-

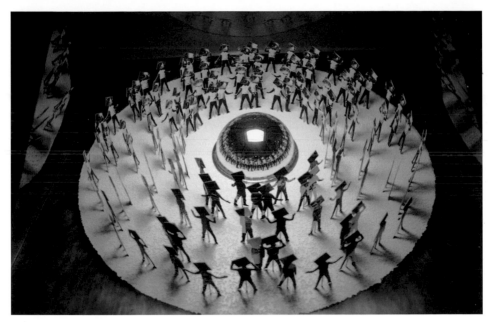

Toshio Iwai, *Time Stratum II*, 1985

cher Schalter, derer ich mir gar nicht bewusst bin, und wenn ich an etwas Neuem arbeite, suche ich nach ihnen und lege sie nach und nach um. Ich versuche herauszufinden, was für faszinierende Dinge ich machen kann, wenn ich alle Sinne meines Körpers benutze. Immer wenn ich etwas intuitiv interessant finde, versuche ich jeden dieser Sinne anzusprechen. Ich versuche, meinen Sehsinn mit meinem Hörsinn zu verbinden, und diese wiederum mit den Bewegungen meines Körpers und meiner Hände.

Auch ist mir die sicht- und hörbare Welt immer nur als ein Stück einer dünnen Schicht des Universums erschienen. Es gibt hohe und tiefe Frequenzen, die für das menschliche Ohr unhörbar sind. Und auch das Auge kann nur ein begrenztes Lichtspektrum wahrnehmen. Im Gegensatz zu anderen Tierarten sehen wir bekanntlich keine Infrarot- und Ultraviolettstrahlen. Außerirdische, wenn es sie gibt, sehen die Welt vermutlich auf andere Weise. Menschen können auch nicht im Wasser leben. Unser Lebensraum ist eine überaus dünne Luftschicht. Von einem kosmischen Standpunkt aus betrachtet, besteht die Welt, die wir wahrzunehmen vermögen, aus einer sehr begrenzten Palette an Reizen. Ich frage mich, wie es wohl wäre, wenn wir jeden bei einem Handy ankommenden Ton und jede von einem Fernseher oder Radio empfangene elektrische Welle hören könnten.

Schönheit in den Dingen der Natur zu entdecken oder das Faszinierende und Schöne einer Sache durch Kunstwerke zu vermitteln, ist etwas, was Künstler seit jeher gemacht haben. Ich gehe diesen Weg weiter, wenn auch mit anderen Medien. Im 20. Jahrhundert interessierte man sich allgemein dafür, die Dinge optisch oder akustisch zum Ausdruck zu bringen. Ich möchte darüber hinausgehen und Werke schaffen, die alle Sinne stimulieren.

Aus dem Englischen von Wilfried Prantner

Toshio Iwai

Toshio Iwai, *Music Insects*, 1990

Toshio Iwai, *UgoUgo Lhuga*, 1992

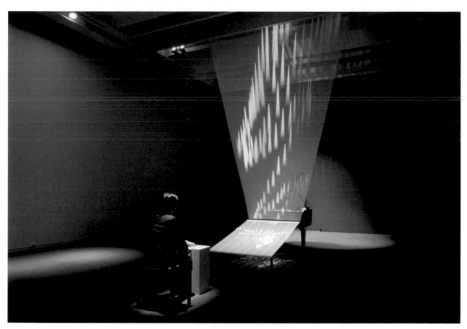

Toshio Iwai, *Piano—as image media*, 1995

Toshio Iwai, *Musical Chess*, 1997

Toshio Iwai

Toshio Iwai, *Composition on the Table No.1 [Push]*, 1999

Toshio Iwai, *Another Time, Another Space—Marshmallow-scope*, 2002

Toshio Iwai, Sho of Light, 2003

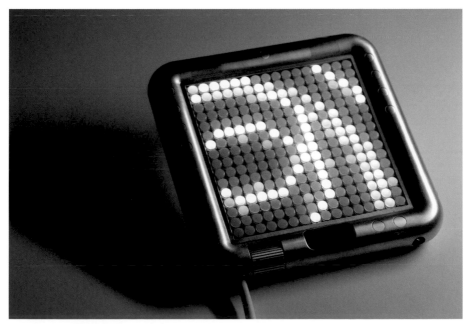

Toshio Iwai, *TENORI-ON*, 2006

Toshio Iwai + NHK Science & Technical Research Laboratories

Morphovision—Distorted House

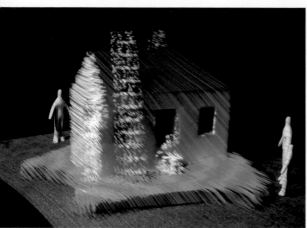 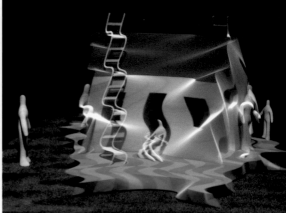

Morphovision creates optical illusions by illuminating objects rotating at high speed with special light. It can make solid objects appear to soften or even fall apart. Here we have a miniature house rotating at high speed, and a touch panel for selecting a light pattern to illuminate the house. The type of distortion produced depends on the pattern selected. One of these patterns gives the house a crooked appearance, as sometimes seen in animation. This, and other effects, are achieved by scanning the object with light in sync with the object's rotation, and changing the form of the light in real time. *Morphovision* distorts actual objects, as opposed to synthesizing 3D objects as in computer graphics. It prompts us to reconsider the nature of images and what it means to "see" the world through one's eyes.

Another Time, Another Space, a work that I created in 1993, uses video cameras, video monitors, and computers. The system temporarily stores video captured by the cameras in computer memory, and combines or records some of the video frames to create temporal and spatial illusions on the video monitors in real time. Visitors standing in front of this work experience a mysterious sensation in which one's body seems to exist beyond time and space.

After this work, I wondered about the possibility of experiencing a distortion of real space not through pictures, but with solid objects. This idea came to me after remembering a work called *3-Dimensional Zoetrope* that I created in 1988. A zoetrope is a 19th century invention that became the forerunner to movies and animation, and in this work I inserted solid dolls made of papier-mâché instead of a paper strip of pictures into the zoetrope's drum, and created the appearance of a figure running. Around this time, I noticed an odd phenomenon. On peering through a slit on the drum, dolls on the near side of the drum appeared fat, while those on the far side appeared thin! The space inside the drum appeared to be distorted, which I found fascinating. Several years later, after creating *Another Time, Another Space,* I remembered my *3-Dimensional Zoetrope,* and started wondering whether I could distort space in a similar manner.

I performed various experiments. First, while rotating a drum with a spiral-shaped slit, I inserted a rod and shook it manually. The rod appeared to soften. I then decided to illuminate a rotating object by having light from a light source in a darkroom scan the object through a disk with

a slit. I observed that the object appeared distorted, much like the distortion produced when a document is carelessly moved on a copy machine while the optical scanner is moving. The result of joint research with NHK Science & Technical Research Laboratories based on these phenomena is *Morphovision*. In the current system, slit-shaped computer-generated images from the projector are reflected off a rotating polygon mirror to scan the miniature house continuously. Here, synchronizing this scanning with the rotation of the house can distort the shape of the house in 3D, and changing the pattern of the slit-shaped projected light can change the shape of the house in various ways.

During the development of *Morphovision* I learned that Joseph Plateau, the inventor of the *Phenakistiscope*, the world's first device for showing moving images, had earlier created a device called the *Anorthoscope* in 1829. This unique device enables a distorted picture to be seen in its original shape through rotating slits. However, while the *Phenakistiscope* later evolved into the zoetrope and other imaging devices, and can be connected to the invention of moving pictures and the birth of today's moving images culture, the *Anorthoscope* evolved into nothing. But now, after an interruption of about 180 years, the *Anorthoscope* lives on in *Morphovision*. I believe that imaging equipment like *Morphovision* that uses real objects may one day evolve into new 3D-imaging equipment and new means of sculpturing.

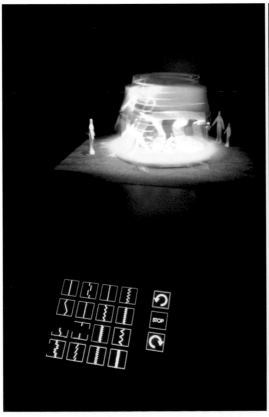

Toshio Iwai + NHK Science & Technical Research Laboratories

Morphovision – Verzerrtes Haus

Morphovision erzeugt optische Illusionen, indem schnell rotierende Objekte mit einem speziellen Licht beschienen werden. Dadurch entsteht der Eindruck, dass Festkörper zerfließen oder gar auseinanderfallen. Bei *Morphovision* dreht sich ein Miniaturhaus und kann über ein Tastenfeld mit verschiedenen Lichtmustern beleuchtet werden. Die Art der Verzerrung hängt vom gewählten Lichtmuster ab. So entsteht bei einer Beleuchtung z. B. der Eindruck, das Häuschen wäre ganz windschief, so wie in manchen Zeichentrickfilmen. Dieser und andere Effekte werden erzielt, indem das Objekt synchron zur Rotation von einem Lichtstrahl abgetastet und das Lichtmuster in Echtzeit verändert wird. Anders als bei der künstlichen Erzeugung von 3D-Objekten in der Computergrafik, verzerrt *Morphovision* reale Objekte. Die Betrachter werden angeregt, sich über das Wesen von Bildern und was es bedeutet, die Welt mit eigenen Augen zu „sehen", Gedanken zu machen.

Another Time, Another Space, eine Installation, die ich 1993 schuf, verwendet Videokameras, -monitore und Computer. Das System speichert Videoaufnahmen temporär am Computer und kombiniert Videokader oder zeichnet diese auf, um auf den Videomonitoren Zeit- und Raumillusionen in Echtzeit zu erzeugen. Betrachter haben das seltsame Gefühl, als würde sich der eigene Körper außerhalb von Raum und Zeit befinden.

Nach diesem Projekt versuchte ich auszuloten, ob eine Verzerrung des echten Raumes auch mit Festkörpern statt Bildern möglich wäre. Auf diese Idee brachte mich eine Installation, die ich bereits 1988 geschaffen hatte: *3 Dimensional Zoetrope*. Das Zoetrop, ein Vorläufer des (Zeichentrick-)Films, ist eine Erfindung des 19. Jahrhunderts. Bei diesem Projekt befestigte ich in der Trommel des Zoetrops Puppen aus Papiermaché statt Papierstreifen mit Bildern, sodass der Eindruck entstand, dass die Puppen zum Leben erwachten. Damals machte ich auch eine seltsame Beobachtung: Wenn man durch die seitlichen Sehschlitze der Trommel spähte, wirkten die Puppen vorne fett und die hinten dünn. Der Raum im Inneren der Trommel schien verzerrt – eine Tatsache, die ich sehr faszinierend fand. Einige Jahre später, nachdem ich bereits *Another Time,*

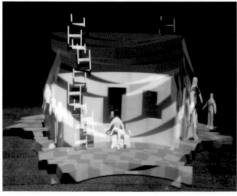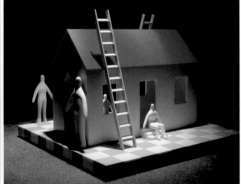

Another Space geschaffen hatten, fiel mir mein *3 Dimensional Zoetrope* wieder ein, und ich begann zu überlegen, ob ich Raum auf eine ähnliche Weise verzerren könnte. Ich führte einige Experimente durch. Zuerst befestigte ich in einer rotierenden Trommel mit einem spiralförmigen Sehschlitz einen Stab, den ich manuell bewegte. Der Stab schien seine feste Form zu verlieren. Dann beschloss ich, ein rotierendes Objekt zu beleuchten, indem ich das Objekt in einer Dunkelkammer durch eine Scheibe mit einem Schlitz mit Licht aus einer Lichtquelle bestrahlte. Ich machte die Beobachtung, dass das Objekt verzerrt erschien, ähnlich wie ein Dokument, das aus Unachtsamkeit während des Scannens in einem Kopiergerät bewegt wird. Auf Grundlage dieses Phänomens entstand *Morphovision* als Forschungsprojekt in Zusammenarbeit mit *NHK Science & Technical Research Laboratories*. In der aktuellen Version wird das Modellhaus permanent gescannt, indem ein rotierender Polygonspiegel die schlitzförmigen, vom Computer generierten Projektionsbilder reflektiert. Synchronisiert man den Scanvorgang mit der Rotation des Hauses, so kann man die Form des Hauses in 3D verzerren; ändert man das Muster des projizierten schlitzförmigen Lichtstrahls, kann die Form des Hauses unterschiedlich verändert werden.

Während der Entwicklung von *Morphovision* erfuhr ich, dass Joseph Plateau, der Erfinder des Phenakistiskops – des weltweit ersten Geräts zur Projektion bewegter Bilder – bereits 1829 das Anorthoskop entwickelt hatte. Dieses einzigartige Gerät ermöglicht es, ein verzerrtes Bild durch rotierende Schlitze in seiner ursprünglichen Form zu betrachten. Während das Phenakistiskop zur Entwicklung des Zoetrops und anderer Geräte zur Darstellung von Bewegungsabläufen aus Einzelbildern führte und mit der Erfindung des bewegten Bilds und der Geburtsstunde der heutigen Filmkultur in Verbindung gebracht werden kann, verschwand das Anorthoskop von der Bildfläche. Nach einer Pause von etwa 180 Jahren erwacht das Anorthoskop nun allerdings in *Morphovision* wieder zum Leben. Ich bin der Ansicht, dass Bildbearbeitungssysteme wie *Morphovision*, die mit realen Objekten arbeiten, sich eines Tages zu neuen 3D-Bildbearbeitungsgeräten entwickeln und neue Möglichkeiten der plastischen Gestaltung eröffnen werden.

Aus dem Englischen von Sonja Pöllabauer

Gerhard Blechinger

Art Becomes Technology

Today, we no longer refer to computer equipment as "new media." Nor does media art have an aura of the New any more; after all, for someone born at the time of the first Ars Electronica, the computer is as old as the pencil. It's as if both have always just sort of been there. Be that as it may—the technical complexity of media art "back in the old days" revolutionized the production of artworks. Artists collaborated with specialists in a wide range of fields because it took teamwork to execute the projects they had in mind. Hardware wasn't developed out of technology in linear fashion; rather, the equipment was endowed with a theme. Technology was taken to the limits, even provoked now and then. Media art was not infrequently a prognosis of hardware and software to come and thus became a model for technical innovation. Today, at the GHK—School of Art and Design Zurich's Department of Technology, what we're doing amounts to working with this strategy in reverse. The production strategy of media art is not used to nurture art but rather for the advancement of technical innovation.

The sector of the consumer electronics industry that produces mobile devices is currently going through a process of development that has already taken place in the computer industry. The trend towards miniaturization is making devices available to us that, on one hand, don't even cause a slight bulge in the pocket of our sport coat and, on the other hand, deliver reception quality that keeps improving. The most important trend, though, is the integration of more and more features, something we're familiar with from our experience with the PC. What was originally a calculating machine has turned into an image processor, a communications device and a piece of gaming equipment. The mobile telecommunications industry is driven by a similar strategy today. Our project *Song fuer C* by artist duo M+M (Marc Weis and Martin De Mattia) might be said to constitute an early and highly advanced example of this.

Proceeding parallel to the concentration on packing devices full of features is the emergence of systems that are custom-tailored to a single task and possess features optimized to carry it out. We call them *dedicated devices*. Our *Video-based Personal Security (VPS)* system was originally created as an idea for a multi-user game. Reverse engineering morphed this gaming scenario into a security application. The way it works is by installing a hidden camera on the lapel of our overcoat. When crime strikes, it transmits a photo of the perpetrator directly to the cell phone of the law enforcement officer patrolling nearest to the scene. Thanks to the system's GPS capabilities, the police immediately know where the incident occurred. Even if the perpetrator succeeds in disabling the device itself, it's too late—the image has already been sent. The *dedicated device* in our example has several features of an advanced cell phone, but is specialized to do a single job: protect the user.

Needless to say, no one today wants his fate to depend on whether and when a data packet makes its way through the telecommunications infrastructure of current providers. With this emergency cell phone, we've stretched the equipment available today to the limits, but we've also given it a theme. VPS calls into question mobile telecommunications' quality of service and makes the question of "Always on?" into a matter of life or death.

Translated from German by Mel Greenwald

Gerhard Blechinger

Kunst wird Technologie

Wir bezeichnen Computertechnologie heute nicht mehr als die „neuen Medien". Medienkunst hat keine Aura des Neuen mehr, ist doch für einen zur ersten Ars Electronica Geborenen der Computer ebenso alt wie der Bleistift. Beide gab es sozusagen schon immer. Dennoch, die technische Komplexität der alten Medienkunst hat damals die Produktion von Kunstwerken revolutioniert. Künstler arbeiteten mit Spezialisten verschiedener Gebiete zusammen, weil die Projekte nur noch von Teams ausgeführt werden konnten. Technologie wurde nicht linear aus der Technik entwickelt, sondern man gab der Technologie ein Thema. Technik wurde überfordert, bisweilen provoziert. Medienkunst war nicht selten Technologie-Prognose, und sie wurde auf diese Weise ein Modell für technische Innovation. Am Institut für Technologie der Hochschule für Gestaltung und Kunst Zürich arbeiten wir heute mit dieser Strategie gleichsam auf umgekehrte Weise. Die Produktionsstrategie der Medienkunst wird dazu genutzt, nicht Kunst, sondern eben technische Innovation voranzutreiben.

Die heutige Industrie der mobilen Endgeräte vollzieht eine Entwicklung nach, die auch in der Computerindustrie bereits stattgefunden hat. Der Trend zur Miniaturisierung beschert uns einerseits Geräte, die Sakkotaschen nicht mehr ausbeulen und andererseits immer bessere Empfangsqualitäten besitzen. Der wichtigste Trend allerdings ist die Einbindung von immer mehr Funktionalitäten, wie wir sie aus dem Bereich des Personalcomputers kannten. Aus den Rechenmaschinen wurden Bild-, Kommunikations- und Spielmaschinen. Eine ähnliche Strategie treibt heute die Mobilfunkindustrie. Unser Projekt *Song fuer C* des Künstlerduos M+M, Marc Weis und Martin De Mattia, ist dafür womöglich ein frühes und avanciertes Beispiel.

Gleichzeitig zur Konzentration von Funktionalitäten entstehen Systeme, die nur für eine einzige Aufgabe zugeschnitten und für diese optimiert sind. Wir nennen sie „dedizierte Geräte". Unser System *Videobased Personal Security (VPS)* entstand ursprünglich als Idee für ein Multiuser-Spiel. Revers-Engineering machte aus dem Gaming-Szenario eine Sicherheitsapplikation. Hierzu haben wir eine unsichtbare Kamera am Revers unseres Mantels angebracht. Sie überträgt im Notfall das Foto eines Angreifers direkt auf das Handy der nächstgelegenen Polizeistreife. Weil das System über GPS verfügt, weiß der Polizist sofort, wo der Übergriff stattfindet. Vielleicht würde es dem Angreifer noch gelingen, dem Opfer das Gerät zu entreißen, doch das Bild ist bereits automatisch versandt und daher mit der Notfallkamera nicht mehr physisch verbunden. Dieses dedizierte Gerät hat in unserem Beispiel einige Funktionalitäten eines avancierten Handys, ist aber auf den Schutz des Trägers spezialisiert.

Freilich wird heute niemand sein Schicksal der Frage überlassen, ob und wann ein Datenpaket seinen Weg durch die Telekommunikationsinfrastruktur heutiger Anbieter findet. Wir haben mit dem Notfallhandy heutige Technologie überfordert, wir haben ihr aber auch ein Thema gegeben. VPS fragt nach Quality of Service im Mobilfunk und macht die Frage *always on?* zu einer von Leben und Tod.

Bernd Wiemann

Innovation is No Coincidence

The mission of Vodafone Group R&D is to explore new fields worldwide for the Vodafone Corporation and to perform research on new technologies, markets and opportunities for products and services.

In going about it, the horizons of mobile communications are being systematically expanded. The technical perspective is augmented by application-oriented considerations and combined with cultural points of view into a productive, transdisciplinary, collaborative effort.

Engineers, scientists and humanities scholars bring technical expertise and business administrative skills to the team. They also take advantage of many different creative processes like futuristic excursions, improvisational theater and especially the challenges of current artistic positions and discussion forums. These are indispensable catalysts for technological research and the generation and testing of new hypotheses for implementing outcomes—for example, applications connected with wellness, preventive medicine, electronic newspapers and leisure time management.

Multifunctional communications technologies that offer a wide range of services and make use of virtual procedures increasingly determine our everyday life and our culture. In the fabric of interrelationships made up of place, time, information and human beings, our movements, commutes and travels, the way we experience space, and the levels of our imagination are becoming ever more intensively interwoven with one another, and this is increasing the complexity of our lifestyles and ways of life. What long-term influence does the growth of knowledge and insight have in a networked world that is become ever more complex as a result? Which instruments are available to enable us to manage the boundless spectrum of data the future will surely bring? The mandate society is issuing to the developers of new technologies is to do away with all that is convoluted and superfluous, and to make complex systems easy to understand and operate.

The omnipresence of mobility can already be experienced today as the interfaces between the private and public spheres in which transformed social processes are being played out. These overlapping domains engendered by high-tech means of communication occupy the focal point of interest of artists from all over the world.

In cooperation with the Mobile Art Forum *Artcircolo,* Vodafone Group R&D Germany has been engaged in an ongoing dialog with artists working in a variety of different genres in order to scrutinize the future of work and everyday life from a wide variety of perspectives, to reflect on the essence of these ideas, to manifest them spatially and to shed light on them. The aim is the development and fostering of new media and mobile art formats that are taking a transdisciplinary approach to a wide range of issues ("Mobile Art Lab" as production platform for international artists and media experts).

Song fuer C by M + M (Marc Weis and Martin De Mattia) and *As if we were alone* by Empfangshalle (Corbinian Böhm and Michael Gruber) are exemplary projects that deal with communications techniques of future mobile media formats and their effects on the way we behave in public. Both describe visions that flip back and forth between fiction and reality.

Translated from German by Mel Greenwald

Bernd Wiemann

Innovation ist kein Zufall

Vodafone Group R&D (Research & Development) hat die Aufgabe, für den Mobilkonzern weltweit Neuland zu erschließen, neue Technologien, Märkte und Möglichkeiten für Produkte und Dienstleistungen zu erforschen.

Hierzu wird der Horizont der mobilen Kommunikation systematisch erweitert – der technische Blickwinkel wird um anwendungsorientierte Sichten ergänzt und mit kulturellen Bezügen zu einem transdisziplinären Zusammenwirken geführt.

Das Team aus Ingenieuren, Natur- und Geisteswissenschaftlern nutzt neben der technischen und betriebswirtschaftlichen Exzellenz vielfältige kreative Prozesse wie Zukunftsreisen, Improvisationstheater und besonders die Herausforderung durch aktuelle Kunstpositionen und Diskussionsforen. Sie sind unverzichtbare Katalysatoren für die Technologieforschung, für die Entwicklung zukünftiger Mobilfunkanwendungen und die Erschließung neuer Einsatz- und Nutzungshypothesen wie beispielsweise Wellness, medizinische Prävention, elektronische Zeitungen, Freizeitmanagement u. a.

Multifunktionale Kommunikationstechnologien mit umfassenden Serviceangeboten und virtuelle Vorgänge bestimmen zunehmend unseren Alltag und unsere Kultur. Das Beziehungsgeflecht zwischen Ort, Zeit, Information und Personen lässt Bewegungsabläufe, Raumerlebnisse und Vorstellungsebenen immer stärker ineinander greifen und erhöht so die Komplexität unserer Lebenssituationen. Welchen längerfristigen Einfluss aber haben Wissenswachstum und Erkenntnis in einer vernetzten Welt, die dadurch immer komplexer wird? Wie sehen die Instrumente aus, die das grenzenlose Spektrum von Einzelinformationen in Zukunft bewältigen können? Für die Entwickler neuer Technologien wird die Frage nach Reduktion, Überschaubarkeit und Beherrschbarkeit solch komplexer Systeme zur gesellschaftsübergreifenden Herausforderung.

Heute bereits erfahrbar wird die allgegenwärtige „mobile Präsenz" als Schnittstelle zwischen Privatsphäre und öffentlichem Raum, in dem veränderte gesellschaftliche Prozesse ablaufen. Diese durch technische Kommunikationsmittel induzierten „Überlappungsräume" von Privatem und Öffentlichem stehen im internationalen Fokus künstlerischen Interesses.

In Zusammenarbeit mit dem Mobilen Kunstforum *Artcircolo* führt Vodafone Group R&D Germany einen kontinuierlichen Dialog mit Künstlern unterschiedlicher Bereiche, um aus verschiedensten Perspektiven zukünftige Arbeits- und Alltagssituationen inhaltlich und räumlich zu reflektieren und transparent zu machen. Ziel ist die Entwicklung und Förderung von neuen Medien- und mobilen Kunstformaten unter Berücksichtigung transdisziplinärer Fragestellungen. Mit diesem Anspruch wurde vor wenigen Jahren ein „Mobile Art Lab" etabliert, das internationalen Künstlern und Medienexperten eine Produktionsplattform anbietet.

Song fuer C von M + M (Marc Weis und Martin De Mattia) und *As if we were alone* von Empfangshalle (Corbinian Böhm und Michael Gruber) sind beispielhafte Projekte dafür, wie sich Künstler mit Kommunikationstechniken zukünftiger mobiler Medienformate und ihren Auswirkungen auf unser Verhalten im öffentlichen Straßenraum auseinandersetzen und eine Vision beschreiben, die sich zwischen Fiktion und Realität bewegt.

Song for C

01.09.06 17:02

With their *Song for C,* artistic duo M+M (Marc Weis and Martin De Mattia) has come up with a *film noir*-style detective story in which the boundary between fiction and real life tends to get a bit blurred. Starring Stephan Bissmeier, Anna Schudt, Christoph Luser, Britta Hammelstein and Barbara Rudnik, *Song for C* utilizes futuristic communications technologies to produce a screenplay that Helmut Krausser developed especially for this project.

The narrative gets the audience of cell phone users partaking of it involved in a drama entailing a variety of different seemingly authentic messages, transmitted images, clues and leads that turn passive viewers into active "voyeurs" of what is transpiring. It works like this: a female detective sends out mobile video dispatches to keep the audience of cell phone users updated about the progress of her investigation and, at the same time, to actively involve them in the case.

The back-story: a father desperately seeking his 18-year-old daughter hires a female detective to track her down. Working undercover, the private eye makes contact with Tom, a shady musician the client's daughter fell in love with...

Song for C is a pilot project that's the outcome of an interdisciplinary joint venture at the interface of art, technology and academia. The project associates jointly developed a new format for the mobile, back-channel-enabled (bi-directional) "multimedia engine" that used to be referred to simply as a cell phone.

With the setup of its Mobile Art Lab as a production domain for the exclusive use of artists, Vodafone Group R&D is launching a collaborative arrangement with the HGKZ—School of Art and Design Zurich, which has already established a presence in this field through its long-term research commitment to mobile telecommunications and the Mobile Application Design postgraduate program instituted at the school in 2001.

From the perspective of high-tech R&D, artists will be carrying out a creative development process to come up with a laundry list of desirable features, whereby artists become early adopters and can thus have input into the development of new technologies. *Song for C* is based on cutting-edge technical systems—some still in the development stage—for mobile telecommunications: multifunction cell phones, DVB-H broadcast and interaction that goes far beyond the scope of currently foreseeable capabilities of mobile TV. Such innovative media formats that are the upshot of interdisciplinary dialog raise a set of issues of overarching significance. How is communication changed by interaction? How powerful an impact are these new technical possibilities having on our life and our culture? How can we maintain an equilibrium between the proliferation of specialized knowledge and the pursuit of a human agenda with objectives like society, behavior and experience?

A cinematic narrative for cell phones by M+M.
Actors: Stephan Bissmeier, Anna Schudt, Christoph Luser, Britta Hammelstein, Barbara Rudnik

Song for C is a cooperation between The School of Art and Design, Zurich (Gerhard Blechinger, Tanja Katharina Gompf) and Mobile Art Lab of Vodafone Group R & D Germany (Bernd Wiemann, Martin Richartz, Serafine A. I. Lindemann/Artcircolo).

Song fuer C

Mit *Song fuer C* entwickeln die Künstler M + M (Marc Weis und Martin De Mattia) eine abgründige, kriminalistische Erzählung, in der die Grenzen zwischen Fiktion und aktuellem realem Geschehen fließend verlaufen. Auf Basis eines eigens entwickelten Drehbuches von Helmut Krausser wird *Song fuer C* mit den Schauspielern Stephan Bissmeier, Anna Schudt, Christoph Luser, Britta Hammelstein und Barbara Rudnik unter Einbeziehung zukunftsorientierter Kommunikationstechnologien filmisch umgesetzt.

Die Erzählung verwickelt den eigentlichen Empfänger, den Handy-User, in ein Spiel unterschiedlicher, authentisch wirkender Nachrichten, Bildübertragungen und Hinweise und macht ihn zum aktiven „Voyeur" der Geschehnisse. So wird der Handy-User von der Detektivin via mobiler Videobotschaften über den Ermittlungsverlauf informiert und aktiv in das Geschehen einbezogen:

Ein Vater ist auf der Suche nach seiner 18jährigen Tochter. Er beauftragt eine Detektivin mit den Ermittlungen. Undercover sucht diese Kontakt zur Tochter. Sie trifft auf Tom, einen zwielichtigen Musiker, in den sich die Tochter verliebt hat ...

Song fuer C ist ein Pilotprojekt, entstanden in interdisziplinärer Partnerschaft zwischen Kunst, Technologie und Academia. Zusammen entwickelten die Projektpartner ein neues Format für die mobile und rückkanalfähige „Multimediaengine", die früher Mobiltelefon hieß.

Mit der Einrichtung des „Mobile Art Lab" als exklusive Produktionsplattform für Künstler startete die Vodafone Group R&D eine Zusammenarbeit mit der HGKZ, die dort im Kontext langjähriger Forschung im Bereich „Mobile" sowie dem 2001 gegründeten Postgraduate-Programm „Mobile Application Design" steht.

Aus der Sicht der Technologieforschung legen Künstler ihre Anforderungen in einem kreativen Entwicklungsprozess fest und sind „Early User" und damit Mitgestalter bei der Findung neuer Techniken. *Song fuer C* basiert auf neuesten, teils noch in Entwicklung befindlichen technischen Systemen des Mobilfunks mit Multifunktions-Handys, DVB-H Broadcast und Interaktion, die den Rahmen des heute absehbaren MobileTV deutlich überschreiten.

Solche im interdisziplinären Dialog kreierten innovativen Medienformate eröffnen übergeordnete Fragenkomplexe: Wie verändert sich die Kommunikation durch die Interaktion, wie stark prägen die neuen technischen Möglichkeiten unser Leben und unsere Kultur? Wie kann das spezialisierte Wissenswachstum im Einklang mit Gesellschaft, Verhalten, Erfahrung – mit menschlichen Zielen bleiben?

Eine filmische Erzählung für Mobiltelefone von M+M.
Schauspieler: Stephan Bissmeier, Anna Schudt, Christoph Luser, Britta Hammelstein, Barbara Rudnik

Song fuer C ist eine Kooperation zwischen Hochschule für Gestaltung und Kunst, Zürich (Gerhard Blechinger, Tanja Katharina Gompf) und Mobile Art Lab der Vodafone Group R & D Germany (Bernd Wiemann, Martin Richartz, Serafine A. I. Lindemann / ArtCircolo).

Empfangshalle

As if we were alone!
New Spaces in the Public Sphere

———

The creative encounter with new communications technologies and the impact they're having on life, culture, and how we behave in the situations that confront us in daily life constituted the point of departure for artistic duo Empfangshalle's vision of a film & installation project whose subject matter is a common feature of social life in societies all around the world. Corbinian Böhm and Michael Gruber understand their art as communication and a process of interaction with the public. Accordingly, Empfangshalle visited metropolises worldwide (including Barcelona, Hongkong, Guangzhou and Berlin) to do research on the behavior of cell phone users. Their sculptural interventions and actions/performances staged to achieve specific effects and reactions visualize the new spaces and gestures engendered while cell phone users are on the line.

There are many examples of how we create mobile "private spheres" for ourselves to communicate without disruption: there's the caller who's completely withdrawn inside himself, his eyes fixed to the ground as he makes his rounds on an uncharted path; and then there's the one seated in the bus with his hand cupped over his mouth in a futile attempt to prevent others from overhearing an urgent discussion of his relationship problems; or the business talker hurriedly fleeing the dead zone to re-establish crystal-clear communication ...

Having come to the realization that "Whoever uses his cell phone in public disassociates himself from his surroundings via real or virtual spaces," the artists formulated and constructed for their pioneering short film the initial prototypes of "mobile telephoning spaces" that will be offered in conjunction with a worldwide telephone service. The result is a "documentary fiction" that conveys viewers into a borderline realm between certainty and illusion, into a domain in which fact and fiction blend.

Translated from German by Mel Greenwald

Director: Thomas Adebahr
Idea, Concept, Execution and Production: Empfangshalle
Camera: Stephan Horst
Equipment and Postproduction: Vis:A:Vis Filmproduktion
Editing: Lisa Hammelehle, Ron Wilson, Markus Wollschläger
Music: by Regina Dannhof (The Starseeds), produced by Major Key Productions, Markus Moser, Ny
Curator: Serafine A. I. Lindemann / Artcircolo
Service: Anita Edenhofer, Matthias Numberger
Couple: Sarah Baumann, Karsten Mielke
Production Support Berlin / Hongkong / Guangchou / Barcelona
Friederike Steinbeck / Ankie Lau, Julianne Lau / George Jie Wu / Wendy Feng / Jose Salado

The project „As if we were alone" is the result of an initiative from and a cooperation with Vodafone Group Research & Development Germany and the Mobile Art Forum Artcircolo.

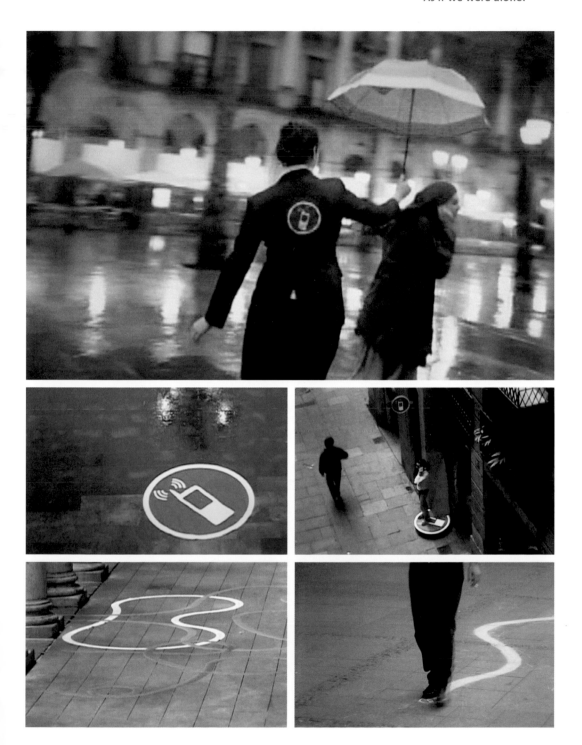

Empfangshalle

As if we were alone!
Neue Räume in der Öffentlichkeit

Die kreative Auseinandersetzung mit neuen Kommunikationstechnologien und ihren Auswirkungen auf unser Leben, unsere Kultur und unser Verhalten in alltäglichen Situationen war für das Künstlerduo Empfangshalle die Grundlage für die Entwicklung einer Vision eines gesellschaftsübergreifenden Projektes in Form von Film und Installation.

Corbinian Böhm und Michael Gruber verstehen ihre Kunst als Kommunikation und interaktiven Prozess mit der Öffentlichkeit. Als solches recherchierte Empfangshalle in internationalen Metropolen wie Barcelona, Hongkong, Guangzhou und Berlin das Verhalten von Handybenutzern und visualisierte durch gezielte Inszenierungen und skulpturale Eingriffe neue Räume und Gesten, die beim mobilen Telefonieren entstehen.

Beispiele dafür, wie wir uns mobile „Privatsphären" schaffen, um ungestört zu kommunizieren,

gibt es viele: den in sich versunkenen Telefonierer, der mit starrem Blick auf den Boden einer unsichtbaren Linie folgend seine Runden zieht, den mit vorgehaltener Hand im Bus Sitzenden, der eindringlich seine Beziehungsprobleme diskutiert, oder den aus dem Funkloch fliehenden eiligen Businesstalker ...

Ausgehend von der Erkenntnis „Wer mobil telefoniert, grenzt sich von seiner Umgebung durch reale oder virtuelle Räume ab", formulieren und konstruieren die Künstler für ihren zukunftsorientierten Kurzfilm erste Prototypen „mobiler Telefonierräume", die im Rahmen eines weltweiten Telefonierservices angeboten werden. Das Ergebnis ist eine „Documentary Fiction", die den Zuschauer in einen Grenzbereich zwischen Gewissheit und Illusion führt, in einen Raum, wo sich Fakt und Fiktion mischen.

Text: Serafine A. I. Lindemann

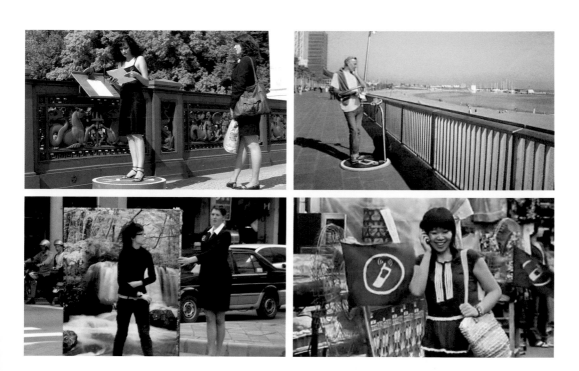

Ran Tao / Jenny Chowdhury

Mobile Assassins

Mobile Assassins is a mobile/updated version of the traditional big game *Assassins* (also known as *Assassin, Paranoia,* or *Killer),* where camera phones are used as both the means of assassination, and also as the vehicle of deploying information about your targets.

The classic game of *Assassins,* which was popularized on college campuses in the early 1980s, is a live-action role-playing game where a player's goal is to "kill" the other participants and be the last assassin left standing. According to Wikipedia: *"Assassins* is a game where each player has a 'target' that they are trying to kill, and each player is in turn the target of another assassin. Players are assigned their targets by the game's coordinators, but do not know the identity of the person assigned to target them."

In the past, you may have played *Assassins* during your college orientation, or maybe amongst a large group of your friends, aiming squirt guns or water balloons at your assigned targets. However, in the age of the technology, we thought it appropriate to update this game by bringing it to a mobile platform. Since the majority of cell phones are now equipped with cameras and most people carry their cell phones everywhere they go, it seemed apparent that using camera phones to "shoot" your target would put an exciting new spin on the game of *Assassins.*

Thus, we've brought the traditional live-action role-playing game into the mobile arena by re-purposing the camera phone as 1) the means of target deployment and 2) the means of assassination. The rest of the rules remain the same. You are assigned a target that you must 'kill', while avoiding being killed yourself by an assassin of whose identity you are unaware.

While *Mobile Assassins* is a game, it is also a valuable tool for icebreaking and team building/ bonding. It promotes interaction among groups by introducing a social and emotional exchange between pairs of people on a large scale. We envision the game being used in the following scenarios: big game tournaments, college orientation, conferences, and corporate and group bonding exercises.

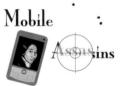

Mobile Assassins ist die mobile, aktualisierte Fassung des Spieleschlagers *Assassins* (auch bekannt als *Assassin, Paranoia* oder *Killer),* bei dem Kamerahandys sowohl als Tötungswerkzeuge als auch als Übermittler von Zielinformationen dienen.

Das klassische Spiel *Assassins,* das Anfang der achtziger Jahre an den US-Colleges populär wurde, ist ein Live-Rollenspiel, dessen Ziel die „Beseitigung" der anderen Mitspieler ist, so dass man als letzter überlebender Auftragskiller übrig bleibt. Laut *Wikipedia* ist „*Assassins* ein Spiel, bei dem jeder Spieler eine ‚Zielperson' hat, die es zu töten gilt, während man selbst Zielscheibe eines anderen Attentäters ist. Die Koordinatoren des Spiels weisen den Spielern – die wiederum nicht wissen, wer auf sie angesetzt wurde – ihre jeweilige Zielperson zu."

In der Vergangenheit hat der eine oder andere *Assassins* vielleicht während der ersten Zeit am College oder in einer großen Runde von Freunden gespielt und ist dabei mit Spritzpistolen oder Wasserballons auf sein Ziel losgegangen. Im Zeitalter der Technologie hielten wir es für angebracht, das Spiel zu aktualisieren und auf eine mobile Plattform zu verlagern. Da heute die Mehrzahl der Mobiltelefone mit Kameras ausgestattet ist und die meisten ihr Mobiltelefon überallhin mitnehmen, lag es auf der Hand, dass der Einsatz von Kamerahandys zum „Töten" der Zielperson *Assassins* zu neuer Spannung verhelfen würde.

Somit haben wir das gute alte Live-Rollenspiel in eine mobile Arena gebracht, indem wir die Kamerahandys zum Vehikel der Zieldatenübermittlung und zum Tötungswerkzeug umfunktionieren. Die übrigen Regeln bleiben aufrecht. Man erhält eine Zielperson zugewiesen, die man „töten" muss, während man versucht, nicht selbst Opfer eines Attentäters zu werden, dessen Identität man nicht kennt.

Mobile Assassins ist nicht nur ein Spiel, sondern leistet auch gute Dienste bei der Anbahnung von Beziehungen, für die Teambildung bzw. den Teamzusammenhalt. Es fördert die Interaktion zwischen verschiedenen Gruppen, indem es einen sozialen und emotionalen Austausch zwischen Spielerpaaren auf breiter Basis eröffnet. Bei folgenden Szenarien können wir uns das Spiel sehr gut vorstellen: bei großen Spielmeisterschaften, Einführungsveranstaltungen an Colleges, Konferenzen sowie Seminaren für Firmen- und Gruppenzusammenhalt.

Aus dem Englischen von Michael Kaufmann

Jenny Chowdhury

The Cell Atlantic CellBooth

Talking on the phone is no longer a private exchange. What if you could carry a phone booth with you and set it up when you needed to converse in private?

Not so long ago, "Chatty Cathys" sought rooms or, if outdoors, phone booths to conduct phone conversations. The personal space provided by these enclosures created the illusion of privacy for the two parties on the phone line.

Now, we talk on cell phones everywhere we go, disregarding issues of privacy (and also those of courtesy). People often don't care if others hear their end of the conversation. In fact, we can often hear both sides of the conversation when the cell phone is especially loud.

In addition, we are also often walking about, hailing cabs, shopping, etc. while we talk on the phone. How much attention are we really giving the person on the other end when we're multi-tasking and hurrying towards our next destination? What would happen if we were forced to stand still while we spoke on the phone?

As I grappled with these issues of privacy, personal space and nostalgia for a "simpler time", the idea of a portable phone booth was born. The portable phone booth, which I call the *Cell Atlantic CellBooth,* is a wearable object you can carry around with you and set up when you need a moment to talk. The deliberate nature of setting up the booth and standing in place while one talks enforces the idea that the call is important—not something to do while picking up the kids, working out, or driving. Ultimately, I desired to recreate the illusion of privacy and stillness afforded by old school, 4-walled phone booths, but also to update the booth as a portable object that would fit into a modern life.

What emerged was a portable phone booth and subsequently a piece of performance art that calls the attention of passers-by to the changes in human behavior due to the ubiquitous use of cell phones. The project prompts people to take stock of how cell phone technology has altered the ways in which we communicate with each other and the environment surrounding us.

http://jennylc.com/cellbooth/

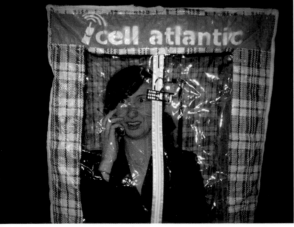
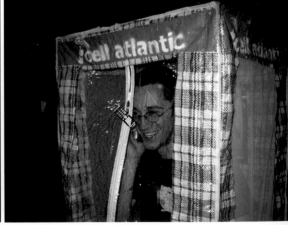

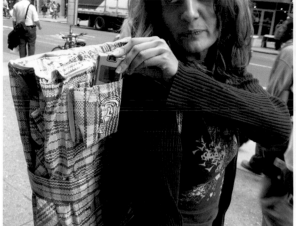
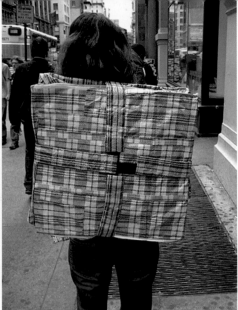

Telefonieren ist heutzutage keine Privatangelegenheit mehr. Wie wäre es also, wenn man eine Telefonzelle mit sich herumtragen und immer dann aufstellen könnte, wenn man ein Privatgespräch führen möchte?

Erst kürzlich wurden für „Chatty Cathys" Räumlichkeiten oder – im Freien – Telefonzellen gesucht, wo man ungestört Telefongespräche führen konnte. Die durch diese Abgrenzung geschaffenen persönlichen Räume erzeugten für beide Gesprächsteilnehmer die Illusion von Privatsphäre.

Heute telefonieren wir auf Schritt und Tritt mit dem Handy und missachten dabei jegliche Privatsphäre (und jegliche Höflichkeit). Den meisten Menschen ist es einerlei, ob ihnen beim Telefonieren jemand zuhört. Und wenn das Handy entsprechend laut eingestellt ist, kann man oft sogar beide Seiten gut verstehen.

Darüber hinaus gehen wir beim Telefonieren oft herum, winken Taxis heran, kaufen ein etc. Wie viel Aufmerksamkeit widmen wir eigentlich der Person am anderen Ende der Leitung, wenn wir daneben all diese Dinge erledigen und unserem nächsten Ziel entgegenhetzen? Was würde passieren, wenn wir während eines Telefonats stillstehen müssten?

Die Beschäftigung mit diesen Fragen der Privatsphäre, des persönlichen Raums und der Sehnsucht nach „einfacheren Zeiten" brachte mich auf die Idee einer tragbaren Telefonzelle. Die *Cell Atlantic CellBooth*, wie ich sie nenne, ist ein tragbares Objekt, das man ständig mit sich führen und immer dann aufbauen kann, wenn man in Ruhe telefonieren will. Der bewusste Akt des Aufstellens der Telefonzelle und das Stillstehen während des Gesprächs verstärken den Eindruck, es handle sich um ein wichtiges Gespräch – nicht um etwas, das man genauso gut machen kann, während man die Kinder abholt, trainiert oder Auto fährt. Letztendlich wollte ich die Illusion von Privatsphäre und Ruhe heraufbeschwören, wie sie in den alten, rundum geschlossenen Telefonzellen herrschte, und zugleich die Telefonzelle als ein tragbares Objekt aktualisieren, das unserem modernen Lebensstil entspricht.

Heraus kam dabei eine im mehrfachen Sinn des Wortes tragbare Telefonzelle, aber auch ein Stück Performance-Kunst, das die Bevölkerung auf die durch den allgegenwärtigen Einsatz von Mobiltelefonen hervorgerufenen Änderungen im menschlichen Verhalten aufmerksam macht. Das Projekt veranlasst die Menschen, sich vor Augen zu führen, inwieweit die Mobiltelefontechnologie unsere Kommunikation miteinander – und mit unserer Umgebung – verändert hat.

Aus dem Englischen von Susanne Steinacher

Aram Bartholl

Silver Cell

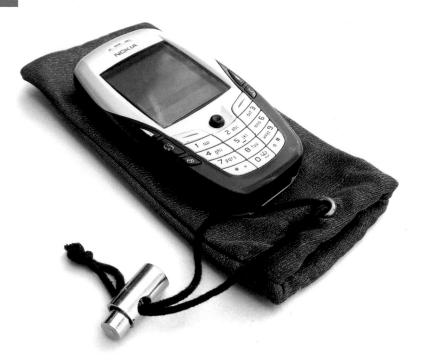

The *Silver Cell* cell phone carrying case works like a Faraday cage. A cell phone placed inside this case can neither transmit nor receive; it is totally shielded. The material it's made of, a completely silver-coated polyamide fabric, remains transparent, so a modern cell phone's display can be read through it.

Most cell phone users are unaware of the fact that their devices regularly send location-related data to the service provider. This carrying case makes it possible to evade any such positioning or tracking, something that even shutting off the cell phone itself cannot always guarantee. The user's own personal dead-zone assures that he/she leaves behind absolutely no trace in any spatial data model.

In order to illustrate how this works, there'll be a product demonstration in a public space. The radio cell of the cellular network in which the demo cell phone is located (i.e. the zone surrounding the demo site) will be temporarily marked. The omnipresent, invisible web of radio cells will thus be made visible. Depending on population density and concentration of users in a particular area, the size of such a radio cell can vary from a few hundred square meters in cities to several square kilometers in rural regions.

This project spotlights cell phones' location-related data exchange activities by passively interrupting them. A simple carrying case is capable of disabling a highly complex piece of mobile telecommunications equipment.

Translated from German by Mel Greenwald

Die Handytasche *Silver Cell* wirkt wie ein faradayscher Käfig. Ein sich in dieser Tasche befindendes Handy kann weder senden noch empfangen. Es ist vollkommen abgeschirmt. Das verwendete Material, ein vollflächig versilbertes Polyamidgewebe, bleibt transparent. Ein modernes Handydisplay kann durch den Stoff immer noch abgelesen werden.

Ohne das Wissen der meisten Nutzer generieren Mobiltelefone beim Provider ortsbezogene Daten. Die Tasche bietet die Möglichkeit, sich einer Ortung oder räumlichen Nachverfolgung zu entziehen. Selbst ein ausgeschaltetes Handy kann dies nicht immer garantieren. Das persönliche Funkloch stellt sicher, dass keine Spuren im räumlichen Datenmodell hinterlassen werden.

Um dieses zu verdeutlichen, gibt es zusätzlich zu dem Objekt eine Aktion im öffentlichen Raum. Die Funkzelle des Handynetzes, in der sich die Handytasche befindet, wird temporär im Bereich des Ausstellungsortes im Straßenraum markiert. Das allgegenwärtige unsichtbare Funkzellenlayer wird somit sichtbar. Je nach Bevölkerungs- und Nutzerdichte variiert die Größe einer solchen Funkzelle von wenigen hundert Metern bis hin zu mehreren Kilometern in ländlichen Gebieten.

Der konstante raumbezogene Datenaustausch eines Handys wird thematisiert, indem er auf passive Weise unterbrochen wird. Eine einfache Tasche setzt das technisch hoch komplexe Mobilfunkgerät außer Gefecht.

Graham Budgett / Jane Mulfinger

REGRETS Linz

Regrets are often the conceptual vehicle of self-improving tendencies, but they are rarely communally active in any meaningful way. The Regrets team seeks to intervene and enable such interaction. In particular, *remorse* is posited here as a positive entity, incorporating recall, reflection, and learning.

Five custom mobile computer units roaming public space in and around a chosen city, community, or event, collect anonymously submitted regrets from the public, gathering and comparing them to comprise a sociological database of contemporary regret. Instant feedback to the individual user based on other contributors' similar concerns is algorithmically generated to "share the burden". The backpack units deliver a metaphor: relieve your burden by placing it on another's back. Random selections of the regrets are made public via locally negotiated sites and existing signage, network, and broadcast facilities. The archive represents a glimpse of a given community at a particular time through the rubric of regret; its results are available for future studies.

Each unit houses a terminal with a wireless connection to a central database located on a remote server. Algorithms use keywords from the submitted text and other self-describing user input to define *similarity*. (Chance will also have a pseudo-poetic and perhaps comedic role to play in output). The booth/backpack-computer method of submission using GSM—as opposed to users' mobile phones and text messages for example—is intrinsic to the anonymity of the messages and also as part of the *display* function (since the collection units, when idle, feature random samplings from the archive). Other locally negotiated venues and networks for public display and broadcast also publicize sampled regrets from the archive.

It has been said that the submissions so far have been surprisingly poetic in their concision. Some phrases feel like they are the tip of the iceberg with a huge narrative unfolding underneath. The *REGRETS* team plans extensive and expansive future intervening collections within diverse communities, organizations, and situations.

http://www.regrets.org.uk

We would like to thank the REGRETS Linz team, Rama Hoetzlein, and the continued contributions of Dora Nemere. *REGRETS Cambridge* was the first local venue, resulting in over 1500 submissions. We have the following institutions and individuals to thank for the original siting: Carl Magagnosc, systems engineer; sponsors: Microsoft Research Cambridge [MSRC]: Richard Harper, Shahram Izadi, Tim Regan, Abigail Sellen, Vicki Ward, Pierre-Louis Xech [MSRC project manager]; University of Westminster [westmARC], Stephen Whaley [westmARC director]; University of California, Santa Barbara, [University of California Institute for Research in the Arts & the Interdisciplinary Humanities Center]: Dick Hebdige, Kim Yasuda.

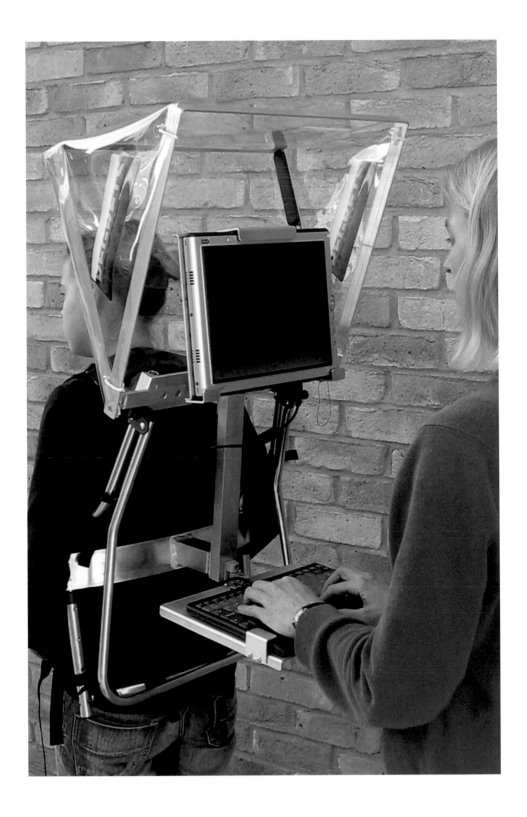

Graham Budgett / Jane Mulfinger

REGRETS Linz

Äußerungen des Bedauerns *(Regrets)* und der Reue stellen oftmals das konzeptuelle Medium für Tendenzen der „Selbstbesserung" dar, sind aber nur selten auf irgendeine Weise für die Gesellschaft von Bedeutung. Das REGRETS-Team setzt Aktionen, um eine derartige Interaktion zu ermöglichen. In diesem Zusammenhang wird *Reue* als positive Größe postuliert, die sich aus den Elementen Erinnerung, Reflexion und Lernen zusammensetzt.

Fünf in einer Rucksackeinheit eingebaute mobile Computer „durchstreifen" am Rücken ihrer Träger den öffentlichen Raum einer bestimmten Stadt, Gemeinde oder eine Veranstaltung und sammeln anonym eingereichte Äußerungen des Bedauerns und der Reue. Diese Äußerungen werden zusammengestellt und verglichen und in eine soziologische Datenbank aktueller Reuebekundungen eingespeist. Der einzelne User bekommt umgehend Feedback, das algorithmisch aus anderen Beiträgen mit ähnlichen Anliegen erzeugt wird, um dadurch „die Last zu teilen". Diese Rucksackgeräte stehen für die Metapher: Befreien Sie sich von Ihrer Bürde, indem Sie diese auf den Rücken eines anderen Menschen laden. Eine zufällige Auswahl von Reuebekundungen wird vor Ort über bestehende Leitsysteme und Netzwerke sowie Sendeanstalten veröffentlicht. Das Archiv ist eine Momentaufnahme einer beliebigen Gemeinde und deren Reuebekundungen zu einem bestimmten Zeitpunkt; die Ergebnisse daraus sind für zukünftige Studien verfügbar.

Jede dieser „Rucksackeinheiten" verfügt über ein Terminal mit kabelloser Verbindung zu einer zentralen Datenbank auf einem Remote-Server. Um Ähnlichkeiten und Übereinstimmungen herauszufinden, werden algorithmisch Schlagwörter aus den übermittelten Texten und Eingaben anderer User herausgefiltert. Die Übermittlung erfolgt über GSM, um die Anonymität der Nachrichten sicherzustellen – im Gegensatz zu von Mobiltelefonen abgeschickten SMS. Dies ist auch für die *Display*funktion wichtig, wenn etwa die Rucksackeinheiten im Leerlauf sind, wird eine zufällige Auswahl aus dem Archiv angezeigt. Darüberhinaus wird an bestimmten Stellen des öffentlichen Raumes und über Anzeigetafeln gesamplte Bedauernsäußerungen aus dem Archiv veröffentlicht.

Die bisher eingereichten Beiträge sind in ihrer Prägnanz überraschend poetisch. Oft vermitteln die Beiträge auch den Eindruck, als seien sie nur die Spitze eines Eisbergs, unter dem sich eine geballte Ladung an Geschichten verbirgt.

http://www.regrets.org.uk

Aus dem Englischen von Eva Gebetsroither

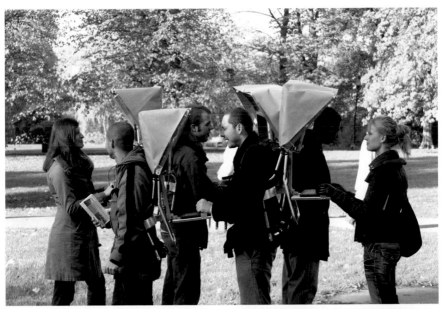

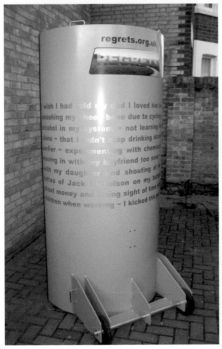

Taylor Hokanson

Sledgehammer Keyboard

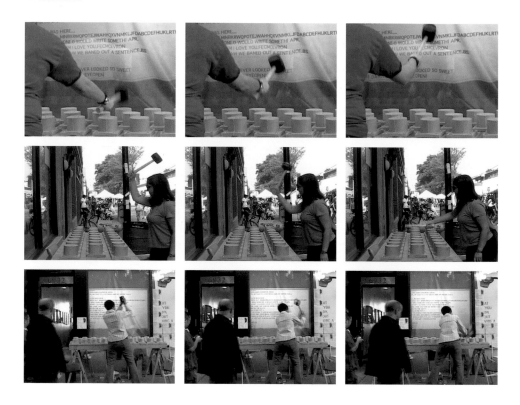

The *Sledgehammer Keyboard* communicates with a computer like its common counterpart—it is the user's experience that is unusual. Participants are invited to lay down their thoughts by striking its keys with a hammer. Each key requires a great force to activate, so users must be aggressive and concise in order to complete an idea.

The printing press, ballpoint pen and desktop computer all represent great leaps in the technology of communication. Each of these benchmarks made the writing process easier, at least in terms of procedure. But perhaps something is lost when an intellectual endeavor becomes too facile. If we put less physical effort into writing, is there also a corresponding shift in mental effort?

Sledgehammer, installed in the public space of Linz's Main Square, gave passers-by the opportunity to vent their pent-up frustrations and work off their rage at poorly designed or malfunctioning technology.

Wie gewöhnliche Tastaturen kommuniziert auch das *Sledgehammer Keyboard* mit einem Computer – das Ungewöhnliche an dieser Installation liegt in der Erfahrung, die sie dem Benutzer vermittelt. Um seine Gedanken zu formulieren, muß der Benutzer die Tasten mit einem Hammer bearbeiten. Eine Taste zu aktivieren erfordert einen hohen Kraftaufwand; die Benutzer müssen also aggressiv und exakt zu Werke gehen, wenn sie einen Gedanken zu Ende führen wollen.

Die Druckerpresse, der Kugelschreiber und der Desktop-Computer stellen allesamt Quantensprünge der Kommunikationstechnologie dar. Jede dieser Errungenschaften hat uns – zumindest verfahrenstechnisch – den Vorgang des Schreibens erleichtert. Vielleicht aber geht so manches verloren, wenn einem ein intellektuelles Vorhaben allzu leicht gemacht wird. Wenn man zum Schreiben weniger Körperkraft aufwenden muss, nimmt dann nicht auch die geistige Anstrengung im selben Maß ab?

Sledgehammer, im öffentlichen Raum des Linzer Hauptplatzes installiert, gab Passanten die Möglichkeit, ihren Ärger über schlecht designte oder nicht funktionierende Technologie loszuwerden.

Aus dem Englischen von Susanne Steinacher

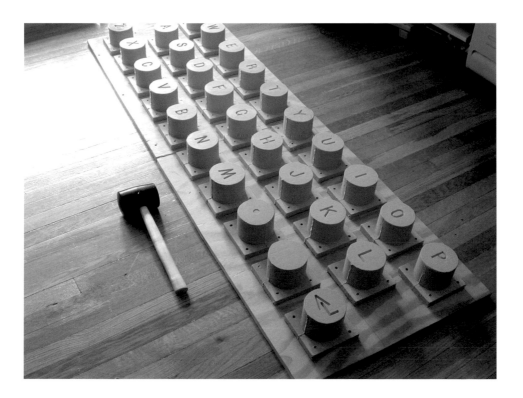

Christopher Rhomberg / Tobias Zucali

maschine-mensch

maschine-mensch is a project in which a computer reduces a human being to the status of a module hooked up to a machine. Computer-controlled electrical muscle stimuli deprive the human being of control over his own muscles. The human thus becomes the slave of the system that he had originally designed—a perversion of the human-machine relationship.

Over the course of human development, mankind has designed and constructed machines in order to exploit their productive capabilities. The machine's speed, the when and how of its operation, have always been determined by men. At the same time, though, humans have had no other choice but to subordinate themselves to the dictates of these repetitive, endlessly monotonous mechanical rhythms that men themselves set in motion.

What'll man do when he's controlled by the machine he himself created, when his subservience is completely his own doing?

What'll man do when he no longer has dominion over the machine but is instead reduced to its slave?

What'll man do when the machine ignores his will as something of no particular importance?

What'll man do when he's exploited by the machine as a tool? When his muscle-power is all that is of importance to the machine, and the rest is regarded as merely insignificant or, at most, a disruptive appendage?

When nothing that essentially defines man's humanity is of any remaining importance or relevance—neither will nor intellect?

Mankind will be relegated to the status of mob, to working trash, to a freely interchangeable replacement part. *maschine-mensch* is a project that takes this fundamental principle about as far as it'll go.

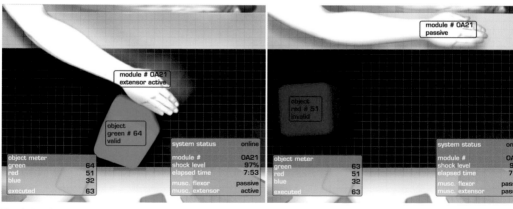

The electronic eye registers an object of the right color; the module is activated via muscle stimuli and it culls out the object.

The electronic eye registers an object of the wrong color; the module remains inactive.

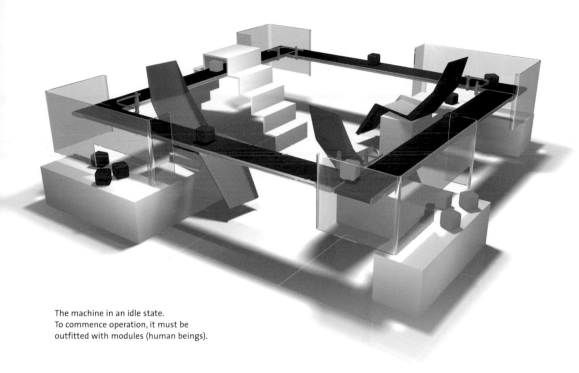

The machine in an idle state.
To commence operation, it must be
outfitted with modules (human beings).

The *maschine-mensch* project responds to these questions with an answer that can be directly experienced, and assigns control over the human subject to a fully automatic system.

The setup on which this experiment is being run is an abstracted assembly line on which electrical muscle stimuli activate three human beings to carry out sorting tasks. In doing so, they become nothing more than tiny, insignificant gears in the overall mechanism. A computer controls these human beings; its impulses override the commands of the human body's own nervous system. Resistance is pointless.

The computer determines when and how the humans' limbs are to be moved. Opting out of the system is impossible; burned out modules (interchangeable parts, i.e. human beings) are replaced only when it's necessary to eliminate further disruption of the production process. The man-machine relationship is perverted.

http://www.maschine-mensch.net

Prix Ars Electronica 2005, Award of Distinction [the next idea] art and technology grant.

Translated from German by Mel Greenwald

A commissioned work by Ars Electronica. Supported by the Arts Division of the Federal Chancellery, Austria. Additional support by: M. Hauser Medizintechnik, Haberkorn/Ulmer GmbH, Leopold Aumayr GmbH & Co KG, Transparent Design, Liska Bekleidung, Eurofoam GmbH. Special thanks to: Manfred Bijak and Monika Rakos / Center for Biomedical Engineering & Physics, University of Vienna, Vienna General Hospital. Composition: David Gottschalk. Realised in cooperation with Ars Electronica Futurelab / Gerald Priewasser, Katharina Nussbaumer.

Christopher Rhomberg / Tobias Zucali

maschine-mensch

maschine-mensch ist ein Projekt, bei dem der Mensch durch einen Computer auf ein Modul einer Maschine reduziert wird. Durch computergesteuerte elektrische Muskelstimulationen wird ihm die Kontrolle über seine Muskeln entzogen. Der Mensch wird zum Sklaven des einst von ihm entworfenen Systems. Das Verhältnis Maschine – Mensch wird pervertiert.

Die Menschheit hat im Laufe ihrer Entwicklung Maschinen entworfen und gebaut, um sich ihrer Leistungen zu bedienen. Die Geschwindigkeit der Maschine, das Wann und Wie, wurden seit jeher vom Menschen bestimmt. Gleichzeitig jedoch bleibt dem Menschen nichts anderes übrig, als sich dem von ihm selbst bestimmten, in ewiger Monotonie wiederholenden Rhythmus seiner Maschinen unterzuordnen.

> Was, wenn nun der Mensch von der Maschine kontrolliert wird, welche er selbst geschaffen, in deren Abhängigkeit er sich ganz von selbst gebracht hat?
>
> Was, wenn der Mensch, der Herr über die Maschine, fortan von der Maschine zum Sklaven reduziert wird?
>
> Was, wenn sein Wille von der Maschine als unerheblich ignoriert wird?
>
> Was, wenn der Mensch von der Maschine als Werkzeug benutzt wird? Wenn einzig seine Muskelkraft von Bedeutung für die Maschine ist – der Rest nur ein unbedeutendes, höchstens als störend befundenes Anhängsel darstellt?
>
> Wenn nichts, was den Menschen zum Mensch macht, von Bedeutung oder relevant bleibt, weder Wille noch Intellekt?
>
> Die Menschheit wird zum Mob diminuiert, zum „Working Trash", zum austauschbaren Verschleißteil. *maschine-mensch* ist ein Projekt, das dieses Grundprinzip auf die Spitze treibt.

Das Projekt *maschine-mensch* bietet eine erfahrbare Antwort auf diese Fragen und überantwortet einem vollautomatischen System die direkte Kontrolle über den Menschen.

Die Versuchsanordnung ist eine abstrahierte Fertigungsstraße, in der drei Menschen mittels elektrischer Muskelstimulationen Sortieraufgaben erfüllen müssen und dabei zu nichts anderem als winzigen, nicht weiter bedeutenden Rädchen im Getriebe werden. Ein Computer steuert diese Menschen, er überstimmt durch seine Impulse die körpereigenen Nervenbefehle – Widerstand ist zwecklos.

Wann und wie die Gliedmaßen bewegt werden sollen, bestimmt der Computer. Ein Ausstieg aus dem System ist nicht möglich – ausgebrannte Module (= Verschleißteile = Menschen) werden lediglich ausgetauscht, um den Produktionsablauf nicht weiter zu stören. Das Verhältnis Maschine – Mensch wird pervertiert.

http://www.maschine-mensch.net

Prix Ars Electronica 2005, Auszeichnung [the next idea] art and technology grant.

Eine Auftragsarbeit von Ars Electronica. Mit Unterstützung von Bundeskanzleramt / Kunstsektion, M. Hauser Medizintechnik, Haberkorn/Ulmer GmbH, Leopold Aumayr GmbH & Co KG, Transparent Design, Liska Bekleidung, Eurofoam GmbH. Spezieller Dank an Manfred Bijak und Monika Rakos / Zentrum für Biomedizinische Technik und Physik, Medizinische Universität Wien, AKH Wien. Komposition: David Gottschalk. Realisiert in Zusamenarbeit mit Ars Electronica Futurelab / Gerald Priewasser, Katharina Nussbaumer.

Sonja Meller

Wish Visuals—You Pick It, We Play It

The object of this game is to intensify the communicative, social aspect of public space by temporarily laying claim to a space and imparting a design to it in a very unconventional way. The players—all 100–200 of them—are issued little flags of different colors; they then form a square on a slope of Schloßberg, a hill overlooking Linz. Pedestrians on the nearby Nibelungen Bridge or in the Urfahr neighborhood will be invited to call in requests for patterns they'd like to see on Schloßberg. Here, they can select from a preset menu of colors and symbols, or they can come up with their own motifs. The players on Schloßberg then jointly attempt to visually implement the image, choosing the appropriate colors and waving the corresponding flags. Viewers observing from afar can see how the image gradually takes shape. If the pattern appears too vague and the players need some fine-tuning, passers-by can issue their advice via cell phone. The image is formed using relatively simple means; nevertheless, it constitutes a complex construction in light of the required coordination of so many participants.

Sonja Meller was born in Salzburg in 1971. She studied sculpture at the Linz University of Artistic and Industrial Design, and Interdisciplinary Social Science with a major in contemporary art at San Francisco State University. She has produced numerous art projects in Austria and abroad dealing with spatial, cultural and social facts and circumstances.

Translated from German by Mel Greenwald

Absicht dieses Spiels ist es, den kommunikativen und sozialen Aspekt im öffentlichen Raum zu intensivieren und diesen Raum auf unkonventionelle Art und Weise temporär in Anspruch zu nehmen und zu gestalten. Die Spieler – 100 bis 200 Personen – bekommen Fähnchen in unterschiedlichen Farben und positionieren sich zu einem Quadrat an einem Hang am Schlossberg. Passanten, die sich auf der Nibelungenbrücke bzw. in Urfahr befinden, werden eingeladen, per Anruf ihr Wunschmotiv auf den Schlossberg zu kommunizieren. Sie können dabei aus einem Menü an Farben und Symbolen wählen oder sich ihr eigenes Motiv zusammenstellen. Die Spieler am Schlossberg versuchen dann gemeinsam, das Bild visuell umzusetzen. Die entsprechenden Farben müssen gewählt bzw. die jeweiligen Fähnchen geschwungen werden. Aus der Entfernung kann nun beobachtet werden, wie sich das Bild nach und nach zusammensetzt. Sollte das Motiv zu vage erscheinen und zusätzlicher Anweisungen bedürfen, können diese von dem Passanten / der Passantin per Telefon vermittelt werden. Während die Umsetzung mit relativ einfachen Mitteln erfolgt, stellt sie ein komplexes Gefüge hinsichtlich des Zusammenspiels aller Mitwirkenden dar.

A joint project by *architekturforum oberösterreich* and Ars Electronica.

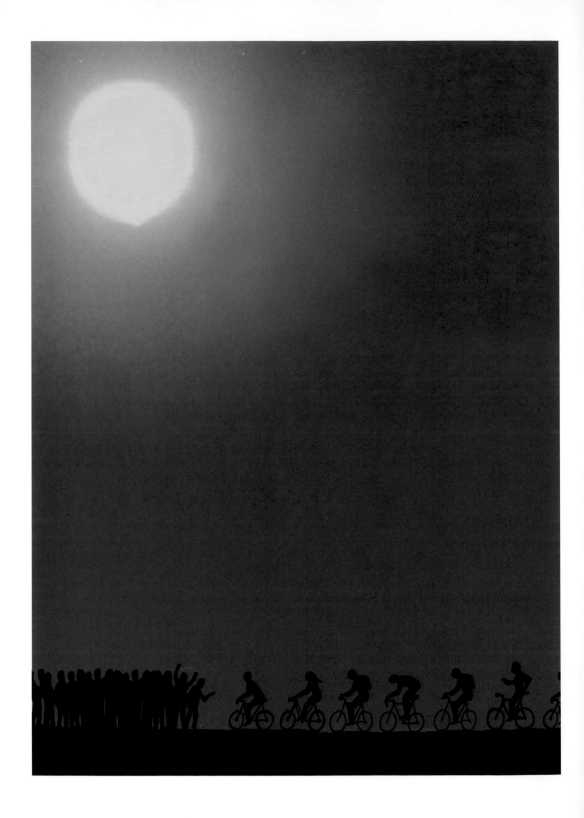

Assocreation

Moon Ride

Over the course of the day, cyclists will be convening on Linz's Main Square for a "Moon Ride." They'll hook up their bikes to one of the countless generators set up there waiting for them to provide the muscle power needed to charge a giant battery. Each revolution of every set of pedals moves the battery charge indicator a little closer to full. After nightfall, the stored energy is used to light up an enormous balloon floating above the cityscape. This discharging process will be visible for miles and can last until the wee hours of the morning.

At a prearranged time after sundown, the cyclists' output will be switched directly to the balloon; the harder they pedal, the brighter the artificial moon glows in the night sky. The humming of the muscle-powered generators will spread out a blanket of sound across the square as the spectacle is played out: onlookers cheering the bikers on to higher and higher performance until the human dynamos, speeding at the brink of exhaustion, bring the balloon to the peak of illumination.

Moon Ride is a sensory encounter with the myths and rites of our light-and-sound-dominated e-culture. At the same time, it's a minimalist reflection of our electronic world that makes visible the charging and discharging processes inherent in everyday life.

Although pedaling a stationary bike is a sight more typical of a health club, the manifestation of a prosperous society and a me-culture of wellness, the participants delivering the force that drives this human power plant will be organized like industrial laborers. They form a mighty human battery to combine their output as individuals. This confluence, this visual fusion of the physical exertions of many, brings about a communal experience borne by the pure joy of taking part in a physical act of power and making an oversized source of light glow like a supernova. This is a form of electronic-industrial mass-level gratification whose climax is the final illumination of the balloon.

Translated from German by Mel Greenwald

A commissioned work by Ars Electronica. Supported by the Arts Division of the Federal Chancellery, Austria. Additional support by: Robert Bosch AG, ICC International Cycle Connection B.V., Meinhart Kabel GmbH, Donau Touristik GesmbH. Special thanks to E-Tech, Linz for the technical support. In collaboration with Ars Electronica Futurelab (Robert Abt und Stefan Mittelböck)

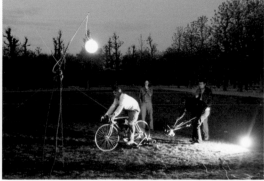

Assocreation

Moon Ride

Untertags schließen sich vorbeifahrende Radfahrer am Linzer Hauptplatz zu einem *Moon Ride* zusammen. Sie spannen ihre Räder in unzählige bereitgestellte Generatoren ein und laden mit ihrer Muskelkraft einen großen Akku auf. Jeder Tritt in die Pedale zeichnet sich auf einer Ladestandsanzeige ab. In der Nacht bringen die gespeicherten Passantenströme einen großen, über den Dächern der Stadt schwebenden Ballon zum Leuchten. Dieser weithin sichtbare Entladungsprozess kann bis in die frühen Morgenstunden dauern.

Zu einem festgelegten Zeitpunkt in der Abenddämmerung wird die Leistung der strampelnden Radfahrer direkt auf den Ballon geschalten, der sich mit zunehmender Tretleistung immer stärker als künstlicher Mond am dunklen Nachthimmel abzeichnet. Das Surren der durch Muskelkraft angetriebenen Generatoren spannt einen Soundteppich über den Platz. Die Zuschauer treiben bei dem Spektakel die Akteure zu immer mehr Leistung an, bis das zur Erschöpfung getriebene Menschenkraftwerk den Ballon in voller Leuchtkraft erstrahlen lässt.

Moon Ride ist eine sinnliche Auseinandersetzung mit den Mythen und Riten der von Licht und Ton dominierten E-Culture. Er ist zugleich ein minimalistisches Spiegelbild unserer elektronischen Welt, das Ladungs- und Entladungsvorgänge im Alltag sichtbar macht.

Während das Radeln am Stand eine typische Erscheinung im Fitnesscenter und Ausdruck der Wellness- und Wohlstandskultur ist, so werden die Teilnehmer bei diesem Menschenkraftwerk wie Arbeiter industriell organisiert. Sie bilden eine menschliche Batterie, um ihre einzelnen Leistungen zusammenzuschließen. Der Zusammenfluss, diese sichtbare Verschmelzung körperlicher Anstrengungen vieler, bewirkt ein gemeinschaftliches Erlebnis, getragen von der Freude, an einem physikalischen Kraftakt teilzunehmen und eine große Lichtquelle zum Leuchten zu bringen. Es ist eine Form von elektronisch-industrieller Massenbefriedigung, bei dem das finale Aufleuchten des Ballons den Höhepunkt verkörpert.

Eine Auftragsarbeit von Ars Electronica. Mit Unterstützung von Bundeskanzleramt / Kunstsektion, Robert Bosch AG, ICC International Cycle Connection B.V., Meinhart Kabel GmbH, Donau Touristik GesmbH. Spezieller Dank an E-Tech, Linz für die technische Unterstützung. In Zusammenarbeit mit Ars Electronica Futurelab (Robert Abt, Stefan Mittelböck).

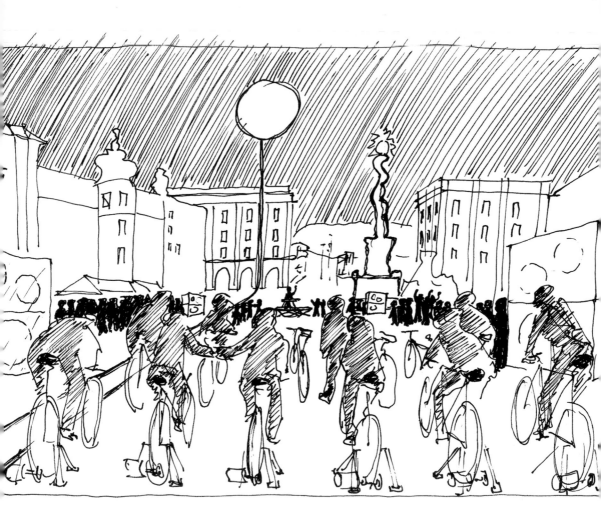

Mathias Stich

HyperWerk

nomadix: interaction on the move!

The touring exhibition *nomadix: interaction on the move!* was created in 2005 at Institute HyperWerk HGK FHNW, and premiered at the World Summit on the Information Society in Tunis.

The most striking features of *nomadix* are its form of projection and its software. The projection system consists of a video beamer mounted on an adjustable tripod head; it projects its images into an inflated, conical sack made of balloon silk set up in front of the lens. The beamer projects its image into this cloth sack, whereby the image then appears as a rear-projection picture on the front side of the "cone."

nomadix consists of several of these systems, referred to as cones. Such a cone can be one-and-a-half to seven meters long. When several cones are arrayed together, the result is a new level of expression: the cones can converse with one another; they can form a space round about the installation visitors, surrounding or separating them; and when the cones are in the mood, they can even join together and dance the can-can. The invention of the cones represents the creation of a new means of expression: the moving moving-picture. In recent months, we've been putting the cone into action in a wide variety of ways and settings in an attempt to explore its potential.

We were given the assignment of developing a mobile exhibition system; this is our approach to a solution. This exhibition, which has been touring France, Tunisia and Switzerland over the last year, showcases 20 interaction-related degree projects by HyperWerk students. The guidelines were clearly stipulated: the entire system could not to weigh more than 300 kilograms; setup/dismantling should be quick and easy; and it was to be suitable for use in exhibition spaces

ranging from 70 to 250 square meters. Needless to say, our agenda also included a wish for the system to function as a sort of roving ambassador exemplifying HyperWerk's innovativeness and media competence.

The creation of vvvv, an ultra-high-performance virtual programming environment developed by MESO and free for non-commercial use, has made available a user-friendly media management system that makes it possible to play video clips and three-dimensional scenes on any number of cones. The adjustment of the robotic components in the tripod heads, the overall choreography and synchronization of motion and imagery, as well as the linkup of the individual cones with one another were also accomplished with vvvv.

We've already tested a wide variety of ways to use our cones, only to come to the conclusion that we've barely scratched the surface and that there's still a lot of potential left to explore. One interesting question, for example, is what a language of movement and interaction for the cones might look like. How would it interrelate with the projected content? Students enrolled in this institution's interdisciplinary and project-oriented BA program conceive, design, test and market tools and processes for implementation under post-industrial circumstances.

http://hyperwerk.ch

Translated from German by Mel Greenwald

As a mobile image projection system, this project was set up at several venues of the
Ars Electronica Festival 2006.

Participants: Alain Simon, Andreas Golinki, André Freiermuth, Andreas Krach, Angelika Overath, Anna Ackermann, Barbara Luem, Beat Räber, Besim Neziri, Catherine Walthard, Christian Reimann, Christian Schumacher, Christian Zuleger, Christina Hagmann, Christof Bütler, Corinne Petitjean, Cristoffel Gehring, Dana Wojciechowski, Daniel Hug, Dionys Borter, Dominik Seitz, Doris Traubenzucker, Elena Mores, Fabian Schweizer, Jan Voellmy, Jinglei Zhang, Joreg, Julie Labhardt, Karin Wichert, Lars Henning, Luca Vicente, Lucas Gross, Lukas Meyer, Marc Tamschick, Marco C. Deppeler, Marco Jann, Markus Abt, Marlon Schaffner, Martin Fleck, Martin Schaffner, Martin Sommer, Mathis Meyer, Matthias Gommel, Matthias Pfäffli, Matthias Stich, Max Spielmann, Mischa Schaub, Moritz Salathé, Nadja Tarnutzer, Nathalie Laissue, Nelly Riggenbach, Nicole Boillat, Paolo Donnicola, Peter Whinyates, Raoul Flaminzeanu, Rasso Auberger, Regine Halter, Renato Soldenhoff, Roman Borer, Sabine Fischer, Samuel Ruckstuhl, Sandra Schafroth, Sebastian Oschatz, Simon Hänggi, Tammo Trantow, Thomas Martin, Tian Lutz.
Nomadix 2, Participants: Markus Abt, Jan Dusek, Leander Herzog; Coach: David Dessens aka Sanch

Mathias Stich

Mathias Stich

nomadix: interaction on the move!

Die Wanderausstellung *nomadix: interaction on the move!* ist 2005 im Institut Hyper-Werk der Basler HGK entstanden und erstmals am Weltgipfel zur Informationsgesellschaft in Tunis gezeigt worden.

nomadix zeichnet sich durch seine Projektionsform und durch seine Software aus. Das Projektionssystem besteht aus einem ansteuerbaren Stativkopf, auf dem ein Videobeamer befestigt ist, vor dessen Linse wiederum ein aufgeblasener, konischer Stoffsack aus Ballonseide hängt. In diesen Stoffsack wirft der Beamer sein Bild, das dann als Rückprojektion auf der Vorderseite des „Cones" auftaucht.

nomadix besteht aus mehreren solcher Cone-Systeme. Ein Cone kann eineinhalb bis sieben Meter lang sein. Stehen mehrere dieser Cones zusammen, entsteht eine neue Ausdrucksebene – die Cones können sich dialogisch unterhalten, sie können um die ZuschauerInnen herum einen Raum bilden, sie dabei einschließen oder trennen, und wenn den Cones danach ist, dann können sie auch noch gemeinsam einen Can-Can tanzen. Mit den Cones ist ein neues Ausdrucksmittel entstanden: das bewegte Bewegtbild. In den letzten Monaten haben wir versucht, mit vielen unterschiedlichen Einsatzformen ihr Potenzial herauszufinden.

Aus der Aufgabenstellung, ein mobiles Ausstellungssystem zu entwickeln, ergab sich unser Lösungsansatz. Mit dieser Ausstellung haben wir 20 Projekte zu Fragen der Interaktion, die im HyperWerk als Diplomarbeiten entstanden waren, im letzten Jahr auf die Reise durch Frankreich, Tunesien und die Schweiz geschickt. Die Rahmenbedingungen waren klar – das gesamte System sollte nicht mehr als 300 Kilogramm wiegen, es sollte einfach und rasch auf- und abbaubar sein, und es sollte Ausstellungsräume zwischen 70 bis 250 Quadratmetern bespielen können; wünschenswert war natürlich auch, dass das System unser Anliegen, als innovatives Institut im Medienbereich aufzutreten, transportieren sollte.

Mit der äußerst leistungsfähigen, visuellen Programmierumgebung vvvv, entwickelt von MESO und frei im nichtkommerziellen Einsatz, wurde ein einfach zu bedienendes Medienverwaltungssystem eingerichtet, das das Abspielen von Videoclips und dreidimensionalen Szenen auf einer beliebigen Zahl von Cones ermöglicht. Die Ansteuerung der robotischen Komponenten in den Stativköpfen, die Gesamtchoreografie und Synchronisation von Bewegung und Bild sowie die Vernetzung der Cones untereinander, wurden ebenfalls mit vvvv realisiert.

Wir haben bereits die unterschiedlichsten Einsatzformen unserer Cones erprobt, doch wir merken, dass das Potenzial noch sehr viel größer sein dürfte; wir haben erst an der Oberfläche gekratzt. Wir fragen uns beispielsweise, wie eine Bewegungs-und Interaktionssprache für die Cones aussehen könnte? Wie verhält sie sich zum projizierten Inhalt? In unserem interdisziplinären und projektorientierten Studiengang konzipieren, gestalten, erproben und vermarkten wir Werkzeuge und Prozesse für postindustrielle Verhältnisse.

http://hyperwerk.ch

Als nomadischer Bildträger kam das Projekt an mehreren Schauplätzen des
Ars Electronica Festival 2006 zum Einsatz.

Aram Bartholl

Random Screen

Random Screen is a mechanical thermodynamic screen that the user can't control and that functions without any electricity. Conventional tea candles illuminate and generate the changes on the 4x4 pixel screen.

This work is one of a series of low-tech screen projects that was originally inspired by the *Blinkenlights* media façade of the Chaos Computer Club in Berlin. The predecessor of *Random Screen* is the *Papierpixel* project in which a manual screen was controlled by a punched tape system that had to be pre-programmed by hand. *Random Screen* takes the reduction of the electronics one step further. The pixels become independent and fire goes digital.

Each individual pixel of *Random Screen* is an independent unit. Core components are a projection foil, a modified beer can and a small tea candle. The candle serves as a source of light; at the same time, the warmth it gives off sets the modified beer can in motion. The can, modified into a sort of freely rotating fan mounted above the candle, can spin around freely. The candlelight shines through a window cut in the beer can onto a projection surface and makes the pixel light up. Depending on how fast the fan spins, it gently turns the respective pixel either on or off. The larger the candle's flame, the brighter the pixel shines and the faster its switching frequency. The candlelight is diffused on a second projection foil in the middle of the pixel box in order to generate as little shadow-flickering as possible on the projection surface. The individual pixel boxes stacked on top of and next to one another form the *Random Screen*. The modularity of the pixels allows the screen surface to be expanded at will, and this construct's simple components make it easy for others to copy.

Translated from German by Mel Greenwald

Random Screen ist ein mechanischer thermodynamischer Bildschirm, der nicht steuerbar ist und vollkommen ohne Elektrizität auskommt. Zur Beleuchtung und Steuerung des vier Mal vier Pixel großen Screens kommen herkömmliche Teelichter zum Einsatz.

Die Arbeit ist Teil einer Reihe von Low-Tech-Screen-Projekten, die ursprünglich von der Medienfassade Blinkenlights des Chaos Computer Clubs Berlin CCC inspiriert wurden. Vorläuferprojekt der Arbeit Random Screen ist das Projekt Papierpixel. Gesteuert wird dieser manuelle Bildschirm über ein Lochstreifensystem, welches vorher von Hand programmiert werden muss. Random Screen geht in der Reduktion der Elektronik noch einen Schritt weiter: Die Pixel verselbstständigen sich, und das Feuer wird digital.

Jeder einzelner Pixel von Random Screen ist eine eigenständige Einheit. Kernbestandteile sind eine Projektionsfolie, eine modifizierte Bierdose und ein Teelicht. Die Kerze dient als Lichtquelle und versetzt gleichzeitig mit ihrer aufsteigenden Wärme die zweckentfremdete Bierdose in Bewegung. Diese dreht sich, zu einer Art Ventilator umgebaut, frei gelagert über der Kerze. Das Licht der Kerze fällt durch ein Fenster in der Dose auf die Projektionsfläche und lässt den Pixel erleuchten. Je nach Geschwindigkeit der Drehbewegung schaltet sich der jeweilige Pixel in einem sanften Ein- und Ausblenden an und aus. Je größer die Flamme der Kerze ist, umso heller leuchtet der Pixel und umso schneller ist seine Schaltfrequenz. Das Licht der Kerze wird auf einer zweiten Projektionsfolie in der Mitte der Pixelbox diffusiert, um möglichst wenig Schattenbewegung auf der Projektionsfläche zu erzielen. Die einzelnen Pixelboxen bilden aufeinander gestapelt zusammen den Random Screen. Die Modulhaftigkeit der Pixel ermöglichen eine beliebig große Screenfläche und lädt mit ihren einfachen Komponenten zum Nachbau ein.

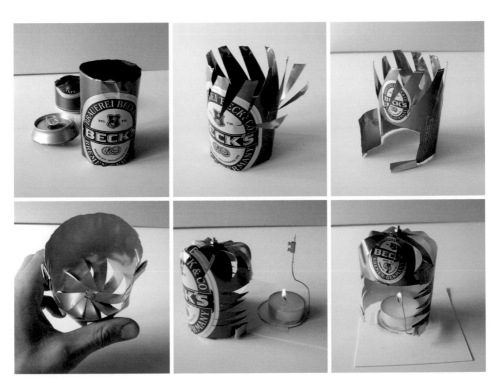

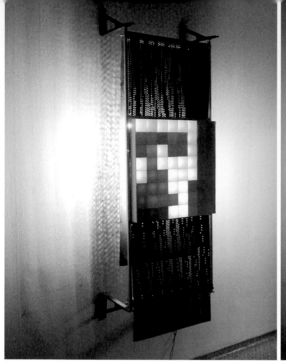
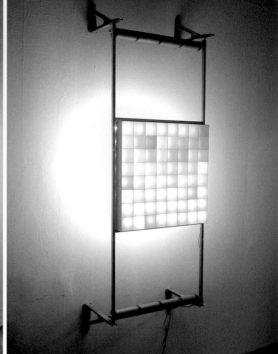

Aram Bartholl

Papierpixel

Papierpixel (Paper Pixel) is an 8x8 pixel screen that's controlled manually via a punched-card system. Each of the 64 pixels on the 50x50 cm projection surface on the front side of the screen is constantly illuminated by an equal number of light bulbs on the back side of the screen. Activating the individual pixels is done by a wide strip of paper pre-programmed with punched holes that runs between the pixel projection surface and the light source. The 64 tracks on this oversized punched-card determine whether a pixel is turned on or off. The light from the bulb is obscured until a hole pre-punched in the strip of paper appears before it and lets the light shine through and briefly illuminate the pixel. To make it possible for the 64 pixels to be controlled independently of one another, the light bulbs are arranged in the direction the punched strip of paper runs in obliquely alternating rows of pixels. The speed with which the programmed paper is pulled by hand through the screen determines the number of frames per second of the particular film sequence being shown.

An oversized hole puncher is used as a programming device; the paper strip to be programmed is pulled through it. The upper part of the sandwich plate contain 64 sharp steel pins that, when they're depressed by hand, each punches a hole in the paper strip and is held in position by a steel spring. Frame by frame, the desired pixels can be activated (i.e. the steel pins can punch holes in the paper in the appropriate spots). The film sequence can be of any length, whereby, for example, it takes three meters of paper to show a 300-frame film sequence. This three-meter-long punched strip can be connected at both ends to form a loop. For longer sequences, the paper strip is rolled up and run from an upper reel to a lower one just like an analog film.

Translated from German by Mel Greenwald

Papierpixel ist ein 8 mal 8 Pixel großer Bildschirm, der manuell über ein Lochkartensystem gesteuert wird. Jeder der 64 Pixel auf der 50 mal 50 Zentimeter großen Projektionsfläche an der Vorderseite des Bildschirms wird konstant mit ebenso vielen Glühbirnen von der Rückseite her beleuchtet. Zur Schaltung der einzelnen Pixel wird zwischen der Pixelprojektionsfläche und der Lichtquelle ein mit Löchern vorprogrammierter Papierstreifen durchgezogen. Auf 64 Spuren steuert diese überdimensionale Lochkarte, ob ein Pixel an oder ausgeschaltet wird. Das ansonsten verdeckte Licht der Glühbirnen fällt hierbei durch ein vorher gestanztes Loch im Papierstreifen und erleuchtet den Pixel für kurze Zeit. Damit die 64 Pixel unabhängig von einander angesteuert werden können, sind die Glühbirnen in der Laufrichtung des Papiers in einer Pixelreihe versetzt angeordnet. Die Geschwindigkeit, mit der das programmierte Papier von Hand durch den Bildschirm gezogen wird, bestimmt am Ende die Anzahl der Frames pro Sekunde der betreffenden Filmsequenz.

Als Programmierinterface kommt ein überdimensionaler Lochapparat zum Einsatz, durch die der zu programmierende Papierstreifen gezogen wird. In dem oberen Teil der Sandwichplatte stecken 64 geschärfte Stahlstifte, die, von Hand gedrückt, jeweils ein Loch im Datenträger hinterlassen und von Stahlfedern in Position gehalten werden. Frame für Frame können die gewünschten Pixel aktiviert bzw. das Papier an den entsprechenden Stellen mit den Stahlstiften gelocht werden. Die Länge einer Filmsequenz ist beliebig, wobei z. B. drei Meter Papierstreifen einer Filmsequenz mit 300 Frames entsprechen. Diese drei Meter lange Lochkarte kann zu einem Loop zusammen montiert werden. Längere Sequenzen werden wie beim analogen Film aufgerollt und von der oberen zu unteren Spule gespielt.

PAPIERPIXEL

Jonathan den Breejen / Marenka Deenstra

The PingPongPixel

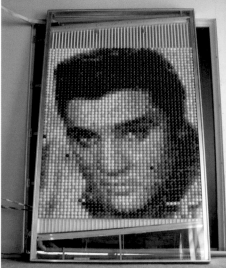

Public spaces are increasingly invaded by commercial display-systems, predominantly in the form of adverts or public information displays.

Providing information to people in the most efficient and fastest way has always been the main purpose of display-systems. *PingPongPixel* is an alternative system that stands in contrast to these display-systems. It competes for attention merely by its slow, basic and entertaining way of presenting information.

The PingPongPixel is an interactive non-luminescent display-system, that consists of 8100 table tennis balls in 6 grey tones, so it can display portraits using table tennis balls as pixels. The spectator can have his/her portrait loaded onto the screen.

The installation consists of 2 units. The first is the display unit, the other one is the cabinet where the table tennis balls are stored and from which they are dispensed.

The display unit is about two by three meters; the produced picture is approx. 2,40 meters high by 1,80 wide! One pixel is 38 millimeters. Each image is built out of 2700 tennis table balls in 6 grey tones!

The system works as following: When an image is shown, the lowest line will fall away so that the whole image moves one row down. This row of balls is transported back, by air, to the storage cabinet and sorted back into their color-specific basket. By dispensing 45 new balls in the right order a new line is formed. This line is blown to the top of the display screen, and dropped onto the balls that are already visible. This goes on until a new picture is fully visible. The portrait is then visible for a couple of minutes. Then the new image is built up as mentioned before, this way there is always something to see! Simple, almost like a matrix printer.

With many thanks to: Paul Jansen Klomp, Alex Geilenkirchen, Koen Koevoets & Comhan Holland

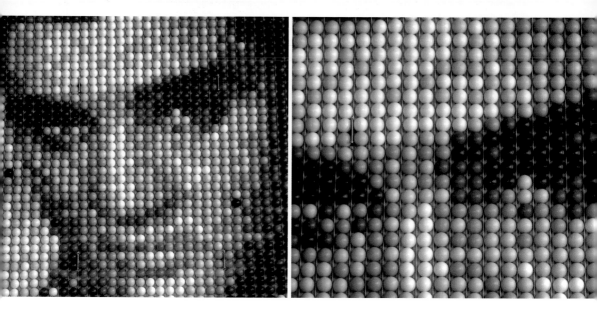

Öffentliche Räume erleben eine Invasion kommerzieller Anzeigesysteme, die in erster Linie Werbe- und öffentlichen Informationszwecken dienen.

Stets war der Zweck solcher Anzeigesysteme, Informationen den Menschen möglichst effizient und schnell zur Verfügung zu stellen. *PingPongPixel* steht in krassem Gegensatz zu diesen Displays. Es versucht ausschließlich durch seine langsame, simple und unterhaltsame Form der Informationsdarbietung die Aufmerksamkeit zu erregen.

The PingPongPixel ist ein interaktives, nicht-leuchtendes Anzeigesystem, das mithilfe von 8.100 Tischtennisbällen in sechs Graustufen, die als Pixel dienen, Porträts darstellen kann. Der Betrachter kann sich sein Konterfei auf die Anzeigetafel laden.

Die Installation besteht aus zwei Einheiten – der Anzeigeneinheit und dem Schrank, in dem die Tischtennisbälle gelagert bzw. aus dem sie ausgeteilt werden.

Die Anzeige ist ca. zwei mal drei Meter groß, und das dargestellte Bild hat ungefähr die Maße 2,40 mal 1,80 Meter. Ein Pixel hat einen Durchmesser von 38 Millimeter und jedes Bild besteht aus 2.700 Tischtennisbällen in sechs Graustufen.

Das System funktioniert folgendermaßen: Wird bereits ein Bild angezeigt, so fällt die unterste Reihe weg, und das gesamte Bild rutscht um eine Zeile nach unten. Die Bälle werden per Gebläse zurück in den Speicher transportiert und in den jeweiligen Farbkorb sortiert. 45 neue Bälle werden in die richtige Reihenfolge gebracht und als oberste Reihe in die Anzeige geblasen, wo sie auf den bereits vorhandenen Bällen zum Liegen kommen. Dies wird solange wiederholt, bis das neue Porträt fertig ist, das dann ein paar Minuten sichtbar bleibt. Anschließend wird auf die eben beschriebene Weise das nächste Bild generiert, so dass immer etwas zu sehen ist. Einfach – fast wie ein Matrixdrucker.

Aus dem Englischen von Michael Kaufmann

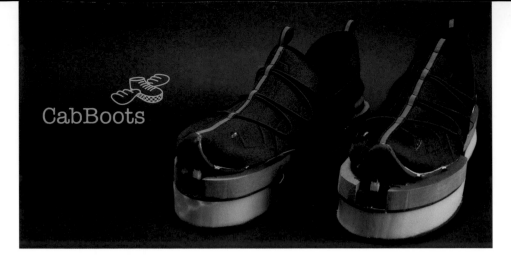

CabBoots

Martin Frey

CabBoots
Shoes with an Integrated Navigation System

CabBoots is a concept for an innovative interface with a pedestrian navigation system. The information transmission process can be perceived tactilely, is intuitively understandable, and is applied to the part of the body most directly involved in the act of walking: the foot. The applied communications metaphor is familiar to all; it's something that everyone who's ever walked along a well-trodden path is aware of. It functions astoundingly well in this new application.

Conventional navigational devices normally communicate with the user on the acoustic and visual levels. *CabBoots* pursues a more intuitive mode of information delivery: the feedback is tactilely perceptible. Here, *CabBoots* utilizes the faculty of kinesthetic perception present in the entire foot and ankle, and thus takes advantage of a simple principle that everyone absorbs as part of the process of learning to walk.

Paths on a natural surface-soil, for instance-usually have a concave cross-section. When you walk along such a well-trodden path, your feet come down on a flat surface only right in the middle of the trail. Veering over to the edge of the path, they land on a slight outward slope that causes the ankle to be angulated slightly. While walking, the body registers this angulation and intuitively compensates by steering back towards the middle. This actually allows you to walk the path "blind."

Electromechanical elements in the sole of the *CabBoots* can produce an artificial angulation of the shoes and, thereby, of the foot. The resulting oblique posture of the foot is difficult to distinguish from the real thing. Individual and virtual paths can thus be communicated via the shoe. Tests with a prototype have shown that the principle of walking a well-trodden path also functions on a virtually-generated topography. A decisive advantage accrues from the intuitive perception of the directions given: channels of communication like seeing and hearing are not involved and thus remain available to receive stimuli from other sources.

In the initial prototype, tiny flaps were used to generate the path. In future models, it would be preferable to replace them with pneumatic activators or ones based on electrorheological fluids. The software to determine the wearer's position and calculate the subsequent path could run on a mobile device like a cell phone or PDA that can communicate wirelessly with the shoe. Needless to say, *CabBoots* could also be a great help to people with visual impairments.

Translated from German by Mel Greenwald

Martin Frey

CabBoots
Schuhe mit integriertem Leitsystem

CabBoots ist das Konzept für ein neuartiges Interface eines Leitsystems für Fußgänger. Die Informationsvermittlung ist taktil spürbar, intuitiv verständlich und setzt an dem Körperteil an, der direkt am Gehen beteiligt ist: am Fuß. Die angewandte Kommunikationsmetapher ist allgemein bekannt, da man sie bereits vom Gehen in Trampelpfaden kennt. Sie funktioniert erstaunlich gut in der neuen Anwendung.

Herkömmliche Navigationsgeräte kommunizieren mit dem Nutzer in der Regel auf akustischer und visueller Ebene. *CabBoots* verfolgt eine intuitivere Informationsvermittlung: Das Feedback ist taktil wahrnehmbar. *CabBoots* greift dabei auf die im gesamten Fuß und dem Fußgelenk erfahrbare kinasthetische Wahrnehmung zurück. Verwendung findet hier ein einfaches, bereits mit dem Gehen erlerntes Prinzip.

Wege auf naturbelassenem Untergrund haben meist eine konkav ausgetretene Oberfläche. Geht man nun entlang eines solchen Trampelpfades, so setzen die Füße lediglich in der Mitte des Weges plan auf. Nähert sich ein Fuß der Begrenzung des Pfades, erzeugt die Wölbung zum Rand hin eine leichtes Anwinkeln des Fußes. Dieser Winkel wird beim Gehen wahrgenommen – man steuert intuitiv gegen und kann damit „blind" den Pfad entlanglaufen.

Elektromechanische Elemente in der Sohle der *CabBoots* können das Anwinkeln des Schuhs und damit des Fußes künstlich erzeugen. Die im Schuh entstehende Schräge ist von einer real vorhandenen kaum zu unterscheiden. Individuelle und virtuelle Pfade können somit über den Schuh kommuniziert werden. Versuche mit einem Prototypen haben gezeigt, dass das Prinzip des „Gehens in einem Trampelpfad" auch auf der virtuell erzeugten Topografie funktioniert. Ein entscheidender Vorteil liegt in der intuitiven Wahrnehmung der Leitanweisungen: Kommunikationskanäle wie das Sehen und Hören sind unberührt und stehen daher für andere Reize offen.

Zur Generierung des Pfades kommen im ersten Prototypen kleine Klappen zum Einsatz. Diese würden zukünftig vorzugsweise durch pneumatische oder auf elektrorheologische Flüssigkeiten basierende Aktoren ersetzt. Die Software zur Positionsbestimmung und Pfadberechnung könnte auf mobilen Geräten wie Handy oder PDA laufen, die per Funk mit den Schuhen kommunizieren. Selbstverständlich könnten *CabBoots* auch für sehbehinderte Menschen sehr hilfreich sein.

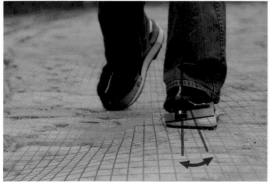
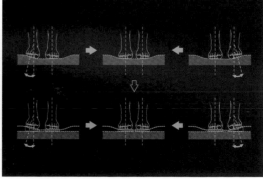

Gerhard Dirmoser / Dietmar Offenhuber

SemaSpace

SemaSpace is a fast and easy to use graph editor for large knowledge networks, and the result of a collaboration between Dietmar Offenhuber and Gerhard Dirmoser. It helps with the creation of interactive graph layouts in 2d and 3d space. The system is powerful enough for the realtime calculation of complex networks and can incorporate additional data such as images, sounds and full texts.

Semantic networks have become a general paradigm for knowledge representation beyond their traditional application in science and technology. Under the phrase of the iconic turn a shift from linear textual narration to diagrammatic reasoning has been taking place. Disciplines like art history, image science and philosophy increasingly use semantic networks and diagrammatic methods in their work.

Gerhard Dirmoser creates complex large-scale wall diagrams on topics like 25 years of Ars Electronica, influenced by the renaissance model of the memory theatre. All information in these diagrams, which often contain more than 10,000 text-fields, has been acquired and organized in a manual fashion. While the special form of organization of this data in radial clusters can still be done manually, it is not feasible for the creation of semantic networks with a similar level of complexity.

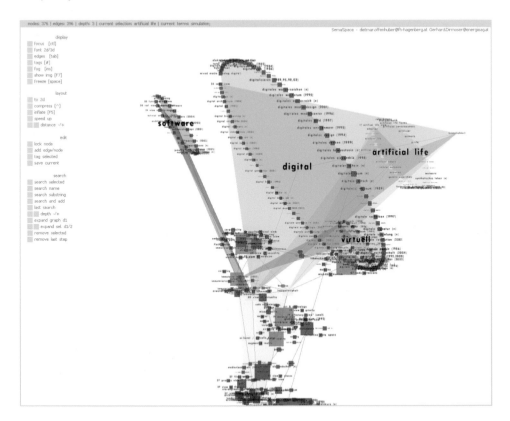

While many systems have been developed for the display and the analysis of semantic networks, existing tools are often not appropriate for assisting this process. *SemaSpace* has been designed to aid the development, evaluation and navigation of complex semantic networks in a graphical, sensual way. *SemaSpace* fills the gap between complex tools for network analysis and simple graph editors or mind-mapping tools. It is powerful enough to handle complex graphs, maintaining a maximum of performance by keeping everything as simple as possible. It creates a browse- and readable data-space in both 2-D and 3-D; different media assets such as sounds, images, URLs or full texts attached to individual nodes can be included and displayed within the network.

SemaSpace ist ein schneller und benutzerfreundlicher Diagrammeditor zur Visualisierung komplexer semantischer Netze, der von Dietmar Offenhuber und Gerhard Dirmoser entwickelt wurde. Der Editor unterstützt die Erstellung von interaktiven zwei- oder dreidimensionalen Diagrammen. Das System erlaubt die Berechnung komplexer Netzstrukturen in Echtzeit und die Integration von zusätzlichen Daten wie Bildern, Klängen und Volltexten.
Semantische Netze sind über ihre Verwendung in Wissenschaft und Technik hinaus zum Paradigma der Wissensrepräsentation geworden. Unter dem Schlagwort der „ikonischen Wende" ist ein Übergang vom linearen, textbasierten Narrativ zur diagrammatischen Darstellung zu verzeichnen. Disziplinen wie Kunstgeschichte, Bildwissenschaft und Philosophie nutzen vermehrt semantische Netze und diagrammatische Methoden.
In Anlehnung an das Gedächtnistheater der Renaissance gestaltete Gerhard Dirmoser riesige Wanddiagramme zu Themen wie „25 Jahre Ars Electronica". Alle Informationen in diesen Diagrammen, die oft mehr als 10.000 Textfelder enthalten, wurden manuell recherchiert und organisiert. Während diese Daten weiter manuell in radialen Begriffsclustern strukturiert werden können, wäre dies für die Schaffung von ähnlich komplexen semantischen Netzen nicht denkbar. Für die Darstellung und Analyse semantischer Netze wurden verschiedene Systeme entwickelt, da gängige Diagrammeditoren diese Funktionen meist nicht unterstützen. *SemaSpace* erlaubt die Veranschaulichung des Aufbaus und die Evaluierung komplexer semantischer Netze auf „sinnliche" Weise sowie die Navigation in diesen. Das Programm schließt die Lücke zwischen komplexen Systemen zur Netzwerkanalyse und einfachen Grafikeditoren oder Mind-Mapping-Programmen. *SemaSpace* kann auch komplexe Grafiken bewältigen und garantiert durch einfache Strukturen maximale Leistung. Das Programm erzeugt einen lesbaren und mit Browsern durchsuchbaren 2D- oder 3D-Datenraum; verschiedene an einzelnen Knotenpunkten angeschlossene Medien (Bild-, Klangdateien, URLs, Volltexte) können integriert und im Netz dargestellt werden.

Aus dem Englischen von Sonja Pöllabauer

Markus Decker / Dietmar Offenhuber

from dust till dawn
Installation for Empty Urban Spaces

The dust and atmosphere of empty urban spaces constitute the medium of interaction in this initial experimental setup. A grid of laser lines just above the ground produces an initially invisible, contiguous light surface. Objects and particles that break through this surface—for instance, dust, cigarette smoke or larger objects-are highlighted by the laser and become visible as a surface or an outline. The outlines and dust patterns are registered, and an XY-grid synthesizer turns their two-dimensional movements into dust pattern sounds. Each step a visitor takes—indeed, visitors' mere physical presence-sets the air into motion and causes dust to swirl up. What this actually represents is a fragile interaction medium that is exceedingly difficult to control, and one that eliminates the non-binding aspect from the concept of tangible media. We strongly advise against wearing clothes that would be adversely affected by contact with dirt.

Translated from German by Mel Greenwald

In cooperation with servus.at; Thanks to Manfred Grillnberger and KunstRaum Goethestrasse

Markus Decker / Dietmar Offenhuber

from dust till dawn
Anordnung für urbane Leerräume

Der Staub und die Atmosphäre leer stehender Räume bilden das Interaktionsmedium des ersten Versuchsaufbaus. Ein knapp über dem Boden angebrachtes Raster von Linienlasern erzeugt eine zunächst nicht sichtbare, zusammenhängende Lichtfläche. Objekte, und Partikel, die diese Fläche durchbrechen, wie etwa Staub, Zigarettenrauch oder größere Objekte, werden im Streiflicht der Laser als Oberfläche oder Umriss sichtbar. Die Umrisse und Staubmuster werden erfasst und ihre zweidimensionalen Bewegungen in einem xy-Raster-Synthesizer zu Staubmustersound. Jeder Schritt der BetrachterIn, ja, deren bloße physische Anwesenheit, setzt die Luft in Bewegung und wirbelt Staub auf. Man hat es hier mit einem fragilen und schwer kontrollierbarem Interaktionsmedium zu tun, das dem Begriff „Tangible media" seine Unverbindlichkeit nimmt: vom Tragen schmutzempfindlicher Kleidung wird abgeraten.

In Kooperation mit servus.at und unterstützt von KunstRaum Goethestrasse und Manfred Grillnberger

Nicole Knauer

curious implantation

It is an installation that transcends space, with a hybrid creation made of synthetic cable ties that the artist has combined in an unconventional and very personal way. Its dimensions are extended through costumes, videos, photographs and transformation through interaction. The translucence, the ephemeral and the transience of the artist's favorite materials and shapes that are represented in this installation can be regarded as a metaphor for the sphere between reality and absurdity. The artist's aim is to use synthetic waste products in a different way to that which was originally intended. Half a million white synthetic cable ties have been combined manually to create a 50 square meters sculpture and costumes that mutate into utopian formations and hybrid creations. *curious implantation* represents a hybrid creation between nature and technology. Its appearance is amorphous, partly moved by human beings and partly by technology. It is an odd installation resembling a scene from a science fiction movie. When entering the gallery space the viewer finds a monstrous creation. The space and the sculpture are white thus visually blending into each other.

The structure of the surface, which seems to be organic at first sight, turns out to be filigree and

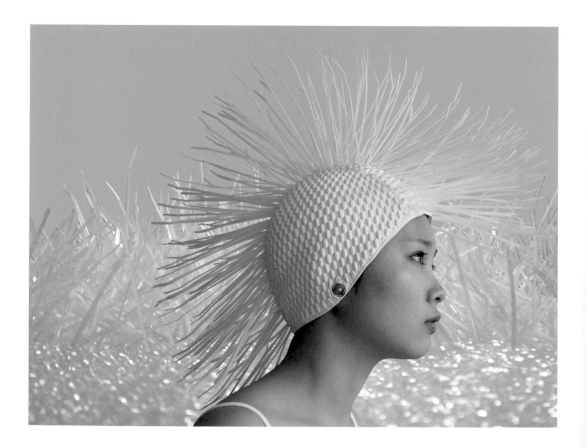

synthetic when viewed more closely. Tightly woven white nylon cable ties cover the whole surface of the sculpture. When the viewer gets closer the sculpture starts moving, becoming alive. The installation changes from a surreal artistic landscape to a strange creature that breathes. The appearance of the surface with its cable tie implants arouses a desire to touch it. At first sight the white sculpture seems to be soft like fur or a meadow. However when touching the surface the viewer experiences an irritation through the bristly resistance of the material. The indirect lighting makes the sculpture look even softer, and therefore emphasizes the contrast to the touching experience. It is similar with the costumes. They appear light and soft, the cable ties resemble feathers or soft ribbons. When moved, they rustle like multi-layered taffeta. However, they are heavy when worn, the cable ties scratch and sting. Undressing, their inner creatures come to light: The cast-off skin of a fable creature, the baleen of a whale, cuttlefish, mussels, corals, ticks or totally unknown creatures.

http://www.nicole-knauer.de

Translated from German by Sonja Meller

curious implantation in cooperation with *KunstRaum Goethestrasse*, Linz.

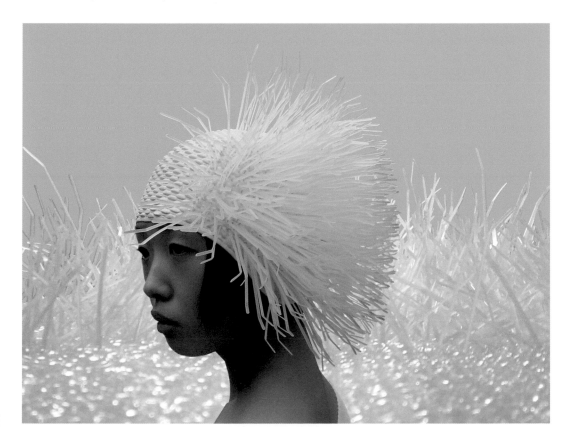

Nicole Knauer

curious implantation

Das Projekt ist eine raumübergreifende Installation, mit von ihr auf persönliche Art und Weise zweckentfremdeten Kunststoffkabelbindern als hybride Kreation, in ihrer Dimensionalität erweitert durch Kostüme, Video, Fotografien und Transformation durch Interaktion. Das Transluzente, Fließende, aber auch das Vergängliche der in dieser Arbeit bevorzugten Materialien und Formen ist interpretierbar als Metapher für den Grenzbereich zwischen Realität und Absurdität. Ihre Motivation ist die Zweckentfremdung der Kunststoffabfallprodukte.

Aus 500.000 Stück handgesteckten weißen Kunststoffkabelbindern gestaltet die Künstlerin eine 50 Quadratmeter füllende Raumplastik und Kostüme, die zu utopischen Gebilden und hybriden Kreationen mutieren. *curious implantation*, eine hybride Kreation zwischen Natur und Technik. Amorph in ihrer Erscheinung, teils durch Menschen und teils durch Technik bewegt. Eine kuriose Rauminstallation ähnlich einem Sciencefiction-Szenenbild.

Beim Betreten der Ausstellungsräumlichkeit findet der Rezipient zunächst ein monströses Gebilde vor. Der Raum und die Plastik sind ganz in weiß gehalten und fließen visuell ineinander. Die organisch wirkende Oberfläche stellt sich bei genauerer Betrachtung als filigran strukturierte Kunststoffoberfläche heraus. Dicht verwobene weiße Nylonkabelbinder überziehen die gesamte Fläche der Raumplastik. Nähert sich der Rezipient der Raumplastik, so entwickelt diese ein Eigenleben, indem sie sich zu bewegen beginnt. Sie verwandelt sich von einer surrealen Kunstlandschaft zu einer scheinbar seltsamen und atmenden Kreatur.

Das Erscheinungsbild der implantierten Kabelbinderoberfläche löst ein haptisches Bedürfnis beim Betrachter aus. Auf den ersten Blick wirkt die weiße Raumplastik weich und flauschig wie ein Fell oder eine Wiese. Bei Berührung der Oberfläche erfährt der Rezipient jedoch eine Irritation durch die borstige Widerstandskraft des Materials. Die indirekte Beleuchtung erhöht die Weichheit der Raumplastik in ihrer visuellen Erscheinung und unterstreicht dadurch die Kontrastwirkung des Materials in seiner haptischen Wahrnehmung.

Ähnlich verhält es sich mit den Kostümen: Sie wirken leicht und flauschig, die Kabelbinder erinnern an Federn oder weiche Bänder. In der Bewegung rascheln sie wie mehrlagiger Taft. Angezogen sind sie jedoch schwer, die Kabelbinder kratzen und stechen. Legt man die Kostüme ab, kommt ihre innere Kreatur zum Vorschein: die abgestreifte Haut eines Fabelwesens, die Barten eines Wals, Tintenfische, Muscheln, Korallen, Zecken, oder gänzlich fremdartige Geschöpfe.

http://www.nicole-knauer.de

curious implantation in Kooperation mit dem KunstRaum Goethestraße, Linz

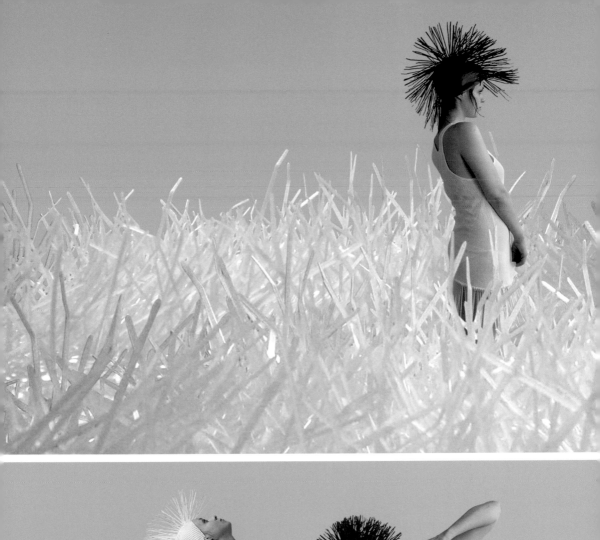
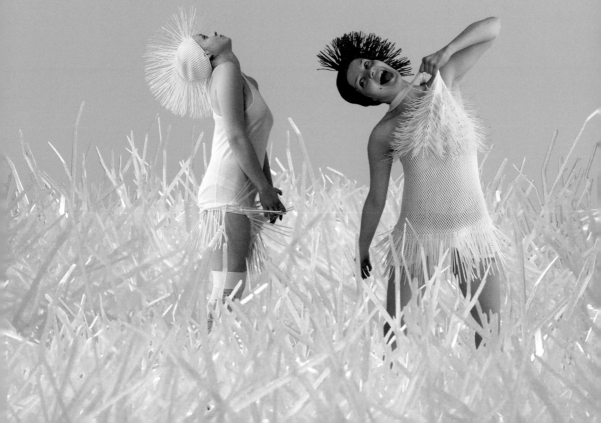

David Cuartielles

Make It Simple
In the space between the KISS principle
and DIY philosophy

"There is something obscure in working with electrons, and it has to do with their ability of being always negative ... it can become a little depressing sometimes."

<div align="right">D. Cuartielles on the concept of the electron at Konstfack, Sweden, 2006</div>

Upgrade your Knowledge

Simplicity in knowledge doesn't aim to take away the beauty of complex structures. It looks for easier ways to bring that complexity to people. If we look into learning as an iterative process of acquiring knowledge in a certain field, simplicity would mean to take small steps at a time, upgrading our understanding of the system at each step. When looking back at the staircase of our knowledge, after climbing up hundreds of simple steps, we would still see the same system, and its complexity wouldn't seem such to us. However, the system would still be the same.

Initiatives like *Arduino, OpenFrameWorks, Processing,* or *Python* focus on the idea of upgrading our understanding of the world through small steps, making the complex simple. Through the development of different projects, workshops, talks, and performances these projects' creators show how it is possible to open up knowledge areas by using the right message and proper dissemination models.

As creators we constantly find ourselves in the situation of making new systems that should be simple to operate and use; we try to follow the *KISS* principle. At the same time, we are constantly willing to learn new things while studying the possibilities of different sensors populating our everyday gadgets. Technology evolves at an ever-increasing pace and we need to upgrade our knowledge continually. Since there are plenty of contents available online in our connected existence, we can become our own teachers if the knowledge is packaged in the right way. The DIY philosophy, inherited from the hacker culture, populates the Internet with "how to" guides that help us to learn as if we were following a recipe while baking a cake.

It is possible to become part of this flow of constant creative consciousness. Electronic Artists and Interaction Designers share their experiences and talk about how they do things openly on the web. Their secrets are unveiled in front of a mixed audience of academics, practitioners, casual surfers and students.

Simplicity concentrates on ways of simplifying the technical aspects surrounding electronic arts and interaction design creation. It looks into the latest upgrade to the system: how to interact with the physical world. This upgrade will definitely not be the last.

People for People: Designing Systems

We live in a universe of electronic appliances that interoperate with each other, augment our cognition, and enhance our lives. All those hardware and software pieces have to match seamlessly for users to be able to access content and information in general.

At the current level of development, machines are made by people. So are interactive artifacts, whether in computers, phones, or embedded systems. The landscape of digital technology driven devices is becoming too complex. We have to distinguish between phone, PDA, computer,

smartphone, console ... in terms of the type of operating system they run and the type of hardware. However, the way we interact with them is becoming more and more standardized, bridging the understanding and ways of using those the-same-but-different artifacts.

Therefore, hardware vendors develop specific toolkits for engineers and designers to learn how the new technology will work. This will allow them to anticipate market changes, and create future products. Designers are those that create for people. They stand on the other side of the line between the object and the user. In particular, the young discipline of interaction design has started to analyze hardware as if it was the missing link between users and systems. The crossroad of electronics and education was, until recently, a domain reserved for engineering students. This situation has changed, and many universities have decided to teach the future designers about the relationship between form and function.

Suspension of Disbelief: Interaction Design

Interaction designers are the filmmakers of contemporary everyday artifacts. Their work consists in creating the illusion of devices that will later be manufactured for a bigger audience. They create interfaces, physical or virtual, which run on machines made by electronic engineers, wrapped in boxes by production engineers, and based on ideas by industrial designers.

The goal of the interaction designer is not just to convey certain aesthetic principles within the form of the devices he/she creates, but to study new ways of aesthetic interaction forms. Current technology allows us to easily explore fields like palpable computing where the physicality of the interaction rules how the device will read the input from the user.

This field of design has brought a different way of looking into the use of electronics within academia. Suddenly microchips, resistors, wires and sensors become the new paint of this new type of design. Circuit boards become canvases on which to paint new ways of interaction, and not just relationships among volts and bits. Prototype is the new black; the mock-ups from industrial designers are now populated by half-functional pieces that are capable of illustrating concepts in new ways.

A Way to Try it out: the Prototype

A prototype is a product wannabe. When designers want to test whether an idea could sell in a mass market, they make prototypes that are tried out on a group of test persons. Prototypes are the suspension of disbelief of product design. On some occasions designers will just look into small details regarding cognitive interaction for a certain device. At other times they will want to enhance the physical layout of an artifact including a simulation of the real functionality. However, a certain understanding of electronics is needed in order to prototype future devices.

It could also be a small-scale version of an art installation, not fully finalized. Electronic Artists are moving beyond the desktop experiences. More art pieces require direct interaction from the user at a cognitive level, and artists learn how to master electronics as a new material.

Whether in Art or Design, this hobby-like way of looking into electronics has a name that has been around for some time: *Do-It-Yourself*. The new creator likes to experiment him/herself whether it is possible to make things work. In a way, the original hacker's philosophy has infected these fields.

Also the vehicles for knowledge sharing are becoming an important tool for communities of artists/designers. Online forums, email lists, wikis and blogs report hundreds of experiments and workshops where creators meet to build up their knowledge together ... sharing.

Dare to Share: Collaborative Knowledge Creation

One of the key issues behind the DIY philosophy has always been the so-called "how to" guides. Step-by-step guides populate thousands of Internet websites, inviting people to try things out and 'Do-It-Themselves'. Knowledge sharing has always been one of the most challenging ideas from the hacker's philosophy.

On the other hand, the world of design and art has always surrounded the author with an aura of magic and mysticism. If a design or an art-piece is good, the creator is elevated to the status of a contemporary god. The production process has to be hidden in order to protect the author's intellectual property rights. This model doesn't really apply to our newly constructed collaborative universe of DIY authors. They try things out and discuss their findings in a distributed-always-connected network. Collaborators solve problems around the clock. Authorship is questioned through the process of creation. Not only has the world of ideas changed the physical location where the prototypes take form. The laboratory used to be a closed space for engineers and scientists. With the new toolkits, anyone can afford a small laboratory at home.

Laboratory: Back to the Physical World

The idea of the laboratory has been transformed thanks to the introduction of alternative ways of production linked to the current demand in new media. We could define a laboratory as a place where people meet for creating as a community. In order to create such a space, the people, ideas and tools are needed.

One of the main constraints within this definition of laboratory is the need of tools. Until recently, tools have been reserved for those counting on the economic power to acquire the right ones. Since the appearance of open source, followed by the more recent birth of open hardware, the laboratory has been transformed. Alternative licensing models allow access to toolkits for those with fewer resources, which has produced unforeseen results.

There have been many successful attempts in creating toolkits. During the last few years we have witnessed the growth of *Linux* as an open source operating system, while many of its derivatives are like parasites on our computer systems, and convince more and more people of the need for a self-supported open source software community. Within the arts field we saw *PureData* and *Processing* as powerful interfaces for multimedia production. From the programming world we adopted *Python,* and the most recent of them all, *OpenFrameWorks,* a collection of libraries for simplifying the creation of computer vision based art pieces. One of the first successful tools ever made as an open hardware tool for prototyping computerless interactive systems is *Arduino;* initiated as a collaboration between two European universities, it has infected the education system all over the planet within one year of coming into existence.

Don't Conclude: Upgrade

The term "upgrade" has been taken from technology. Knowledge evolves together with our way of looking at the world. All the variables that compose our insignificant time-slot within the general existence of the universe are fed by millions of inputs of data. Our understanding of the world, as well as our own way of functioning as humans, both at a physiological, and at a social level, depends on our ability to update (upgrade) to the latest theoretical framework, getting the latest tools both conceptually, and for more empirical experiments.

Simplicity concentrates on ways of simplifying the technical aspects surrounding electronic arts and interaction design creation. It looks into the latest upgrade to the system: how to interact with the physical world. This upgrade will definitely not be the last.

David Cuartielles

Make It Simple
Im Raum zwischen dem KISS-Prinzip
und der DIY-Philosophie[1]

——

„Das Arbeiten mit Elektronen hat auch eine dunkle Seite, und das hat mit deren Fähigkeit, immer negativ zu sein, zu tun ... das kann ganz schön deprimierend sein."

David Cuartielles über das Konzept des Elektrons an der Konstfack-Universität, Schweden, 2006.

Erweitere dein Wissen

Einfachheit im Wissen zielt nicht darauf ab, komplexe Strukturen ihrer Schönheit zu berauben. Sie sucht nach einfacheren Wegen, den Menschen die Komplexität näher zu bringen. Betrachtet man das Lernen als einen sich wiederholenden Prozess zur Wissensaneignung in einem Fachgebiet, so bedeutet Einfachheit, immer nur kleine Schritte zu machen, indem man sein Verständnis für das System mit jedem Schritt erweitert. Blicken wir nach Hunderten erklommener Stufen das Treppenhaus unseres Wissens hinab, sähen wir immer noch dasselbe System, ohne dass uns seine Komplexität auffiele. Trotzdem wäre das System immer noch dasselbe.

Initiativen wie *Arduino, OpenFrameWorks, Processing* oder *Python* wollen unser Verständnis der Welt mittels kleiner Schritte erweitern und das Komplexe einfach machen. Diese Entwickler zeigen in verschiedensten Projekten, Workshops, Gesprächen und Performances Möglichkeiten auf, Wissensbereiche durch den Einsatz der richtigen Message und Verbreitungsmodelle zu eröffnen. Als Kreative sind wir ständig dabei, neue Systeme zu entwickeln, die einfach zu bedienen und zu nützen sind und dem KISS-Prinzip folgen. Gleichzeitig erlernen wir immer neue Fertigkeiten, während wir die Möglichkeiten der verschiedenen Sensoren auf den Werkzeugen des täglichen Gebrauchs erkunden. Der technische Fortschritt erfolgt immer schneller, und wir müssen unseren Kenntnisstand in einem fort ausbauen. Da in unserer vernetzten Existenz vieles online verfügbar ist, können wir zu unseren eigenen Lehrern werden, sofern das Wissen richtig verpackt ist. Die DIY-Philosophie – ein Erbe der Hackerkultur – füttert das Internet zu allen erdenklichen Themen mit Schritt-für-Schritt-Anleitungen, denen wir nur wie einem Rezept zum Kuchenbacken folgen brauchen.

Man kann sogar Teil dieses konstanten kreativen Bewusstseinsflusses werden. Elektronikkünstler und Interaktionsdesigner teilen ihre Erfahrungen und beschreiben ihre Vorgangsweisen offen im Web. Sie enthüllen ihre Geheimnisse vor einem gemischten Publikum aus Akademikern, Praktikern, gelegentlichen Surfern und Studenten.

Einfachheit konzentriert sich auf die Vereinfachung der technischen Aspekte rund um die Schöpfung von elektronischer Kunst und Interaktionsdesign. Sie untersucht die letzte Systemerweiterung: die Art und Weise der Interaktion mit der physischen Welt. Aber diese Aufrüstung war mit Sicherheit nicht die letzte.

Menschen für Menschen: Der Entwurf von Systemen

Wir sind umgeben von einem Universum elektronischer Geräte, die interoperieren, unsere Erkenntnis erweitern und unser Leben bereichern. Alle diese Hard- und Softwarekomponenten müssen sich nahtlos aneinander fügen, damit den Benutzern Informationsinhalte generell zugänglich sind. Zum derzeitigen Entwicklungsstand werden Maschinen ebenso wie interaktive Artefakte, ob nun in Computern, Telefonen oder eingebetteten Systemen, von Menschen

gemacht. Die Landschaft digitaltechnikbasierter Geräte wird allmählich zu komplex. Wir unterscheiden bereits zwischen Telefon, PDA, Computer, Smartphone, Konsole … hinsichtlich des eingesetzten Betriebssystems und des Hardwaretyps. Dennoch wird die Art der Interaktion mit ihnen zunehmend standardisierter, indem eine Brücke für das Verständnis und die Bedienung dieser gleichartigen, aber unterschiedlichen Artefakte geschlagen wird.

Daher entwickeln die Hardwarehersteller spezielle Toolkits für Techniker und Designer, um ihnen die neue Technologie näher zu bringen. Auf diese Weise können sie Veränderungen am Markt verfolgen und neue Produkte schaffen. Die Designer entwickeln für die Menschen; sie stehen auf der anderen Seite der Verbindungslinie zwischen Objekt und Anwender. Insbesondere die junge Disziplin Interaktionsdesign analysiert die Hardware wie das Missing Link zwischen den Anwendern und den Systemen. Der Schnittpunkt zwischen Elektronik und Ausbildung war bis vor kurzem Technikstudenten vorbehalten. Das hat sich geändert, und viele Universitäten sind dazu übergegangen, den zukünftigen Designern die Beziehung zwischen Form und Funktion zu lehren.

Ende des Unglaubens: Interaktionsdesign

Interaktionsdesigner sind die Filmemacher der modernen Alltagsartefakte. Ihre Aufgabe besteht darin, eine Illusion von Geräten zu erzeugen, die später für ein breites Publikum produziert werden sollen. Sie kreieren physische oder virtuelle Schnittstellen, die auf von Elektronikern gemachten, von Fertigungsplanern in Schachteln verpackten und von Industriedesignern erdachten Maschinen laufen.

Der Interaktionsdesigner möchte durch die Form des von ihm/ihr entwickelten Geräts nicht bloß gewisse ästhetische Prinzipien vermitteln, sondern will neue Wege ästhetischer Interaktionsformen beschreiten. Die moderne Technik lässt uns ganz leicht Gebiete wie *Palpable Computing* (greifbare Computertechnologien) ausloten, in denen die physische Manifestation der Interaktion das Auslesen der Anwendereingabe durch das Gerät steuert.

Dieses Designgebiet hat der Wissenschaft eine neue Betrachtungsweise des Elektronikeinsatzes beschert. Plötzlich werden Mikrochips, Widerstände, Drähte und Sensoren zur neuen Farbe dieses neuen Designtyps. Platinen werden zu Leinwänden, auf die neue Interaktionsmuster gemalt werden, und nicht mehr bloß Relationen von Volts und Bits. Der Prototyp ist das neue Leitprinzip; die Modelle der Industriedesigner sind nun mit halb funktionierenden Bauteilen bestückt, die deren Konzepte auf eine neue Art veranschaulichen können.

Eine Möglichkeit des Ausprobierens: der Prototyp

Ein Prototyp ist ein Möchtegernprodukt. Wollen Entwickler herausfinden, ob sich eine Idee verkaufen lässt, bauen sie Prototypen, die an Testpersonen ausprobiert werden. Prototypen bedeuten den Ausschluss der Überraschung bei der Produktentwicklung. Manchmal untersuchen Entwickler nur winzige Details hinsichtlich der kognitiven Interaktion mit einem Gerät. Ein anderes Mal soll das Layout eines Produkts verbessert und die tatsächliche Funktionalität simuliert werden. Es braucht jedoch ein gewisses Maß an Elektronikverständnis, um einen Prototypen für ein neues Gerät bauen zu können.

Es könnte sich genauso gut um eine noch nicht vollendete, verkleinerte Version einer Kunstinstallation handeln. Elektronikkünstler müssen über die Desktop-Erfahrung hinausgehen. Immer mehr Kunstwerke verlangen vom Betrachter eine direkte Interaktion auf kognitiver Ebene, und die Künstler lernen, die Elektronik als neues Medium zu meistern.

Egal ob in der Kunst oder in der Entwicklung, diese hobbymäßige Betrachtung der Elektronik wird mit einem gängigen Begriff bezeichnet: *Do-It-Yourself.* Der neue Schöpfer möchte gerne

selbst experimentieren, ob etwas funktionieren kann. So hat die ursprüngliche Hackerphilosophie diese Bereiche infiziert.

Weiters werden die Mittel des Wissenstransfers für die Künstler- und Entwicklergemeinden zu einem wichtigen Werkzeug. Online-Foren, Mailinglisten, Wikis und Blogs berichten von Hunderten von Experimenten und Workshops, bei denen sich kreative Köpfe treffen, um gemeinsam ihr Wissen aufzubauen ... indem sie es teilen.

Das Wagnis des Teilens: Gemeinsame Wissensbildung

Ein wesentlicher Faktor hinter der DIY-Philosophie waren stets die Schritt-für-Schritt-Anleitungen, von denen es Tausende im Internet gibt und die Menschen einladen, dies und das auszuprobieren und es „selbst zu machen". In der Hackerphilosophie war der Wissensaustausch einer der Kernpunkte.

Auf der anderen Seite wurde in der Design- und Kunstwelt der Autor immer mit einer magisch-mystischen Aura umgeben. War ein Design oder ein Kunstwerk gut, so wurde dessen Schöpfer in den Status eines modernen Gotts erhoben. Der Produktionsprozess muss verborgen bleiben, um die Urheberrechte des Autors zu wahren.

Dieses Modell will aber nicht zu unserem neuen Gemeinschaftsuniversum von DIY-Autoren passen. Sie probieren alles Mögliche aus und diskutieren ihre Ergebnisse in einem verteilten und immer verbundenen Netzwerk. An Problemlösungen wird rund um die Uhr gemeinsam gearbeitet. Die Autorenschaft wird durch den Entstehungsprozess in Frage gestellt.

Der physische Ort, an dem Prototypen Gestalt annehmen, hat sich nicht zuletzt durch die Gedankenwelt verändert. Waren Labors früher abgeschlossene Räume für Techniker und Wissenschafter, so kann sich heute jeder dank der neuen Toolkits ein Labor zu Hause leisten.

Das Labor: Zurück in die physische Welt

Das Konzept des Labors hat sich durch die Einführung alternativer Produktionsmethoden, die mit den Bedürfnissen der Neuen Medien einhergehen, grundlegend geändert. Man könnte ein Labor als einen Ort definieren, an dem sich Menschen zu einem gemeinsamen Schaffensprozess versammeln. Dazu braucht es Menschen, Ideen und Werkzeuge.

Eine der wesentlichen Beschränkungen dieser Labordefinition ergibt sich aus dem Bedarf an Werkzeugen. Bis vor kurzem waren Werkzeuge jenen vorbehalten, die über die entsprechenden Mittel verfügten, um die richtigen zu erwerben. Seit dem Aufkommen von *Open Source* und in jüngerer Zeit von *Open Hardware* hat sich das Labor verändert. Alternative Lizenzierungsmodelle ermöglichen nun auch jenen mit weniger Ressourcen einen Zugang zu Werkzeugen, was zu unvorhergesehenen Ergebnissen geführt hat.

Es wurden viele erfolgreiche Versuche unternommen, Toolkits zu erstellen. Während der letzten paar Jahre waren wir Zeugen des Wachstums von Linux, einem Open-Source-Betriebssystem, dessen unzählige Derivate Parasiten gleich in unseren Computersystem werken und mehr und mehr Menschen von der Notwendigkeit einer sich selbst unterstützenden Open-Source-Gemeinschaft überzeugen.

In der Kunst erlebten wir PureData und Processing als mächtige Schnittstellen für die Multimediaproduktion. Python und, als jüngster Vertreter, OpenFrameWorks – eine Sammlung von Bibliotheken, die die Erstellung von Kunstwerken mit computerbasierter Objekterkennung wesentlich vereinfacht – wurden aus der Programmierwelt übernommen. Eines der ersten erfolgreichen Open-Hardware-Tools überhaupt ist Arduino, das zum Erstellen von Prototypen für computerlose Interaktivsysteme dient. Hervorgegangen aus einem Gemeinschaftsprojekt zweier europäischer

Universitäten, hat es das Ausbildungssystem des gesamten Planeten innerhalb von nur einem Jahr infiziert.

Keine Schlussfolgerungen: Rüste auf

Der Begriff „aufrüsten" wurde aus der Technik entlehnt. Wissen entwickelt sich zusammmen mit unserer Betrachtungsweise der Welt. All die Variablen, die unsere unbedeutende Zeitspanne innerhalb der gesamten Existenz des Universums ausmachen, werden durch Aber-millionen von Dateneingaben gefüttert. Unser Verständnis der Welt sowie unsere Funktions-weise als Mensch – sowohl auf physiologischer als auch auf sozialer Ebene – hängen von unse-rer Fähigkeit ab, uns an die neuesten theoretischen Rahmenbedingungen anzupassen (aufzurüs-ten) und uns die modernsten Werkzeuge für sowohl konzeptionelle Bereiche als auch weitere empirische Experimente zu beschaffen.

Einfachheit legt den Fokus auf die Vereinfachung der technischen Aspekte rund um die Schaf-fung von elektronischer Kunst und Interaktionsdesign. Sie untersucht die jüngste Systemerwei-terung: die Art und Weise der Interaktion mit der physischen Welt. Aber diese Aufrüstung war mit Sicherheit nicht die letzte.

Aus dem Englischen von Michael Kaufmann

1 Anm. d. Ü.: Keep It Small and Simple – Halt es klein und einfach; bzw. Do It Yourself – Mach es selber.

David Cuartielles

electrolobby
Make it simple

Within the Ars Electronica Festival, the *electrolobby* is the festival area for Digital Culture & Lifestyle. With the title *Make it simple* this year's *electrolobby* takes a look at the myth of electronic nomadism. D. Cuartielles, curator of this space, briefly depicts the contemporary new-media creators' reality and how it is represented in the *electrolobby*.

Whether as laptop performer, software artist, web-designer, or network administrator, we assist in the realm of the Digital Tuareg. With laptop computers as *Tagelmusts*,[1] these nomads master the craft of digital creativity. Following the path of open self-education these wanderers have found tools to resist the omnipresence of media conglomerates and created an intellectual niche in modern digital lifestyles.

Easier forms of software have helped introduce many to the complex desert of bits. Tools like *Processing, PureData,* and their close-source equivalents have made it possible for many to learn collaboratively and share knowledge in their communities of practice.

On the other hand, we assist at the birth of *Open Hardware,* a new category of tools designed mainly for lighting up the somewhat obscure world of hardware. Unlike software this media has a physical entity, and also a completely different set of assets, licensing strategies, and production means. The electronic nomads now have a whole range of alternative ways of "riding" their laptops available, interfacing them with new types of sensor technologies.

The *electrolobby* offers an interlaced program of workshops, minishops, talks, company visits, interactive works, and performances, all of them spiced in indigo turbans and with the openness of a community of creators willing to expand.

1 Tagelmust: the Tuareg's veil

Arduino Workshop
http://www.Arduino.cc/

Arduino is an open hardware and open/free software initiative by David Cuartielles from K3 (Sweden), and Massimo Banzi and Dave Mellis from the Interaction Design Institute Ivrea (Italy), who are all engaged in the field of Physical Computing.

From the beginning *Arduino* has been an initiative aiming to provide the design and art community with a tool to create alternative electronic interfaces. These could act as more natural bonds to computers and digital artifacts in general, allowing us (humans) to interact in new, unforeseen ways.

The project was born from the need of having a set of tools to conduct courses in electronics prototyping at art and design universities. The authors wanted to unify the work in form and function, through providing designers and artists with access to the essence of digital technologies.

More than 20 universities are using *Arduino* in their education programs, some of them for their engineering classes. Several open source (and free software) communities have welcomed *Arduino* as their platform for interfacing the physical world. Furthermore, the project has expanded into secondary education in some schools in Spain, after a pilot run during Spring 2006 in Madrid.

The whole project is under a Creative Commons license that allows other people to manufacture their own boards.

The Ars Electronica workshop is an introduction to electronics for art installations and design making use of the *Arduino* platform. The participants require no previous knowledge of electronics or programming, just an open mind for a challenging week with a hand full of bytes.

Prix Ars Electronica 2006, Honorary Mention Digital Communities

Python Workshop
http://www.mobilenin.com

Python is best defined by a quote taken from *Wikipedia:* "Python is a multi-paradigm language. This means that, rather than forcing coders to adopt one particular style of coding, it permits several. Object orientation, structured programming, functional programming, and aspect-oriented programming are all supported."

© Jürgen Scheible

In other words, it is a scripting language, whose design focuses on ease of use. It is extremely portable, to the extent that it is used for many mobile devices as well as embedded systems or game consoles.

Python has been released under a GPL license and operates under an Apache-like model, which allows developers to include it in their systems and migrate it to different platforms.

On the other side of the screen, we find the possibilities for artists and designers to use this powerful programming language as the basis for the development of new concepts. In the course of relatively short practical creativity workshops, it is possible to learn how to handle digital contents within mobile devices, share video streams, build storytelling applications, or communicate wirelessly to other systems.

OpenFrameWorks Workshop
http://www.openframeworks.cc

It is only recently that everyday computer systems have become able to process full frame video in real time. As the computational and hardware costs drop for such systems, video manipulation and analysis becomes an increasingly useful tool for artists' use in interactive installations and performances.

OpenFrameWorks is a new open source, cross platform, c++ library, which was designed to make programming in c++ for students accessible and easy. In it, the developers wrap several different libraries like OpenGL for graphics, QuickTime for movie playing and capturing, and Free Type for font rendering, into a convenient package in order to create a simple, intuitive framework for creating projects using c++. It is designed to work in freely available compilers, and will run under any of the current operating systems.

Workshops using *OpenFrameWorks* concentrate on helping students make engaging, challenging and meaningful work through creative software coding and intelligent use of computer vision techniques. They are a mixture of practical advice related to the world of computer graphics and animation, coding, and computer vision.

Students are also introduced to the examination of the aesthetic implications of the vision systems and the challenges involved in employing them in meaningful, artistic practice.

Interactivos? Arduino workshop for secondary school teachers, MediaLabMadrid, May 2006

Interactivos? Making circuits, MediaLabMadrid, April 2006

 ## Interactivos?
http://www.interactivos.org

A workshop held at the MediaLabMadrid, within the Centro Cultural Conde Duque, that was organized together with three developers of open hardware and software tools, David Cuartielles, Zachary Lieberman and Hans-Christoph Steiner. Twenty-five participants worked together on fifteen projects over the course of two intensive weeks, in a workshop environment charged with, and full of creative energy.

A selection of projects developed at *interactivos?* are on exhibit in the Ars Electronica Festival's *electrolobby*.

Interactivos? was a hybrid workshop, exhibition and seminar which, rather than focusing on skill learning, concentrated on the production of actual projects. A unique environment was created in which participants worked collectively from day one to create compelling work that explored the boundaries of physical computing and human computer interaction. The typical format of instructor and pupil was eschewed in favor of an open one, in which participants worked side-by-side with practitioners as well as the public.

Interactivos? was designed to fill a need, specific to the community in Madrid, for more advanced, production-oriented events. The desire was to transcend the typical one-way experience of normal workshops in order to find a way to open up these events to a wider audience. At the start of the project, the exhibition space, where the event was held, was transformed overnight into a work space. When the workshop concluded it became once again an exhibition space, where the works produced were then displayed.

White Lies, Sara Stiber, Erika Nyström, Magnus Johnsson, Markus Isaksson, Estebán

Magic Lamp, Alberto García Pi, with the collaboration of Julio Obellerio, Martín Nadal and Alberto Cortés

Most of these projects should be seen as prototypes, or the beginning of longer-term research. For example, *IC_Multidimensional Particle Projector for Emergent Processes* is an experiment in combining computation with architecture. The project presents a multidimensional space of cellular automata that can be manipulated by users, creating emergent patterns that are represented as fluid, structural forms in a 3d space.

One line of research was physical computing projects that strove to build meaningful, beautiful, and even controversial relationships between humans and artifacts.

UrbanForest, White Lies and *The Rocking Chair* are three interactive prototypes that explore the realm of the personal through haptic interaction. *Waves* presents a kinetic and sound sculpture in which the shapes and sounds of movement are made physical by interaction with the audience.

Additionally, Zachary Lieberman led a group in the workshop that focused on exploring computer vision techniques utilizing a new open-source c++ library entitled *openframeworks*. Four resulting works are on display: *Predator, Memento, Magic Lamp* and *D3Sombra*. These projects combine auditory and visual responses to users' motions in order to create seamless, organic, and playful forms of interaction.

Interactivos? was one part of MediaLabMadrid's overall strategy of creating compelling environments for exploring and expanding the discipline and discourse of media art practice.

David Cuartielles

electrolobby
Make it simple

Die *electrolobby* ist die Arena für Digital Culture & Lifestyle beim Ars Electronica Festival. Unter dem Titel *Make it simple* nimmt sie dieses Jahr den Mythos des elektronischen Nomadentums unter die Lupe. D. Cuartielles, der Kurator dieser Programmschiene, schildert kurz die Realität zeitgenössischer Kreativer in den Neuen Medien und wie diese in der *electrolobby* zur Darstellung kommt.

Ob als Laptop-Performer, Softwarekünstler, Webdesigner oder Netzwerkadministrator, wir nehmen alle teil am Reich der digitalen Tuareg. Mit dem Laptop als Tagelmust[1] meistern diese Nomaden die Kunst kreativen digitalen Gestaltens. Den Pfad offener Selbstausbildung beschreitend, haben sie Mittel und Wege gefunden, sich der Omnipräsenz der Medienkonglomerate zu widersetzen und sich intellektuelle Nischen in zeitgenössischen digitalen Lebensstilen zu schaffen.

Einfachere Arten von Software haben vielen den Zugang zur komplexen Wüste der Bits erleichtert. Tools wie Processing, PureData und deren Close-Source-Äquivalente haben es vielen ermöglicht, gemeinsam zu lernen und ihr Wissen mit ihren Praxisgemeinschaften zu teilen.

Andererseits sind wir auch Geburtshelfer der Open Hardware, einer neuen Kategorie von Tools, die hauptsächlich dazu gedacht sind, Licht in die etwas nebulöse Welt der Hardware zu bringen. Im Gegensatz zur Software besitzen diese eine physische Präsenz sowie einen völlig anderen Bestand an Grundelementen, Lizenzierungsstrategien und Produktionsmitteln. Elektronischen Nomaden eröffnen sich damit eine ganze Reihe alternativer Möglichkeiten, ihren Laptop zu „reiten" und ihn mit neuartigen Sensortechnologien zu verknüpfen.

Die *electrolobby* bietet ein dicht verflochtenes Programm aus Workshops, Minishops, Gesprächen, Firmenbesuchen, interaktiven Arbeiten und Performances, gewürzt mit indigofarbenen Turbanen und der Offenheit einer Community von lernwilligen Schöpfern.

1 Tagelmust: Kopfbedeckung der Tuareg.

Arduino-Workshop
http://www.Arduino.cc/

Arduino ist eine Open-Hardware- und Open/Free-Software-Initiative von David Cuartielles von K3 (Schweden) sowie Massimo Banzi und Dave Mellis vom Interaction Design Institute Ivrea (Italien), die alle auf dem Gebiet des Physical Computing tätig sind.

Arduino ging es von Anfang an darum, der Design- und Kunstcommunity ein Tool zur Entwicklung alternativer elektronischer Interfaces zur Verfügung zu stellen, die als natürlichere Verbindung mit Computern und digitalen Artefakten im Allgemeinen dienen können und es uns (Menschen) ermöglichen, auf neue, unvorhergesehene Weisen zu interagieren.

Das Projekt entstand aus dem Bedürfnis, eine Reihe von Tools für Elektronikprototypingkurse auf Kunst- und Designhochschulen zur Verfügung zu haben. Die Autoren wollten Form und Funktion miteinander verbinden, indem sie Designern und Künstlern einen Zugang zu den Grundlagen digitaler Technologien bieten.

Mehr als 20 Universitäten verwenden *Arduino* im Unterricht, einige davon auch in ihren Technik-

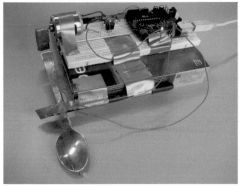
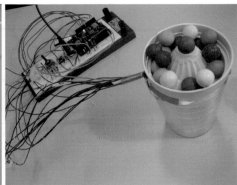

studiengängen. Etliche Open-Source- (und Free-Software-)Communities haben *Arduino* als Platt-form zur Verbindung mit der physischen Welt übernommen. Nach einem Pilotversuch in Madrid im Frühjahr 2006 hat das Projekt an einigen spanischen Schulen überdies auch Eingang in den Sekundarschulunterricht gefunden. Das gesamte Projekt läuft unter einer Creative-Commons-Lizenz, was es anderen erlaubt, ihre eigenen Platinen herzustellen.

Der Workshop bei der Ars Electronica führt anhand der *Arduino*-Plattform in die Elektronik für Design und Kunstinstallationen ein. Teilnehmer müssen kein Vorwissen über Elektronik oder Pro-grammierung mitbringen, lediglich ein unvoreingenommenes Interesse an einer spannenden Woche mit einer Handvoll Bytes.

Prix Ars Electronica 2006, Anerkennung Digital Communities

Python-Workshop
http://www.mobilenin.com

Python lässt sich am besten mit einem Zitat aus *Wikipedia* definieren: „Python ist eine multiparadigmatische Programmiersprache. Das heißt, sie zwingt Programmierer nicht zu einem bestimmten Programmierstil, sondern lässt mehrere zu. Objektorientierte, strukturierte, funktionale und aspektorientierte Programmierung werden gleichermaßen unterstützt."

Mit anderen Worten, es ist eine Skriptsprache, deren Design auf einfache Verwendbarkeit ausge-richtet ist. Sie ist extrem transportabel, so dass viele Mobilgeräte, aber auch eingebettete Syste-me oder Spielkonsolen mit Interpretern für diese Sprache ausgestattet sind.

Python wurde unter einer GPL-Lizenz veröffentlicht und operiert mit einer Art Apache-Modell, sodass Entwickler sie leicht in ihre Systeme einbauen und auf unterschiedliche Plattformen aus-schwärmen lassen können.

Auf der anderen Seite des Bildschirms haben Künstler und Designer die Möglichkeit, diese leistungsfähige Programmiersprache als Grundlage für die Entwicklung neuer Kon-zepte zu verwenden. In kurzen praktischen Kreativworkshops kann man lernen, digitale Inhalte mithilfe von Mobilgeräten zu bear-beiten, Videostreams auszutauschen, Story-telling-Applikationen zu bauen oder drahtlos mit anderen Systemen zu kommunizieren.

© Jurgen Scheible

OpenFrameWorks-Workshop
http://www.openframeworks.cc

Erst in letzter Zeit sind normale Computersysteme leistungsstark genug geworden, um bildschirmfüllende Videos in Echtzeit zu verarbeiten. Mit den sinkenden Rechen- und Hardwarekosten für solche Systeme kommt die Videomanipulation und -analyse immer öfter in interaktiven Installationen und Performances von Künstlern zum Einsatz.

OpenFrameWorks ist eine neue plattformübergreifende C++-Open-Source-Bibliothek, die die C++-Programmierung erleichtern und zugänglicher machen soll. Die Entwickler schnüren unterschiedliche Bibliotheken wie OpenGL für Grafik, QuickTime für die Aufnahme und Wiedergabe von Filmen und Free Type für die Gestaltung von Schriften zu einem praktischen Paket, das ein einfaches, intuitiv verwendbares Grundgerüst zur Entwicklung von Projekten mit C++ bildet. Es ist so gebaut, dass es mit frei erhältlichen Compilern arbeitet und auf allen Betriebssystemen läuft.

Schwerpunkt der Workshops mit *OpenFrameWorks* ist es, die Lernenden durch kreative Softwareprogrammierung und den intelligenten Einsatz von Objekterkennungstechniken beim Verfertigen fesselnder, herausfordernder und Sinn stiftender Arbeiten zu unterstützen. Die Workshops sind eine Mischung praktischer Ratschläge in den Bereichen Computergrafik und Animation, Programmierung und Objekterkennung.

Die Teilnehmer werden auch angeleitet, die ästhetischen Implikationen der Objekterkennungssysteme kritisch zu überprüfen und sich den Herausforderungen zu stellen, die ihr Einsatz für eine sinnvolle künstlerische Praxis mit sich bringt.

Interactivos?
http://www.interactivos.org

Interactivos? war ein am MedialabMadrid im Centro Cultural Conde Duque abgehaltener Workshop, der mit drei Entwicklern von Open-Hardware- und Software-Tools – David Cuartielles, Zachary Lieberman und Hans-Christoph Steiner – organisiert wurde. Zwei intensive Wochen lang erarbeiteten 25 Teilnehmer in einer kreativen, energiegeladenen Atmosphäre gemeinsam 15 Projekte. Eine Auswahl dieser bei *Interactivos?* entwickelten Projekte wird in der *electrolobby* beim Ars Electronica Festival präsentiert.

Interactivos? war ein Hybrid aus Workshop, Ausstellung und Seminar, das sich weniger auf das Erlernen bestimmter Fertigkeiten konzentrierte, sondern eher auf die Durchführung wirklicher Projekte. Es wurde eine einzigartige Umgebung geschaffen, in der die Teilnehmer vom ersten Tag

an gemeinsam an faszinierenden Werken arbeiteten, die die Grenzen von Physical Computing und Mensch-Computer-Interaktion ausloteten. Anstelle des typischen Lehrer-Schüler-Verhältnisses wurde ein offenes Format angestrebt, in dem die Teilnehmer Seite an Seite mit erfahrenen Praktikern und der Öffentlichkeit arbeiteten.

Interactivos? sollte ein spezifisches Bedürfnis der Madrider Community nach fortschrittlichen, produktionsorientierten Ereignissen stillen. Es ging darum, die einseitige Erfahrung normaler Workshops zu überwinden und eine Möglichkeit zu finden, solche Ereignisse einem größeren Publikum zu öffnen. Zunächst wurde der Ausstellungsraum, in dem der Workshop stattfand, über Nacht in eine Werkstatt umgewandelt. Am Ende des Workshops wurde er erneut zum Ausstellungsraum, in dem dann die enstandenen Arbeiten gezeigt wurden.

Die meisten der gezeigten Projekte sind als Prototypen zu verstehen oder als der Beginn einer längeren Forschungsarbeit. Der *IC_Multidimensional Particle Projector for Emergent Processes* zum Beispiel experimentiert mit der Verbindung von Computertechnik und Architektur. Präsentiert wird ein multidimensionaler Raum aus zellulären Automaten, die von den Besuchern manipuliert werden können und emergente Muster erzeugen, die als flüssige strukturelle Formen in einem 3D-Raum dargestellt werden.

Ein Forschungsbereich waren Physical-Computing-Projekte, die sinnvolle, schöne, aber auch kontroverse Beziehungen zwischen Menschen und Artefakten herzustellen versuchten. *UrbanForest, White Lies* und *The Rocking Chair* sind drei interaktive Prototypen, die die Sphäre des Persönlichen mittels haptischer Interaktion untersuchen. *Waves* ist eine kinetische und auditive Skulptur, in der die Formen und Geräusche von Bewegungen durch Interaktion mit dem Publikum physische Gestalt annehmen.

Zachary Lieberman leitete eine Gruppe, die mithilfe der neuen C++-Open-Source-Bibliothek *OpenFrameWorks* an Objekterkennungstechniken arbeitete. Davon werden vier Arbeitsergebnisse gezeigt: *Predator, Memento, Magic Lamp* und *D3Sombra*. Diese Projekte verbinden auditive und visuelle Reaktionen auf die Bewegungen der Besucher zu nahtlosen, organischen und spielerischen Interaktionsformen.

Interactivos? ist ein Teil der allgemeinen Strategie des MediaLabMadrid, fesselnde Umgebungen zur Erforschung und Erweiterung der Disziplin und des Diskurses der Medienkunst zu schaffen.

Aus dem Englischen von Wilfried Prantner

Waves, Daniel Palacios Jiménez *Memento*, Jeldrik Schmuch/Ulrike Gollner

Karin Ohlenschläger / Luis Rico

Productive Interventions from the Fringes of Media Art

The model of hegemonic exhibition venues and dominant axes of artistic and cultural production that still prevailed in the late 20th century has undergone a significant change in recent years. These centers and the alignments among them are increasingly being displaced by new structures of nodes and networks that are constantly growing deeper into the very substance of society itself and are thus making totally new linkages, structures and movements possible.

In this context, the question of the production and representation of process-related artistic projects—regardless of whether they entail old or new media—has long since become an issue occupying the attention of a growing number of institutions. For over four years now, Media-LabMadrid has also been facing these challenges. Our response has not only involved new artistic formats but also innovative, dynamic ways of producing, participating in and partaking of art. The source of the conceptual and formal impetus driving this creative process has been primarily the fringes of media art in connection with other social and cultural practices. With today's system-related production principles of contemporary software-and-hardware-art, it has become more and more difficult to differentiate between products and processes. They are increasingly subject to communicative and socially dependent dynamics, whereby the sum total of these singular forces can trigger the emergence of totally new processes. In order to make this development not only visible but also comprehensible, MediaLabMadrid has established a polyvalent, transdisciplinary sphere of action in which research, production, education and exhibition formats can simultaneously articulate themselves as an open system and reciprocally interact with each other. One of the most recent such projects *(www.interactivos.org)* scrutinized the concept of interactivity not only in connection with its project-based forms and contents, but also in a much broader, system-encompassing sense applied to the interrelationships among, and co-evolution of, institutions, mediators, artists, programmers and members of the

public. Meanwhile, directors Laura Fernández and Marcos García have been coordinating the transformation of Conde Duque, the City of Madrid's traditional exhibition center, into a venue for communication, production, seminars and exhibits in which selected projects of both an individual and a collective nature can be developed, discussed and produced. What all these works have had in common is the use of open hardware and open software tools by David Cuartielles, Zachary Lieberman, Casey Reaves and Hans Christoph Steiner, who conducted interrelated workshops at MediaLabMadrid at various times over a period of five weeks. The selected projects and their authors were also open to spontaneous input from, and interaction with workshop participants.

Here, the collaboration of artists, architects, programmers, musicians, mathematicians, designers, students, teachers and representatives of the regional Ministry of Education produced a wide range of surprising results: for instance, writing instructions for an Arduino tools application designed for the educational field, or developing a "Multidimensional Particle Projector for Emergent Processes" for architects and urban planners (Alvaro Castro and Carlos Cabañero: *www.alvarocastro.es)*. In Madrid, diverse sound sculptures and virtual musical instruments were enhanced and upgraded by K3, *(http://webzone.k3.mah.se/projects/implement)*, a group of Swedish students from the University of Malmö's School of Arts and Communication, as well as conceived and produced by artists, composers and engineers such as Enrique Tomás *(www.mlab.uiah.fi/-korayt/emipro.html)* and Daniel Palacios *(www.waves.stopandplay.com)*. Moreover, these workshop, seminar and exhibit activities were not limited to the premises of the Conde Duque exhibition center; they were also supplemented by spontaneous presentations at the Autonomous University of Madrid, and included a presence by night in the Dorkbot Presentation at the nearby LaDinamo independent cultural center and at the Radar Electronic Sounds Bar.

In this context, these dynamic, productive interventions also call into question traditional structures and divisions. Simultaneously, they generate channels for feedback effects from artistic, scientific, technological and social processes that are interlinked in ever-denser networks reciprocally nurturing one another in this very fruitful setting engendered by contemporary media culture.

http://www.medialabmadrid.org
http://www.banquete.org

Karin Ohlenschläger / Luis Rico

Produktive Interferenzen aus den Grenzbereichen der Medienkunst

Das noch im 20. Jahrhundert vorherrschende Modell hegemonischer Ausstellungszentren und dominierender Produktionsachsen von Kunst und Kultur hat in den letzten Jahren einen bedeutenden Wandel erfahren. Die Zentren und Achsen weichen zunehmend neuen Strukturen von Knoten und Netzen, die immer tiefer in soziale Bereiche hineinwachsen und damit ganz neue Verbindungen, Strukturen und Bewegungen möglich machen.

In diesem Zusammenhang ist die Frage der Produktion und Repräsentation prozessgebundener künstlerischer Projekte – sei es mit alten oder neuen Medien – schon seit langem ein Thema, das immer mehr Institutionen beschäftigt. Seit über vier Jahren stellt sich auch das MediaLabMadrid diesen Herausforderungen nicht nur mit neuen Formaten, sondern auch mit innovativen Produktions-, Partizipations- und Rezeptionsdynamiken, deren konzeptuelle und formale Impulse vor allem aus den Grenzbereichen der Medienkunst in Verbindung mit anderen sozialen und kulturellen Praktiken kommen. Bei den heutigen systembezogenen Produktionsprinzipien aktueller Soft- und Hardwarekunst werden Produkte und Prozesse immer schwerer trennbar. Sie unterliegen zunehmend kommunikativen und gemeinschaftsabhängigen Dynamiken, deren Summe von Singularitäten die Emergenz ganz neuer Prozesse anregen kann. Um diese Entwicklungen nicht nur sichtbar, sondern auch nachvollziehbar zu machen, hat das MediaLabMadrid einen polyvalenten, transdisziplinären Aktionsraum geschaffen, in dem sich Forschung, Produktion, Bildungs- und Ausstellungformate simultan als offenes System artikulieren und verknüpfen lassen. In einem der jüngsten Projekte dieser Art *(www.interactivos.org)*, wurde das Konzept der Interaktivität nicht nur in Bezug auf seine projektbezogenen Formen und Inhalte hinterfragt, sondern darüber hinaus auch systemübergreifend auf die Beziehung und Ko-Evolution von Institution, Vermittlern, Künstlern, Programmierern und Publikum angewendet. Das traditionelle Ausstellungszentrum Conde Duque der Stadt Madrid verwandelte sich dabei unter der Koordinations-

leitung von Laura Fernández und Marcos García in einen Kommunikations-, Produktions-, Seminar- und Ausstellungsraum, in dem die ausgewählten Projekte sowohl individuell als auch kollektiv entwickelt, diskutiert und produziert wurden. Der gemeinsame Nenner all dieser Arbeiten war die Anwendung von Open-Hardware- und Open-Software-Tools von David Cuartielles, Zachary Lieberman, Casey Reas und Hans Christoph Steiner, die zu verschiedenen Zeitpunkten im MediaLabMadrid über fünf Wochen ineinandergreifende Workshops leiteten. Die ausgewählten Projekte und ihre Autoren waren dabei auch für andere interessierte Teilnehmer oder spontane Besucherbeiträge offen.

Künstler, Architekten, Programmierer, Musiker, Mathematiker und Designer, Studenten, Lehrer und andere Vertreter des regionalen Erziehungsministerium arbeiteten dabei mit sehr unterschiedlichen und überraschenden Resultaten zusammen: Die einen schrieben an einer Applikationanleitung der *Arduino*-Tools für den Erziehungsbereich, andere entwickelten einen *Multidimensional Particle Projector for Emergent Processes* für Architekten und Stadtplaner (Alvaro Castro und Carlos Cabañero, *www.alvarocastro.es*). Unterschiedliche Klangskulpturen und virtuelle Musikinstrumente wurden in Madrid sowohl von der schwedischen Studentengruppe der School of Arts and Communication, K3, der Universität Malmö weiterentwickelt *(webzone.k3.mah.se/projects/implement)* als auch von Künstlern, Komponisten oder Ingenieuren wie Enrique Tomás *(www.mlab.uiah.fi/-korayt/emipro.html)* oder Daniel Palacios *(www.waves.stopandplay.com)* konzipiert und produziert. Die Workshop-, Seminar- und Ausstellungsdynamik beschränkte sich allerdings nicht nur auf die Räumlichkeiten des Ausstellungszentrums Conde Duque, sondern erweiterte sich um spontane Präsentationen in der Autonomen Universität Madrid oder war nachts auf der Dorkbot-Präsentation im naheliegenden unabhängigen Kulturzentrum LaDinamo oder in der Radar Electronic Sounds Bar präsent.

Diese Dynamik produktiver Interferenzen hinterfragt in diesem Zusammenhang auch traditionelle Strukturen und Arbeitsteilungen. Gleichzeitig generiert sie Feedbackschleifen künstlerischer, wissenschaftlicher, technologischer und sozialer Prozesse, die sich im Umfeld der gegenwärtigen Medienkultur immer dichter vernetzen und gegenseitig fördern.

http://www.medialabmadrid.org
http://www.banquete.org

Philip Dean, Media Lab at the University of Art and Design Helsinki (TaiK)

The Beta Lounge

The 2006 Ars Electonica Campus exhibition, the *Beta Lounge,* features the work of the Media Lab faculty of the University of Art and Design Helsinki, Finland (TaiK). The Media Lab was established in 1994. Since then it has been an extremely active player, as part of one of the world's leading universities of art and design, in the development of interdisciplinary Masters and Doctoral-level education, as well as international research & development. The lab's work encompasses the broad spectrum of subjects within the emerging fields of interactive digital media and digital design. The last 12 years have been a time of experimentation, searching and innovation. Today the Media Lab Helsinki is the most international university faculty in Finland; a community of over 150 persons with staff and students originating from all corners of the globe.

Within the context of academia the Media Lab is a complex hybrid unit whose efforts and results often defy simple explanation due to their multidisciplinary and multicultural nature.

The mission of the Media Lab Helsinki is to explore, discover and comprehend the new digital technology and its impact on society; to find and exploit the possibilities it opens to communication, interaction and expression, and to evaluate, understand and deal with the challenges it poses to design and creative production. The *Beta Lounge* exhibition aims to illuminate the challenges and results of the lab's ongoing mission according to its agenda of recent years. The agenda has changed and grown constantly during the lab's brief history. *New* Media are a 'fast moving target', they rely on new technologies and much of the potential of new media has also been realised through rapid development of technologies and their deployment and applications as mass-market consumer products.

As a faculty of an art and design university, the Media Lab Helsinki does not adhere to any one particular theoretical, cultural or philosophical standpoint. The education and research of the lab is a well-balanced mixture of theory and practice, of *minds on* and *hands on*. Within this area of design the nature of the resulting products is significantly different from traditional designs. Results exist typically in the constraints of computers and computer systems and are often best described as *software*. Their development, dissemination and critical evaluation cannot be based on traditional art and design practices and values. The development of new media has subsequently spawned new areas of art and design that demand knowledge exchange and research collaboration between groups of experts in diverse fields in an international context.

The *Beta Lounge* exhibition presents the work of Master (MA) students, Doctor of Art (DA) students and the Media Lab's four established research groups. This is not a retrospective show, but several alumni students have been invited to show their prized work in the exhibition.

Education within the Media Lab Helsinki at TaiK is typically problem-based and students are encouraged to experiment and develop innovative concepts for their joint projects. The interdisciplinary nature of the faculty is furthered by the involvement of foreign exchange students and students from other Finnish universities and other faculties of TaiK. Students are encouraged to find their own particular strengths and areas of expertise. There is no one formula for study in the lab and there is no one particular sector of industry in which graduates are expected to find employment. Graduates are expected to gain positions within companies and organisations where they can influence development processes and bring their multi-disciplinary and multicultural understanding into play. Some graduates form companies and others undertake research careers.

The development of research has played a major role in the Media Lab since 1995. Within the

numerous national and international R&D projects the Media Lab's responsibility has typically been in digital design, experimental practice-based production, design research and also in project creation, leadership and management. Considerable R&D efforts have been made within applied research framework projects of the EU's Information Society Technologies programmes (IST) as well as other Finnish and EU programmes. The projects shown fall into many fields; in digital cultural heritage, e-learning, advanced interactive audiovisual narrative systems as well as the enablement of people to take advantage of digital development and to design their own lives with digital tools.

Finland is the birthplace and home to Nokia, and a land where nowadays innovation in the field of mobile technologies is expected to be prevalent. As may be seen in the *Beta Lounge* the students and staff of the Media Lab are increasingly interested in designing mobile devices and experimenting with new interaction possibilities in which the phone becomes an input device and/or terminal connecting people to local and global systems of information, collaboration or to entertainment or scholarly content.

Since 1994 the Media Lab Helsinki has served as a pioneering and efficient experimental environment, a *Beta Lounge*, for study and the development of New Media. The lab's students, designers, researchers and artists attempt to develop meaningful solutions that apply mastery of the new possibilities and technologies within the context of people's real needs and desires.

▬▬▬▬

Die Ausstellung *Beta Lounge* auf dem Campus der Ars Electronica zeigt die Arbeit des Media Lab der Universität für Kunst & Design Helsinki (TaiK), Finnland. Seit seiner Gründung im Jahr 1994 spielt das Media Lab als Fakultät einer der führenden Universitäten für Kunst & Design eine äußerst aktive Rolle in der Entwicklung einer interdisziplinären universitären Ausbildung sowie im Bereich internationale Forschung & Entwicklung. Das Media Lab befasst sich mit dem breiten Themenspektrum, das sich in den neu entstehenden Wirkungsfeldern der interaktiven digitalen Medien und des digitalen Designs eröffnet. Die letzten zwölf Jahre waren eine Zeit der Experimente, der Suche und der Innovation. Heute ist das Media Lab Helsinki die am stärksten international ausgerichtete Universitätsfakultät Finnlands, deren insgesamt über 150 Mitarbeiter und Studenten aus allen Teilen der Welt kommen.

Das Media Lab ist im Kontext der Academia ein komplexer Hybrid, der aufgrund seines multidisziplinären und multikulturellen Charakters nicht so einfach zu beschreiben ist.

Die Aufgabe des Media Lab besteht darin, die neue digitale Technik und ihren Einfluss auf die Gesellschaft zu erforschen, zu sondieren und zu verstehen, Möglichkeiten, die diese in den Bereichen Kommunikation, Interaktion und Ausdruck eröffnet, zu entdecken und auszuwerten, sowie die Herausforderungen, vor die sie das Design und die kreative Produktion stellt, zu evaluieren, zu verstehen und zu bewältigen. Die *Beta Lounge* möchte die Herausforderungen aufzeigen, denen sich das Media Lab gemäß seinem Programm der letzten Jahre gestellt hat, sowie die Ergebnisse dieser Auseinandersetzung. Das Programm hat sich verändert und wurde in der kurzen Geschichte des Media Lab ständig erweitert. Neue Medien sind ein „sich schnell bewegendes Ziel", sie sind von neuen Techniken abhängig, wobei ihr Potenzial zu einem Großteil auch durch die rasche technische Entwicklung und die Anwendung der Neuerungen als Konsumgüter für den Massenmarkt verwirklicht wurde.

Als Fakultät einer Universität für Kunst & Design ist das Media Lab Helsinki keinem bestimmten theoretischen, kulturellen oder philosophischen Standpunkt verpflichtet. Ausbildung und For-

schung beruhen auf einem ausgewogenen Verhältnis von Theorie und Praxis, von Kopf- und Handarbeit. Die in diesem Rahmen entstehenden Produkte unterscheiden sich deutlich von traditionellen Entwicklungen. Sie existieren ausschließlich innerhalb von Computersystemen und lassen sich häufig am besten als Software beschreiben. Ihre Entwicklung, Verbreitung und kritische Einschätzung kann daher nicht auf den traditionellen Methoden und Werten von Kunst & Design basieren. Die Entwicklung neuer Medien hat in weiterer Folge auch neue Möglichkeiten im Bereich Kunst & Design hervorgebracht, die Wissensaustausch und Forschungskooperation zwischen Expertengruppen unterschiedlicher Fachrichtungen in einem internationalen Kontext verlangen.

Die *Beta Lounge* präsentiert die Arbeit von Studenten und der vier Forschungsgruppen des Media Lab. Sie versteht sich nicht als Retrospektive; vielmehr wurden mehrere Absolventen eingeladen, ihre ausgezeichneten Arbeiten in der Ausstellung zu zeigen.

Die Ausbildung am Media Lab Helsinki ist problemorientiert, die Studenten werden ermutigt, zu experimentieren und innovative Konzepte für ihre gemeinsamen Projekte zu entwickeln. Der interdisziplinäre Charakter der Fakultät wird durch die Einbindung von Austauschstudenten, von Studenten anderer finnischer Universitäten und Fakultäten des TaiK verstärkt. Die Studenten werden darüber hinaus ermutigt, ihre eigenen Stärken und Fachgebiete zu entdecken. Das Studium am Lab folgt keinem schematischen Lehrplan, und es wird auch nicht erwartet, dass die Absolventen eine Beschäftigung in einem bestimmten Industriesektor finden. Man hofft vielmehr, dass sie Positionen in Firmen und Organisationen einnehmen, in denen sie Entwicklungsprozesse beeinflussen und ihr multidisziplinäres und multikulturelles Verständnis einbringen können. Manche Absolventen gründen auch eigene Firmen oder entscheiden sich für eine Laufbahn in der Forschung.

Die Entwicklung der Forschung ist seit 1995 ein Schwerpunkt des Media Lab. Im Rahmen der zahlreichen nationalen und internationalen Projekte zu Forschung und Entwicklung konzentrierte sich das Media Lab auf digitales Design, experimentelle praxisorientierte Produktion, Designforschung sowie auf Projekterstellung, Führungsstil und Management. Beachtliche Bemühungen wurden auch in Rahmenprojekten zu angewandter Forschung der IST-Programme *(Information Society Technologies Programmes)* der EU sowie weiterer finnischer und EU-Programme unternommen. Die gezeigten Projekte beschäftigen sich mit so unterschiedlichen Themen wie digitalem Kulturerbe, E-Learning, hoch entwickelten interaktiven audiovisuellen Erzählsystemen sowie der Befähigung von Menschen, von der digitalen Entwicklung zu profitieren und ihr Leben mit digitalen Werkzeugen zu gestalten.

Finnland ist die Geburtsstätte und die Heimat von Nokia, und ein Land, von dem heute Innovation im Bereich mobiler Techniken erwartet wird. Wie in der *Beta Lounge* zu sehen ist, sind die Studenten und die Lehrenden des Media Lab zunehmend daran interessiert, für mobile Geräte zu designen und mit neuen Möglichkeiten der Interaktion zu experimentieren, bei denen das Telefon zu einem Eingabegerät und/oder Terminal wird, das die Menschen mit lokalen und globalen Informations-, Kooperations- und Unterhaltungssystemen oder wissenschaftlichen Inhalten verbindet.

Das Media Lab Helsinki ist seit 1994 ein richtungweisendes und leistungsfähiges experimentelles Umfeld, eine *Beta Lounge* für das Studium und die Entwicklung Neuer Medien. Die Studenten, Designer, Forscher und Künstler des Lab versuchen sinnvolle Lösungen zu entwickeln, die die neuen Möglichkeiten und Techniken an die wahren Bedürfnisse und Sehnsüchte der Menschen heranführen.

Aus dem Englischen von Martina Bauer

███████ ## Arki Research Group

How will our everyday life be transformed by all the digital devices, networks and software that are invading our activities and environments? Is this development programmed by others or do we have ways to influence it? These questions motivate the work of the Arki research group.

"Arki" is a Finnish word for "everyday life", and expresses the focus of the group. Its work is not motivated by product design but instead by the interests, practices and the quality of life of individuals and those close to them.

The two main research and development directions of Arki are
• to find ways to enable more people to take advantage of the digital development and to design their own lives with digital tools, and
• to study the evolution of the media environment and design new interesting media formats and tools.

The 18-member group is involved in projects that envision future information environments and develop social media applications and tools for designing them. The activities are based on co-design with both future users and industry.

http://arki.uiah.fi

Wie wird sich unser Alltag durch all die digitalen Geräte, Netzwerke und Software-lösungen verändern, die in unser Umfeld eindringen und unsere Handlungen mitbestimmen? Wurde uns diese Entwicklung von anderen vorgegeben oder haben wir noch die Möglichkeit, darauf Einfluss zu nehmen? Auf Fragen wie diesen basiert die Arbeit der Forschungsgruppe Arki.

„Arki" ist ein finnisches Wort für „Alltag" und spricht das zentrale Thema der Gruppe an, deren Arbeit nicht auf Produktdesign ausgerichtet ist, sondern sich an den Interessen, Praktiken und der Lebensqualität von Individuen und ihrem Umfeld orientiert.

Die zwei wesentlichen Forschungs- und Entwicklungsansätze von Arki sind:
• Möglichkeiten zu finden, die mehr Menschen erlauben, von der digitalen Entwicklung zu profitieren und ihr Leben mit digitalen Werkzeugen zu gestalten, und
• die Entwicklung des Medien-Environments zu untersuchen und neue interessante Medienformate und -tools zu entwickeln.

Die aus 18 Mitgliedern bestehende Gruppe befasst sich mit Projekten, bei denen zukünftige Informationsumgebungen erforscht und gesellschaftliche Medienanwendungen und Tools für deren Gestaltung entwickelt werden. Prägend für die Aktivitäten ist die gemeinsame Gestaltung mit den zukünftigern Usern und der Industrie.

http://arki-uiah.fi

■ Arki projects

Arki Research group shows the following works in the Campus exhibition of Ars Electronica Festival 2006:

Mediaspaces creates insight about how the media environment changes in digital convergence, and what new media formats and social uses of media emerge, enabled by the new possibilities.

P2P-FUSION creates a peer-to-peer system for creative reuse and collaborative editing of audiovisual programs as well as new social media practices that take advantage of it.

ADIK studies different practices of communities and how they evolve in interaction with the rapid development of digital technology. How do people, through their practices, transform and complement new tools? How do new tools enable new practices?

EnComPAs is a EUREKA CELTIC project of 12 partners from 5 countries. Arki leads the codesign activities and develops multidevice media sharing applications.

ICING is an EU-IST project that develops e-Government solutions for Helsinki, Dublin and Barcelona. Arki develops the Urban Mediator, an interface for citizen interaction with the city.

▉▉▉ Systems of Representation (SysRep)

The group was created in 1997 by Lily Díaz-Kommonen. The group conducts research into the representation of knowledge with particular emphasis on digital cultural heritage. Within this area, the research explores these topics:

- Visualization methods and tools
- Digital cartography
- Ontology design and implementation
- 3-D user interface design.

What is Digital Cultural Heritage?

Cultural heritage is a broad term used to refer to forms of cultural and artistic expression inherited from the near or distant past of a given country or cultural area. As precious evidence, cultural heritage is seen both as a record and manifestation of human presence throughout history.

In recent years, partly through the development of the Information Society with its associated trends of globalisation, growing interconnectedness and instant multi-modal communications, which simultaneously merge communities as well as erode the boundaries of traditional societies, the concept of digital cultural heritage evolved to reflect the use of digital practices in the recording and preservation of cultural heritage artefacts.

Key research projects:

Digital Facsimile of the Map of Mexico 1550 (1997–present)
Exploring Carta Marina (2002–2004)
Illuminating History, Through the Eyes of Media (1996–2000)

http://mlab.uiah.fi/www/research/research_groups/systems_of_representation

Die Gruppe wurde 1997 von Lily Díaz-Kommonen gegründet und forscht im Bereich der Wissensrepräsentation mit Schwerpunkt „digitales Kulturerbe". Folgende Themen stehen dabei im Mittelpunkt:

- Visualisierungsmethoden und -tools,
- digitale Kartografie,
- Ontologie-Design und Implementierung,
- Entwicklung von 3D-Schnittstellen.

Was versteht man unter digitalem Kulturerbe?
Der Begriff Kulturerbe bezeichnet kulturelle und künstlerische Ausdrucksformen aus der jüngeren oder älteren Vergangenheit eines bestimmten Landes oder einer Kulturregion, die für eine Epoche oder künstlerische Entwicklung beispielhaft sind. Als wertvolles Relikt der Vergangenheit wird Kulturerbe sowohl als Zeugnis wie auch als Manifestation menschlicher Gegenwart quer durch die Geschichte gesehen.

Nicht zuletzt durch die Entwicklung der Informationsgesellschaft und die damit verbundenen Tendenzen der Globalisierung, der wachsenden Vernetzung und der Möglichkeiten multimodaler Direktkommunikation, die gleichzeitig Gemeinschaften zusammenschließt und die Grenzen traditioneller Gesellschaften unterminiert, entwickelte sich in den letzten Jahren der Begriff des digitalen Kulturerbes für die Verwendung digitaler Methoden bei der Aufzeichnung und Bewahrung von Artefakten des Kulturerbes.

Schlüsselprojekte in der Forschung:
Digitales Faksimile der Landkarte von Mexiko 1550 (1997–Gegenwart)
Untersuchung der *Carta marina* (2002–2004)
Geschichtsbetrachtung aus der Sicht der Medien (1996–2000)

http://mlab.uiah.fi/www/research/research_groups/systems_of_representation

■ **Digital Facsimile of Map of Mexico 1550**

Built around the notion of Design of the Artificial, this project by the Systems of Representation research group is a collaboration between the University of Art and Design, Media Lab, Helsinki University of Technology, the Institute of Photogrammetry, and Uppsala University Library in Sweden.

The project develops information technology tools and content in the area of digital cultural heritage. Among the tools created is an OpenGL interactive installation for the Map. The DisplayMap Tool that enabled exhibiting the map on the World Wide Web was developed in 2003.

This tool was refined into an advanced Open Source tool called ImaNote, now distributed through Savanna.

In 2005 a video narrative workshop was held with Universidad Iberoamericana de Ciudad de México, in which students created an anthology of Legends of the Historic Center of Mexico City that is licensed through Creative Commons.

The project won 1st Prize in the 2004 Digital Storytelling Competition sponsored by Art Center Nabi in South Korea with the collaboration of UNESCO and the International Council of Museums (ICOM).

Detail of the Digital Facsimile of the Map of Mexico 1550 attributed to Alonzo de Santa Cruz, Cosmographer to His Majesty Charles V of Spain. From the original in Uppsala University Library, Sweden.

▬▬▬ Crucible Studio for the Art and Design of Storytelling in New Media

Crucible Studio is dedicated to exploring, defining and creating new forms of story-telling in dialog with contemporary and upcoming media technologies and traditions of performance and drama. Founded in 2002, the research studio is situated between the Media Lab and Media Centre Lume of the University of Art and Design Helsinki, which provides a unique environment where professionally equipped and maintained production facilities are linked with a content-led, practice-based and multidisciplinary research group. The experienced professional artists, scholars, designers and engineers, in collaboration with both Doctor of Arts (DA) and MA students, aim to deepen the emotional perception of interactive media through staging the drama for the interactor in a shared collective experience. The research takes place mainly through international, academic and corporate collaboration funded by the European Union's framework, cultural and IST programmes, while some basic and applied research is funded nationally by the Finnish Academy and the Finnish Funding Agency for Technology and Innovation, TEKES.
http://crucible.lume.fi

Das *Crucible Studio* widmet sich der Erforschung, Definition und Kreation neuer Formen des Geschichtenerzählens im Dialog mit aktuellen und zukünftigen Medientechnologien und Traditionen in Performance und Drama. Das 2002 gegründete Forschungsstudio befindet sich zwischen dem Media Lab und dem Media Centre Lume der Universität für Kunst & Design Helsinki, wodurch einer inhaltlich orientierten, praxisnahen und multidisziplinären Forschungsgruppe ein einzigartiges Umfeld mit professionell ausgestatteten und geführten Produktionseinrichtungen zur Verfügung steht. Die erfahrenen Künstler, Wissenschaftler, Designer und Ingenieure arbeiten mit Kunststudenten zusammen, um die emotionelle Wahrnehmung interaktiver Medien zu intensivieren, indem sie das interaktive Drama als kollektive Erfahrung inszenieren. Die Forschung basiert in erster Linie auf der internationalen Unterstützung von Universitäten und Firmen und wird durch die Rahmen-, Kultur- und IST-Programme der Europäischen Union finanziert, während die Grundlagen- und angewandte Forschung teilweise von der Finnischen Akademie und der TEKES, der Technologieagentur Finnlands, unterstützt werden.
http://crucible.lume.fi

■ New Millennium, New Media & Accidental Lovers

New Millennium, New Media (nm2) is a collaborative research project which unites leading creative and technology experts from across Europe to address a great opportunity for businesses and consumers: how to develop compelling new media forms which take advantage of the unique characteristics of broadband networks.
http://www.ist-nm2.org/
Among the seven nm2 research productions is Crucible Studio's *Accidental Lovers* that is being tested with a mass audience during 2006–2007 through a series of national interactive broadcasts by the Finnish National Broadcasting Company (YLE Channel 1). The participatory and episodic black musical comedy explores the variations of a deadly love relationship between a 61 year old cabaret singer Juulia and her 31 year old pop star lover, Roope. Viewers affect the unfolding drama by sending SMS messages with their mobile phones to a system that triggers story events based on keyword recognition.

Photo by Heli Sorjonen

Roope (Lorenz Backman) singing a
serenade to Juulia (Kristiina Elstelä).

Photo by Heli Sorjonen

Juulia's (Kristiina Elstelä) and Roope's
(Lorenz Backman) wedding with the Fates
(Mia Renwall, Minna Rimpilä, Riitta Elstelä).

Photo by Kebede Mergia

Solitary Juulia (Kristiina Elstelä) with her cat Pörhö.

Photo by Kebede Mergia

Mika "Lumi" Tuomola directing Kristiina Elstelä
(Juulia) in a conclusion music video "Poikkisahattu
nainen" ("Die zersägte Dame" by Friedrich Hollaender,
Finnish translation by Vesa Tapio Valo). The young Fates
(Mia Renwall, Minna Rimpilä) get into their characters.

Production stills from Accidental Lovers
(Crucible Studio/University of Art and Design Helsinki 2006, director Mika Tuomola).

■■■■■ **Learning Environments Research Group**

The Learning Environments group, formed in 1998, is a thematic research group of the Media Lab at the University of Art and Design Helsinki. The group is involved in research, design and development of learning environments that are meaningfully enhanced with information and communication technologies including applications for computer supported collaborative learning (CSCL), ubiquitous and mobile tools and tools for creative group work and design. The group's approach to research and design of New Media and learning is theory-based but design-oriented. The group's works are based on the social constructivist theory that sees learning as a participation in social processes of knowledge construction.

The group's research and design takes place in applied multidisciplinary research projects funded by The European Commission in the Information Society Technologies (IST), National Technology Agency of Finland (TEKES), the Nordic Council of Ministers, UNESCO and corporations. The group collaborates with a number of national and international public, academic and corporate partners.

http://mlab.uiah.fi/www/research/research_groups/learning_environments
http://legroup.uiah.fi/

Die 1998 gegründete Gruppe für Lernumgebungen ist eine eigenständige Forschungsgruppe des Media Lab an der Universität für Kunst & Design Helsinki. Die Gruppe beschäftigt sich mit Forschung, Design und Entwicklung von Lernumgebungen, die durch Informations- und Kommunikationstechnologien wie u. a. Anwendungen für CSCL (computerunterstütztes kooperatives Lernen), Tools für Ubiquitous Computing sowie solche für kreative Gruppenarbeit und Design unterstützt werden. Der Ansatz der Gruppe bei der Forschung und dem Design neuer Medien und Lernen ist theoriebasiert, aber designorientiert. Die Arbeiten der Gruppe beruhen auf der konstruktivistischen Gesellschaftstheorie, der zufolge Lernen Partizipation an gesellschaftlichen Prozessen der Wissenskonstruktion ist.

Die Forschungs- und Designarbeit der Gruppe ist in ein angewandtes multidisziplinäres Forschungsprojekt eingebunden, das von der EU im Rahmen der IST-Programme, der Technologieagentur Finnlands (TEKES), dem nordischen Ministerrat, der UNESCO und von Firmen finanziert wird. Die Gruppe kooperiert mit nationalen und internationalern Partnern aus dem öffentlichen, universitären und wirtschaftlichen Bereich.

Aus dem Englischen von Martina Bauer.

■ **MobilED**

The MobilED project presented by the Learning Environments Research Group in the Campus exhibition 2006 involves research and design of learning environments that are meaningfully enhanced with mobile technologies and services. In the MobilED project we have designed scenarios, prototypes and practices of how mobile technologies could be used for teaching, learning and empowerment of students within and outside the school context. The MobilED SERVER is an audio wiki service for mobile phones. You can make queries to wiki content, such as the Wikipedia Free Encyclopaedia, by sending your search term with SMS to the MobilED SERVER. After a while you will receive a call back and a speech synthesizer will read you the content found from the server. You can navigate the content with your phone's number buttons and contribute to the wiki with your own voice by recording your entry. MobilED is a two-year cooperative project with the Council for Scientific and Industrial Research (CSIR) of South Africa and several other partners in India, Brazil and Finland.

Perttu Hämäläinen, Mikko Lindholm, Ari Nykänen

Animaatiokone

Animaatiokone is an easy-to-use, futuristic installation that turns you into a master animator. It is built on custom animation software and technology that make animating quicker and more fun than ever. All you need to start is a piece of plasticine.

Animaatiokone aims to teach people about animation and show how easy it can be to create stop-motion animation. Award winning *Animaatiokone* combines technological and user interface innovations into a novel collaborative storytelling tool. The transparent studio dome and the overhead monitor allow the public to watch the animator at work and they can learn from each other. The dome contains a miniature

studio with a backdrop and a movable camera and set pieces. Animations are captured one after another, each animator continuing from where the previous one stopped. The results vary from absurdly twisting drama to a fragmented animation sketch-book and subliminal glimpses. All animations are presented on the *Animaatiokone* website. The website features the contributions of more than a thousand users, many of whom are first-timers.

Johanna Höysniemi, Perttu Hämäläinen

QuiQui's Giant Bounce

QuiQui's Giant Bounce is a physically and vocally interactive computer game aimed at 4 to 9 year old children. The game is not controlled using a joystick or a keyboard. Instead, the user's body movements and voice are sensed via a webcam and a microphone. The main character QuiQui is a curious little green dragon that mimics the user's movements and shouts and exhales sparkles when the user shouts. The game is based on research on children's physical development, augmented with usability tests and interviews at schools and daycare centers. The goal is to provide an immersive and physically engaging alternative to traditional computer games: QuiQui animates children to use their

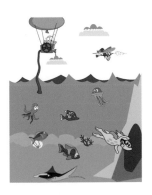

whole body and develops their physical skills such as coordination and balance. The ways of moving in a game are motivated by an enticing storyline and rich audiovisual content. The game features technological innovations that enable physical interaction in every home. Compared to games based on sensory devices like a dance mat, QuiQui's user interface is full-body and wireless.

Concept and user interface design, technical design and implementation, sound design: Perttu Hämäläinen
Concept and user interface design, children's usability testing, sport science, animation, www design: Johanna Höysniemi
Visual design, illustration and animation: Teppo Rouvi
Story: Laura Turkki

Janne Kaasalainen, Tanja Bastamow, Miikka Junnila,
Miska Natunen, Jürgen Scheible
Snowman in Hell

Hell is no place for a snowman—but some days are worse than others. You start a desperate journey through the perils of evil and treachery. Listening to the voice of a murdered man inside your head, you begin to realize that your fortune is bound to the souls burning in the eternal flames ...

Snowman in Hell is an experimental computer game with hectic action and sophisticated puzzles. It's also an epic horror story about a snowman with nothing to lose, inspired by Dante's *Inferno* and film noir. There is a need for games that do things differently. Even a traditional platform game can feel fresh if there is something new in the mix: schizophrenic dialog during the levels, graphics made from garbage and clay, para-realistic simulation of physics, delicately grotesque soundscape ... Quoting Pelit, the biggest game magazine in Finland: "Snowman in Hell guarantees an unforgettable experience."

http://mlab.uiah.fi/snowman

Starring: Tuukka Jukola – Vergilius, Tanja Bastamow – Norma, Jürgen Scheible – The Pope, Miikka Junnila – Nathan; Concept design: Miikka Junnila, Janne Kaasalainen, Miska Natunen, Jürgen Scheible; Dialog & Story writing: Miikka Junnila; Programming: Miska Natunen; Graphic design: Tanja Bastamow, Janne Kaasalainen; Cutscene graphics: Miikka Junnila; Animations: Tanja Bastamow, Miikka Junnila, Janne Kaasalainen; Clay modelling: Tanja Bastamow, Miikka Junnila, Janne Kaasalainen; Music & Sound design: Jürgen Scheible; Producer: Pipsa Asiala/Media Lab; Guestbook Application: Twinkle Oy; Thanks to: Teijo Pellinen, Tapio Schultz, Maureen Thomas, Rasmus Vuori, Media Lab, School of Motion Picture, TV and Production Design & Lume staff; 2004 University of Art and Design Helsinki Media Lab; School of Motion Picture, TV and Production Design

Helena Hyvärinen, Reka Kiraly, Cvijeta Miljak
Päämaja/Headquarters
An interactive DVD film

Päämaja/Headquarters is an interactive film on a DVD platform. The story is situated in a surreal world of elevators, and introduces a liftboy being challenged by an almost invisible antagonist—a flea in a quest for power. An interactive point in the film reveals the possible outcomes of their struggle, and leads to three different conclusions. In general, the film explores aspects of the omnipresent theme of human relationships to power and plays with ideas of hierarchy and self-perception. *Päämaja/Headquarters* was inspired by ideas from Dostoevsky's novel *Crime and Punishment*.

Cvijeta Miljak

Story created by: Helena Hyvärinen, Reka Kiraly, Cvijeta Miljak; Director: Helena Hyvärinen; Cinematographer: Cvijeta Miljak; Assistant director: Reka Kiraly; Editing: Cvijeta Miljak; Sound designer: Helena Hyvärinen; Actor: Aapo Korkeaoja (+ additional scenes: Aki Kotkas, Riikka Paavola); Original music: Kaapo Huttunen; Virtual world animator: Cvijeta Miljak; Set designers: Helena Hyvärinen, Reka Kiraly, Cvijeta Miljak; Costume designer: Reka Kiraly; Virtual flea animator: Reka Kiraly; Studio technicians: Toni Tolin, Mazdak Nassir; Graphic designer: Reka Kiraly; Producer: Cvijeta Miljak

Li Xin, Eirik Fatland
Credits NeverEnding

Credits NeverEnding is an interactive TV program, created for the Finnish television channel Dina. *Credits NeverEnding* is intended for television's off hours, and was developed as part of a project to produce intentionally boring TV—"Boredom is a luxury anyone can afford". The sight of movie credits on television is usually taken to signify the ending of one program, and the beginning of another. *Credits NeverEnding* subverts this convention by being credits for a movie that never existed, and holding the viewer in suspense for a program that never comes. The credits loop and change, but may scroll over the screen for hours on end.

Li Xin

The names and titles on the list come from the viewers themselves. A viewer with the right mix of attentiveness and time to kill will eventually discover the URL of the website where new credits may be entered. Viewers enjoy nearly total freedom to shape the neverending credits, including promoting themselves. *Nothing is true until it is on television.*

Design & Concept: Li Xin
Programming & Design: Eirik Fatland
Music: Anthony Rajiekov (used under a Creative Commons license)

219

Miikka Junnila, Andrii Khrupa, Anssi Mutanen,
Noora Ojala, Karoliina Talvitie-Lamberg
Molly | Case

Molly | Case is an interactive short film inspired by William Gibson's *Neuromancer*. Two people are longing for a connection with each other in a little hotel room of the future, but the different realities of the world as we know it, cyberspace and the world of dreams, don't allow real contact. A mirror acts as a gate between the subjective realities of Case and Molly, and the user can change his/her point of view whenever he/she likes.

ICE, the invisible barrier software in the cyberspace makes sure data remains untouched. Similar psychological barriers keep all levels of reality cold and distant, from the electric, dynamic blues of the cyberspace to the lack of light in reality. This mood is the heart of the film. The mixed reality levels make the story complicated, and multiple viewings are needed to understand the whole tragedy. This also emphasizes the need for interaction to open up the different perspectives.

The project group: Miikka Junnila, Andrii Khrupa, Anssi Mutanen, Noora Ojala, Karoliina Talvitie-Lamberg
Starring: Samu Loijas, Hanna Seppä
Composer: Tuukka Tarma

Minna Nurminen, Petri Kola
Sankari Show—The Ultimate Live Talk Karaoke

Sankari ("hero" in Finnish) is a new type of improvisational show. In the *Sankari Show* members of the audience make up and perform the lines for Elias, the main character, as he tries to navigate his way through everyday life's rough patches. Sankari is both media art and a TV format. It received an honorable mention at the Transmediale05 digital art festival in Berlin and took the top prize at the 2003 MindTrek event. Currently *Sankari* is being developed as a TV show.

Participants in the *Sankari Show* compete against each other in the areas of verbal and improvisational ability. The hero of the show is Elias, but he doesn't have a voice—alone he is helpless. Contestants give him a voice and what they say determines his fate. Sankari offers people a fun way to perform in front of an audience. It's karaoke, a TV drama and a video game.

Sankari was created at UIAH as the final thesis of Minna Nurminen and Petri Kola. From the very beginning, the idea was to create a media piece equally at home on television or as a performance at bars and festivals.

Game design & Script writing: Petri Kola, Minna Nurminen, Mikko Lindholm; Director, interaction design & programming: Petri Kola; Game & video editing: Minna Nurminen; Executive producer: Pipsa Asiala, TaiK Medialab; Producers: Markku Nousiainen, Satu Lavinen, Petri Kola, Minna Nurminen; Cinematography: Toke Lahti; Sound design: Aura Neuvonen; Set design: Riikka Paavola; Music: Seppo Santala; Graphic design: Jarno Luotonen; Elias: Heikki Pitkänen; Laura: Olga Koskikallio; Anders: Ilkka Villi; Boss: Markku Nousiainen

Michihito Mizutani
Emotional Communication

The *Emotional Communication* project provides a series of communication tools. These tools are not intended to substitute the existing communication tools such as mobile phones. The Emotional Communication tools are subtle and quiet tools. They are useless when you need to convey a clear message to others. We can use mobile phones for this. The Emotional Communication tools will help you feel others who you want to be connected to. They can fill the gap of physical and mental distance between friends and family.

The communication tools are called Talking Glass, Sharing the Moment and Narrowcasting TV. Talking Glass is a cup, which enables users to enjoy interaction while they raise their glasses for a toast. In Sharing the Moment, a couple with a long distance relationship can share a moment of living together. Finally in Narrowcasting TV, elderly people can receive photos on their TV screens, taken with a mobile phone by their children or grandchildren.

Collaboration partner for Talking Glass: Ida Blekeli

Wille Mäkelä
Painted into air

Painted into air is an immersive fine art exhibition, originally presented at the Museum of Contemporary Art Kiasma, Helsinki, in 2005. Spectators can step into the stereo display of a two-screen corner, and move among three-dimensional free hand traces. Wille Mäkelä and ten well-known Finnish and Estonian artists have sketched experimental paintings. During their brief but astonishing new experience of painting into air, each of the guest artists found a personal way to study the depth. Among others, one artist described the process as starting everything from the beginning, just like a young child. Exploring the traces in immersion, spectators may now find bridges between the new medium and traditional handwork.

Experimental Virtual Environment in TML—laboratory of Helsinki University of Technology, 2003–2005: Design of the immersive free hand tool and the immersive viewer corner by Tommi Ilmonen and Wille Mäkelä. Software by Tommi Ilmonen.
Painted into air: Experimental spatial paintings by Wille Mäkelä and well-known fine art professionals.
Finnish painters: Anna Tuori, Elina Merenmies, Jukka Korkeila and Markus Konttinen; sculptors: Joakim Sederholm, Pekka Kauhanen and Martti Aiha; graphic artist: Outi Heiskanen; architect: Hannele Grönlund, and Estonian animation director and graphic artist Priit Pärn.

Sanna Ikäläinen, Wille Mäkelä / Finnish Central Art Archives

Marianne Decoster-Taivalkoski
Aquatic

Aquatic is an enveloping, interactive water soundscape installation. The visitors are invited to participate in a multisensorial experience by exploring the soundscape through bodily movements within the empty space of the installation. They hear it as the accurate feedback of their movements.

Aquatic proposes an immersive and poetic experience of imaginary water worlds playing with kinaesthesia and sound images. It gives the main role to one's imagination in the building of the experience of immersion. It proposes a reflection about the influence of sounds on our sense of space and our imagination. How sounds, bodily movements and interaction arouse in us body memories and sensations.

The soundscape handles three emotional states free to one's interpretation: soft and quiet waters, refreshing streaming waters and tempest waters.

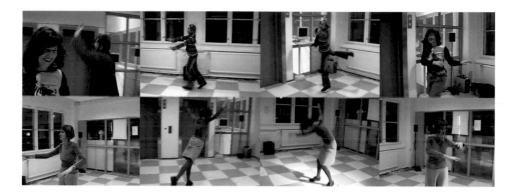

The system uses David Rokeby's VNS software and Max MSP to generate a real-time sound feed-back to bodily movements registered with video sensors. Since its development in 2001–2003, *Aquatic* has been installed in various art museums and public places within the city of Helsinki since 2004.

Supported by AVEK (Veli Granö), The Finnish Promotion Center for Audiovisual Culture

Kati Åberg
Emotions in Man

Emotions in Man is a interactive contemporary dance dvd. The piece investigates the use of interaction as a means of enlivening the viewing experience for recordings of performing arts and also ways of using interactive functions in a dvd.

In this light-hearted piece, the viewer decides, which of five basic emotions—joy, sorrow, anger, love or fear—to give to the dancer. There are many levels of intensity for each emotion, so the viewer can choose to give the dancer ever more of one emotion, or suddenly plunge him into a totally new emotion. These moments of decision-making occur throughout the piece and deter-mine how the choreography evolves. The viewer must make choices or else the dancer gets bored, walks out and the piece ends. The piece is sold at art book shops, is in the selection of public libraries in Finland and has also toured festivals around Europe as an installation. Shall we dance?

Directing, editing, concept, multimedia authoring, production: Kati Åberg; Choreography, dance: Jyrki Karttunen; Music, voice: Anna-Kaisa Liedes; Cinematography: Peter Flinckenberg

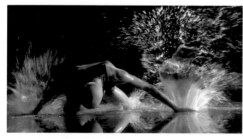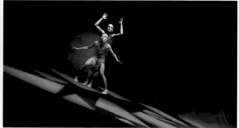

In the picture: choreographer and dancer Jyrki Karttunen

Markku Nousiainen and workgroup

UMBRA
Creating Theatrical Illusions with Digital Media

Umbra is a dance performance where live performers meet a virtual world created with the aid of digital media. It's a fantasy tale inspired by old innovations and the aesthetics of magic lanterns and early cinema. The story of *Umbra* is about an innovator who tries to accomplish a perpetual motion machine with the aid of his dance movements. He is assisted by a robot servant (actually, a small remote-controlled robot prototype). One day, the innovator is confronted by a stranger who enters his lab. The style of the performance is determined by monochromatic silhouette animations, worn-out costumes and futuristic but rusty technology.

My motivation for the project was to experiment with different elements in storytelling: live dancers, virtual characters and virtual scenography, and a mechanical robot, to see how they can be combined. I wanted to create a performance reminiscent of the pre-cinema magic, but with today's digital tools. The resulting performance is both highly technological and old-fashioned, in the sense that the projections have a role similar to that of traditional theatrical illusions. *Umbra* is exhibited as a video installation.

Concept, script, animations, production: Markku Nousiainen; choreography: Ilkka Kokkonen; dance: Eero Vesterinen, Riku Immonen; music: Petteri Mård; sound design: Aura Neuvonen; lighting design: William Iles; scenography: Kaisa Rasila; costumes: Sanna Levo; script consultant: Helena Hyvärinen.
Production by University of Art and Design UIAH, Media Lab; Theatre Academy, Department of Dance; Dance Group Täpinä; Robot provided by Helsinki University of Technology, Laboratory of Automation Technology

Markku Nousiainen

Markku Nousiainen

Kristian Simolin and Pauli Laine
Joutokäynti—Idle Running

Joutokäynti—Idle Running is an animated media art work. The center stage is given to a group of workmen, who have been placed in simplified, industrial surroundings. Each of the workmen repeats his individual, restless and inward movement, which changes only slightly when repeated. The rhythm and the repeated movements of the characters, together with the soundtrack, form a hypnotic rhythm. In the animation, the world consists of a short, unchanging moment that continues forever. The characters are in constant motion, but the movement does not have a goal.

The starting point of *Idle Running's* animated movements are those small repetitive motions people make when they are nervous or frustrated: the rhythmic tapping of the foot or the hand, or the fiddling about with an object or a garment. Tiny movements like these form a restless world of motions characteristic of queues, public transport, and waiting rooms. The psychological meaning of the small, recurring movements is adaptation to oppressive surroundings and situations.

Concept & 3-D: Kristian Simolin; music: Pauli Laine

Meeri Mäkäräinen
Ruby

Ruby is a computer program that produces an animation of a gemstone brought to life. The program performs a physical simulation of two elastic membranes vibrating in an environment where the laws of physics have been modified. In a perfect physical simulation vibrating membranes would gradually lose their kinetic energy due to resistant forces. In this simulation, however, membranes gain energy from vibration instead of consuming it. The extra energy is a source of complex emergent behaviour of the membranes—the membranes make movements that could not have been predicted. The simulation is visualised with an animation in which two translucent square-shaped membranes vibrate together. The membranes are rendered with polygons, which is why we see angular forms. The angular look of the polygons combines with the organic nature of the elastic membranes to create a continuous metamorphosis between a faceted gemstone and a flourishing flower.

Heli Ellis, Laura Palosaari, Anne Dahlgren,
Anne Parkkali, Liz Lehtonen, Ville Raitio,
Taneli Bruun, Maria Palaväki, Katja Pällijef

Tikki

Tikki is an animated short film about a woman who gradually realizes that sewing a never-ending straight stitch under the control of long-gone parents isn't necessarily the only way to live one's life. The change is, however, easier said than done. In *Tikki* the classical tempter appears in the form of a bright red thread, the only fully saturated spot of color in the earthy color scheme of the film. The red thread curves playfully around the direct black stitch, enticing it to deviate from the beaten track.

The chosen medium, animation, allows the filmmakers to freely use symbolic elements such as a chalk line drawn onto the fabric that represents the supervision of the parents. Although *Tikki* is mainly animated in 3-D, it also employs 2-D techniques, which creates a parallel method of storytelling in multiple realities. In 2-D we jump into the main character's thoughts, whereas in 3-D we remain in a more coherent, "real" world.

Richard Widerberg, Zeenath Hasan

IMPROVe

IMPROVe is an aural architecture for socio-cultural exchange. Sonic realities of the everyday are improvised live in a non-linear mode. *IMPROVe* explores the role of the mobile phone user as a creator of her/ his own content. It attempts to define the mobile device as a tool for environment awareness by making the user conscious of their immediate sonic surrounding.

Scenario

A group of friends record sound objects and soundscapes from their daily life through a mobile device. The group meets in a local pub with a soundsystem. Here they perform a live-remix of

© Antti Ahonen

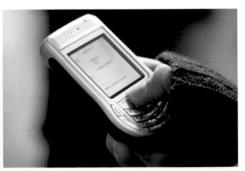

226

the sounds on their mobile devices. Through the sonic improvisation of their everyday sound-scape, they affect their experience of the here and the now.

Functionality

IMPROVe collects sounds via a mobile device and sends them to a location where they can be played back into a soundsystem. The same mobile device controls the playback of the collected sounds in the soundsystem. Playback control occurs in the physical location of the soundsystem. The playbacked sounds are processed live via interaction on the mobile device. The output of the processed sound can be directly heard through the soundsystem.

Development Partners: MAHITI; Project Partners: Åsa Ståhl, Kristina Lindström

Media Arsonists
Equilibrium

This project is a visual representation of the balance of "power" or state of equilibrium in the world. The visualization is based on live news feeds, which are refreshed in real-time in 12–24 hour periods.

News articles from live RSS feeds, such as BBC World and CNN are passed through a PHP server, which obtains a set of results for each article's content. We use Google API searches with positive/negative keyword sets to determine the "contemporary" value of the news. I.e. if the number of search results that Google returns from the news article is higher for positive keywords, then the article gets a percentage of 50–100, or 0–50 conversely. The results from Google are based on a cross-section of the current Internet population's views, and therefore are not necessarily biased or attached to any particular political, national or regional model. Each article is categorised using a set of specific keywords, The category which yields the highest number of search results becomes the article's category. The purpose of this project is to provide a live and changing picture of global news trends that influence our everyday lives. In a sense it's like a clock, but rather than show the time, it shows the direction or state of current affairs. Equilibrium.

Concept, UI design and implementation: Dominic Baudish; UI design, implementation and programming: Lauri Huikuri; Graphic Design: Vilja Helkiö; Server-side programming: Wesa Aapro

Solarhive.com

Viki Ølgod, Viara Gentchev, Ksenia Avetisova
The Eyesight Project

The *Eyesight Project* is an interactive sculpture created to increase the awareness of our post-modern approach to surveillance. Visibility in a way replaces force as a tool of control, we ask ourselves what the contemporary definition of privacy is or may become in the future.

Eyesight's concept explores the archetype of total surveillance; a way to improve discipline in society such as the architectural form invented in the early 1780s by Samuel Bentham (Panopticon).

The idea of a closed circuit television system monitored by a handful of functionaries is one way for our contemporary mind to grasp the idea.

In a world of constant society-driven need for security, surveillance becomes the calming factor in achieving this inner peace, and thus a familiar part of our daily life. The installation displays the omni-present icon of surveillance: the eye in the sky. As a spectator trying to grasp the pulse of the surveillance society the installation visualizes the never-encountered observer.

Kalle Määttä—Dignity Nation Representative
Dignity Nation / Global Dignity Project

Dignity Nation is a movement and community created around the Dignity Principles introduced in *Global Dignity Project (www.globaldignity.org)*. The goal of the Nation is to create such a force that the voice of dignity can be heard even on the highest levels of power!

The mission of the *Dignity Project* is to implement globally the universal right of every human being to lead a dignified life. By signing the five Dignity Principles (introduced under *http:// globaldignity.org/index.php*) you express your adoption of these principles for your action. To give your voice a face, you also become a "citizen" of the virtual Dignity Nation, where your name is shown along with your picture. It's not a real country but a community that exists to concretize the idea that you belong to a group of people that calls for more dignity in our world.

Jürgen Scheible
Lenin's Godson's MobileArtBlog

The *MobileArtBlog* is a blog of digital art images created with a mobile phone. It is the travel journal of artist Lenin's Godson. Instead of ordinary images and text, this blog holds a collection of popart images, each in phone screen size, which the artist creates out of stimulating experiences along his travels. Inspired by shapes, colors and forms of objects in different cities, places and situations, he attempts to capture the moment by turning it into a memorable art piece on the spot.

By using Python programming on the phone for making collages through taking a photo, resizing, copying and placing it freely on the canvas, the art image is instantly created and uploaded incl. GPS data.

Fans and art lovers can receive the images in real time via a Konfabulator widget or RSS feed on their PC or mobile, enabling instant sharing on a global scale. People can instantly rate an image, triggering feedback to the phone of Lenin's Godson and making it vibrate.

Among the views of the imagery on his blog is a Google map, which shows where the artist has traveled.

www.leninsgodson.com/mobileartblog

Jürgen Scheible
Word in Space

Word in Space is an audience participatory art installation that invites people to use their mobile phone to post a word or image into a 3-D space onto a large public display. The posted words float slowly in the screen space as 3-D text, images as textures on small cubes, rotating around their X or Y axis, retreating gradually from the picture plane over time. The idea for this work originates from the German idiom "Ein Wort in den Raum stellen" meaning to "put a word up for discussion and thought".

By creating graphical objects, the audience can place their thoughts into space, which can then be observed visually. This allows meditating on them, letting the mind wander round, still helping to keep the focus. At the same time, the words and images posted by other people can spark new thoughts in each viewer's own thinking, connecting the minds.

The fading away of the objects into an ethereal space might remind the viewer that our human lives will also one day fade away—from the real space to where?

www.leninsgodson.com/wordinspace

Teemu Kivikangas, Sumea Studio, Digital Chocolate, Inc.

Johnny Crash & Johnny Crash Stuntman Does Texas

Two critically acclaimed mobile games about a teenager who has watched way too many episodes of certain reality television shows and is determined to become a celebrity himself by doing crazy stunts. Your goal as Johnny is to perform outrageous stunt flights as a human cannonball. Fly inside a thundercloud and be electrocuted by lightning, or try crash landing into a cactus. Or maybe you need a haircut—trim your hair with helicopter blades! Never has performing pain-inflicting stunts been so freakishly entertaining.

Game play is simple and quick to learn—you need only one button to play—yet highly addictive and hard to master. After the flight you can review a replay of your flight and keep a scrapbook filled with snapshots of your "greatest hits". Titles are exhibited with focus on character development, illustrating the design process of game character from an initial idea into a finished product. Developed by Sumea Studio, Digital Chocolate Europe.

© Sumea Studio, Digital Chocolate, Inc.

Kalle Mäntsälä, Matthieu Savary

What You Do Is What You Hear!

An interactive, audiovisual installation designed to provide a meaningful environment for better understanding the major properties of sound and mainly for children to use, for educational purposes.

The user interface is based on a self-evident metaphor: the sound object, where graphical shapes incarnate sound sources that the user can manipulate on the virtual stage by moving his/her hands in front of the screen (one hand each if two people are playing together). By affecting the position of a certain sound object, the user plays with its pitch, volume & panning.

The installation has a two-level gameplay:
Level 1 (learning mode) offers varying combinations of positions (represented by holes in the 'shapes & colors' theme chosen for the installation) to be reached by each sound object. In musical terms, these combinations of positions are called chords.
Level 2 (free mode) offers a free stage to play with all objects in an uncensored, eventually non-harmonious way!

Wesa Aapro
Consumer Gadget

Consumer Gadget is a tool for consumers who would like to spend their money more ethically, supporting sustainable development and other good things. The main idea is to utilize the bar codes of consumer products for the cause of good: bar codes are unique identifiers that can be used to fetch ethical information about the product. *Consumer Gadget* is a software for mobile phones, so it can be used at the time of purchasing. Users can scan bar codes with the latest camera phones and get the ethical information over GPRS connection, but the information is also available for users with older phone models using WAP or SMS technologies. *Consumer Gadget* can be used free of charge and is based on open source technology.

Jürgen Scheible
MobiLenin—Mobile Group
Interaction with a Multi-track Music Video

MobiLenin is an audience participatory art installation that allows people to interact simultaneously with a multi-track music video shown on a large public display using their personal mobile phones, effectively empowering the group with the joint authorship of the video. It aims to provide enriched entertaining and social experiences by allowing people to interact with the musician "Lenin's Godson" in the virtual domain, exceeding the limitations of the physical domain, e.g. by turning him into a skeleton. By a collective vote using the mobile, the performance style of the artist can be changed in real time ranging from "not playing guitar", "not singing", to performing as a skeleton. Voting occurs in ongoing voting intervals triggered by the system. As an incentive for interaction, MobiLenin provides a lottery. The winner receives a coupon for free pizza or beer in the form of an image on the mobile phone.
MobiLenin provides a new form of interactive entertainment for pubs and other public places.
www.leninsgodson.com/mobilenin

Teemu Kivikangas, Richard Widerberg
Metamorphosis

An audiovisual performance based on recordings of ice in both the Northern and the Southern hemisphere. The sounds used in the work are recordings from the ice of a lake in Northern Sweden. One can hear how the ice is constantly moving, affected by the wind, the temperature, the water beneath and the air pressure. Visual material depicts the same element, ice, in a very different context—South American megalopolises of Buenos Aires, Rio de Janeiro and Lima in the blazing heat of the summer—where it leads a short life before melting into water.

The visuals contrast and juxtapose the sounds from the isolated nature of the extreme North with images from the busy, overcrowded cities of the extreme South. This audiovisual material is then manipulated, re-cut and re-interpreted by the performers in real-time with two synchronized computers. The result is an experimental movie creating an image of transition, transformation and adaptation.

Koray Tahiroglu and Joni Lyytikäinen

SolarDuo Project

The project began during a workshop in 2003 at Media Lab Helsinki when Koray Tahiroglu & Joni Lyytikainen tried to connect a solar panel directly to a sound mixer. However, they discovered that more electric components were needed to achieve different sound structures from a solar panel. The artists created circuits that are based on the example by Ralf Schreiber, which inspired them to create their own solar panel instruments.

SolarDuo Project experiments with the possible sound structures that light waves can create. The project utilizes analog sounds together with the algorithms that generate changing sets of sonic relations over time. Analog sounds and computer-generated sounds release an unexpected richness of the sound processing in real-time performances. In their performance they also sonify solar data, which is gathered from terrestrial and orbiting solar instruments.

http://mlab.uiah.fi/~korayt/solarduoprj.html

SolarDuo Project performed at Piksel05 Festival Bergen, Norway; Del Sound Art Festival—the 9th Istanbul Biennial Istanbul, Turkey; Aureobel Launch Event, Art's Birthday 2005 and Art's Birthday 2004 in Helsinki, Finland.

Joni Lyytikäinen Jürgen Scheible Koray Tahiroglu

Campus exhibition curated by:
Perttu Rastas, Philip Dean, Antti Ikonen, Kati Åberg, Teijo Pellinen, Lily Díaz-Kommonen

Christa Sommerer & Laurent Mignonneau

Tangible, Audible, Playable, Wearable
Interface Culture Student Works at Ars Electronica 2006

One year after its establishment, the Interface Culture masters program was already able to present works by its students at the 2005 Ars Electronica Festival. This exhibition included examples of interactive art, tangible interfaces, intuitive instruments for playing and composing music, acoustic and object-based interfaces, CAVE applications and interactive games. This year's projects can be divided more or less into five thematic clusters corresponding to courses of study in the Interface Culture program:

Interactive Media Archeology

These works deal with media archeology (taught by Gebhard Sengmüller). For example, the interactive installation *re:call phone* shows how a telephone from the 1920s can add new sensor technology and a picture screen to become an interactive tool that lets users experience the history of telecommunications in a playful way. *The Digital Barrel-Organ* combines an old barrel-organ with digital MP3 sounds to deliver a satiric commentary on the pressure to innovate that contemporary musicians face. Other works are *FLOP, Ritter der Kokosnuss* and *Metaskop, sCANNED OBJECTS*.

Interactive Artificial Life Projects

Programming courses (taught by Christine Sugrue, Robert Praxmarer and Friedrich Kirschner) familiarize students with generative processes. The results include several interactive installations that deal with the "game of life" theme and computer-generated nature: *Life, Nature, ebenda no.1—coinciding entities* and *Mikrokosmos*.

Fashionable Technology

Another area of emphasis of the Interface Culture program is fashionable technologies (taught by Sabine Seymour) and the development of sensor technologies (taught by Laurent Mignonneau). In a project entitled *No more under cover,* for instance, books that have been out on loan from the library too long gradually change color. Other works include *Enlightened Collection* and *Clothing that arranges the body.*

Intelligent Environments, Tangible Interfaces and Auditory Interfaces

This field (teachers: Martin Kaltenbrunner, Andreas Weixler and Christopher Lindinger) has given rise to projects such as *iShaker* which makes it possible to generate beats and sounds with three iPods, *Atem Raum,* an interactive environment that reacts to breathing, *Title: Shape, Color & Sound,* a tangible interface that combines the worlds of Ittens and Schönberg, and *Scream Point,* an ironic work about interactive photography.

Robotic Interfaces

In a special course by Time's Up (Tim Boykett and Marc9), students get an introduction to the basics of artistic robotics and present a performance by their robots.

This exhibition documents how interactive technologies are coming into increasing use in creative applications and hybrid art projects, and, via innovative recombination of technology and art, are giving rise to interesting prototypes at the nexus of media art, design and R&D.

Ein Jahr nach seiner Gründung konnte das Masterstudiumprogramm „Interface Culture" Arbeiten von Studierenden bei der Ars Electronica 2005 präsentieren. Dabei wurden Projekte aus den Bereichen interaktive Kunst, Tangible Interfaces, intuitive Musik- und Kompositionsinstrumente, akustische und gegenständliche Schnittstellen, CAVE-Applikationen sowie Beispiele von interaktiven Spielen vorgestellt. Die Themen der diesjährigen Ausstellung gliedern sich grob in fünf Schwerpunkte, die sich auch in den Kursen des Programms von Interface Cultu re widerspiegeln:

Interaktive Medienarchäologie

Diese Arbeiten beschäftigen sich mit dem Thema Medienarchäologie (unterrichtet von Gebhard Sengmüller). Die interaktive Installation *re:call phone* etwa zeigt, wie ein Telefon aus den 1920er Jahren neue Sensorik und Bild kombiniert und zu einem interaktiven Tool wird, das die Geschichte der Telekommunikation spielerisch erfahrbar macht. *Die digitale Drehorgel* kombiniert eine alte Drehorgel mit digitalen MP3-Sounds und kommentiert so auf satirische Weise die heutige Musikrezeption. Weitere Arbeiten sind: *FLOP, Ritter der Kokosnuss* und *Metaskop, sCANNED OBJECTS.*

Interaktive Artificial-Life-Projekte

In Programmierkursen (unterrichtet von Christine Sugrue, Robert Praxmarer, Friedrich Kirschner) wurden Studierende mit generativen Prozessen vertraut gemacht. Daraus entstanden mehrere Arbeiten, die sich mit dem Thema „Game of Life" und computergenerierter Natur beschäftigen, wie etwa die interaktiven Installationen *Life, Nature, ebenda no.1—coinciding entities* und *Mikrokosmos.*

Fashionable Technology

Ein weiterer Schwerpunkt des Interface-Culture-Programms ist Fashionable Technologies (unterrichtet von Sabine Seymour) sowie die Entwicklung von Sensortechnologien (unterrichtet von Laurent Mignonneau). Beim Projekt *No more under cover* z. B. verfärben sich Bücher graduell, die zu lange aus der Bibliothek ausgeliehen wurden. Weitere Arbeiten sind: *Enlighted Collection* und *Clothing that arrange the body.*

Intelligent Environments, Tangible Interfaces und Auditory Interfaces

In diesen Bereichen (unterrichtet von Martin Kaltenbrunner, Andreas Weixler und Christopher Lindinger) entstanden Projekte wie *iShaker,* bei dem mit drei iPods Beats und Sounds generiert werden können, oder *Atem Raum,* ein interaktives Environment, das auf Atmung reagiert, und *Title: Shape, Color & Sound,* ein tangibles Interface, das Ittens und Schönbergs Welten kombiniert, während *Scream Point* eine ironische Arbeit zur interaktiven Fotografie ist.

Robotik-Interfaces

In einem speziellen Kurs von Time's Up (Tim Boykett und Marc9) konnten Studierende die Grundlagen künstlerischer Robotik kennenlernen und selbst eine Performance ihrer Roboterresultate vorstellen.

Diese Ausstellung dokumentiert, wie interaktive Technologien immer mehr auch in kreativen Anwendungen und hybriden Kunstprojekten Anwendung finden können und sich durch die Neukombination von Technik und Kunst interessante Prototypen im Zwischenbereich von Medienkunst, Design, Forschung und Anwendung ergeben.

Doris Diensthuber / Christian Meixner
re:call phone—An Interactive Telephone Station

This installation consists of a telephone station equipped with a 1950s-style wall model phone and a monitor. The user activates the rotary dial to navigate through the history of the telephone and telephoning, whereby combinations of dates serve as phone numbers. The information dialed up is displayed on the monitor; plus, users can listen to informative texts being played through the earpiece of the receiver. A listing of telephone numbers provides an overview of the available topics, ranging from the early days of the telephone to the current state of the art, and also including bizarre and humorous anecdotes about the phone in art and research.

Bernhard Pusch
The Digital Barrel-Organ

An updated barrel-organ is the centerpiece of this project. It features fully digitized playlist management, human resources management and social skills, which enable the modern barrel-organ entrepreneur to administer his musical affairs in a more effective and thus profit-maximizing way.
This project is a satiric take on the pressures of resource optimization and individualization in an increasingly digitized world. In these times of mobile MP3 players, even barrel-organists have to come up with something new: the digital barrel-organ!
www.indivigital.at

Christina Heidecker
FLOP

The 3.5" disk was the most common data storage medium of the 1980s. Now, 20 years after its heyday, *Flop* attempts to revive this medium. A video sequence is saved to several disks. In order to view the whole video, the user has to insert one disk after another into the computer's drive. The content of the video is a collage recreating the atmosphere of the '80s.
This labor of Sisyphus recalls the inconvenient steps required to work with a computer a mere 20 years ago. The installation provides a stark contrast to the hurried, often impatient way we deal with digital media today, and encourages visitors to chill out and take their time.

Taife Smetschka
Ritter der Kokosnuss (Monty Python and the Holy Grail)

"1st soldier with a keen interest in birds: What?
Ridden on a horse?
King Arthur: Yes!
1st soldier with a keen interest in birds: You're using coconuts!
King Arthur: What?
1st soldier with a keen interest in birds: You've got two empty halves of coconut and you're bangin' 'em together."
 This installation consists of a video projection of a clip from "Monty Python and the Holy Grail" and two coconut halves. By bangin' 'em together, installation visitors can start both the video and a race between two knights of King Arthur's Round Table.

Irmgard Falkinger-Reiter
sCANNED OBJECTs

Visitors to the installation can use a scanner and a printer to create their very own object-collage. The printed-out image of it is then loaded into a tin can that the visitor can take home as a souvenir. In this way, a momentary, ephemeral experience during a visit to an exhibit can be preserved for all time. Whoever decides to open the can and confront these memories can do so, but the image is then subjected to external influences of weathering, degradation and decay.

Bernhard Schorner
Metaskop

Everyone's seen them—these tiny image viewers in the form of miniature television sets. Not so very long ago, these plastic TVs could still be purchased as souvenirs. The images available for viewing were mostly the sights of sightseeing tours and typical motifs of places frequented by tourists. The classic content of this medium is a metaphor of emptiness, an information vacuum. To offer an ironic depiction of this point of view, *Metaskop* totally dispenses with a picture; all that's to be seen is the name of the image. The *Metaskop* works with meta-information about the picture not on display. For example, instead of representing Venetian gondoliers, the viewer can only read the word "gondolier." The tiny image viewer's inner life has been eliminated and replaced by an LED displaying crawl text. One might regard this as a sort of *reductio ad absurdum,* or simply as Simplicity. Supported by www.plastiskop.de

Andreas Zingerle
Metakom

A shift of communication from classic real-world venues in society to new domains situated in virtual spaces is now taking place. This piece of sculpture visualizes the current state of virtual communication through analog, mechanical movements. The motion of the sculpture is not designed to be triggered by individuals but rather by society as a whole.

Mika Satomi
Life()

Life() represents a classic Cellular Automata simulation *Game of Life* as a daily scene of a city. A visitor is embedded as an inhabitant of this city. As the visitor looks around, his/her eye gaze is detected, which navigates him/her through the space. Each step of the visitor has an influence on the neighboring cells, while the existences of other cells have an influence on the visitors' gaze. This simple simulation is challenging the complexity of our life.

Cassandra Melhorn
ebenda no. 1—coinciding entities

ebenda no. 1 is an interactive environment consisting of a red glowing organic object mounted within surveillanced space. About a hundred light cells on the object display the visitors' distance to other visitors in the exhibition space, based on mapped coordinates. As two visitors approach one another closely, the number of activated light cells increases. In this way the visitors can influence the predefined lighting system as contributing participants in the evolution of a hybrid society. *ebenda no.1* sensitizes the physical body in difference to the immaterial construction of being.

http://www.periodic-garden.net/ebenda_series/

Gustavo Morant Garcia / Franziska Parschau
iShaker

The iPod is more than just an MP3 player; it's a cult object, fashion phenomenon and expression of a person's attitude towards life. Nevertheless, its memory capacity is getting bigger and bigger, and its content, in turn, ever more trivial. The iPod has become the instrument of compulsive collectors, the object of choice of those torn between an unfulfilled freedom of choice and an inability to make a choice. But what if the iPod could activate people? To take action. To make decisions. To be creative. Don't just play back music; creating music together is our motto! We make music! With the iPod. Any form of movement is welcome. And we thus come full circle: the *iShaker* becomes the "I shaker."

Timm-Oliver Wilks, Harald Moser, Thorsten Kiesl, David Purviance
Nature

As philosophical concepts, what's natural (derived from nature) and what's not natural reflect human beings' relationships to their environment. In this context, "environment" signifies "not I," that which is external to human beings. The installation entitled *Nature* treats human beings' relationships to their environment, and also deals in a very extraordinary way with negative aspects of this, for example, environmental pollution. The aim is to produce a visualization of modern-day environmental problems.

Hannah Perner-Wilson
COWSinTHEfield

COWSinTHEfield was made as decoration for a party with an Austrian theme. Cows and electric fences are both typical Austrian things to me, and using an electric shock for visual interaction is an interesting experiment. This installation presents nostalgic Austrian childhood memories to be experienced again.

Susanne Posegga
Mikrokosmos

Mikrokosmos, programmed in Processing, is a life simulation that's launched on the basis of various random parameters and then, with no possibility of external intervention, runs as long as it takes for the system to collapse.

Various species behave according to simple dictates: reproducing, eating, growing, dying. *Mikrokosmos* is a graphic work and, at the same time, an experiment. How long does the system function? Is its ruin the result of overpopulation or extinction?

Angela-Maria Holzer, Harald Moser
No more under cover

Books which are overdue at the library can no longer hide next to their non-overdue neighbors on the shelf. The time-aware cover gives them away at a glance: as time passes, the color of the cover changes continuously from an innocent white on day one to a guilt-ridden deep purple on day five. The specifics (length of the interval, colors) can, of course, be customized to different needs.

Irmgard Falkinger-Reiter
The Enlighted Collection

A collection of hand-knitted garments made of unusual materials such as gauze bandages, wires and aluminium foil. Technical components are added, e.g. LEDs, sensors and batteries. The sensors react to different environmental influences by lighting up the LEDs. Garments illuminate as soon as someone approaches or noise increases, making the wearers more visible.

Hannah Perner-Wilson
Clothing that arranges the body

Clothing that arranges the body is a garment made up of pockets that connect their content with the outside via the flow of electricity. Instead of regular plugs and plugholes the electrical current flows through material fastenings such as poppers, hooks and buttons. The garment's appearance playfully approaches the wearer's use of electronic devices within close proximity of their body.

Thomas Wagner / Andreas Zingerle / Christina Heidecker
AtemRaum (Breathing Space)

Thoughts and feeling like happiness, grief, security and loneliness influence and change our breathing. In these hectic times in which people are under incessant pressure to perform, checked by constraints and harried by fears, most of us don't even notice what a state of distress our breathing is in. The purpose of this installation is to make visitors conscious of unconscious breathing and especially of breathing with the diaphragm. AtemRaum is designed to let people experience breath and foster an approach to it characterized by self-awareness. We want to achieve this through the use of sound and the haptic experience of the movements of the exhibit's walls.

Penesta Dika / Tomor Elezkurtaj
Shape, Color & Sound

This work is about creating simultaneously "audible images" and "visible sound" through tangible shapes/objects. The concept is based among others on the color-circle of J. Itten, the twelve-tone-technique of A. Schönberg and on elementary geometrical shapes of Euclidean Geometry. The main objects for this tangible Interface, made for the ReacTable, are three geometrical objects, whose surfaces represent a tone and a color. The users can create simultaneously visual and acoustic works that can be, among other things, rearranged, saved and played overlaid.

Bernhard Schorner/Franziska Parschau
The Polaroid Effect

The Polaroid Effect is an installation that deals with a problematic issue: the transitory nature of media. The point of departure of these considerations is Polaroid's decision to cease production of its extremely popular SX-70 film. The question we pose in light of this is whether the disappearance of a medium necessarily means its complete and final obliteration. The installation is based on photographic material developed right on the wall. Due to the effects of sunlight, the images disappear during the course of the exhibition. That which fades away is no longer viewed, no longer needed. The cycle of deterioration begins.

Timm-Oliver Wilks
serial_killer

serial_killer is a real-time computer game featuring a touchscreen interface. It integrates visitors to the exhibit venue into the game's plot/action, exploits them and, unbeknownst to them, sets them up as one another's opponents. Real and virtual worlds get mixed together and juxtaposed so as to contrast their various characteristics and consequences. The installation is thus a play on the continually arising discussion of violence in computer games and the capacity to differentiate between virtual worlds and the real one.

Sebastian Dietrich/Harald Moser
Scream Point

Unlike the familiar photo machines for taking passport photographs, portraits and fun cards, the *Scream Point* doesn't charge you any money for this non-existent personal consultation. Instead it demands a show of emotion. How?

You have to shout at the *Scream Point* in order to receive a result or a photograph. The appearance of the *Scream Point* will correspond to that of its models placed in front of, or inside, train stations and shopping centres. But inside it, a different process takes place. Instead of the usual mirror you will find a screen that shows your picture. The reproduction of yourself is, indeed, completely blurred. The only way to sharpen the picture is to shout loudly. As soon as a certain decibel level is reached, the reproduction becomes sharp and freezes. When you leave the *Scream Point* you will get the Internet address, where you can find your picture and download it.

Hannah Perner-Wilson
Kein Gedankenloser Transport
(Not Mindless Transportation)

How do we experience mobility in a context that goes beyond using it without giving it a further thought? Can we look at traffic and transportation from an enlivened perspective? *Kein Gedankenloser Transport* is a series of three real-time animated films that offer a particular take on human mobility. The aim here is to impress upon viewers that every single person is a part of this traffic, and that this freedom of movement doesn't mean freedom from having to think about how we do it. This work was conceived to be shown on large-scale video display screens in public.

Time's Up
It's Alive!

Taking its title from Australian Media Artist Alex Davies' oft-repeated exclaimed response to moving objects, *It's Alive!* (with a possible extra "eek!" for authenticity) asked a group of students to investigate movement *outside* the realms of the digital. Real movement in real space in real time. An informational overload in the form of videos and machine art anecdotes was the seed for a discussion and development process which led into in a four day long, intensely immersive workshop at the Time's Up labs. The main course of action scripted to the students was "try. fail. try again. fail differently."

Dieter Daniels / Claus Pias

When Cybernetics meets Aesthetics

"Study cybernetics!" So began a 1977 publication designed to introduce young readers to cybernetics.[1] It would end up being one of the last such exhortations, as the first wave of enthusiasm for cybernetics was already ebbing in the mid '70s. Nevertheless, what had transpired over the previous 25 years or so was perhaps the most significant upheaval in the entire history of ideas of the 20th century. As an intellectual discipline positioned at the nexus of neurology, computer processor architecture and information theory, cybernetics had attempted to develop a universal theory of regulation and control that could claim applicability to both living creatures and machines, economic as well as physical processes, and phenomena of a sociological and an aesthetic nature. A general model of logical machines (Warren McCulloch), a non-deterministic concept of feedback (Norbert Wiener) and a stochastic theory of information and communication (Claude Shannon) constituted the stuff from which both a philosophical challenge and a technological utopia emerged. Cybernetics is said to have represented the end of philosophy for Martin Heidegger, whereas Arnold Gehlen saw it as the consummation of technology and thus the final stage of human history. And Pierre Bertaux even drew the conclusion that a "new man" would now have to be engendered. But as great as the disappointment was that the many lofty speculations of the 1950s and '60s left in their wake, cybernetics was to just as great an extent the point of departure of the epoch-making constructions that have been described since the late '60s as Knowledge-based (Lane), Information (Lyotard), Control (Deleuze) and Post-industrial (Bell) Society.

Thus, a plausible hypothesis might be that the science fiction that always made up a substantial part of cybernetics has, in the meantime, quietly come true, but there's still no sign of a grand, all-encompassing theory about the conception of self prevailing in a society in which this science fiction is now an operative fact. Modern everyday life is determined by information, control and feedback processes involving human beings, media and machines. As a sort of second nature, these processes and effects constitute a link-up between the cultural and technological spheres. The term cyberspace—derived from cybernetics and widely used in the '80s and '90s—has, in retrospect, rather confused matters with respect to cybernetic concepts or reduced them to technical solutions. Nevertheless, seeing things from a distance of half a century provides us with an extremely incisive impression of the very radical nature of this dramatic epistemic turning point within the context of its historical circumstances. Furthermore, we are presently arriving at that threshold at which the quantum leap from communicative to collective memory normally takes place. Now is the time to rediscover cybernetics' scornfully dismissed and long-forgotten utopian potential and to draw upon it for a diagnosis of our current situation.

First and foremost here is the hope that a meta-disciplinary analysis of control, regulation and feedback processes could be the way to bridge the gap between "two cultures"—technology and the natural sciences on one hand, and the arts and humanities on the other. Art has always been assigned an exemplary role in the ongoing effort to close this gap. Theoreticians like Max Bense and Abraham Moles have demanded that aesthetics be solidly grounded in a mathematical and technical language in which its practitioners would be just as fluent as their colleagues in the exact sciences. They insistently maintained the structural equivalence of technical and aesthetic approaches to construing reality, and called upon artists to adopt the so-called new technologies so that art would not find itself in a position "beyond the fringe of civilization" (Bense). So then, if it's the conceptual origins of a "third culture" (Brockman) that one seeks, then

it's cybernetics—and, in particular, the proceedings of the Macy Conferences from which this field emerged—where the major finds are to be made.[2]

Accordingly, a second hypothesis might be that the history of cybernetics sheds significant light on the current state of media art. Even though the lines of tradition of information aesthetics were severed in Europe around 1968 and cybernetic approaches in the USA ended up flowing into the counterculture, the efforts aimed at overcoming cultural bifurcation are still with us and are just as problematic as ever. To this day, technically advanced media art stands—both ideologically and factually—with one foot in each of these "two cultures," a situation manifested very poignantly by its unsuitability for either display in a traditional museum setting or implementation in the technology of everyday life. And this is precisely why the media art euphoria of the '90s has since given way to increasing uncertainty about what such pieces have in common and what sets them apart from works in other genres, since, in the wake of the complete mediatization of society and culture, media art seems to have lost its uniqueness and thus the credentials entitling it to legitimacy and esteem. But it's this very situation that ultimately paves the way for media art to return to its former distinctiveness situated in a privileged position where a dialog between the "two cultures" actually can take place.

When Cybernetics meets Aesthetics is the title of a conference that will bring the revaluation of cybernetics to bear as a potentially decisive contribution to the dialog focused on the necessary redefinition of the status of media art. How can the diametrical opposition of the "two cultures" ultimately attain convergence in artistic-technical work with media? Can the modern-day "art of complexity" of simulating social networks, natural systems of rules, and the dynamics of feedback effects at work in the economy be understood as a cybernetic process? Which current prospects are opened up by reviewing the theory and practice of the cybernetic art of the 1950s and '60s?

The speakers at this conference are scholars of media, culture and art who are contributing to the revival of cybernetics, as well as contemporary eyewitnesses to the origins of cybernetic art. They'll be taking a retrospective look at some of the highlights of cybernetic art in the '60s such as *9 Evenings: Theater and Engineering* from *Experiments in Art and Technology* (1966) as well as the 1968 exhibition *Cybernetic Serendipity*. One of the issues to be investigated will be the extent to which such art can be documented. Parallel to this, participants will discuss overarching theoretical aspects of the current relevance of cybernetic thinking and pursue lateral connections to the leitmotif of the Ars Electronica Symposium on complexity theory.

These considerations are meant to serve as the point of departure for the process of positioning the Ludwig Boltzmann Institute Media.Art.Research. that was founded in Linz in 2005. The institution's mission is to adopt a holistic scholarly perspective in dealing with the fundamental principles of documenting and describing media art and digital culture.

1 Viktor Pekelis, *Kleine Enzyklopädie von der großen Kybernetik*, East Berlin 1977, p. 10 (first edition: Moscow 1973)
2 *Cybernetics/Kybernetik. Die Macy-Konferenzen 1946–1953*, 2 Vols., Ed. by C. Pias, Berlin / Zurich 2003–04

Dieter Daniels / Claus Pias

When Cybernetics meets Aesthetics

„Studiert die Kybernetik!" Mit diesem Appell hob 1977 eine Einführung in die Kybernetik für junge Leser an.[1] Es sollte einer der letzten emphatischen Aufrufe bleiben, denn Mitte der 1970er Jahre war die erste Begeisterungswelle der Kybernetik zum Erliegen gekommen. Was sich jedoch in den davor liegenden gut 25 Jahren ereignet hatte, ist der vielleicht bedeutsamste Umbruch in der Wissensgeschichte des 20. Jahrhunderts. Im Zusammenwirken von Neurologie, Rechnerbau und Informationstheorie hatte die Kybernetik es unternommen, eine universale Theorie der Regulation, Steuerung und Kontrolle zu entwickeln, die für Lebewesen ebenso wie für Maschinen, für ökonomische ebenso wie für psychische Prozesse, für soziologische ebenso wie für ästhetische Phänomene zu gelten beansprucht. Aus einem allgemeinen Modell logischer Maschinen (Warren McCulloch), einem nicht-deterministischen Konzept von Rückkopplung (Norbert Wiener) und einer stochastischen Theorie des Symbolischen (Claude Shannon) war eine philosophische Herausforderung und zugleich eine technologische Utopie erwachsen. Martin Heidegger sollte angesichts der Kybernetik das Ende der Philosophie konstatieren. Für Arnold Gehlen bedeutete sie die Vollendung der Technik und damit die letzte Stufe der Menschheitsgeschichte. Und Pierre Bertaux zog gar die Konsequenz, dass nun ein „neuer Mensch" entstehen müsse. So sehr jedoch viele der hoch fliegenden Spekulationen der 1950er und 1960er Jahre enttäuscht wurden, so sehr hat die Kybernetik zugleich jene epochale Veränderung herbeigeführt, die seit den späten 1960er Jahren als „Wissens-" (Lane), „Informations-" (Lyotard), „Kontroll-" (Deleuze) oder „postindustrielle Gesellschaft" (Bell) beschrieben wurde.

Eine These könnte daher lauten, dass jene „Sciencefiction", die Kybernetik zu einem guten Teil immer auch war, mittlerweile unbemerkt in Erfüllung gegangen, aber eine übergreifende Theorie zu ihrem Selbstverständnis abhanden gekommen ist. Unsere Gegenwart ist von Informations-, Steuerungs- und Feedbackprozessen zwischen Menschen, Medien und Maschinen bestimmt, die als eine „zweite Natur" die Sphären der Kultur und der Technik überbrücken. Der von der Kybernetik abgeleitete „Cyberspace" der 1980/90er Jahre hat im Rückblick die kybernetischen Konzepte eher verunklärt oder sie auf technische Lösungen reduziert. Aus der Distanz eines halben Jahrhunderts jedoch wird nicht nur die Radikalität einer epistemischen Erschütterung in ihren historischen Bedingungen prägnanter, sondern wird derzeit auch jene Schwelle erreicht, an der sich üblicherweise der Sprung vom „kommunikativen" ins „kollektive" Gedächtnis ereignet. Es ist der Moment, das lange Zeit vergessene und missachtete utopische Potenzial der Kybernetik wiederzuentdecken und für eine Diagnose unserer Gegenwart fruchtbar zu machen.

Dazu gehört vor allem die Hoffnung, dass eine metadisziplinäre Analyse von Prozessen der Steuerung, Regelung und Rückkoppelung zu einer Überwindung des Bruchs zwischen den „zwei Kulturen" von Technik und Naturwissenschaft einseits, Kunst und Geisteswissenschaft andererseits führen kann. Der Kunst kam bei diesem Überwindungsversuch immer schon eine exemplarische Rolle zu. Theoretiker wie Max Bense oder Abraham Moles forderten die Tieferlegung der Ästhetik auf eine mathematische und technologische Sprache, die sie mit den exakten Wissenschaften teilen sollte. Sie insistierten auf der strukturellen Gleichartigkeit technischer und ästhetischer Realitätssetzungen und forderten Künstler auf, sich der Neuen Technologien anzunehmen, damit die Kunst nicht „außerhalb der Zivilisation" (Bense) gerate. Sucht man also nach den konzeptuellen Ursprüngen einer „Third Culture" (Brockman), so wird man sie in der Kybernetik und insbesondere schon in ihren Gründungsakten, den Macy-Konferenzen, finden.[2]

Eine zweite These könnte daher lauten, dass die Geschichte der Kybernetik Aufschluss über die gegenwärtige Situation der Medienkunst gibt. Gleichwohl um 1968 die Traditionslinie der Informationsästhetik in Europa unterbrochen wurde und die kybernetischen Ansätze in den USA in die Counterculture einmündeten, sind die Anstrengungen zu einer Überwindung der „zwei Kulturen" präsent und problematisch zugleich geblieben. Die technisch avancierte Medienkunst steht bis heute sowohl ideologisch wie faktisch zwischen den Kulturen. Dies zeigt sich nicht zuletzt an ihrer Situation „zwischen den Stühlen", da sie weder zur Musealisierung noch zur Implementierung in den technischen Alltag taugt. Die Medienkunst-Euphorie der 1990er ist deshalb einer zunehmenden Unklarheit ihrer Ab- oder Eingrenzung gewichen, da sie angesichts einer völlig mediatisierten Gesellschaft und Kultur ihre Spezifik und Legitimation verloren zu haben scheint. Doch gerade diese Situation macht eine Rückbesinnung auf die Einzigartigkeit von Medienkunst möglich: als privilegierter Ort, wo tatsächlich ein Dialog der „zwei Kulturen" stattfindet.

Die Konferenz *When Cybernetics meets Aesthetics* bringt daher die Neubewertung der Kybernetik in den Dialog mit der notwendigen Neudefinition des Status von Medienkunst. Wie kann der Gegensatz der „zwei Kulturen" in der künstlerisch-technischen Medienarbeit ein Konvergenz-Ziel finden? Lässt sich die heutige „Art of Complexity" der Simulation von sozialen Netzwerken, natürlichen Regelsystemen oder ökonomischen Rückkoppelungsdynamiken als kybernetischer Prozess verstehen? Welche aktuellen Perspektiven eröffnet ein Rückblick auf die Theorie und Praxis kybernetischer Kunst der 1950/60er?

Die Referenten der Tagung sind Medien-, Kultur- und Kunstwissenschaftler, die zur Neubewertung der Kybernetik beitragen, sowie Zeitzeugen aus der Entstehungszeit kybernetischer Kunst. Das Themenfeld umfasst einen Rückblick auf zentrale Momente der kybernetischen Kunst der 1960er Jahre wie die *9 Evenings: Theater and Engineering* von „Experiments in Art and Technology" (1966) sowie die Ausstellung *Cybernetic Serendipity* (1968). Dabei wird auch die Frage der Dokumentierbarkeit solcher Kunst untersucht. Parallel dazu werden übergreifende theoretische Aspekte der Aktualität kybernetischen Denkens thematisiert und Querverweise auf das Leitmotiv des Symposiums der Ars Electronica zur Komplexitätstheorie gezogen.

Diese Themen sollen zugleich als Ausgangspunkt für die Positionierung des 2005 in Linz neu gegründeten Ludwig Boltzmann Instituts Medien.Kunst.Forschung. dienen, das sich aus einer übergeordneten wissenschaftlichen Perspektive mit den Grundlagen der Beschreibung und Dokumentation von Medienkunst und digitaler Kultur befasst.

1 Viktor Pekelis, *Kleine Enzyklopädie von der großen Kybernetik*, Berlin (Ost) 1977, S. 10 (Erstausgabe Moskau 1973).
2 *Cybernetics/Kybernetik. Die Macy-Konferenzen 1946–1953*, 2 Bde., hrsg. v. C. Pias, Berlin / Zürich 2003/04.

When Cybernetics meets Aesthetics
A conference being held in conjunction with the 2006 Ars Electronica Festival

Organizer: Ludwig Boltzmann Institute Media.Art.Research, Linz, in cooperation with the University of Vienna, Department of Philosophy

Concept: Prof. Dr. Dieter Daniels (Ludwig Boltzmann Institute Media.Art.Research) in collaboration with Prof. Dr. Claus Pias (University of Vienna)

Participants:
Cornelius Borck, Canada Research Chair in Philosophy and Language of Medicine, McGill University, Montreal
Barbara Büscher, Professor of Media Dramaturgy, Leipzig University of Music and Theater
Dieter Daniels, Professor of Art History and Media Theory and Director of the Ludwig Boltzmann Institute Media.Art.Research, Linz
Claus Pias, Professor of Epistemology and Philosophy of Digital Media, University of Vienna, Department of Philosophy
Jasia Reichardt, curator of the *Cybernetic Serendipity* exhibition in London
Stefan Rieger, adjunct lecturer at the University of Cologne's Department of German Language and Literature; currently recipient of a Heisenberg Grant from the DFG – German Research Foundation
Margit Rosen, Cologne Academy of Media Arts and the Karlsruhe University of Design
Edward A. Shanken, Professor of Art History, Savannah College of Art & Design

Andreas Broeckmann, Dieter Daniels

Placing and Re-placing Media Art: Shifting Scenarios between the Laboratory and the Museum

At which venues of artistic production does art enter into a dialog with media, science and technology? What can these locations tell us about the unique aspects of working in media art? How are they connected to various scientific, academic, military, economic and other contexts? What is the source of the legitimacy ascribed nowadays to the existence of a separate discourse and special institutions dedicated to media art? What are the specific features of these places, and where might their future lie?
Panel discussion organized by the Ludwig Boltzmann Institute Media.Art.Research in cooperation with *re:place 2007*, The Second International Conference on the Histories of Media Arts, Sciences and Technologies
With Dieter Daniels (AT/DE), Andreas Broeckmann (DE), Gunalan Nadarajan (SG/US), Edward Shanken (US), et al.

Was sind die Orte künstlerischen Schaffens, an denen die Kunst mit Medien, Wissenschaft und Technologie in Dialog tritt? Was können uns diese Orte über die Besonderheiten medienkünstlerischen Arbeitens sagen? Wie verhalten sie sich zu diversen wissenschaftlichen, akademischen, militärischen, ökonomischen und anderen Kontexten und Praktiken? Worin liegt die Legitimation eines eigenständigen Diskurses und spezieller Institutionen, die sich auf das Thema Medienkunst konzentrieren? Was machte die Besonderheit dieser Orte aus – und wo liegt ihre mögliche Zukunft?
Panel-Diskussion veranstaltet vom Ludwig Boltzmann Institut Medien. Kunst.Forschung in Kooperation mit re:place 2007, Konferenz zur Geschichte der Kunst durch Medien, Wissenschaft und Technologie (Berlin, November 2007, The Second International Conference on the Histories of Media Arts, Sciences and Technologies)
Mit Dieter Daniels (AT/DE), Andreas Broeckmann (DE), Gunalan Nadarajan (SG/US), Edward Shanken (US), u. a.

The Upgrade! International

The Upgrade! is an international network of gatherings concerning art, technology and culture. As an emerging network of autonomous nodes committed to bridging cultural divides, *The Upgrade!* operates along an axis of simplicity, by sustaining a monthly gathering format, and as a space for artists to present and share their work. As an international organisation, the network engages complex problems as it struggles to find a model for decision-making, representation, funding, organisation and growth within trusted community-based collaborations. *The Upgrade!* began in 1999 with a regular gathering in New York City organised by Yael Kanarek. *Upgrade! New York* partnered with *Eyebeam* in 2000, and in 2004 *The Upgrade* went international with Vancouver and Montreal, followed by over a dozen worldwide locations in 2005 (and growing!). The first *Upgrade! International Gathering* was held in September 2005 in NYC at *Eyebeam,* with representatives from each node, and the second will be held in Oklahoma City, USA, from November 30th–December 3rd, 2006.
www.theupgrade.net

Current Nodes: AMSTERDAM (Lucas Evers / Nat Muller); BOSTON (Jo-Anne Green); CARACAS (Yucef Merhi / Deborah Mizrahi); CHICAGO (Tiffany Holmes / Lincoln Schatz); ISTANBUL (Emre Erkal / Erhan Muratoglu / Basak Senova / NOMAD); JOHANNESBURG (Christof Doherty / Nathaniel Stern); LISBON (Luís Silva); MONTREAL (Anik Fournier / Sophie Le-Phat Ho / tobias c. van Veen) _ MUNICH (Tamiko Thiel); NEW YORK (Yael Kanarek / Jesse Pearlman Karlsberg / Liz Slagus); OKLAHOMA CITY (Adam Brown); SALVADOR (José Balbino / midiatatica.org / Oitininha); SCOTLAND (New Media Scotland); SEOUL (Suhjung Hur); SKOPJE (Antonio Dimitrov / Elena Veljanovska); SOFIA (Petko Dourmana / Ivaylo Ivanov / Yana Kostova / Yovo Panchev); TEL AVIV / JERUSALEM (Salamanca / Mushon Zer-Aviv); VANCOUVER (Kate Armstrong); WELLINGTON (Marcia Lyons)
Future Nodes: ATHENS (Daphne Dragona); BELGRADE (Maja Ciric / Jasmina Maric / Zana Poliakov); BERLIN (Public Art Lab); LIVERPOOL (N.N.); PARIS (Incident.net); VIENNA (Ursula Hentschlaeger / Zelko Wiener)

Amsterdam
Boston
Caracas
Chicago
Istanbul
Johannesburg
Lisbon
Montréal
Munich
Oklahoma City
New York
Scotland
Salvador
Seoul
Skopje
Sofia
Tel Aviv-Jerusalem
Vancouver
Wellington

Upgrade! ist ein internationales Netzwerk, das Zusammenkünfte zu den Themen Kunst, Technologie und Kultur organisiert. Als ein wachsendes Netz autonomer Knoten, das sich die Überbrückung kultureller Kluften zur Aufgabe gemacht hat, fungieren die monatlichen Treffen von *Upgrade!* als Einfachheitsachse und schaffen einen Raum für Künstler, in dem sie ihre Arbeiten präsentieren und zugänglich machen können. Als internationale Organisation kämpft das Netzwerk bei seiner Suche nach einem geeigneten Modell für Entscheidungsfindung, Repräsentanz, Finanzierung, Organisation und Wachstum innerhalb der vertrauenswürdigen Kooperationen in der Community natürlich auch mit komplexen Problemen.

Upgrade! wurde von Yael Kanarek 1999 ins Leben gerufen, indem er regelmäßige Zusammenkünfte in New York veranstaltete. 2000 ging *Upgrade! New York* eine Partnerschaft mit dem Medienkunstzentrum *Eyebeam* ein, um 2004 mit Montreal und Vancouver international zu werden. Diesen beiden folgten 2005 über ein Dutzend weiterer Städte auf der ganzen Welt (und es ist kein Ende in Sicht). Das erste internationale *Upgrade!*-Treffen, an dem Vertreter jedes Knoten teilnahmen, fand im September 2005 im *Eyebeam* in New York statt. Das zweite wird vom 30. November bis 3. Dezember 2006 in Oklahoma City abgehalten.

Aus dem Englischen von Michael Kaufmann

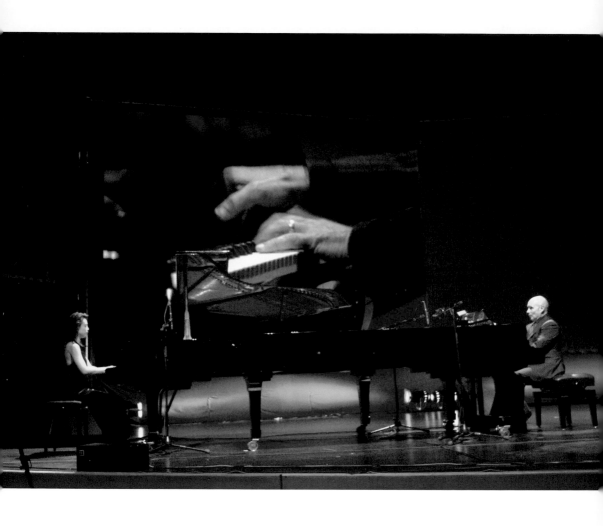

Dennis Russell Davies

Music for the Eyes

Communication in today's world has achieved a level of almost unbelievable sophis-
tication and technical advancement, yet people the world over live in ever increasing isolation
in societies where specialization has become the operating principle. While the continuing
advance of digital technology in literally every aspect of modern live represents, unfortunately,
the negative consequences of overspecialization and a resultant general feeling of isolation,
clearly the marvellous progress in the digital arts and sciences brings hope of a generous and
humane solution to some of an isolated society's most difficult problems.
Several years ago, Gerfried Stocker and I discussed intensely the problems that serious concert
music was facing in a world that had become increasingly visually oriented, and was being
simultaneously overwhelmed with brutal noise levels in everyday life as well as indiscriminate
and primitive usage of (over) amplification. Increasingly, concert music was being dominated by
"specialists" in old music, new music, baroque music and renaissance music, with an ever-
increasing gap between today's composers and the general concert public. We both agreed that
the traditional acoustic instruments of the modern symphony orchestra were relevant and
potentially stimulating for today's listeners of all ages, and we decided to combine the resources
of the Ars Electronica's visual technology, the musical expertise of the Bruckner Orchester Linz,
and the composers whose music in recent years has found its expression through the medium
of the modern (acoustical) symphony orchestra but is still struggling to find a wider audience.
Since 2003 the Ars Electronica Festival and the Bruckner Orchester Linz have presented works by
Edgar Varese, Iannis Xenakis, Morton Sobotnik, Philip Glass, Steve Reich, Pierre Boulez, John Cage,
Györgi Ligeti, Péter Eötvös in conjunction and simultaneously with digital creations by visual
artists.
All of the new video works were created under the influence of already existing, but decidedly
contemporary music, and were designed to be performed simultaneously with a live symphon-
ic performance. In nearly every case, I had the strong impression that the music and the visual
performance could continue to exist independently of each other, but that together they blend-
ed to create a form that effectively communicated sophisticated new sounds and images to a
receptive and new audience.
This continues to be our goal, and to this end Gerfried Stocker and I have selected for the Ars
Electronica Festival 2006 what we feel to be a dynamic and interesting constellation of com-
posers and visual artists. On Sunday, September 3, Ars Electronica, the Bruckner Orchester Linz,
the Brucknerhaus, and the Lentos Museum will present in live performances over several hours
and in different venues the results of this collaboration.
I had the good fortune of enjoying the friendship and working closely with John Cage from the
early 1970s until his death in 1992. Similar to other musicians and music lovers, the way I
thought about and listened to music and the sounds of the environments in which I lived was
profoundly changed by his music and ideas. Because he was a courageous pioneer, he was often
a lonely figure as a composer, but his work brought musicians and performers of all kinds
together to create unexpected and often spectacular events. His scores could be visually capti-
vating, and I am confident he would have been comfortable with our "visualization" project, and
probably a contributor to this form as well. His openness to new ideas and generous acceptance
of all forms of serious art is our guiding spirit in this Festival.
Charles Amirkhanian's work as a composer has been in the realm of sound pieces, with words,

syllables, and vocal sounds forming the acoustical substance of his creations. But in addition he is one of the most informed and informative authorities on performed serious music world wide, and has been a tremendous help, for me and for other conductors and performers, in finding interesting, often unjustly neglected, music to play.

My first contact with Ludger Brümmer was in the 1980s in Cologne when I conducted a new orchestral work of his at a Cologne Radio Festival for young composers. He has since become an influential figure in German music and is currently music director for ZKM in Karlsruhe. He has conceived and developed a new form for live performance with pianist Maki Namekawa, composing music and creating visual elements to be performed together *(Le Temps du Miroir)*. On September 3 Ars Electronica will present a new work by the same collaborators. Philippe Manoury has had a long association with Pierre Boulez and the IRCAM at the Centre Pompidou in Paris. I conducted the premier of his opera *K....* at the Opera Bastille in Paris in 2001, and since then we collaborated on a revival of *K....* as well as other works for symphony orchestra. His special interest has included extending the acoustic possibilities of the symphony orchestra through digital and acoustical means, and for our festival the use of visual elements with live symphonic performance is a natural development of his work.

Heutzutage hat die Kommunikation bereits einen nahezu unglaublichen Grad an Komplexität und technischer Raffinesse erreicht; dennoch leben die Menschen rund um den Globus in immer größerer Isolation in Gesellschaften, deren Triebfeder die Spezialisierung ist. Während der unaufhaltbare Fortschritt der digitalen Technologie in sämtlichen Bereichen des modernen Lebens – leider – für die negativen Konsequenzen der Überspezialisierung und das daraus resultierende allgemeine Gefühl der Isolation steht, so geben die erfreulichen Entwicklungen in den Bereichen digitale Kunst und digitale Wissenschaft Anlass zur Hoffnung auf eine großzügige, humane Lösung der gravierendsten Probleme isolierter Gesellschaften.

Vor einigen Jahren haben Gerfried Stocker und ich lebhaft über die Probleme der ernsten Konzertmusik diskutiert. Es herrscht eine immer stärkere visuelle Orientierung vor, während die Welt gleichzeitig mit brutalen Lautstärkepegeln im Alltag sowie unkritischer, primitiver (übermäßiger) Verstärkung zugedröhnt wird. In der Konzertmusik dominieren immer häufiger „Spezialisten" der Alten Musik, Neuen Musik, Barock- und Renaissancemusik, wobei die Kluft zwischen zeitgenössischen Komponisten und traditionellem Konzertpublikum ständig breiter wird. Da wir beide der Ansicht waren, dass die traditionellen akustischen Instrumente eines modernen Symphonieorchesters zeitgenössischen Zuhörern jeder Altersstufe wichtige und potenziell inspirierende Impulse liefern können, beschlossen wir, die Ressourcen der Ars Electronica im Bereich visuelle Technologie und die musikalische Expertise des Bruckner Orchesters Linz mit Komponisten zu kombinieren, die sich in den letzten Jahren moderner (akustischer) Symphonieorchester bedient haben, deren Werken jedoch ein größerer Publikumserfolg bislang versagt geblieben ist. Seit 2003 haben das Ars Electronica Festival und das Bruckner Orchester Linz Werke von Edgar Varese, Iannis Xenakis, Morton Sobotnik, Philip Glass, Steve Reich, Pierre Boulez, John Cage, Györgi Ligeti, Péter Eötvös mit digitalen Visuals von Medienkünstlern kombiniert und gemeinsam aufgeführt.

Für sämtliche neue Videoarbeiten wurde bereits vorhandene, jedoch ausschließlich zeitgenössische Musik herangezogen und für die gemeinsame Live-Aufführung mit einer symphonischen Performance konzipiert. In fast allen Fällen konnte ich mich des Eindrucks nicht erwehren, dass Musik und visuelle Performance auch unabhängig voneinander existieren könnten, dass sie aber durch ihr Zusammenwirken zu einer Form verschmolzen waren, die für ein neues, aufgeschlossenes Publikum eindrucksvoll neuartige, anspruchsvolle Klänge und Bilder schuf.

Dies bleibt auch weiterhin unser Ziel, und zu diesem Zweck haben Gerfried Stocker und ich für das Ars Electronica Festival 2006 eine unserer Ansicht nach sehr dynamische und interessante Konstellation von Komponisten und visuellen Künstlern ausgewählt. Am Sonntag, dem 3. September, präsentieren Ars Electronica, Bruckner Orchester Linz, Brucknerhaus und Lentos Museum in mehrstündigen Live-Performances die Resultate dieser Zusammenarbeit an verschiedenen Veranstaltungsorten.

Ich hatte das Glück, mit John Cage seit den frühen 1970er Jahren und bis zu seinem Tod 1992 eng befreundet gewesen zu sein und mit ihm zusammenarbeiten zu dürfen. Seine Musik und seine Ideen haben die Art und Weise, wie ich Musik und Umweltgeräusche wahrnehme und beurteile, grundlegend verändert. Ähnlich ist es auch zahlreichen anderen Musikern und Musikliebhabern gegangen. Als der wagemutige Pionier, der er war, galt John Cage als Komponist oft als eine einsame Figur. Sein Werk brachte aber die unterschiedlichsten Musiker und Performancekünstler zusammen und inspirierte sie zu unerwarteten, oft spektakulären Events. Seine Partituren konnten visuell faszinierend sein, und ich bin mir sicher, er wäre mit unserer „Visualisierung" dieses Projekts zufrieden gewesen und hätte wahrscheinlich auch zu dieser neuen Form etwas beizutragen gewusst. Seine Aufgeschlossenheit für neuen Ideen und seine großzügige Akzeptanz sämtlicher Formen ernsthafter Kunst sind unser Leitgedanke bei diesem Festival.

Charles Amirkhanians kompositorisches Werk bewegt sich im Reich der Klangstücke, wobei Worte, Silben und Vokalklänge die akustische Substanz seiner Kreationen bilden. Darüber hinaus ist er weltweit einer der informiertesten und informativsten Kapazitäten für E-Musikaufführungen; so hat er mich und andere Dirigenten und Performancekünstler bei der Suche nach aufführbaren Werken schon häufig auf interessante und oft zu Unrecht unbekannte Musikstücke aufmerksam gemacht.

Ludger Brümmer traf ich erstmals in den 1980er Jahren in Köln, als ich bei einem von Radio Köln veranstalteten Festival für junge Komponisten sein neues Werk für Orchester dirigierte. Seitdem zählt er zu den einflussreichen Figuren der deutschen Musik und ist derzeit Musikdirektor des ZKM in Karlsruhe. Mit der Pianistin Maki Namekawa hat er eine neue Form der Live-Performance konzipiert und weiter entwickelt, bei der Musik und visuelle Elemente für eine gemeinsame Aufführung komponiert bzw. entworfen werden (*Le Temps du Miroir*). Am 3. September wird die Ars Electronica ein neues Werk dieses Teams präsentieren.

Phillipe Manoury arbeitet seit langem mit Pierre Boulez und dem IRCAM am Centre Pompidou in Paris zusammen. 2001 dirigierte ich die Premiere seiner Oper *K...* in der Opera Bastille in Paris und seitdem haben wir an einer Wiederaufführung von *K...* und weiterer Werke für Symphonieorchester gearbeitet. Sein besonderes Interesse gilt der Erweiterung der akustischen Möglichkeiten eines Symphonieorchesters durch digitale und akustische Mittel, weshalb die Kombination von visuellen Elementen mit einer symphonischen Live-Performance für unser Festival eine natürliche Weiterentwicklung darstellt.

Aus dem Englischen von Susanne Steinacher

zu seinem geburtstag, 1975

wie **D** u weißt gehe ich nicht ab von meiner art
musik zu hör **E** n.
ich lausche ei **N** fach
jederart kla **N** g die mich zufällig umgibt.
Oder wenn **I** ch abgehe von meiner art
mu **S** ik zu hören

gehe ich etwas hö **R** en von jemandem
über den ich nichts weiß. n **U** r
diese **S** jahr
anlä **S** slich deiner proben
und der gr **E** tes
habe ich ge **L** auscht
sowoh **L**

hay **D** n
als **A** uch
beetho **V** en! Und nicht nur einmal
sondern immer und immer w **I** eder! gott weiß
was gescheh **E** n wird
al **S** folge daraus.

Acrostichon by John Cage in honour of
Dennis Russell Davies' birthday.

Akrostichon von John Cage anlässlich des Geburtstags von
Dennis Russell Davies. Übersetzung Hans G. Schürmann.

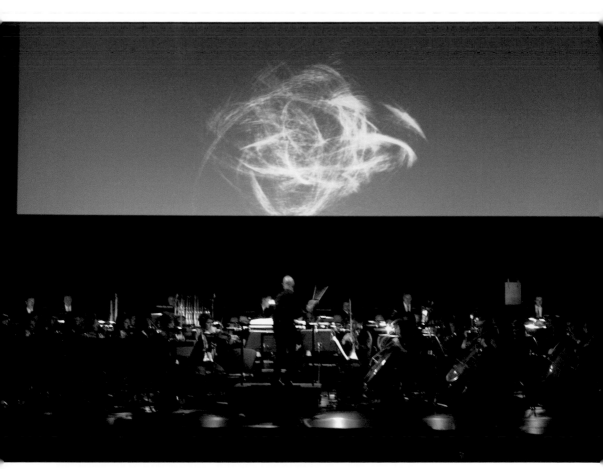

Ars Electronica 2005, *Listening between the Lines, Pierre Boulez: Notation I – IV (1978),* performed by Bruckner Orchester Linz / Dennis Russell Davies. Visuals by Kirk Woolford.

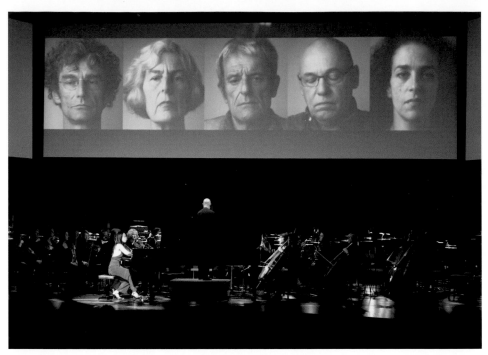

Ars Electronica 2005, Listening between the Lines, Elliott Carter: Dialogue (2004), performed by Bruckner Orchester Linz, Maki Namekawa / Dennis Russell Davies. Visuals by Eva Teppe.

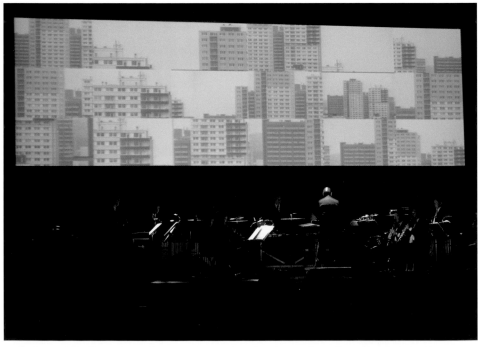

Ars Electronica 2004, L'Espace Temporel, Steve Reich: Music for 18 Musicians, performed by Bruckner Orchester Linz, Synergy Vocals / Dennis Russell Davies. Visualization by Dietmar Offenhuber, Norbert Pfaffenbichler, Lotte Schreiber.

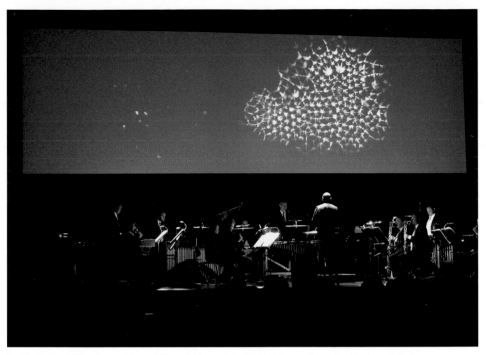

Ars Electronica 2004, L'Espace Temporel, Steve Reich: Music for 18 Musicians, performed by Bruckner Orchester Linz, Synergy Vocals / Dennis Russell Davies. Visualization by Casey Reas.

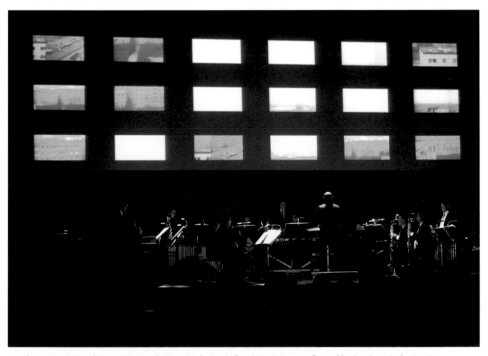

Ars Electronica 2004, L'Espace Temporel, Steve Reich: Music for 18 Musicians, performed by Bruckner Orchester Linz, Synergy Vocals / Dennis Russell Davies. Visualization by Dietmar Offenhuber, Norbert Pfaffenbichler, Lotte Schreiber.

Maki Namekawa

When Music and Computer Programs Grow Together

In Japanese calligraphy, the thoughts that are to be expressed are set down on paper in the rhythm of inhaling and exhaling. The characters can have a completely different meaning, depending on how the person writing them feels at the moment. The script lives and breathes. This is also the case with music and its notation. The first time I was ever confronted by the score of the piano part of a piece of music that was supposed to function together with a computer program, I gave a great deal of thought to how such collaboration might work and even whether it could. But I had the good fortune to be able to work together personally with composer/visual artist Ludger Brümmer on several projects. This experience made it clear to me that digital technologies in the hands of a "musical artist" enable music and a computer program to grow together, whereby human breathing plays an essential role. Ludger Brümmer has developed a capacity to give the musical interpreter space to breathe and to phrase; at the same time, he is also able to react quickly with his computer to the musical impetus that I provide. For me, this is like chamber music reconfigured for the Digital Age.

John Cage's personal development as a composer displays parallels to trends in New Music over recent decades. At the start of his career, he wrote meticulously detailed scores of his compositions in the expectation that the musicians would adhere very closely to these guidelines. Later on, he gave his interpreters greater freedom to use their imagination and even withdrew to a much less prescriptive position as a composer thanks to his "chance methods" work such as *Yijing* that today, in times of digital live performances, is still an example of great current relevance for many composers.

Translated from German by Mel Greenwald

In der japanischen Kalligrafie werden die Gedanken, die man ausdrücken will, im Rhythmus des Ein- und Ausatmens auf das Papier gebracht. Die Zeichen könnten nach Tagesverfassung eine völlige andere Bedeutung haben. Die Schrift lebt und atmet. So ist das auch bei der Musik und ihrer Notation. Als ich das erste Mal mit einer notierten Klavierstimme konfrontiert wurde, die in einem Konzert zusammen mit einem Computerprogramm eingesetzt werden sollte, überlegte ich lange, wie das wohl funktionieren könnte. Glücklicherweise konnte ich aber mit dem Komponisten und Visual Artist Ludger Brümmer sehr eng zusammenarbeiten und dabei wurde mir klar, dass digitale Techniken in den Händen eines „musikalischen Künstlers" das Zusammenwachsen einer Musik mit einem Computerprogramm ermöglichten, wobei das menschliche Atmen eine wesentliche Rolle spielt. Ludger Brümmer hat eine Fähigkeit entwickelt, dem Interpreten Raum zum Atmen und Phrasieren zu geben, wobei er auf musikalische Impulse meinerseits schnell mit seinem Computer reagieren kann. Das ist für mich wie Kammermusik, neu gestaltet im digitalen Zeitalter.

Die persönliche Entwicklung des Komponisten John Cage weist Parallelitäten mit Tendenzen in der Neuen Musik der letzten Jahrzehnte auf. Am Anfang seine Karriere hat er seine Kompositionen sehr genau und akkurat notiert, in der Erwartung, dass sich Musiker streng an diese Vorgaben halten würden. Später hat er seinen Interpreten zunehmend Freiheit und Fantasie ermöglicht und sich dank seiner Arbeit mit „Chance Methods" wie dem *Yijing* sogar als Komponist zurückgenommen – ein selbst heute, in Zeiten digitaler Live-Performances, immer noch aktuelles Beispiel für viele Komponisten.

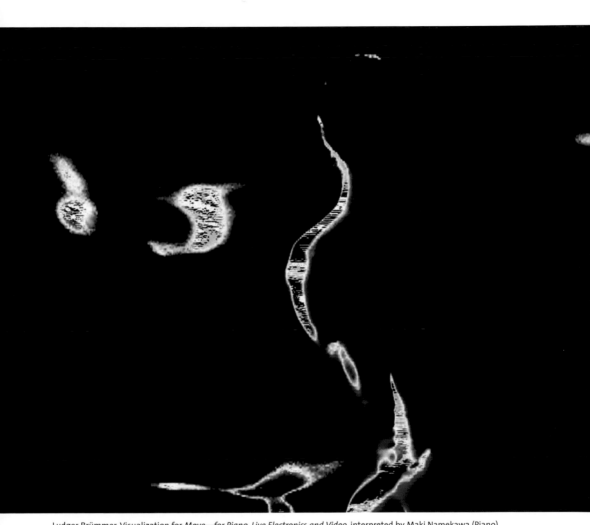

Ludger Brümmer, Visualization for *Move—for Piano, Live Electronics and Video*, interpreted by Maki Namekawa (Piano) and Ludger Brümmer (Live Electronics) within the concert *Some Sounds and Some Fury*.

Some Sounds and Some Fury

With this year's concert evening, Ars Electronica is, in a certain respect, formally establishing as an ongoing Festival feature the multi-year derivational phase of an intermedial practice of music that represents a fusion of primarily visual and tonal elements and that, in the form of exemplary reproductions of the classics of sound art as well as current manifestations of this genre in various configurations, has found an ideal stage setting at the Brucknerhaus since 2003. *Principles of Indeterminism* (2003), *L'Espace Temporel* (2004) and *Listening between the Lines* (2005) have been presented heretofore. In this series' fourth installment, the work's format and the stage itself determine the theme. This is a format that, due to its particular constellation of personnel—conductor Dennis Russell Davies, the Bruckner Orchester under his direction, and pianist Maki Namekawa—has made it possible to put on a consistently high-quality program of performances that have continually explored and expanded the realm of interplay, on the one hand, at the nexus of orchestral music and digital practices of composition and distribution, as well as, on the other hand, in the zone of interaction where tonal and visual forms of expression come together. What have established themselves thereby are a format and a setting for new developments that are representative of media/digital art both as a source of inspiration and as a partner of traditional disciplines.[1]

Some Sounds and Some Fury once again spotlights examples of this interplay, which it turns into a leitmotif whose comprehensive principle is to consider the past protagonists who have done much to expand the boundaries of this discipline as coexistent contemporaries and, in the tradition of an excursion through a border region, to establish communion between them and those currently engaged in similar activities. The point of this is to take lines of tradition—those having to do not only with aesthetic substance, but also with concepts and techniques as well—and to weave them into a sort of network in which tearing down borders and interdisciplinarity are endowed with a stable cultural foundation even in a branch of the cultural industry in which traditions are normally deemed to be mostly unfounded.

One outstanding composer who immediately comes to mind in connection with this intention is Philippe Manoury who, during his many years at IRCAM, worked together with Miller S. Puckette on the development of MAX, the granddaddy of all software for live interactive musical performance. Charles Amirkhanian is another individual who absolutely epitomizes the artist as crosser of borders between disciplines in acoustic art. And, of course, when the subject of co-existence and derivation comes up in connection with media music, the name that is inevitably mentioned is John Cage, whose efforts to break down the hierarchies involving composer, musical interpreter and listener anticipated today's strategies of interactivity.

David Behrman has been creating electronic components for his work as a composer and sound artist since the 1970s. Ludgar Brümmer makes use of physics parameters in the synthesis of notation, sound and visuals. Ryoichi Kurokawa's work, on the other hand, is an example of the synonymity of image and sound in production and presentation. This is also the area of activity of Naut Humon, artist and head of the Recombinant Media Labs in San Francisco, who has also acted as co-curator since the beginning of this concert series.

Text: Heimo Ranzenbacher

Translated from German by Mel Greenwald

1 Another fascinating line of development to emerge from this context includes the projects that have presented large-format, real-time visualizations of operas and symphonies. These are discussed at length on page 290 of this catalog.

Some Sounds and Some Fury

Mit dem diesjährigen Konzertabend etabliert Ars Electronica in gewisser Hinsicht die mehrjährige Phase der Herleitung einer intermedialen, primär Bild und Klang vereinenden Praxis der Musik, die in Form von exemplarischen Nacherzählungen und gegenwärtigen Ausprägungen im Brucknerhaus seit 2003 ihre Bühne gefunden hat: *Principles of Indeterminism* (2003), *L'Espace Temporel* (2004), *Listening between the Lines* (2005). Im vierten Jahr der Reihe sind es das Format und die Bühne selbst, die das Thema bestimmen, ein Format, das es infolge seiner besonderen personellen Konstellation – namentlich durch den Dirigenten Dennis Russel Davies, das von ihm geleitete Brucknerorchester und die Pianistin Maki Namekawa – erlaubt, in kontinuierlicher Qualität Programme zu gestalten, die die Grenzgänge zwischen Orchestermusik und digitaler Kompositions- und Distributionspraxis einerseits und zwischen klanglichen und visuellen Ausdrucksformen andererseits immer wieder ausloten und erweitern. Format und Bühne haben sich dadurch für neue Entwicklungen etabliert, die zugleich repräsentativ sind für die Medien- und digitale Kunst als Quelle der Inspiration und Partner traditioneller Disziplinen.[1]

Some Sounds and Some Fury verdeutlicht einmal mehr dieses Zusammenspiel; sein Leitmotiv ist das Prinzip, die für die Erweiterung disziplinärer Grenzen maßgeblichen Protagonisten als mitlebend zu betrachten und in der Tradition des Grenzganges mit (in ihrem Sinne heute Tätigen) kurzzuschließen. Es geht dabei darum, aus Traditionslinien – nicht nur hinsichtlich der ästhetische Substanz, sondern auch der Konzepte und Techniken – eine Art Netz zu flechten, in dem Entgrenzung und Interdisziplinarität selbst kulturellen Halt im Kulturbetrieb erfahren, in dem ihre Traditionen gewöhnlich eher haltlos sind.

Ein für solche Intentionen ebenso nahe liegendes wie herausragendes Beispiel ist Philippe Manoury, der als Komponist jahrelang am IRCAM an Miller S. Puckettes Entwicklung von MAX (der grundlegenden Software für interaktives Live-Spiel schlechthin) mitgewirkt hat. Wie kaum ein anderer steht auch Charles Amirkhanian für Grenzgängertum im Bereich der akustischen Kunst; und wenn man vom Mitleben und der Herleitung im Bereich der Medienmusik spricht, dann spricht man natürlich implizit von John Cage, der durch den Bruch mit den Hierarchien zwischen Komponist, Interpret und Zuhörer Strategien der Interaktivität vorweggenommen hat.

David Behrman entwirft seit den 1970er Jahren elektronische Bauteile für seine Arbeit als Komponist und Klangkünstler; Ludger Brümmer bedient sich physikalischer Parameter zur Synthese von Notation, Klang und Bild; Ryoichi Kurokawas Arbeiten wiederum sind ein Beispiel für Synonymität zwischen Bild und Klang in Produktion und Präsentation – ein Tätigkeitsgebiet, das auch der Leiter der Recombinant Media Labs in San Francisco und Künstler Naut Humon bearbeitet, der auch seit Beginn dieser Konzertserie als Co-Kurator tätig ist.

Text: Heimo Ranzenbacher

1 Eine weitere und höchst spannende Projektschiene, die sich aus diesem Zusammenhang heraus entwickelt hat, sind die großformatigen Realtime-Visualisierungen für Opern und Symphonien, über die in diesem Katalog ausführlich zu lesen ist – siehe Seite 293.

Some Sounds and Some Furys is a further step in an ongoing collaboration between Brucknerhaus Linz and Ars Electronica that attempts to create new experimental fusions between music and visual art.

Some Sounds and Some Furys ist ein weiterer Schritt in der Zusammenarbeit von Brucknerhaus Linz und Ars Electronica mit dem Ziel, neue Konzepte der Verbindung von Musik und neuen visuellen Ausdrucksformen zu erproben.

Some Sounds and Some Furys – Program

Loudspeakers (for Morton Feldmann), 1990, by Charles Armikhanian

Concerto for Prepared Piano and Orchestra, 1951, by John Cage. Performed by Bruckner Orchester Linz / Dennis Russell Davies, Maki Namekawa: Piano, Visuals by Jorn Ebner.

Sound and Fury, pour grand orchestre, 1999, by Philippe Manoury. Performed by Bruckner Orchester Linz / Dennis Russell Davies. Visuals by 1nOut (Robert Praxmarer / Reinhold Bidner).

Move—For Piano, Live Electronics and Video, Premiere, by Ludger Brümmer. Performed by Maki Namekawa – Piano and Ludger Brümmer – Computer and Visuals.

Audiovisual Crossmedia Concert by Ryoichi Kurokawa. Performed by Ryoichi Kurokawa. Visuals by Ryoichi Kurokawa.

Image-Sound Interaction Performance by Naut Humon.

Klangpark Intervention: *Music with Melody-Driven Electronics,* by David Behrman

Curators: Dennis Russell Davies, Naut Humon, Gerfried Stocker.

Charles Amirkhanian
Loudspeakers (for Morton Feldmann), 1990

Charles Amirkhanian, born in 1945 in California, is one of today's most versatile practitioners of new music and sound art, and he has also been instrumental in the dissemination of contemporary music through his work in the USA.
Composer, sound poet, performance artist and radio producer; from 1969 to 1992, musical director of radio station KPFA in Berkeley; from 1993 to 1997, director of the Djerassi Foundation in California. In his works, Amirkhanian has repeatedly pursued intra- and interdisciplinary approaches, and combines—often with the synclavier—sampled acoustic environmental sounds ("representational sounds") with traditional musical patterns and experimental, multilingual literature with music. *Loudspeakers,* a 1990 piece dedicated to Morton Feldman that has been selected for *Some Sounds and Some Fury,* is based on an interview with the composer that has been digitally processed on the synclavier.

Der 1945 geborene Kalifornier Charles Amirkhanian ist nicht nur einer der vielseitigsten Vertreter der Neuen Musik und Soundart, sondern hat sich auch als einer ihrer engagiertesten Förderer in den USA profiliert.

Komponist, Klang-Poet, Performance- und Radiokünstler, von 1969 bis 1992 Musikdirektor der Radiostation KPFA in Berkeley, von 1993 bis 1997 Direktor der Djerassi Foundation in Kalifornien, verfolgt Amirkhanian in seinen Stücken immer wieder intra- und interdisziplinäre Ansätze, verbindet – häufig mit dem Synclavier – gesampelte Impressionen der akustischen Umwelt („darstellende Klänge") mit traditionellen musikalischen Mustern und experimentelle, mehrsprachiche Literatur mit Musik. Das für *Some Sounds and some Fury* ausgewählte, Morton Feldman gewidmete Stück *Loudspeakers* aus dem Jahr 1990 basiert auf einem mittels Synclavier digital verarbeiteten Interview des Komponisten.

John Cage
Concerto for Prepared Piano and Chamber Orchestra, 1951

John Cage (1912–1992) is an iconic figure (comparable to Marcel Duchamp in the graphic arts) who stands for a radically aleatory principle of composition that constitutes a stark contrast to the concept of a work of art in a finalized form, and thus for a negation of the hierarchies imposed upon the listener. Cage was inspired by the philosophy of Zen and by the *Book of Changes (Yijing)*.

His violin concert that premiered in New York is a paradigmatic example of these aesthetics. Cage himself called it a work in progress that changed its form with every performance. The classic line of demarcation between podium and audience is erased; the orchestra is dispersed throughout the performance venue; there is no score to regulate the process of playing together, and each member becomes a soloist left to his/her own devices. Cage: "The pianist is free to decide which parts to play, as a whole or in part, and in which particular order. The accompanying orchestra can comprise any number of musicians playing any number of instruments, and there is no time limit set on the performance."

John Cage (1912–1992) steht (wie Marcel Duchamp in der bildenden Kunst) ikonisch für ein dem finalen Werkbegriff völlig entgegengesetztes, radikal aleatorisches Kompositionsprinzip und damit für die Negation der Hierarchien über das Hören. Inspiriert wurde Cage dazu von der Philosophie des Zen und dem *Buch der Wandlungen (Yijing)*.

Sein in New York erstmals aufgeführtes Klavierkonzert ist paradigmatisch für diese Ästhetik. Cage selbst hat es ein „Work in progress" genannt; es ändert mit jeder Aufführung seine Gestalt. Die klassische Demarkationslinie zwischen Podium und Publikum ist außer Kraft gesetzt, das Orchester spielt im Aufführungsraum verteilt; es existiert keine Partitur zur Regelung des Zusammenspiels, jede/r ist in seiner Eigenverantwortlichkeit Solist. Cage: „Dem Pianisten steht es frei, irgendwelche Teile seiner Wahl ganz oder teilweise und in beliebiger Reihenfolge zu realisieren. Die Orchesterbegleitung kann jede beliebige Anzahl von Spielern einer beliebigen Zahl von Instrumenten umfassen, und eine Aufführung kann beliebig lange dauern."

2,25 m

3,85 m

Jorn Ebner

Flash Movie for the *Concerto for Prepared Piano and Chamber Orchestra* by John Cage. The sequence of images is conceived as an additional, visual score that complements the compositional structures of the music: from a free gestural form within a fixed framework all the way to a fixed gestural framework. The primarily formal elements are ultimately merged together with figurative ones in order to establish a reference to spatial organization in everyday life. Abstract-gestural and figurative forms combine to form an experimental configuration that explores the uses of graphic elements.

Flash Movie für das *Concerto for Prepared Piano and Orchestra* von John Cage. Die Bilderfolge ist als zusätzliche, visuelle Partitur konzipiert, die den kompositorischen Strukturen der Musik folgt: von freier gestischer Form innerhalb eines festen Rahmens hin zu einem festen gestischen Rahmen. Die vornehmlich formalen Elemente werden schließlich mit figurativen verbunden, um einen Bezug zu räumlicher Organisation im Alltag herzustellen. Abstrakt-gestische und figurative Formen kombinieren sich in einem „Versuch über den Nutzen von Bildelementen".

Philippe Manoury
Sound and Fury, pour grand orchestre, 1999

Philippe Manoury (1952), long-time lecturer at the IRCAM in Paris, is the foremost analyst among contemporary composers. His highly pronounced interest in the mathematical laws governing music and their relationship to time and space is reflected not only in works like *Slova,* a choral triptych, and *Sonus ex machina,* an interactive cycle of pieces for various instruments, but also in his artistic collaboration with mathematician Miller Puckette on the development of the visual programming language MAX. Since late 2004, Philippe Manoury has held a teaching position at the University of California, San Diego.
Sound and Fury (1999) is a computer-based composition written for a very large orchestra which is symmetrically disposed, and makes quite extensive use of left-right spatial effects.

Philippe Manoury (1952), langjähriger Dozent am Pariser IRCAM, ist der Analytiker unter den zeitgenössischen Komponisten. Sein ausgeprägtes Interesse an den mathematischen Gesetzmäßigkeiten der Musik und an ihrem Verhältnis zur Zeit und zum Raum spiegelt sich nicht nur in Werken wie dem Chortriptychon *Slova* und *Sonus ex machina*, einem Zyklus interaktiver Stücke, wider, sondern auch in seiner künstlerischen Patronanz bei der Entwicklung der visuellen Programmiersprache MAX durch Miller Puckette. Seit Herbst 2004 unterrichtet Philippe Manoury an der University of California San Diego.
Sound and Fury (1999) ist eine computerbasierte Komposition, geschrieben für ein großes Orchester, dessen symmetrische Positionierung ein Spiel mit raumgreifenden Stereoeffekten ermöglicht.

1nOut

1nOut is an artist collective that works both collaboratively and individually on a variety of video and interactive art projects, with a focus on generating synaesthetic experiences. The artists will mix analog and digital processes to live up to Philippe Manoury's ideas of algorithmic and spatial composition. In their visual interpretation they will try to achieve an aesthetic blend that resembles, in a playful way, their reception of the digital-analogue paradox we are living in. The work explores the shades of gray—between black and white—which should give the audience an experience of fuzziness, fault and, despite algorithmic perfection, harmony.

1nOut ist ein Künstlerkollektiv, dessen Mitglieder gemeinsam, aber auch jeder für sich an zahlreichen Video- und interaktiven Kunstprojekten arbeiten, die als Schwerpunkt die Generierung synästhetischer Erfahrungen haben. Die Künstler kombinieren analoge und digitale Prozesse, um Philippe Manourys Ideen einer algorithmischen und räumlichen Komposition zu verwirklichen. In ihrer visuellen Interpretation strebt die Gruppe einen ästhetischen Mix an, der auf spielerische Weise das digital-analoge Paradoxon, in dem wir leben, widerspiegelt.
Das Projekt erforscht Graustufen zwischen Schwarz und Weiß und möchte auf diese Weise dem Publikum die Erfahrung von Verschwommenheit, Störung und, trotz algorithmischer Perfektion, Harmonie vermitteln.

Ludger Brümmer
Move —for Piano, Live Electronics and Video
Premiere

Ludger Brümmer (1958) completed his studies in music, art, pedagogy and composition in Essen. Since 2003, he has headed the Institute for Music and Acoustics at the ZKM. His recent creative works have been audiovisual compositions in which digitally produced motion and sound elements are placed into a referential system with "physical models" displaying the material-specific acoustic behavior of objects—for example, the audiovisual composition *Lizard Point* and the 2002 work *Gestalt*. In *Move*, Brümmer presents the piano as a meta-instrument that controls everything—even the computer. While the computer player constantly re-determines the reaction and action of his instrument, the pianist's actions create triggers without which nothing would happen. In the process, the role of the video, under the temporal control of the piano at the beginning, changes into an independently narrative element, the line that supports the structure of the piece.

The composition was created in 2006 in the studios of ZKM Karlsruhe.

Ludger Brümmer (1958) absolvierte das Studium der Komposition an der Folkwang Hochschule Essen. Seit 2003 leitet er das Institut für Musik und Akustik am Zentrum für Kunst und Medientechnologie Karlsruhe, ZKM. Schwerpunkt in seinem jüngeren Schaffen waren zuletzt audiovisuelle Kompositionen, wobei digital erzeugte Bewegungs- und Klangelemente in ein Bezugssystem zu „physikalischen Modellen" (dem materialspezifischen akustischen Verhalten von Objekten) gesetzt werden – so etwa in der audiovisuelle Komposition *Lizard Point* und der 2002 realisierten Arbeit *Gestalt*.

In *Move* präsentiert Brümmer das Klavier als alles – auch den Computer – kontrollierendes Meta-Instrument. Während der Computerspieler die Reaktion und Aktion seines Instrumentes ständig neu bestimmt, sorgt der Pianist mit seinen Aktionen für Auslöser, ohne die nichts passieren würde. Die Rolle des Videos wandelt sich dabei vom anfangs vom Klavier zeitlich kontrollierten Element zu einer eigenständig erzählenden, die Struktur des Stückes unterstützenden Linie.

Ryoichi Kurokawa
Audiovisual Crossmedia Concert

Ryoichi Kurokawa is an audiovisual artist who lives in Osaka. His works take on multiple forms such as screening works, recordings, installation and live performance. Kurokawa composes time-based sculptures with digitally generated materials and field-recorded sources, in which the minimal and complexities coexist. Kurokawa perceives sound and imagery as a unit, not as separate entities, and constructs exquisite and very precise computer-based works with audiovisual language. This reduces the distance between sound and imagery, and enhances the reciprocity and the synchronization of sound and visual composition.

The multiscreen audiovisual live performance is constantly being updated. Our audiovisual organ is stretched by the abstract sound and by the imagery, perfectly synchronized with the audio, which is projected on two screens arranged in parallel. Digitally generated abstract graphics move organically, filmed pictures make a two-dimensional move, and chaotic noise and minimal rhythm affect them in a complicated way. Kurokawa, who considers the image and the sound as a unit, can create a new flow of thought and reduce the distance between images and sounds. Not only between video and music, but also between two pictures, a dialogue exists; and these elements can convey a spatial awareness that we would be unable to perceive with single channel works.

Ryoichi Kurokawas Arbeiten umfassen Projektionen, Audioaufnahmen, Installationen und Live-Performances. Kurokawa komponiert Zeitskulpturen aus digital generierten Materialien und Feldaufnahmen, in denen Minimalmus und Komplexität Hand in Hand gehen. Er sieht Klang und Bild nicht als getrennte Dinge, sondern als Einheit und verarbeitet diese audiovisuelle Sprache zu überaus exquisiten und präzisen computerbasierten Werken. Dadurch verdichtet sich der gegenseitige Abstand, die Reziprozität und die Synchronisation der Klang- und Bildkomposition.

Das *audiovisual crossmedia concert* ist eine ständig aktualisierte audiovisuelle Live-Performance mit Mehrfachprojektion, die durch den abstrakten Sound und die perfekt damit synchronisierten, auf zwei parallele Projektionsflächen geworfenen Bilder die audiovisuelle Aufnahmefähigkeit erweitert. Digital generierte abstrakte Grafiken bewegen sich organisch, gefilmte Bilder dagegen zweidimensional, und das alles in komplizierter Abhängigkeit von chaotischer Noisemusik und minimalistischen Rhythmen. Kurokawa sieht Bild und Klang als Einheit und lässt die Gedanken zwischen ihnen neu zirkulieren. Nicht nur Video und Musik, sondern auch die Bilder selbst treten in Dialog miteinander und vermitteln so ein räumliches Bewusstsein, das wir bei einkanaligen Arbeiten nicht empfinden würden.

Aus dem Englischen von Wilfried Prantner

███ **Naut Humon**

As a founding member of the electronic noise formation "Rhythm and Noise," Naut Humon's roots are in popular culture. He is head of the Recombinant Media Labs in San Francisco, whose research is focused on audio-visual developments based on the Surround Traffic Control cinesonic system, which is also available for external production and presentation purposes. Naut Humon is a producer and curator for the Asphodel label, and a long-time member of the jury in the Prix Ars Electronica's Digital Musics category. His own projects are installations and performances featuring image-sound interaction.

Naut Humon hat als Gründungsmitglied der Electronic-Noise-Formation „Rhythm and Noise" seine Wurzeln in der Popularkultur. Er leitet die Recombinant Media Labs in San Francisco. Der Forschungsschwerpunkt liegt auf audiovisuellen Entwicklungen, basierend auf dem Surround Traffic Control Cinesonic-System, das auch externen Produktions- und Präsentationszwecken offen steht. Darüber hinaus ist Naut Humon Produzent und Kurator des Labels Asphodel und langjähriges Jurymitglied der Kategorie Digital Musics des Prix Ars Electronica. In seinen eigenen Projekten befasst er sich mit installativen und performativen Praxen im Bereich der Klang- und Bild-Interaktion.

███ David Behrman
Music with Melody-Driven Electronics

Salzburg native David Behrman (1937) has been a musician, composer and sound artist since the 1960s. One of the pioneers of electronic music, he (together with Robert Ashley, Alvin Lucier and Gordon Mumma) founded the Sonic Arts Union in 1966. Since the 1970s, live electronics, often in combination with expressive dance performance, has been a definitive element in Behrman's work. He has also designed his own electronic components and music software for interactive, real-time control of sound events. In the audio-video installation "View Finder" (2001), for example, camera images of movements in the performance space influence the character of the music produced by an old home-brew analog synthesizer.
Music with Melody-Driven Electronics is divided spatially between the part of the musical projection in the Klangpark and the part of the visual projection in the Brucknerhaus lobby.

Der in Salzburg geborene David Behrman (1937) ist seit den 1960er Jahren als Musiker, Komponist und Klangkünstler tätig und zählt zu den Pionieren der elektronischen Musik (gemeinsam mit Robert Ashley, Alvin Lucier und Gordon Mumma gründete er 1966 die Sonic Arts Union). Seit den 1970er Jahren gehört Live-Electronik, immer wieder im Verbund mit performativer Gestik, zu den formbildenden Elementen der Arbeiten Behrmans, in weiterer Folge waren es auch selbst entworfene elektronische Bauelemente und Musiksoftware zur interaktiven Echtzeitsteuerung des Klanggeschehens. In der Audio-Video-Installation *View Finder* (2001) beispielsweise beeinflussen Bewegungsaufnahmen einer Kamera im Aufführungsraum den Charakter der Musik, bei der alte analoge Eigenbau-Synthesizer Verwendung finden.
Music with Melody-Driven Electronics teilt sich räumlich in den Teil der musikalischen Projektion in den Klangpark und in den Teil der visuellen Projektion im Foyer des Brucknerhauses.

Translated from German by Mel Greenwald
Music with Melody-Driven Electronics is part of the Klangpark 2006 project *Music with Roots in the Aether* by Robert Ashley.

Klangpark 2006—Music for a Landscape

The leitmotif for the ongoing *Klangpark* project is *Music for a Landscape*—for the Danube and the riverside park adjacent to the Brucknerhaus. A high-performance loudspeaker system delivering superb sound reproduction will be set up to provide an optimal listening experience throughout the alfresco concert venue.

For Klangpark 2006, we've plumbed what might be called the historic depths of media art and come up with Robert Ashley's *Music with Roots in the Aether* project, a very exciting approach to staging music and linking it up with visual forms of expression. This contribution to the Festival's programmatic emphasis on music visualization dovetails nicely with the Festival theme by offering a refreshing immersion in one of the most intensive phases of minimal music.

Music with Roots in the Aether
Video Portraits of Composers and their Music
Produced and Directed by Robert Ashley

Music with Roots in the Aether is a music-theater piece in color video. It is the final version of an idea that I had thought about and worked on for a few years: to make a very large collaborative piece with other composers whose music I like. Originally I hoped that it could be realized as a live performance piece, in a much different form, but that was too impractical to think about for very long. Among the real choices, video is by far the best medium for many reasons. The collaborative aspect of *Music with Roots in the Aether* is in the theater of the interviews, at least primarily! and I am indebted to all of the composers involved for their generosity in allowing me to portray them in this manner.

The piece turns out to be, in addition, a large-scale documentation of an important stylistic that came into American concert music in about 1960. These composers of the "post-serial"/"post-Cage" movement have all made international reputations for the originality of their work and for their contributions to this area of musical compositions.

The style of the video presentation comes from the need I felt to find a new way of showing music being performed. I have always objected to the meaning that camera editing in television—which derives from the most mundane and dumbest practical considerations in film-making—gives to music. (Film is montaged, first of all, because it has to be. Cameras can't run very many minutes at a time. Everybody who has ever tried to film music being made has had to deal with this problem. Then it got over into television from our habits.) The idea of the visual style of *Music with Roots in the Aether* is plain: to watch as closely as possible the action of the performers and to not "cut" the seen material in any way—that is, to not editorialize on the time domain of the music through arbitrary space-time substitutions.

The visual style for showing the music being made became the "theater" (the stage) for the interviews, and the portraits of the composers were designed to happen in that style.

I am also indebted to the artists who helped work out the realization of this music/video style in the recording process. In particular, I think that the camera ideas of Philip Makanna and the sound recording of Maggi Payne use a kind of concentration of attention that is very new to "visual" media and that is more like music than like film or like television.

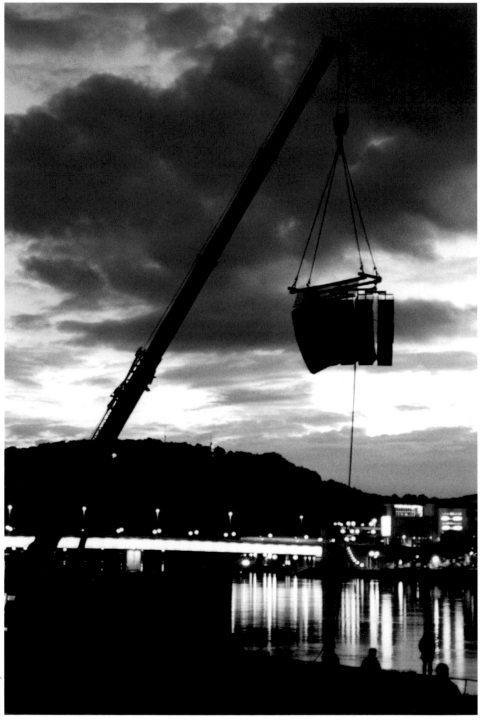

Robert Worby

Klangpark 2006 – Musik für eine Landschaft

Musik für eine Landschaft – für die Donau und den Park vor dem Brucknerhaus – ist das Leitmotiv des Klangparks. Eine leistungsstarke und klanglich ausgezeichnete Lautsprecheranlage steht zur Verfügung und sorgt für optimale Beschallung des großen Freigeländes.

Für den Klangpark 2006 sind wir gewissermaßen in die historischen Tiefen der Medienkunst hinabgestiegen und haben Robert Ashleys Projekt *Music with Roots in the Aether* gehoben: ein höchst spannender Ansatz der Inszenierung von Musik und der Verbindung mit visuellen Ausdrucksformen. Ein Beitrag zum Programmschwerpunkt Musikvisualisierung und dem Festivalthema entsprechend auch ein Sprung in die starke Phase der Minimal Music.

Music with Roots in the Aether
Videoporträts von Komponisten und ihrer Musik
Produktion und Regie: Robert Ashley

Music with Roots in the Aether ist ein Farbvideo-Musiktheater. Es ist die Realisierung einer Idee, an der ich mehrere Jahre gearbeitet habe: ein großes Gemeinschaftswerk mit anderen Komponisten zu schaffen, deren Musik ich mag. Ursprünglich wollte ich diese Idee als Live-Performance in ganz anderer Form realisieren, was sich aber bald als undurchführbar herausstellte. Unter den realisierbaren Möglichkeiten erwies sich Video aus mehreren Gründen als das mit Abstand beste Medium.

Der Aspekt der Zusammenarbeit von *Music with Roots in the Aether* kommt in erster Linie im „Theater der Interviews" zum Tragen, und ich bin allen beteiligten Komponisten für ihre Großzügigkeit, sie so porträtieren zu dürfen, zu großem Dank verpflichtet.

Das Stück ist darüber hinaus eine groß angelegte Dokumentation einer bedeutenden Stilrichtung, die um 1960 in der amerikanischen Konzertmusik aufkam. Die Komponisten dieser „postseriellen"/Post-Cage-Bewegung erlangten aufgrund der Originalität ihrer Arbeit und ihrer Beiträge in diesem Bereich der Komposition internationale Anerkennung.

Der Stil der Videopräsentation ergab sich aus der Notwendigkeit, einen neuen Weg zu finden, den Prozess des Musikmachens zu zeigen. Ich war nie der Meinung, dass der Filmschnitt im Fernsehen – der auf den profansten und dümmsten praktischen Überlegungen des Filmens basiert – Musik gerecht wird. (Beim Film ist der Schnitt in erster Linie schlicht und einfach notwendig, da eine Kamera nur wenige Minuten am Stück laufen kann. Jeder, der einmal versuchte, Musikvorführungen zu filmen, kennt dieses Problem. Diese Gewohnheit hat sich auch auf das Fernsehen übertragen.) Der visuelle Stil von *Music with Roots in the Aether* geht von einer einfachen Idee aus: Die Aktion der Protagonisten soll aus nächster Nähe zu sehen sein und das gesehene Material nicht geschnitten werden – d. h. die zeitliche Dimension der Musik nicht durch willkürliche Raum-Zeit-Substitutionen manipuliert werden.

Um das Entstehen von Musik zu zeigen, wurde als visueller Kunstgriff das „Theater" (die Bühne) für die Interviews eingeführt, um die Porträts der Komponisten in diesem Rahmen zu realisieren. Ich danke auch den Künstlern, die diesen Musikvideostil für die Aufnahmen entwickelt haben: Insbesondere Philip Makannas Kameraführung und Maggi Paynes Tonaufnahmen setzen auf eine Form konzentrierter Aufmerksamkeit, die in den „visuellen" Medien eine Neuerung darstellt und der Musik näher ist als dem Film oder dem Fernsehen.

Aus dem Englischen von Martina Bauer

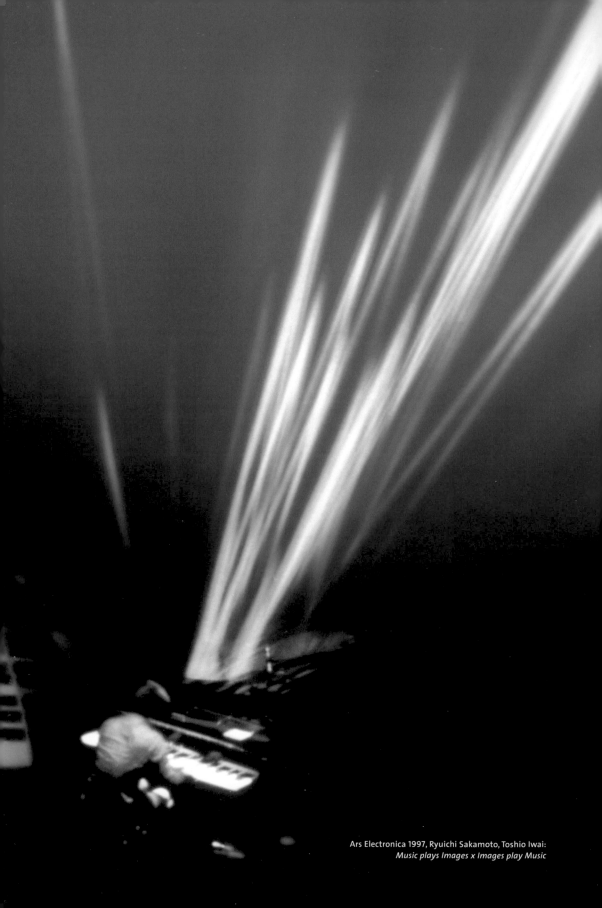

Ars Electronica 1997, Ryuichi Sakamoto, Toshio Iwai:
Music plays Images x Images play Music

Susanne Scheel

Music Visualization—The Interplay of Color and Sound

Simplicity—the art of complexity—The complexity referred to in the title of this year's Ars Electronica can be found, for example, in our everyday use of technology. The complexity of today's technologies and the digitization and realtime processes that make it possible to use these technologies in art are often regarded as essential requirements for the realization of artistic projects that deal with a synthesis of image and music. This view is not completely ungrounded, but the fact is that an interest in relating music to image is by no means an invention of the modern age. If we reduce image and music to the concepts of color and sound, we open up a vista on a long tradition of color/sound connections reaching back to ancient Greece and even as far back as prehistoric times. In various periods, a variety of color/sound theories have been developed and diverse attempts made to put these theories into practice. And it is in fact owing to technical advances that at the beginning of the 20th century people were finally in a position to realize to satisfaction their dream of the parallel performance of music and image. Today, simultaneous reception of color and sound, or more precisely moving images and music, as conveyed with the help of technology has become an everyday occurrence, and new symbioses are constantly being formed between pop, high and subcultures.

A short history of sound and color

Over the centuries, man has tried time and again to form relationships between colors and sounds, and to investigate and explain the hidden rules behind such connections. Different eras and mindsets have brought forth varying color/sound analogies or theories. It must be stated from the outset that there is no generally applicable or uniform way of assigning colors to sounds. Up until the 18th century, however, the existence of such a fixed color/sound relationship was never called into question, not until the growing dominance of rationalist thought and the natural sciences began to cast doubt on this hypothesis.[1]

In the earliest history of the various peoples of the earth, colors and sounds formed part of the belief in symbols and creation myths. Together with the elements of water, fire, earth and light, and the planets and seasons, colors and sounds were enlisted to create analogies to help explain the world, frequently in close connection with astrology.[2] With the number-based scientific principle of Pythagoras and the resulting doctrine of the "harmony of the spheres" espoused by the Pythagoreans in the 6th century BC, numerical symbolism began to dominate our understanding of the world, and continued to do so well into the 17th century.[3] As part of his numerical symbolism, Pythagoras created the foundations for the comprehension of musical harmony, intensively studying the music of the spheres, which consisted of purely mathematical tones and supposedly reflected the cosmic order. These tones had in addition a "visible equivalent in the [known] color spectrum."[4] The basis for this system of analogies is the number seven, the number of planets that had been discovered at the time. 200 years later, this number would also be transferred onto colors by Aristotle, in correspondence with the seven tones of the musical

1 Jewanski, 1999, 579ff
2 Jewanski, 1999, 67ff
3 Jewanski, 1999, 73ff
4 Moritz, 1987, 18

octave.[5] Aristotle's color scale thus had seven colors,[6] which he assigned to tone intervals with the help of simple numerical relationships, thus forming the basis for the color/sound relationship in antiquity.[7] Aristotle's color doctrine retained its validity all through the Middle Ages, which likewise produced various color theories, usually oriented along the lines of numerical symbolism, but quite disparate in terms of number and composition of colors.[8]

A decisive turning point in color/sound theory took place in the early 18th century, prompted by Newton's experiments with prisms and the publication of his Opticks in 1704. He demonstrated that white light is composed of the seven colors of the spectrum and that these can be mathematically equated with the seven intervals of the musical scale. Bolstered by Newton's authority, a relationship between color and sound now seemed to have been proven by the laws of physics and thus solidly grounded in the natural sciences. His theory did not encounter any criticism until later in the 18th century.[9] However, despite nascent doubts as to the actual existence of a color/sound analogy, additional theories followed, based either on physical/natural laws or on empirical studies of human sensibility, investigating physiological and psychological processes, especially in the Romantic period.

Practical realization

Not only was an attempt made to set down the mutual relationships between color and sound on a theoretical level; people also endeavored to put these relationships into practice. William Moritz presumes that Leonardo da Vinci was one of the first to project colored lights, around 1500.[10] In the subsequent period, people tried to create special instruments that would be able to produce sounds and colored light simultaneously. Giuseppe Arcimboldi (1527–1593), who studied alchemy at the Prague court of Hapsburg Emperor Rudolf II, is often cited as the first to build a color piano.[11] The existence of such a piano cannot be conclusively proven, however.[12] Arcimboldi's graphic cembalo is supposed to have demonstrated "a relationship that cannot be precisely specified between heard music and a complete color scale"[13] and "which ranged from black to white, passing through all the colors of the rainbow."[14]

The work of Louis Bertrand Castel in the 18th century is viewed as the first high point in the practical implementation of color/sound relationships.[15] Castel worked at transferring the idea to art by way of a music of color, and developed the concept of the Clavecin oculaire, or Ocular Harpsichord. This was a color piano that "would offer a play of colors simultaneous with the music, with a shaft of colored light opening with every key pressed."[16] It cannot however be demonstrated with sufficient certainty that he ever actually finished and presented his Clavecin oculaire.[17] The technical possibilities at the time simply did not allow for the construction of an instrument

5 Jewanski, 1999, 83ff
6 White, yellow, red, purple, green, blue and black
7 Jewanski, 1999, 87, 582f
8 Jewanski, 1999, 120f
9 Jewanski, 1999, 229ff, 253, 259ff, 583
10 Moritz, 1987, 19
11 Cf., for example, Moritz, 1987, 19f; Schneider, 2003
12 Jewanski, 1999, 170 – 179
13 Moritz, 1987, 20
14 ibid.
15 Jewanski, 1999, 274
16 Jewanski, 1999, 584
17 Jewanski, 1999, 292 – 294, 323 – 338.

capable of playing music plus colored lights. By the 19th century, knowledge of color/sound rela-
tionships had fallen into oblivion and was only taken up again in the early 20th century.[18]

Music visualization in the 20th century

A number of audio-visual experiments were undertaken especially in the first third
of the 20th century concerned primarily with color music or colored light music as well as
abstract film. Initially, it was the field of visual art that occupied itself with the connection
between colors and sounds. The more abstract and less representational the art, the greater its
interest in music. Musical principles were first applied to painting and then to abstract film,
while at the same time a number of color instruments were developed.

Nonrepresentational painting

In nonrepresentational painting, Wassiliy Kandinsky was the main artist who turned
his attention to musical principles and the possibility of transferring these to visual art.[19] He
tried to integrate rhythm and mathematically abstract composition into painting, with the goal
of creating a formal language based on simple elements and expressed in a precisely composed
work. He assumed that music, as a nonrepresentational art form, had the power to move peo-
ple both intellectually and emotionally, and he wanted to see if this could work for painting as
well. By integrating musical principles, the element of time could for the first time be trans-
ferred onto the otherwise frozen genre of painting. Temporal concepts such as rhythm, dynam-
ics, speed and simultaneity were translated onto canvas as artists attempted to capture them
pictorially.[20]

Abstract or absolute film

It didn't take long for film, as a moving medium taking place in time, to be discovered
for artistic processes. The abstract or absolute films of the German avant-garde assimilated the
idea of integrating musical principles and thus no longer relied on objects, representational func-
tion or narrative. Film and music proved to have certain affinities: the moment of movement, the
temporal sequence and the process of changing with time.[21] As disparate as the various filmmak-
ers were in their approaches and the resulting films, similarities can still be found. Hans Richter,
Walter Ruttmann and Viking Eggeling in particular designed their films in the style of musical
compositions. Through the medium of film, abstract forms could be conveyed on a temporal axis
and the pictorial material presented in a music-like arrangement—painting in motion.[22] What is
remarkable is that abstract film in the 1920s remained largely silent, despite being modeled on
music. This seems just as absurd as it is logical: "as an internalized and literally 'imagined' music,
Richter's, Eggeling's and Ruttmann's films had no need for external sound".[23] The filmmakers,
however, with the exception of Eggeling, were not explicitly opposed to the idea of a musical
accompaniment for their films.
Oskar Fischinger even designed his films according to musical specifications. He likewise worked

18 Jewanski, 1999, 585ff
19 Cf. Weibel, 1987, 59f; Kienscherf, 1998, 45f; Hahl-Koch, 1985, 354 – 359
20 Cf. Emons, 2000, 235ff
21 Emons, 1987, 51
22 Emons, 1987, 53
23 Emons, 2000, 251

with a reduced and usually abstract language of form, but for him music was the point of departure for the filmmaking process: the matching of music to image was based primarily on the flow of music.[24]

Music

In the music world as well, composers tried to combine colors and sounds in their pieces. Alexander Skrjabin was the first major composer to integrate relationships between colors and musical tones in his work, composing a so-called 'luce' voice for a color piano for Le poème du feu Promethée.[25] Arnold Schönberg as well took an interest in integrating gestures, colors and lights into the music in Die glückliche Hand, trying to handle these elements like musical notes.[26]

In the course of these multifarious artistic experiments, interest in exploring the color/sound relationship boomed in the 1920s. People thought they were founding a new and successful branch of science, with a focus on synaesthetic studies. Scientific and artistic approaches were given equal weight.[27] A substantial influence on these developments can be attributed to the color-and-light musician Alexander László, whose work we will look at in more detail in the following.

Color music

First, we would like to emphasize again that it was only in the late 19th and early 20th centuries that a state of technology had been achieved that made it possible to realize the dream of color music. By the 1920s, many instruments capable of playing colors and sounds had been presented to the public: for example, in 1895 by Alexander Wallace Rimington.[28] His color piano was followed by instruments like the color organ invented by Alexander Burnett Hektor, Mary Hallock Greenewalt's Sarabet, Thomas Wilfred's Clavilux, the Optophonic Piano created by Russian painter Baranoff-Rossiné, Alexander László's Sonchromatoscope, the Color-Light Plays courtesy of Ludwig Hirschfeld-Mack and Kurt Schwertfeger, and others.[29] As diverse as these instruments and approaches were, all of the color-and-light artists had one thing in common: they were searching for a new artistic genre.[30]

The color-and-light music of Alexander László

After studying piano, Alexander László had a heightened sensitivity to the various timbres his instrument was capable of producing, combined with an ability to see colors while playing. Because of the difficulty of conveying these sensations to others, he came to the decision to integrate these color associations into his concerts and to make them accessible to the audience by means of a specially designed apparatus. He published his theory on color-and-light music for the first time in March 1925, in a newspaper article in which he claimed to have "discovered the solution to the color/sound problem."[31] His goal was to "merge painting and music as arts."[32] He took his own personal synaesthetic perceptions as starting point, instead of trying to

24 Muxel, 2003, 45
25 Jewanski, 1999, 40f
26 Kienscherf, 1996, 149ff
27 Jewanski, 1999, 13
28 Jewanski, 1999, 40
29 Cf. Hahl-Koch, 1985; Jewanski, 1997, 17; Moritz, 1987, 21ff; Centre Pompidou, 2004
30 Jewanski, 1997, 17
31 Jewanski, 1997, 15
32 László in Jewanski, 1997, 15

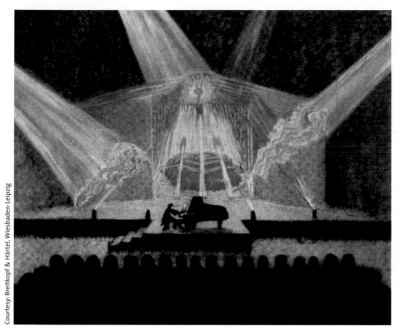

Courtesy: Breitkopf & Härtel, Wiesbaden-Leipzig

A color-and-light-concert by Alexander László, painted by Matthias Holl.

calculate a physical connection between colors and music—as so often in the history of the color/sound relationship. Formerly, people had often tried to match individual notes on the music scale with certain colors; now László was interested in forming looser associations between sound and color.[33]

Alexander László pursued a synaesthetic approach that allowed him to open up the music of color to the integration of color moods and images. He was not interested in the interplay of single colors and tones, but rather in the genesis of a new art form out of the equal elements of painting and music. In keeping with the currents of his day, he tried to transfer immobile painting onto a temporal plane. In order to combine painting and music into a new art form, he enlisted the technologies available at the time to construct a device that could project colors, forms and images while a pianist was playing: the Sonchromatoscope. Of course, he struggled here with the difference in quality of painting and music in terms of time:

"I had the choice of either taking music, which takes place in time, out of the temporal context, or making fixed and unchanging painting evolve over time in order to find a common denominator between both art forms. It is obvious why I chose the latter. I took the painted picture out of its frozen state and let it unfold in the same temporal framework as the musical composition."[34]

But László didn't want "colored surfaces to merely appear in a harmonious sequence, but rather abstract pictures as a presentation set to music."[35] He thus went beyond a pure color illustration and instead integrated whole images. Starting in 1926, experimental filmmaker Oskar Fischinger then supplemented this music of colored light with his abstract films.[36]

33 Jewanski, 2000, 53
34 Jewanski, 2000, 53
35 ibid.
36 Jewanski, 1997, 20f

Susanne Scheel

The Sonchromatoscope

Alexander László used projection as a means to equate non-temporal painting with temporal music. His Sonchromatoscope produced a four-part projection to the accompaniment of piano music, creating three-part images with the fourth level made up of complex superimposed colors and forms.[37] László worked with slides, movable abstract forms and colored light. The projections followed an exact score for which László had composed the music. The Sonchromatoscope consisted of a switchboard used to operate it, along with four large and four small projectors that were connected with one another. The switchboard was equipped with keys and levers and was described as being "similar to a harmonium."[38] From here, each projector could be controlled and the various color and image levels mixed, comparable to the function of today's mixing console. The Sonchromatoscope was placed opposite the stage at the other end of the room, while László sat on a podium playing the piano, the screen behind him. The audience was thus between László and the switchboard operator. The switchboard was framed by the two main projectors I and II, which László described as "bringing the essential, the elementary, the main event, the picture".[39] These were in turn framed by the two secondary projectors III and IV, which produced the secondary motifs. These four large projectors were then connected with four small footlight machines. These were the "carriers of the actual pictorial motifs, which, as in slide projections, were shifted abruptly and switched on and off."[40]

Courtesy: Breitkopf & Härtel, Wiesbaden-Leipzig

Courtesy: Breitkopf & Härtel, Wiesbaden-Leipzig

The entire Sonchromatoscope, consisting of a switchboard connected to four large and four small color projection devices.

It is difficult to reconstruct today how László's color and light concerts actually might have looked since no photographs exist of the performances. We may assume that his presentations were multicolored and that, through the use of several projection planes, were also many-layered and probably abstract. The many colors and layers presented must have been quite impressive with their "manifold, stimulatingly colored and surprising images."[41]

37 Jewanski, 1997, 21
38 Schröter [1925] in Jewanski, 2000, 56
39 László in Jewanski, 1997, 22
40 Jewanski, 2000, 57
41 Jewanski, 1997, 32

278

Alexander László's career with colored lights and music lasted only two short years, coming to an abrupt end in autumn 1927. Even so, he enjoyed an extraordinary amount of fame, reaching beyond Germany's borders. The reviews of his concerts ran the gamut from "euphoric approbation"[42] to just as unconditional rejection. Sobering is the general conclusion of his critics that László had failed to fulfill his own, widely propagated aspiration of creating a synthesis between two equal arts in order to give birth to a new total work of art.[43]

Electronic and digital images

While in the early 1930s interest in color instruments waned, experimental film was just coming to the fore. The experimental filmmakers on the American west coast in particular avidly took up Oskar Fischinger's ideas, and their visual music exerted a considerable influence on subsequent generations of artists. With the development of electronics, the exploration of audiovisual forms of representation at first shifted from motion pictures/film to the "moving medium of the electronic image (video, digital)."[44] Up until this time, the visualization of music had concentrated on the interplay of the elements of sound and image as analogy or as a synchronous process. Electronics, however, now gave rise to video art and movements such as Fluxus that focused more on the interplay of art and music in an attempt to achieve a "fusion of the media based on intertextuality, intermediality, and interaction."[45] The free-form, intermedia Fluxus events, happenings and performances released the acoustic, visual or sculptural elements of the arts and media from their original reference point, so that finally everything could be related to everything else.[46]

The interplay of sound and color or music and (moving) image can take many forms but must always be viewed in the context of cultural processes as well as artistic and theoretical investigations. A new form of music visualization has evolved on today's club scene, known as VJing. Now also active beyond the confines of club culture, VJs are increasingly influencing the visual aesthetic in other artistic realms. An audiovisual phenomenon, VJing combines (electronic) music and moving images in the form of a performance made possible by digital technologies. Similar to what a DJ does, a VJ uses modern technology to 'mix' music with moving images, so-called "visuals," by way of spontaneous association and rhythmic interpretation, live and in real-time, and then projects the results onto screens or monitors. The rhythmic structure of the moving images is dictated by the DJ's music mix. VJing is part of the overall club experience and is thus part of a cultural practice that—beyond the club context—exhibits links to fields such as design, architecture, art and graphic design. Of course, VJing did not simply emerge from a void, but can instead be traced aesthetically and technically to the tradition of the audiovisual art forms presented above. Similar to László, music and moving image are generated separately.

Music visualizations in the 20th century are distinguished by the integration of technology into artistic processes. Today's forms of music visualization tend to make use of digital technologies and realtime processes. Even during the first third of the 20th century, however, the pioneers of color music and experimental film were already testing the use of technical practices for producing visual translations of music. With advancing technology, more and more opportunities

42 Jewanski, 1997, 28
43 Jewanski, 1997, 30
44 Weibel, 1987, 108
45 Weibel, 1987, 116
46 Weibel, 1987, 116f

for interconnecting music and image became available as the decades passed. Today's audiovisual forms display a great deal of freedom in combining music and image, or in general in merging various art forms. We can thus conclude that in the 20th century technology has found special applications in art, especially in terms of new formative possibilities.[47] In recent years in particular, it can be observed that contemporary, usually electronic music is exerting a substantial influence on graphic and visual forms of expression seen in the creation of media images, and that music is often reflected in the visual arts—a phenomenon that strongly shapes our everyday culture. These developments are evident both in the integration of media art approaches in the traditional performing arts of opera, theatre and ballet, as well as in the context of exhibitions and art festivals. Ars Electronica's Futurelab has undertaken impressive experiments in the past few years aimed at creating new forms of music visualization by utilizing modern technologies and extending their possibilities or adding special new enhancements. In terms of visualizing already-existing music, for example, the pilot project Das Rheingold—Visionized was launched in 2004, followed by the 3-D visualization of Mahler's Resurrection Symphony.[48] Or, in the interest of creating completely new forms of representation by means of targeted collaboration between visual and musical artists, projects have been undertaken such as Music Plays Images x Images Play Music by Ryuichi Sakamoto and Toshio Iwai, part of Ars Electronica 1997. This resulted in "a performance that fuses musical sounds with visual images in a wide variety of ways. From the resulting feedback, a completely new kind of space of musicality and visuality emerged."[49]

Whatever the future brings for musical visualizations, the technical possibilities for audiovisual presentation are by no means exhausted, and the exploration of ways to combine colors and music continues unabated, having lost nothing of its fascination.

Translated from German by Jennifer Taylor-Gaida

Susanne Scheel revised excerpt from Magister degree thesis "VJing – Music Visualization in the 20th Century"

47 Cf. also Franke, 1979, 1
48 Deutsch, Johannes, 2004; o.V., 2005
49 Iwai, Toshio & Sakamoto, Ryuichi, 1997

Susanne Scheel

Musikvisualisierung – das Zusammenspiel von Farbe und Ton

Simplicity – the art of complexity: Die Komplexität, auf die im Titel der diesjährigen Ars Electronica verwiesen wird, findet sich in unserem alltäglichen Gebrauch von Technologie wieder. Diese Komplexität heutiger Technologien und die aufgrund von Digitalisierung und Echt-zeit-Prozessen mögliche Anwendung dieser Technologien in der Kunst werden häufig als Grund-voraussetzung für die Umsetzung künstlerischer Projekte angesehen, die sich mit einer Synthe-se aus Bild und Musik beschäftigen. Diese Einschätzung ist sicherlich nicht unbegründet, den-noch sind Bezüge zwischen Musik und Bild keine Erfindung der Neuzeit. Reduziert man Bild und Musik auf die Begriffe Farbe und Ton, so wird ein Blick auf eine lange Tradition von Farbe-Ton-Beziehungen ermöglicht, die bis zur griechischen Antike und sogar bis zur Frühgeschichte zurückreicht. Zu verschiedenen Zeiten wurden verschiedene Farbe-Ton-Theorien entwickelt und unterschiedliche Versuche unternommen, ebensolche Theorien auch praktisch umzusetzen. Tat-sächlich ist es aber dem technischen Fortschritt zu verdanken, dass man sich zu Beginn des 20. Jahrhunderts in der Lage sah, den Traum der parallelen Aufführung von Musik und Bild auf zufrieden stellende Art und Weise umzusetzen. Heutzutage ist eine durch Technik vermittelte parallele Rezeption von Farbe und Ton bzw. bewegtem Bild und Musik zu etwas Alltäglichem geworden, und es bilden sich immer neue Symbiosen zwischen Pop-, Hoch- und Subkulturen.

Ton und Farbe in einer kurzen Geschichte

Im Verlauf der Geschichte hat man immer wieder versucht, Farben und Töne zueinan-der in Beziehung zu setzen und die verborgenen Regeln dieser Bezüge zu erforschen und zu erklären. Unterschiedliche Zeiten und Denkweisen haben unterschiedliche Farbe-Ton-Analogien bzw. Theorien hervorgebracht. Vorwegnehmend ist festzustellen, dass es keine allgemeingültige oder einheitliche Zuordnung von Farbe und Ton gibt. Bis ins 18. Jahrhundert hinein hat man jedoch die Existenz einer Farbe-Ton-Beziehung nie angezweifelt, erst mit dem aufkommenden Rationalismus und dem Erstarken der Naturwissenschaften wurden die Farbe-Ton-Theorien kri-tisch in Frage gestellt.[1]

Schon in der Frühgeschichte der Völker waren Farben und Töne Teil der Symbolphilosophien und Schöpfungsmythen. Mit den Elementen Wasser, Feuer, Erde und Licht, den Planeten und Jahreszei-ten bildeten sie welterklärende Analogien und standen häufig in engem Bezug zur Astrologie.[2] Durch das auf Zahlen beruhende Wissenschaftsprinzip des Pythagoras und die daraus resultie-rende Harmonielehre der Pythagoräer im 6. Jahrhundert v. Chr. begann die Zahlensymbolik das Weltverständnis bis ins 17. Jahrhundert hinein zu beherrschen.[3] Innerhalb der Zahlensymbolik schuf Pythagoras die Grundlagen der musikalischen Harmonielehre und setzte sich intensiv mit der Sphärenmusik auseinander, die aus rein mathematischen Tönen bestand und die kosmische Ordnung spiegelte. Diese Töne hatten darüber hinaus ein „sichtbares Äquivalent auf der Skala des [damals bekannten] Farbspektrums".[4] Die Grundlage dieses Analogiesystems bildete die

1 Jewanski, 1999, 579ff
2 Jewanski, 1999, 67ff
3 Jewanski, 1999, 73ff
4 Moritz, 1987, 18

Siebenzahl der damals bekannten Planeten, die 200 Jahre später auch von Aristoteles, entsprechend den sieben Tönen der Oktave, auf die Farben übertragen wurde.[5] Aristoteles' Farbskala enthielt somit sieben Farben,[6] denen er mit Hilfe einfacher Zahlenverhältnisse Tonintervalle zuordnete und damit die Grundlage für die antike Farbe-Ton-Beziehung schuf.[7] Aristoteles' Farbenlehre behielt ihre Gültigkeit auch im Mittelalter, das ebenfalls verschiedene Farblehren hervorbrachte, die sich zumeist an der Zahlensymbolik orientierten, aber bezüglich der Farbzusammensetzung und der Anzahl der Farben größte Unterschiede aufwiesen.[8]

Eine entscheidende Wende in der Farbe-Ton-Theorie vollzog sich im beginnenden 18. Jahrhundert durch die Prismenversuche Newtons und die Veröffentlichung seiner *Opticks* 1704. Darin bewies er die Zusammensetzung weißen Lichts aus sieben Spektralfarben und die rechnerische Übereinstimmung mit den sieben Intervallen einer Tonleiter. Kraft Newtons Autorität schien nun eine Farbe-Ton-Beziehung physikalisch und somit naturwissenschaftlich begründet zu sein, eine tatsächliche Kritik an der als gegeben vorausgesetzten Beziehung zwischen Farbe und Ton kann erst im Verlauf des 18. Jahrhundert zum ersten Mal nachgewiesen werden.[9] Trotz der beginnenden Zweifel an der tatsächlichen Existenz einer Farbe-Ton-Analogie wurden weitere Theorien entwickelt, die sich entweder an physikalisch-naturwissenschaftlichen Grundsätzen orientierten oder die Untersuchungen, wie in der Romantik, auf den Bereich der Empfindsamkeit und physiologische und psychologische Prozesse verlagerten.

Praktische Umsetzung

Es wurde jedoch nicht nur versucht, die gemeinsamen Beziehungen von Farbe und Ton auf theoretischer Ebene zu erfassen, sondern auch, diese praktisch umzusetzen. William Moritz geht davon aus, dass Leonardo da Vinci um 1500 einer der Ersten war, der farbige Lichter projizierte.[10] In der Folgezeit versuchte man, spezielle Instrumente anzufertigen, die in der Lage sein sollten, Töne und farbiges Licht gleichzeitig hervorzubringen. Vielfach wird als erster Erbauer eines Farbklaviers Giuseppe Arcimboldi (1527–1593) genannt,[11] der am Prager Hof des habsburgischen Kaisers Rudolf II. alchemistische Studien betrieb. Die Existenz eines solchen Farbklaviers ist jedoch nicht eindeutig nachweisbar.[12] Arcimboldis grafisches Cembalo soll „eine nicht näher spezifizierte Beziehung von hörbarer Musik zu einer kompletten Farbskala"[13] gezeigt haben, „die sich von Schwarz bis Weiß über alle Farben des Regenbogens erstreckte".[14]

Als erster Höhepunkt der praktischen Umsetzung von Farbe-Ton-Beziehungen wird die Arbeit Louis Bertrand Castels im 18. Jahrhundert betrachtet.[15] Dieser strebte einen Transfer auf die Kunst im Sinne einer Farbenmusik an und entwickelte die Idee seines *Clavecin oculaire*. Es handelte sich hierbei um ein Farbklavier, bei dem „gleichzeitig zur Musik ein Farbenspiel dargeboten werden sollte, jeder Tastendruck öffnete den Schacht zu einem farbigen Licht".[16] Ob er jedoch

5	Jewanski, 1999, 83ff
6	Weiß, Gelb, Rot, Purpur, Grün, Blau und Schwarz
7	Jewanski, 1999, 87, 582f
8	Jewanski, 1999, 120f
9	Jewanski, 1999, 229ff, 253, 259ff, 583
10	Moritz, 1987, 19
11	vgl. hierzu u.a. Moritz, 1987, 19f; Schneider, 2003
12	Jewanski, 1999, 170-179
13	Moritz, 1987, 20
14	ibid.
15	Jewanski, 1999, 274
16	Jewanski, 1999, 584

jemals sein Clavecin oculaire fertig stellen und vorführen konnte, kann nicht eindeutig nachgewiesen werden.[17] Die technischen Möglichkeiten dieser Zeit reichten noch nicht aus, um erfolgreiche farblichtmusikalische Instrumente konstruieren zu können. Im 19. Jahrhundert gerieten schließlich die Kenntnisse über Farbe-Ton-Beziehungen in Vergessenheit und wurden erst zu Beginn des 20. Jahrhundert wieder aufgegriffen.[18]

Musikvisualisierung im 20. Jahrhundert

Vor allem das erste Drittel des 20. Jahrhundert zeichnet sich durch eine Vielzahl audiovisueller Experimente aus, die besonders in der Farben- oder Farblichtmusik und im abstrakten Film ihren Ausdruck fanden. Zunächst war es jedoch die darstellende Kunst, die sich mit der Verbindung von Farben und Tönen beschäftigte. Je abstrakter und gegenstandsloser die Kunst wurde, umso größer wurde ihr Interesse an Musik. Musikalische Prinzipien wurden zunächst auf die Malerei und dann auf den abstrakten Film übertragen, während parallel dazu eine Vielzahl von Farbinstrumenten entwickelt wurde.

Die gegenstandslose Malerei

In der gegenstandslosen Malerei war es besonders Wassiliy Kandinsky, der sich mit musikalischen Prinzipien und der Möglichkeit einer Übertragung auf die bildende Kunst auseinandersetzte.[19] Er versuchte, Rhythmus und mathematisch abstrakte Komposition in die Malerei zu integrieren, mit dem Ziel, eine auf einfachen Elementen beruhende Formensprache zu schaffen, die in einem genau durchkomponierten Werk gestaltet werden sollte. Er ging davon aus, dass die Musik als nicht gegenständliche Kunstform geistig und emotional berührt, und wollte dieses Prinzip mit der Malerei verbinden. Durch die Integration von musikalischen Grundsätzen konnte erstmalig das Element der Zeit auf die ansonsten starre und unbewegliche Malerei übertragen werden. Zeitliche Begriffe wie Rhythmus, Dynamik, Geschwindigkeit, Gleichzeitigkeit wurden auf die Leinwand transferiert und sollten bildnerisch dargestellt werden.[20]

Der abstrakte bzw. absolute Film

Es dauerte nicht lange, bis der Film als bewegliches und zeitlich ablaufendes Medium für künstlerische Prozesse entdeckt wurde. Der abstrakte bzw. absolute Film der deutschen Avantgarde übernahm die Idee der Integration von musikalischen Prinzipien und damit die Lösung vom Gegenständlichen, von der abbildenden Funktion und von der Erzählung. Film und Musik zeichneten sich durch bestimmte Gemeinsamkeiten aus: den Moment der Bewegung, den zeitlichen Ablauf und die Veränderung in der Zeit.[21] So unterschiedlich die einzelnen Filmemacher in ihren Ansätzen, Umsetzungen und Filmen auch waren, so lassen sich doch einige Gemeinsamkeiten finden. Vor allem Hans Richter, Walter Ruttmann und Viking Eggeling gestalteten ihre Filme in Anlehnung an musikalische Komposition. Abstrakte Formen sollten durch das Medium Film auf die Zeitachse transportiert und das Bildmaterial in einer quasi musikalischen Anordnung präsentiert werden – Malerei in Bewegung.[22] Bemerkenswert ist, dass der abstrakte Film der 1920er Jahre trotz der Vorbildfunktion der Musik weitgehend stumm blieb. Dies

17 Jewanski, 1999, 292–294, 323–338.
18 Jewanski, 1999, 585ff
19 vgl. hierzu Weibel, 1987, 59f; Kienscherf, 1998, 45f; Hahl-Koch, 1985, 354–359
20 vgl. hierzu Emons, 2000, 235ff
21 Emons, 1987, 51
22 Emons, 1987, 53

erscheint ebenso absurd wie folgerichtig: „als gleichsam verinnerlichte und im Wortsinne ‚ima-ginierte' Musik bedurften Richters, Eggelings und Ruttmanns Filme des äußeren Klanges nicht".[23] Allerdings sprachen sie sich mit Ausnahme von Eggeling auch nicht grundsätzlich gegen eine musikalische Begleitung aus.

Oskar Fischinger hingegen gestaltete seine Filme nach musikalischer Vorgabe. Auch er arbeitete mit einer reduzierten und zumeist abstrakten Formensprache, allerdings war für ihn die Musik der Ausgangspunkt für die filmischen Prozesse: die Zuordnung von Musik und Bild ergab sich vorwiegend aus dem Bewegungsduktus der Musik.[24]

Musik

Auch in der Musik bemühte man sich, Farben und Töne in Kompositionen zu kombi-nieren. Alexander Skrjabin war der erste bedeutende Komponist, der Beziehungen von Farben und Tönen in sein Werk *Le poème du feu Prométhée* integrierte und eine so genannte Luce-Stim-me für ein Farbenklavier komponierte.[25] Auch Arnold Schönberg befasste sich in seinem Werk *Die glückliche Hand* mit der Integration von Gesten, Farben und Licht in die Musik und bemühte sich, diese Elemente wie Töne zu behandeln.[26]

Im Zuge dieser vielfältigen künstlerischen Auseinandersetzungen kam es in den 1920er Jahren zu einer großen Begeisterung für die Farbe-Ton-Beziehung. Man glaubte, einen neuen und erfolg-reichen Wissenschaftszweig zu gründen, der seinen Schwerpunkt in synästhetischen Untersu-chungen finden sollte. Wissenschaftliche und künstlerische Ansätze fanden hierbei gleicherma-ßen Beachtung.[27] Einen wesentlichen Einfluss auf diese Entwicklung hatte der Farblichtmusiker Alexander László, dessen Arbeit im Folgenden genauer dargestellt werden soll.

Farbenmusik

Zunächst sei noch einmal betont, dass erst im ausgehenden 19. und beginnenden 20. Jahrhundert ein Stand der Technik erreicht wurde, der es ermöglichte, den Traum der Farbenmu-sik in die Tat umzusetzen. Bis in die 1920er Jahre hinein konnte so eine Vielzahl von Farb- bzw. Licht-Klang-Instrumenten in der Öffentlichkeit präsentiert werden: 1895 trat Alexander Wallace Rimington mit einem Farbklavier an die Öffentlichkeit.[28] Ihm folgten Farbinstrumente bzw. Licht-Klang-Instrumente wie die Farborgel von Alexander Burnett Hektor, Mary Hallock Greenewalts Farborgel Sarabet, Thomas Wilfreds Clavilux, das Optophonische Klavier des russischen Malers Baranoff-Rossiné, Alexander Lászlós Sonchromatoskop, die Reflektorischen Lichtspiele von Lud-wig Hirschfeld-Mack und Kurt Schwertfeger und andere.[29] So unterschiedlich die einzelnen Instrumente und Umsetzungen ausfielen, so hatten doch alle Farblicht-Künstler eines gemein-sam: Sie befanden sich auf der Suche nach einer neuen Kunstgattung.[30]

Die Farblichtmusik Alexander Lászlós

Alexander László hatte durch sein Klavierstudium ein erhöhtes Gespür für die Klang-farben seines Instrumentes erworben, das sich mit der Fähigkeit verband, beim Klavierspiel Far-

23 Emons, 2000, 251
24 Muxel, 2003, 45
25 Jewanski, 1999, 40f
26 Kienscherf, 1996, 149ff
27 Jewanski, 1999, 13
28 Jewanski, 1999, 40
29 vgl. hierzu Hahl-Koch, 1985; Jewanski, 1997, 17; Moritz, 1987, 21ff; Centre Pompidou, 2004
30 Jewanski, 1997, 17

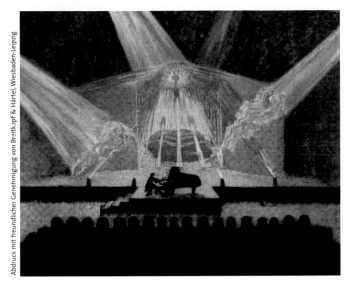

Ein Farblichtkonzert von Alexander László, gemalt von Matthias Holl.

ben zu sehen. Aus der Schwierigkeit heraus, diese Empfindungen seiner Umwelt mitzuteilen, gelangte er zu dem Entschluss, diese Farbassoziationen in seine Konzerte zu integrieren und sie mittels einer Apparatur dem Publikum zugängig zu machen. Zum ersten Mal trat er mit seiner Theorie der Farblichtmusik im März 1925 in einem Zeitungsartikel mit dem Bewusstsein an die Öffentlichkeit, „die Lösung des Farbe-Klang-Problems gefunden zu haben".[31] Sein Ziel war es, „die Malerei und die Musik als Künste miteinander zu verbinden".[32] Er ging dabei von seinen persönlichen synästhetischen Empfindungen aus, anstatt – wie in der Geschichte der Farbe-Ton-Beziehung schon so oft – die Beziehung zwischen Farbe und Musik physikalisch zu berechnen. Zuvor hatte man häufig versucht, einzelnen Tönen bestimmte Farben zuzuordnen, László setzte stattdessen Klänge und Farben zueinander in Beziehung.[33]

Alexander László verfolgte einen synästhetischen Ansatz, der es ihm ermöglichte, die Farbenmusik für die Integration von Farbstimmungen und Bildern zu öffnen. Es ging ihm nicht um das Zusammenspiel von Farbe und Ton im Einzelnen, sondern um die Genese einer neuen Kunst aus den gleichberechtigten Elementen Malerei und Musik. Entsprechend den Strömungen seiner Zeit übertrug er die starre Malerei auf eine zeitliche Ebene. Um Malerei und Musik in einer neuen Kunst zusammenführen zu können, bediente er sich der damals zur Verfügung stehenden Technologien und konstruierte ein Gerät, das parallel zu der Musik eines Pianisten Farben, Formen und Bilder projizieren konnte: das Sonchromatoskop. Dabei hatte er mit der unterschiedlichen Beschaffenheit von Malerei und Musik bezüglich der Zeit zu kämpfen:

> Es blieb die Wahl, entweder die zeitliche Musik unzeitlich zu machen, oder die unzeitliche Malerei zeitlich, um einen gemeinsamen Nenner für beide Künste zu finden. Ohne weiteres ist einleuchtend, daß ich das letztere wählte. Ich nahm das malerische Bild aus seiner Unbeweglichkeit und ließ es im gleichen Zeitraum wie die musikalische Komposition abrollen.[34]

31 Jewanski, 1997, 15
32 László in Jewanski, 1997, 15
33 Jewanski, 2000, 53
34 Jewanski, 2000, 53

László wollte jedoch „nicht nur farbige Flächen in harmonischer Folge, sondern abstrakte Bilder in gleichzeitiger Darstellung mit der Musik erscheinen lassen".[35] Er ging somit zugunsten der Integration ganzer Bilder über eine reine Farbillustration hinaus. Seit 1926 ergänzte der Experimentalfilmer Oskar Fischinger die Farblichtmusik mit seinen abstrakten Filmen.[36]

Das Sonchromatoskop

Alexander László bediente sich der Projektion, um die unzeitliche Malerei der zeitlichen Musik anzugleichen. Sein Sonchromatoskop vollführte zu am Piano gespielter Musik eine Vierfachprojektion und schuf dreiteilige Bilder, über die als vierte Ebene noch einmal komplexe Farben und Formen projiziert wurden.[37] László arbeitete mit Diapositiven, beweglichen abstrakten Formen und farbigem Licht. Die Projektionen folgten einer genauen Partitur, die László zur Musik komponiert hatte. Das Sonchromatoskop bestand aus einem Schalttisch, von dem aus es bedient wurde, sowie vier großen und vier kleinen Projektoren, die miteinander verbunden waren. Der Schalttisch war mit Registern und Hebeln versehen und wurde als „ähnlich einem Harmonium"[38] beschrieben. Von ihm aus konnten die einzelnen Projektoren gesteuert und die verschiedenen Farb- und Bildebenen miteinander gemischt werden, womit es in seiner Funktionsweise mit heutigen Mischpulten vergleichbar ist. Das Sonchromatoskop wurde gegenüber der Bühne am Ende des Saales aufgestellt, während László mit seinem Klavier auf dem Podium saß, die Leinwand im Rücken. Das Publikum befand sich zwischen László und seinen Mitarbeitern, die den Schalttisch bedienten. Der Schalttisch wurde eingerahmt von den zwei Projektoren Hauptwerk I und II, über die László sagte, sie „bringen das Wesentliche, das Elementare, das Geschehnis, das Bild".[39] Diese wiederum wurden eingerahmt von den beiden Projektoren Nebenwerk III und IV, die nebensächliche Motive wiedergaben. Diese vier großen Projektoren waren

weiterhin mit vier kleineren Rampenwerken verbunden. Die kleineren Rampenwerke waren die „Träger der eigentlichen Bildmotive, die nach dem bisherigen Lichtbildvorführungsverfahren ruckweise verschoben, ein- und ausgeschaltet"[40] wurden.

Wie die Farblichtkonzerte Lászlós tatsächlich aussahen, ist heute schwer nachzuvollziehen, da es keine Aufnahmen der Aufführungen gibt. Grundsätzlich ist davon auszugehen, dass seine Präsentationen vielfarbig und durch die Verwendung mehrerer Bildebenen auch vielschichtig und eher abstrakt waren. Die Vielfarbigkeit und Vielschichtigkeit der Projektionen muss von beeindruckendem Charakter gewesen sein, der

László bedient einen der Projektoren. Bei den Konzerten saß er auf der Bühne und spielte Klavier.

35 ibid.
36 Jewanski, 1997, 20f
37 Jewanski, 1997, 21
38 Schröter [1925] in Jewanski, 2000, 56
39 László in Jewanski, 1997, 22
40 Jewanski, 2000, 57

Die gesamte Anlage des Farblichtklaviers, bestehend aus dem Schaltbrett, den vier großen und den vier kleinen Projektionsapparaten.

auf die „mannigfaltigen, farbig reizvollen und überraschenden Bilder"[41] zurückgeführt wurde. Die Farblichtmusik-Karriere von Alexander László währte nur ganze zwei Jahre und lief im Herbst 1927 aus. László erfreute sich eines ausgesprochen hohen Bekanntheitsgrades, der über die Grenzen Deutschlands hinausging. In den Rezensionen seiner Konzerte traf sich vereinzelt „euphorische Zustimmung"[42] mit ebenso bedingungsloser Ablehnung. Ernüchternd mutet die allgemeine Auffassung der Kritiker an, László sei an seinem eigenen, weithin propagierten hohen Anspruch gescheitert; eine Synthese zweier gleichberechtigter Künste zu einem neuen Gesamtkunstwerk habe nicht stattgefunden.[43]

Elektronische und digitale Bilder

Während zu Beginn der 1930er Jahre das Interesse an Farbinstrumenten abebbte, trat der Experimentalfilm seinen Siegeszug an. Vor allem die experimentellen Filmemacher an der amerikanischen Westküste nahmen die Ideen Oskar Fischingers auf und beeinflussten durch ihre visuelle Musik die folgenden Künstlergenerationen maßgeblich. Durch die Entwicklung elektronischer Technologien verlagerte sich zunächst die Auseinandersetzung mit audiovisuellen Darstellungsformen vom Bewegungs-/Bildmedium Film zum „Bewegungsmedium elektronisches Bild (video, digital)".[44] Bis zu diesem Punkt hatte sich die Visualisierung von Musik auf das Zusammenwirken der Elemente Klang und Bild als Analogie oder als synchroner Vorgang konzentriert. Mit der Elektronik, der durch sie aufkommenden Videokunst und Bewegungen wie Fluxus richtete sich der Fokus auf das Zusammenspiel von Kunst und Musik, zugunsten einer „Fusion der Medien auf der Grundlage von Intertextualität, Intermedialität, Interaktion".[45] Durch die freien intermedialen Inszenierungen der Fluxus-Ereignisse, der Happenings und Performances wurden die akustischen, visuellen oder auch skulpturalen Elemente der Künste und Medien von ihren ursprünglichen Bezügen losgelöst, so dass schließlich alles zu allem in Beziehung gesetzt werden konnte.[46]

Das Zusammenspiel von Ton und Farbe bzw. Musik und (bewegtem) Bild ist vielfältig und ist dabei immer Teil kultureller Prozesse sowie künstlerischer und theoretischer Auseinandersetzungen gewesen. Eine neue Form der Musikvisualisierung ist im Umfeld der Clubkultur entstanden: das VJing. Aus diesem Kontext seit einigen Jahren heraustretend, beeinflussen VJs durch ihre Arbeit zusehends auch die Bildästhetik in künstlerischen Bereichen. Als audiovisuelles Phänomen verbindet VJing (elektronische) Musik und bewegte Bilder performativ und ist durch die Verwendung von digitaler Technologie bestimmt. Ähnlich der Arbeit eines DJs „mixt" der VJ

41 Jewanski, 1997, 32
42 Jewanski, 1997, 28
43 Jewanski, 1997, 30
44 Weibel, 1987, 108
45 Weibel, 1987, 116
46 Weibel, 1987, 116f

in spontan-assoziativer und rhythmisch-interpretierender Reaktion auf die Musik Bewegtbilder, so genannte Visuals, live und in Echtzeit mittels moderner Technik und projiziert diese auf Leinwände bzw. Monitore. Die rhythmische Struktur der bewegten Bilder ist durch den Musik-Mix des DJs vorgegeben. VJing ist Teil des Gesamterlebnisses Club und ist somit auch Teil einer kulturellen Praxis, die – über den Clubkontext hinaus – Anknüpfungspunkte mit Bereichen wie Design, Architektur, Kunst und Grafikdesign aufweist. VJing ist jedoch nicht aus dem Nichts entstanden, sondern kann ästhetisch und technisch in der Tradition der vorgestellten audiovisuellen Kunstformen gesehen werden. Ähnlich wie bei Lázló wurden Musik und bewegtes Bild getrennt voneinander generiert.

Musikvisualisierungen im 20. Jahrhundert zeichnen sich durch die Integration von Technik in künstlerische Prozesse aus. Heutige Formen von Musikvisualisierung sind geprägt von digitalen Technologien und Echtzeitprozessen. Im ersten Drittel des 20. Jahrhundert erprobten aber schon die Pioniere der Farbenmusik und des Experimentalfilms technische Praktiken visueller Umsatzformen im Zusammenspiel mit Musik. Aufgrund der zur Verfügung stehenden Technologie wurde das Zusammenspiel von Musik und Bild im Verlauf der Jahrzehnte zunehmend offener. Heutige Formen des Audiovisuellen verfügen über freie Kombinationsmöglichkeiten von Musik und Bild bzw. von verschiedenen Kunstformen im Allgemeinen. Es zeigt sich also, dass im 20. Jahrhundert Technologie einen speziellen Anwendungsbereich in der Kunst gefunden hat, der besonders die gestalterischen Möglichkeiten betrifft.[47] Vor allem in jüngerer Zeit ist zu beobachten, dass die zeitgenössische, zumeist elektronische Musik großen Einfluss auf die grafischen und visuellen Ausdrucksformen medialer Bildgestaltung nimmt bzw. sich in ihr widerspiegelt, ein Vorgang, der unsere Alltagskultur maßgeblich prägt und gestaltet. Diese Entwicklungen machen sich ebenso in der Integration medialer Kunstansätze in die traditionellen Aufführungshäuser von Oper, Theater und Ballett bemerkbar wie im Rahmen von Ausstellungen und Kunstfestivals. Das Ars Electronica Futurelab hat in den letzten Jahren beeindruckende Versuche unternommen, mittels moderner Technologien und deren Erweiterung bzw. durch spezielle Entwicklungen neue Formen der Musikvisualisierung zu schaffen. Zum einen, um bereits existierende Musik zu visualisieren, wie durch das Pilotprojekt *Das Rheingold – Visionized* von 2004 und darauf folgend die 3D-Visualisierung von Mahlers Auferstehungs-Sinfonie.[48] Oder zum anderen, um völlig neue Darstellungsmöglichkeiten durch die gezielte Zusammenarbeit von visuellen und musikalischen Künstlern gemeinsam zu schaffen, wie bei dem Projekt *Music Plays Images x Images Play Music* von Ryuichi Sakamoto und Toshio Iwai im Rahmen der Ars Electronica 1997. Es entstand „eine Performance, die musikalische Klänge auf verschiedenste Art mit visuellen Bildern verknüpft. Aus dem dabei entstehenden Feedback entstand ein völlig neuartiger Raum der Musikalität und Visualität".[49]

Was auch immer zukünftige Musikvisualisierungen mit sich bringen, die technischen Möglichkeiten audiovisueller Präsentation sind noch lange nicht erschöpft, und die Faszination der Farbenmusik scheint nach wie vor ungebrochen und noch immer nicht an Aktualität verloren zu haben.

Überarbeiteter Auszug aus der Magisterarbeit „VJing – Musikvisualisierung im 20. Jahrhundert"

47 vgl. hierzu auch Franke, 1979, 1
48 Deutsch, Johannes, 2004; o.V., 2005
49 Iwai, Toshio & Sakamoto, Ryuichi, 1997

Literatur

Centre Pompidou (Hrsg.) (2004). *Sons & Lumières. Une histoire du son dans l'art du XXe siècle.* Katalog zur Ausstellung „Sons & Lumières" im Centre Pompidou, Galerie 1, 22. September 2004 bis 3. Januar 2005. Paris: Éditions du Centre Pompidou.

Deutsch, Johannes (2004). Das Rheingold. In Gerfried Stocker, Christine Schöpf (Hrsg.) *Ars Electronica 2004, Timeshift —The World in Twenty-Five Years* (S. 319 – 321). Ostfildern Ruit: Hatje Cantz.

Emons, Hans (1987). Das mißverstandene Modell. Zur Rolle der Musik im abstrakten Film der Zwanziger Jahre. In: Klaus-Ernst Behne (Hrsg.), *film-musik-video oder Die Konkurrenz von Auge und Ohr* (S. 51 – 64). Regensburg: Gustav Bosse Verlag.

Emons, Hans (2000). „Musik des Lichts". Tonkunst und filmische Abstraktion. In Josef Kloppenburg (Hrsg.), *Musik multimedial: Filmmusik, Videoclip, Fernsehen* (S. 231 – 258). Laaber: Laaber.

Franke, Herbert W. (1979). Einleitung. In Linzer Veranstaltungsgesellschaft mbH Ernst Kubin, Horst Stadlmayr (Hrsg.) *Katalog der Ars Electronica* 1979. (S. 8 – 27). Linz: J. Wimmer Ges.m.b.H. & Co

Hahl-Koch, Jelena (1985). Kandinsky und der ‚Blaue Reiter'. In Karin v. Maur (Hrsg.), *Vom Klang der Bilder. Die Musik in der Kunst des 20. Jahrhunderts* (S. 354 – 359). München: Prestel.

Iwai, Toshio & Sakamoto, Ryuichi (1997). Music Plays Images x Images Play Music. In *Ars Electronica 1997. Fleshfactor – informationsmaschine mensch* (S. 356 – 359). Wien, New York: Springer.

Jewanski, Jörg (1997). Die Farblichtmusik Alexander Lászlós. *Zeitschrift für Kunstgeschichte, 1* (S. 12 – 43).

Jewanski, Jörg (1999). *Ist C = Rot? Eine Kultur- und Wissenschaftsgeschichte zum Problem der wechselseitigen Beziehung zwischen Ton und Farbe: Von Aristoteles bis Goethe.* Sinzig: Studio, Verlag Schewe.

Jewanski, Jörg (2000). Wie ein Komet am Sternenhimmel. Die Erstaufführung von Alexander Lászlós Farblichtmusik am 16. Juni 1925. In Antje Erben (Hrsg.), *Grenzgänge – Übergänge : Bericht über das 13. Internationale Symposium des Dachverbandes der Studierenden der Musikwissenschaft e.V. in Frankfurt am Main* (S. 51 – 81). Hamburg: Bockel.

Kienscherf, Barbara (1996). *Das Auge hört mit. Die Idee der Farblichtmusik und ihre Problematik – beispielhaft dargestellt an Werken von Alexander Skrjabin und Arnold Schönberg.* Frankfurt am Main: Europäischer Verlag der Wissenschaften.

Kienscherf, Barbara (1998). FarbLichtMusik. Auf den Spuren einer ungewöhnlichen Beziehung. *Jahresring, 45,* (S. 38 – 52).

Moritz, William (1987). Der Traum von der Farbmusik. In Veruschka Bódy & Peter Weibel (Hrsg.), *Clip, Klapp, Bum: von der visuellen Musik zum Musikvideo* (S. 17 – 52). Köln: DuMont.

Muxel, Andreas (2003). Formprozessor. Interpretation von Musik und Transformation in Elemente der visuellen Gestaltung. Diplomarbeit zur Erlangung des akademischen Grades eines Magisters (FH) im Studiengang InterMedia an der Fachhochschule Vorarlberg. *http://kisd.de/~muxel/homepage/diploma/thesis.pdf* (6.9.2005).

o.V. (2005). Mahlers Auferstehungs-Sinfonie Visionized. 3D-Visualisierung der Sinfonie Nr. 2. *http://www.aec.at/de/futurelab/projects_sub.asp?iProjectID=13244* (05. 06. 2006).

Schneider, Dirk (2003). Musikclip Musikvideo. Genese musikalischer Bilderwelten. *http://www.musicline.de/de/genre/lexikon/Pop/Videoclip* (04. 12. 2004).

Weibel, Peter (1987). Von der visuellen Musik zum Musikvideo. In Veruschka Bódy & Peter Weibel (Hrsg.), *Clip, Klapp, Bum: von der visuellen Musik zum Musikvideo* (S. 53 – 163). Köln: DuMont.

Abbildung Seite 286: Otto A. Graef: Farblichtmusik, in: Neue Musik-Zeitung 47 (17), 1926, 397 (Reproduktion: Photostelle der Hessischen- und Hochschulbibliothek Darmstadt). Dank an Jörg Jewanski.

Abbildung 287: Albert Schroter: Die Farblichtmusik, in: Münchner Illustrierte Presse/Illustrierte Technik, Nr. 18, 1925, 94, Abb. 19 (Reproduktion: Photostelle der Bayrischen Staatsbibliothek München). Dank an Jörg Jewanski.

The Further Adventures of Surfaces, Sounds, Pixels and Colors

3-D Music Visualizations from the Ars Electronica Futurelab

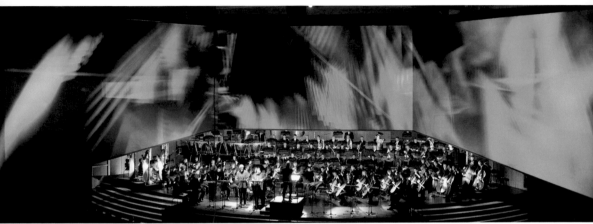

2004, Brucknerhaus Linz, *Das Rheingold* performed by Bruckner Orchester Linz / Dennis Russell Davies,
Visualization: Johannes Deutsch and Ars Electronica Futurelab. Photo: Christian Herzenberger

The virtual staging of Richard Wagner's *Das Rheingold* in 2004 was the Ars Electronica Futurelab's first milestone in a series of experimental visualizations that have pioneered new approaches to presenting classical works of music featuring linkages between the music and three-dimensional visuals. Following up on this effort a year later, Futurelab staffers again worked with graphic artist Johannes Deutsch to produce Gustav Mahler's *2nd Symphony* as an interactive visualization in three-dimensional space. The treatment of Igor Stravinsky's *Le Sacre du Printemps* as a blend of dance performance, visuals and tonal space in collaboration with media artist, director and composer Klaus Obermaier is this year's sequel.

The link-up of auditory and visual sensory levels would seem to be a natural. After all, in extreme cases—certain physiological conditions or drug-induced states—image and sound do indeed merge into a single sensory experience. Thus, it's no wonder that the resulting profusion of creative possibilities have also aroused artistic efforts to deal with certain themes. There have also been individuals who experience synaesthesia who have used this unique form of creativity to produce new and visionary works. Franz Liszt, for instance, composed pieces in which he set a particular painting to music, and Wassily Kandinsky painted music that he saw. This special gift also provided the impetus for the first devices—first and foremost, Alexander Scriabin's "clavier à lumière"—that were designed to give users access to these subjective visions and thus to enable them to experience the music more intensively. In the 1920s, Alexander László attempted to establish his so-called color-light-music as an "art of the future," and he successively expanded and enhanced his "Sonchromatoscope" into a regular multimedia infrastructure.

The numerous approaches to using digital means to treat a substantive theme continued all the way up to the infancy of computer graphics. Visuals for every occasion have long been a part of the standard repertoire of the culture of everyday life, and the upshot has been a broad spectrum

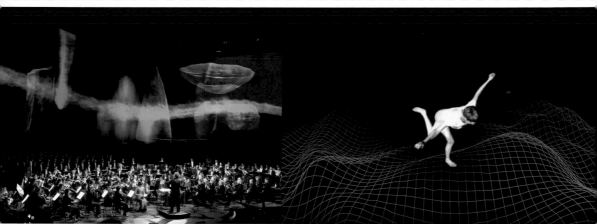

2006, Cologne Philharmonic Hall, Gustav Mahler, *2nd Symphony*.
Visualization: Johannes Deutsch and Ars Electronica Futurelab.
Photo: WDR Thomas Kost

2006, Detail of Visualization *Le Sacre du Printemps*, Klaus Obermaier and
Ars Electronica Futurelab; Dancer: Julia Mach; Photo: Christine Sugrue

of experimentation ranging from the more or less random play of color all the way to attempts to depict sounds and music with scientific exactitude. The Brucknerhaus' long-term working relationship with the Ars Electronica Futurelab yielded a concrete plan to get involved in exploring this experimental field, and these joint ventures have in turn created more and more opportunities for the traditionally oriented Brucknerfest to hook up with the avant-garde Ars Electronica. Wolfgang Winkler, artistic director of the Brucknerhaus, approached the Ars Electronica Futurelab with the idea of bringing together classical performances with three-dimensional worlds of imagery. The staff of the Futurelab under the direction of Horst Hörtner then went about developing the main elements of an interaction design for this new form of performance.

The Ars Electronica Futurelab's visualizations are neither directly related to synaesthesia, nor do they constitute the attempt to translate from one form of sensory perception into the other. Rather, the media lab brings forth a sphere of audiovisual fusion that enables interplay to occur between the composition, the conductor's interpretation of it, the musicians, and the work of artists in many disciplines.

For *Das Rheingold*, several different artistic approaches and technological solutions developed by the Ars Electronica Futurelab were combined, modified, coordinated with one another and enhanced. Working together for more than a year, the project team came up with an array of tools that are able to "hear" the music and to interpret the modulations of the signals in accordance with artistic criteria. The linkage of technological development with conceptualizing a multimedia visualization of a tonal space thus opens up a new mode of configuring works of art and engenders new approaches to partaking of classical compositions.

Some of Richard Wagner's works were infused by the mysticism of light. He had concrete conceptions of the images that would transport the audience into the world of Germanic

mythology and—in what is tantamount to the performance of a ritual—obeisance is still being rendered to many of these ideas in the ways Wagner's operas are staged today. Indeed, the visualization by Johannes Deutsch and the Ars Electronica Futurelab also followed the narrative prescribed by the author and offered the possibility of identification with the characters. Nevertheless, thanks to the stereoscopic projection and the viewer-encompassing screen, the audience, instead of just watching the stage, finds itself right in the middle of what's happening. The performance space is filled by both images and sound. With the virtual world being linked up to the instruments and the vocalists' voices, the visuals take on qualities of the sound, the result of which is to intensify the work's emotional impact and to make possible a new, immersive mode of experiencing this classical piece.

The R&D effort that went into *Das Rheingold* constituted the basis for a subsequent music visualization project, the *Resurrection Symphony* by Gustav Mahler.

The occasion for this production was a gala concert to kick off the 50th anniversary celebration of WDR, the western German public broadcasting company. The piece was conducted by Semyon Bychkov in Cologne's Philharmonic Hall and also televised live.

The libretto did provide a point of departure for virtually staging *Das Rheingold*, but it was necessary to try a very different tack here. The elements of the symphony are indeed pregnant with significance and plot developments are identifiable; nevertheless, it was completely out of the question to make the visual representation of the tonal space more concrete than what the music itself was saying.

The Ars Electronica Futurelab project team's task was to immerse itself in the pictorial universe that Johannes Deutsch had invented for this piece and to utilize the possibilities of computer graphics to come up with its counterpart. Johannes Deutsch had performed a detailed analysis of the music and sketched 18 objects as a dramaturgical framework for the visualization. The audio signals are analyzed for particular characteristics and linked to a virtual representation. They influence both the individual elements, as well as the overall staging of the production, and lead to an interplay of the modulated spatial imagery synchronized with the musicians' performance and the spontaneous reactions of the visualization to selected tonal events.

For the performance of the work, a procedure was developed that makes it possible to model the virtual world in successive steps into the tonal imagery. To achieve this, the symphony was recorded prior to the actual live concert using 48 sensors and an equal number of channels. Then, during the performance, this recording could serve as the basis for simulating those impulses that would have an impact on the visuals during the live concert. In this way, the graphic elements could be configured by an editor in step-by-step fashion in accordance with the impressions made by the music. The graphics are based, on one hand, on the 18 sculptures that were created by Johannes Deutsch and translated into 3-D models by the Ars Electronica Futurelab and, on the other hand, on functional graphic elements with which the digital spatial construction was composed. Furthermore, linking up the visuals with the music being performed in the concert hall also called for the development of an interaction vocabulary according to which the musical impulses from the computer could be interpreted and input in real time into the visual representations. Finally, with the help of software components, all the artistic elements were assembled into the grand-scale visualization that features full interaction in which the visuals are adapted to the musical activity. The foundation upon which all of this was constructed was Mahler's composition.

Text: Pascal Maresch

Vom Treiben der Flächen, Töne, Pixel und Farben

3D-Musikvisualisierungen aus dem Ars Electronica Futurelab

Das Ars Electronica Futurelab hat 2004 mit der virtuellen Inszenierung von Richard Wagners *Das Rheingold* den ersten Meilenstein in einer Reihe von experimentellen Visualisierungen gesetzt, die neue Wege im Umgang mit klassischen Werken der Musik erschließen, indem Verknüpfungen zwischen der Musik und einem dreidimensionalen Bildraum hergestellt werden. Darauf aufbauend wurde im Folgejahr, erneut gemeinsam mit dem bildenden Künstler Johannes Deutsch, die *II. Sinfonie* von Gustav Mahler als interaktive Visualisierung im dreidimensionalen Raum realisiert. Mit der Bearbeitung von Igor Strawinskys *Le Sacre du Printemps* in einer Verbindung von Tanzperformance, Bild- und Klangraum wird diese Reihe, gemeinsam mit dem Medienkünstler, Regisseur und Komponisten Klaus Obermaier, in diesem Jahr fortgesetzt.

Die Verbindung der Sinnesebenen von Ton und Bild scheint naturgegeben. Im Extremfall – aufgrund besonderer physiologischer Umstände oder auch drogeninduziert – verschmelzen Bild und Ton zu einem einzigen sinnlichen Ereignis. Es verwundert nicht, dass die sich daraus ergebende Vielfalt gestalterischer Möglichkeiten auch künstlerische Auseinandersetzungen provoziert. Einige Synästhetiker haben ihre Kompetenz kreativ genutzt, um daraus Neues, Visionäres zu schaffen. Musiker wie Franz Liszt vertonten Gemälde in Kompositionen, Vasilij Kandinsky malte Musik, die er sah. Dieser besonderen Begabung sind auch die ersten Apparate zu verdanken, die, allen voran Alexander Scarabins „clavier à lumière", einen Einblick in die subjektiven Visionen, und damit ein intensiveres Erleben der Musik ermöglichen sollten. Alexander László versuchte in den 1920er Jahren mit seiner „Farblichtmusik" eine „Kunst der Zukunft" zu begründen und baute sein „Sonchromatoskop" sukzessive zu einer regelrechten Multimedia-Infrastruktur aus.

Die Reihe der Ansätze, das Thema auch mit digitalen Mitteln zu bearbeiten, reicht unmittelbar bis zu den Anfängen der Computergrafik. Visuals zu jeder Gelegenheit sind heute längst Bestandteil der Alltagskultur. So ergibt sich ein breites Experimentierfeld vom mehr oder weniger beliebigen Farbenspiel bis hin zu den Versuchen, Töne und Musik wissenschaftlich exakt abzubilden. Aus der mehrjährigen Zusammenarbeit des Brucknerhaus Linz mit dem Ars Electronica Futurelab entwickelte sich das Vorhaben, an der Erforschung dieses Experimentierfelds teilzuhaben. Diese Kooperationen schaffen zunehmend Berührungspunkte zwischen dem traditionell ausgerichteten Brucknerfest und der Avantgarde der Ars Electronica. Wolfgang Winkler, künstlerischer Leiter des Brucknerhauses, wandte sich an das Ars Electronica Futurelab mit der Idee, klassische Aufführungen mit dreidimensionalen Bildwelten zu verbinden. Das Team des Futurelab unter Horst Hörtner entwickelte daraufhin die Grundzüge eines Interaktionsdesigns für diese neue Aufführungsform.

Die Visualisierungen des Ars Electronica Futurelab stützen sich nicht unmittelbar auf die Erfahrungen der Synästhetiker und stellen auch keinen Versuch dar, von einer in die andere Sinneswahrnehmung zu übersetzen. Vielmehr stellt das Medienlabor einen audiovisuellen Fusionsraum her, der neue Verknüpfungspunkte zwischen der Komposition, der Interpretation des Dirigenten, der Musiker und den Interpretationen von Künstlern unterschiedlicher Disziplinen schafft.

Für *Das Rheingold* wurden unterschiedliche, vom Ars Electronica Futurelab entwickelte künstlerische Ansätze und technologische Lösungen kombiniert, modifiziert, aufeinander abgestimmt

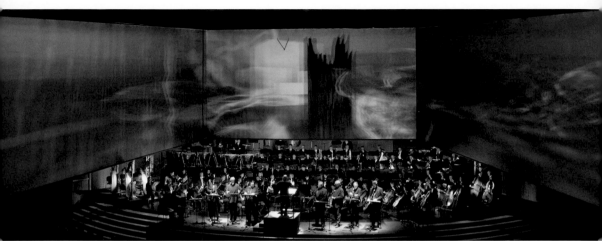

2004, Brucknerhaus Linz, *Das Rheingold*, Bruckner Orchester Linz / Dennis Russell Davies, Visualisierung: Johannes Deutsch und Ars Electronica Futurelab.
Foto: Christian Herzenberger

und weiterentwickelt. Das Team hatte in dem mehr als einjährigen Prozess ein Instrumentarium geschaffen, das sich dazu eignet, die Musik zu „hören" und die Modulationen der Signale nach gestalterischen Kriterien auszulegen. Die Verknüpfung von Technologie-Entwicklung mit dem Konzept für eine multimediale Klangraum-Visualisierung erschließt auf diese Weise neue Modi der Gestaltung und schafft neue Zugänge der Rezeption klassischer Kompositionen.

Richard Wagners Werke waren teilweise geprägt von Lichtmystik. Er hatte konkrete Vorstellungen von den Bildern, die das Publikum in die germanische Mythenwelt versetzen sollten, und vielen dieser Vorstellungen wird, einer Art Ritus folgend, bis heute in den Inszenierungen der Wagner Opern gehuldigt. Auch die Visualisierung von Johannes Deutsch und dem Ars Electronica Futurelab folgte der vom Verfasser vorgegebenen Handlung und bot die Möglichkeit der Identifikation mit den Charakteren. Durch die stereoskopische Projektion und die die Zuschauer umspannende Leinwand fand sich das Publikum, anstatt auf eine Bühne zu blicken, inmitten des Geschehens wieder. Die Bilder füllten ebenso wie der Klang den Raum. Durch die Kopplung der virtuellen Welt mit den Instrumenten und den Singstimmen nahmen die Bilder Eigenschaften des Klanges an. Dadurch ließ sich die emotionale Wirkung verstärken, und ein neues immersives Erleben des klassischen Stoffs wurde möglich.

Die für *Das Rheingold* geleisteten Entwicklungen bildeten die Basis für ein weiteres Musikvisualisierungsprojekt, der *Auferstehungssymphonie* von Gustav Mahler.

Den Rahmen hierfür bildete ein Festkonzert als Auftakt des Jubiläumsjahres zum 50-jährigen Bestehen des Westdeutschen Rundfunks. Unter der Leitung von Semyon Bychkov wurde das Ereignis in der Kölner Philharmonie aufgeführt und auch live im Fernsehen übertragen.

Lieferte für die virtuelle Inszenierung von *Das Rheingold* das Libretto eine Grundlage, so musste hier ein anderer Weg verfolgt werden. Die Elemente der Sinfonie sind zwar mit Bedeutungen aufgeladen, Verläufe sind identifizierbar, aber das visuelle Abbild des Klangraumes kann bzw. soll nicht konkreter werden als das, was die Musik aussagt.

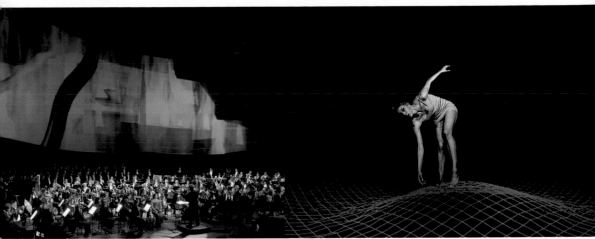

2006, Kölner Philharmonie, *II. Sinfonie* von Gustav Mahler, Visualisierung: Johannes Deutsch und Ars Electronica Futurelab. Foto: WDR Thomas Kost.

2006, Detail der Visualisierung von *Le Sacre du Printemps*, von Klaus Obermaier und Ars Electronica Futurelab; Tänzerin: Julia Mach; Foto: Christine Sugrue

Für das Team des Ars Electronica Futurelab stellte sich die Aufgabe, in die von Johannes Deutsch assoziierte Bildwelt einzutauchen und mit den Möglichkeiten der Computergrafik eine Analogie zu finden. Johannes Deutsch hatte das Musikstück einer eingehenden Analyse unterzogen und mit 18 Objekten einen dramaturgischen Rahmen für die visuelle Umsetzung skizziert. Die Audiosignale wurden nach entsprechenden Gesichtspunkten analysiert und mit einer visuellen Darstellung verknüpft. Sie beeinflussten sowohl einzelne Elemente als auch die Gesamtinszenierung und führten zu einer Verbindung von der mit dem Spiel der Musiker synchronisierten Modulation des Raumbildes und den spontanen Reaktionen der Visualisierung auf ausgewählte Klangereignisse.

Für die Ausführung der Arbeit wurde ein Verfahren entwickelt, mit dem die virtuelle Welt schrittweise in das Klangbild hineinmodelliert werden konnte. Hierzu wurde die Sinfonie im Vorfeld mit 48 Sensoren und ebenso vielen Kanalspuren aufgenommen. Anhand dieser Aufnahme konnten bei der Produktion jene Impulse simuliert werden, die auch bei der Aufführung auf die Bilder einwirken würden. So konnten die grafischen Elemente über einen Editor Schritt für Schritt nach dem musikalischen Eindruck ausformuliert werden. Die Grafik basiert einerseits auf den 18 von Johannes Deutsch angefertigten Skulpturen, die das Ars Electronica Futurelab als 3D-Modelle umsetzte, und auf funktionalen grafischen Elementen, mit denen die digitale Raumkonstruktion erschlossen wird. Die Verbindung des Bildes mit der Musik im Saal erforderte zudem die Entwicklung eines Interaktionsvokabulars, nach dem die musikalischen Impulse vom Computer interpretiert und in Echtzeit in die visuellen Darstellungen einfließen konnten. Schließlich wurden die Gestaltungselemente mithilfe der Softwarebausteine zur Gesamtvisualisierung zusammengesetzt, die Verknüpfungen hergestellt und die visuellen Eindrücke an die Klangereignisse angepasst. Die Grundlage bildete dabei stets die musikalische Vorlage Mahlers.

Text: Pascal Maresch

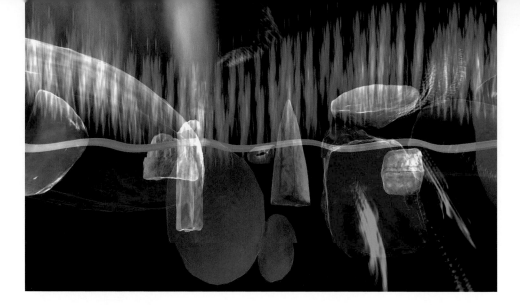

Johannes Deutsch

Vision Mahler

"What a world this is that brings forth such sounds and shapes as its reflected likeness!"

Gustav Mahler

The musical performance of Gustav Mahler's *2nd Symphony* is interactively interconnected with the visual interpretation of the piece. The arrangement of the visualization concentrates on what the music expresses and the emotions it brings forth. Thus, Gustav Mahler's cultural-historical setting and the sources of his own inspiration do not come into play in this visualization. This work is a matter of blending together two interpretations: one expressed musically and the other visually.

Eighteen three-dimensional objects constitute a virtual domain that depicts the universe of the *2nd Symphony* on an abstract level. Analogously to the music, the objects of the visualization undergo a process of transformation that Mahler lets us experience auditorially in five movements. The thematic junctures and stages of the *2nd Symphony*—suffering, romanticism, irony, love, doubt and hope—are correlated to the transformation of these virtual objects. In the first movement, for example, objects assemble, form structures and then break down; in the second movement they dance, radiate and shine; the third movement infuses the forms with irony and distorts them; love is aglow with light in the fourth movement, and is succeeded in the fifth by tremors and destruction; then objects burst, signaling an exodus from the virtual world. Not until the finale does redemption make its appearance—everything shimmers, sails and floats away.

While the objects are proceeding through the stages of the symphony, throbbing becomes visible on their own surfaces as if their pulses were beating or their lungs breathing. The degree to which the objects pulsate and how—and even whether—their radiance visibly manifests itself depends upon the music and the interpretation of it in the performance. The visuals are generated live and interact with the music that drives the virtual objects like a pacemaker. In this way, the visualization reflects the oscillating, almost excessive depiction of dramatic and lyrical components of the music—to a point that is tantamount to transference into the realm

of the terpsichorean or the religious, and, at the same time, also brings out powerful expressions ranging from release and joy to the most profound anguish.

The transmutability of the objects is the precondition for capturing the symphonic uniqueness of the *2nd Symphony* and enabling this quality to flow into the visualization.

Gustav Mahler's compositions are widely admired for their ideal synthesis of word and music; nevertheless, what is especially fascinating to a media artist about the *2nd Symphony* is its direct translation of meanings into music. Their sequential ordering in the music allows Mahler's statements to be understood literally, as it were, and the sequence of emotions triggered by the music projects a mental film in the mind of the person partaking of it. In striving to take full advantage of this potential, the 3-D space—both in the Philharmonic Hall and in the televised version—is used to produce a visual crescendo accompanying the music with brilliance and darkness, majesty and quaking tremors raining down on and pervading all the objects. The visualization's objects expand to completely immerse and encompass all the senses of those partaking of it.

This visualization is by no means a work of animation; rather, it is a virtual world generated in real time and linked to the music. The visual dramaturgy is so plastic that the interpretation of the piece by conductor Semyon Bychkov and the WDR Symphony Orchestra can make a direct impact on the visualization of Mahler's *2nd Symphony*. This means that the interpretation of the orchestral work manifests itself not only in the music, but in the design of the visualization too.

On television, the visualization was depicted in a unique presentation format in order to allow the public watching on their home sets to really get a feel for this experimental, interactive concert event being performed live at the Philharmonic Hall. Special infrastructure within the software systems—devices that generate an interactive visual world in real time as a symbiosis of the musical and visual interpretations—functions as an intelligent, virtual "camera" to capture the digital artistic space created by Johannes Deutsch and the Ars Electronica Futurelab in the Philharmonic Hall and to represent it in a way that is customized to the point of view of the TV viewing audience. The information systems of the digital artistic realm calculate when, where and from what perspective the optimal interactive blend of music and visuals can be achieved for viewing by the television audience. In addition, attaining such dynamic virtual camera angles is facilitated by the use of movement patterns specifically programmed for this purpose. These preset camera paths along with special glasses help give the television audience the illusion of a spatial expansion of the TV image.

The virtual "camera" automatically co-generates these television images throughout the entire performance. Thus, a visualization of Mahler's *2nd Symphony* from several different angles is made available to the TV viewing audience. At the director's console, the four direct TV channels of the visualization are combined with the images captured by the TV cameras set up in the Philharmonic Hall to engender a multi-layered visual realm.

Translated from German by Kristina Bausch and Mel Greenwald

Vision Mahler, the visualization of Gustav Mahler's *Symphony No. 2 in C minor (Resurrection Symphony),* premiered on January 1, 2006 in Cologne at a gala concert held to celebrate the 50th anniversary of WDR, a western German public broadcasting company. The work was performed under the direction of Semyon Bychkov before a live audience in Cologne's Philharmonic Hall and simulcast on TV.

Artistic design of the concert: Johannes Deutsch and Ars Electronica Futurelab
Project team: Johannes Deutsch, Robert Abt, Florian Berger, Peter Freudling, Horst Hörtner, Andreas Jalsovec, Christopher Lindinger, Pascal Maresch, Stefan Mittlböck-Jungwirth, Nina Valkanova

Johannes Deutsch

Vision Mahler

„Was ist das für eine Welt, welche solche Klänge und Gestalten als Widerbild auswirft!"

Gustav Mahler

Die musikalische Aufführung der *II. Sinfonie* von Gustav Mahler wird interaktiv mit der visuellen Interpretation der *II. Sinfonie* verbunden. Die Gestaltung der Visualisierung konzentriert sich auf die Aussagen in der Musik und auf die von ihr ausgelösten Emotionen. Das kulturhistorische Ambiente Gustav Mahlers und seine eigenen Inspirationsquellen sind in diesem Zusammenhang nicht Thema der Visualisierung. Es geht um die Verbindung zweier Interpretationen: um jene in der Musik und um jene in der Vision.

Achtzehn dreidimensionale Objekte repräsentieren als virtuelle Welt die Welt der *II. Sinfonie* auf einer abstrakten Ebene. Analog zur Musik durchlaufen die Objekte der Visualisierung eine Transformation, welche uns Mahler als musikalisches Geschehen in fünf Sätzen zu Gehör bringt. Die thematischen Stationen und Stadien der Sinfonie – Leiden, Romantik, Ironie, Liebe, Zweifel und Hoffnung – werden mit der Verwandlung der Objekte in Assoziation gebracht, wenn beispielsweise im ersten Satz Objekte sich aufrichten und wieder zusammenbrechen; wenn sie im zweiten Satz tanzen, strahlen und glänzen. Der dritte Satz fegt mit Ironie über die Formen und verzerrt sie; in der Liebe (im vierten Satz) erstrahlt das Licht; und im fünften Satz folgen Erdbeben und Zerstörung, Objekte bersten, ein Exodus setzt in der virtuellen Welt ein. Erst ganz zuletzt ereignet sich die Erlösung, alles flirrt, segelt und verschwebt.

Während die Objekte die Stationen der Sinfonie durchlaufen, werden an ihnen Eigenbewegungen ähnlich einem Pulsschlag oder dem Atem sichtbar. In welche Schwingung die Objekte dabei geraten und wie und ob auch ihre Ausstrahlung sichtbar wird, hängt von der Musik und der Interpretation in der Aufführung ab. Live und interaktiv ist die Vision mit der Musik verbunden, und die Musik belebt die virtuellen Objekte wie ein Schrittmacher. Auf diese Weise reflektiert die Visualisierung gleichzeitig die wechselhafte, beinahe extreme Darstellung von dramatischen und lyrischen Satzteilen, bis hin zum Wandel ins Tänzerische und Religiöse und den kraftvollen Ausdruck von der Gelöstheit und Freude bis zur tiefsten Erschütterung.

Die Verwandlungsfähigkeit der Objekte ist die Voraussetzung, um die symphonische Besonderheit der *II. Sinfonie* erfassen und in die Visualisierung einfließen lassen zu können.

Wenn Gustav Mahlers Vertonungen allgemein für ihre ideale Verbindung von Wort und Ton bekannt sind, dann fasziniert den Medienkünstler an der *II. Sinfonie* ganz besonders die direkte Umsetzung von Inhalten in Musik. Durch ihre sequenzielle Anordnung in der Musik lassen sich Mahlers Aussagen gewissermaßen *wörtlich* verstehen, und die Abfolgen der von der Musik ausgelösten Emotionen evozieren beim Rezipienten einen mentalen Film. Diesem Potenzial folgend, wurde, während sich Glanz und Finsternis, Majestätik und Beben über und durch alle Objekte ziehen, der 3D-Raum in der Philharmonie und im Fernsehen dazu genutzt, um analog zur Musik ein visuelles Crescendo zu erzeugen. Die Objekte der Visualisierung weiteten sich zum Rezipienten immersiv alle Sinne erfassend aus.

Diese Visualisierung ist keine Animation, sondern eine in Echtzeit generierte und mit der Musik verbundene virtuelle Welt. Die visuelle Dramaturgie ist so plastisch, dass der Einfluss der Interpretation des Dirigenten Semyon Bychkov und des WDR Sinfonie Orchesters sich direkt auf die Visualisierung von Mahlers *II. Sinfonie* auswirken konnten. Das bedeutet, dass die Interpretation

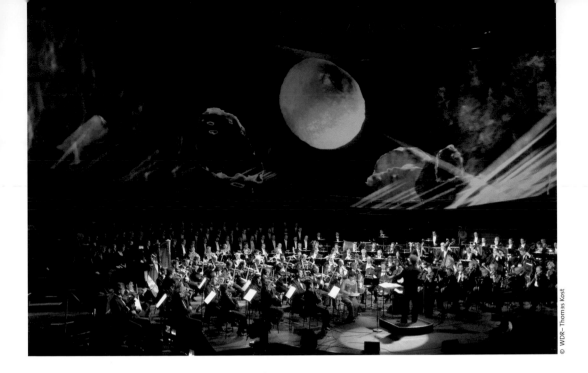

des Orchesterwerks nicht nur in der Musik, sondern auch in der Gestaltung der Visualisierung zum Ausdruck gebracht wurde!

Im Fernsehen wurde die Visualisierung in einer eigenen Darstellungsform gezeigt, um dem Publikum am Bildschirm Zugang zum experimentellen interaktiven Konzertereignis in der Philharmonie zu verschaffen. Eine Infrastruktur innerhalb der Softwaresysteme – die in Echtzeit eine interaktive virtuelle Welt als Symbiose zweier Interpretationen, aus Musik und Vision, generierten – erschloss als intelligente virtuelle „Kamera" den von Johannes Deutsch und Ars Electronica Futurelab geschaffenen digitalen Kunstraum in der Philharmonie für den Blickwinkel des Fernsehens. Die Informationssysteme des digitalen Kunstraums errechneten, wann, wo und aus welcher Perspektive die interaktive Verschmelzung von Musik und Vision für die Fernsehperspektive am treffendsten zu Stande kam. Darüber hinaus wurde eine dynamische virtuelle Kamerasicht durch den Einsatz von gezielt programmierten Bewegungsmustern unterstützt, diese erlaubten dem Fernsehpublikum mit Hilfe spezieller Brillen die Illusion einer räumlichen Ausdehnung des TV-Bilds. Die virtuelle „Kamera" generierte während der gesamten Aufführung die Fernsehansicht automatisch mit. Dem Fernsehpublikum stand die Visualisierung von Mahlers *II. Sinfonie* deshalb aus mehreren Blickwinkeln zur Verfügung. In der Regie wurden die vier direkten Kanäle der Visualisierung mit den TV-Bildern der in der Philharmonie aufgestellten Fernsehkameras zu einem mehrschichtigen Bildraum verbunden.

„Vision Mahler", die Visualisierung der *Auferstehungssymphonie* von Gustav Mahler *(Mahlers II. Sinfonie)* wurde anlässlich des Festkonzerts zum 50-jährigen Bestehen des Westdeutschen Rundfunks am 1. Jänner 2006 in Köln uraufgeführt. Unter der Leitung von Semyon Bychkov wurde das Ereignis in der Kölner Philharmonie aufgeführt und auch live im Fernsehen übertragen.

Medienkünstlerische Gestaltung des Konzerts: Johannes Deutsch und Ars Electronica Futurelab.
Projektteam: Johannes Deutsch, Robert Abt, Florian Berger, Peter Freudling, Horst Hörtner, Andreas Jalsovec, Christopher Lindinger, Pascal Maresch, Stefan Mittlböck-Jungwirth, Nina Valkanova

Wolfgang Winkler

The Visualization of Music

Music is an art form that is very closely connected to visualization. This applies first and foremost to the score itself. This is the written expression of how the composer wanted the piece's content to be played and is the basis of any subsequent interpretation or reading of it. On the other hand, there is the musician, the orchestra and its conductor. Whether the concert-goer is aware of this or not, the visual impression that a concert makes is of decisive importance to the process of partaking of it. A concert of complex music broadcast on the radio—that is, without a visual image—is heard in a very different way than the same music played in a concert hall. Visuals and music, one might say, condition each other. The Ars Electronica Center and the Brucknerhaus have made these considerations the basic concept of their joint undertaking: music and visualization. The visualization of the opera *Das Rheingold* that was presented two years ago in a joint production by the Brucknerhaus and the FutureLab is a model of the various possibilities of visually staging a work, which are for the most part determined by the technology available to the respective production. At that time, Johannes Deutsch was the artist who translated the content of *Das Rheingold* into his own visual language that was, in turn, configured in real time by the FutureLab's technology as well as by musical parameters like tempo and volume.

The production of Igor Strawinsky's *Le Sacre du Printemps* opera this year carries on this concept. Basically, it presents a new dimension of the visualization of music. With this idea as its point of departure, it also constitutes a possibility of enhancing the stage setting of any theater by adding this dimension. As a new production element at the 2006 Bruckner Festival, the realization of three-dimensionality will also transcend the confines of the concert hall. Since this concert will simultaneously resound in the Donaupark in the context of the classic Linzer Klangwolke, concertgoers in attendance alfresco in the riverside park adjacent to the Brucknerhaus will also have the opportunity to partake of the visual effects produced within the concert hall.

Translated from German by Mel Greenwald

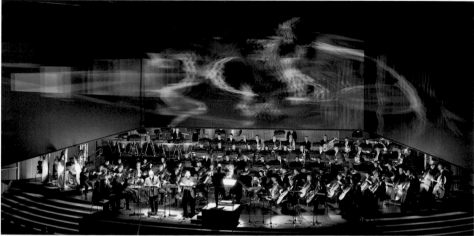

2004, Brucknerhaus Linz, *Das Rheingold* performed by Bruckner Orchester Linz / Dennis Russell Davies
Visualization: Johannes Deutsch and Ars Electronica Futurelab

Wolfgang Winkler

Die Visualisierung von Musik

Musik ist eine Kunst, die extrem stark mit Visualisierung zusammenhängt. Ganz an vorderer Stelle steht bei dieser Betrachtung die Partitur selbst. Sie ist der schriftliche Ausdruck des inhaltlichen Wollens des Komponisten und Basis jeglicher Interpretation, sprich Lesart. Auf der anderen Seite stehen der Musiker, das Orchester und sein Dirigent. Ob der Konzertbesucher will oder nicht, die Optik eines Konzertes ist für seine Rezeption von entscheidender Bedeutung. Ein Konzert mit komplexer Musik im Radio, also ohne Bild, wird ganz anders gehört als dieselbe Musik im Konzertsaal. Bild und Musik, könnte man also formulieren, bedingen einander.

Diesen Gedanken haben Ars Electronica und das Brucknerhaus zur Idee ihrer gemeinsamen Projekte gemacht: Musik und Visualisierung. Die Visualisierung der Oper *Das Rheingold,* wie sie vor zwei Jahren in einer gemeinsamen Produktion von Brucknerhaus und Ars Electronica Futurelab vorgestellt wurde ist ein Modell für die verschiedenen Möglichkeiten einer visuellen Umsetzung, die größtenteils auch durch die verfügbare Technik bestimmt sind.

Damals war Johannes Deutsch der bildende Künstler, der den Inhalt von *Das Rheingold* in seine Bildsprache umsetzte, die wiederum durch die Technologie des Ars Electronica Futurelab und durch musikalische Parameter wie Schnelligkeit und Lautstärke in Echtzeit gesteuert wurde.

Die Produktion von *Le Sacre du Printemps* von Igor Strawinsky ist die Weiterführung dieses Gedankens. Grundsätzlich geht es um eine neue Dimension der Sichtbarmachung von Musik. Ausgehend davon bietet sich die Möglichkeit, auch den Bühnenraum jedes Theaters um diese Dimension zu erweitern. Ein neues Feld bei der Produktion im Rahmen des Brucknerfest 2006 ist die Umsetzung der Dreidimensionalität auch außerhalb des Konzertsaales. Da dieses Konzert gleichzeitig als klassische Linzer Klangwolke im Donaupark erklingt, haben die Besucher dort die Möglichkeit, die Optik des Saales auch im freien Raum zu verfolgen.

Christine Sugrue

2006, Detail der Visualisierung von *Le Sacre du Printemps,* von Klaus Obermaier und Ars Electronica Futurelab; Tänzerin: Julia Mach

The Visualization of Le Sacre du Printemps

This current effort to apply technology and creativity to Stravinsky's *Le Sacre du Printemps* actually seizes upon the Ars Electronica Futurelab's original idea of visualizing pieces of music that were from the very outset meant for the stage (i.e. which include vividly pictorial visual components). Once again, a 3-D space generated by musical impulses creates the framework for a narrative structure that is, in this particular case, also coupled with another means of expression: dance.

Such cross-medial projects represent an amalgamation of not only technologies and artistic genres, but also personalities and ways of approaching a work, which gives rise to new methods of cooperation. In *Le Sacre du Printemps* it was media artist, director and composer Klaus Obermaier who collaborated with Ars Electronica Futurelab staffers to identify the appropriate means to achieve the desired end and to develop a performance concept. In cooperation with dancer Julia Mach and the Ars Electronica Futurelab's people, Klaus Obermaier then worked out the various elements and assembled them into the final form of the performance. This project is the beneficiary of experience gained from previous work of this kind, including the interactive visualizations and concrete dance performance *Apparition* by Klaus Obermaier (also implemented by the Ars Electronica Futurelab), and has thus generated a complex network that is constantly expanding the palette of computer-supported means of expression.

These current approaches—some extremely advanced and even trend-setting techniques with great promise for the future—are being applied to highly traditional, classical material in *Le Sacre du Printemps,* a work whose explosive musical power is not just visualized in this production; rather, this artistic treatment complements and enhances it with additional levels of experience.

Text: Pascal Maresch

Christine Sugrue

Klaus Obermaier

Music – Dance – Space
The Visualization of Le Sacre du Printemps

The epoch prior to World War I, the time in which Stravinsky was composing *Le Sacre du Printemps* (The Rite of Spring), was characterized by an ecstatic desire to experience the intensity of life, an emotion that would later mutate into an equally euphoric enthusiasm for war. In tune with this time, Stravinsky conceived *Le Sacre* as an orgiastic mass ballet. The dissolution of social structures is reflected in his having taken leave of conventional compositional forms of development and structures; in their stead are fragmentary, batch-like serial arrangements of the individual movements; abrupt shifts; music in different keys and rhythms superimposed upon one another.

Now, nearly a hundred years later, the issue of the day is the authenticity of experience in the light of the ongoing virtualization of the spaces in which modern life is played out. It's the dissolution of our sensory perception, of the space-time continuum, the blurred dividing line between real and virtual, fact and fake that takes us to the limits of our existence.

The discrepancy between subjective perception and seemingly objective perception produced by stereoscopic camera systems whose images are filtered and manipulated by computer constitutes the basis of my staging of *Le Sacre du Printemps*.

The immersion of the "chosen ones" in virtuality, their fusion with music and space, as an up-to-date "sacrifice" for uncertain Newness, as metaphor of redemption and anticipation of the

eternal happiness that new technologies and old religions promise us. Or at least as a new dimension of perception.

In conventional productions of *Le Sacre*, choreographers and dancers work to the music. In this case, though, the dynamism and structure of the music interactively transform the virtual presence of the dancer and her avatars and thus produce a sort of "meta-choreography."

Stereo cameras transfer dancer Julia Mach into a virtual three-dimensional space. Time-strata and unusual perspectives overlay one another and duplicate themselves, and give rise to completely novel insights into the human body and its sequences of movements. Musical motifs interactively influence and manipulate these 3-D projections. Music is no longer just the choreography's point of departure; it's the consummation of the choreography.

Stereo projection as virtual stage

There have been repeated attempts to combine projections of spatial images with real performers on a stage. The vision being pursued was a virtual stage setting in which the *dramatis personae* could move about as if they were in real spaces. But it is precisely in this point that we encounter a fundamental misunderstanding: the (subjective) perception of a real space differs fundamentally from the (seemingly objective) perception of a stereoscopically projected space. The viewer's angle of observation of the performer and of the performer's relation to the real space changes depending on the position of the viewer in the auditorium. In a stereoscopic projection, however, this angle of observation remains the same for all viewers, regardless of their location in the auditorium. Thus, a 3-D projected space and a real space are incompatible; accordingly, *Le Sacre du Printemps* physically separates the performance space and the 3-D projection.

Translated from German by Mel Greenwald

Le Sacre du Printemps is the opening concert of the Brucknerfest Linz 2006 and the Classic *Klangwolke* (Cloud of Sound). The concert as well as the accompanying 3-D visualizations will be broadcast live on big screens set up in Danube Park adjacent to the Brucknerhaus. Bruckner Orchester Linz conducted by Dennis Russell Davies / Karen Kamensek.

Le Sacre du Printemps by Igor Stravinsky. Staging by Ars Electronica and Brucknerhaus Linz; based on an idea by Wolfgang Winkler / Klaus Obermaier / Gerfried Stocker.
Artistic design of the visualization and choreography by Klaus Obermaier. Dancer: Julia Mach.
Interactive Design and technical development: Ars Electronica Futurelab: Matthias Bauer, Rainer Eilmsteiner, Horst Hörtner, Christopher Lindinger, Christine Sugrue
Production Management Brucknerhaus: Tiberius Binder.
A co-production of Brucknerhaus Linz and Ars Electronica.

Die Visualisierung von Le Sacre du Printemps

Mit der Bearbeitung von Strawinskys *Le Sacre du Printemps* wird die ursprüngliche Idee vom Ars Electronica Futurelab wieder aufgegriffen, Musikstücke zu visualisieren, die von vornherein für die Bühne, d. h. mit bildhaften visuellen Komponenten, angelegt waren. Erneut schafft ein an musikalische Impulse gekoppelter 3D-Raum den Rahmen für eine Erzählstruktur, in diesem Fall in Kombination mit den Ausdrucksmitteln des Tanzes.

Bei derartigen crossmedialen Projekten treffen nicht nur unterschiedliche Technologien und Kunstgattungen aufeinander, sondern auch Persönlichkeiten und Herangehensweisen, wodurch auch neue Methoden der Zusammenarbeit entstehen. Bei *Le Sacre du Printemps* war es der Medienkünstler, Regisseur und Komponist Klaus Obermaier, der gemeinsam mit dem Team des Ars Electronica Futurelab die entsprechenden Gestaltungsmittel identifizierte und ein Aufführungskonzept für das Stück entwickelte. Klaus Obermaier erarbeitete daraufhin mit der Tänzerin Julia Mach und dem Team des Ars Electronica Futurelab die unterschiedlichen Elemente und setzte sie zu der endgültigen Performance zusammen. Das Projekt bündelt die gesammelten Erfahrungen aus den vorhergegangenen Arbeiten, den interaktiven Visualisierungen und konkret der Tanzperformance *Apparition* von Klaus Obermaier, die ebenfalls mit dem Ars Electronica Futurelab verwirklicht wurde, und generiert so ein komplexes Netzwerk, das die Palette computertechnisch unterstützter Ausdruckmittel stetig erweitert.

Diese aktuellen und teils zukunftsweisenden Ansätze treffen im Fall von *Le Sacre du Printemps* auf einen sehr traditionellen klassischen Stoff, dessen musikalische Sprengkraft in dieser künstlerischen Auseinandersetzung nicht nur visualisiert, sondern um weitere Erfahrungsebenen ergänzt wird.

Text: Pascal Maresch

Klaus Obermaier

Klaus Obermaier

Musik – Tanz – Raum
Die Visualisierung von Le Sacre du Printemps

Die Epoche vor dem Ersten Weltkrieg, als Strawinsky *Le Sacre du Printemps* komponierte, war durch ein rauschhaftes Verlangen nach Intensität des Lebens gekennzeichnet, das später ebenso heftig in Kriegsbegeisterung umschlug. Folgerichtig konzipierte Strawinsky *Le Sacre du Printemps* als orgiastisches Massenballett. Die Auflösung gesellschaftlicher Strukturen spiegelt sich wider in der Auflösung herkömmlicher kompositorischer Entwicklungen und Strukturen: bruchstückhafte, blockartige Aneinanderreihung der Sätze; abrupte Wechsel; Überlagerungen unterschiedlicher Tonarten und Rhythmen.

Heute, beinahe hundert Jahre später, stellt sich die Frage nach Authentizität des Erlebens aufgrund der stetig fortschreitenden Virtualisierung unserer Lebensräume. Es ist die Auflösung unserer sinnlichen Wahrnehmung, des Raum-Zeit-Kontinuums, die sich verwischende Trennlinie zwischen real und virtuell, Fakt und Fake, die uns an die Grenzen unserer Existenz führt.

Die Diskrepanz zwischen subjektiver Wahrnehmung und der scheinbar objektiven Wahrnehmung durch stereoskopische Kamerasysteme, deren Bilder durch Computer gefiltert und manipuliert werden, bildet die Basis für meine Inszenierung von *Le Sacre du Printemps*: das Eintauchen der „Auserwählten" in die Virtualität, ihre Verschmelzung mit Musik und Raum, als zeitgemäßes „Opfer" für das ungewisse Neue, als Metapher der Erlösung und Vorwegnahme des ewigen Glücks, das uns neue Technologien und alte Religionen versprechen. Oder zumindest als neue Dimension der Wahrnehmung.

In herkömmlichen Inszenierungen von *Le Sacre du Printemps* wird zur Musik choreografiert und getanzt. In diesem Fall jedoch transformieren die Dynamik und Struktur der Musik interaktiv die virtuelle Präsenz der Tänzerin und ihrer Avatare und erzeugen so eine Art Meta-Choreografie. Stereokameras transferieren die Tänzerin Julia Mach in einen virtuellen dreidimensionalen Raum. Zeitschichten und ungewöhnliche Blickwinkel überlagern und vervielfältigen sich und ermöglichen völlig neue Einblicke auf den Körper und seine Bewegungsabläufe. Musikalische Motive beeinflussen und manipulieren interaktiv diese 3D-Projektionen. Musik ist nicht mehr nur Ausgangspunkt, sondern auch Vollendung der Choreografie.

Stereoprojektion als virtuelle Bühne

Es gab immer wieder Versuche, Raumbildprojektionen mit realen Performern auf einer Bühne zu verbinden. Der Traum war ein virtuelles Bühnenbild, in dem sich die Akteure wie in echten Räumen bewegen können. Aber genau hier liegt ein grundsätzliches Missverständnis: Die (subjektive) Wahrnehmung eines realen Raumes unterscheidet sich fundamental von der (scheinbar objektiven) Wahrnehmung eines stereoskopisch projizierten Raumes. Je nach Position des Betrachters im Zuschauerraum verändert sich der Einblickswinkel auf den Performer und dessen Beziehung zum realen Raum. In der stereoskopischen Projektion bleibt dieser Blickwinkel jedoch für alle Betrachter gleich, auch von unterschiedlichen Positionen aus. 3D-projizierter und realer Raum sind also nicht kompatibel und daraus folgt in *Le Sacre du Printemps* die räumliche Trennung von Performance-Space und 3D-Projektion.

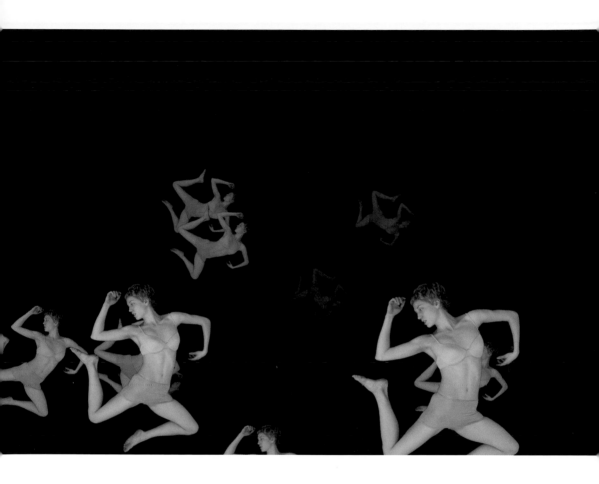

Le Sacre du Printemps ist das Eröffnungskonzert des Brucknerfest Linz 2006, verbunden mit der klassischen Klangwolke. Das Konzert wie auch die 3D Visualisierungen werden auf großen Leinwänden live in den Donaupark vor dem Brucknerhaus übertragen. Mit dem Bruckner Orchester Linz unter Dennis Russell Davies/Karen Kamensek.

Le Sacre du Printemps von Igor Strawinsky, in einer Umsetzung von Ars Electronica und Brucknerhaus Linz nach einer Idee von Wolfgang Winkler/Klaus Obermaier/Gerfried Stocker.
Künstlerische Gestaltung der Visualisierung und Choreografie: Klaus Obermaier. Tanz: Julia Mach.
Interaktives Design und technische Entwicklung: Ars Electronica Futurelab: Matthias Bauer, Rainer Eilmsteiner, Horst Hörtner, Christopher Lindinger, Christine Sugrue. Produktionsleitung Brucknerhaus: Tiberius Binder
Eine Koproduktion von Brucknerhaus Linz und Ars Electronica.

Pixelspaces 2006: Goblin City
Media, Art and Public Spaces

The urban realm is being equipped to function as a multimedia environment. Digitization is making a physical impact on the cityscape itself. Architecture is being endowed with the qualities of media and infrastructure ranging from built-in telematic furnishings to location-based services forms interfaces to linking up virtual and material spheres of communication. Creative encounters beyond the realm of advertising and high-tech décor deliver real proof of the growing awareness of the mediatization of modern society. The results of these confluences integrate themselves into their physical settings as subtle interventions, in addition to ones charged with accomplishing often mundane tasks. The manifestations of media art beyond the confines of the exhibition context—as an architectural component or in the form of the telematic configuration of an environment—has meant the emergence of a new quality on the part of installations.

Pixelspaces is a symposium series hosted by Ars Electronica Futurelab that discusses contemporary currents from the point of view of a media laboratory. As part of Pixelspaces 2006, which has been dubbed *Goblin City,* projects and approaches will be presented that navigate the tension-charged relationships between media, art and public space.

The discussion surrounding art in public spaces is rooted in the 1960s and thus in the very same decade in which media art originated. Then, mathematicians and programmers were the ones taking the recently developed industrial plotter and utilizing it in ways other than the one for which it was intended. They established an artistic genre by presenting their works at exhibitions and calling it "computer art."

On the other hand, there have been the efforts of (usually politically motivated) artists to take leave of the exhibition venue altogether in order for their works to reach not just an audience of experts but John Q. Public. The thinking here is to dispense with having to outfit these works with a heavy-handed "ATTENTION: Art!" label and instead to undertake subtle irritations designed to stimulate and enrich the perceptual world of passers-by. For the most part, this is not a matter of the public sphere as such but rather of the integration of a specific location. Daniel Buren and Hans Haacke are among the leading lights in this area.

The idea of art in public spaces has been accepted by government officials responsible for cultural policymaking—at least in German-speaking Europe—and is being implemented on a wide scale here just like the various "Art in Architecture" programs that such efforts often closely resemble. In this way, a piece of architecture enters into a dialog with its respective surroundings. People living in an urban setting are subjected to countless stimuli, some of which are artistically intended. We've grown accustomed to being confronted by objects and structures whose meaning isn't immediately obvious, and these interventions constitute a welcome relief from the advertising messages, traffic signs and functional structures with which we are deluged. Moreover, cut-and-dried features can be replaced by solutions that display a great deal of artistic flair as they carry out the concrete tasks of everyday life.

The experience that has been amassed in this field in recent decades applies to an equal extent to the media art projects that are becoming increasingly familiar features in public spaces and on building façades. When it's done right, architecture and media come together to form a holistic entity that was preconceived to work together; in most cases, however, thought isn't given to such projects until well after the architectural blueprints and the spatial use concept have

already been finalized. This state of affairs, in turn, makes it more difficult to come to terms with the physical location and the particular circumstances that are operational there, which is, perhaps for this very reason, the greatest challenge that faces the designers of such projects. This customized rapport with a specific place and, above all, the fulfillment of the responsibility owing to the public that uses it cannot be taken lightly, particularly because the casual pedestrian—in contrast to someone who intentionally visits a museum—doesn't deliberately seek out an encounter with art.

A desirable quality that is highly relevant to the interactive projects in this category is that the involvement of members of the public is as intuitive as possible—that is, completely as a matter of course without thereby diminishing the work's meaningfulness and expressiveness. After all, when the individual partaking of such a work encounters the artifact itself in an unmediated way, then inherent in this experience is the possibility of triggering something unforeseen and addressing new groups of recipients.

An expansion of this state of being attuned to a specific location applies to a recent form of virtual extension of the urban sphere: *location-based services*. Hand-held devices provide access to information networks that completely overlay the cityscape and are increasingly linked up with local media projection surfaces. Media artists are in the process of discovering and exploring this emerging domain as a playing field for their activities. Furthermore, digital architectures are more flexible and thus offer media designers a sort of home-field advantage as they go about developing and implementing new concepts for the configuration of the virtual public sphere. Some frequently cited aims of such projects are eliminating transmitter-receiver hierarchies, installing infrastructure and facilitating access to it.

Now, at a time when the social and technical preconditions seem to be in place to allow media art to pervade all areas and aspects of life, the marketability of *ubiquitous computing* is achieving critical mass in numerous respects, and the emergence of the *realtime city* is being proclaimed, we're interested in scrutinizing the chief protagonists here, their various approaches and the works that are contributing to this development.

Text: Pascal Maresch

Translated from German by Mel Greenwald

Der urbane Raum wird zum multimedialen Environment aufgerüstet – die Digitalisierung hinterlässt ihre Spuren im Stadt-Bild. Der Architektur werden Eigenschaften von Medien übertragen, Ausstattungen durch telematische Möbel bis hin zu Location Based Services bilden Schnittstellen zu virtuellen und materiellen Kommunikationsräumen. In der kreativen Auseinandersetzung jenseits von Werbebotschaft und Dekor zeichnet sich dabei ein wachsendes Bewusstsein für die Medialisierung der Gesellschaft ab. Die Resultate dieser Auseinandersetzungen integrieren sich als subtile Interventionen, aber auch mit der Erfüllung profaner Aufgaben in ihre Umgebung. Mit der Manifestation von Medienkunst außerhalb des Ausstellungskontexts, als Teil der Architektur oder in Form telematischer Umweltgestaltung hat sich eine neue Qualität von Installationen herausgebildet.

Pixelspaces ist die vom Ars Electronica Futurelab veranstaltete Symposiumsreihe, in der aktuelle Strömungen aufgegriffen und aus der Sicht eines Medienlabors diskutiert werden. Im Rahmen von Pixelspaces 2006 *Goblin City* werden Projekte und Ansätze vorgestellt, die sich im Spannungsfeld von Medien, Kunst und öffentlichem Raum bewegen.

Die Diskussion um Kunst im öffentlichen Raum hat ihre Wurzeln in den 1960er Jahren, also in

eben jener Dekade, in der auch die digitale Kunst ihren Ursprung nahm. Es waren Mathematiker und Programmierer, die die gerade erst entwickelten industriellen Plotter zweckentfremdeten. Sie begründeten eine Kunstgattung, indem sie ihre Werke in Ausstellungen präsentierten und diese mit der Bezeichnung „Computerkunst" versahen.

Auf der anderen Seite versuchten meist politisch motivierte Künstler, die Ausstellungsgebäude zu verlassen, um mit ihren Arbeiten nicht ein Fachpublikum, sondern die Menschen auf der Straße zu erreichen. Diese Kunst sollte nicht mit dem Hinweis „Achtung Kunst!" auf sich aufmerksam machen, sondern die gewohnte Wahrnehmungswelt der Passanten durch subtile Irritationen anregen und bereichern. Meist geht es dabei nicht nur um den öffentlichen Raum an sich, sondern um die Einbeziehung des spezifischen Orts.

Die Idee von Kunst im öffentlichen Raum wurde zumindest im deutschsprachigen Raum durch die Kulturpolitik übernommen und kommt, ebenso wie das „Kunst am Bau"-Programm, flächendeckend zum Einsatz. So tritt auch die Architektur in kommunikativen Austausch mit ihrer jeweiligen Umwelt. Der Mensch in seinem urbanen Lebensraum ist einer Unmenge von Reizen ausgesetzt. Wir sind es mittlerweile gewohnt, auf Objekte und Strukturen zu treffen, deren Sinn sich nicht von vornherein offenbart. Diese Interventionen setzen sich ohne Zweifel wohltuend von der Flut an Werbebotschaften, Verkehrsregulierungen und Zweckbauten ab. Darüber hinaus können nüchterne Funktionalitäten auch durch künstlerische Lösungen ersetzt werden.

Die in den vergangen Jahrzehnten gesammelten Erfahrungen gelten in gleichem Maße für Medienkunstprojekte, die zunehmend den öffentlichen Raum und die Fassaden der Gebäude erobern. Im Idealfall bilden Architektur und Medien eine Einheit, indem sie von vornherein gemeinsam konzipiert werden. Meist kommt es jedoch erst zu derartigen Projekten, nachdem der architektonische Entwurf oder das Raumkonzept bereits feststeht. Dieser Umstand erschwert dann wieder die Auseinandersetzung mit dem Ort und den Gegebenheiten, was sich vielleicht gerade deshalb zu einer der dringlichsten Herausforderungen für die Gestalter zu entwickeln scheint. Diese „Ortsbezogenheit" und vor allem aber auch die Verantwortung gegenüber der Öffentlichkeit ist nicht von der Hand zu weisen, insbesondere, weil sich der Passant der Konfrontation mit Kunst, im Gegensatz zum zielgerichteten Besucher einer Ausstellung, nicht willentlich aussetzt.

Eine weitere für diese Kategorie teils interaktiver Projekte relevante Eigenschaft ist die möglichst intuitive Involvierung – das Funktionieren *en passant*, ohne dabei an Aussagekraft einzubüßen. Denn, trifft der Rezipient auch unvermittelt auf das Artefakt, so birgt das auch die Chance, Unvorhergesehenes auszulösen und neue Personenkreise anzusprechen.

Eine Erweiterung der „Ortsbezogenheit" betrifft eine jüngere Form virtueller Ausdehnung des urbanen Raums – Location Based Services. Mobile Endgeräte bilden die Schnittstellen zu den die Städte überlagernden Informationsnetzwerken und werden zunehmend mit den Medienoberflächen der Umgebung verwoben. Die Medienkunst hat diese erst im Entstehen begriffene Welt als Spielwiese für sich entdeckt. Digitale Architekturen sind flexibler, und die Mediengestalter befinden sich hier gewissermaßen auf eigenem Terrain, wo sie neue Konzepte für den Ausbau des virtuellen öffentlichen Raums entwickeln und umsetzen. Immer wiederkehrende Zielsetzungen sind das Eliminieren der Hierarchien von Sender und Empfänger, das Aufbauen von Infrastruktur und das Öffnen von Zugängen zu deren Nutzung.

Jetzt, in einer Zeit, in der die gesellschaftlichen und technischen Voraussetzungen für ein Vordringen der Medienkunst in alle Lebensbereiche gegeben zu sein scheinen, *Ubiquitous Computing* in vielerlei Hinsicht Marktfähigkeit erreicht und die *Real-time City* proklamiert wird, interessieren uns die Akteure, ihre unterschiedlichen Ansätze und die Arbeiten, die zu dieser Entwicklung beitragen.

Text: Pascal Maresch

James Powderly, Evan Roth
and all the agents of the GRL (U.S., the Eyebeam R&D OpenLab)

The Graffiti Research Lab

The modern city is characterized by aggressive neon signage and in-yer-face bill-boards that can be seen as a proxy for the commercialization of our society. In response, Graffiti Research Lab has developed an arsenal of technologies like LED throwies, graffiti-writing caption software and mobile urban projectors that allow individuals to stake their own claim to a piece of the cityscape. Affordable DIY components facilitate a form of urban protest that carries on the graffiti tradition using state of the art high tech.

Die Stadt der Gegenwart ist gekennzeichnet von aggressiven Leuchtreklamen und Plakaten, die stellvertretend für die Kommerzialisierung unserer Gesellschaft stehen. Das Graffiti Research Lab hat im Gegenzug dazu verschiedene Technologien wie LED Throwies, Graffiti-schreibende Caption-Software oder mobile urbane Projektoren entwickelt, die es dem Individuum ermöglichen, Raum in einer Stadt für sich zu beanspruchen. Kostengünstige D.I.Y.-Komponenten erlauben eine Form des urbanen Protests, der die Tradition von Graffitis mit neuer Elektronik und Technik verquickt.

Prix Ars Electronica 2006, Award of Distinction, Interactive Art

■ *THE G.R.L. School Bus*

At the 2006 Maker's Faire in San Mateo, California, the Graffiti Research Lab purchased, painted and outfitted a 40-foot 1974 school bus with graffiti technologies. The GRL, including agents Michelle Kempner, Huong Ngo, James Powderly, Todd Polenberg and Evan Roth, along with over 1000 workshop participants, installed LED throwies, several electro-grafs and LED spinners on the black bus, while 100s of children and adults caught their tags with markers and paint.

Auf der *2006 Maker's Faire* im kalifornischen San Mateo erstand das Graffiti Research Lab einen zwölf Meter langen Schulbus, Baujahr 1974, bemalte ihn und stattete ihn mit Graffititechnik aus. Das G.R.L. mit Agents wie Michelle Kempner, Huong Ngo, James Powderly, Todd Polenberg und Evan Roth installierte gemeinsam mit über tausend Workshopteilnehmern LED-Throwies, mehrere Electro-Grafs und LED-Spinners auf dem schwarzen Bus, während hunderte von Kindern und Erwachsenen ihre Tags mit Markern und Farbe hinterließen.

JESUS 2.0 on the corner of Lafayette and Kenmare

D.C. street artist Mark Jenkins collaborated with the GRL to create and install Jesus 2.0. Using a number of his tape sculptures, LED throwies and a really long pole, Mark and agents of the GRL brought about the second-coming in the streets of New York City.

Der Washingtoner Straßenkünstler Mark Jenkins hat zusammen mit dem G.R.L. *Jesus 2.0* geschaffen und installiert. Mittels einiger seiner Klebebandskulpturen, LED-Throwies und eines sehr langen Pfahls verlegten Mark und Agents des G.R.L. die Wiederkehr in die Straßen von New York City.

AMERIKA1

The writer Katsu catching a 36 foot long and 15 foot tall AMERIKA1 throw-up in the lab using the GRL developed *High-Writer* (featured in the foreground of the image). The *High-Writer*, developed by agents Powderly and Roth, is a 6–12 foot telescoping pole with a spray can mounted on top that can be triggered by a repurposed bicycle braking system. Instructions for making the High-Writer can be found at *http://graffitiresearchlab.com*

Katsu beim Erstellen eines 11 Meter langen und 4,5 Meter hohen *AMERIKA1*-Throw-Up mit dem vom G.R.L. entwickelten *High-Writer* (im Vordergrund des Bilds zu sehen). Der *High-Writer* wurde von den Agents Powderly und Roth entwickelt: Eine Sprühdose wird auf einem von 1,8 Meter auf 3,6 Meter ausfahrbaren Teleskopstab montiert und mittels einer umfunktionierten Fahrradbremse betätigt. Die Bauanleitung für den *High-Writer* findet man auf *http://graffitiresearchlab.com*.

Kai Kasugai, Philipp Hoppe

denCity.net —augmented urbanism

In *denCity.net* urban places and objects are tagged with QR-codes (~ barcodes), giving them a virtual address. All tags are virtually interlinked by *denCity.net*. The tags contain the respective location's ID and GPS coordinates: smoothly combining the virtual with the real, each tag in *denCity.net* has a physical location.

denCity.net examines the enrichment of real urban sites by a virtual dimension of information and networking. The project explores the territorialization of the virtual and the deterritorialization of the physical, *en route* to an augmented perception of urban reality and density.

Im Rahmen des Projekts *denCity.net* erhalten urbane Plätze und Objekte QR-Codes (Barcodes) und damit eine virtuelle Adresse. Sämtliche Tags werden durch *denCity.net* virtuell miteinander verbunden und enthalten eine ID und die GPS-Koordinaten der jeweiligen Örtlichkeit: Dadurch wird das Virtuelle in selbstverständlicher Weise mit dem Realen verbunden, wobei jedem Tag ein konkreter Ort zugeordnet ist.

denCity.net untersucht, wie sich reale urbane Plätze durch die virtuelle Dimension von Information und Vernetzung bereichern lassen. Das Projekt erforscht die Territorialisierung des Virtuellen und die Deterriorialisierung des physisch erfahrbaren Raums im Hinblick auf eine intensivierte Wahrnehmung urbaner Realität und Dichte.

Dan Phiffer / Mushon Zer-Aviv

ShiftSpace—a public space on the web

Having wandered for years in an owner-centric Cyberspace, where do we turn for online public spaces? Using a loosely coupled network of distributed proxies, *ShiftSpace* seeks to provide a new set of collective virtual spaces built above the existing tunnels and stations that make up our hypertextual subway system. We are building an Open Source meta-web and we would enjoy your company.

ShiftSpace is currently developed in NYU's Interactive Telecommunication Program.
ShiftSpace is supported through a grant given by the Swiss Confederation.

Jahrelang haben wir uns durch einen besitzorientieren Cyberspace bewegt – wo aber finden wir öffentliche Räume im Netz? Mittels eines lose gekoppelten Netzwerks verteilter Proxyserver versucht *ShiftSpace* eine neue Reihe kollektiver virtueller Räume über den vorhandenen Tunnels und Stationen unseres hypertextuellen U-Bahnsystems zu konstruieren. Wir kreieren ein Open-Source-Meta-Web und freuen uns über jeden Besucher.

ShiftSpace wird derzeit im Interactive Telecommunication Program der New York University entwickelt und von der Schweizer Eidgenossenschaft unterstützt.

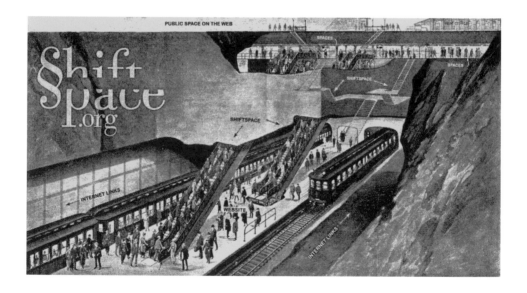

Pascal Maresch

Maren Richter

Ist Linz schön?
Linz 2009—European Capital of Culture

Ist Linz schön? (Is Linz Beautiful?) is a project marking Linz's selection as European Capital of Culture 2009. Already in advance of this event, the project is endeavoring to confront the urban space with its emotional, social, economic and political currents.

The programmed change from industrial city to cultural center has shaped Linz in many ways during the past decades. The residents of Linz have now been called on to describe their relationship to their city and to actively participate in the processes that are developing in the effort to build a local cultural identity for the city by 2009.

Ist Linz schön? invites people to engage in reflection and discussion. Commentaries as well as image and audio files can be posted on the website of the same name.

Shortly after project launch, an anonymous actor documented how the concept works by leaving behind a record of the question in the form of graffiti on a controversial city wall.

Ist Linz schön? ist ein Projekt zur Kulturhauptstadt Europas Linz 2009. Schon im Vorfeld sucht das Projekt die Auseinandersetzung mit dem urbanen Raum und seinen emotionalen, sozialen, ökonomischen und politischen Aufladungen.

Der programmierte Wandel von der Industriestadt zur Kulturstadt prägte Linz in den letzten Jahrzehnten in mehrfacher Weise. Die Bewohner von Linz wurden jetzt aufgerufen, ihr Verhältnis zu Linz zu benennen und aktiv in die Prozesse einzugreifen, die sich rund um die Bestrebungen entwickeln, bis 2009 eine lokale kulturelle Identität der Stadt aufzubauen.

Ist Linz schön? lädt ein zur Reflexion und Diskussion. Kommentare, Bild- und Audiofiles können auf der gleichnamigen Webseite gepostet werden.

Ein Unbekannter hat kurz nach Projektstart das Funktionieren des Konzepts dokumentiert, indem er die Frage aufgegriffen und als Graffiti auf einer umstrittenen Mauer im Stadtbild hinterlassen hat.

Carlo Ratti, Burak Arikan
SENSEable City Laboratory, MIT

The real-time city is now real! The increasing deployment of sensors and hand-held electronics in recent years is allowing a new approach to the study of the built environment. The way we describe and understand cities is being radically transformed—alongside the tools we use to design them and impact on their physical structure. Studying these changes from a critical point of view and anticipating them is the goal of the *SENSEable City Laboratory*, a new research initiative at the Massachusetts Institute of Technology.

The *Real Time Rome* project, shown here, uses aggregated data from cell phones, buses and taxis in Rome to better understand urban dynamics in real time. By revealing the pulse of the city, the project aims to show how technology can help individuals make more informed decisions about their environment. In the long run, will it be possible to reduce the inefficiencies of present day urban systems and open the way to a more sustainable urban future?

Real Time Rome was developed by MIT SENSEable City Lab for the Venice Biennale 2006 with Telecom Italia as principal sponsor.

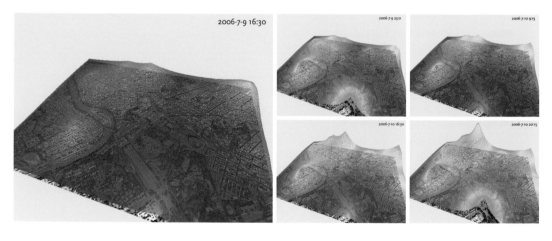

2006-7-9 16:30 · 2006-7-9 23:0 · 2006-7-10 9:15 · 2006-7-10 16:30 · 2006-7-10 20:15

Real Time Rome / Software 2: Pulse—Average cellphone users distribution on the satellite image of the city of Rome. The final match of the World Cup 2006 was played on July 9th, from 8 to 10 pm approximately. Afterwards, people started celebrating around the Circo Massimo in Rome, shown in the image. The following day the Italian winning team arrived in Rome and celebrations continued from the afternoon till morning.

Die Stadt in Echtzeit ist nun Realität! Die rasante Verbreitung von Sensoren und tragbaren Elektronikprodukten in den letzten Jahren ermöglicht neue Methoden in der Erforschung der Raumentwicklung. Unser Verständnis und die Beschreibbarkeit von Städten wird durch die Instrumente, die wir zu ihrer Gestaltung und zur Beeinflussung ihrer Struktur verwenden, radikal verwandelt. Das Ziel des SENSEable City Laboratory, einer neuen Forschungsinitiative des Massachusetts Institute of Technology (MIT), ist die kritische Erforschung und Antizipation dieser Veränderungen.

Real Time Rome verwendet Nutzerdatensammlungen von Mobiltelefonen, Bussen und Taxis in Rom, um die urbane Dynamik in Echtzeit besser verstehen zu können. Das Projekt macht den Rhythmus der Stadt evident und versucht dadurch zu zeigen, wie die Technik dem Einzelnen helfen kann, Informationen für Entscheidungen hinsichtlich seiner Umgebung zu nutzen. Wird es auf lange Sicht möglich sein, die Unzulänglichkeiten der heutigen urbanen Systeme zu reduzieren und den Weg für eine nachhaltigere urbane Zukunft zu bahnen?

Real-Time-Rome wurde mit Unterstützung von Telecom Italia vom SENSEable City Lab am Massachusetts Institute of Technology (MIT) für die Biennale von Venedig 2006 entwickelt.

Director of the SENSEable City Laboratory: Carlo Ratti
Director of the Real-Time-Rome project: Andres Sevtsuk
Visual Software Designer: Burak Arikan
Team: Assaf Biderman, Francesco Calabrese, Filippo Dal Fiore, Saba Ghole, Daniel Guatierrez, Sonya Huang, Sriram Krishnan, Justin Moe, James Patten, Francisca Rojas, Najeeb Marc Tarazi

Andrew Shoben
▬ Greyworld

Greyworld explores the potential of small interventions, embedded in the urban fabric of a public space, to allow some form of self-expression in areas of the city that people see everyday, but normally exclude and ignore. Their work strives to establish special intimacies through the unexpected articulation of objects installed in public spaces—to "short circuit" both the environmental and social expectations supplied by the surrounding urban realm.
Andrew Shoben is willing to share his passion for a new kind of public art that responds to, and reflects, the diversity of life lived in and around a public space. Public art that places the viewer at the centre of the creative experience, and offers a glimpse into another magical layer of reality.

Greyworld erforscht die Möglichkeiten einfacher, in das urbane Geflecht eines öffentlichen Platzes eingebetteter Interventionen, die es erlauben, sich in diesen täglich wahrgenommenen, aber für gewöhnlich ausgeblendeten und ignorierten Bereichen der Stadt in einem gewissen Rahmen auszudrücken. *Greyworld* versucht, durch die unerwartete Artikulation von auf öffentlichen Plätzen installierten Objekten eine besondere Intimität erzeugen und damit die vom städtischen Umfeld angebotenen Umwelt- und Sozialerwartungen „kurzzuschließen".
Andrew Shoben möchte seine Begeisterung für eine neue öffentliche Kunst weitergeben, die auf die Vielfalt des in und um öffentliche Plätze gelebten Lebens reagiert und sie widerspiegelt. Eine Kunst, die den Betrachter ins Zentrum der kreativen Erfahrung rückt und ihm so einen Blick in eine andere, magische Schicht der Wirklichkeit werfen lässt.

The Source
The Source, an eight-storey-high kinetic sculpture, is the new symbol for the London Stock Exchange. Every morning, millions of viewers around the world will watch the installation come to life, signifying the opening of the London Markets.
The Source is formed by a grid of cables arranged in a square, 162 cables in all, reaching eight stories to the glass roof. Nine spheres are mounted on each cable, and are free to move independently up and down its length. In essence the spheres act like animated pixels, able to model any shape in three dimensions—a fluid, dynamic, three-dimensional television.

Visitors to the atrium are greeted by this motion: its particles rising and falling, generating an infinite range of figurative and abstract shapes that rise, dissolve, and reform at different heights in the atrium. The shape of the sun rising on a new day of trade, the names and positions of currently traded stocks, the DNA helix at the centre of life formed by the work, and floating in the 32 meter void of the atrium. This complex and sophisticated installation is a microcosm of activity, a living reflection of market forces.

Die acht Stockwerke hohe kinetische Skulptur *The Source* ist das neue Wahrzeichen der Londoner Börse. Jeden Morgen verfolgen Millionen Menschen rund um den Globus, wie die Installation – und mit ihr der Londoner Marktplatz – zum Leben erwacht.
Die quadratisch angeordneten 162 Seile von *The Source* sind über acht Etagen bis zum Glasdach gespannt. Auf jedem Seil sind neun frei bewegliche Kugeln montiert, die als animierte Pixel jede dreidimensionale Figur modellieren können – ein dynamisch fließender 3D-Fernseher.
Besucher des Atriums werden von den aufsteigenden und herabfallenden Partikeln begrüßt, die unendlich viele figürliche oder abstrakte Formen generieren, aufsteigen, sich auflösen und in anderer Höhe erneut formieren: als Sonne, die an einem neuen Handelstag aufgeht, als die Bezeichnungen und Positionen aktuell gehandelter Aktien, als DNA-Helix im Zentrum des Lebens, das die in der 32 Meter hohen Weite des Atriums schwebende Arbeit darstellt.
Diese komplexe, ausgeklügelte Installation bildet einen Mikrokosmos der täglichen Aktivität, ein lebendiges Spiegelbild der Marktkräfte.

Bins and Benches

Five bins and four benches have been injected with a magic serum of life so that they can break free from their staid and fixed positions to roam free in a public square in Cambridge.

Travelling free and happy in their natural environment, they move and flock, drifting across the space. They frolic with the other species that inhabit their world, exploring their plaza. Each bin or bench has its own personality and impulses—if it's raining, a bench may decide to park up under a tree waiting for someone to sit on it; whilst on a Wednesday, the bins will line up waiting to be emptied. Occasionally, they will all burst into song with the bins forming a baritone barbershop quintet and the benches a high soprano choir.

The work of art was completed in July 2006 and it is a permanent feature outside the Junction Theatre in Cambridge. It is open to the public seven days a week.

Fünf Mülleimern und vier Bänken wurde ein magisches Lebensserum geimpft, so dass sie ihren angestammten Standplatz verlassen haben und sich frei auf einem öffentlichen Platz in Cambridge herumbewegen.Frei und glücklich durchwandern sie ihre Umgebung, eilen und sammeln sich und treiben im Raum. Sie tollen mit den anderen Individuen herum, die ihre Welt bewohnen, und erkunden ihren Platz. Jeder Mülleimer und jede Bank hat eine eigene Persönlichkeit: Bei Regen etwa stellt sich eine Bank unter einen Baum und wartet auf jemanden, der sich hinsetzt. Dagegen stellen sich die Mülleimer am Mittwoch in einer Reihe zum Ausleeren auf. Und gelegentlich stimmen sie ein gemeinsames Lied an, mit den Mülleimern als Barbershop-Baritonquintett und den Bänken als Sopranchor.

Die Arbeit wurde im Juli 2006 vollendet und ist als permanente Installation am Junction Theatre in Cambridge zu sehen.

Worldbench

Worldbench is an ambitious art installation that uses park benches to unite locations around the world—from Berlin to Newcastle, London to Cape Town.

Each installation is situated in a school and consists of a bench placed next to a wall, onto which is projected the mirror image of the bench. However, whilst one side of the bench may be in the grey playground of a primary school in Newcastle, the other is in the sun-baked playground of a school in Cape Town. The people sitting on the bench can have an idle conversation, may discuss their lunch, or perhaps indulge in a little light flirtation, which they might have done, had they been sitting on the *same* bench, and were *not* separated by thousands of miles.

Several benches have been installed in five schools across the UK, one in a dynamic interracial primary school in Cape Town, and another in a secondary school in Berlin.

In der Installation *World Bench* verbinden Parkbänke Orte auf der ganzen Welt, von Berlin bis Newcastle und von London bis Kapstadt. Sämtliche Parkbänke sind in Schulen installiert und stehen jeweils an einer Wand, auf die ein Spiegelbild einer Bank projiziert wird. Allerdings kann die eine Bank z. B. auf dem grauen Spielplatz einer Grundschule in Newcastle stehen, während die andere in der Gluthitze eines Schulhofs in Kapstadt zu finden ist. Die Menschen auf der Bank können sich über Belanglosigkeiten wie das Mittagessen unterhalten, oder in einen kleinen Flirt verwickelt sein, den sie auch hätten, würden sie gemeinsam auf derselben Bank und nicht tausende von Meilen voneinander entfernt sitzen.

In Großbritannien wurden Bänke in fünf Schulen installiert, eine Bank steht in einer dynamischen gemischtrassigen Grundschule in Kapstadt und eine weitere in einer höheren Schule in Berlin.

Railings

Railings plays on the simple pleasure of picking up a stick and running it along a set of railings to make a lovely "clack-clack-clack" sound. We tuned the railings so that they play "The Girl from Ipanema" when you run a stick along them.

Railings spielt mit dem einfachen Vergnügen, mit einem Stock einen Zaun entlang zu fahren und diesen netten „klack-klack-klack"-Sound zu erzeugen. Wir haben Zäune so gestimmt, dass beim Entlangfahren mit dem Stock *The Girl from Ipanem* erklingt.

320

Toshio Iwai

Creating Digital Public Art

SOUND-LENS, 2001

Ever since Edison invented the light bulb in the 19th century, countless types of artificial lights flood the city. Although uneventful looking, these lights constantly blink on and off or change their intensity in a certain frequency. This, however, is invisible to our eyes. *SOUND-LENS*, a portable device resembling a walkman, converts these high frequency transitions of light directly into sound, creating an amazing fusion of light and sound, in other words integrating sight and hearing. When we listen to light using the *SOUND-LENS*, our sensory organs can enter another dimension, allowing us to experience the world from a totally different aspect.

Seit Edison im 19. Jahrhundert die Glühbirne erfand, überflutet künstliches Licht in unzähligen Varianten die Stadt. So unauffällig diese Lichter sind, sie blinken permanent und wechseln ihre Intensität in einer bestimmten Frequenz, was jedoch unterhalb unserer Wahrnehmungsschwelle liegt. *SOUND-LENS*, ein an einen Walkman erinnerndes, tragbares Gerät, wandelt diese Hochfrequenzübergänge des Lichts direkt in Sound um, wodurch eine erstaunliche Verschmelzung von Licht und Ton oder, anders ausgedrückt, eine Synthese von Sehen und Hören entsteht. Wenn wir dem Licht mit Hilfe der *SOUND-LENS* „zuhören", können wir mit unseren Sinnen die Welt unter einem völlig neuen Gesichtspunkt betrachten.

Another Time, Another Space in Marunouchi, 2002

This large-scale public interactive installation was installed for the grand opening of the Marunouchi building in Tokyo in 2002. With tens of thousands of people passing through this public space every day, I wanted to make a piece with a high participation factor, which anyone could easily interact and perform with. Video imagery was stored in the memory of a computer, and then shown through a computer program, turning it into a strange flow of time. This work was based on an installation which I exhibited in Antwerp Central Station for the EC Japan Feest for cultural exchange between Japan and Belgium in 1993.

Diese groß angelegte, interaktive Installation entstand 2002 anlässlich der Neueröffnung des Marunouchi-Gebäudes in Tokio. Ich wollte mit den zehntausenden Menschen, die täglich über diesen öffentlichen Platz strömten, ein Projekt mit einem partizipatorischen Ansatz realisieren, bei dem jeder Einzelne mühelos interagieren und auftreten konnte. Videostreams wurden am Computer gespeichert und dann per Software präsentiert, wodurch ein seltsamer Zeitfluss entstand. Diese Arbeit basiert auf einer Installation, die ich 1993 im Antwerpener Hauptbahnhof für das EU-Japan-Fest realisiert habe, das unter dem Motto des kulturellen Austauschs zwischen Japan und Belgien stand.

BloombergICE, 2002

This is a permanent installation designed for a Bloomberg showroom, the international information agency in Tokyo. The basic idea of *BloombergICE* is to show the aesthetic and playful use of information. This large glass icicle translates stock exchange data into moving graphics, so that anyone can understand the ups and downs of Wall Street without any difficulty. In addition, there are 800 infrared sensors with an LED display behind the screen. People can enjoy manipulating light and sounds by moving their hands and body, without any direct physical contact. There are various games and experiences—a digital harp, a wave generator or electronic volleyball, for example. This work was created in collaboration with Klein Dytham architecture.

Dies ist eine permanente Installation, die für einen Showroom der internationalen Informationsagentur Bloomberg in Tokio entworfen wurde. Die Grundidee von *BloombergICE* ist es, einen ästhetischen und verspielten Umgang mit Informationen zu zeigen. Ein großer Eiszapfen aus Glas setzt Börsendaten in bewegte Grafiken um, sodass jeder das Auf und Ab an der Wall Street problemlos nachvollziehen kann. Hinter einer Projektionswand befinden sich 800 Infrarotsensoren mit LED-Display, wodurch man Licht und Sound ohne Berührung, nur durch Hand- und Körperbewegungen spielerisch manipulieren lassen. Man kann verschiedene Spiele auswählen – etwa eine digitale Harfe, einen Wavegenerator oder elektronisches Volleyball –, die neue Erfahrungen ermöglichen. Dieses Projekt entstand in Zusammenarbeit mit dem Architekturbüro Klein Dytham.

Aus dem Englischen von Martina Bauer und Michael Kaufmann

Ars Electronica Futurelab

WikiMap

The communications project that the Ars Electronica Futurelab developed in 2005 for the City of Linz's *Hotspot* initiative has quickly spawned spin-offs and an interesting enhancement application. Now, there's also a WikiMap Madrid (produced in cooperation with MediaLabMadrid) and a WikiMap Europe (featuring statistical data and individuals' opinions about the EU) as well as a WikiMap for regional online community projects in Upper Austria. With the latest development various WikiMaps can be directly implemented in Google Earth.

Das im Jahr 2005 vom Ars Electronica Futurelab fur die *Hotspot* Initiative der Stadt Linz realisierte Kommunikationsprojekt hat sich rasant weiterentwickelt. In der Zwischenzeit ist auch eine WikiMap Madrid (in Zusammenarbeit mit dem MediaLabMadrid entstanden), ebenso eine WikiMap Europe (mit statistischen Daten und individuellen Meinungen zur EU) und eine WikiMap für regionale Online-Kommunikationsprojekte in Oberösterreich. Die jüngste Entwicklung ermöglicht es, die verschiedenen WikiMaps auch direkt in Google Earth zu implementieren.

Development: Ars Electronica Futurelab
Commissioned by the City of Linz (WikiMap Linz), Federal Chancellery of Austria (WikiMap Europe),
Provision: BMBWK, Land Oberösterreich (WkiMap Upper Austria) Cartographic material and support: Magistrat Linz,
Informationstechnologie, Geodaten Management,
Stadtkommunikation Linz, MediaLabMadrid, EUROSTAT, Statistik Austria, Land Oberösterreich: DORIS

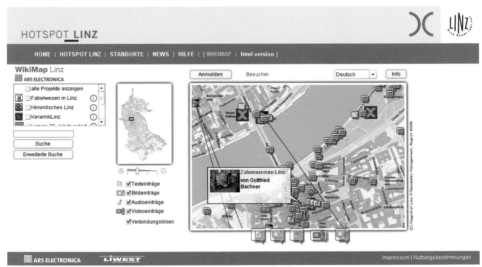

WikiMap Linz, *http://wikimap.hotspotlinz.at/*

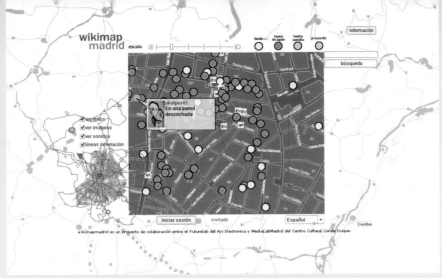

WikiMap Madrid, *http://www.wikimap.es/*

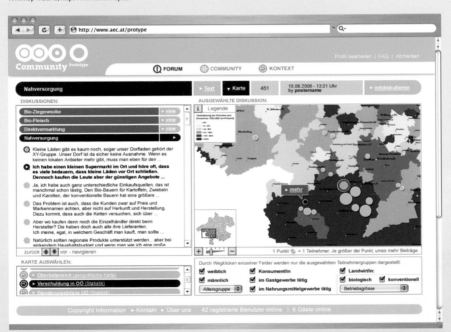

Provision Wikimap, *http://www.aec.at/protype*

Google Earth, *http://www.aec.at/wikimap/googleearth-linz*

Google Earth, *http://www.aec.at/wikimap/googleearth-linz*

325

Theater and New Technologies

One important part of the Ars Electronica Futurelab's mission is to experiment with the widest possible array of new technological applications in as many areas of creativity as possible. This is the background of the collaborative efforts the Futurelab has undertaken with the Phönix Theater Linz since 2005. This play for youngsters by Franz Schwabeneder based on Ray Bradbury's sci-fi short story is enhanced by interactive stage elements and stereoscopic computer animation.

Experts from the Ars Electronica Futurelab are enhancing this piece's dramaturgy via virtual expansion of the stage set. Futurelab staffers aren't just providing the technology that makes this production possible; they're endowing this theatrical performance with what amounts to an additional artistic level. In an effort undertaken especially for the *The Electric Grandmother*, they gathered ideas and inspiration from kids attending Ars Electronica workshops and young participants in the 2006 Prix's u19 freestyle computing category to create scenographic elements in the form of computer-animated film footage. This material will be projected stereoscopically and blend together with the classical performance elements to form a media art theatrical production.

The Electric Grandmother
By Franz Schwabeneder. Based on a short story by Ray Bradbury.
For audiences age 7 and up.

Her name is Cecily and her serial number is 0000214. She's the first humanoid model-microcircuit-biocommunications-activity-electrical-grandmother. She was created by famed robotics engineer Guido Fantoccini to be a helpful companion—for example, to a family that had lost its mother. This is the very blow that fate had delivered to Thaddäus, his daughter Agatha and his sons Thomas and Timo. So, one evening, Guido Fantoccini arrives by flymobile to bring the

family an electric grandmother. The granny-robot takes over the organization of the household and assumes the childrearing duties in word and in deed. After all, she's the result of state-of-the-art programming and possesses an immense body of knowledge in virtually all areas of life. At first, Agatha is not the least bit happy with the new "family member" since she fears that the "android box" will repress her memory of her beloved mother, but the electric grandmother also knows how to deal with the pain a child feels. On the other hand, Timo, the youngest member of the family, has discovered that his new granny is absolutely wonderful at telling stories, and these exciting tales nurture his enormous talent as an inventor. Together with his brother Thomas, he builds a tunnel designed for "digital teleportation," but there's dreadful danger lurking at the end of this tunnel. And if it wasn't for the electric grandmother ...

Translated from German by Mel Greenwald

Director: Franz Schwabeneder; Artistic Advisor: Ioan C. Toma; Cast: Randolf Destaller, Gabriele Deutsch, Thomas Pohl, Christian Scharrer, Waltraud Starck; Sets/Props: Bonnie Tillemann; Lighting: Erich Uiberlacker; Virtual Staging: Ars Electronica Futurelab / Christine Pilsl, Christopher Lindinger, Andreas Jalsovec, Stefan Schilcher
The Electric Grandmother is a cooperation of Phoenix Theater, Linz and Ars Electronica and was premiered at Schäxpir 2006 International Theater Festival. Thanks to the Museum of the Province of Upper Austria.

Theater und Neue Technologien

Für das Ars Electronica Futurelab ist es von besonderer Bedeutung, in möglichst vielen und unterschiedlichen Bereichen den kreativen Einsatz von neuen Technologien zu erproben und zu erforschen. Vor diesem Hintergrund wurde 2005 die Kooperation zwischen dem Ars Electronica Futurelab und dem Phönix Theater Linz begründet. Dieses Theaterstück für Kinder von Franz Schwabeneder, das auf einer Science Fiction Story von Ray Bradbury beruht, wird um interaktive Bühnenelemente und stereoskopische Computeranimationen erweitert.

Experten des Ars Electronica Futurelab unterstützen die Dramaturgie des Stücks durch eine virtuelle Erweiterung des Bühnenraums. Neben der technologischen Umsetzung gestaltet das Labor eine zusätzliche künstlerische Ebene der Theateraufführung: Speziell für *Die elektronische Großmutter* kreiert das Team unter Einbezug der Impulse von Kindern aus Workshops und dem u19-Freestyle Computing Wettbewerb 2006 szenografische Elemente in Form von Computeranimationen. Sie werden stereoskopisch projiziert und verschmelzen mit der klassischen Aufführungspraxis zu einer medienkünstlerischen Theaterinszenierung.

Die Elektronische Großmutter
Bühnenstück von Franz Schwabeneder. Nach Ray Bradbury. Für alle ab 7.

Sie heißt Cecily und trägt die Markennummer 0000214. Sie ist die erste Humanoid-Modell-Ministromkreis-Biokommunikations-Activity-Elektrische-Großmutter und wurde vom berühmten Roboterkonstrukteur Guido Fantoccini erschaffen, um zu helfen. Zum Beispiel einer Familie, die die Mutter verloren hat. Dieses Schicksal hat Thaddäus, seine Tochter Agatha und seine Söhne Thomas und Timo ereilt. Eines Abends also bringt Guido die elektrische Großmutter mit seinem Flugmobil zu der Familie. Die Roboter-Oma übernimmt die Organisation des Haushalts und steht den Kindern mit Rat und Tat zur Seite, denn schließlich ist sie top programmiert und verfügt in nahezu allen Lebensbereichen über immenses Wissen. Agatha hat zunächst gar keine Freude mit dem neuen „Familienmitglied" – sie befürchtet, die „Androidenschachtel" würde Erinnerungen an die geliebte Mutter verdrängen, aber die elektrische Großmutter weiß auch mit dem Schmerz eines Kindes umzugehen. Timo, der Jüngste der Familie, hat in der neuen Oma eine wunderbare Geschichtenerzählerin gefunden. Ihre spannenden Erzählungen fördern sein riesiges Erfindertalent: Mit seinem Bruder baut er einen Tunnel für die „digitale Teleportation". Doch am Ende des Tunnels droht schreckliche Gefahr. Wenn da nicht die elektrische Großmutter wäre ...

© Christian Herzenberger

Christine Schöpf / Dietmar Offenhuber

Ars Electronica Animation Festival

"I waited for technology to catch up with my vision," is a frequently quoted line from George Lucas, one of the great masterminds of the cinema. Early works turned out by Lucas' special effects factory, Industrial Light & Magic (ILM)—films like *Young Sherlock Holmes, Abyss, Terminator 2* and *Jurassic Park*—are all examples of the pursuit of this course. Each film was the outcome of the next step in software development, advances in the depiction of, for instance, light, natural materials, motion and facial expressions. And in each one, the proportion of digital imagery grew steadily longer: from only 6 minutes in *Jurassic Park* to, a couple of years later, a full 40 minutes in *Casper* (also from ILM). Parallel to this development, pure computer animation was also making rapid progress; the 1995 release of *Toy Story* by Pixar Studios meant that the first such feature film had reached the big screen.

At that time, it was no doubt also a keen interest in technology that led to the reception of the film's story being supplemented in many cases with publications providing highly detailed descriptions of the various hardware and software used, as well as documentaries chronicling the "makings of."

And today—12, 15 years later? Aside from specialists in the field, who's interested nowadays in "how'd-they-do-that" and "what'd-they-use"? One describes in and with images and not with techniques. Our communication is defined by digital imagery, and our perception of the real worlds that surround us is based on an almost endless world of images. All the facets across the board of everyday life—politics, social phenomena, statistical data, lifestyle, gaming, shopping, fashion, entertainment, etc.—have their place in a descriptive catalog of different languages of forms. Even the imagining of unreal worlds and creatures is subject to hardly any limitations— "merely" ones imagination, that's all.

Approximately 1,000 films—major Hollywood productions, creative TV commercials, shorts, experimental videos and individual motion picture miniatures from 71 countries around the world, as well as works by Austrian youngsters age 19 and under that were submitted for prize consideration to the 2006 Prix Ars Electronica, illustrate the entire multicultural bandwidth of contemporary animated filmmaking.

Each year, the 15 best works will be singled out for recognition with prizes and awards of recognition.

Plus, with 11 hours of selected films, the Computer Animation Festival will provide a comprehensive look at the current state of cinematic creativity on both a commercial and an artistic level.

Translated from German by Mel Greenwald

Christine Schöpf / Dietmar Offenhuber

Ars Electronica Animation Festival

„Ich habe auf die Technologie gewartet, mit der ich meine Vorstellungen umsetzen kann." Ein viel zitierter Ausspruch des großen Kino-Vordenkers George Lucas. Filme wie *Young Sherlock Holmes, Abyss, Terminator 2, Jurrassic Park* – allesamt frühe Beispiele aus dessen Effekt-Schmiede Industrial Light & Magic (ILM) – stehen als Beispiele auf diesem Weg. Jeder Film war ein neuer Schritt in der Softwareentwicklung (das eine Mal war es das Licht, das andere Mal die naturgetreuen Materialien, Motion Capture, Mimik etc.), und immer länger war der Anteil digitaler Bilder: Sechs Minuten kamen bei *Jurrassic Park* aus dem Computer, und zwei Jahre danach waren es schon ganze 40 Minuten in *Casper* (ebenfalls ILM). Parallel dazu machte die reine Computeranimation rapide Fortschritte, und 1995 kam mit *Toy Story* aus den Pixar Studios der erste abendfüllende Film in die Kinos.

Dieses dezidierte Interesse an der Technologie sorgte wohl auch dafür, dass zu dieser Zeit oft detailgenaue Hard- und Softwarebeschreibungen und Making-Ofs die Storyrezeption überlagerten.

Und heute – gerademal zwölf, 15 Jahre später? Wer, abgesehen von Spezialisten, fragt heute nach dem Wie und Womit? Man beschreibt in und mit Bildern und nicht mit Techniken. Unsere Kommunikation definiert sich über digitale Bilder, die Wahrnehmung der uns umgebenden realen Welten beruht auf einer nahezu grenzenlosen Bildwelt. Unterschiedlichste Bereiche des alltäglichen Lebens – Politik, gesellschaftliche Phänomene, statistische Daten, Lifestyle, Gaming, Shopping, Fashion, Entertainment etc. – haben ihren Platz in einem Beschreibungskatalog unterschiedlichster Formensprachen. Und auch der Imagination irrealer Welten und Lebewesen sind kaum Grenzen gesetzt, die einzige ist wohl „nur" die Fantasie.

Rund tausend Filme – von Hollywood-Großproduktionen, fantasievollen Werbeclips, Kurzfilmen, Experimentalvideos, individuellen Bild/Bewegungsminiaturen aus 71 Ländern weltweit bis hin zu Produktionen Jugendlicher unter 19 Jahren –, alle eingereicht zum Prix Ars Electronica 2006, illustrieren die multikulturelle Bandbreite der zeitgenössischen Geschichtenerzähler. Die 15 besten Arbeiten daraus werden alljährlich mit Preisen und Anerkennungen ausgezeichnet. Das Computer Animation Festival gibt darüber hinaus mit elf Stunden Programm einen breiteren Einblick in den Status Quo digitalen Filmschaffens auf kommerzieller ebenso wie auf künstlerischer Ebene.

Ars Electronica Animation Festival 2006
Program

■ **Generative Animation**

A program of current artistic examples of processual, program-controlled image design curated by artists Lia (A) and Miguel Carvahais (ES).

Ein von den Künstlern Lia (A) und Miguel Carvahais (ES) kuratiertes Programm aktueller künstlerischer Beispiele von prozesshafter, programmgesteuerte Bildgestaltung.

■ **Prix Selection: Small World Machines**

The world as a fantastic machine whose mechanism does not always obey laws we are capable of grasping. The inhabitants of it are sometimes grains of sand and sometimes tiny gears. A mix of poetic, absurd and occasionally furious miniatures.

Die Welt als fantastische Maschine, deren Getriebe nicht immer nachvollziehbaren Gesetzen folgt. Die Bewohner sind darin mal Sand, mal Rädchen. Ein Mix poetischer, absurder und manchmal bitterböser Miniaturen.

■ **Prix Selection: Exquisite Monsters**

The world of computer animation is inhabited by many different species of monsters—friendly ones and menacing ones too, those that are mechanical, animalistic and human. The computer becomes a genetics lab in which the engineers' inventiveness knows no limits.

Die Welt der Computeranimation wird von Monstern unterschiedlichster Spezies bevölkert, von freundlichen Kreaturen ebenso wie von bedrohlichen, von mechanischen wie von tierischen und menschlichen. Der Computer wird zum Genlabor, der Erfindungsreichtum ihrer Schöpfer kennt keine Grenzen.

■ **Prix Selection: Narration**

Storytelling has always been one of filmmakers' main motivations. Recollections emerge from out of a photo album; roommates discuss some problems that have arisen and encounter the unexpected; an car race charged with tension and excitement; and even discarded alarm clocks, which also have their stories to tell—these narratives relate common and uncommon situations from everyday life!

Geschichtenerzählen war und ist eine der Hauptmotivationen für Filmemacher. Erinnerungen steigen aus einem Fotoalbum hoch, eine Wohngemeinschaft diskutiert anfallende Probleme und kommt dabei auf Unvermutetes, ein spannungsgeladenes Autorennen und auch ausrangierte Wecker haben ihre Geschichte – gewöhnliche und ungewöhnliche Alltagssituationen werden erzählt.

■ **Prix Selection: Visual Effects and Commercials**

There's hardly a feature film or ad spot made today that doesn't utilize special effects. The most common ones are high-speed or highly unusual tracking shots, utopian scenery and death-defying stunts. In some films' credits, the FX crew takes up more footage than all the other technicians combined. This program is a "greatest hits" compilation from recent films and commercials.

Kaum ein Spielfilm, kaum ein Werbeclip existiert ohne Spezialeffekte, seien es rasante wie außergewöhnliche Kamerafahrten, utopische Szenerien oder halsbrecherische Stunts. Im Film-Abspann nehmen die Macher der Effekte oft mehr Platz ein als alle anderen Mitwirkenden am Set zusammen. Dieses Programm ist ein Best-Of aus Film und Werbung der letzten Zeit.

■ **Prix Selection: Time in Motion**

Movement, rhythm, speed and standstill are the ingredients of this program. The spectrum ranges from a chase cartoon to suggestive visual music in which image, color, movement and sound blend together.

Bewegung, Rhythmus, Geschwindigkeit und Stillstand sind in diesem Programm die Ingredienzien. Die Bandbreite reicht vom Chase Cartoon bis zu suggestiver visueller Musik, in der Bild, Farbe, Bewegung und Sound verschmelzen.

■ **Prix Selection: Music Videos**

With the revival of analog trick techniques, the retro look has become totally hot in the music video production field. Rarely in the past has this genre included as much animation as it has in the last two years.

Mit dem Revival analoger Tricktechniken zeigt man sich in der Musikvideo-Branche gerne retro. Selten zuvor waren in diesem Genre so viele Animationen zu sehen wie in den letzten zwei Jahren.

■ **Prix Selection: Monochromatic/b/w**

Color reduction and a language of graphic forms are the characteristics of this program. The content is a highly diverse mix of short stories.

Farbreduktion und grafische Formensprache sind Charakteristika in diesem Programm, das in seinem inhaltlichen Spektrum mit einem Mix unterschiedlicher Shortstories aufwartet.

■ **Prix Selection: Late Night**

A program for night people with a dark sense of humor: offbeat situations, stirring flashes of inspiration and trashy aesthetics assure a thoroughly tolerable chill-out.

Ein Programm für Nachtschwärmer mit schwarzem Humor: schräge Situationen, mitreißende Geistesblitze und trashige Ästhetik gewährleisten den adäquaten Chill-Out.

■ **Freestyle Animation u19**

Participants in the Prix Ars Electronica's annual competition for young people show how it's done. The choice of tools and media is open-ya know, freestyle computing, just like it sez. And the stuff these talented young animators and up-and-coming directors have come up with is really cool. This "best of" lineup was curated by Sirikit Amman, member of the u19 jury.

Wo es lang geht, demonstrieren die jungen TeilnehmerInnen des Prix Ars Electronica alljährlich im Jugendbewerb. Die Wahl der Mittel ist frei – freestyle computing eben. Und zunehmend lassen die Einreichungen großartige kommende Regisseure und Animationstalente erwarten. Das von Sirikit Amman kuratierte Programm ist ein Best-of der letzten Jahre.

■ **Japanese Animation**

Visual imaginativeness and unconventional narrative forms characterize animation made in Japan. This program curated by the *Media Arts Festival Tokyo* showcases a cross-section of artistic productions from recent years.

Visueller Einfallsreichtum und unkonventionelle Erzählformen kennzeichnen die Animationen made in Japan. Das vom Media Arts Festival Tokyo kuratierte Programm gibt einen Querschnitt über künstlerische Produktionen des vergangenen Jahres.

Prix Ars Electronica 2006
International Competition for CyberArts

3,177 entries from 71 countries—in 2006, the Prix Ars Electronica attracted a record number of submissions. A total of € 117,500 in prize money has been awarded to the winners. Since 1987, the Prix Ars Electronica has served as an interdisciplinary platform for everyone who uses the computer as a universal medium for implementing and designing their creative projects at the interface of art, technology and society. The competition is organized by the Ars Electronica Center and ORF's Upper Austria Regional Studio, and the prizes are awarded during the Ars Electronica Festival each year. The Prix Ars Electronica is one of the most important awards for creativity and pioneering spirit in the field of digital media.

Four of its competitive categories—Computer Animation / Visual Effects, Digital Musics, Interactive Art and Net Vision—focus on digital media design. The introduction of the Digital Communities category in 2004 is emblematic of Prix Ars Electronica's intensified confrontation with the impact art and technology are having on social developments. The u19—freestyle computing category for youngsters and [the next idea] grant for up-and-coming artists showcase approaches to new media being taken by promising young creatives.

The number of countries represented is indicative of the Prix's international importance. In addition to the major industrialized nations of the West, Ars Electronica's activities are also having an impact in smaller countries in distant regions of the globe. Submissions from such diverse places as Azerbaijan, Thailand, Nigeria and Brazil underscore the Prix Ars Electronica's intercultural reach.

The results of the competition with detailed project descriptions are published in:
CyberArts 2006
International Compendium of Prix Ars Electronica
H. Leopoldseder / C. Schöpf / G. Stocker (eds.)
Hatje Cantz, Ostfildern-Ruit

Selected works of Prix Ars Electronica are being presented in the CyberArts 2006 Exhibition at the O.K Center for Contemporary Art.

Computer Animation / Visual Effects

Golden Nica
Jan Bitzer, Ilija Brunck, Tom Weber /
Filmakademie Baden Württemberg: 458nm

Distinctions
Daniel Nocke / Studio FILM BILDER:
Kein Platz für Gerold

Jun Awazu: NEGADON: The Monster from Mars

Honorary Mentions
YAMATOWORKS (Shuhei Morita, Shiro Kuro):
Kakurenbo: Hide and Seek

Marco Spier, Marie Hyon / PSYOP: MTV: Crow

Volckman Christian / onyx films: renaissance

Philippe Grammaticopoulos: The Regulator

Stephan Larson: Discord: metal and meat

Saschka Unseld, Jakob Schuh / Studio Soi:
Strasse der Spezialisten

Thomas Leonard, Guillaume Marques, Paul Jacamon / SUPINFOCOM: CAFARD

Perrine Marais / Filmakademie Baden-Württemberg: Als ich hier angekommen bin

The Mill: Rexona—Stunt City

Kei Oyama: Shinsatsu-Shitsu
(Consultation Room)

Stu Maschwitz / The Orphanage: Sin City

Mark Andrews, Andrew Jimenez /
Pixar Animation Studios:
ONE MAN BAND

Digital Musics

Golden Nica
Eliane Radigue / shiiin: L' île re-sonante

Distinctions
Joe Colley: psychic stress soundtracks

Kaffe Matthews / Annette Works:
Sonic Bed_London

Honorary Mentions
Sabine Breitsameter, Robert Gawlowski:
Radio_Copernicus. das deutsch-polnische
Künstlerradio

Stephen O'Malley, Greg Anderson / SUNN O))):
Black One

Mike Harding / Touch: Spire Live in Geneva

Tobitani Kensuke, Satoshi Fukushima,
Yoshihisa Suzuki / Mimiz: february sessions

*Es, Lisa, Vinylman, Ugh, LIftman, Frosen Pine &
Meu: Satanicpornocultshop: Zap Meemees

Yannis Kyriakides: Wordless

Carsten Stabenow, Geert-Jan Hobijn /
staalplaat soundsystem: YOKOMONO

Ambrose Field: Storm!

Nikolaus Gansterer, Katharina Klement,
Josef Novotny: 8∞

Yvonne Cornelius (Niobe) / Sonig: Voodooluba

Ekkehard Ehlers / Staubgold:
A Life Without Fear

Matmos: The Rose Has Teeth In The Mouth
Of A Beast

Net Vision

Golden Nica
exonemo: The Road Movie

Distinctions
Michael Stadler: Tsunami Harddisk Detector

Wayne Clements: un_wiki

Honorary Mentions
Ricardo Miranda Zuniga : Dentimundo (US)

Michael Aschauer : Dun.AV—Danube
Panorama Project

Sandro Catallo, Markus Cremers: Tank-FX (DE)

Roxana Torre: Personal World Map

Virtual Marathon Team:
The Virtual Marathon

h.o: COLORS project

Peter Edmunds: SwarmSketch

Hasan M. Elahi: Tracking Transience

Gavin Baily, Tom Corby: cyclone.soc

AND-OR / Beat Suter, Rene Bauer:
Streamfishing

Christoph Wachter, Mathias Jud:
ZONE*INTERDITE

Digital Communities

Golden Nica
canal*ACCESSIBLE

Distinctions
Codecheck

Proyecto Cyberela—Radio Telecentros

Honorary Mentions
The Organic City

Mountain Forum

stencilboard.at—prevent disappearance

MetaReciclagem

Arduino

Northfield.org—Citizen Journalism

UgaBYTES Initiative

The Freecycle Network

CodeTree

Charter97.org —news from Belarus

Semapedia.org

Pambazuka News

u19—freestyle computing

Golden Nica
Ehrentraud Hager, Alexander Niederklapfer,
David Wurm, Magdalena Wurm / Krmpf Krmpf
Studios: Abenteuer Arbeitsweg

Distinctions
Robogreiner / Ralph Aichhorn, Katharina Greul,
Felix Gruber, Fabian Guschelbauer: Robofisch

Irene Kriechbaum: Faceology

Distinctions / Non-Cash Preis
Julius Lugmayr: Wunderwelt Candy CAVE

1C/GRG 1 Stubenbastei, 1010 Wien: Trick und Politik

Honorary Mentions
Lisa Steiner: Kiwi-Monster

Stjepan Milićević, Markus Weber:
Die Fische und der Hai

The ThreeCees / 3C BRG Landeck:
Comic-Life: Musik-Comic der 3C

PIEP!

Dominik Amschl: Winamp Fernsteuerung

Gabriel Freinbichler: Donaufischer.at,
der Fischertreffpunkt im (Fischer-)Netz

Jiri Kuban: Ich kauf mir 'ne Rakete

Nana Susanne Thurner: War

Emanuel Jauk: AC_FORM

Thomas Hainscho: www.zu-fall.net.ms

[the next idea]

Art and Technology Grant
Himanshu Khatri: Aquaplay

Nicoletta Blacher

Space Conquests: Do It Yourself!

What characteristics are displayed by interactive installations and programs that motivate their users to engage in experimentation? In conjunction with *The Age of Simulation— Learning and Research in the 21ˢᵗ Century*, a conference of international experts recently held in Linz, the Ars Electronica Center developed a special exhibit focusing on this theme in early 2006 *(http://www.aec.at/simulation)*.[1] Setting up a simulation path through the Museum of the Future is designed to make a sort of proving ground available to visitors. In this area, the specific exhibition situation in the Ars Electronica Center features a juxtaposition of simulation models from many different fields in which simulation is being applied and a broad spectrum of exhibit formats—from interactive installations and 3-D visuals, artistic animated works & videos and educational computer games all the way to network visualizations. Here, the Museum of the Future presents itself at its finest: as a creative environment designed to explore the possibilities of hands-on experimentation at the interface of real and virtual space.

Along with the growing complexity of information, its ever-diminishing half-life and the acceleration of technological development, there's an increasing need for appropriate forms of mediation that dynamically take the user's physical location into consideration. Questions dealing with the user-friendliness of interfaces and their degree of interactivity are increasingly to be understood in the context of accessibility—in the all-encompassing sense of barrier-free design as well as in the sense of possibilities available to users to define their own role and to provide for active, creative utilization by a broad spectrum of users with varying cultural and technological backgrounds.

The Museum of the Future's current exhibits and ancillary programs designed to mediate users' encounters with the exhibits' content offer settings to make contact with new domains, to experience and learn about them..

During the Festival, this year's prizewinning projects in the *u19—freestyle computing* category will be on display in the new Simulation Lab (former Mediatheque). The creative youngsters who made them use an incredibly diverse mix of materials and tools to produce works that superbly illustrate the importance of the do-it-yourself principle in a proactive and critical process of exploring and mastering digital domains and possibilities of representation. Using media and media's influence on cultural forms of expression and the latitude for action open to young people will constitute a core theme of the Ars Electronica Center's fall and spring activities. The 10ᵗʰ anniversary of the *u19—freestyle computing* category provides one fitting occasion in this connection. To this can be added current initiatives by local youth groups leading up to Linz serving as European Capital of Culture in 2009. These young people are involved in exploring the performative quality of digital space in its sensory and aesthetic dimensions, and the possibilities of a process of exchange among different youth scenes for purposes of brainstorming, planning and establishing a presence in the public sphere.

This approach will be carried on in the utilization mode of the Simulation Lab, alternately a venue for presenting mapping projects and urban simulations and a setting for workshops. It is precisely the juxtaposition of screen-based applications and interactive scenarios that brings about the reflection of spaces for experience and action. The first Linz WikiMap developed by the Ars Electronica Futurelab in the fall of 2005 was a contribution to the city's Hotspot wireless LAN ini-

1 A joint production of Ars Electronica and FAS.reserach. Powered by www.innovitives-oesterreich.at

tiative. Since then, additional WikiMaps have been developed on an ongoing basis in collaboration with various partners and users *(www.aec.at/wikimap)*. These include virtual interactive maps that have been commissioned by regional and international clients as platforms for a wide variety of projects ranging from associative, artistically inspired efforts to capture a cityscape all the way to treatments of concrete design proposals—such as Wikimap Madrid in cooperation with MediaLab Madrid and Wikimap Europe in conjunction with Austria's EU Council presidency. With the continuous enhancement of the communications tools built into them, these WikiMaps make available a host of marvelous opportunities to take advantage of the Internet as a domain of information, communication and new ideas at points where they dovetail with on-site activities. Another mediation tool developed by the Ars Electronica Futurelab combines screen-based applications with the walk-through accessibility of a self-designed space. With the *World Editor* any user can design his/her own virtual world for the CAVE. A special program enables computer users—even those with no prior experience in this area—to arrange landscapes and to populate them with figures and other objects. In going about this, drawings or photos can serve as models, and users can enhance their work with sounds and ambient noise to generate atmosphere. Afterwards, workshop attendees can personally experience their creations right in the CAVE.

Do-it-yourself is the guiding principle of the Robolab. Sensors of all sorts are used to produce an amazing variety of creations—from eminently sensible to serendipitously fantastic. The assembly of *ELEKIT* robot components rounds out the program, a combination of high-quality design and playful encounter with sensor technology.

With its intramural and extramural activities, the Ars Electronica Center offers an open program governed by a hands-on approach to the encounter with digital domains. This can be played out in concrete references to reality or in the form of mind mappings, and experienced as a journey of discovery to the user's own potential.

■■■ u19—freestyle exhibition

u19—freestyle computing is Austria's largest computer competition for young people. It's been held annually since 1998 in conjunction with the Prix Ars Electronica and has successfully established itself as a setting in which the creative spirit of youth can interface with our digital future. The growing number and diversity of submissions each year—including Internet applications, websites, graphics, computer animation, sounds and homebrew software and hardware—are indicative of an unconventional and creative encounter with our mediatized society. During the Festival, this year's winners will be on display in the Simulation Lab (2nd Upper Level). The permanent exhibit on the 1st Upper Level showcases the incredible diversity of u19 entries and the fascinating 4- to 19-year-olds who created them. The *Console* station utilizes objects resembling trading cards as tools to control data visualization, videos and animated films. The *Wall of Fame* features the young inventors and artists themselves. Our encounter with the filmmaking crew that produced this year's u19 Golden Nica winner inspired us to set up a miniature animation studio in the u19 exhibit area. The "making of" spot documenting this first production to emerge from the *Krmpf Krmpf Studios* is meant to get young visitors to the Museum of the Future into the do-it-yourself spirit and develop their own film sequences.[1] The studio provides a camera, simple editing equipment, a selection of background projections and—just like in this year's Golden Nica winner—Lego blocks for set construction and Lego figures as the starring cast.

Translated from German by Mel Greenwald

[1] Consulted by Ehrentraud Hager, Alexander Niederklapfer, David Wurm, Magdalena Wurm (Krmpf Krmpf Studios)

Nicoletta Blacher

Raumeroberungen: Do It Yourself!

Welche Eigenschaften weisen interaktive Installationen und Programme auf, die Lust auf Experimente machen? Begleitend zur internationalen Fachkonferenz „The Age of Simulation – Lernen und Forschen im 21. Jahrhundert" entwickelte das Ars Electronica Center mit Beginn 2006 einen eigenen Ausstellungsschwerpunkt: die Gestaltung eines Simulationpfades durch das Museum der Zukunft als „Testumgebung" für die Besucher *(http://www.aec.at/simulation).*[1] Die spezifische Ausstellungssituation im Ars Electronica Center bietet dabei eine Gegenüberstellung von Simulationsmodellen aus vielfältigen Anwendungsbereichen in unterschiedlichen Ausstellungsformaten, von interaktiven Installationen und 3D-Visualisierungen, künstlerischen Animationen und Videos, edukativen Computerspielen bis hin zu Netzwerkvisualisierungen – das Museum der Zukunft als *Creative Environment* zum Ausloten der Möglichkeiten für eigene Experimente an der Schnittstelle von realem und virtuellem Raum.

Mit der Komplexität und Halbwertszeit von Informationen sowie der Schnelligkeit technologischer Entwicklungen steigt der Bedarf an geeigneten Vermittlungsformen, die dynamisch den Standort des Nutzers miteinbeziehen. Fragen nach nutzerfreundlichen Interfaces und dem Grad von Interaktivität sind zunehmend im Kontext von Zugänglichkeit zu verstehen, wobei Zugänglichkeit in diesem umfassenden Sinne nicht nur Barrierefreiheit meint, sondern auch Möglichkeiten zur Rollendefinition seitens der Nutzer oder eine aktive und kreative Nutzung für verschiedene Zielgruppen mit unterschiedlichem kulturellen und technologischem Hintergrund.

Das Museum der Zukunft bietet mit der Ausstellung und seinen Vermittlungsprogrammen

Erlebnis- und Wissensräume, aber auch Andockstellen, um hier vielfältige Links zwischen diesen komplexen Herausforderungen und dem eigenen Leben herzustellen.

Während des Festivals Ars Electronica 2006 werden im neuen Simulationslab (der ehemaligen Mediathek) die diesjährigen Gewinnerprojekte der Kategorie *u19 – freestyle computing* des Prix Ars Electronica gezeigt, die im Mix von unterschiedlichsten Baumaterialien und digitalen Tools deutlich machen, wie wichtig das Prinzip des „Do It Yourself" zur aktiven und kritischen Eroberung neuer medialer Räume und Darstellungsmöglichkeiten ist. Wie Medien von Jugendlichen genutzt werden und welchen Einfluss sie auf die kulturellen Ausdrucksformen und Aktionsräume von Jugendlichen haben, ist eines der wesentlichen Themen, mit denen sich das Ars Electronica Center auseinandersetzt. Anlass sind zehn Jahre *u19 – freestyle computing* und aktuelle Aktivitäten von Linzer Jugendgruppen auf dem Weg von Linz zur Europäischen Kulturhauptstadt 09. Die Erforschung der performativen Qualität des digitalen Raumes in seiner sinnlichen und ästhetischen Dimension sowie die Möglichkeiten des Austausches zwischen unterschiedlichen Szenen für Brainstorming- und Planungsprozesse und die Herstellung von Öffentlichkeiten sind zentrale Fragen der Jugendlichen.

In der regulären Bespielung des Simulationslabs als Präsentationsraum für Mappingprojekte, Stadtsimulationen und in seiner alternierender Nutzung als Workshopraum wird dieser Ansatz weitergeführt. Gerade die Gegenüberstellung von screenbasierten Anwendungen und interaktiven Ausstellungsszenarien ermöglicht die Reflexion von Erlebnis- und Handlungsräumen. Die erste im Herbst 2005 vom Ars Electronica Futurelab entwickelte *WikiMap* für Linz war ein Beitrag zur Hotspot-Initiative der Stadt Linz. Weitere WikiMaps wurden kontinuierlich mit verschiedenen Partnern und den Usern entwickelt *(http://www.aec.at/wikimap)*; sie sind virtuelle interaktive Maps, die von regionalen und internationalen Partnern als Plattform für zahlreiche Projekte genutzt werden: von assoziativ künstlerisch inspirierten Stadteroberungen bis hin zu Fragestellungen zukünftiger Gestaltung wie z. B. in der *WikiMap Madrid*, einer Zusammenarbeit mit dem MediaLabMadrid, oder in der *WikiMap Europe*, die im Rahmen der österreichischen EU-Ratspräsidentschaft erarbeitet wurde. Die WikiMaps mit der stetigen Erweiterung von Kommunikationstools bieten zahlreiche Anlässe, die Möglichkeiten des Internet als Informations-, Kommunikations- und Ideenraum in der Überschneidung mit Aktivitäten vor Ort zu nutzen.

Ein weiteres vom Ars Electronica Futurelab entwickeltes Vermittlungstool verbindet screenbasierte Anwendungen mit der Begehbarkeit eines selbst gestalteten Raumes. Mit dem *Welteneditor* kann jede/r seine/ihre eigene virtuelle Welt im CAVE gestalten: Ein spezielles Programm ermöglicht es, ohne besondere Computervorkenntnisse Landschaften, Figuren und andere Objekte in ein räumliches Verhältnis zu setzen. Als Vorlage können Zeichnungen oder Fotos dienen, die, ergänzt durch Sounds und Umfeldgeräusche, Atmosphäre schaffen. Im Anschluss an diese Workshops kann dann im CAVE die selbst geschaffene Welt erlebt werden.

Das „Do It Yourself"-Prinzip eines Baumarktes wird im *Robolab* fortgesetzt. Sensoren aller Art werden zur sinnvollen oder fantastischen Produktion genutzt. Die Präsentation und der Zusammenbau der Robotikbausätze von ELEKIT ergänzen das Programm: hochwertiges Design und spielerische Auseinandersetzung mit Sensorik.

Das Ars Electronica Center bietet mit den Aktivitäten im und außerhalb des Museums ein offenes Programm, wo nach dem Prinzip „Do It yourself" sowohl Raumeroberungen mit konkretem Bezug zur Realität oder in Form von Mindmappings durchgespielt als auch Entdeckungsreisen zum eigenen Potenzial gemacht werden können.

1 Ein Projekt von Ars Electronica und FAS.research, gefördert von www.innovatives-oesterreich.at

Nicoletta Blacher

▬▬▬ u19 – freestyle exhibition

u19 – freestyle computing ist Österreichs größter Jugendcomputerwettbewerb, der sich seit 1998 im Rahmen des internationalen Prix Ars Electronica als Schnittstelle zwischen dem kreativen Geist der Jugendlichen und unserer Zukunft etabliert hat. Die steigende Anzahl und Vielfalt der jährlichen Einreichungen von Internetanwendungen, Webpages, Grafiken, Computeranimationen, Sounds, selbst programmierter Software und Hardware-Anwendungen zeigt eine unkonventionelle und kreative Auseinandersetzung mit unserer Mediengesellschaft.

Im Simulationslab (zweites Obergeschoß) werden während des Festivals die diesjährigen Gewinnerprojekte präsentiert. Mit der permanenten Ausstellung im ersten Obergeschoß wird den Einreichungen in ihrer Vielfalt und den dahinterstehenden Persönlichkeiten zwischen vier und 19 Jahren eine Plattform gegeben. Die Station *Console* nutzt an Sammelkarten angelehnte Objekte als Steuerungstools für die Visualisierung von Daten, Videos und Animationen. Die *Wall of Fame* setzt die jungen Erfinder und Künstler in Szene. Die Begegnung mit den Gewinnern der diesjährigen Goldenen Nica für den Film *Abenteuer Arbeitsweg* inspirierte zum Aufbau eines Mini-Trickfilmstudios im u19-Bereich. Ganz nach dem Motto „Do It Yourself" war das Making-Of dieser ersten Produktion aus den Krmpf Krmpf Studios die Anregung dafür, BesucherInnen des Ars Electronica Center ihre eigenen Filmsequenzen entwickeln zu lassen.[1] Das Trickfilmstudio mit Kamera und einfacher Schnittmöglichkeit liefert in Anlehnung an die Arbeit der Jugendlichen eine Auswahl von Hintergrundprojektionen, Lego als Baumaterial für die Kulisse und ein Requisitenarsenal.

1 Beratung: Ehrentraud Hager, Alexander Niederklapfer, David Wurm, Magdalena Wurm / Krmpf Krmpf Studios

Krmpf Krmpf Studios, *Abenteuer Arbeitsweg*, Prix Ars Electronica 2006, Goldene Nica – u19 freestyle computing.

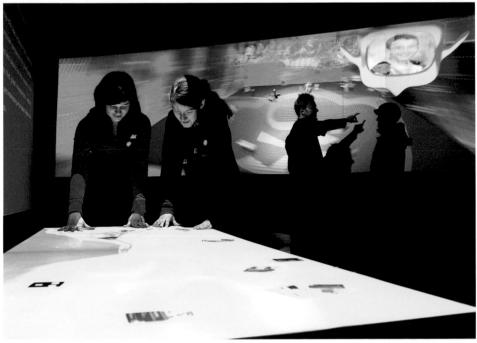

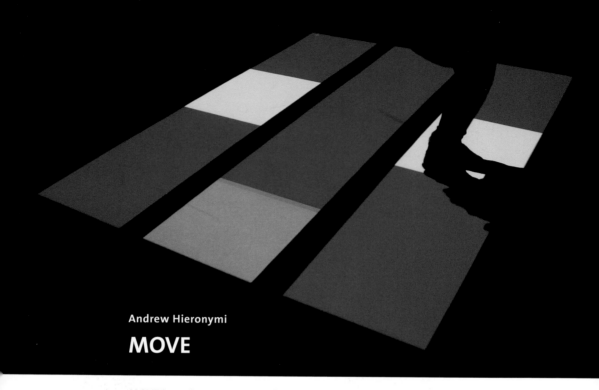

Andrew Hieronymi

MOVE

MOVE is an interactive installation divided into six distinct modules, *JUMP, AVOID, CHASE, THROW, HIDE* and *COLLECT* and uses a camera vision detection system as an interface. When visitors approach the installation, they see a projection on the floor. The projection displays *MOVE's* 'menu', which consists of an animation that alternatively shows one of the geometrically distinct shapes (3x2 feet) representing each of the modules. As soon as the presence of the participant standing above the projection is detected, the shape extends to its full size (10x8 feet) and the interaction with the module can start. The interaction lasts as long as the participant is able to prevent collision with the opposing graphical element. If the participant loses, a distinct sound signals the end of the game. Each module of *MOVE* offers a single-user interaction, based on a verb corresponding to the action the participant is invited to perform. Each verb corresponds to a common procedure acted out by avatars during videogame play. Each module offers an interaction with abstracted shapes (circles, rectangles) behaving according to simplified rules of physics (collision, friction). Each module is color-coded with consistency, where the color red is used for the graphical element that poses the core challenge. Each module increases in difficulty in a similar linear manner.

What makes *MOVE* unusual is that unlike most computer vision or sensor-based games, like *Eye Toy* or *Dance Dance Revolution*, the participant *IS* the avatar. He is not seeing a representation of himself, or an indirect result of his actions on a separate screen, but instead interacts directly with the projected graphical constituents of the game. Because those graphical elements are non-representational they do not allow for a projection in a fictional space. The combination of abstracted shapes and direct interaction reinforces in the player the focus on the action itself (*JUMP, AVOID, CHASE, THROW, HIDE* or *COLLECT*) instead of an ulterior goal.

http://users.design.ucla.edu/~ahierony/move/
http://ahieronymi.net/

Project Assistant: Togo Kida / Project developed at: University of California, Los Angeles

MOVE ist eine interaktive Installation mit sechs verschiedenen Modulen: JUMP, AVO-ID, CHASE, THROW, HIDE und COLLECT. Ein Kamerasystem zur Objekterkennung dient als Interface. Nähert man sich der Installation, so erkennt man, dass verschiedene geometrische Körper (91 x 61 cm) auf die Bodenfläche projiziert werden, die als „Menü" von MOVE dienen; jedes Modul wird durch ein anderes Objekt dargestellt. Sobald das System erkennt, dass ein Spieler auf der Projektionsfläche steht, entfaltet sich der geometrische Körper zu seiner vollen Größe (3 x 2,4 m) und die Interaktion mit dem Modul kann beginnen. Solange der Teilnehmer eine Kollision mit dem gegnerischen Grafikelement vermeiden kann, geht es weiter. Kollidiert er, signalisiert ein spezieller Ton das Ende des Spiels. Es kann jeweils nur eine Person mit dem System interagieren, wobei vom Spieler jeweils eine Aktion verlangt wird, die den die Module bezeichnenden Verben entspricht. Jedes Verb beschreibt eine Handlung, die Avatare in Videospielen häufig ausführen. Die Interaktion erfolgt in jedem Modul mit abstrahierten Formen (Kreisen, Rechtecken), die sich nach vereinfachten Regeln der Physik (Kollision, Friktion) bewegen. Für jedes Spiel werden die gleichen Farben verwendet; das Grafikelement, dem es auszuweichen gilt, ist rot. Der Schwierigkeitsgrad nimmt in jedem Modul linear zu.

Was macht MOVE besonders? Anders als bei vielen bildgestützten oder sensorbasierten Spielen wie etwa Eye-toy oder Dance Dance Revolution ist der Teilnehmer selbst der Avatar; er sieht keine Repräsentation seiner selbst oder das indirekte Ergebnis seiner Handlungen auf einem separaten Monitor, sondern er interagiert direkt mit den projizierten Grafikelementen des Spiels. Da diese keine Stellvertreter sind, kann auch das Geschehen nicht in einen fiktiven Raum projiziert werden. Die Kombination von abstrakten Formen und direkter Interaktion motiviert den Spieler, sich auf die Handlung selbst zu konzentrieren (JUMP, AVOID, CHASE, THROW, HIDE oder COLLECT), anstatt ein übergeordnetes Ziel zu verfolgen.

Aus dem Englischen von Sonja Pöllabauer

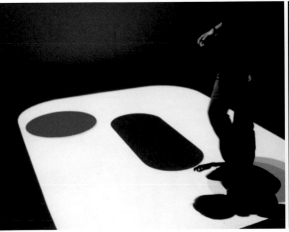 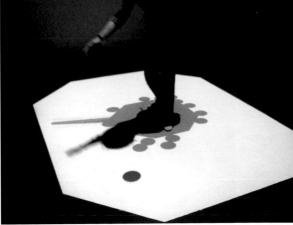

Digital Marionette

The *Digital Marionette,* an interactive installation, impressively shows the audience the look and feel of a puppet in the multimedia era: The handcrafted wooden marionette is replaced by a Lara Croft-like cyber character; the traditional strings attached to the puppet control handles emerge into a network of computer cables.

The installation consists of a projection of a digital face, which can be controlled by the visitors. The puppet can talk via speech input, and the classical puppet controls serve as controllers for head direction and face emotions, such as joy, anger, or sadness. A live camera recording the puppet projection and the audience lets the anonymous puppet master observe the puppet play, as well as the other visitors' reactions.

The translation from old to new, from analog to digital, takes place via the most popular computer input device: the mouse. The puppet control handles are attached to sliding strips of mouse pads, and eight computer mice track movements of the individual strings attached to the puppet. This approach is at the same time efficient, low-cost and easily understandable by the non-expert visitor. Speech input is realised via speech recognition, where the recognised phonemes are mapped to a set of facial expressions and visemes.

The whole artistic concept was designed and realised in an interdisciplinary manner, incorporating art historical facts about marionettes, the architectural space, interaction design, and state of the art research results from computer graphics and speech recognition.

http://www.corebounce.org

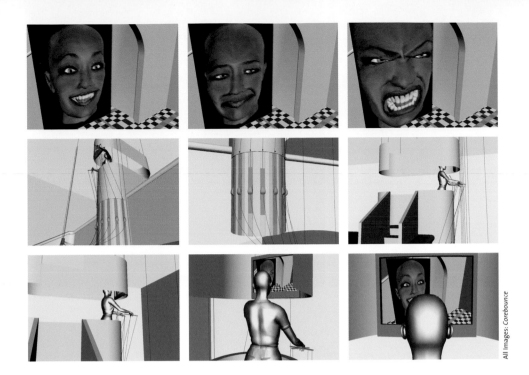

All Images: *Corebounce*

Die interaktive Installation *Digital Marionette* präsentiert dem Publikum die Marionette des multimedialen Zeitalters: Eine Cyberfigur vom Typ einer Lara Croft ersetzt die handgeschnitzte Holzpuppe, und statt über Holzkreuze mit Drähten bewegt man die Marionette über miteinander vernetzte Computerkabel.

Die Installation besteht aus der Projektion eines digitalen Gesichts, das die Besucher steuern können. Per Spracheingabe bringt man die Marionette zum Sprechen, und über die klassischen Steuerelemente bewegt man den Kopf und bestimmt den Gesichtsausdruck (z. B. Freude, Zorn, Trauer). Sowohl die Projektion der Marionette als auch das Publikum werden von einer Livekamera aufgezeichnet, damit der anonyme Puppenspieler das Puppenspiel und die Zuschauerreaktionen gleichzeitig beobachten kann.

Die Übertragung vom Alten ins Neue, vom Analogen ins Digitale erfolgt über das beliebteste Computereingabegerät: die Maus. Die Steuerelemente sind mit beweglichen Mousepad-Streifen verbunden; acht Computermäuse registrieren die Bewegungen der einzelnen Steuerdrähte. Dieser Ansatz ist zugleich zeitsparend, preisgünstig und auch für Laien leicht verständlich. Die Spracheingabe erfolgt über Spracherkennung, wobei wiedererkannte Phoneme einer Reihe von Gesichtsausdrücken und Visemen zugeordnet werden.

Das künstlerische Gesamtkonzept ist in Design und Umsetzung interdisziplinär und kombiniert kunsthistorische Fakten über Marionetten mit Themen wie architektonischem Raum, Interaktionsdesign und den neuesten Forschungsergebnissen aus den Bereichen Computergrafik und Spracherkennung.

Aus dem Englischen von Susanne Steinacher

The *Digital Marionette* was designed and realised by the Corebounce Art Collective: Pascal Müller, Computer Vision Lab, ETH Zurich; Stefan Müller Arisona, Computer Systems Institute, ETH Zurich; Simon Schubiger-Banz, Swisscom Innovations, Bern; Matthias Specht, Anthropological Institute, University of Zurich
With additional support from: Leading Curator: Eva Afuhs, Museum Bellerive, Zurich; Guest Curator and Architecture: Sergio Cavero, Architectures Générales, Zurich; Interface Construction: Christian Iten, Interaction Design, HGKZ, Zurich; Speech Recognition: Urs Viktor Marti, Swisscom Innovations, Bern; Motion Capturing & Scanning: Gregor Kalberer, ETH Zurich; Technical Construction: Craig Neil, Museum Bellerive, Zurich

The Sancho Plan

The Sancho Plan are an award-winning collective that produce live audiovisual performances, experimental musical animations and interactive audio toys. Their AV works explore the real-time interaction between music and video and its potential for narrative and storytelling.

Through the careful combination of animation, sound, music and technology, *The Sancho Plan* create fantastical worlds in which animated musical characters are triggered by a variety of electronic drum pads.

Instantly engaging and universally understandable, this audiovisual installation invites you to enjoy three playful interactive adventures. In *Robo Sanchiens,* experience a futuristic duel of robotic drummers. In *Heraldz,* strange trumpet-like storks fire musical balls into the air. And in *Drum Machine,* based on the award-winning animation created in collaboration with *tokyoplastic.com,* you control Japanese Kodo-style drummers who use their heads in place of sticks.

The Sancho Plan's creative output has been shown in clubs, festivals, cinemas, theatres and on television and computer screens around the world. Their live audiovisual performance premiered at *Optronica* at London's National Film Theatre in July 2005, and has since been enjoyed by audiences at other festivals throughout the UK. Nominated for the best VJ category at the 2003 Diesel-U-Music Awards and winners of the People's Choice Award at the Sundance Online Film Festival 2004, *The Sancho Plan* are presently working with AV pioneers Coldcut to develop a series of interactive musical toys, scheduled for commercial release in 2007. Headed by Ed Cookson with key collaborators Lewis Sykes, Adam Hoyle, Motionteller, Nick Sweetman and Ed Niblett, *The Sancho Plan* draws on a network of practitioners with a diverse range of talents to create unified and truly innovative contemporary audiovisual work of a rare quality.

http://www.thesanchoplan.com

The Sancho Plan ist ein preisgekröntes Kollektiv, das audiovisuelle Live-Performances, experimentelle Musikanimationen und interaktive Musikspielzeuge produziert. In ihren AV-Medienarbeiten erforscht die Gruppe die Echtzeitinteraktion zwischen Musik und Video und deren narratives Potenzial.

Mittels einer sorgfältig abgestimmten Kombination von Animation, Sound, Musik und Technik lässt *The Sancho Plan* fantastische Welten entstehen, in denen animierte Musikfiguren durch eine Vielzahl elektronischer Drum-Pads aktiviert werden.

Die auf Anhieb mitreißende und eingängige audiovisuelle Installation lädt zu drei verspielten interaktiven Abenteuern ein. Erleben Sie in *Robo Sanchiens* ein futuristisches Duell trommelnder Roboter. In *Heraldz* feuern seltsame trompetenähnliche Störche Musikbälle in die Luft. Und in *Drum Machine,* das auf der preisgekrönten, in Zusammenarbeit mit *tokyoplastic.com* produzierten Animation basiert, steuert der Spieler japanische Trommler im Kodo-Stil, die anstelle von Schlägeln ihre Köpfe verwenden.

Die kreativen Produktionen von *The Sancho Plan* wurden in Clubs, Kinos, Theatern, bei Festivals und auf den Fernseh- und Computerbildschirmen der ganzen Welt gezeigt. Ihre audiovisuelle Live-Performance hatte im Juli 2005 beim Optronica-Festival im National Film Theater Premiere und wurde seither bei zahlreichen Festivals in ganz Großbritannien vom Publikum begeistert aufgenommen. *The Sancho Plan* wurde 2003 für die Diesel-U-Music Awards in der Kategorie bester Video-Jockey nominiert und gewann beim Sundance Online Film Festival 2004 den People's Choice Award. Derzeit arbeitet die Gruppe mit den AV-Pionieren Coldcut an einer Serie interaktiver Musikspielzeuge, die 2007 auf den Markt kommen soll. Die Gruppe um Ed Cookson und seine wichtigsten Mitarbeiter Lewis Sykes, Adam Hoyle, Motionteller, Nick Sweetman und Ed Niblett arbeitet mit einem Netzwerk von Talenten aus den unterschiedlichsten Bereichen zusammen, um qualitativ hochwertige innovative zeitgenössische audiovisuelle Arbeiten aus einem Guss zu schaffen.

Aus dem Englischen von Martina Bauer

Takafumi Aoki

Kobito—Virtual Brownies

One common way to create imaginary, virtual creatures is to overlay computer graphics images on real scenes. But this method is not sufficient, because it allows people to only see the imaginary creatures. In *Kobito-Virtual Brownies,* imaginary creatures interact with the real world. They move real objects, and people interact with them through the real objects. The real objects function as a kind of "Haptic interface."

The goal of this project is to make people feel Kobitos as "creatures that exist in our real world." To make Kobitos exist virtually and naturally, it is necessary to avoid using markers, head-mounted displays, or wearable sensors, which are very common in virtual reality systems, but unfamiliar in daily life. And users must be able to interact with Kobitos in various ways.

The interaction between the Kobitos and a tea caddy is realized with physical simulation. Usually, physical simulation deals only with imaginary objects, but in this case, it includes a real object (the caddy). This is realized by synchronizing the movement between the real caddy (in the real world) and the imaginary caddy (in the physical-simulation world). Attendees can see the interaction through the Kobito window, which displays a combined image of the Kobito CG and the image of the real scene. No previous virtual reality system has enabled imaginary creatures to move real objects.

Kobitos can be good playmates, because they are sometimes invisible and at other times visible. When they are invisible and they move something in the real world, they generate a sense of wonder. Interaction with such a creature could be a new type of entertainment. Beyond entertainment, this technology could be very useful in daily life. Kobitos are intermediates between physical agents and imaginary agents, so they could act as agents between human beings and machines.

Kobitos are a new type of agent. Usually Kobitos don't bother you. Whenever you want to see them, you can see them through the Kobito window. The most important thing is that Kobitos work even when they are invisible.

Takafumi Aoki, Hironori Mitake, Rikiya Ayukawa, Takatsugu Kuriyama, Toshihiro Kawase, Takashi Matsushita, Takashi Toyama, Hiroshi Ichikawa, Kazuyuki Asano, Itaru Matsumura, Yuichiro Iio, Makoto Sato, Shoichi Hasegawa, Society for the Study of Robotics; *http://rogiken.org;* Supported by Tokyo Institute of Technology

Eine gängige Methode, imaginäre, virtuelle Geschöpfe zu generieren, besteht darin, reale Szenen mit computergenerierten Bildern zu überlagern. Sie ist jedoch unzulänglich, weil nur die konstruierten Figuren zu sehen sind. Die imaginären Kreaturen von *Kobito – Virtual Brownies* interagieren mit der Realität. Sie bewegen wirkliche Objekte, über die die Zuschauer wiederum mit ihnen interagieren können. Diese Gegenstände fungieren als haptisches Interface.

Die *Kobitos* sollen als real in unserer Welt existierende Geschöpfe wahrgenommen werden. Damit sie sowohl virtuell als auch real existieren können, muss man auf den Einsatz von Markern, VR-Helmen oder Sensoren verzichten, da diese in der virtuellen Realität zwar üblich sind, nicht aber im täglichen Leben. Weiters muss eine vielfältige Interaktion mit den *Kobitos* möglich sein.

Die Interaktion zwischen den *Kobitos* und einer Teedose wird mithilfe physikalischer Simulation erreicht, die normalerweise ausschließlich mit konstruierten Objekten arbeitet, aber in diesem Fall auch ein reales Objekt (eine Dose) umfasst. Zu diesem Zweck müssen die Bewegungen der physischen Dose (in der realen Welt) und der virtuellen (in der Welt der physikalischen Simulation) synchronisiert werden. Besucher betrachten die Szene durch das *Kobito*-Fenster, das ein kombiniertes Bild der *Kobito*-Computeranimation und der Realität zeigt. Bisher wurden noch nie physische Objekte von Geschöpfen eines VR-Systems bewegt.

Kobitos können tolle Spielkameraden sein, weil sie manchmal unsichtbar und dann wieder sichtbar sind. Man meint ein Wunder zu erleben, wenn sie als Unsichtbare Dinge der realen Welt bewegen. Diese Art der Interaktion könnte zu einer völlig neuen Unterhaltungsform werden. Abgesehen davon kann diese Technologie auch im Alltag sehr nützlich sein. *Kobitos* sind Vermittler zwischen physischen und virtuellen Kräften und könnten daher als Verbindungsglied zwischen Mensch und Maschine fungieren.

Kobitos sind ein neuer Agententypus, die uns im Allgemeinen nicht stören. Wann immer man sie sehen möchte, kann man sie durch das *Kobito*-Fenster betrachten. Am wichtigsten ist aber der Umstand, dass sie auch dann arbeiten, wenn sie unsichtbar sind.

Aus dem Englischen von Michael Kaufmann

Kumiko Kushiyama – PRESTO / JST

Thermoesthesia

Thermoesthesia is a new style of interactive artwork with an original thermal sense display. The thermal sense display has been developed to allow users to feel the temperature of the visually displayed objects, which are cool or warm, by directly touching the objects.
The primary objective of this work is to enrich the touch expression. *Thermoesthesia* is expected to extend the style of the interactive information access activity in daily life that is ubiquitous in our information-intensive society. *Thermoesthesia* offers audiences the experience of not only touching and feeling, but also of interacting directly with the images using their hands. The interaction with a redesigned and simulated physical phenomenon allows the audiences to re-experience the phenomenon in a different, unfamiliar way, which provides a chance to rediscover the world.

Thermal sense display

The basic concept of the project is to add the actual thermal property, such as cool or warm, to each part of the images projected on a screen. We used 80 Peltier device modules for the thermal display. Each module consists of stacked 40 x 40 millimeters Peltier devices. The upper surface of each module, where the audiences touch, was cooled or warmed by switching the current of the Peltier modules by using a PC and electric switching circuits. The thermal display range of the developed device is from 5 to 45 degrees C.

Interactive image generation

Furthermore, the photo-sensor based touch-panel system using infrared LEDs, which is implemented two millimeters above the screen, detects the hand position. The hand contact detection allows users to actively interact with the images that have thermal properties.

As the typical interactive content with thermal sense, "Cold-snow crystal" is the simulation of snow crystals growth. The real-time interactive program was developed using C language and openGL library. *Nakaya diagram,* was utilized to generate various forms of snow crystals, in accordance with the air temperature and the humidity.

Thermoesthesia was proposed for a new style of interactive communication based on virtual reality technology. The authors hope that the proposed work will stimulate the various fields and open up a way for future interactive creations.

Project team: Toshiie Kitazawa, Shinji Sasada, Mototsugu Tamura / Japan Electronics College
This project was supported by PRESTO / JST, Japan Science and Technology Agency

Kumiko Kushiyama

Thermoesthesia

Thermoesthesia ist eine neue Form eines interaktiven Kunst-werks mit einem Thermodisplay. Die Thermodisplays wurden entwickelt, damit die User die Temperaturen der dargestellten Objekte fühlen kön-nen, indem sie die kühlen oder warmen Objekte direkt berühren.

Bei dieser Arbeit geht es primär darum, das Berührungserlebnis um neue Aspekte zu bereichern. *Thermoesthesia* soll den interaktiven Zugang zu Informationen im täglichen Leben der Gesellschaft, in der die uneinge-schränkte Verfügbarkeit von Informationen eine zentrale Rolle spielt, erweitern. *Thermoästhesie* bietet dem Publikum nicht nur eine Touch-and-Feel-Erfahrung, sondern die Möglichkeit, mit den Händen direkt mit Bildern zu interagieren. Die Interaktion mit einem neu gestalteten und simulierten physischen Phänomen ermöglicht es dem Publikum, das Phä-nomen auf eine andere Art und Weise als gewohnt zu erfahren, was eine Chance darstellt, die Welt neu zu entdecken.

Thermodisplay

Das grundlegende Konzept des Projekts besteht darin, jeden Teil der auf eine Leinwand projizierten Bilder mit deren tatsächlicher thermischer Eigenschaft, wie z. B. kühl oder warm, zu versehen. Das Ther-modisplay verwendet 80 Peltier-Module. Jedes Modul besteht aus über-einander angeordneten, 40 x 40 Millimeter großen Peltier-Bauteilen. Die Oberfläche eines jeden Moduls, die vom Besucher berührt wird, wird gekühlt bzw. erwärmt, wobei ein PC und elektrische Schaltkreise den Stromfluss in den Peltier-Modulen steuern. Der thermische Anzeigebereich des Displays beträgt 5 bis 45 Grad Celsius.

Interaktive Generierung von Bildern

Das fotosensorische Touch-Pad-System erkennt die Position der Hand mittels Infra-rot-Leuchtdioden, die 2 Millimeter über dem Schirm montiert sind. Durch die Kontakterkennung mit der Hand kann der User aktiv mit den Thermobildern interagieren.

Ein typisches Beispiel eines interaktiven Inhalts mit thermischen Eigenschaften ist der kalte Schneekristall, der das Wachstum dieser Kristalle simuliert. Das interaktive Echtzeitprogramm wurde in der Programmiersprache C und mit OpenGL-Library entwickelt. Ein Nakaya-Diagramm wurde für die Generierung unterschiedlicher Schneekristalle unter Berücksichtigung von Luft-temperatur und Feuchtigkeit verwendet.

Thermoesthesia möchte eine neue Form der interaktiven Kommunikation vorschlagen, die auf Virtual-Reality-Technologie basiert. Die Autoren erhoffen sich von diesem Projekt Impulse in den verschiedensten Bereichen und neue Wege für zukünftige interaktive Kreationen.

Aus dem Englischen von Eva Gebetsroither

Sheldon Brown

The Scalable City

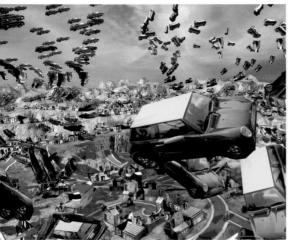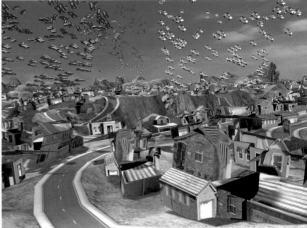

The Scalable City is a speculative built environment created via a data visualization pipeline. Each step in this pipeline builds upon the previous one, exaggerating the artifacts and patterns of algorithmic process.

Within *The Scalable City* are 5 major components: Landscape, Roads, Lots, Architecture and Vehicles. Each component is created by a process where real world data is subjected to algorithmic transformations before being redeployed as elements of a new urban condition of software I/O. For instance, the landscape (a complex natural form) is transformed by a simple algorithmic process of: duplicate, rotate, copy and paste; creating a new landscape form which retains naturalism in its details, but with a high level of algorithmic decoratism in its larger scale structure. Space filling road systems are "grown" into this landscape, located via computer vision analysis. The resultant decorative forms are evocative of nouveau iron grates, illuminated texts and oriental space-filling spiral patterns.

Vehicles, lots and architectural forms follow similar paths of manifestation—each demonstrating the effects of the embrace of software forms as the current script of spatial experience.

Throughout this environment, a variety of computer concept buzzwords take on imagined physical form, providing the basis for social interaction amongst them. All processes encode their results with artifacts that express their virtues and shortcomings. Culture has been undergoing a transformation from analog to digital forms and methods for several decades. These transformative moments produce tensions between speculation and anxiety. In *The Scalable City*, the aesthetic gestures embody the tension between exuberance and foreboding, neither embracing nor rejecting an algorithmic world view, but inspiring its expressivity while cautioning about its own internal logics becoming the dominant determinate of its outcomes.

http://crca.ucsd.edu/sheldon/scalable/

Project team: Alex Dragulescu, Mike Caloud, Joey Hammer, Erik Hill, Carl Burton

Sheldon Brown

The Scalable City

The Scalable City ist eine fiktive Stadtlandschaft, die mittels Datenvisualisierungs-Pipeline kreiert wurde. Jede Stufe dieser Pipeline baut auf der vorangegangenen auf, wodurch die Artefakte und Muster des algorithmischen Prozesses verzerrt und überzeichnet werden.

The Scalable City besteht aus fünf Hauptkomponenten: Landschaft, Straßen, Parzellen, Architektur und Fahrzeuge. Jede dieser Komponenten wird durch einen Prozess konstruiert, bei dem reale Daten algorithmischen Transformationen unterzogen werden, bevor sie durch Software-I/O als Elemente einer urbanen Bedingung neu eingesetzt werden. So wird z. B. die Landschaft (eine komplexe natürliche Form) durch einen einfachen algorithmischen Prozess in Form von Duplizieren, Drehen, Kopieren und Einfügen transformiert; dadurch entsteht eine neue Landschaftsform, die in ihren Details naturalistisch anmutet, aber in ihren großräumigen Strukturen ein hohes Maß an algorithmischer Verzierung zeigt.

Raumfüllende Straßensysteme „wachsen" in diese Landschaft hinein, die per Objekterkennung platziert werden. Die daraus resultierenden dekorativen Formen erinnern an Jugendstileisengitter, Illuminationen alter Handschriften oder die orientalische Ornamentik der Spiralmuster.

Fahrzeuge, Parzellen und architektonische Formen manifestieren sich auf ähnliche Weise – und demonstrieren die Effekte von Softwareformen als jeweiliges Raumerfahrungsskript.

Diese urbane Landschaft ist von Modeworten aus der Computerwelt gesprenkelt, die eine imaginative physische Form annehmen und die Basis für eine soziale Interaktion bilden. Die Ergebnisse all dieser Prozesse sind als Artefakte kodiert, die ihre Vorzüge und Mängel zum Ausdruck bringen. Die Kultur hat sich im Verlauf mehrerer Jahrzehnte durch den Übergang von analogen zu digitalen Formen und Methoden verwandelt. Diese transformativen Momente produzieren Spannungen, die zwischen Spekulation und Angst oszillieren. In *The Scalable City* verkörpern die ästhetischen Gesten die Spannung zwischen Überschwang und düsteren Vorahnungen, wobei die algorithmische Weltsicht weder übernommen noch verworfen wird, sondern ihre Expressivität aufgezeigt und gleichzeitig vor der ihr inhärenten Logik, die die Ergebnisse festlegt, gewarnt wird.

http://crca.ucsd.edu/sheldon/scalable/

Aus dem Englischen von Martina Bauer

Projektteam: Alex Dragulescu, Mike Caloud, Joey Hammer, Erik Hill, Carl Burton

Satellite imagery of Southern California is gathered

The height values from the satellite images are sampled and recorded into a height map

Algorithmic processes are applied to the height map

The 2-D height map is turned into 3-D geometry, and a road system is generated

The road geometry is dropped onto the landscape, and embedded into the landscape

The surface properties forall the 3-D geometry are set

Tmema (Golan Levin and Zachary Lieberman)

The Manual Input Station

The *Manual Input Station* is a series of interactive audiovisual vignettes which probe the expressive possibilities of hand gestures and finger movements.
Our installation consists of a combination of custom interactive software, analog overhead projectors and digital computer video projectors. The analog and digital projectors are aligned so that their projections overlap, resulting in an unusual quality of hybridized, dynamic light. During use, a computer vision system analyses the silhouettes of the user's hands and other objects as they move across the glass tops of the overhead projectors. The shapes and gestures are then analyzed by our custom software. In response, the system generates synthetic graphics and sounds that are tightly coupled to the forms and movements of the user's actions. The synthetic responses are co-projected with the organic, analog shadows, resulting in an almost magical form of augmented-reality shadow play.
http://www.tmema.org

The *Manual Input Station* is based on the performance project *The Manual Input Session,* presented in 2004 at the Ars Electronica Festival, and has now been adapted expressly for the exhibition in the Ars Elecronica Center.

Die *Manual Input Station* untersucht anhand einer Serie interaktiver audiovisueller Schablonen die Ausdrucksmöglichkeiten von Hand- und Fingergesten.

Unsere Installation kombiniert eine eigens geschriebene Interaktionssoftware mit analogen Overhead- und digitalen Videoprojektoren. Die analogen und digitalen Projektoren werden so ausgerichtet, dass sich die Bilder überlappen und ein eigentümliches dynamisches Hybridlicht ergeben. Während der Interaktion erfasst ein Objekterkennungssystem die Bewegungen der Handsilhouetten des Benutzers und anderer Objekte auf den Glasscheiben der Overheadprojektoren. Die Formen und Gesten werden von unserer speziellen Software verarbeitet und in synthetisierte Grafiken und Klänge umgesetzt, die eng mit den Objektumrissen und den Benutzeraktionen gekoppelt sind. Die synthetischen Erwiderungen überlagern sich mit den organischen, analogen Schatten und ergeben so ein beinahe magisch wirkendes Augmented-Reality-Schattenspiel.

The Manual Input Station ist eine für den Einsatz im Museum weiterentwickelte Form des Performanceprojekts *The Manual Input Session*, das beim Ars Electronica Festival 2004 präsentiert wurde.

Aus dem Englischen von Michael Kaufmann

John Gerrard

Smoke Tree
A virtual sculpture

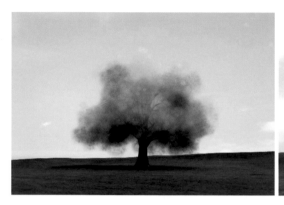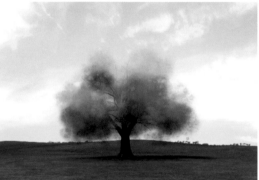

In the work an oak tree is central to the frame, however a strange transformation has come about with the result that the foliage of the tree is abundantly producing carbon in the place of oxygen. This process continually unfolds creating a mesmerizing and ever-changing tableaux, a sculpture in virtual smoke which presents a disquieting yet strangely plausible possibility.

Based on an existing Holm Oak in a rural landscape near the artists childhood home in southern Ireland the work operates within a single day which orbits from dusk to dawn around the central motif. As in previous works the presentation frame operates as a navigation device, allowing the public to move around the tree as an "image object" or virtual sculpture. This is the first work in a series.

http://www.johngerrad.net

3-D production: Werner Pötzelberger / Yama Vienna

John Gerrard

Smoke Tree
Eine virtuelle Skulptur

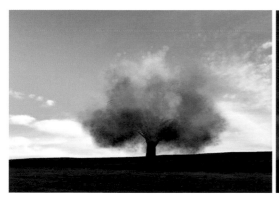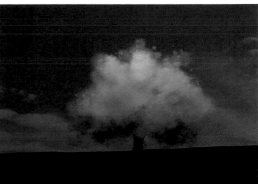

Im Mittelpunkt des Werks steht eine Eiche, die allerdings eine eigenartige Transformation erfahren hat: Statt Sauerstoff produzieren die Blätter Kohlenstoff im Überfluss. Dieser Prozess setzt sich beständig fort und schafft ein faszinierendes, immer wechselndes Tableau; eine in virtuellen Rauch aufgehende Skulptur, die eine beunruhigende aber seltsam plausible Möglichkeit darstellt.

Als Vorbild dient eine Steineiche in der Nähe des Hauses im Süden Irlands, in dem der Künstler seine Kindheit verbrachte. Das Werk beschreibt einen einzelnen Tag und kreist um das zentrale Motiv, dem Lauf der Sonne folgend. Der Bilderrahmen fungiert, wie schon in früheren Arbeiten, als Navigationshilfe, die es dem Betrachter ermöglicht, sich um den Baum als „Bildobjekt" bzw. virtuelle Skulptur zu bewegen. Dies ist die erste Arbeit aus einer Werkreihe.

Aus dem Englischen von Michael Kaufmann

3D-Realisierung: Werner Pötzelberger/Yama, Wien

Airacuda

Bionic object with fin drive

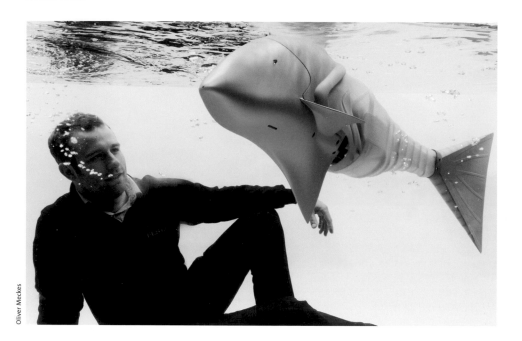

Oliver Meckes

Airacuda is a remote controlled and pneumatically driven fish that consistently harnesses bionic principles. Bionic, as we define it, is about translating biological operating modes into technical applications as closely as possible. Nature serves as a source of inspiration.

The Airacuda mimics a fish concerning its function, structural design, as well as shape. Airacuda's kinematical concept closely resembles the one deployed in its biological role model—propulsion is achieved through a mechanical fin drive.

In terms of structural design the fin drive is modeled based on tail fins found in many fish; also, it applies a Fluidic Muscle showing qualities very similar to real muscles. The structure itself consists of two alternating pressure and tension flanks connected by a vertical frame. This concept is called Fin Ray Effect® and was originally developed by Leif Kniese.

The Fluidic Muscle is a Festo product basically consisting of a flexible hose made from rubber and embedded aramid fibres. When inflated with pressurized air, the Fluidic Muscle expands in diameter and at the same time contracts longitudinally.

As a matter of fact, balancing the *Airacuda* when waterborne is also modeled after its natural archetype—that is, using an air bladder. To do so, the hull has an internal cavity, which can be flooded with water or filled with air, respectively. A pressure sensor evaluates depth and sends a corresponding signal to the electronic components, which then regulates the valves for either vacuum or compressed air to enter the air chamber.

To provide for a light but powerful energy supply, pressurized air is stored in a bottle at 300 bar. Operating *Airacuda* for approximately 35 minutes requires roughly 400 liters of compressed air. The air is distributed to the Fluidic Muscles in a controlled manner by means of the electronically steered valves. When inflated with compressed air at 6 bar the muscles contract by about 20 percent, and thus set off the structural motion.

All electronic as well as pneumatic components are housed waterproof inside the head. The entire structure is coated with silicon film. Both tail fin and head are designed and manufactured using the latest technology, which is CAD and related numeric controlled equipment. The complex form was generated using only highly sophisticated laser-sintering technology without any manual labor.

Specifications
Length: 100 cm—Width: 28 cm—Height: 45 cm—Weight: approx. 4 kg
Material used for head, structure and tail fin: laser-sintered polyamide
Material used for skin: silicone
Propulsion system: 4 Fluidic Muscle, ø 5 mm (prototype, not commercially available yet)
Compressed air storage: 1.5 litre bottle, 300 bar

Project partners
Project initiator: Dr. Wilfried Stoll, Chairman of the Supervisory Board, Festo AG
Project team: Dipl.-Des. Elias Maria Knubben, Festo AG & Co. KG
Dipl.-Ing. (FH) Markus Fischer, Festo AG & Co. KG
Membrane Technology: Bernd Lorenz, Dipl.-Ing. (FH) Achim Schanze, Walter Harrer, Festo AG & Co. KG
Hardware design, electronics: Dipl.-Ing. (FH) Walter Suchy, Dr.-Ing. Otto Szenn, Festo AG & Co. KG
Model: Christoph Altekamp, Matthias Kübler, Stuttgart, Germany
Fin Ray Effect®: Leif Kniese, Evologics GmbH, Berlin, Germany

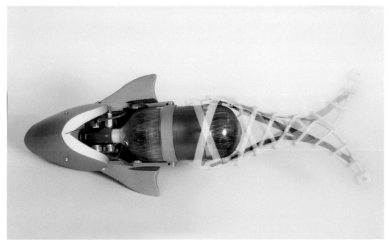

Walter Fogel

FESTO

Airacuda

Ein bionisches Objekt mit Flossenantrieb

Mit *Airacuda,* einem ferngesteuerten, pneumatisch angetriebenen Fisch, wurde ein bionisches Konzept konsequent umgesetzt. Unter Bionik verstehen wir die möglichst direkte Übersetzung von biologischen Funktionsweisen in technische Anwendungen. Die Natur dient als Vorbild und Inspirationsquelle.

Der *Airacuda* ist in seiner Funktion, seinem konstruktiven Aufbau und seiner Form einem Fisch nachempfunden. Die Kinematik seiner Bewegungen kommt dem biologischen Vorbild sehr nahe, und der Vortrieb wird mit einem Flossenantrieb erreicht.

Es kommt zum einen eine Struktur zum Einsatz, wie man sie in der Schwanzflosse vieler Fische findet, und zum anderen wird ein fluidischer Muskel verwendet. Die Struktur (Fin Ray Effect®) besteht aus einer alternierenden Zug- und Druckflanke, die mit Spanten verbunden ist, und wurde von Leif Kniese entwickelt.

Der Fluidic Muscle ist ein Produkt von FESTO und ist im Prinzip ein Schlauch aus Elastomer mit eingewobenen Aramidfasern. Wird der Fluidic Muscle mit Druckluft befüllt, wird dieser im Durchmesser größer und in der Länge kürzer.

Auch die Austarierung im Wasser gelingt dem *Airacuda,* wie seinem natürlichen Vorbild, mit Hilfe einer Luftblase. Im Inneren befindet sich ein Hohlraum, der mit Wasser geflutet oder mit Luft befüllt werden kann. Ein Drucksensor ermittelt die Tiefe und gibt ein Signal an die Elektronik, die dann entsprechende Ventile öffnet und die Kammer mit Vakuum oder Druckluft versorgt.

Die Luft ist mit 300 bar Druck in einer Flasche gespeichert. Für die gesamte Dauer des Einsatzes von bis zu 35 Minuten werden ca. 400 Liter komprimierter Luft von elektronisch ferngesteuerten Ventilen gezielt an die fluidischen Muskeln abgegeben. Bei 6 bar Druck verkürzen sich diese um bis zu 20 Prozent und bringen so die Struktur in Bewegung.

Alle Elektronik- und Pneumatikkomponenten sind wasserdicht im Inneren des Kopfes untergebracht. Die Struktur ist mit einer Haut aus Silikon eingekleidet. Die Flosse und der Kopf sind mit modernster Technik gefertigt. Die am CAD konstruierte und gestaltete Form ist komplett von computergesteuerten Maschinen gefertigt. Mit hoch technisierter Lasersintertechnologie ist diese komplexe Form ohne menschliche Handarbeit entstanden.

Aus dem Englischen von Bernhard Dietz

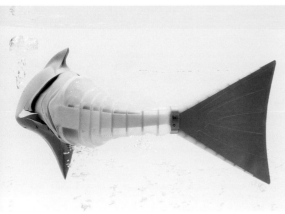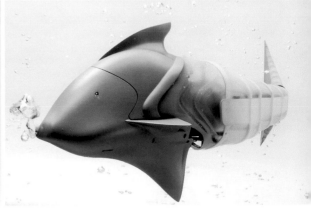

Foto: Walter Fogel

Technische Daten
Länge: 100 cm; Breite: 28 cm; Höhe: 45 cm; Gewicht: ca. 4 kg
Material Kopf, Struktur und Schwanzflosse: Polyamid, lasergesintert
Material Haut: Silikon
Antrieb: 4 Fluidic Muscles, ø 5 mm, Prototyp,
Druckluftspeicher: 1,5l, 300 bar

Projektinitiator: Dr. Wilfried Stoll, Aufsichtsratsvorsitzender der Festo AG
Projektteam: Dipl.-Des. Elias Maria Knubben, Dipl.-Ing. (FH) Markus Fischer, Festo AG & Co. KG
Membrantechnologie: Bernd Lorenz, Dipl.-Ing. (FH) Achim Schanze, Walter Harrer, Festo AG & Co. KG
Elektronikentwicklung: Dipl.-Ing. (FH) Walter Suchy, Dr.-Ing. Otto Szenn, Festo AG & Co. KG
Modellbau: Christoph Altekamp, Matthias Kübler, Stuttgart
Fin Ray Effect®: Leif Kniese, Evologics GmbH, Berlin

Biographies

Marko Ahtisaari (FI). Recently appointed to be Director of Design Strategy for Nokia. He studied economics, philosophy and musical composition at Columbia University, New York City, where he subsequently lectured in logic, philosophy of economics, and the history of thought. Prior to working at Nokia, he developed mobile applications for major clients at the design consultancy Satama Interactive. Marko continues to make music, and was awarded a Grammy Showcase Award for new artists.

Paola Antonelli (IT/US) joined The Museum of Modern Art in 1994 and is the Acting Chief Curator of the Department of Architecture and Design. Her most recent show was *SAFE: Design Takes On Risk*, devoted to objects designed to protect the body and the soul, of people worldwide. Paola Antonelli has curated several architecture and design exhibitions in Italy, France, and Japan. She has lectured on design and architecture in Europe and the United States and has served on several international architecture and design juries.

Takafumi Aoki (JP), born in 1983, received the Bachelor of Science at the Department of Information Science of Tokyo Institute of Technology. He was member of Sato & Koike Group, Precision and Intelligence Lab, Tokyo Institute of Technology and he received the GIFU VR Award at the International collegiate Virtual Reality Contest (IVRC) in 2004. His works were presented at Siggraph.

Burak Arikan (US) recently completed his master's degree in the Physical Language Workshop at the MIT Media Laboratory. While at MIT, he pursued research exploring systems that address the transition from connectivity to collectivity in the context of creative expression. His current work is focused on building platforms for artists and designers that enable collectivity based on composing distributed electronic objects over the Internet. Prior to attending MIT, he worked as an information architect and visual designer in the United States and Turkey. He received a Master of Arts degree in Visual Communication Design from Istanbul Bilgi University in 2004, and a Bachelor of Science degree in Civil Engineering from Yildiz Technical University in 2001.

Charles Armirkhanian (US), born in 1945, is widely known for his live and taped works utilizing speech (or sound poetry) elements in rhythmic patterns resembling percussion music. From 1969 to 1992 he was Music Director of KPFA Radio (Berkeley, CA). From 1993–1997 he was Executive Director of the Djerassi Resident Artists Program (Woodside, CA). Currently he is the founding Artistic Director of the Other Minds Festival of avant-garde music in San Francisco.

Robert Ashley (US), born in 1930, is known for his work in new forms of opera and multi-disciplinary projects. In the 1960s, Ashley organized Ann Arbor's legendary ONCE Festival and directed the ONCE Group. During the 1970s, he directed the Center for Contemporary Music at Mills College, toured with the Sonic Arts Union, and produced and directed Music with Roots in the Aether, a 14-hour television opera/documentary about the work and ideas of seven American composers. Ashley wrote and produced numerous operas that have toured throughout Europe, Asia and the United States.

Assocreation (AT), established in Vienna in 1997, Assocreation sees itself as an individual whose agents act anonymously. The group confronts the public with the way modern human beings relate both to the space around them and the ground beneath their feet. Their work features a number of body-related projects presented at Ars Electronica, at the Bienal de Valencia, at Jack the Pelican Gallery in Brooklyn, at Kunsthalle Wien-project space, as well as in the streets of New York, Warsaw, Zurich, Copenhagen, Paris and other cities.

Alexander Baratsits, Radio FRO (AT), involved in Community Radio since 1991. 1995 together with Johanna Dorer publication of "Radiokultur von Morgen". 1995–2001 Chairperson of the Association of Free Radios Austria. 1997–2002 CEO of Radio FRO, Linz. Concepts, production and publication of various projects in the fields of free media, media art and intercultural art (Festival der Regionen 1999, 2001), Ars Electronica Festival (1995, 1998–2002, 2005).

Aram Bartoll (DE), born in 1972, has lived in Berlin since 1995. He studied architecture at the Berlin University of the Arts. Since his graduation in 2001, he has worked as a free-lance artist; major areas of activity: locative media, game art and screens. He also develops concepts in the fields of interactive media and mobile communications for private-sector and institutional clients.

David Behrman (AT/US), born in 1937, holds degrees from Harvard and Columbia and produced the Music of Our Time series for Columbia Records in the 1960s. He is the co-founder of the Sonic Arts Union and toured with the Merce Cunningham Dance Company in the 1970s and 1990s. Behrman served as co-director for the Center for Contemporary Music at Mills College (1975–1980), taught at Ohio State University and C.A.L. Arts, and designed children's computer games at Children's Television Workshop. Many of his sound installations can be played by non-professionals at international museums.

Walter Bender (US) is a senior research scientist and director of the Electronic Publishing group at MIT Medialab; he also directs the Gray Matters special interest group, which focuses on technology's impact on the aging population. In 1992, Bender founded the News in the Future consortium and has been a member of the Lab's SIMPLICITY, Things That Think, and Digital Life consortia. Walter Bender is currently president for software and content development of *One Laptop per Child*, a not-for-profit association that is developing and deploying technologies that will revolutionize how the world's children engage in learning. Before taking his leave of absence from MIT, Bender was executive director of the MIT Media Laboratory, and holder of the Alexander W. Dreyfoos Chair.

Nicoletta Blacher (AT), born in 1965; studied theater, psychology, philosophy and German language and literature; has worked since 1998 conceiving cultural and artistic projects, in PR and culture management in Vienna, Berlin and Paris, including establishing and directing the Österreichischer Kultur-Service; since 2005, director of the Ars Electronica Center Linz-Museum of the Future.

Wolfgang Blau (DE/US) (aka W. Harrer) is an independent journalist in San Francisco. He writes for ZDF, *Deutsche Welle* and *Technology Review* and consults various media companies. In 1999, he initiated *Audio-WELT*, the first online audio-portal of a European daily newspaper. In 2004, he started the first podcast of a German media company at ZDF and *Deutsche Welle.*

Gerhard Blechinger (DE/CH), born in 1964, is Vice Rector of the University for Art and Design in Zurich Switzerland (HGKZ), responsible for Research and Development in the field of art, design and media technology. Recent projects include new media formats for 3G handheld devices and mobile security. From 1998 to 2000 he was Vice Director of the Media museum and Director of the Media lab at the Center for Art and Media in Karlsruhe, Germany. In 1996 he received his PhD in Aesthetics and Theory of Design from the University of Wuppertal, Germany.

Jonathan den Breejen (NL), born in 1974. Lives and works in Enschede. Den Breejen's background lies in the field of the Media Arts and Media Technology. He is currently developing multiple non-luminescent display systems.

Andreas Broeckmann (DE), lives and works in Berlin. From 2000–2006 he has been the artistic director of transmediale-festival for art and digital culture Berlin. Since 2005 he has also been one of three artistic directors of TESLA-Laboratory for Arts and Media in Berlin. Andreas studied art history, sociology, and media studies and is currently organizing "re·place 2007", The Second International Conference on the History of Media Arts, Sciences and Technologies.

Sheldon Brown (US) is Director of the Center for Research in Computing and the Arts (CRCA) at the University of California at San Diego (UCSD) where he is a Professor of Visual Arts and the head of New Media Arts for the California Institute of Telecommunications and Information Technologies (Cal-(IT)2). As an artist, he is concerned with overlapping and reconfiguring private and public spaces.

Ludger Brümmer (DE), born in 1958, studied composition with Nicolaus A. Huber and Dirk Reith at the Folkwang Hochschule Essen. He received a scholarship from DAAD to attend the Center for Computer Research in Music and Acoustics at Stanford University in California from 1991–1993. He was Research Fellow at Kingston University London from 2000 and Professor for Composition at the Sonic Art Research Centre in Belfast from 2002. He has headed the Institute for Music and Acoustics at the Center for Art and Media (ZKM) Karlsruhe since 2003.

Bill Buxton (CA/UK) is a designer and a researcher concerned with human aspects of technology. His work reflects a particular interest in the use of technology to support creative activities such as design, film making and music. Buxton's research specialties include technologies, techniques and theories of input to computers, technology mediated human-human collaboration, and ubiquitous computing. From 1994–2002, he was Chief Scientist of Alias|Wavefront,(now part of Autodesk) and from 1995, its parent company SGI Inc. In 2005, he was appointed Principal Researcher of Microsoft Research. Buxton is an Associate Professor in the Department of Computer Science at the University of Toronto.

Gary Chang (CN), born in 1962, graduated from The University of Hong Kong in 1987 with a degree in Architecture. He founded his company EDGE in 1994. Chang has won many awards in Asia and across the globe for his architectural, interior and product designs. *The Suitcase House* at the Commune by the Great Wall, *Kung-Fu Tea Set* for Alessi and Gary's own Apartment in Hong Kong are the representative projects among his designs. He was among the first group of representatives from Hong Kong to be invited to participate in the International Biennial Exhibition of Architecture, Venice in 2000 and 2002. Chang lectures around the world and has published a series of literary and academic works.

Jenny Chowdhury (US) aka JennyLC, is a new media artist whose work explores the use of cell phones as social props. Typically in humor tinged fashion, her projects call attention to how cell phone technology has altered the ways in which people communicate with each other and their surrounding environment. JennyLC holds a degree in Electrical and Biomedical Engineering and is currently working towards her Masters at NYU's Interactive Telecommunications Program (ITP).

Corebounce (CH) Art Collective. The activities of Corebounce Association fall between art and science. It is their goal to consolidate research results in computer science in the creation of new and modern tools for today's hybrid arts and artists. The initiators and main members of Corebounce Association are Pascal Müller, Dr. Stefan Müller Arisona, Dr. Simon Schubiger Banz, and Matthias Specht. They perform regularly at electronic music events and art festivals nationally and internationally. *http://www.corebounce.org*

David Cuartielles (ES/SE) is one of the main advocates of Interactive Prototyping, the discipline dealing with the realization of prototypes including technologies that require intentional human action for the performance of tasks. His work has focused in the creation of interactive pieces, but also in the design of tools for others to create interactive pieces.

Philip Dean (FI) graduated from the London School of Printing, London Institute, in 1981 with a degree in Photography, Film and Television. He moved to Finland to pursue postgraduate studies in 1982 at the University of Art and Design, department of Photographic Art. In 1993 Dean was appointed to lead the planning and development of a new department in the University of Art and Design Helsinki, the Media Lab, of which he has been Director for 11 years.

Markus Decker (AT), born in 1972, lives and works in Linz, Austria. He works with all kinds of electronic media, electronic audio-digital and analog.

Marenka Deenstra (NL), born in 1977; lives and works in Utrecht. Marenka studied both Industrial Product Design and Media Technology. She currently works as Product Designer in Utrecht.

Johannes Deutsch (AT), born in 1960, painter and media artist; studied at the Polytechnic College for Graphic Arts in Linz (1975–80) and did postgraduate work at the Institute for New Media at the Städel School in Frankfurt (1990–92); numerous one-man shows including exhibitions at the Museum of Modern Art in Vienna (1992), the Bonn Art Museum and the Frankfurt Art Association (both in 1998); participant in exhibitions at the New Berlin Art Association (1994) and the Ludwig Museum in Cologne (1999 and 2000). Among his interactive VR projects are three produced in cooperation with the Ars Electronica Futurelab: *Gesichtsraum, Rheingold-Visionized* and *Vision Mahler.*

Gerhard Dirmoser (AT), works in Linz as a systems analyst (spezializing in geographical information systems) and has also been dealing with semantic networks for over 15 years. He has produced studies in network concerned with cybernetic aesthetics, structuralism, French philosophy, art in context, terms of thinking, verbs, atmospheric concepts, design gestures, mapping issues, and the history of Ars Electronica. In collaboration with Josef Lehner, he conceived the SemaNet tool and, together with Grintec, developed the WiLa application module for the depiction of semantic networks.

Jorn Ebner (DE / UK), born in 1966; artist; lives and works in Newcastle upon Tyne and Berlin; studied art at Central Saint Martins, London (1995–98) and English literature at the University of Hamburg (1990–95); recipient of the Art Prize of the Medienforum München in 2001 for an Internet project entitled *Lee Marvin Toolbox;* 2006 exhibitions: "Landschaft (Komponenten)," KX, Hamburg, and "Ordinary Monuments," Vane, Newcastle.

Empfangshalle (DE). Empfangshalle (Corbinian Böhm, born1966, and Michael Gruber, born 1965) doesn't work in hermetic art spaces; instead, it conceives itself as a space in its own right amidst the public sphere, a discrete display that links up with its viewers or overlays them. Infrastructural interventions make invisible or unconscious elements discernible. The definition of Empfangshalle's art is a derivative of its interaction with society. These projects are temporarily, precisely staged events that operate with elements of randomness: garbage men on a trip around the world, church steeples out of water. *http://www.Empfangshalle.de*

Martin Frey (DE), born in 1978; interaction and interface designer; 2003: awarded polytechnic college diploma in communications design; 2006: graduated cum laude from the Berlin University of the Arts.

John Gerrard (IRL), born 1974, is an artist whose varied works investigates the emotional possibilities of digital technologies, creating works which question our identities, our relations to each other and towards the physical environment. His sculptures frequently hinge on the new temporal and experiential possibilities to be found in real-time 3-D. See *http://www.johngerrard.net.* In 2004 he completed a long term artists' residency in the Ars Electronica Futurelab.

Olga Goriunova (USSR/FI), born in 1977, is a new media researcher, organizer, writer, and lecturer. She is a co-maker of the Readme software art festival series (Moscow 2002, Helsinki 2003, Aarhus 2004, Dortmund 2005), editor of related publications, and a co-organizer of *Runme.org* software art repository. Author of numerous articles on new media art and culture, she has also taught in many educational media institutions in Russia, Kazakhstan, Moldova and has lectured world-wide. She is currently a Ph.D. researcher in Media Lab, University of Industrial Arts and Design, Helsinki, Finland. *http://runme.org*

The Graffiti Research Lab (US) is dedicated to outfitting graffiti writers, street artists, and protesters with open source technologies for urban communication. The goal of the G.R.L. is to technologically empower individuals to creatively alter and reclaim their surroundings from unchecked development and corporate visual culture. During 2006, the G.R.L. toured across the globe demonstrating and teaching new graffiti technologies and DIY skills to diverse public audiences, working with writers and street artists like Mark Jenkins, ABOVE and BORF. Their work has been featured in alternative and mainstream news sources such as the *New York Times, Wooster Collective, TIME Magazine, Visual Resistance* and *The Village Voice.*

Sam Hecht / Industrial Facility (UK). Industrial Facility is a design office formed by designer Sam Hecht, and architect Kim Colin in 2002. Industrial Facility has since developed projects for companies such as Epson Japan, Droog, Magis, Panasonic, Harrison Fisher, Whirlpool, KitchenAid and Muji. With Muji, Sam Hecht holds the position of creative adviser for Europe and retained designer for Japan. His belief is in the importance of design as a means of simplifying our lives in an inspirational way. The studio achieves this by following a rigorous path of investigation and analysis, and has been well documented, with over 30 international awards. His work forms part of the permanent collections of the MoMA, New York; The Centre Pompidou, Paris; The State Museum of Applied Arts, Munich; the Museum Für Angewandte Kunst, Frankfurt; and the Israel Museum, Jerusalem. *www.industrialfacility.co.uk*

Andrew Hieronymi (CH/US). His recent work focuses on the boundaries between games and art in physical environments. In 2005 he received an MFA from the Design|Media Arts department at UCLA, Los Angeles. In 1998, Hieronymi received a BFA from École Superieure des Beaux Arts, Geneva. Hieronymi's work has recently been shown at "Future Play" (Michigan), "Microwavefest" (Hong Kong), "Media_city" (Korea), FILE (Brazil), "Chiangmai" (Thailand), and "CTheory" (New York).

Taylor Hokanson (US), born in 1978, lives and works in Chicago. Hokanson's work probes the conceptual issues of text and writing through sculpture and installation. Hacked electronics, microprocessor control, and general technophilia characterize his oeuvre. Current research involves computer-controlled fabrication techniques and their effect on authorship, craft, and the value of art. *www.taylorhokanson.com*

Philipp Hoppe (DE) is a student of architecture at RWTH Aachen, Germany. From 2004 to 2005, he studied philosophy in Rio de Janeiro, Brazil. He did a theoretical project about situationist architecture and is currently working on a project investigating space as an immersive medium that interacts both physically and informationally with its users. Interested in virtual dimensions of urban environments, in 2005 he teamed up with Kai Kasugai to create *denCity.net*.

Horst Hörtner (AT) studied telematics at the Technical University in Graz. He has worked on developing real-time control systems and on art projects. He is the co-founder of x-space and has worked for the Seville EXPO, documenta IX, austro-mir and others. Since 1995 he has been directing the Ars Electronica Futurelab.

Rupert Huber (AT), born in 1967, is a composer and a musician. Composing music takes place in time, but also in space. Electronic music allows the composer to combine real spaces, or to create a musical space that is transferred into the listener's head. Rupert Huber has received commissions for musical compositions from the Centre Pompidou, Wiener Festwochen and Ars Electronica, and his Tosca project album is available worldwide. He is currently working on music for piano in unusual locations.

Naut Humon (US) is the director of operations for the RECOMBINANT MEDIA LABS, in San Francisco. This network of A/V based actions houses the surround Traffic control Cinesonic system for performance exhibitions and international residencies. He is also producer and curator for the Asphodel label along with his own projects for speaker-screen installations.

HyperWerk (CH) was founded in 1999 at the FHBB Polytechnic College in Basel as a pilot project: a radically experimental, interdisciplinary course of study in the design of interactive forms of education and work. In 2006, it became a department of the Basel University of Art and Design's Institute for Postindustrial Design, where 120 HyperWerkers are BA candidates undertaking joint forays into the gentle art of process design. *http://hyperwerk.ch*.

1nOut (Robert Praxmarer, Reinhold Bidner, AT) is an artist collective that works both collaboratively and individually on a variety of video and interactive art projects with a focus on generating synaesthetic experiences. The artists mix analogue and digital processes in their work to achieve a perfect aesthetic blend which can be understood as a reflection upon all of our lives. Cross-disciplinary by nature, their approaches reach from a self programmed real-time video montage system based on Praxmarer's ongoing PhD work to the charming photo stills and composed video works from Bidner.

Tsuneku Ipp (JP / AT) is a master of the art of origami, which she has practiced in Austria since 1988. Tsuneku Ipp has held numerous origami workshops and spoken extensively on the subject. Her own works have been featured in many exhibitions—for instance, in Vienna's Museum of Applied Arts.

Toshio Iwai (JP), born in 1962. Graduated from the Plastic Art and Mixed Media master's course at the University of Tsukuba. Produced experimental animation as a student, and then moved to creating works with computers. Has presented interactive and other works at numerous museum exhibitions within Japan and abroad. In 1997 won the Golden Nica at Ars Electronica for his performance with Ryuichi Sakamoto. Wide-ranging activities include television programs and collaborations with musicians. Recently released *Electroplankton* for Nintendo DS and is working on *TENORI-ON* with Yamaha Corp. Currently continues to expand the field of media art expression into public space, game machines, and product development.

Yukie Kamiya (US) is Adjunct Curator at the New Museum of Contemporary Art, New York. She has curated exhibitions in North and South America, Europe and Asia, including "Adaptive Behavior" at the New Museum of Contemporary Art, 2004. She has also contributed numerous texts to catalogs and to periodical publications.

Kai Kasugai (DE) studied architecture at RWTH Aachen, Germany and the Edinburgh College of Art, UK. He graduated 2006 in Aachen. During his studies, he worked for various departments, the longest time at the department for Computer Aided Architectural Design (CAAD) where he helped programming the PHP/mySQL-driven student and faculty administration platform. Taking special interest in the intersections between software and architecture, in 2005 he teamed up with Philipp Hoppe to analyze the potentials of virtual social networks within cityscape and urban planning.

Nicole Knauer (DE), born in 1967, studied graphic and communications design in Munich and visual arts in Linz. As a visual artist whose emphasis is on artistic conception, Nicole Knauer works primarily in the field of art and interventions in public spaces, as well as in video and photography. Another important facet of her work-both as an artist and as a curator-is critically calling into question sociopolitical conditions through participatory approaches that are initiated as multi-layered, interdisciplinary interface projects.

Jason Kottke (US) designs, codes, and writes for the web, with a special interest in clear, simple, user-centered design, microcontent, and the writable web. Jason has maintained the popular and influential weblog *kottke.org* since March 1998, writing about web technology, photography, media, design, the writable web, and rip/mix/burn culture. He calls New York City home.

Robert Kovács (HU/AT) plays the world-renowned Bruckner Organ at the St. Florian Monastery in Upper Austria and is first organist of the Tonkünstler Orchestra. He began taking piano lessons at the age of five and added the organ to his repertoire at 11. He completed his musical studies at the Budapest Conservatory and won 1st Prize at the Hungarian Festival for Young Organists. At the former Hochschule für Musik in Vienna, Kovács studied sacred music and the organ as a concert instrument under Hans Haselböck and Peter Planyavsky. Robert Kovács graduated cum laude and received an award of recognition from the Austrian Federal Ministry of Education, Science and Culture.

Ryoichi Kurokawa (JP), born in 1978. In 1999, started creating video and sound works and presenting audiovisual work, video installation, and screening in various art, music and film festivals. At the same time, started performing audiovisual live and released CDs and DVDs. Also performed live-visual for the group Sketch Show- former YMO (Yellow Magic Orchestra) members, Haruomi Hosono + Yukihiro Takahashi-at the Sonár Festival, Barcelona and Cybersonica/ICA, London and for *Human Audio Sponge* (Sketch Show + Ryuichi Sakamoto) at the Sonár 2004 Festival. Kurokawa's projects and audiovisual concerts have been presented internationally.

Kumiko Kushiyama (JP) is a student of the Japan Electronics College and is currently working together with PRESTO/JST on her new project *Thermoesthesia* presented at the Ars Electronica Center.

Veronika Leiner, Radio FRO (AT) Studied German and Spanish literature and linguistics in Salzburg, Seville and Dublin. Postgraduate in Cultural and Media Management. Working with Community Radio since 1999, concepts and production of various free media and cultural projects (Festival der Regionen 2003, 2005, Ars Electronica Festival 2004, 2005), 2004–2006 CEO of Radio FRO, the free non-commercial radio station in Linz, Austria and board member of the Association of Free Radios Austria. Now working for the Association of Free Radios Austria.

Golan Levin (US) explores the intersection of abstract communication and interactivity. Through performances, digital artifacts, and virtual environments, often created with a variety of collaborators, Levin applies creative twists to digital technologies that highlight our relationship with machines and make visible our ways of interacting with each other.

M + M (Marc Weis and Martin de Mattía, DE) works in the interstice between visual arts and film. The artistic duo carries out interventions-that occasionally come across as rather bizarre-in network-linked spheres of life such as the telephone system. Their focus is on new cinematic forms of narration. M+M's work has been featured at numerous solo and group exhibitions and screenings including shows at the Musée d'Art Contemporain in Montreal, the Museum für Fotografie in Berlin, Videonale 10 in the Kunstmuseum Bonn, and the ZKM in Karlsruhe.

Thomas Macho (AT/DE) is professor of cultural history at Humboldt University in Berlin. His doctoral dissertation written at the University of Vienna in 1976 is entitled *Dialectics of Musical Works of Art*. His postdoctoral thesis in philosophy entitled *On the Metaphors of Death. Phenomenology at the Limits of Experience* was written in 1983 in Klagenfurt. Macho is co-founder of the Hermann von Helmhotz Center for Cultural Technology and, since 2006, head of the Department of Philosophy III at Humboldt University in Berlin.

John Maeda (US) is a world-renowned graphic designer, visual artist, and computer scientist at the MIT Media Lab, and is a founding voice for "simplicity" in the digital age. Named by *Esquire* magazine as one of the 21 most important people for the twenty-first century, Maeda first made his mark by redefining the use of electronic media as a tool of expression for people of all ages and skills. A faculty member at the Media Lab since 1996, Maeda holds the E. Rudge and Nancy Allen Professorship of Media Arts and Sciences, and co-directs the Lab's design-oriented Physical Language Workshop and its SIMPLICITY consortium. He has had major exhibits of his work in Paris, London, New York, and Tokyo, and has written several books on his philosophy of "humanizing technology" through his perspective on the digital arts. Maeda received both his BS and MS degrees from MIT, and earned his PhD in design from Tsukuba University Institute of Art and Design in Japan. (Copyright 2006, Massachusetts Institute of Technology and John Maeda)

Philippe Manoury (FR/US), born in 1952, began his musical studies at the age of nine. In 1981 he was invited by the IRCAM to do research. Since then he has consistently participated in the Institute's activities as composer and teacher. In collaboration with the mathematician Miller Puckette he has conducted research involving the interactions in real time between acoustic instruments and the new techniques linked to musical data processing. This work led to an interactive cycle of pieces for various instruments. Since late 2004, Philippe Manoury has been living the United States where he teaches at the University of California at San Diego.

Pascal Maresch (CH/AT) studied journalism, communications and art history at the Paris Lodron University of Salzburg, Austria. In 1998, he joined the staff of the Futurelab, Ars Electronica's media laboratory. Since 2003, he has been working on setting up the Ars Electronica Futurelab's next focal-point area of research: computer-controlled music visualization

Sonja Meller (AT), born in 1971, studied sculpture at Linz University of Artistic and Industrial Design, and Interdisciplinary Social Science with a major in contemporary art at San Francisco State University. She has produced numerous art projects in Austria and abroad dealing with spatial, cultural and social facts and circumstances.

Maki Namekawa (JP/AT) is one of the young musicians who are introducing new works by leading composers into the mainstream of German concert activity. As a soloist and a chamber musician equally at home in classical music and contemporary repertoire, Maki Namekawa appears regularly at major concert venues in Japan and Europe, at international festivals (including the Musik-Biennale Berlin, the Festival Eclat in Stuttgart, Ars Electronica Linz, the Rheingau Festival and the Ruhr Piano Festival), on radio broadcasts and with prestigious orchestras such as the Stuttgart Chamber Orchestra, Bruckner Orchester Linz, Munich Philharmonic and Concertgebouw Orkest Amsterdam.

Michael Nyman (UK) musician and composer. In the early '60s he had abandoned composition preferring to work as a musicologist; he became the first to apply the word "minimalism" to music. Back to composition he founded the Michael Nyman Band, the laboratory in which Nyman has formulated his compositional style around strong melodies, flexible yet assertive rhythms, and precisely articulated ensemble playing. His music has reached its largest audience by way of his film scores, most famously for Peter Greenaway. Among his last operas count The Commissar Vanishes, based on David King's book about Stalinist manipulation of photographic documents and the opera Facing Goy (2000), which is a taut thriller taking genetics as its subject matter. Michael's latest venture is the launch of his own record label—MN Records. The label opened in Spring 2005 with 'The Piano Sings' the composer's debut solo piano album.

Klaus Obermaier (AT) is a media artist, director and composer who lives in Vienna and has been working with video and interactive media since the late 1980s. His intermedial performances, compositions and installations have been shown worldwide. In 2006, he has been a guest professor at the IUAV University in Venice, where he teaches new media in stage performances.

Dietmar Offenhuber (AT) graduated in architecture at the TU Vienna and worked as a key researcher at the Ars Electronica Futurelab. In 2004 he received a Fellowship from the Japan Foundation for the IAMAS Institute. From 2004 to 2006 he was professor for animation and interactive media at the University of Applied Sciences in Hagenberg (AT). From Fall 2006 he is researcher at the MIT Medialab.

Karin Ohlenschläger (DE/ES), is an art critic and curator who specialises in contemporary art and new media. She is co-director of the MediaLabMadrid Program at the Conde Duque Cultural Center in Madrid (Spain) and a founding member of the Banquete Foundation. *http://www.medialabmadrid.org, http://www.banquete.org*

Tsuyoshi Ozawa (JP). His activities are multi-faceted and spread across various domains, culturally and geographically. It's a constantly opening and shifting world. It is, however, also a world in itself. In Tsuyoshi Ozawa's work, one can never ignore an immensely important aspect: political commitment. His work clearly involves critical thoughts on issues such as history and reality in geopolitical conflicts. His works were exhibited at Walker Art Center, Minneapolis, 50th International Art Exhibition, Z.O.U. Zone of Urgency, Venice and he had solo exhibitions at Mori Art Museum, Tokyo and at Yvon Lambert, Paris.

Dan Phiffer (US) is a programmer and creative worker from California, currently residing in Brooklyn. As a student at NYU's Interactive Telecommunications Program Dan helps coordinate a weekly tutorial series called Drive-Bys. Dan is most interested in exploring the possibilities and limitations of the web as a medium of creative expression and shared cultural experiences.

Claus Pias (DE / AT), born in 1967; professor of epistemology and philosophy of digital media at the University of Vienna's Department of Philosophy and Pedagogy; 2006: visiting fellow at Vienna's IFK-International Research Center for Cultural Studies.

James Powderly (US) has a masters degree from NYU's ITP program and comes to Eyebeam from Honeybee Robotics where he worked as the director of technology development and an engineer from 2002. At Honeybee, James developed technology for NASA's Mars rover that is currently on the surface of the red planet, and engineered an installation for the Architects Diller + Scofidio that was shown at the Whitney Museum of American Art. James has previously worked at Eyebeam as an artist in residence, he is a partner in RobotClothes, and the co-founder of the Robotics Society of America New York City Chapter.

Carlo Ratti (US) is a civil engineer and architect who teaches at the Massachussetts Institute of Technology, where he directs the SENSEable City Laboratory. He is also a founding partner of the architecture office carlorattiassociati-Chiara Morandini, Walter Nicolino, Carlo Ratti.

Regrets (Jane Mulfinger, US; Graham Budgett, US), both artists and faculty members of the University of California, Santa Barbara, have exhibited widely in the public arena and in commercial galleries including: Camden Arts Centre; St. Pancras Station; The British Library; The Victoria & Albert Museum; The Photographers' Gallery & the Mayor Gallery, London; Künstlerhaus Bethanien, Berlin; Projects UK, Newcastle; Franklin Furnace Archive, New York; Orchard Gallery, Derry; Ben Maltz/Otis Gallery, Los Angeles; and Pasadena Armory Center for the Arts.

Maren Richter (AT) is a curator and author as well as a project developer in the visual arts field for Linz 2009—European Capital of Culture. Among the recent exhibitions she has curated are: "Wayward Economy," Maintrend Gallery Taipei, 2005; "Micronation Travelling Agency" partner project, Transmediale 2006, Berlin; "Wrong(ed) Attitude," Sparwasser HQ/Berlin, 2006; "Naked Life," MOCA Taipei, 2006.

Luis Rico (ES) is an artist and cultural producer who specializes in transdisciplinary cultural projects that bring together artistic, scientific, technological, and social practices. He is co-director of the MediaLabMadrid Program at the Conde Duque Cultural Center in Madrid (Spain) and a founding member of the Banquete Foundation. *http://www.medialabmadrid.org, http://www.banquete.org*

Christopher Romberg (CH), born in 1976, BA (Hons); graduated from high school in Feldkirch, Austria; exhibition technician at Kunsthaus Bregenz and the Generali Foundation, Vienna; studied product & furniture design at the New Design Centre St. Pölten and Kingston University, London; recipient of an Award of Recognition in the Miele Design Competition; EOOS Design Bureau staff member; freelancer since 2005.

Evan Roth (US) is a recent MFA graduate from the Design Technology department at Parsons where he was his class valedictorian. He is the creator of *Graffiti Analysis* (video), a project that uses motion tracking, computer vision technology, and a custom C++ application to record and analyze a graffiti writer's pen movement over time. Evan's media experiments also include *Explicit Content Only, Postal Labels Against Bush,* and *Graffiti Taxonomy.*

Dennis Russell Davies (US/AT) studied piano and conducting at the Juilliard School in New York. Following chief conductor stints in St. Paul, Stuttgart, Bonn and Vienna as well as appearances at the Bayreuth and Salzburg festivals, he has been chief conductor of the Bruckner Orchester Linz since 2002 and Professor of Orchestral Conducting at the Mozarteum Conservatory in Salzburg. He also works regularly with many other ensembles, including the Concertgebouw Orkest Amsterdam, the Gewandhausorchester Leipzig, the Münchner Philharmoniker and the orchestra of the Opéra National de Paris.

The Sancho Plan (UK) are an award-winning collective that produce live audiovisual performances, experimental musical animations and interactive audio toys. Their AV works explore the real-time interaction between music and video and its potential for narrative and storytelling. Through the careful combination of animation, sound, music and technology, The Sancho Plan create fantastical worlds in which animated musical characters are triggered by a variety of electronic drum pads. Their creative output has been shown in clubs, festivals, cinemas, theatres and on television and computer screens around the world. The Sancho Plan are presently working with AV pioneers Coldcut to develop a series of interactive musical toys, scheduled for commercial release in 2007.

SCAPHA (Hilke Fährmann, DE; Jürgen Schneider, DE). Hilke Fährmann is an actress and integral dance and expression therapist ITA and Jürgen Schneider is a percussionist and composer. Both work together in the legendary Scapha Performances, where they are both players and actors at the same time.

Susanne Scheel (DE) studied film and television, theater, journalism and communication at Ruhr University, Bochum. Received masters degree with paper "VJing—Musikvisualisierung im 20. Jahrhundert" ("VJing-Music Visualization in the 20th Century") in October 2005. Before and during her studies, she worked in various capacities in the cultural, television and event fields. Most recently curator and organizer of the International VJ Contest at the International Video Festival in Bochum. Currently working as freelance project assistant on "Talking Cities" (an architecture and design exhibition).

Jürgen Scheible (DE/FI) is a researcher, engineer and media artist. He is a PhD candidate at Media Lab, University of Art and Design, Helsinki and a visiting scientist at MIT, USA. In 2006 he became a Forum Nokia Champion for being a bridgebuilder between art & engineering.

Christine Schöpf (AT) studied German and Romance languages. PhD, journalist, since 1981 head of the department art and science at the ORF Upper Austrian Regional Studio, focusing on Ars Electronica and Prix Ars Electronica. Since 1979 in a number of different capacities, key contributions to the development of Ars Electronica. Together with Gerfried Stocker artistic co-director of Ars Electronica since 1996.

Franz Schwabeneder (AT), born in 1942; in 1965, he began working as a journalist for the *Oberösterreichische Nachrichten* newspaper, heading its "Culture and Media" section from 1973 to his retirement in 2003; journalistic activities on book projects include *Die Ars Electronica—Kunst im Zeitsprung* and *Promenade 39—Das Landestheater Linz 1803–2003*; he authored an important part of Linz's application to be named 2009 European Capital of Culture.

Andrew Shoben (UK). In 1993 he founded Greyworld in Paris. Their goal is to create works of art that articulate public spaces, allowing some form of self-expression in areas of the city that people see every day but normally exclude and ignore. They have exhibited work around the world, with permanent installations in 12 countries. Andrew Shoben is a former lecturer at the Royal College of Art, and is a visiting Professor to several universities in the UK and the US. Since 1999, he has been a special advisor to the Arts Council of England (LAB) and has been nominated for a NESTA fellowship. He has recently been invited to host an major arts TV series for broadcast on British television.
http://www.greyworld.org

Christa Sommerer (AT)/Laurent Mignonneau (FR/AT) are internationally renowned media artists working in the field of interactive computer installation. They currently hold positions as Professors for Interface Culture at the University of Art and Design in Linz Austria and at the IAMAS International Academy of Media Arts and Sciences in Gifu, Japan. Descriptions of their works can be found at Christa's homepage: *http://www.iamas.ac.jp/~christa*

SPIRE (Charles Matthews, Christian Fennesz, Philip Jeck), *http://www.spire.org.uk* **Charles Matthews (UK),** born in 1966, studied at the Royal College of Music, London, and at Trinity College, Cambridge, where he was an organ scholar. From 1987 to 1989 he worked almost exclusively as a church organist. Since this time he has pursued a diverse and international career as organist, pianist, composer and teacher. **Christian Fennesz (AT/FR)** uses guitar and computer to create shimmering, swirling electronic sound of enormous range and complex musicality. His lush and luminant compositions are anything but sterile computer experiments. They resemble sensitive, telescopic recordings of rainforest insect life or natural atmospheric occurrences, an inherent naturalism permeating each piece. **Philip Jeck (UK)** born in 1952, studied Visual Arts at Dartington College of Arts, Devon. Began exploring composition using record players and electronics in the early 1980s. Performed solo shows throughout Europe and in Japan and USA. Composed and performed scores for dance and theatre companies. Philip Jeck is best known for his highly subversive work *Vinyl Requiem* with Lol Sargent.

Gerfried Stocker (AT), born in 1964, artistic director of Ars Electronica and media artist. In 1991, he founded x-space, an independent working group of artists and technicians specialized in the realization of interdisciplinary projects. In this framework, numerous installations, performances and exhibition projects have been carried out in the field of interaction, robotics and telecommunications. He has also been responsible for the conception and realization of various worldwide radio network projects. Since 1995, he has been artistic and managing director of the Ars Electronica Center and, since 1996, jointly with Christine Schöpf, artistic director of Ars Electronica Festival.

Ran Tao (US) is an engineer, artist and designer currently working towards a Masters at NYU's Interactive Telecommunications Program (ITP). Her work focuses mainly on enhancing social interaction and taking notice of the ever-changing environment, both physical and virtual, that shapes everyday life. Ran also holds a degree in Electrical Engineering and Computer Science from MIT.

Tmema (Golan Levin, Zachary Lieberman, US). Working since 2002, Tmema develops interactive performances and museum installations, web-based information visualizations, reactive commercial environments, and experimental software systems which meld high-end computation to deeply-rooted sensibilities in human-centered arts and design.

Oliviero Toscani (IT), son of a photo-journalist of the *Corriere Della Sera,* studied photography and design at the Hochschule für Gestaltung in Zurich from 1961 to 1965. He is internationally renowned as the creative force behind some of the world's most successful magazines and brands, including corporate images and advertising campaigns. From 1982 to 2000 he built United Colors of Benetton into one of the world's most recognized brands, giving the company its corporate image, identity and communication strategy, and developing its online presence. In 1990 he conceived, created and directed *Colors,* the world's first global magazine, setting a trend for all new editorial and communications projects; in 1993, he invented, founded, and directed Fabrica, the International center for research in the arts of modern communication. Now he is focusing his creative and communication experience to find new languages for the different medias and he is creating with the institutions a new research center for modern communication.

Bernd Wiemann (DE), born in 1946, is managing director of Vodafone Group R&D Germany in Munich. He is a graduate in measurement and control technology from the University of Applied Science in Furtwangen in southwestern Germany and holds a PhD in computer science from Munich Technical University. In 1992 he became the founding managing director of Mannesmann Pilotentwicklung, which he has headed ever since and which became Vodafone Group R&D Germany in 2001.

Wolfgang Winkler (AT) studied musicology at the University of Graz; since 1998 member of the board of directors and artistic director of LIVA; teacher at the Anton Bruckner Private University Linz, the Johannes Kepler University of Linz and the Salzburg Academy.

Peter Wippermann (DE). Following an apprenticeship as a typesetter and a stint in his father's graphics design studio, he was art director at Rowohlt Verlag and of *Die Zeit's* magazine supplement. In 1988, he (together with Jürgen Kaffer and Peter Kabel) established the Hamburg bureau of the Society for Communications Design. In 1992 in Hamburg, Peter Wippermann and Matthias Horx set up Trendbüro, a consultancy for societal change. In 1993, he was appointed professor of communications design at the University of Essen. He and Horst Wackerbarth founded the Stiftung Akademie Bildsprache foundation in 1999. Wippermann specializes in communication strategies for trend-driven brand management. He attempts "to identify market opportunities that result from society's longings." His objective is the "emotional design" of products and services. The expression "Ich-AG" (Me, Inc.) has been attributed to him.

Mushon Zer-Aviv (IL) is an Israeli designer, a media activist and a net artist. He is the co-founder of *ShiftSpace* (.org)-a new Open Source platform seeking to extend the current borders of the web and to allow the creation of public spaces within it. For this, Mushon has recently won the Swiss Projekt Sitemapping new media grant. Mushon is a new media lecturer at the Shenkar college in Tel Aviv and is the co-founder of *Shual* (.com) design studio. He has curated the BD4D Tel Aviv and the *Upgrade!* Tel Aviv New Media events series. Mushon currently lives with his wife and cat in New York, studying for his masters degree in ITP, NYU's new media program.

Tobias Zucali (AT), born in 1980, BA (Hons); received training at the HBLA for Artistic Design, Linz; studied interior design at the New Design Centre St. Pölten and Kingston University, London; currently enrolled in the masters program in interface culture at the UFG Linz; co-creator of *Monument in Motion* (Anton Pustet Verlag), an animated film about architecture.